University of Wales

Centre for Advanced Welsh

and Celtic Studies

———————————

THE VISUAL CULTURE OF WALES

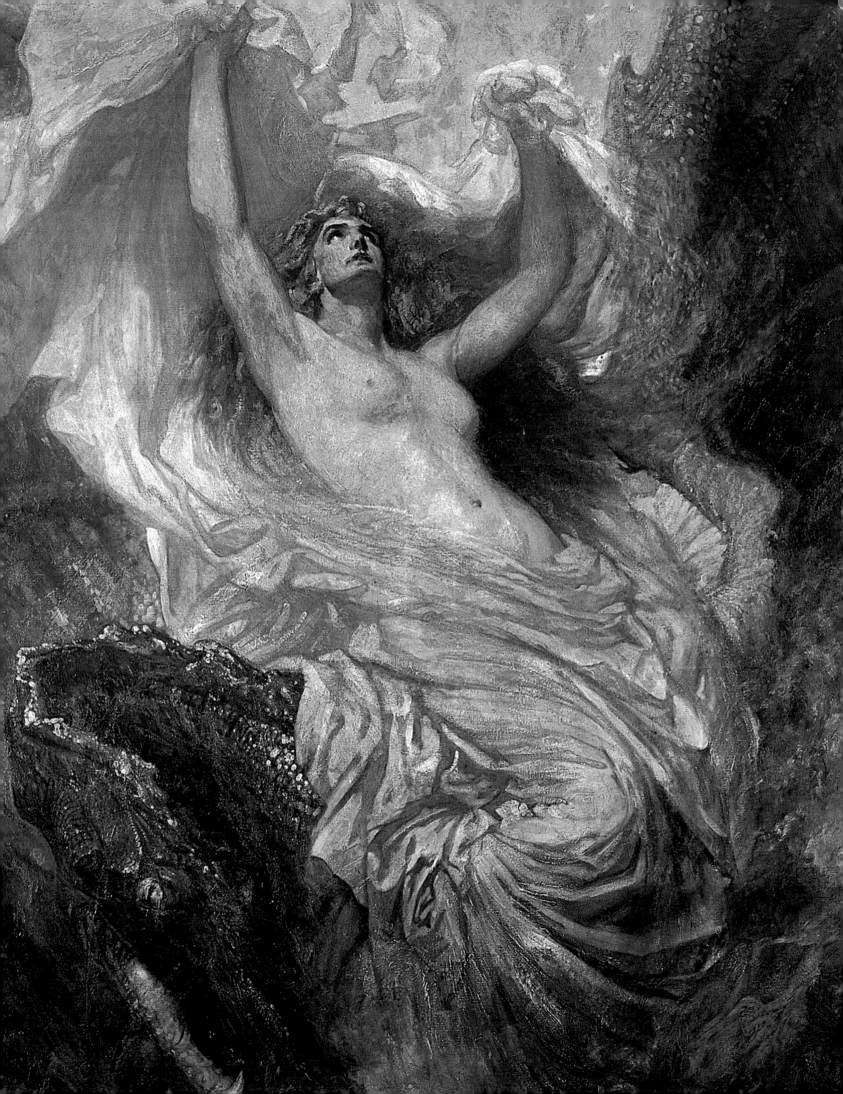

THE VISUAL CULTURE of WALES:

Imaging the Nation

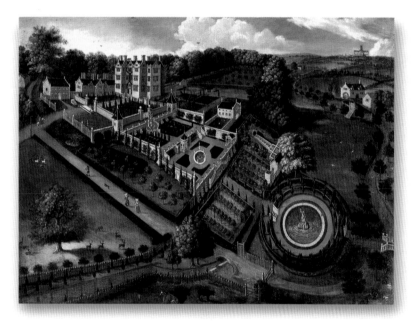

Peter Lord

UNIVERSITY OF WALES PRESS, CARDIFF

2000

THE VISUAL CULTURE *of* ❧ WALES

General Editor: Geraint H. Jenkins
Designer: Olwen Fowler

© University of Wales, 2000

Printed in Wales by
Cambrian Printers, Aberystwyth

**British Library
Cataloguing-in-Publication Data**
A catalogue record for this book is available from the British Library.

ISBN 0–7083–1587–9

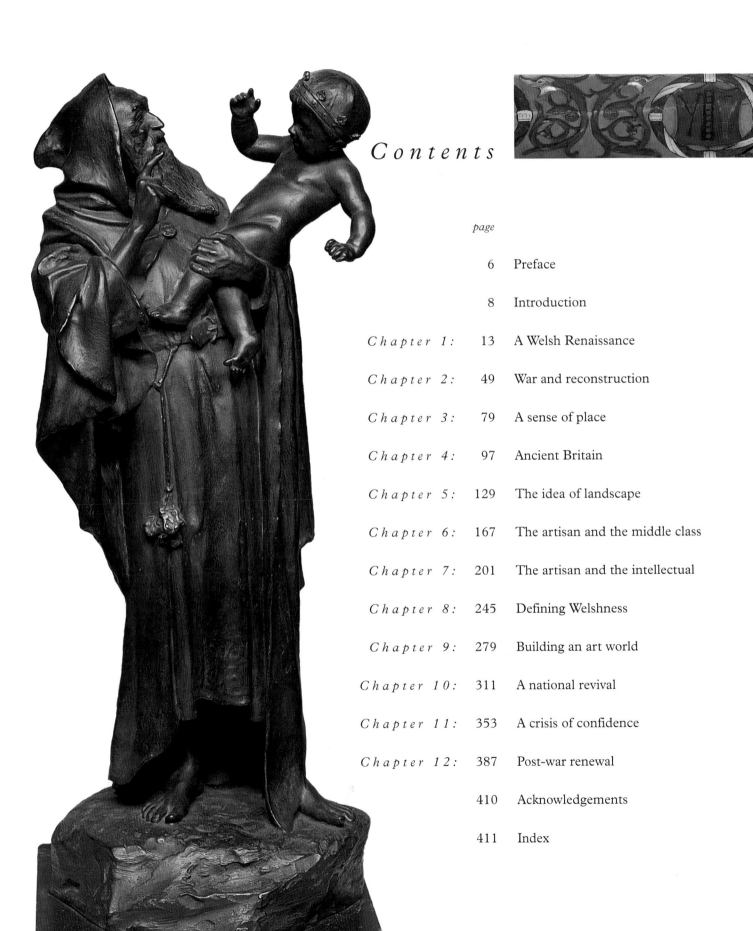

Contents

PREFACE

In an article entitled 'The University of Wales and Art', published seventy-five years ago, Edmund D. Jones, headmaster of Barmouth County School and an ardent champion of the arts, claimed that it lay within the power of the national University 'to enrich and broaden the culture of the entire nation' by cultivating interest in the artistic heritage of Wales. Despite this impassioned plea, the history of the artistic culture we have lost was not seriously addressed. However, it is extremely gratifying that, at the dawn of the third millennium, one of the features of the growing self-confidence and maturity of Wales is the blossoming interest in our indigenous artistic heritage and it is particularly appropriate that this groundbreaking project on 'The Visual Culture of Wales' is being conducted in a prestigious dedicated research centre within the University of Wales. The aim of this volume, the second in a proposed trilogy published in English and in Welsh, is to explore the imaging of the people and the land of Wales from the early Tudor period to the 1960s. Like its predecessor, *The Visual Culture of Wales: Industrial Society*, this handsomely-illustrated volume draws extensively on new archival and illustrative material and is designed to fill a substantial gap in our knowledge of the development of images and image-making within the broader context of social, economic, political and institutional changes in Wales.

Like all publications of the University of Wales Centre for Advanced Welsh and Celtic Studies, this volume is the outcome of an intensive collaborative research enterprise, and I am happy to acknowledge publicly many debts. My principal debt is to the author of this series, Peter Lord, who, by precept and example, has led the project from the front with extraordinary energy and commitment. It is to his credit that this volume, which embodies the fruits of his unrivalled knowledge of the visual culture of Wales in the modern period, reveals more clearly than ever before a compelling artistic heritage. Lindsay Clements's role has been invaluable: with exemplary tact, patience and efficiency, she assembled all the required photography, both old and new, and resolved matters of copyright. By establishing an excellent relationship with the staff of the National Museum and Gallery Cardiff, Angela Gaffney was able to examine a rich and exciting range of resources. Stephanie Jones undertook helpful research into the role of landowning families as promoters and patrons of visual art, while Paul R. Harries displayed considerable initiative as well as perseverance in acquiring new information about unknown or neglected artists. John Morgan-Guy gave us the benefit of his expertise on early Tudor imagery and Nerys A. Howells helped with relevant bardic material. Martin Crampin, who is helping to prepare enhanced CD-ROM versions of the entire series, has been unfailingly supportive, and the ready assistance of Sara Bevan and Emma Burgoyne is also gratefully acknowledged. Members of other projects at the Centre have also rallied round when required, and I am especially indebted to Jeffrey D. Pritchard, formerly Secretary General of the University of Wales, and D. Ian George, Director of Resources, for their support and their confidence in this enterprise.

Our debt to institutional support is immeasurable. No project on this scale could hope to succeed without the full co-operation of the staff of the National Library of Wales and the National Museums and Galleries of Wales, and, from our point of view, neither institution was found wanting. The generosity of the Lottery Division of the Arts Council of Wales has been of vital importance, and it is also a particular pleasure to acknowledge the financial support of the Derek Williams Trust, the Foundation for Sport and the Arts, the University of Wales Board of Celtic Studies, the Gwendoline and Margaret Davies Charities, and the Garfield Weston Foundation. My colleagues and I are deeply indebted to the trustees and directors of galleries, libraries and museums, and also to private owners who have allowed access to their collections and given permission to reproduce art works in their possession. This project has excited considerable interest among the art-loving public at large and I wish to thank the owners of art works and local historians for willingly sharing their specialist knowledge. Miles Wynn Cato, David Mortimer-Jones and Thomas Lloyd deserve special mention for their unselfish contributions.

A sincere debt of thanks is owed to Oliver Fairclough, Keeper of Art, National Museum and Gallery Cardiff, Isabel Hitchman, formerly Senior Visual Arts and Craft Officer at the Arts Council of Wales, D. Huw Owen, Keeper of Maps and Prints, the National Library of Wales, and Thomas Lloyd for reading the entire typescript and making many valuable comments and corrections. The fullest possible assistance and encouragement were provided by members of the Advisory Board of this project and our heartfelt thanks go to Peter Davies, Oliver Fairclough, Isabel Hitchman, Sheila Hourahane, Donald Moore, Huw Owen, Nich Pearson, Richard Suggett and John Williams-Davies.

Creative support of the highest calibre was received at all stages from the designer Olwen Fowler, and the sustained assistance of Mark Davey and Gareth Lloyd Hughes, photographers at the National Library of Wales, is gratefully acknowledged. The support staff at the Centre thrive on pressure and a special debt is owed to them. Glenys Howells's scrupulous attention to detail saved us all from many errors, the secretarial and administrative support of Aeres Bowen Davies and Elin M. Humphreys was efficient at all times, and William H. Howells completed the index with patient good humour. Finally, a warm debt is owed to the staff of Cambrian Printers and the University of Wales Press for their sustained interest in this major project and for helping the entire team to capture the rich vitality of the visual culture of modern Wales.

Geraint H. Jenkins
June 2000

INTRODUCTION

This volume presents the imaging of the people and the land of Wales over a period of some four hundred and fifty years. Even without its industrial communities, which are considered in a separate volume, the nation revealed in the images is diverse and complex, thereby presenting many difficulties in the construction of a coherent narrative. The problem of when to begin the survey, for instance, revolves around the vexed question of the point at which the medieval world gave way to the modern, if, indeed, such a distinction (implying a radical change of philosophical framework) is a valid one. In this, as in other difficult areas, I have tried to respond to the images themselves. It is clear that there was a period in the sixteenth century in which the earlier centrality of the Church, both as a patron and as a focus for secular patronage, yielded to the private individual. Notwithstanding the dissolution of the monasteries in the 1530s, this change took the form of an accelerating process rather than a revolution. Nevertheless, it was accompanied by the development of new forms, in particular the framed portrait painted on panel or canvas, which signified a fundamental change in the world-view of those people concerned with making and commissioning visual images. Since the painting, sculpture and other images of the period both reflected and helped to drive that change, the decision to begin this survey with a consideration of the new forms is justified. Furthermore, the emergence of the painted portrait, in particular, occurred during the Tudor dynasty, a period which had a uniquely important impact on Welsh consciousness. It is the expression of that consciousness through the visual image which forms the central theme of this volume.

The decision to bring the period under discussion to a close in about 1960 reflects changes at that time in the way images were produced and presented to the public. Although these changes were an acceleration of processes already under way rather than a revolution, nevertheless they indicate the beginning of a

new era. The rapid expansion of government funding of higher education changed
the nature of art colleges by drawing in large numbers of young teachers, mostly
from outside Wales, at a time when ideas about art as an international language
were already marginalizing those for whom cultural individuation was the central
concern. Government funding of the Arts Council of Great Britain also increased
and, especially following the establishment of the Welsh Arts Council in 1967, this
resulted in greater direct support for artists and the production of a wider range of
exhibitions for the public than ever before. Local authority investment in art and
craft centres provided new galleries. Beyond art, the development of a mass audience
for television increased the impact of the visual image on the lives of most people.
Both the new form itself and the fact that a high percentage of the material it
presented originated in the United States profoundly changed the wider culture.

It has often been alleged that a national consciousness heavily conditioned by
the needs of differentiation from a dominant neighbour is a characteristic Welsh
weakness. As a result of the political and economic decline of that neighbour,
a complementary growth in our own self-confidence, and a wider change in
perceptions of nationality, it is the hope of many at the beginning of the
twenty-first century that this essentially colonialized state of mind may at last
be transcended. However, simply in the interests of hastening change, it would
be obscurantist to construct a historical tradition of visual culture in which the
question of self-identification in the immediate context of England was not central.
For nearly two centuries of the four whose images form the core of this volume,
the most politically powerful of all the European states was interposed between
Wales and the wider world. The images of those centuries, contemporary comment
concerning them, and the parallel expressions of literature and music, all suggest
that patrons, makers and observers were deeply concerned with the expression of
Welsh identity. Comparable concerns, of course, are to be discerned in images made
in other countries. Nevertheless, since the union with England in the sixteenth
century, to be Welsh has often seemed to be synonymous with being politically
and socially peripheral. As a consequence, questions of national identity are deeply
embedded in a broad spectrum of Welsh imagery and provide the written and
visual narrative of this volume with its coherence.

In part, therefore, this volume is concerned with explicitly national imagery
which arises from these circumstances. Since the late sixteenth century, image
makers have occasionally taken Welsh myth and history or contemporary ideas

of Welshness as their subjects. In some periods imaging Wales in this overt way has become a major preoccupation, generally at the same time as similar preoccupations have arisen in other parts of Europe. For instance, the art of the national movement of the early twentieth century is reflected both in Ireland to the west and Finland to the east. Ideas linking landscape and nation, which emerged in the late eighteenth century and which interested artists for well over a century, find parallels in the German-speaking world. Within this broad European context, Welsh imaging of such ideas developed characteristics rooted in the particular history of the culture.

This volume discusses a wider range of imagery than the explicitly and obviously national. However, although the primary intention of a family portrait, for instance, may be to differentiate John Jones from his grandfather of the same name, pictures of this kind can carry other layers of meaning. Since being Welsh has never been a condition which could be taken for granted, concern about what a likeness might signify beyond family or locality, and in particular in terms of nationality, is often to be discerned not far below the surface. By adopting domestic painted portraiture in the sixteenth century, Welsh intellectuals were certainly concerned with individuating themselves. Nevertheless, many of these early portraits also signal a desire both to be included in the pan-European Renaissance culture in which the genre arose, and to identify with the modernist ways of the Tudor state in which they had a particular investment. Again, a national subtext is evident in the predilection for portraiture which emerged among the new Welsh middle class in the early nineteenth century. The most important practitioner, Hugh Hughes, sought to iconize Nonconformists he painted from among this class because he regarded their value system as the model for the reconstruction of Welsh identity.

It is not my intention to pursue single-mindedly this preoccupation with national identity to the exclusion of others. I have tried to present a broad and inclusive view of the visual culture of Wales, omitting in this volume only those works pertaining to the evolution of industrial society. For instance, in discussing Christopher Williams's *The Charge of the Welsh Division at Mametz Wood*, I have recognized what I believe to be the artist's primary intention to make a universal statement about the savagery and waste of war. Nevertheless, I have been led not only by the images but by what I understand to be relevant in both their social and art historical context. Williams's decision not to glorify battle nor to present

victims as heroes in a wartime public commission signifies an attitude of mind which owes much to the cultural circumstances of his upbringing in Wales. Even in the mid-twentieth century, when ideas about pure painting and the personal language of the individual artist came to dominate the thinking of the avant garde, the question of national identification arose. Ceri Richards, who was, for a time, highly regarded by a London art community notable for its strong animus against the national, regional or local, made works which arose from the particularity of his Welsh origins.

The same is true of landscape painting, a complicated subject in Wales since it involves the interaction of the perceptions of large numbers of visiting artists, most of whom came from England, with those of Welsh intellectuals. While it is unlikely that questions of Welsh identity were uppermost in the mind of the Revd William Gilpin when he observed the River Wye in 1770, his conclusions had a considerable, if indirect, impact on the matter. Gilpin's writings were important in encouraging an emergent fashion for Welsh landscape which resulted in setting mountain scenery at the centre of English ideas about Wales. The fashion reinforced a Welsh perception of long standing which became fundamental to the imaging of the nation in the nineteenth and twentieth centuries. Intimately linked to aesthetic fashions in landscape was the perception of the people who lived there. However convoluted the eighteenth-century construct of the Welsh landscape as the home of the Ancient Britons and, therefore, as a living exposition of English pre-history, its influence on the Welsh mind cannot be ignored. In the first half of the nineteenth century, artists abandoned Ancient Britons in favour of presenting the Welsh as a pious rural folk, facilitating the construct of *y Werin Gymreig* by O. M. Edwards and his contemporaries, a myth which dominated self-perceptions among romantic nationalists well into the twentieth century.

Like its two companions, this volume is concerned with the significance of visual images in Welsh culture rather than with the biographies of Welsh-born image makers. As a consequence, several artists of international repute, such as Gwen John, are not discussed or illustrated. This is not to be understood as a comment on the quality of their work, but simply as a rejection of place of birth or, indeed, ethnicity, as a qualification for inclusion in a discussion of cultural evolution in Wales. Gwen John took no part in intellectual or institutional life in Wales, and

her images did not directly engage with Welsh life.
Ethnicity has been the definitive factor in all earlier texts,
from T. Mardy Rees's *Welsh Painters, Engravers, Sculptors
(1527–1911)* in 1912 to Eric Rowan's *Art in Wales* in
1985, often with absurd consequences. T. Mardy Rees,
for example, provided extensive discussions of the life
and works of G. F. Watts and William Morris, who claimed
Welsh descent but made no direct contribution to the life of Wales. On the
other hand, he excluded figures of seminal importance in the evolution of the
visual culture of Wales such as the landscape painter Henry Clarence Whaite
on the grounds that he was born in Manchester of English parents. However,
since some of these texts form part of the tradition of Welsh visual culture
constructed here, in the sense that they reflected or exerted an influence on the
ethos of their period, some artists of Welsh birth or descent, lauded in them but
otherwise insignificant in Wales, are included. This is true, for instance, of the
sculptor John Gibson, who left Wales at the age of ten and whose imagery was
not concerned with Welsh life, but whose international status during his lifetime
meant that he was repeatedly cited by nineteenth-century improvers as an example
to which young Welsh artists should aspire. Unwittingly, therefore, he became
involved in the evolution of Welsh visual culture. In the same way, a volume
proceeding beyond this one into the second half of the twentieth century
might well give more consideration to the work of Gwen John since her
reputation grew during that period to the point where she is now widely
perceived to be an important Welsh artist. However, that was not the case

in the period under discussion and the temptation to
include her work and that of others, similarly placed,
has been resisted. This volume concerns shared cultural
experiences – the experiences of the communities of
Wales. The richness of the imagery revealed within
that framework does not require to be bolstered by
the inclusion of individuals whose work is marginal
to the imaging of the nation.

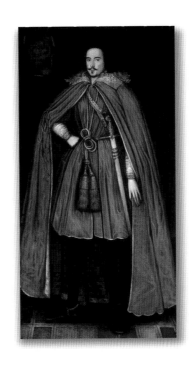

chapter

one

A WELSH RENAISSANCE

1. *Gwydir*, c.1500
with additions c.1550

In the early modern period it was primarily those people made wealthy by inheritance, profession or trade who stimulated the visual culture of Wales with their patronage. The poor were very poor, and the few surviving sixteenth- and seventeenth-century inventories of the property of the common people (and even of some of those who, by virtue of their lineage, could describe themselves as gentry) often reveal pathetic material deprivation. The possession of a few pots and pans and only the barest essentials of furniture provided little scope for decoration, and none for the expression of material well-being in the form of non-essential items such as pictures.[1] No doubt the poor expressed the world of their imagination in the non-material forms of music, story-telling and poetry. Even the cheap printed ballad with a woodcut illustration did not form a part of their world until the middle of the eighteenth century. On the other hand, landowners extended the range of their investment in a visual culture to which they had contributed for centuries. They were well placed to do so, since the sixteenth century proved to be a golden age for the grander gentry in particular. Long-standing economic and social dominance was reinforced 'by the enjoyment of assured political, judicial and administrative authority', as a consequence of the passing of those acts of Parliament which merged Wales fully with England. The new order defined the shire as 'the essential unit of politics, defence, justice, and administration',[2] and thereby concentrated power in the hands of the dominant county families. Patronage by monastic institutions, already in decline, had come to an abrupt end in the 1530s, but the ill wind that blew through the Roman Church blew favourably for the rising gentry, and many families who were already wealthy enriched themselves further by acquiring monastic lands and buildings. Old gentry families were joined in the new prosperity by newcomers of an entrepreneurial turn of mind, sometimes living in towns. Both groups spent their increasing incomes on material improvement, and in particular on their houses.

In the countryside, medieval hall houses were transformed by the addition of fireplaces and upper floors which facilitated the evolution of domestic life from the communal to the private in apartments with a variety of functions and characteristics. From the mid-sixteenth century until the end of the seventeenth century the number of entirely new houses incorporating such features seems to have increased at a steady rate, with occasional falls attributable to exceptional economic circumstances and to the civil wars. This increase applied not only to

[1] See, for instance, Gareth Haulfryn Williams, 'A Study of Caernarfonshire Probate Records, 1630–1690' (unpublished University of Wales MA thesis, 1972).

[2] Glanmor Williams, 'The Gentry of Wales' in idem, *Religion, Language and Nationality in Wales* (Cardiff, 1979), p. 156.

lowland Wales and the border regions, but also, on a smaller scale, to upland counties such as Caernarfonshire.[3] The character of the most advanced new houses changed dramatically in the later sixteenth and seventeenth centuries, reflecting both the aspirations to greater comfort and privacy exemplified in the internal modernization of the older houses, and a new emphasis on the exterior. Medieval hall houses had no particular façade, but new houses presented frontages to the world as an image of the ideas of their owners. The patronage of the majority, no doubt, simply followed fashions widespread in England as well as in Wales in the period. However, an intellectual minority in Wales were among the leaders of those fashions. From the mid-sixteenth century onwards a remarkable renaissance in Welsh intellectual life occurred.[4] Many of those who took advantage of opportunities to advance themselves materially at the Tudor court, in the Church and the law also proved to be proficient in the arts and sciences. Furthermore, a number of them acquired Renaissance ideas by direct contact with continental cultures, rather than through the medium of the court in England. For instance, Edward Stradling of St Donat's in Glamorgan travelled extensively in Italy, and his contemporary, Richard Clough of Denbigh, went to Palestine as a young man, and subsequently worked in Antwerp and visited Spain and Germany. Both as creative individuals and as patrons they opened out the indigenous culture of Wales without forsaking its roots. Indeed, it is noteworthy that such internationalists were often the most acutely aware of the value of the indigenous tradition. They were modernizers but, as is often the case in periods of renewal, at the same time they retained a particularly strong sense of the past, and in the case of the Welsh gentry, for all the importance of the court, it was the Welsh past in particular which they cherished most. Individuals such as Edward Stradling and Humphrey Llwyd of Denbigh played an important part in saving medieval literature from oblivion and in laying the foundations of the Welsh antiquarian tradition which would be crucial in the building of the modern nation. New prose writing emerged, including both original works and translations of important English and continental works, and although Morris Kyffin remarked of his *Deffynniad Ffydd Eglwys Loegr*, published in 1595, that it would be more profitable for him to write in 'some language other than Welsh', he chose not to do so.[5] It was from among this group that political pressure was applied and patronage was found to enable William Morgan to complete the Welsh translation of the Bible, begun by William Salesbury, for publication in 1588, perhaps the most crucial venture in securing the development of the language and a sense of Welsh identity over the subsequent three hundred years.

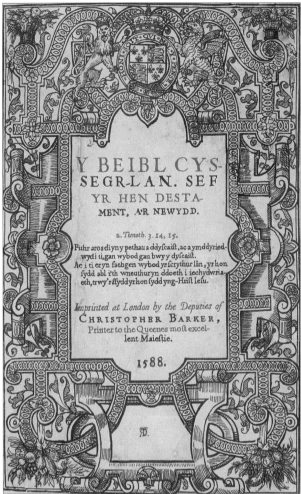

2. Anon.,
Y Beibl Cyssegr-lan, 1588,
Engraving, 237 × 151

[3] Eurwyn Wiliam, '"Let Use be Preferred to Uniformity": Domestic Architecture' in J. Gwynfor Jones (ed.), *Class, Community and Culture in Tudor Wales* (Cardiff, 1989), pp. 175–7. Wiliam discusses the revision of Hoskins's concept of 'the great rebuilding' and its relevance to Wales.

[4] See Glanmor Williams, 'Education and Culture' in idem, *Recovery, Reorientation and Reformation: Wales c.1415–1642* (Oxford, 1987), pp. 429–50.

[5] *Deffynniad Ffydd Eglwys Loegr*, ed. W. P. Williams (Bangor, 1908), p. [ix]. The text is a translation of Jewel's *Apologia*, and is considered a classic of Welsh prose.

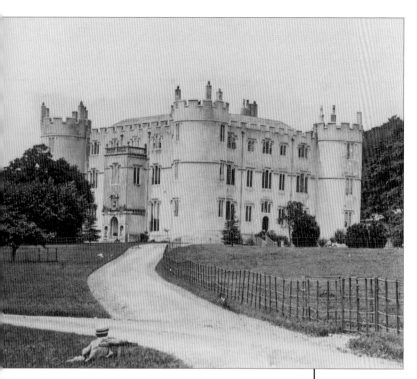

3. *Ruperra*, 1626

4. *The Gatehouse
at Corsygedol*, 1630

[6] Renaissance building is discussed in detail in Peter Smith, *Houses of the Welsh Countryside* (London, 1988), pp. 224–37.

[7] See Ralph A. Griffiths, 'The Rise of the Stradlings of St Donat's', *Morgannwg*, 7 (1963), 15–47.

[8] Smith, *Houses of the Welsh Countryside*, pp. 520–1.

[9] Inigo Jones (1573–1652) was born in London, the son of a clothworker of the same name who, according to tradition, was Welsh. The identification of the greatest London architect of the Stuart age as Welsh by descent was of great importance to patriotically-minded commentators on art in Wales even in the twentieth century. It is now generally accepted that there are no buildings by Inigo Jones in Wales, but John B. Hilling, *The Historic Architecture of Wales* (Cardiff, 1976), p. 112, believes that the Corsygedol gatehouse can 'be reliably attributed to Jones'. Hilling points out that William Vaughan was a personal friend of the architect. For the career of Inigo Jones, see John Peacock and Richard Tavernor, 'Inigo Jones' in Jane Turner (ed.), *The Dictionary of Art* (34 vols., London, 1997), 17, pp. 633–9.

[10] NLW, Peniarth MS 91, nos. 26–8.

The apparent contradiction between the progressive attitudes of these intellectuals and their interest in history extended to the radical houses that they built and to the artefacts they contained.[6] Both the Classical tradition, revealed by the Italian Renaissance, and the northern medieval world of knights and chivalry excited their romantic imagination. Edward Stradling elaborated his gardens on the Italian model and adorned St Donat's Castle with sculptures representing Roman emperors.[7] On the other hand, Plas Teg, built by Sir John Trevor in 1610, and Ruperra, built by Sir Thomas Morgan in 1626, both of whom were court officials, expressed a sense of history in their castle-like form. Gatehouses, serving little military purpose, proliferated in the north and the south-west of the country.[8] The gatehouse constructed in 1630 by William Vaughan at Corsygedol, with its symmetrical front elevation, elegantly proportioned, is among a number of Welsh buildings traditionally, but doubtfully, attributed to Inigo Jones, the leading London architect of the age.[9] The poets of the period reported heraldic banners fluttering from the rooftops of gentry houses such as Rug in Merioneth,[10] and new buildings were frequently adorned with the coats of arms of their owners, carved and painted. The concern with the display of lineage in heraldic decoration and inscription was manifested in many forms of artefact and was common both to Welsh and English visual culture at this time. Nevertheless, the particular poetic tradition in Wales, which continued to be supported by many of the individuals now extending their patronage into visual forms, provided a distinct cultural context for the new antiquarianism.

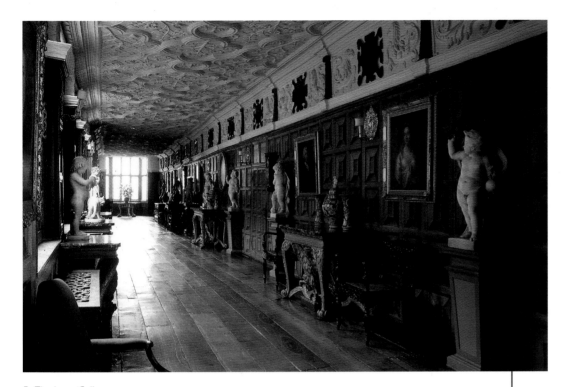

5. *The Long Gallery*
at Powis Castle, 1587–95

[11] Thomas Pennant, *Tours in Wales* (3 vols.,
Caernarvon, 1883), II, p. 135. Bachegraig may
have provided the pattern for four other houses
which repeat its square plan, central chimney and
pyramidal roof: Upper Edwinsford, Cards.; Cemais
Bychan, Mont.; Tŷ-mawr, Llansilin, Denbs.; and
Trimley Hall, Llanfynydd, Flints. See Smith, *Houses
of the Welsh Countryside*, pp. 232, 240–1.

More forthright modernists of the Welsh Renaissance expressed themselves
by commissioning houses whose form was derived from contemporary Italian
models. At Powis Castle Sir Edward Herbert, son of the first Earl of Pembroke,
added a long gallery above a loggia of four bays supported on Doric columns.
Such innovations were often transmitted through the Netherlands, and Richard
Clough's first house, Plas Clough, had Dutch crow-stepped gables. However,
Bachegraig, which he built in 1567, went much further and was the most
conspicuously modernist house in sixteenth-century Wales. The house and
associated decorative elements which Clough commissioned still seemed
remarkable to Thomas Pennant two hundred years after it was built:

6. Moses Griffith,
Bachegraig, c.1781,
Watercolour, 77 × 125

> It consists of a mansion, and three sides, inclosing a square court. The first
> consists of a vast hall, and parlour: the rest of it rises into six wonderful stories,
> including the cupola and forms from the second floor the figure of a pyramid
> ... In the windows of the parlour are several pieces of painted glass, of the arms
> of the knight of the *holy sepulchre*; as his own with a heart at the bottom.[11]

The increasing wealth and consequent patronage of the gentry in their rural estates
were matched by the growth of towns. Urban prosperity was fed not only by those
rising through trade and professional employment, but also by the establishment
of branches of gentry families in towns. Robert Wynn, who built the most notable
surviving town house of the sixteenth century, Plas Mawr in Conwy, was the son

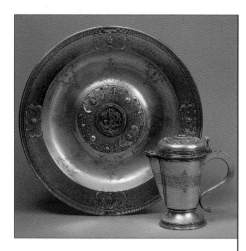

7. *Ewer and Basin*, Bruges, 1561,
Silver, silver gilt and enamel,
ewer 213h., basin 491d.

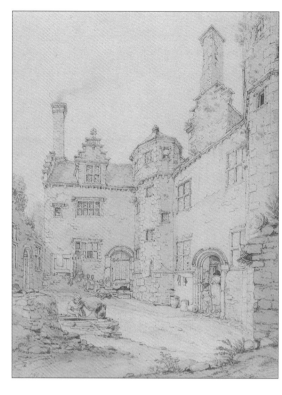

8. William Alexander,
Plas Mawr, Conwy, 1802,
Watercolour and pencil,
304 x 232

[12] R. C. Turner, 'Robert Wynn and the Building of Plas Mawr, Conwy', *NLWJ*, XXIX, no. 2 (1995), 194.

[13] For examples, see W. M. Myddelton, *Chirk Castle Accounts (Continued), A.D. 1666–1753* (privately printed, Horncastle, 1931), p. viii. The same was true for other parts of the country. Edward Vaughan of Trawsgoed, Cardiganshire, apprenticed his younger brother Morgan to a Shropshire draper in 1601. See Gerald Morgan, *A Welsh House and its Family: The Vaughans of Trawsgoed* (Llandysul, 1997), p. 38. For the social context of the building of Plas Mawr, see Turner, 'Robert Wynn and the Building of Plas Mawr, Conwy', 177–95.

of John Wyn ap Maredudd of Gwydir, and was therefore a part of the dominant gentry dynasty of north-west Wales. Like Clough, who is also believed to have had a town house, Robert Wynn travelled widely on court business. He was in the service of Philip Hoby, among whose missions was to visit Spain and Portugal with the painter Holbein in search of a suitable and attractive wife for Henry VIII. Having left court service to live in Conwy, it seems certain that Wynn maintained himself not only by the possession of land, but also by trade.[12] In the sixteenth and seventeenth centuries, the uppermost echelons of the gentry did not regard involvement in trade as beneath their dignity, and they put their children into apprenticeships and mercantile activity.[13] Conversely, many of those successful in trade aspired to the ownership of country estates. The Myddeltons, who became for over a century the greatest gentry family in the north-east, were able to purchase their seat of Chirk Castle in 1595 because of the success of Sir Thomas Myddelton as a merchant in London.

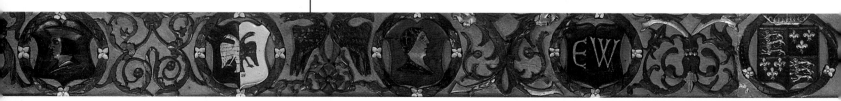

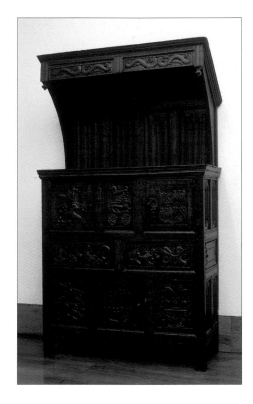

9. *The Wynn Cupboard,*
*c.*1545, Oak

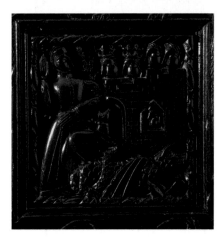

New and modernized buildings provided increased opportunities both for the decoration of the structure itself and for housing movable objects. Medieval artefacts underwent stylistic evolution, but the period also saw the development of new forms. Although the Reformation deprived wood carvers of the opportunity to make the figurative carving which so distinguished the churches of early Tudor Wales, the domestic patronage of the wealthy provided new opportunities to decorate an expanding range of furniture. Cupboards and testers were a particularly appropriate base for display. The Wynn cupboard, made in the Conwy valley for John Wyn ap Maredudd of Gwydir in about 1545, is exceptional both in form and in the richness of its decoration, but its forthright assertion of the identity of the owner through heraldry and family emblems is characteristic of many other wood carvings of the period. Panels might illustrate mythological subjects or celebrate the courtly life in miniature which was lived at great houses such as Gwydir, with illustrations of hawking and hunting. In the south, a group of fine profile heads carved on panels survive, isolated from their original context,[14] which was probably one of a group of mid-century town houses in Cardiff. The castle itself was rebuilt by William Herbert, Earl of Pembroke. Greyfriars House next door was occupied by his brother, Sir George (whose grandson subsequently rebuilt the house on a grand scale), while Edward Stradling and Thomas Carne kept houses in the outer courtyard. The establishment of the country gentry in town in such a remarkable agglomeration must have provided substantial patronage.

10. Harry ap Griffith,
Panels from the *Cotehele Tester,*
*c.*1530–40, Oak,
432 × 432

[14] The panels are built into a screen of earlier date in the church of St John, Cardiff.

11. *Frieze*
from Raglan
*Castle, c.*1513,
Oak, 600h.

[15] The frieze survives in a private house. It was probably among the items removed from Raglan prior to the siege during the civil wars, see Chapter 2, note 9. In the 1820s the Duke of Beaufort, in an act of antiquarian enthusiasm, re-roofed the great hall and the frieze was returned, where it was drawn by the Revd John Skinner in 1832, BL MS 33725, pp. 300–4, drawings 88–92. The frieze was subsequently removed and perhaps stored at Usk Priory, giving rise to the belief that it had originated there.

[16] Such fire surrounds seem to have been particularly popular in Denbighshire, and the fashion persisted into the seventeenth century. The fire surround at Plas Tirion, Llanrwst, for instance, is closely similar in style to that at Plas Mawr, but is dated 1628.

[17] Matthew Griffiths, '"Very Wealthy by Merchandise"? Urban Fortunes' in Jones (ed.), *Class, Community and Culture in Tudor Wales*, pp. 222–3. The Chirk Castle accounts bear out Griffiths's evidence in the field of artisan commissions, which were given in Ruthin, Denbigh, and in particular Wrexham, as well as in Chester.

[18] Errors occur in all three languages used on the inscriptions at Rhiwlas, home of John Wynn ap Cadwaladr, where the carpenter worked in 1574. Wynn's uncle, Elis Prys, Y Doctor Coch (The Red Doctor), of Plas Iolyn, Pentrefoelas, had commissioned the carpenter two years earlier, and the family relationship of the men reinforces the idea of the existence of a patronage network. The work of the carpenter is analysed in detail by A. J. Parkinson, 'A Master Carpenter in North Wales', *Arch. Camb.*, CXXIV (1975), 73–101, and ibid., CXXV (1976), 169–71.

[19] A painted fragment survives from Brogynin, Cardiganshire, among the areas of Wales most remote from substantial towns in the seventeenth century. However, this decoration may be of a later date, representing a survival in the countryside of earlier urban fashions.

12. *Overmantel in the Hall at Plas Mawr*, 1580, Painted plaster, 1800 × 2570

Among the most notable surviving carvings from a domestic setting in south Wales is the frieze which originally adorned the great hall at Raglan Castle. It was probably commissioned to celebrate the elevation of Charles Somerset to the earldom of Worcester in 1513.[15] It carries a lively assortment of grotesques, portrait heads, his own arms and those of his relatives and royal patrons, and symbols of Christ's passion. The frieze was probably installed between a dado and hanging textiles which, like the plate displayed on the new furniture of the period, sometimes originated on the Continent. For instance, in the 1560s William Mostyn commissioned a silver and silver gilt ewer and basin in Bruges, which was adorned with his arms in enamel. Nevertheless, the family relationships linking the occupants of gentry houses in the sixteenth and seventeenth centuries provided a network of potential patronage from which indigenous artisans in particular were able to profit. It appears that the same individual or group of plasterers worked for Robert Wynn at Plas Mawr in 1577 and 1580, for his cousin Morris Kyffin at Maenan in 1582, and for his nephew Sir John Wynn at Gwydir in 1597. The work is notable for the figurative and heraldic mouldings on the overmantels, emphasizing the fact that an enclosed fireplace was still a relatively recent and prestigious innovation.[16] The ornate ceilings of the newly built Plas Mawr were one of the features which the advent of the fireplace permitted, though in the medieval hall house of Maenan Morris Kyffin did not insert a second floor, preferring to create ornate infill panels between the ancient crucks. The plasterers are not known by name or by their place of origin. They may have been specialists who ranged very widely, echoing the practice of the medieval tile makers who progressed to work on a series of monastic buildings, but it is more likely that they were generalists, venturing out from an urban base

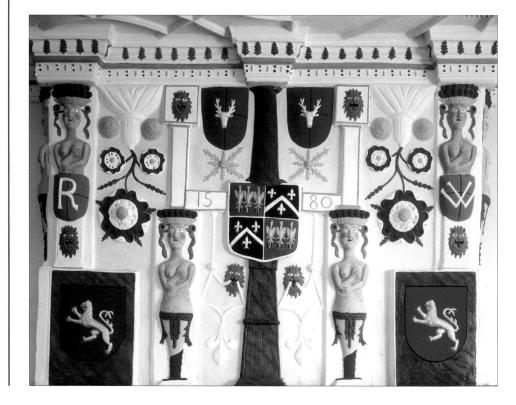

where more mundane work sustained them between these up-market commissions. Although Welsh towns were small, it is clear that the variety of trades they sustained was not significantly less than in the larger but otherwise equivalent regional and market centres of England.[17]

A second and contemporary example of the use made by artisans of the gentry network related to a larger number of houses and the more widespread skills of the carpenter. The fine woodwork of a single workshop has been identified in at least sixteen houses, mainly located in Denbighshire and Flintshire, but extending also into Merioneth and Caernarfonshire. The work, carried out between 1570 and 1598, was unified by a particular style of carving on partition screens, reinforced by idiosyncratic letter forms on inscriptions. The carpenter cannot be identified by name and the most that can be said of him, beyond his considerable woodworking skill, is that the wide variety of spelling errors on inscriptions in Welsh, English and Latin suggests that he was illiterate. It appears that the carpenter prefabricated his screens and re-erected them on site, although whether this indicates the existence of a single workshop at a central point such as Denbigh is unclear.[18]

14. Anon., *Kitchen Screen, Plas Newydd, Cefn*, Denbighshire, c.1583, Oak

The screen at Rhiwlas carried painted decoration in green and white. This may not necessarily have been contemporary with its erection, but it was certainly of early date. Such schemes of decoration, painted on both wooden screens and plaster, were probably common in gentry houses of the late sixteenth and seventeenth centuries, and their survival in fragmentary form in several parts of Wales suggests the widespread availability of artisan painters.[19] They represented the evolution of a medieval practice with new stylistic conventions. In Glamorgan,

15. Anon., *Wall painting at Castell-y-mynach*, 1602, Painted plaster

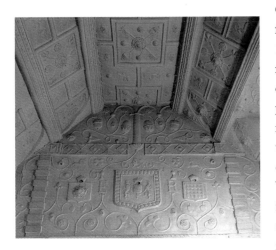

13. *Ceiling and wall at Maenan*, 1582, Plaster

Castell-y-mynach was decorated for its owner Thomas Mathew in 1602 with a scheme which, in part, repeated the conventions of many others. The work was divided into panels by strapwork designs which reflected the carved framing of the panelled screens made by the carpenter of the houses in north Wales. However, Castell-y-mynach is unique since it contained a subject painting apparently on a mythological theme. Only the left and centre portions of the work are now visible, showing a storm at sea and a god-like figure, perhaps Neptune, to the side. A close parallel for the decorative elements of the scheme at Castell-y-mynach was to be found in a late sixteenth-century

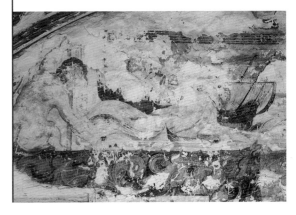

16. Anon., *Wall painting at No. 15 Tudor Street, Abergavenny*, c.1600, reconstruction drawing by D. M. D. Thacker

17. John Jones, Gellilyfdy, *Decorative Capital*, c.1632–57, Pen and ink, 190 × 140

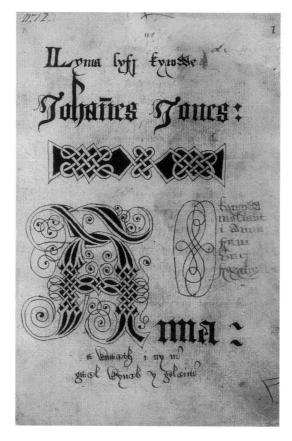

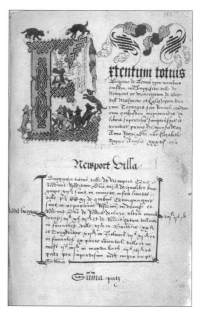

18. Anon., *Illuminated Capital* from 'The Vairdre Book', 1594, Pen and ink, 286 × 195

[20] The survey made before the demolition of the house in 1958 is kept at Abergavenny Museum.

[21] NLW, Peniarth MS 307.

[22] NLW, Bronwydd MS 3.

town house at Tudor Street, Abergavenny.[20] The painting was carried out on plaster and covered at least one wall of what was probably the main bedroom in its entirety. Both decorative and figurative panels were surmounted by two heavy friezes of interlacings and grotesque heads. Such designs were available in pattern books and formed the basis of a coherent decorative style in the period, adapted for use in a wide range of forms. The calligrapher John Jones of Gellilyfdy, Flintshire, made extensive use of grotesque heads and interlacings, very similar to those of the Abergavenny house, to illuminate the medieval texts he copied for Welsh antiquarians, notably Robert Vaughan of Hengwrt. Furthermore, in 1639 he produced a manuscript book of ornamental alphabets[21] which echo some of the letter forms of the north Wales carpenter, who had worked at Gellilyfdy. These designs reflect modern taste in the period, elaborating and enriching the text, and were not, in general, inspired by decorations to be found on ancient manuscripts or by a detailed knowledge of Celtic interlace. Nevertheless, 'The Vairdre Book' of documents relating to the barony of Cemaes in Pembrokeshire, compiled by George Owen of Henllys and others, contains a decorated page in which interlacings in the modern style enclose the unmistakable figure of the Celtic god Cernunnos.[22] The source of this remarkable illustration is untraced.

At Penrhyn Old Hall in Caernarfonshire the plastered infill between the roof trusses was decorated with two figures set in roundels which may have been portraits rather than

19. *Inscription on a beam at Gellilyfdy*, 1586

20. Anon.,
*Decorative roundels
at Penrhyn Old Hall,*
c.1590, Painted plaster

21. Anon., *Elis ap Richard
and Jane Hanmer at Althrey Hall,*
c.1545–58, Paint on limewash

symbolic figures since they were attired in modern dress. They were surrounded by pious mottoes of the kind carved by the north Wales carpenter. However, the most unusual survival of figurative decoration is a double portrait at Althrey Hall in Flintshire, painted on plaster. It probably represented Elis ap Richard and Jane Hanmer, owners of the estate, standing together in court dress, and, if it was not painted posthumously, it was of remarkably early date, since Elis died in 1558. Furthermore, the form of a mural decoration was most uncommon. If Elis was reflecting avant-garde taste in his commission of a portrait, he might have been expected to do so in the form of a painting on a panel such as those which had become fashionable in court circles during the reign of Henry VIII.

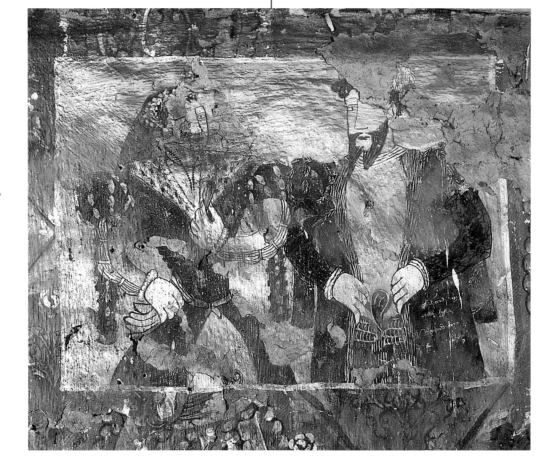

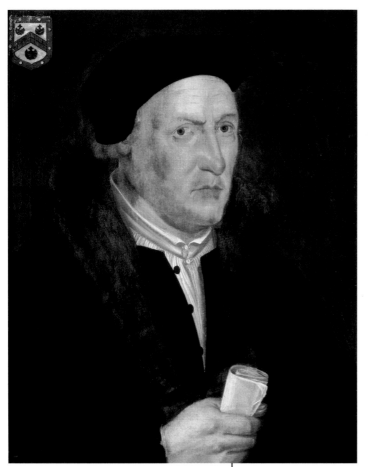

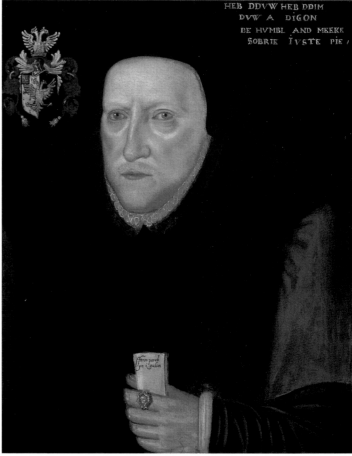

22. Anon.,
Sir Thomas Exmewe, c.1526–9,
Oil on panel, 540 × 432

23. Anon.,
Edward Goodman of Ruthin,
c.1550, 564 × 448

24. Anon., *Henry VII,*
c.1500, Oil, 572 × 445

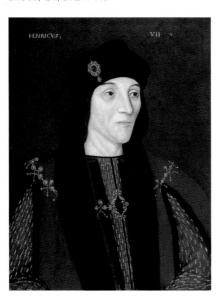

The painted portrait, as a movable object on panel or canvas, was among the most dramatic and lasting innovations in visual culture facilitated by sixteenth-century changes in lifestyle. Portraiture itself was not new, though individuals had generally been identified by arms and inscriptions rather than by physical likeness. Many Welsh examples from the medieval period, both in the form of memorial sculpture and a few donor portraits included in religious images painted on glass or panel, have survived. However, the portable painted portrait as a celebration of the vanity and status of a living individual was a Renaissance innovation, which developed in Italy and northern continental Europe before being adopted at the Tudor court. Among the first Welsh people to be painted within the new convention was Henry Tudor, who founded the dynasty in 1485. However, it was during the reign of his son, Henry VIII, that the fashion became widespread. It was stimulated by the arrival at court of a number of painters from the Continent, the most notable of whom was Hans Holbein, who came in 1526. Holbein's work established conventions which were followed into the early seventeenth century by more conservative painters. The fashion for portraiture appealed not only to those at court but also to the rich and influential among the mercantile class. Among

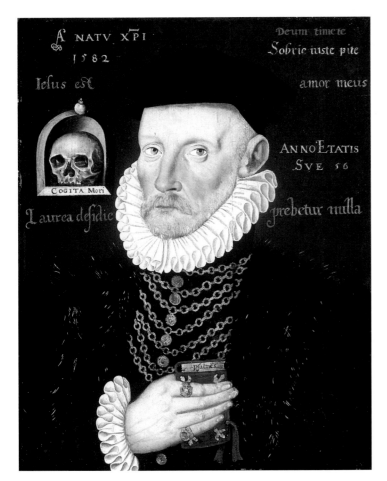

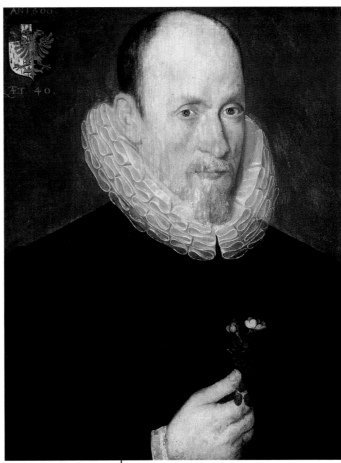

25. Anon.,
Gawen Goodman of Ruthin,
1582, Oil, 495 × 420

26. Anon.,
Godfrey Goodman of Ruthin,
1600, Oil, 528 × 410

the earliest Welsh patrons was Edward Goodman of Ruthin, who was painted in about 1550. Goodman was a wealthy and prominent public figure in the town, but not someone who might have been expected to be an assiduous follower of London fashions. The explanation for his patronage probably lies in his ownership of a portrait of the goldsmith Sir Thomas Exmewe, who was born in Ruthin but had made his fortune in London, where, in 1517, he became Lord Mayor. Goodman lived in Exmewe House, formerly the home of his illustrious contemporary, where the portrait hung from an early date. It is unsigned but was influenced by the style of Holbein and was probably painted, therefore, between Holbein's arrival in 1526 and the death of Thomas Exmewe three years later.[23] Edward Goodman's own portrait is similar in form to that of Exmewe, although it is a less sophisticated product. On his death, Goodman was commemorated with a brass in the church in Ruthin, perhaps given by the corporation since he had been mayor of the town. The face, though very much simplified, clearly derives from the painting. Edward Goodman's son Gawen commissioned his own portrait in 1582, and all three hung in the parlour of Exmewe House. While Gawen cannot be counted among the literati, he was known to the poet and adventurer Tomos

[23] The Exmewe portrait was tentatively attributed to Holbein by Lewis H. O. Pryce, 'Sir Thomas Exmewe', *Arch. Camb.,* XIX (1919), 232–75. There is some circumstantial evidence to support this attribution. In London, Exmewe was a close friend and neighbour of Thomas Kytsonne, who was certainly painted by Holbein. More recently the portrait has been attributed to John Bettes, although it must be earlier than that painter's *floruit* dates as presently accepted (1531–76). The provenance of the Exmewe portrait is good, since it is mentioned by name in the will of Gawen Goodman in 1627.

27. Anon.,
Memorial to Edward and
Ciselye Goodman of Ruthin,
Church of St Peter, Ruthin,
1583, Brass, 380 × 480

28. Anon., *Memorial to Gabriel*
Goodman of Ruthin, Church
of St Peter, Ruthin, 1601,
Painted stone, 910h.

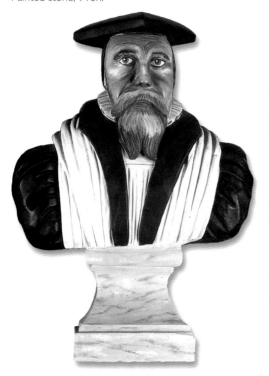

Prys of Plas Iolyn (son of 'Y Doctor Coch'), who wrote a sarcastic *cywydd gofyn* (request-*cywydd*) allegedly on his behalf to Sir Robert Salusbury of Rug, suggesting that he was particularly mean with his money – not usually a characteristic of a patron of the arts – at least 'until the pot warms his head'.[24]

Gawen Goodman was generous enough in the pursuit of the reputation of his own family, however, because it was presumably he who, a year after having his portrait painted, commissioned a second memorial brass in Ruthin church. The occasion for the commission was the death of his mother Dorothy, who was portrayed at her husband's side with her three sons and four daughters behind them. The most illustrious of these children was Gawen's brother Gabriel, who made his way in the Church, rather than in trade, rising to become Dean of Westminster from 1561 until his death in 1601. Gabriel's image on the family brass is clearly not related to his painted portrait, which was probably intended to hang in the almshouses he endowed, along with the grammar school, in his native town. The likelihood is, therefore, that the painting dates from about 1590, the year of the founding of Christ's Hospital. On Gabriel Goodman's death a polychrome wooden bust, clearly based on the painted portrait, was carved and set up in Ruthin church in his memory. The group of Goodman family portraits, which share the heraldic attributes of arms and mottoes, and the bold and forthright characterization of the period, was completed by that of Godfrey Goodman, Gawen's second son. The picture was commissioned in 1600 when he was forty.[25]

The sustained patronage which produced this sequence of painted portraits and related images is remarkable both because of its early date and because it came from a mercantile family. However, Gabriel Goodman's intellectual status provides his portrait with an additional context within depictions of his peers among the talented group of Welsh literati and courtiers who emerged in the second half of the sixteenth century. Among them Humphrey Llwyd, who had trained as a physician, was a characteristic Renaissance figure on account of the wide range of his antiquarian interests and his knowledge of contemporary sciences and music. His portrait was painted in 1561 by an unknown artist. Like so many other intellectuals of the period he hailed from Denbighshire, and it was his neighbour Richard Clough who put him in touch with Abraham Ortelius at Antwerp, the publisher with whom he co-operated in the production of his maps of Wales.[26] Clough's modernist inclinations, manifested in his two houses, have already been noted, and the influence upon him of the dynamic culture of the Low Countries extended to the commissioning of portraiture. In 1568, a year after his marriage to Katheryn of Berain in Denbighshire, he commissioned her portrait, perhaps from Adriaen van Cronenburgh. Katheryn displayed her wealth in the form of a heavy gold chain, rings, a necklace and a pendant brooch, counterbalanced by what is probably a devotional book held in one hand to suggest piety, while the other rests on a skull, symbolic of mortality – the same iconography as that displayed in the portrait of Gawen Goodman. This portrait would have been an object of considerable interest and status when it was brought back to Wales since it was

29. Anon.,
Humphrey Llwyd of Denbigh,
1561, Oil, 430 × 340

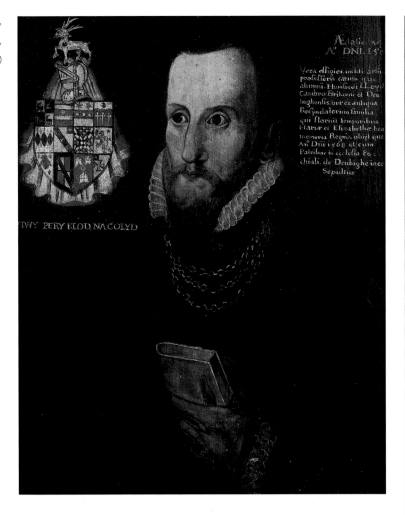

[24] 'Gwdmon, ŵr ffyddlon i'r ffydd. / O dring at winoedd y dref / Yn ddidrip ni ddaw adref. / Gwn yr yf Gawen ei ran, / O daw sec, nid yf sucan … / Hael yw a glân, hylaw glod, / A duwiol uwchben diod; / Weithiau'n ddwblwaith, yn ddiboen, / 'E rôi'i grys oddi ar ei groen. / Ni cheir pin llaw gan Gawen / Nes i'r pot gynhesu'r pen …' (Goodman, a faithful man in the faith. / If he climbs to the wines of the town, / Without stumbling he does not come home. / I know that Gawen drinks his share, / If there is sack, he will not drink gruel … / He is generous and handsome, skilful [his] praise, / And pious in his drink; / Sometimes twice, without grief, / He would give his shirt off his back. / You won't even get a hand pin from Gawen / Until the pot warms his head), 'Cywydd i ofyn march gan Syr Robert Salbri o Rug dros Gawen Gwdmon o Ruthun' (A *cywydd* requesting a horse from Sir Robert Salusbury of Rug on behalf of Gawen Goodman of Ruthin), transcribed in William Dyfed Rowlands, 'Cywyddau Tomos Prys o Blas Iolyn' (unpublished University of Wales PhD thesis, 2 vols., 1997), I, p. 150. Gawen Goodman's second wife was Gaenor, sister of Tomos Prys.

[25] All four portraits acquired similar decorated frames and subsequently passed to the Wynne family of Coed Coch. Neither the painted portraits nor the brasses and the carving are signed. The Wynnes also owned a panel painting of the arms of Gawen Goodman in a similar frame. The arms were granted in 1573, but the painting was inexplicably dated 1641. The arms were illustrated in Christie's sale of Coed Coch furniture, 18 April 1996, p. 128.

[26] Llwyd wrote: 'Richard Clough, a verie honest man, and one that was the cause and procurer of this our love and acquaintance, as well your friend as mine, shall bring your letters from you to me, and mine to you, that interest I know we both have in him.' F. J. North, *Humphrey Lhuyd's Maps of England and Wales* (Cardiff, 1937), p. 9.

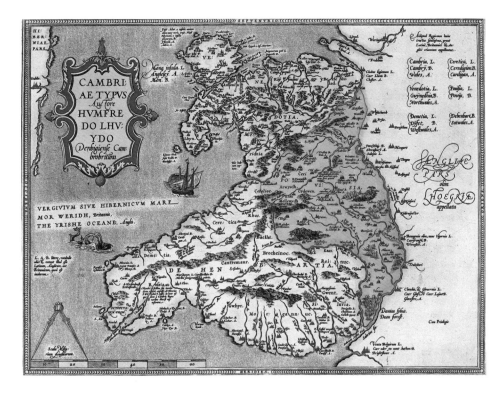

30. Abraham Ortelius,
Map of Wales, 1579,
Engraving and watercolour,
365 × 495

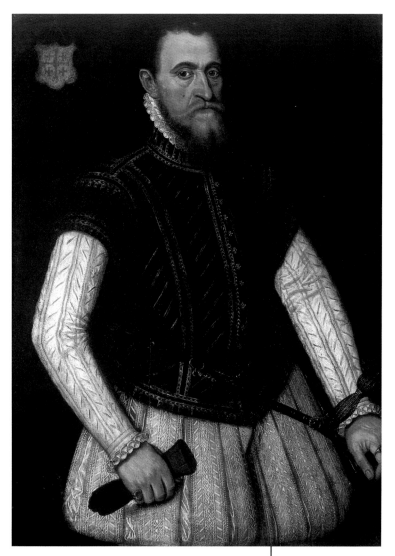

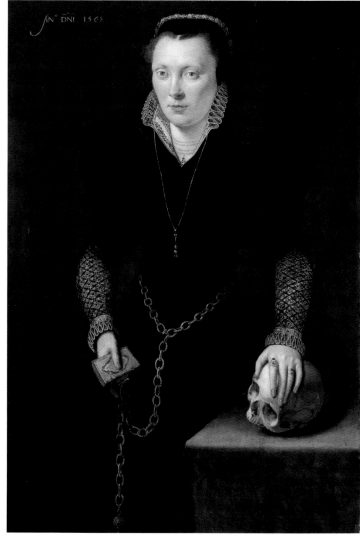

above:

31. Anon.,
Richard Clough, c.1550,
Oil, 939 × 685

right:

32. Adriaen van
Cronenburgh, *Katheryn
of Berain*, 1568,
Oil, 972 × 686

[27] It is unlikely that the portrait of Katheryn of
Berain was hung in either of Richard Clough's
houses since he died in 1570, shortly after the
picture was painted on the Continent. The
portrait probably found its first Welsh home
at Gwydir following the marriage of Katheryn
to Maurice Wynn in 1573.

[28] There is no early documentary evidence
relating to the portrait or to the contents of
Tretower, and doubts have been expressed
as to the identity of the sitter. See Karen Hearn,
*Dynasties: Painting in Tudor and Jacobean England
1530–1630* (London, 1995), pp. 92–3.

considerably more sophisticated than most contemporary indigenous work, such as
Humphrey Llwyd's portrait. Indeed, Clough's own portrait is not a pair with that
of his wife, and is more likely to have been an earlier production of insular origin.

The destruction of Bachegraig and of the interior of Plas Clough has made it
impossible to assess the patron's pictures in a domestic setting, a problem which
complicates the understanding of most Welsh portraits of the sixteenth and early
seventeenth centuries.[27] Even houses such as Chirk and Powis Castles, which
have survived with pictures of the period, have subsequently undergone such
considerable internal alteration and accretion of later works that it is difficult
to appreciate the nature of the original relationship between architecture and
artefact. Conversely, most houses surviving in something close to their early
condition have lost their contents. The magnificent portrait of Christopher
Vaughan of Tretower, Breconshire, showing the sitter in Italian-made armour,
was probably painted in the Low Countries in about 1560, and must have been
among the most sophisticated pictures to be seen in Wales in its period. It was

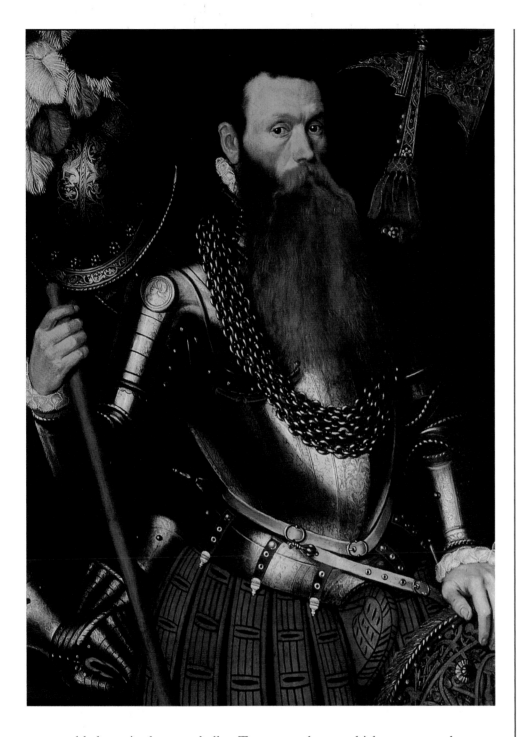

34. *The Hall at Tretower,*
mid-15th century

33. Anon.,
Christopher Vaughan of Tretower,
c.1560, Oil, 984 × 724

presumably hung in the great hall at Tretower, a house which represents the
final stage of the evolution of its medieval type, in which the fireplaces were
constructed as integral features. The departure of the family from Tretower in
the eighteenth century had the consequence of leaving the beautiful house and
its enclosing courtyard as a time capsule, affected only by superficial alterations
in the seventeenth century. Notwithstanding its perfection of form, however, it
stands desolate. Having become detached from its intended setting, the picture
survived as an isolated relic, passed down by marriage through the female line
into an English gentry family in the Welsh Marches.[28]

35. Robert Peake the Elder, *Edward Herbert, First Baron Herbert of Chirbury*, 1604, Oil, 2184 × 1143

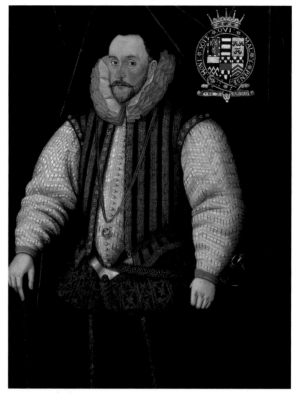

36. Anon.,

Henry Herbert, Second Earl of Pembroke,

c.1590, Oil, 1350 × 1026

Among the most enthusiastic Welsh portrait patrons of the period was Edward Herbert, first Baron Herbert of Chirbury, born in 1583 into the Montgomeryshire branch of this labyrinthine family. He flourished at that moment when the emphasis of his family's interests was shifting towards England, and he was much involved with the Stuart court and its fashions. Edward's cousins, the Herberts of Pembroke, manifested the typical gentry taste of the period, exemplified by the portrait *Henry Herbert, Second Earl of Pembroke*, painted by an unknown artist in the late sixteenth century, and that of his son, William, the third earl, painted by Abraham van Blyenberch, in 1617.[29] However, Edward Herbert, the eldest of a remarkably talented group of siblings, was an altogether more flamboyant and adventurous individual.[30] He described his career as a philosopher, poet and adventurer in one of the earliest autobiographies in the English language, a work which also gives important information about his penchant for commissioning portraits of himself. In 1604 he was made a Knight of the Order of the Bath and, during the elaborate and fanciful ceremonies, much beloved by courtiers of the period who perceived themselves as reincarnations of the knights of the mythical age of chivalry, he found time to sit for the painter Robert Peake the Elder:

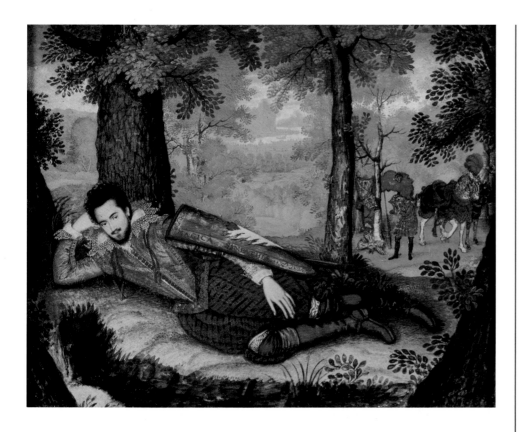

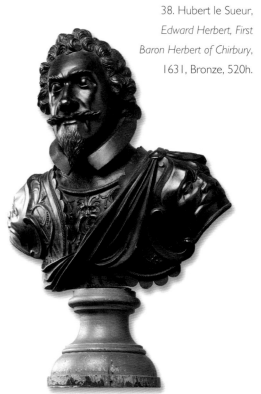

38. Hubert le Sueur,
*Edward Herbert, First
Baron Herbert of Chirbury*,
1631, Bronze, 520h.

The second day to wear Robes of Crimson Taffita (in which habit I am painted in my Study) and so to ride from St. James's to Whitehall with our Esquires before us, and the third day to wear a Gown of Purple Sattin, upon the left Sleeve whereof is fastned certain Strings weaved of white Silk and Gold tied in a knot, and tassells to it of the same, which all the Knights are obliged to wear untill they have done something famous in Arms, or 'till some Lady of Honour take it off, and fasten it on her Sleeve, saying I will answer he shall prove a good Knight.[31]

Herbert subsequently commissioned an equestrian portrait, and a head and shoulders from William Larkin, one version of which was copied in miniature by Isaac Oliver for Lady Ayres, whose habit of looking upon it 'with more earnestness and Passion than I cou'd have easily believ'd' much incensed her husband, who plotted to murder the sitter.[32] Oliver, a Huguenot painter who had settled in London where he was apprenticed to the great English miniaturist Nicholas Hilliard, also produced an original miniature of Edward Herbert which has come to be regarded among the icons of the age. Herbert lies on his side, by a stream, in the fashionable mood of melancholy deemed appropriate for the poet and philosopher, with an allusion to sympathetic magic inscribed on his shield. In the luxuriant wooded background Herbert's esquire prepares his helmet, lance and charger. The sitter had, indeed, taken part in deeds of arms, and had also played politician as ambassador to the French court. Presumably as a result of his experience there, in 1631 he commissioned the French sculptor Hubert le Sueur to make a bronze bust.

37. Isaac Oliver,
*Edward Herbert, First Baron
Herbert of Chirbury*, c.1610,
Oil, 228 × 184

[29] Van Blyenberch was of Flemish origin but worked in London, where, for a brief period, he was much in favour, painting the Prince of Wales and Ben Jonson, among others.

[30] Edward (1583–1648) was the son of Richard and Magdalen Herbert of Montgomery Castle, and the elder brother of the poet George Herbert. He was educated for a short time under Edward Thelwall at Ruthin, where it was intended he should learn Welsh, before moving to Oxford. He is not to be confused with Edward Herbert of Powis Castle, son of the first Earl of Pembroke.

[31] Edward Herbert, *The Life of Edward Lord Herbert of Cherbury* (London, 1770), pp. 54–5. Robert Peake was well established as a portrait painter by the 1580s and, on the accession of James I, he soon became principal painter to Prince Henry, apparently maintaining a large studio. See Roy Strong, *The English Icon: Elizabethan and Jacobean Portraiture* (London, 1969), p. 225.

[32] Herbert, *The Life of Edward Lord Herbert of Cherbury*, p. 86.

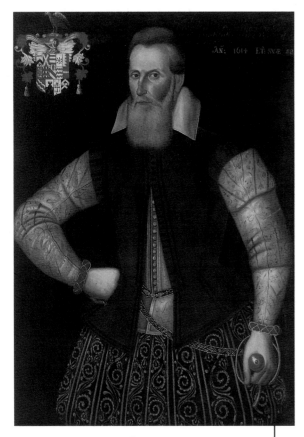

39. Anon.,

Sir Thomas Mansel of Margam,

c.1600, Oil, 965 × 685

At the same time as the romantic Edward Herbert was making his career, the Mansel family was rising in power in Glamorgan. The Mansels of Oxwich were among those families who built on the investment made in monastic lands following the dissolution, in their case the purchase of Margam Abbey, on the site of which a new house was built. Sir Thomas Mansel, who inherited in 1595, developed his fortunes in a rather more sober fashion than Edward Herbert, though his younger brother, Robert, distinguished himself as Admiral of the Narrow Seas. During the first two decades of the seventeenth century this generation of the family commissioned a notable group of portraits in the formal and heraldic style that was soon to be swept from fashion by the London career of Van Dyck. The single portrait of Sir Thomas Mansel presents him as a man of about forty, and so it must date from the early years of the seventeenth century.[33] In two closely related family groups, which probably represent Sir Thomas and his second wife, Jane, he has clearly aged by some ten or twenty years. In one case the couple stand alone, but in the other they are accompanied by their daughter Mary, who would marry Edward Stradling of St Donat's. It is unclear which is the earlier picture, but in the double portrait Jane holds a marigold, symbolic of grief, and it may be that this indicates the death of her first husband, John Bussy. If so, the triple portrait would have been copied from the double

40. Anon.,

Sir Thomas Mansel of Margam,

his wife Jane and their daughter Mary,

c.1625, Oil, 1193 × 1193

[33] Contrary to the inscription, which gives 1614 and Sir Thomas's age as fifty-eight. The Mansel portraits present difficulties of identification and dating because they were incorrectly inscribed in the eighteenth century.

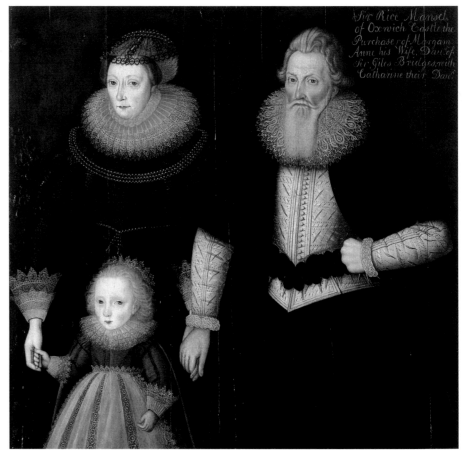

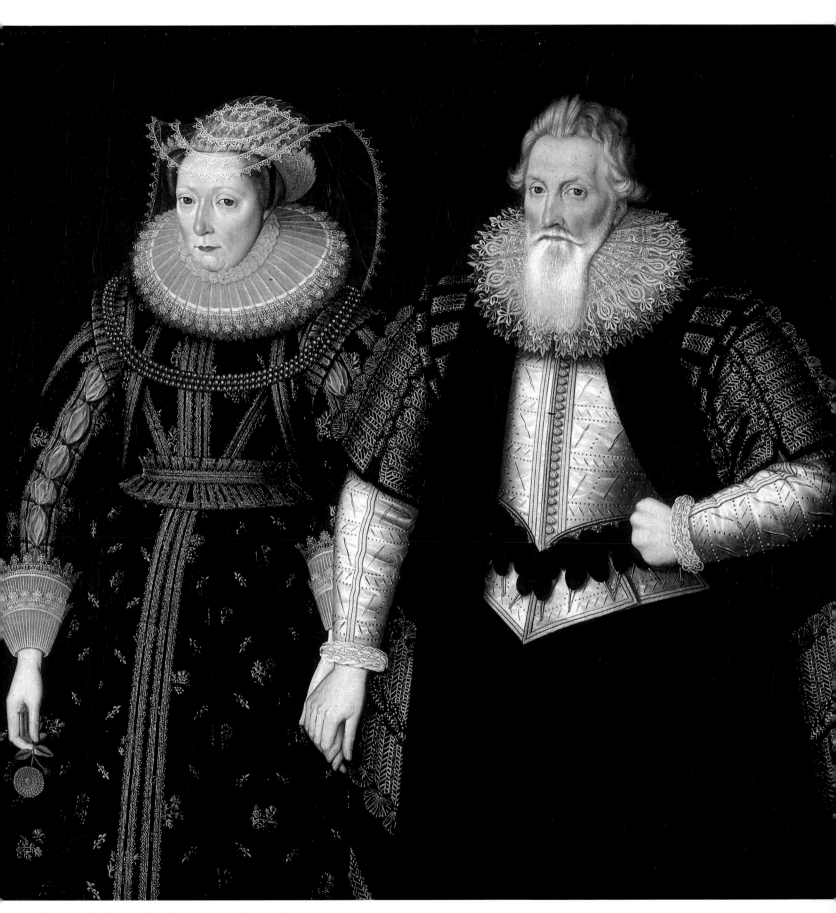

41. Anon., *Sir Thomas Mansel of Margam and his wife Jane,*
*c.*1625, Oil, 1180 × 1260

42. Gilbert Jackson,
John Williams, 1625,
Oil, 2146 × 1447

34 See, for instance, the portrait by Gheerhaerts of Mary Throckmorton, Lady Scudamore, c.1614–15, illustrated in Strong, *The English Icon*, p. 285.

35 Among them was Richard, second Baron Herbert of Chirbury. Sir Thomas Hanmer was noted for his interest in plants, and a portrait of his second wife, Susan, shows her with *Gerard's Herbal* and another weighty tome, presumably on the same subject.

36 J. Steegman, *A Survey of Portraits in Welsh Houses, Vol. I, North Wales* (Cardiff, 1957), gives Robert Morgan, Catherine Morgan, and an unknown woman of the Morgan family and her daughter, at Golden Grove (Flintshire), 1632; a woman of the Trevor family at Trefalun (Denbighshire), c.1635; a man of the Edwards family at Rhual (Flintshire), 1639. The identity of the female member of the Thelwall family who sat with her daughters is traditionally given as 'Sidney Wynne, Mrs Thelwall', but Steegman believed that the portrait was of an earlier generation, thereby making the tentative attribution to Jackson possible.

portrait, the daughter holding her mother's hand in place of the flower, symbolizing a new generation alleviating the grief of her earlier loss. Such complex allusions were commonplace in the portraiture of the period. The more elaborate decoration and softer modelling of the double portrait are also indicative of its status as the source work.

The painter of the Mansel portraits is unknown. It is often assumed that families with strong court connections, such as the Herberts and the Mansels, were painted in London, but it is quite possible that specialist painters were summoned from London to Wales, or that a local painter was commissioned to work in the style of the court. Though rather stiff in characterization, the Mansel double portrait is not unlike the work of Marcus Gheerhaerts the Younger, and may represent an imitation of his manner by a Welsh painter.[34] However, a small number of signed portraits painted for well-placed Welsh families of the period have survived, and these give a clearer indication of the patterns of patronage. Sir Thomas Hanmer of Flint was at the court of Charles I, where his wife Elizabeth was Lady in Waiting to Queen Henrietta Maria. In 1631 he commissioned a pair of portraits from Cornelius Johnson, one of the most prestigious painters of the period working in England and who was appointed 'King's Painter' in the following year. Johnson was also commissioned by other Welsh sitters,[35] as was his less well-known contemporary Gilbert Jackson, which suggests the exploitation of the Welsh gentry network. Both painters produced full-length portraits of John Williams, born in Conwy but a product of Gabriel Goodman's grammar school in Ruthin. Williams then went to Cambridge and rose to prominence under James I as Dean of Westminster and subsequently Bishop of Lincoln. In 1621 he was made Lord Keeper and four years later, presumably shortly before he was removed from office, he was painted by both Johnson and Jackson. Johnson's portrait was given to Westminster Abbey Library, which Williams patronized with the provision of lavish interior fittings. The portraits are similar but not identical and it is unclear if they represent separate personal sittings to the two painters or a slightly altered copy of one painter's work by the other. Over the following fourteen years Gilbert Jackson painted a disproportionate number of Welsh people from the north-east of the country, which suggests that Williams may have recommended him. In 1628 he painted Eubule Thelwall, Principal of Jesus College, Oxford, an extremely fortuitous commission since the sitter had no fewer than nine brothers. Jackson certainly painted Bevis Thelwall in the same year and Ambrose Thelwall in 1632, and three unsigned portraits of other brothers were to a common format and hung together in the family home, and they too may safely be assumed to be his work. Jackson may also have been responsible for a group portrait of an unidentified woman of the Thelwall family and her three daughters, and he certainly went on to paint at least five portraits of members of other Flintshire and Denbighshire families between 1632 and 1639.[36]

Whether or not this extensive Welsh practice can be taken to imply that Jackson visited Wales is uncertain. His sitters may have gone to him in London or Oxford, but for some patrons such a journey was certainly unpalatable. By the second quarter of the seventeenth century, those who lived in north Wales could avail themselves of portrait painters based in Chester. The gentry network, which was exploited by plasterers and carpenters, seems also to have served Thomas Leigh well since he painted at least five portraits of the Esclus and Gwysaney families in 1643. Sir Richard Lloyd of Esclus, a Royalist judge, is known to have been active in Chester in that year which saw the beginning of the troubles in north-east Wales, and for that reason it seems probable that he and his wife sat for Leigh in the city. However, the fact that in the same year Leigh also painted portraits of Robert and Ann Davies of Gwysaney, and Ann's sister Eleanor, suggests that he came to Wales. Following a common practice in this period, Leigh also painted copy portraits of Robert and Ann to hang at Llannerch, home of Ann's father, Sir Peter Mytton. A second Chester painter, John Souch, had earlier painted Sir Roger Puleston, MP for Flintshire, and this commission is particularly interesting for the light it sheds on painting practice in the period. It is known that Souch was apprenticed to the herald painter Randle Holme between 1607 and 1610.

43. Thomas Leigh,
Robert Davies of Gwysaney,
1643, Oil, 660 × 558

Herald painters operated in a workshop tradition, controlled by craft guilds, whose traditions extended back into the middle ages. The advent of new forms such as the portrait were symptomatic of fundamental changes in social and economic organization which eventually swept the guilds away, but the older tradition continued to exert its influence on the aesthetics of portraiture as late as the seventeenth century. Both the application of coats of arms and inscriptions to the face of the painting and also the rigidity of design and flatness of the forms of early portraits were redolent of heraldry. A conceptual explanation of a sitter's circumstances through heraldry and inscription on a dark and featureless background was favoured in Welsh portraits well into the seventeenth century. However, in 1627, a window onto nature in the form of a landscape replaced the conventional coat of arms to define Edward Morgan of Llantarnam's prominent place in the world. He had been MP and sheriff of Monmouthshire in the 1580s. In the absence of indigenous specialists at a time when the fashion for portrait paintings first spread from the Continent, locally-based herald and sign painters may well have met the demand from early patrons such as the Goodmans. Visual evidence suggests that herald painters continued to diversify into portraiture well into the seventeenth century. Among Holme's Welsh clients were the Nannau family, and in 1632 Huw Nanney became the first of them to commission a portrait. The result is redolent of the conventions of the herald painter and is remarkably archaic, bearing in mind that it was painted in the year in which Van Dyck returned to London.[37] Given the connection with the family, the Randle Holme I workshop may have been responsible.[38]

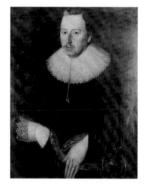

44. John Souch,
Sir Roger Puleston,
1618, Oil, 736 × 609

[37] Van Dyck had visited London briefly in 1620–1.

[38] See Miles K. W. Cato, 'Nannau and Early Portraiture in North Wales', *Journal of the Merioneth Historical and Record Society*, XI, part 2 (1991), 183. The National Museum of Wales holds a portrait of Thomas ap Ieuan ap David of Arddynwent signed with a monogram which has been interpreted as FHR, possibly standing for Randle Holme Fecit. However, the monogram was previously read (by Sotheby's) as HTK and the attribution to Randle Holme must be considered speculative. It is certainly clear that the National Museum portrait and that of Huw Nanney are by different hands.

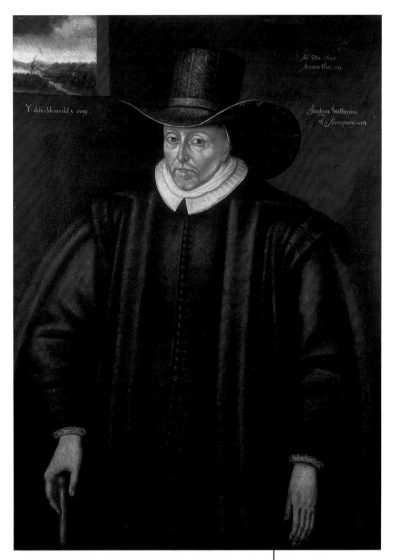

Chester was the most important centre for herald painters
serving north Wales. Randle Holme I had trained in the workshop
of Thomas Chaloner and his son Jacob, and it was they who
carried out a commission from the Myddeltons of Chirk to make
an illuminated pedigree roll and, in 1613, to paint heraldic
banners.[39] Randle Holme I seems to have acquired the Chaloner
workshop by marrying his master's widow in or after 1598, and
the business descended through a further three generations of
painters of the same name.[40] Their business combined the
practical skills of the painter with genealogical and heraldic
research, which took them into churches and houses all over
north Wales. In 1621, for instance, Holme went to Beaumaris
church where he made drawings of carved and painted arms
on tomb effigies, and details of stained glass windows.[41]

Heraldic work became a particularly lucrative part of the
painter's business on the death of members of prominent
families, and the ceremonial of funerals carried gentry
patronage in the visual culture from the private into the
public domain. On the death of Huw Nanney in 1647, for
instance, Randle Holme I was commissioned both to organize
the procession and to design and supply the customary heraldry
for the funeral. This would have included flags and streamers
painted on both silk and cheaper fabrics for display in the cortège and in the church,
as well as chevrons and escutcheons painted on wood. He wrote to Howel Vaughan,
son of Robert Vaughan of Hengwrt, regarding the arrangements:

I receued your letter, and according to you[r] directions, haue made all
things fully accordinge as the shortnesse of the tyme would permitt, and haue
receaued for the same xij[li] which consideringe the great charge of gould was
litle enough: as for to giue you any directions for the placeinge and naylinge
them on the staues you know by the last w[ch] was done. I have made 9 [shields]
for the body w[ch] you may order as beneath ... for the funerall order, first the
poore 2 & 2, then the seruants of the howse in Clokes, then the baner carried
by a kinesman of blood: then the helme & crest by an other, then the Cote of
armes by an other, then the precher, then the Corpes carried by the gentrey of
kindred, then his sonne & heyre alone, then his brethren 2 & 2, (& so all w[ch]
haue blacks accordinge to neernesse of blood,) then the women in black, in
like maner, then the Knightes, Esquiers, etc ...[42]

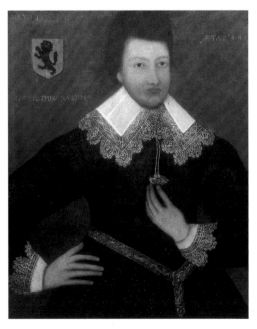

46. Anon., *Huw Nanney the Younger, of Nannau,*
1632, Oil, 787 x 660

[39] W. M. Myddelton, *Chirk Castle Accounts A.D. 1605–1666* (privately printed, St Albans, 1908), p. 12. The pedigree roll is BM Sloane MS 3977.

[40] J. P. Earwaker, 'The Four Randle Holmes, of Chester', *Journal of the Chester Archaeological and Historic Society*, 4 (1892), 113–70.

[41] *Arch. Camb.*, LXXIX (1924), 149, 151.

[42] Ibid., VI (1860), 24.

[43] Myddelton, *Chirk Castle Accounts*, p. 143. A detailed list of painted items for the funeral of Sir Richard Myddelton in 1716, supplied by Francis Bassano of Chester, is given in idem, *Chirk Castle Accounts (Continued)*, pp. 388–9.

[44] William Hamper (ed.), *The Life, Diary, and Correspondence of Sir W. Dugdale, Knight* (London, 1827), pp. 129 and 132–3.

[45] At the church of Llanbeblig, Caernarfonshire, the alabaster tomb of a member of the Gruffydd family was adorned with such figures in remarkable profusion. Not only were the seven daughters and eight sons of the deceased depicted, but on a separate panel one of these sons, who was the donor of the tomb, was repeated with his wife and their ten children. Each of the pillars separating the figurative panels carried a coat of arms.

For the funeral of Sir Thomas Myddelton in June 1666, Randle Holme III's bill amounted to £59 10s. A poem, 'Upon the Ffunerall of Sr Tho. M.', inserted into the family accounts, described the decorated procession, led by the county troop of horse and:

> Then after came his horse, arayd,
> with scutcheons, and his Armes displayed ...
>
> The, standerds, with silke and Gould,
> Embossd most Glorious to behould.[43]

47. Randle Holme I, *Drawings of tombs and heraldry in Beaumaris church*, 1621, Pen and ink, 195 × 300

The arms of the deceased were sometimes left in the church and, within buildings associated with notable families, considerable collections could accumulate over the years. Those set up by Randle Holme III for Sir Thomas Myddelton proved contentious, and provide an insight into the death throes of the guild regulation of painters. Herald painters were licensed to work by the College of Heralds and it appears that Randle Holme III fell into dispute with this authority. The Heralds' representative, William Dugdale, rode to Chirk on 7 August 1668 'to view what was hung up by Holmes, yᵉ Paynter, at Sʳ T. Middleton's funerall'. He was apparently not pleased with what he saw and two years later returned and 'puld down and defaced divers penons, and other Atchievements hung up by Holmes, for Sr. Tho. Middleton, and his Son'.[44]

48. Randle Holme III, *The Hearse set up for the Lord Bulkeley, Viscount Cashall*, 1688, Pen and ink, 195 × 275

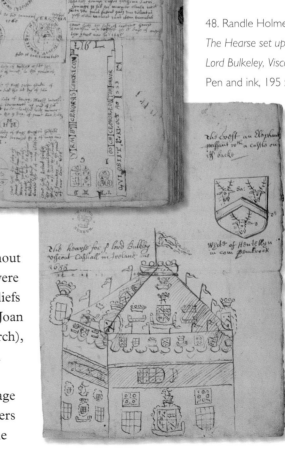

The Church remained the main public focus for gentry patronage of the visual culture, as it had been throughout the middle ages. The medieval forms of the effigy and the brass were retained but evolved under the influence of changing religious beliefs and aesthetic fashions. The alabaster monument to Sir John and Joan Salusbury, erected in 1588 in the church of Llanfarchell (Whitchurch), Denbighshire, like many contemporary memorials in other Welsh churches, is a transitional object. While repeating, in essence, the medieval form, it nevertheless indicates the concerns of the new age by the proliferation of miniature carved portraits of family members and heraldry on its supporting architectural plinth.[45] As well as the

49. Donbins,
*Tomb of Sir John and
Joan Salusbury*, Church of
St Marcella, Llanfarchell,
1588, Alabaster

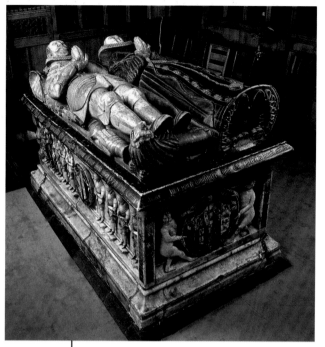

50. Anon., *Tomb of
Humphrey Llwyd*,
Church of St Marcella,
Llanfarchell, 1568,
Stone

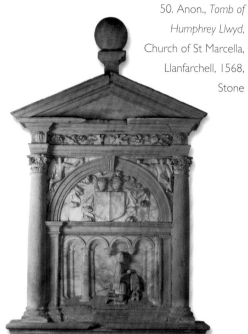

51. Walter Hancock,
*Memorial to Richard
and Magdalen Herbert*,
Church of St Nicholas,
Montgomery, 1600,
Alabaster

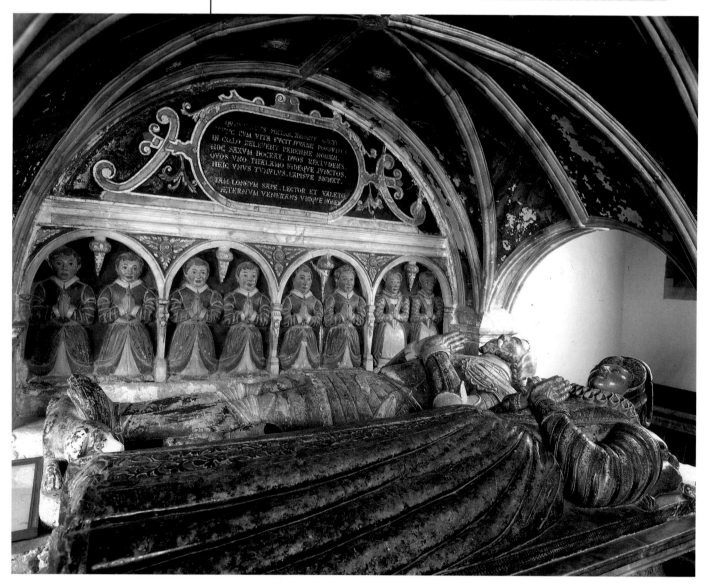

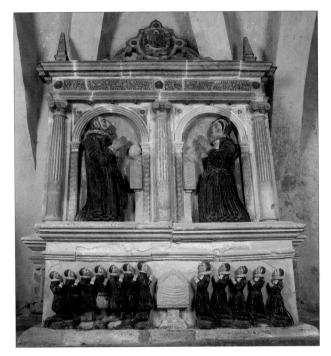

52. Anon.,
Memorial to Roger Lort,
Church of St James and
Elidir, Stackpole,
1613, Stone

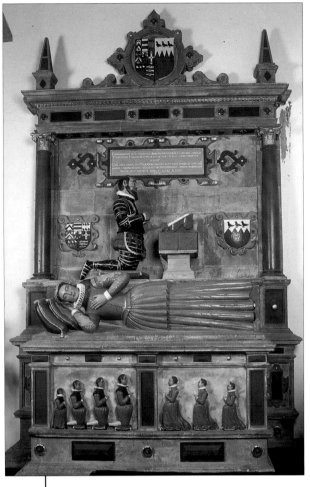

53. Anon.,
Memorial to Margaret Mercer,
Church of St Mary, Tenby,
1610, Alabaster

Salusbury tomb, the church of Llanfarchell houses the memorial to Humphrey Llwyd, erected after his death in 1568, which demonstrates a more dramatic shift away from medieval conventions. Reflecting Llwyd's status as a modernist, his wall-mounted memorial is a fully Renaissance product, setting his carved portrait within a realistic architectural space achieved by low relief perspective. It is contained in a magnificent frame of mixed Classical features and ornament. Llwyd was depicted in life, kneeling at prayer, a motif which became commonly employed on both the free-standing and wall-mounted polychrome memorials which proliferated towards the end of the century. Perhaps the most splendid of them, to Richard and Magdalen Herbert, parents of Edward, first Baron Herbert of Chirbury, was constructed in 1600 in the church of St Nicholas, Montgomery.[46] Edward and his brothers are portrayed in life, kneeling in pairs behind the recumbent deceased, who lie above the cadaver of Richard, in the allegorical manner of some painted portraits of the period. The transience of human life suggested by the cadaver was reinforced by painted figures, representing Vanity and Time, in the spandrels of the arch which supports the flamboyant strapwork surround to the family arms. The splendour of the Herbert tomb is echoed by a memorial to Margaret Mercer in Tenby, but is distinguished from it by the fact that its patron had risen in the world by trade rather than by the ownership of land. It was erected in 1610, following her death in childbirth, by her husband, who is depicted in life, kneeling at prayer above her recumbent body. Many small country churches also house polychrome memorials of the early seventeenth century. The memorial to Roger Lort at Stackpole, erected in 1613, is characteristic of them by virtue of its location in a private chapel, in this case adjoining the chancel. It is notable for the survival of most of the original paint and, like the Mercer memorial, it may well be of local workmanship.

[46] Probably to the design of the architect Walter Hancock, for whom see Richard Haslam, *The Buildings of Wales: Powys* (London/Cardiff, 1979), p. 166.

54. Anon.,
Sir John Wynn of Gwydir,
1619, Oil, 914 × 723

55. Robert Vaughan,
Sir John Wynn of Gwydir, c.1649,
Engraving, 303 × 211

56. Robert Vaughan, *Sᴿ John Wynn of Gwedvr*,
Gwydir Chapel in the Church of St Grwst,
Llanrwst, c.1649, Brass, 495d.

[47] For further examples,
see J. Mostyn Lewis,
*Welsh Monumental
Brasses* (Cardiff, 1974).

[48] There is circumstantial
evidence that Vaughan was
Welsh. He worked for other
Welsh clients, notably Rowland
Vaughan, for whose translation of
Usher's *Principles of the Christian Religion*,
published in 1658, the engraver provided a
portrait which he signed in Welsh 'Rob:Vaughan
ai lluniodd'. He also illustrated the author James
Howell's *Survey of the Seignorie of Venice*. However,
Isaac Williams, first Keeper of Art at the National
Museum of Wales, caused considerable confusion
by identifying Robert Vaughan the engraver with
the antiquary of the same name, in *Early Welsh
Line and Mezzotint Engravers* (Cardiff, 1933). This
quite erroneous association stimulated responses
from Bob Owen in *Y Genedl Gymreig*, 9 November
1933, in which the evidence for Vaughan's
Welshness is reviewed, and T. A. Glenn, 'Robert
Vaughan of Hengwrt and Robert Vaughan the
London Engraver', *Arch. Camb.*, LXXXIX (1934),
Part 2, 291–307. In his enthusiasm to refute
Williams, Glenn suggested that Vaughan was
of Dutch descent.

[49] NLW, Calendar of Wynn (of Gwydir) Papers,
no. 2310.

The kneeling figure at prayer, as seen at Llanfarchell and Tenby, also became commonplace on brasses. Again at Llanfarchell, the particularly splendid brass to Richard and Jane Myddelton depicts the husband and wife at prayer, facing each other over lecterns on which are placed devotional books. The Myddeltons are supported by the figures of their nine sons and seven daughters.[47] However, the remarkable set of brasses commissioned by the Wynn family of Gwydir and set up in their chapel at Llanrwst church broke with the medieval tradition and its early modern derivative; they approached much more closely the form of the painted portrait. The chapel was completed eight years after the death of Sir John Wynn in 1627, but his commemorative brass was apparently not made until the 1640s. It was commissioned by his second son, Sir Richard Wynn, who was highly placed at court as treasurer to Queen Henrietta Maria. At his London house in the Strand he kept his father's painted portrait, done in 1619, from which the brass was engraved by Robert Vaughan, with some modifications, and also the very similar plate from which the printed version was produced.[48] Vaughan followed the pattern which he had established with the brass to Sir John Wynn in those he subsequently made to Lady Sydney Wynn, his wife, and Sir Owen Wynn, younger brother of Richard. The last of these brasses was commissioned by Owen's son Maurice, who was required by the engraver to state whether he wished to have his father 'engraven'd with a face new trimmed' or with the bushy beard that he habitually wore. The more respectable option was chosen.[49] The brass to Lady Mary Mostyn, sister to Richard and Owen, was not carried out by Vaughan but by the Wrexham

goldsmith Sylvanus Crue, in 1658. The square format, set diamond-fashion, was retained, but otherwise Crue departed from Vaughan's pattern by setting the sitter in an oval. The change to a Wrexham engraver eased the practical difficulty of such commissions by obviating the need to carry to London the portrait of Lady Mary, painted in 1634, which was the source of the likeness. Mary's husband had died after the picture was painted and so Crue portrayed her wearing the conventional cap with a widow's peak.

57. Sylvanus Crue, *Lady Mary Mostyn*, Gwydir Chapel in the Church of St Grwst, Llanrwst, 1658, Brass, 457d.

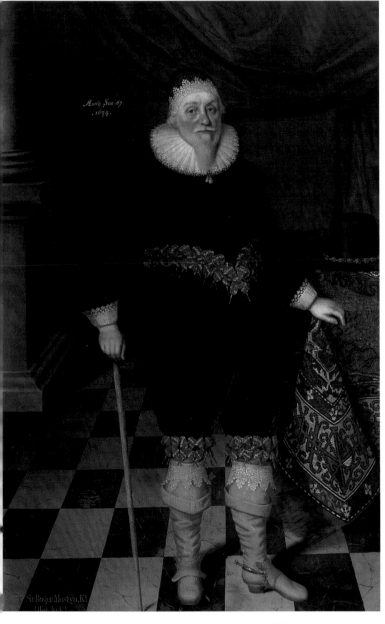

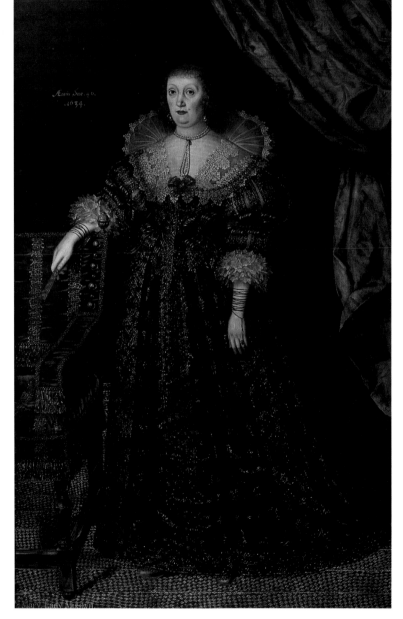

58. Anon., *Lord Mostyn*, 1634, Oil, 2108 × 1346

59. Anon., *Lady Mary Mostyn*, 1634, Oil, 2108 × 1346

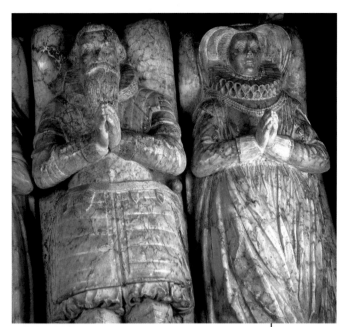

60. Maximilian Colt,
*Memorial to Sir Thomas Mansel of
Margam, Mary his first wife and Jane
his second,* Church of Margam Abbey,
Margam, 1639, Alabaster

There was clearly considerable cross-fertilization between the painted portrait, the memorial brass and the carved polychrome memorial. Facial likeness, which must have been approximate at best on most medieval effigies, was improved by the availability of portable pictures. The earliest documentary evidence of sculptors copying portraits in Wales dates from 1676, when John Bushnell, a London sculptor, was commissioned to carve a memorial to Elizabeth Myddelton at Chirk, and to aid him in his work a portrait of the deceased was brought from her father's house for the sculptor 'to draw a pattern'.[50] Seven years later Mr Gomsall of Chester, described as a limner, was paid to draw a portrait from the dead body of a son of Sir Thomas Myddelton to be sent to London for the same purpose. However, it is clear from visual evidence such as that provided by the Goodman commissions for brasses and the polychrome bust at Ruthin that the practice was common by the late sixteenth century. Early in the seventeenth century the effigies of Sir Thomas and Jane Mansel were placed on a splendid tomb at Margam which also supported an image of Sir Thomas's first wife, Mary. It was carved by Maximilian Colt, a Huguenot working in London and perhaps the most prestigious sculptor of the age, who was responsible for the tomb of Elizabeth I. The faces of Sir Thomas and Jane are clearly based on the painted double portrait of c.1625. The most unusual example of the close relationship between the polychrome memorials of the late sixteenth and early seventeenth centuries and the painted portrait is that of Sir Edward and Lady Agnes Stradling at St Donat's. The great antiquarian, Sir Edward Stradling, transferred the bodies of a number of his ancestors to the chapel built onto the church by his father, and in 1590 he commissioned three panel paintings to celebrate them. The pictures were designed like three-dimensional memorials and should be considered, in consequence, not as particularly idiosyncratic portraits but rather as substitutes for sculptures, which had not been commissioned because of the scattering of the family burials. The central figures kneel to face each other, supported on two of the panels by their children. Sir Edward's father, Thomas, had been a prominent Roman Catholic who prospered under Mary but whose adherence to the faith under Elizabeth had cost the family dear, which may account for the absence of a memorial portrait to him. The pictures carry extensive inscriptions and heraldry and although the figures themselves exist in a realistic three-dimensional space, this is terminated immediately behind them, the painter having made no attempt to provide a background. On his death in 1609 Sir Edward's own portrait with his wife, Agnes, became the basis for a polychrome memorial of the kind for which the pictures had originally substituted.[51]

[50] Myddelton, *Chirk Castle Accounts (Continued),* p. 119. The accounts are not entirely clear about the transport of the portrait. It was suggested by Edward Hubbard, *The Buildings of Wales: Clwyd (Denbighshire and Flintshire)* (Cardiff, 1986), p. 128, that the portrait was sent to London, but a more plausible reading of the accounts is that it was sent to Chirk and that Bushnell saw it there on a visit in connection with the commission.

[51] Anthony L. Jones, *Heraldry in the Churches, Castles and Manor Houses of Glamorgan: South Glamorgan No. 4* (Cowbridge, [1990]), pp. 24–35. A tradition in the Bird family of Cowbridge records that the painter of the portraits was their ancestor.

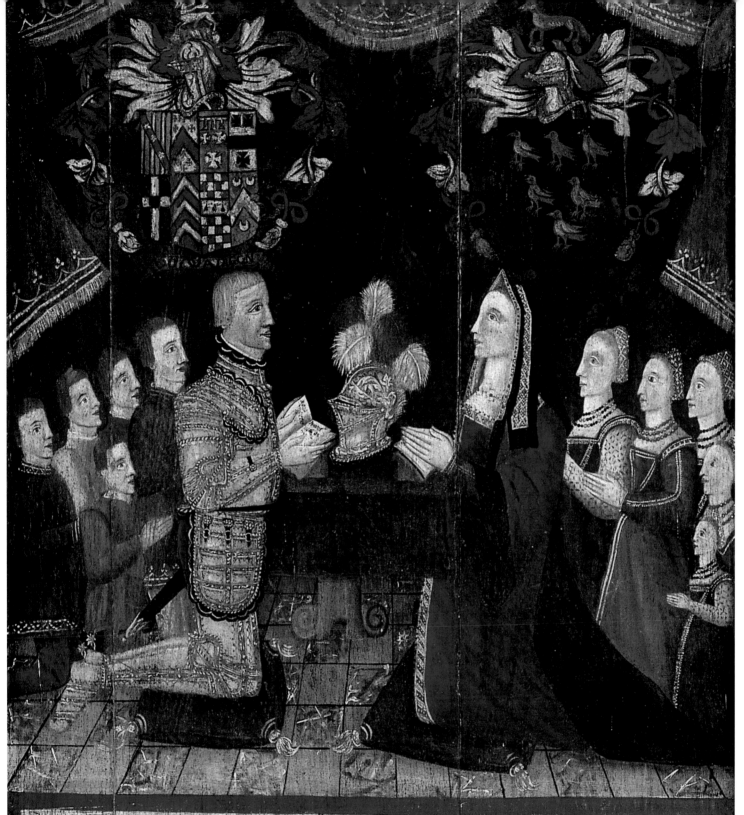

HERE LYETH EDWARD STRADLINGE KNIGHT THE ·4· OF THAT NAME SONNE TO THOMAS
STRADLINGE ESQVIER AND IENET HIS WYFE (THE DAVGHTER OF THOMAS MATHEWE OF RADER
IN THE COVNTY OF GLAMORGAN ESQVIER) WHO DIED IN THE CASTELL OF SAINT DONATTS THE
8· DAY OF MAY IN THE YERE OF OVR LORD ·1535· AND WAS BVRIED IN THE CHAVNCEL OF THE
CHVRCH THER WHOS BONES WERE AFTER TRANSLATED BY HIS NEPHEWE EDWARD STRADLINGE
KNIGHT THE ·5· OF THAT NAME INTO THE CHAPPELL THER IN THE YERE OF OVR LORD ·1573· ALLSO
HERE LYETH ELIZABETH HIS WIFE DAVGHTER TO THOMAS ARVNDELL OF LANHEYRON IN THE COVNTY
OF CORNEWALL KNIGHT WHO DYED IN CHILDBEAD AT MERTHERMAWRE THE 20· DAY OF FEBRVARY IN
THE YERE OF OVR LORD ·1513· AND WAS BVRYED THER WHOS BONES THOMAS STRADLINGE KNIGHT
HER SONNE CAVSED TO BE TAKEN VP AND CARYED TO SAINT DONATTS AND BVRYED IN THE CHAVNCELL
OF THE CHVRCH THER WITH HER HVSBAND THE ·8· DAY OF MAYE IN THE YERE OF OVR LORD·1536·
AND WERE AFTERWARDS BY EDWARD STRADLINGE KNIGHT THE·5· OF THAT NAME HER NEPHEWE
TRANSLATETED OVT OF THE CHAVNCELL INTO THE CHAPPEL THER IN THE YERE OF OVR LORD 1573

62. Anon.,
Memorial to John Trevor,
Church of All Saints, Gresford,
1589, Marble

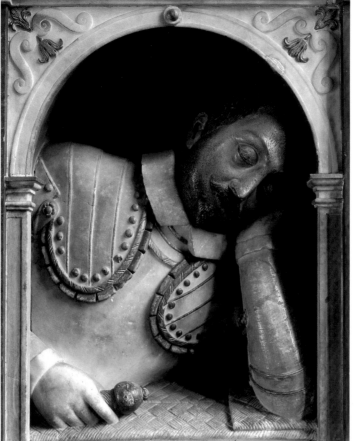

[52] John Trevor was yet
another example of the
success of the gentry of the north-east as
courtiers and soldiers and, like his contemporary
Richard Clough, he brought fashions to Wales
both from London and the Continent. He built
one of the finest modernist houses of the
Elizabethan period, Trefalun in Denbighshire,
and his second son, another John Trevor, later
built the equally important Plas Teg.

[53] The effect is heightened by their location, in
an upright position, on either side of the altar.
It is known that at one time they were placed
horizontally in the nave, though this may not
necessarily represent their original location.
See J. A. Bradney, *A History of Monmouthshire*
(4 vols., London, 1906–32), I, Part II, p. 272.

[54] Two further low relief slabs, one dated 1621,
are of more complex iconography, but probably
emanate from the same workshop. Similar relief
carved memorials have been identified at
Grosmont and Llanfoist.

[55] Quoted by A. J. Parkinson in W. Nigel Yates,
Rug Chapel, Llangar Church, Gwydir Uchaf Chapel
(Cardiff, 1993), p. 37.

[56] Wiliam Cynwal similarly practised both as a
poet and a genealogist. His genealogical table of
the family of Katheryn of Berain is of high quality.
MS Christchurch, Oxford, 184. See Michael
Powell Siddons, 'Welsh Pedigree Rolls', *National
Library of Wales Journal*, XXIX (1995), 1–16.

Tombs carved in alabaster
had to be commissioned
from one of several manufacturies
in England where the stone was
available, and so their general form
is common to most parts of Britain.
Late Elizabethan and Jacobean
polychrome memorials carved in
other stones also generally conform
to a widespread pattern, though local
manufacture and idiosyncratic patronage are more evident. At Gresford church,
the monument to John Trevor, who died in 1589, made use in sculpture of the
melancholic pose developed in contemporary miniatures to indicate the man of
taste, so magnificently expressed in Isaac Oliver's later portrait of Edward Herbert.[52]
The most unusual form of this monument was clearly the source for the tomb of
another local gentleman, Efan Llwyd of Bodidris, constructed half a century later
at nearby Llanarmon-yn-Iâl.

The new forms developed for sophisticated patrons such as Trevor did not,
however, always exercise such a dominant influence on local production. In a
group of Monmouthshire churches a school of carving developed in the 1620s
which, although it memorialized figures whose experience of the world extended
well beyond the parish in which they were buried, was as much dependent on
medieval models as on the new portraiture in painting and sculpture. At
Llanvetherine the figures of the Revd David and Mary Powell were carved,
life-size, in low relief with dramatic boldness, and, presumably, were originally
painted.[53] Mary Powell wears what appears to be a high beaver hat, similar to
that which was later standardized by Lady Llanover in nearby Abergavenny as
a Welsh national costume. The same sculptor was clearly at work in Llantilio
Crossenny, where there is a single male effigy of closely similar style, though
unidentified by inscription.[54]

63. Anon., *Revd David Powell*,
Church of St James the Elder, Llanvetherine,
Date uncertain, Stone, 2082 × 775

below: 64. Rhys Cain,
*The Arms of Edward Almer and
part of his Pedigree Roll*, detail,
1602, Gouache, 575 × 2159

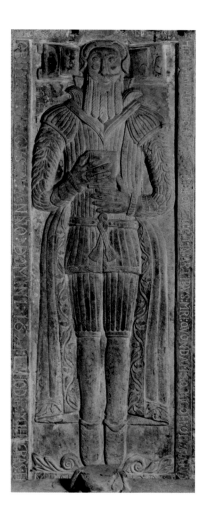

Although brasses and carved memorials were located in churches, they were essentially secular objects. Religious painting in the churches of the period was constrained by the iconoclasm liberated by the Order in Council of 1547 which required 'the obliteration and destruction of all popish and superstitious books and images'.[55] Nevertheless, it is clear that commissions continued to be given. Rhys Cain practised heraldic painting in Oswestry from the last quarter of the sixteenth century, and, like the Chaloners in Chester, bequeathed the business to his son, Siôn Cain. Older biographical dictionaries assert, improbably, that Rhys Cain was born in Trawsfynydd, but he had family connections on the borders from where he was able to sustain a practice both as a compositor and painter of pedigrees, and as a poet.[56] Large painted pedigree rolls of a number of prominent families survive, and he was held in high regard by the leading antiquarian of the period, Robert Vaughan of Hengwrt. However, like the Chester painters, it appears that Rhys was sustained by a more broadly-based practice than heraldry alone. In an *englyn*, he was criticized by an unknown Puritan for the painting of a religious image:

> May not one image be made by his hand, – Oh Lord Jesus!
> He chose to defy us;
> But may he believe silently in Christ,
> The everlasting One, and his holy word yonder.[57]

[57] The anonymous *englyn* is preserved in two manuscripts, NLW MS 1668B, f. 59[v] and NLW MS 11816B, f. 216[r]: 'Na wnaed yr un lun â'i law, – Duw Iesu, / Dewisodd ein beiddiaw; / Ond credu i Grist yn ddistaw / Ŵr didranc, a'i air da draw.' (In modern orthography.)

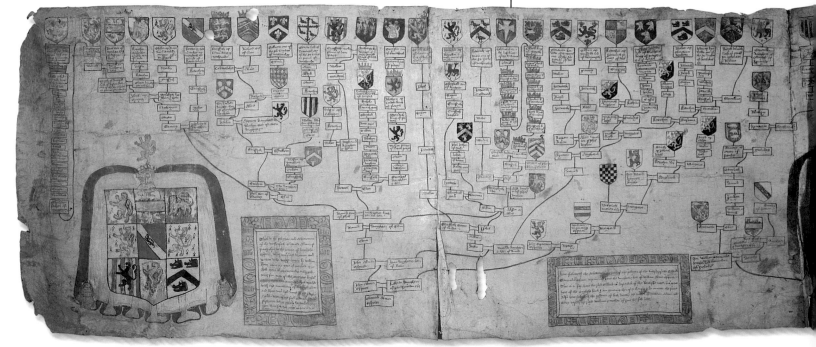

65. Anon.,
Rug Chapel, 1637

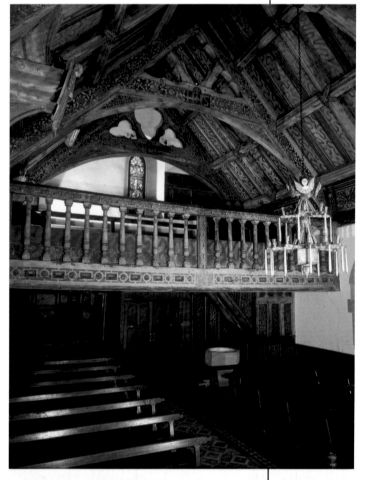

Rhys clearly had High Church sympathies, and made an aggressive rebuttal:

> The foolish ungodly person flees – out of sight
>> As a result of seeing a picture of Jesus;
> May he create, if that is better,
> A picture of the devil everywhere in his house.[58]

The picture of Christ to which the Puritan took exception was probably a small object of private devotion. Although by the 1630s, under the influence of Charles I, attempts were made by Arminians to re-establish elements of church ritual and associated architectural and decorative practices, medieval Roman Catholic iconography was not generally revived in public. Few private works belonging to Welsh Roman Catholics such as Sir Thomas Stradling, who commissioned four pictures of the miraculous appearance of the image of the cross in a tree blown down in a great gale, have survived. At Abergavenny, probably during the Commonwealth period, Thomas Gunter commissioned an *Adoration of the Magi* for his private and presumably secret chapel. The picture was painted on plaster in the manner of decorative schemes and seems to have been the work of an artisan, probably using an engraving of a continental Renaissance work as a model.

The High Church inclinations of Charles I provided a respite in which the most magnificent surviving example of public religious art of the period, Rug Chapel, was built by William Salusbury in 1637. The scheme, whose style suggests the work of local artisans, involved polychrome wood carvings of angels, flat painted patterns on ceilings and walls based on flowers and animals, and texts. For all its reference to medieval practice in the overall effect of such rich decoration, the absence of any subject painting like that commissioned by the recusant Thomas Gunter, and also the presence of texts in the Welsh language, indicate that Rug was a Reformation product. The lectern-pulpit was decorated with the Lord's Prayer, reflecting the new stress laid on the Word and on its accessibility to the common people in their own language.

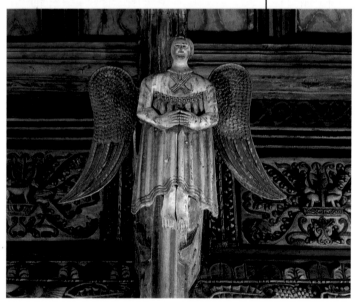

66. Anon., *Angel in Rug Chapel*,
1637, Painted wood

Such pictures and texts were among the very few visual images to which the common people had access, and it is likely that wall painting was carried out in ordinary parish churches, as well as in the private chapels of the gentry, during the first half of the seventeenth century. As a result of the abandonment of the Roman Catholic doctrine of purgatory, new images tended to focus the mind of the observer on the immediacy and finality of death. The most common iconography was the upright skeletal figure often accompanied by an hour glass or the pick and shovel of the gravedigger, as at Llangar, near Corwen. There, and at many other parish churches, such images replaced the more varied medieval iconography, but they are difficult to date and most of the surviving examples were probably made after the Restoration. At Llaneilian in Anglesey, for instance, a particularly impressive figure of Death was painted, which carried the inscription 'Colyn Angau yw Pechod' (Sin is the Sting of Death). The figure is on the underside of a rood loft, the body of which had survived the iconoclasm of the sixteenth century, though not its original paintings. The same iconography was employed at Rug Chapel, but the work there was more sophisticated in conception than that at Llaneilian and most other parish churches, and this presumably reflected the detailed instructions of the patron. At Rug a skeleton was depicted recumbent under a table on which stood the symbols of death, painted not schematically but with an attempt at creating the illusion of a wall-hung memorial, flanked by two fluted ionic columns. The images were reinforced by appropriate quotations from a fifteenth-century *cywydd* attributed to Ieuan ap Rhydderch, 'Englynion y Misoedd' (Stanzas of the Months), and – most significantly – a carol written by the Catholic martyr Richard White: 'val i treila r tan gan bwull, gwur y ganwull gynudd. fellu r enioes ar r hod sudd yn darfod beunudd' (as the flame gradually consumes the tallow of the lighted candle so life under the firmament perishes daily).[59]

67. Anon.,
Adoration of the Magi,
c.1650, Painted plaster,
1450 × 860, detail

68. Anon.,
Figure of Death, Church of
St Eilian, Llaneilian, Anglesey,
late 17th or early
18th century

[58] The response is preserved in a much larger number of manuscripts, thirteen of which give the attribution to Rhys Cain, see NLW MS 11816B, f. 215ᵛ and NLW MS 1580B, p. 373, for instance: 'Yr annuwiol ffôl a ffy – o'r golwg, / Er gweled llun Iesu; /Llunied, os gwell yw hynny, /Llun diawl ym mhob lle'n ei dŷ.' (In modern orthography.)

[59] The quotations and fuller details of the scheme are given in D. B. Hague, 'Rug Chapel, Corwen', *Journal of the Merioneth Historical and Record Society*, III, part II (1958), 175–6 and in Yates, *Rug Chapel, Llangar Church, Gwydir Uchaf Chapel*, pp. 10–21.

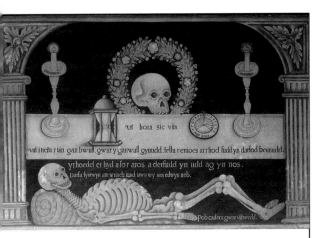

69. Anon.,
Image of Death,
Rug Chapel, c.1637

60 Browne Willis, *A Survey of the Cathedral Church of Bangor* (London, 1721), pp. 306–7, described the scheme in 1721. It is now lost, along with some of the glass, which included a portrait of Charles I.

Similar High Church sentiments resurfaced after the Restoration. In the memorial chapel to Hugh Owen at Llangadwaladr in Anglesey the scheme seems to have reverted almost to medieval tradition, with paintings of Christ appearing before the twelve disciples, a resurrection, an ascension and the four evangelists.[60] A less ambitious scheme was commissioned for a new Wynn chapel at Gwydir Uchaf. The patron, Sir Richard Wynn, son of Sir Owen, celebrated in Robert Vaughan's brass at the earlier Wynn chapel at Llanrwst, died in 1674, a year after commissioning the building, the simple and restrained external architecture of which was in stark contrast to its elaborate painted ceiling. As at Rug, it was clearly of artisan workmanship but followed a scheme whose iconography was designed by, or to meet the needs of, a sophisticated patron in touch with prominent church leaders. The four sections of the vault and the top of the east wall represented the Creation and the Persons of the Trinity, flanked by angels suggestive of the warning against damnation, adoration, peace and resurrection. The points at which the arches sprang from the walls were covered by flat, cut-out angels of a kind that would soon appear as a basic element of iconography on gravestones and memorials to less elevated individuals than the Wynns. The stone-carved effigy and the memorial brass had been the preserve of the gentry, but in the second half of the seventeenth century both the fashion for and the means to commission memorials began to spread down to the lower strata of society.

70. Anon.,
Vault at the Wynn Chapel, Gwydir Uchaf,
Llanrwst, c.1673

c h a p t e r

t w o

WAR AND

RECONSTRUCTION

The VVelſh-Mans Poſtures,
OR,
The true manner how her doe exerciſe her
company of Souldiers in her own Countrey in a
warlike manners with ſome other new-found
experiments, and pretty extravagants ſitting
for all Chriſtian podies to caknow.

Printed in the yeare. When her did her enemy jeere, **1642.**

71. Anon.,
The Welsh-Mans Postures,
1642, Wood engraving,
140 × 118

[1] Shakespeare had mimicked Welsh accents, especially in his characterization of Fluellin, and the use of 'Wenglish' was one of the ways in which the Welsh were stereotyped as a nation from an early date. It is the application of Wenglish to a contemporary individual which makes Williams's case noteworthy. See Peter Lord, *Words with Pictures: Welsh Images and Images of Wales in the Popular Press, 1640–1860* (Aberystwyth, 1995), pp. 41–3. Archbishop John Williams was also depicted in a wall-mounted memorial of conventional iconography, kneeling before a lectern, in Llandygái church.

[2] Archbishop Williams was criticized for his change of allegiance in a popular ballad: 'Gwae fo byth i deulu'r Wig a'r Penrhyn / Am iddynt lwyr fradychu Syr John Owen' (Woe betide the families of Wig and Penrhyn / For completely betraying Sir John Owen). Quoted in A. Grace Roberts, 'Archbishop Williams [1582–1650]', *The Welsh Outlook*, XIII (1926), 38.

Civil wars are characteristically complex affairs, setting neighbours against one another and providing excuses for the settling of old scores which have little bearing on the main political and religious issues. During the military conflict between Charles I and Parliament, which began in 1642 and came to an end with the execution of the king in 1649, even the networks of family relationships among the gentry, carefully built up by marriage over generations and which generally determined loyalty to one side or the other, were sometimes torn asunder. Furthermore, loyalties declared to one side at the start of hostilities could change as a result of either local expediency or wider political considerations. Some more moderate reformers with Parliamentarian sympathies in 1642 found the second phase of the war in 1648, and the execution of the king, hard to support. It was certainly impossible even for retiring and scholarly individuals such as Robert Vaughan of Hengwrt to remain unaffected by the war. Both on account of the disturbances themselves and because of the huge expenses undertaken by some families in raising militias and creating fortifications, patronage of the arts was seriously affected, and some of the leading continental painters in London returned home. During the Interregnum those activists who ended the war on the wrong side continued to suffer as a result of fines, sequestrations and, in some cases, exile. On the other hand, winners were rewarded, and their ability to pay for portraiture and to build was temporarily enhanced.

The civil wars and the Commonwealth gave rise to a small but significant iconography, expressed in Wales mainly in portraiture, but extending also into printed imagery. Since printing was illegal in Wales, the role both of prominent individuals and of the Welsh as a nation was expressed from an English point of view. Furthermore, because the English popular press was based in London this comment came almost exclusively from Parliamentarians and was largely hostile to the Welsh. In October 1642 the king's forces were routed at Edgehill in Warwickshire, a skirmish in which Welsh levies played a largely ignominious part. The debacle, and particularly its Welsh associations, was much celebrated in London popular prints such as *The Welsh-Mans Postures*. The bawdy picture and text suggested both the ineptitude of the Welsh as soldiers and the more anal characteristics which the English liked to attribute to them in this period. Such popular imagery can have had almost no impact in Wales itself, since, even if examples found their way out of London, the texts with which they were associated were written in the English language, which was not spoken by the majority of the common people.

The career of John Williams, Archbishop of York at the outbreak of the war, while certainly not typical (since he was an individual with a particularly high public profile), nevertheless exemplified the labyrinthine complexities of the war. In addition to the early portraits, Williams acquired the most extensive iconography of any Welsh person of the period. He first appeared in the London popular woodcuts in 1641 as a supporter of Archbishop Laud's attempts at church reform, which resulted in his being dispatched by Parliament to the Tower of

72. Wenceslas Hollar,
Archbishop John Williams,
1642, Engraving,
230 × 169

London. This had the effect of confirming his Royalist sympathies and on his release he joined the king at York. Later in 1642 he returned to north Wales to fortify the defences of Conwy Castle for the impending struggle. In that year Wenceslas Hollar, who was in the service of the Earl of Arundel and took the king's side in the war, made a fine engraving of the archbishop attired in the cross belts of a soldier and with fuses burning ready to fire the musket slung over his shoulder. Hollar had clearly seen either Jackson's or Johnson's portrait of Williams (or drawings after them), on which he based the face, but he set his subject against a landscape of the castle, Aberconwy and the land to the east of the river. The topographical accuracy of the view suggests that Hollar had visited Conwy. His print was soon purloined by those of more populist inclinations and was given a new background of a war horse and cathedral. A verse was appended in which Williams's speech was rendered in 'Wenglish' – apparently the earliest example of this stereotypical characteristic being applied to a living Welsh public figure for satirical purposes.[1]

In May 1645 John Williams suffered the indignity of being removed from command of his castle at Conwy by his own side, in the person of Sir John Owen of Clenennau, who, having distinguished himself fighting in England on the Royalist side, was appointed commander of the forces of the north-western counties. During the ensuing recriminations, Williams changed sides, and Thomas Mytton, with the Archbishop's support, ejected Owen from Conwy in August 1646. Sir John remained a popular figure among Royalists[2] and was celebrated in a portrait for which he was posed in his armour against a dramatic night sky, with a battle scene and a burning castle behind him. However, it is most unlikely that this picture was painted until after the Restoration in 1660, and it may be posthumous.

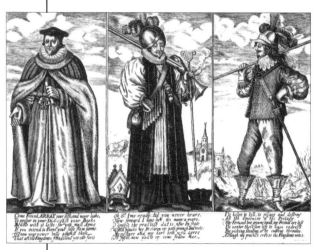

73. Anon.,
*Judge Malet, Archbishop John Williams,
and Colonel Lunsford,* c.1642, Engraving,
220 × 283

Sir John Owen's opponent at Conwy, Thomas Mytton, was related by marriage to Sir Thomas Myddelton of Chirk Castle, major-general of the Parliamentarian forces in north Wales. As we have seen, Sir Thomas had prospered in trade in

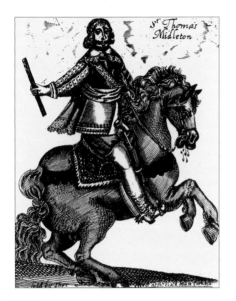

74. Anon.,
Sir Thomas Midleton,
c.1642–6, Engraving,
130 × 104

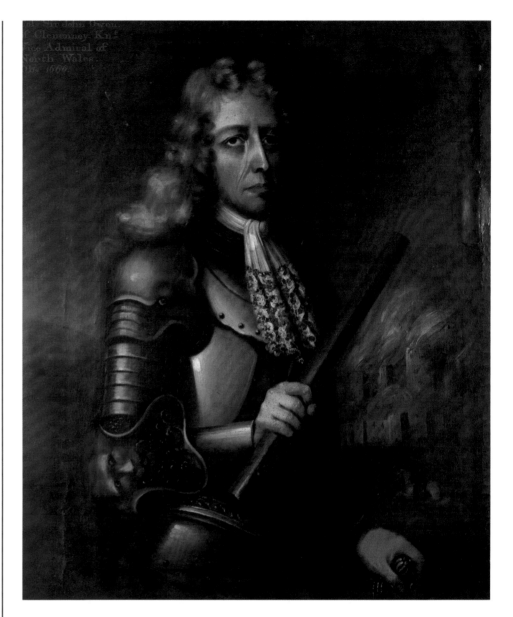

75. Anon.,
Sir John Owen of Clenennau,
c.1660, Oil, 940 × 795

London, where his father had been Lord Mayor, so his Parliamentarian allegiance was unsurprising. Since he ended the war on the winning side, his iconography was acquired somewhat earlier than that of Owen, and a dramatic popular print showing him seated on a rearing charger, inscribed 'Sold by Thos. Hind at the black bull Cornhill', probably dates from the 1640s. A portrait of Myddelton in armour may be the work of Robert Walker, the official Cromwellian painter. It hung at Chirk Castle among a small group of portraits of supporters of the Commonwealth, including that of Sir William Fairfax, first cousin to General Lord Fairfax, who was killed fighting alongside Sir Thomas at the siege of Montgomery Castle in 1644. Sir Thomas's close connection with the Cromwellian cause was emphasized by the presence at Chirk of a portrait of the Lord Protector's friend, Sir Henry Vane, who became Governor of Massachusetts.[3]

[3] The portrait of the Parliamentarian general John Lambert, which now hangs at Chirk with the other pictures, did not belong to Sir Thomas Myddelton.

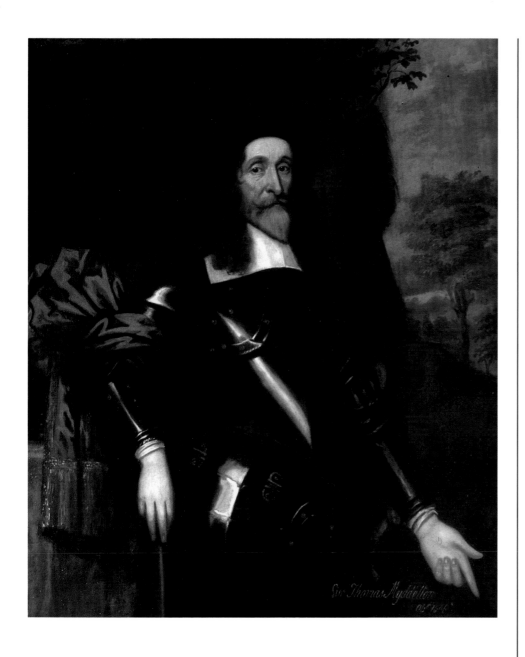

76. Attributed to Robert Walker,
Sir Thomas Myddelton,
c.1650–60, Oil,
1231 × 1010

It may be indicative of attitudes to visual culture that no images of the leading Welsh Puritan divines, Walter Cradock, Vavasor Powell and Morgan Llwyd, appear to have been produced. Nevertheless, some of the wealthy supporters of Puritanism, like Sir Thomas Myddelton, were by no means averse to having themselves celebrated in paint. Following Cromwell's famous dictum that he should be depicted 'warts and all', portraiture in this period was divested of the panache given to it by Van Dyck in his London career, which extended, with intervals, from 1620 until late in 1639. Given the military campaigns of the 1640s, the prevalence of stern portraits of gentlemen in armour is not surprising and examples from families all over Wales testify to the prevailing ethos. Nevertheless, this was not entirely the consequence of the war since, as we have seen, the fashion for the medieval had begun earlier and was expressed in the building and heraldic obsessions of the early seventeenth-century gentry.[4]

[4] The trend had been given a particularly prestigious boost by Van Dyck's portrait of 1635–6, *Charles I Armoured as a Christian Knight.*

In the visual culture the severity of attitudes during the wars and the Interregnum expressed itself most obviously in the defacement of those religious images which had survived the iconoclasm of the preceding century. Many of the most magnificent examples of medieval work, including nearly all those in monastic establishments, had been destroyed in the sixteenth century. When Thomas Churchyard visited Abergavenny in about 1587, for instance, the huge Tree of Jesse sculpture had already been despoiled. However, there were survivals, and the Royalist soldier Richard Symonds recorded in his diary in 1645, 'A very faire guilt roode left, and old organs', in the same town.[5] Symonds also noted: 'Almost in every parish the crosse or sometime two or three crosses perfect in Brecknockshire, Glamorganshire, etc.'[6] However, most of them were not to survive much longer. In the north-east, the destruction had already begun:

> About 9 Nov., 1643, Sir W. Brereton and his forces came to Faringdon and Holt, and entered through the same, and went to Wrexham, Flint and Holywell, and did pull down the organs, defaced the windows in all the churches, and the monuments of divers, and pulled down the arms and hatchments.[7]

The organ pipes at Wrexham were melted down and made into ammunition for the use of Sir Thomas Myddelton's forces. Another eyewitness reported, with obvious contempt for the perpetrators, the destruction at Hawarden:

> I myself coming into the church of Hawarden the morning after they were there, found the Common Prayer-Book scattered up and down the chancel, and some well read man, without doubt, conceiving that the Common Prayers had been in the beginning of a poor innocent old church bible, tore out almost all Genesis for failing. It stood so dangerously it was suspected to be malignant. In windows where there was oriental glass they broke in pieces only the faces; to be as frugal as they could, they left sometimes the whole bodies of painted bishops, though in their rochets. But if there was anything in the language of the beast, though it was but an *hoc fecit*, or at worst, *orate* &c. (and I but guess, for I could not read it when it was gone), which had stood many years, and might many more, without idolatry, that was dashed out. They had pulled the rails down about the table, and very honestly reared them to the wall (it was well they were in a coal country, where fuel was plentiful), and brought down the table to the midst of the church.[8]

Memorials to gentry families located in religious buildings had fared better at the dissolution and under Edward VI, both because their material was of little monetary value and because they were essentially secular and not usually decorated

[5] *Richard Symonds's Diary of the Marches of the Royal Army*, ed. C. E. Long, with a supplementary introduction by Ian Roy (Camden Classic Reprints 3, Cambridge, 1997), p. 238.

[6] Ibid., p. 208.

[7] BL Harleian MS 2125, f. 135.

[8] J. Roland Phillips, *Memoirs of the Civil War in Wales and the Marches 1642–1649* (2 vols., London, 1874), II, p. 114.

[9] Horatia Durant, *Henry, 1st Duke of Beaufort and His Duchess, Mary* (Pontypool, 1973), p. 37. The family tombs in Raglan church were also despoiled.

[10] Thomas Dineley, *The Account of the Official Progress of His Grace Henry the First Duke of Beaufort through Wales in 1684* (London, 1888), p. 210.

[11] Ibid., p. 77.

[12] Ibid., p. 145.

[13] Phillips, *Memoirs of the Civil War*, I, p. 181.

[14] Dineley, *The Account of the Official Progress of His Grace Henry the First Duke of Beaufort through Wales*, p. 147.

with imagery which damned them as papist. Few important houses had suffered to the extent of Dinefwr, where the owner, Rhys ap Gruffydd, was executed in 1531 for his opposition, on religious grounds, to the divorce of Henry VIII from Catherine of Aragon, and much of the family property was forfeited. No doubt the relics of those who kept their heads down at the dissolution escaped the attention of the sequestrators. During the civil wars, however, many gentry memorials fell victim either to the levelling instincts of the soldiery or were defaced because they were associated with individuals fighting on the wrong side. When Henry Somerset, third Marquess of Worcester, realized that he would be besieged by Parliamentarian forces at his house in Raglan Castle, he dispatched the family portraits and the Tudor panelling to his brother at Troy House near Monmouth, where he presumed correctly that they would be safe. Unfortunately, he kept his library, which included medieval manuscripts, at Raglan, all of which was lost.[9] Further west, in the Priory Church at Brecon, the particularly fine tiered memorial to the Games family, described by Thomas Churchyard in 1587, was reported by Thomas Dineley in 1684 to have been destroyed by the 'usurpers souldiers'.[10] At Welshpool Dineley noted: 'In the Chancell on the left hand ascending, against ye wall is what ye irregularity of the Usurpers souldiers hath left of a fair monument, where, I suppose, had been 2 Figures of marble kneeling.'[11] This had been the memorial to Sir Edward Herbert, erected scarcely fifty years earlier, whose descendants were, unfortunately, prominent Royalists. Among the most notable casualties of the civil wars was the massive sarcophagus of Llywelyn ap Iorwerth at Llanrwst, on the sides of which had been brass and enamel coats of arms, but which '(for a little gain) escaped not the profane hands of the sacrilegious late Rebells'.[12]

No doubt the pain experienced by some at witnessing the destruction of old and familiar religious images was in inverse proportion to the exhilaration experienced by Puritans who rejoiced in the cleansing of public worship. As J. R. Phillips memorably observed in his *Memoirs of the Civil War in Wales*, 'however much we may regret the pulling down of organs, the defacing of windows, and the destruction of works of art, we should never forget that to these men these things were odious, as signs of a faith which they detested, and which to their narrow fanatic minds was damnable'.[13] In some places pre-Reformation images were hidden to protect them during the disturbances. The magnificent Jesse window at Llanrhaeadr-yng-Nghinmeirch was apparently removed and hidden during the civil wars, an ambitious undertaking for local people, given the scale and complexity of the work. Dineley noted a further example in Llanrwst:

> Over the Timber Arch of the Chancell neer the Rood Loft, lieth hid the ancient figure of the Crucifixion as bigg as the life. This I suppose is shewn to none but the curious, and rarely to them.[14]

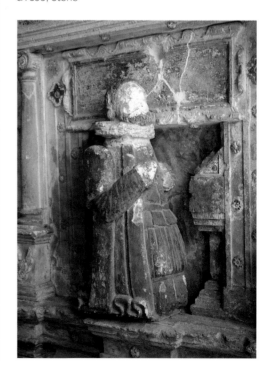

77. Anon.,
Defaced memorial to William Risam,
Church of St Mary, Tenby,
c.1633, Stone

15 Williams, 'A Study of Caernarfonshire Probate Records, 1630–1690', p. 378.

16 Myddelton, *Chirk Castle Accounts*, p. 20.

The suggestion made by Dineley of caution on the part of those responsible for the safekeeping of the image as late as 1684 is a reminder that iconoclasm did not cease at the Restoration. Hostility to Roman Catholics persisted, fed by fears of an invasion from Ireland, especially in areas where there were famous medieval shrines, such as Clynnog Fawr and Holywell. In 1687 a private Catholic chapel at Penrhyn Creuddyn was defaced on the pretext of a search for arms which might have been hidden to aid an invasion.[15]

There is little evidence of the attitudes of leading Welsh Puritan divines to such matters, although it is known that Vavasor Powell was among Mytton's soldiers at the siege of Beaumaris Castle, and he probably witnessed or participated in acts of destruction. It is equally difficult to determine what attitude was taken by the likes of Sir Thomas Myddelton. Although of the Puritan party, his views on portraiture, as we have seen, were liberal, and he clearly had a taste for fine things in general. Before the war he had regularly contributed to the upkeep of his own church, and in 1637 he had donated £5 towards the repairing and beautifying of St Paul's Cathedral in London.[16] Myddelton's career in the wars and subsequently was far from straightforward. In 1659 he declared for the king, a premature decision which resulted in his ejection from his castle, which was ordered to be demolished. Work proceeded sufficiently far to prevent him ever living there again.

78. William Henry Toms
after Thomas Badeslade,
*The West Prospect of Chirk Castle
in Denbighshire, c.*1735,
Engraving, 462 × 696

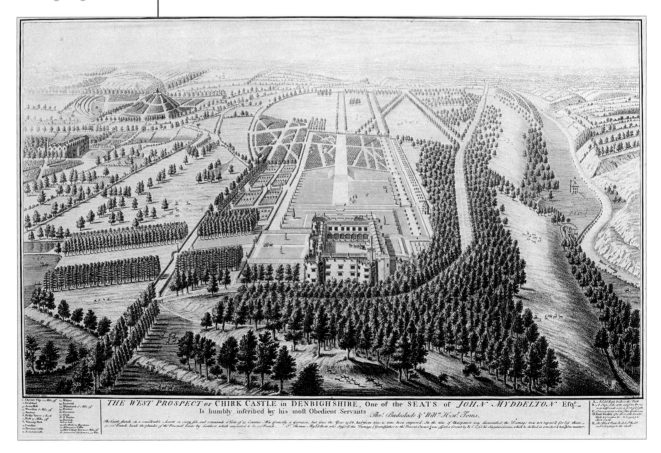

79. Thomas Mann Baynes,
Porch at Beaupré, Glamorgan,
erected 1660, c.1815–50,
Lithograph, 182 × 204

80. *Great Castle House,*
Monmouth, 1673

Both the general deprivations of the war and the fact that the golden age of intellectual activity and favour at the Tudor and early Stuart court had passed meant that the efforts of the Welsh gentry to reassert themselves at the Restoration were not, in general, carried out on a spectacular scale. The grand scale of the rebuilding and adornment of Chirk Castle was exceptional. It was carried out by Sir Thomas Myddelton (grandson of the Sir Thomas who had fought in the civil wars), who had enjoyed a Grand Tour of the Continent, and subsequently by his brother Richard, who succeeded him in 1683.[17] The magnificence of the work was matched by only a few other examples, although they were to be found in most parts of the country. They emphasized the widening gap between a taste for international styles promoted by a small élite and a continuing vernacular, which reflected the general social and economic trend of the age. One of the major socio-economic features of this period is the manner in which substantial landowners expanded their estates at the expense of the lesser gentry.[18] Edward Rice completed the gradual process of family recovery from the disaster of his great-grandfather's execution by rebuilding Newton, in the shadow of Dinefwr Castle, in the year of the Restoration. Equally quick to celebrate the return of the old order were the Bassett family who added a splendid, if somewhat incongruous, Italianate entrance porch to their medievalist Tudor mansion of Beaupré in Glamorgan. Great Castle House at Monmouth was just one of a group of Restoration buildings commissioned by Henry Somerset, third Marquess of Worcester, though possibly the most refined in Wales.[19] It was completed in 1673 with two wings protruding only sufficiently to frame the focal point of a pillared entrance reaching to third-floor level. For all its compact

[17] Thomas Myddelton had taken his Grand Tour with another brother, Robert, who died in 1674 in London following a surgical operation.

[18] The reasons for the widening gap between the great landowning families and the lesser gentry are discussed in Geraint H. Jenkins, *The Foundations of Modern Wales, 1642–1780* (Oxford, 1987), pp. 92–102.

[19] He rebuilt Troy House, see below, Chapter 3, pp. 82–3, and also set about the reconstruction of Badminton in Gloucestershire. Henry Somerset had inherited Badminton from a cousin and made it his main residence, marking the removal of the main line of the family from Wales to England. Nevertheless, the bulk of the family estates remained in Wales and consequently the family involvement in Welsh affairs persisted. Henry's title as Marquess of Worcester was superseded in 1682 when he was made Duke of Beaufort. The son and heir retained the Worcester title.

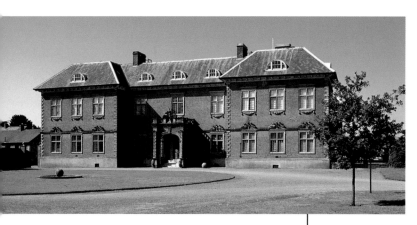

81. *Tredegar House,*
Newport, 1664

20 That the gates were an important and expensive commission is demonstrated by payments of £100 and £420 made in 1714 and 1715. NLW, Tredegar MSS 328, 329, and 332. For an introduction to the architecture of Tredegar House and its associated artworks, see David Freeman, *Tredegar House* (Newport Borough Council, 1989).

21 Howard Colvin, *A Biographical Dictionary of British Architects 1600–1840* (3rd ed., New Haven and London, 1995), pp. 521–2.

22 Myddelton, *Chirk Castle Accounts (Continued),* p. 95.

23 Ibid., p. 97. Ffrancis is occasionally spelt with a single F in the accounts.

elegance, however, Great Castle House was dwarfed in scale by Tredegar House, constructed for Sir William Morgan in the decade after 1664. The brick front elevation of Tredegar House gave the impression of a completely new building but, in fact, it encased an older house which had been sufficient to welcome Charles I and his retinue after the battle of Naseby in 1645. Internally, the ground floor comprised a series of state rooms of grand proportion and size, opening in a straight line, one into the other, reaching a climax with the Gilt Room. Each incorporated a complete decorative scheme of panelling and carving, plasterwork and painting. It is the internationalism of Tredegar House which is its most significant feature, both architecturally and socially. The Morgans had been in exile on the Continent with the Stuart court and their experience there was clearly reflected in the features of the house. Dutch influence was particularly strong, manifested on the exterior by the carved festoons hanging under the first-floor window openings, which were close to features on the Mauritshuis in The Hague and the Amsterdam town hall. Inside, the paintings of the virtues which decorated the Gilt Room were copied from sculptures also in Amsterdam town hall. The ceiling was painted with a copy of *The Glorification of Pope Urban VIII's Reign* by Pietro da Cortona from the Palazzo Barberini in Rome, and the dining room had a copy of a painting by Rubens, both of which were available to the unknown painter as engravings. The process of development at Tredegar House continued into the early eighteenth century, with internal adornments such as a series of carved heads of Roman emperors, and externally with the enclosure of the gardens by iron gates commissioned from the Bristol smiths, William and Simon Edney, in about 1714.[20]

Unfortunately, with the exception of the gates, nothing is known of the artists and craftspeople who worked at Tredegar House, though the remodelling has recently been attributed to Roger Hurlbutt of Warwickshire.[21] However, the pattern of patronage was closely similar to that at Chirk Castle, where very full records give a clear idea of the practice of artisan painters and other local craftspeople, as well as commissions to more remote practitioners in the period. For instance, in August 1672 Sir Thomas Myddelton paid a shilling 'to Tudder yule, for goeinge to Mountgomy to enquire after Tho. francis the herald painter'.[22] Four months later, the Chirk Castle accountant recorded in detail the commission he was given:

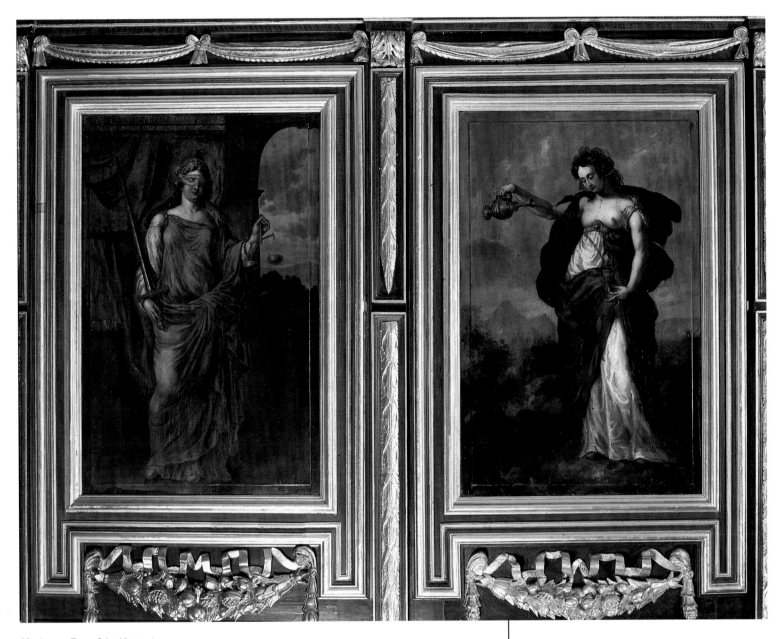

82. Anon., *Two of the Virtues in
the Gilt Room at Tredegar House*,
1688, Oil, 1143 × 762

83. Anon.,
*Carved head of a
Roman emperor at
Tredegar House*,
c.1680, Oak,
660h.

Paid Thomas ffrancis, the Herald Painter,
for paintinge 119 yards of wainscott in the
draweinge roome, at xviijd p yard 8 18 6
Paid him for payntinge of 89 yards in the
chambers in the newe Tower at xviijd p yard 6 13 6
Paid him for makeinge 3 landskips for
3 chimney peeces, one at the Draweinge roome,
one at the red, and another at the blacke Chamber,
in the newe Tower xijli xs, & for the Bwll signe xs 8 0 0[23]

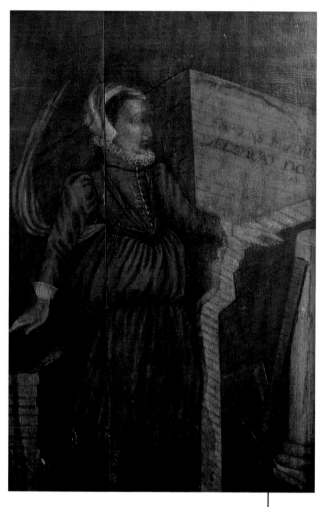

84. Possibly Thomas Ffrancis,
The Muse of Architecture,
c.1672–9, Oil, 660 × 457

85. Thomas Dugdale,
*Wood Carving from the
Long Gallery at Chirk
Castle, c.1667–78*

86. John Bushnell,
*Memorial to Sir Thomas
and Lady Myddelton*,
Church of St Mary, Chirk,
1676, Marble

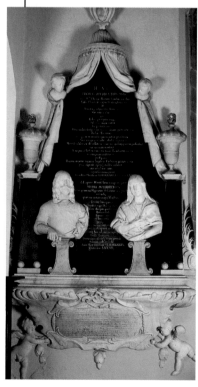

[24] NLW MS 21297E, letter from William Jones to Edward Lhuyd, dated 29 October 1698.

[25] Myddelton, *Chirk Castle Accounts (Continued)*, p. 102. The work was destroyed when the staircase was replaced in 1778.

[26] Dugdale seems to have been active in Shropshire, Chester and Liverpool, as well as in Wales.

[27] Myddelton, *Chirk Castle Accounts (Continued)*, pp. 99–123. For instance, 4 May 1673 (p. 99), to John Lloyd of Trevor, and 19 September 1677 (p. 123), to Thomas Willoughby, a tenant farmer of the Myddeltons.

[28] Griffiths, "'Very Wealthy by Merchandise"? Urban Fortunes' in Jones (ed.), *Class, Community and Culture in Tudor Wales*, pp. 228–9.

Ffrancis seems to have been based at Montgomery, for he was recorded there again in 1698, though he remained in the occasional employ of the Myddelton family only until 1679.[24] Subsequent changes of fashion removed almost all trace of the decorative schemes on which he worked, although a surviving painting on panel of a female figure symbolic of the Muse of Architecture may represent a fragment of a larger seventeenth-century design. Thomas Ffrancis may be taken as a model of the generalist artisan painter. He formed part of a team of workers necessary to carry out the complicated interiors of the period. In his decoration of wainscotting at Chirk Castle, for instance, Ffrancis was completing the work of the carpenter, and a similar combination of skills was necessary in the case of the more ambitious woodwork of the carver, Nicholas Needeham. In 1673 Needeham was engaged to enliven the staircase at the castle with 'Turke and blackeymore figures', among others.[25] Thomas Ffrancis was paid a shilling each for colouring all twenty-four of them. In subsequent years Needeham's assistant, Thomas Dugdale, carved fifteen capitals in the new drawing room and carried out all the carving in the long gallery and some work in the chapel.[26] Such commissions not only resulted in further work for fellow artisans but also had wider repercussions for the local economy, since the material was bought in the area. The castle accountant recorded payments to landowners and farmers for elm trees 'for the Carver to cutt figures'.[27] Dugdale's work at the castle also illustrated the continuing expansion of the market for artisans in the towns. While working at Chirk, he carved four figures to crown The Mount, the new house of Sir Kenrick Eyton in Wrexham. The figures were to be larger than those on the Myddelton staircase, and reflected the particular prosperity of Wrexham, which, by 1670, had become the largest town in Wales by a considerable margin.[28]

Prestigious commissions, including portraits and memorials, sometimes went to London artists and artisans, though not necessarily so. John Bushnell, renowned equally for his technical ability and his arrogance, was paid £400 to make memorials to Sir Thomas and Lady Myddelton, and, as we have seen, to Elizabeth, wife of Sir Thomas, the second baronet, for the church at Chirk.[29] However, the next large family memorial, commissioned by Mary Myddelton in 1719 to her father, Sir Richard, was given to Robert Wynne, whose workshop, known as The Elaboratory, was in Ruthin. Probably in the same year he was commissioned to erect a memorial of similar size for the Wynne family for the church at Ruabon. If these, and many other commissions to Robert Wynne, cannot be shown conclusively to represent the favouring of a Welsh or of a local artist for patriotic or parochial reasons, they certainly suggest that there was no particular cachet attached to commissioning in London if good quality workers were available locally, since both the patrons involved could easily afford to do so.

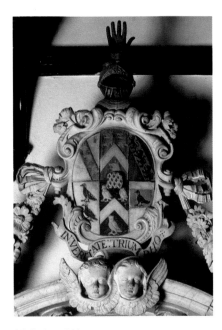

87. Robert Wynne,
Memorial to Sir Richard Myddelton, Church of St Mary, Chirk, detail, *c.*1719, Marble

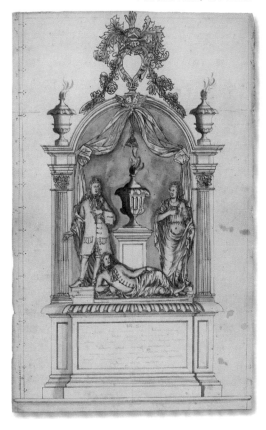

88. Robert Wynne,
Memorial to Sir Richard and Lady Myddelton, 1719,
Pen and wash, 460 × 285

Robert Wynne was born in about 1655 in Llanbedr Dyffryn Clwyd and was probably apprenticed to Peter Roberts, a London mason, although how this came about is unclear. He seems to have remained in London until the end of the century although no works made by him there have been identified. However, in 1707 he signed a tablet at Llanbadarn Fawr near Aberystwyth, which may suggest that he was again working in Wales even though the tablet celebrates Sir Thomas Powell, a London Welshman. He undertook commissions of all kinds, including the making of marble fireplaces for John Mellor of Erddig, the carving of coats of arms, and of small, wall-mounted memorials such as that to his brother, John Wynne, publican of the Hand in Ruthin. However, his reputation rests on life-size effigies in baroque architectural surrounds commissioned by the Myddeltons and the Wynns, and, almost certainly, the memorial to Maurice Jones at Llanrhaeadr-yng-Nghinmeirch in the Vale of Clwyd. The best attested of this group is the Myddelton memorial for which a drawing survives in which the reclining figure of Sir Richard's son, William, whose death in 1718 presumably occasioned the commission, is a movable cut-out. On the back, the sculptor wrote:

29 For the difficulties of working with Bushnell and his unusual career, see Rupert Gunnis, *Dictionary of British Sculptors 1660–1851* (London, 1953), pp. 72–4.

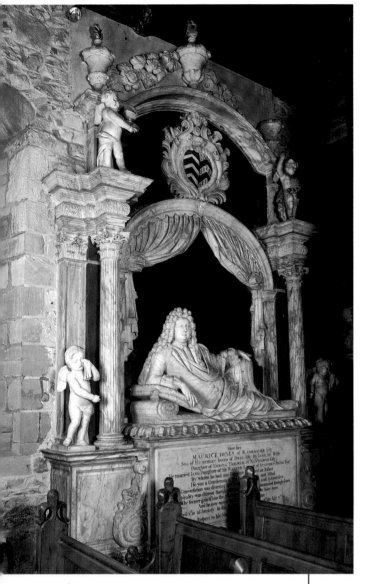

89. Robert Wynne,
Memorial to Maurice Jones,
Church of St Dyfnog,
Llanrhaeadr-yng-Nghinmeirch,
c.1720, Marble

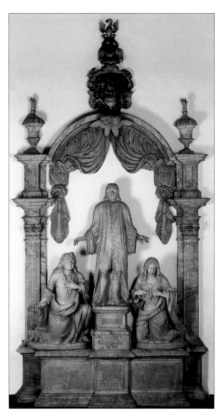

90. Robert Wynne,
Memorial to Henry Wynn,
Church of St Mary, Ruabon,
1719, Marble

This is a draft picked upon by Agreement with the Honourable Madam Myddelton the 5th of May 1719 to be made & Erected in ye Church of Churk by me Robert Wynne.

> 17 foot High & 6 inches
> 8 Foot Broad
> all of Italian Marble.[30]

[30] NLW, Plas Power Papers, Box 12. Robert Wynne was paid £400 for the memorial.

[31] Pennant, *Tours in Wales*, I, p. 367. The inconsistency of this figure with its companions at Ruabon, and with those at Chirk and Llanrhaeadr, has suggested to some critics that it was executed by a different hand.

The three large memorials were consistent in style, with the mysterious exception of the comparatively naive figure of Henry Wynn, tenth son of Sir John Wynn of Gwydir, at Ruabon. This inconsistency, coupled with changes in taste, gave subsequent critics an excuse to under-rate Wynne's work. Among them was Thomas Pennant, who wrote that the image of Henry Wynn in the everyday dress of his period presented 'a most unhappy subject for a sculptor'.[31] None of Wynne's other figures had this curiously wooden character, and the overall quality of the memorials was high and comparable to London work. Since almost nothing is known of Wynne's attitudes, apart from what is revealed by his work, it is impossible to say whether or not he returned to Wales in the belief that it would be possible for him to develop a practice at a level above that of the ordinary jobbing mason. His return certainly coincided with a considerable expansion in the market for pictures, as we shall see, and it may be that he gained confidence from this parallel activity. Regrettably, Wynne's attempt ended in financial disaster, and by 1730 he was incarcerated in a debtors' prison. He died the following year.

92. Robert and John Davies, *Gates at Chirk Castle*, 1712–19, Wrought iron

91. Robert and John Davies, *Chancel Gates*, Church of St Giles, Wrexham, detail, 1707, Wrought iron

In 1713–14 Robert Wynne was paid to make a pattern of a bird for the blacksmith Robert Davies, who was engaged on a commission to make new gates for Chirk Castle. The commission had been given two years earlier and, like so much else in the period, reflected the influence of fashions in the Low Countries. In this case the medium for the transfer had been the smith Jean Tijou, who had arrived in England by 1667 and worked at important country seats and at St Paul's Cathedral and Hampton Court until about 1711. Imposing wrought iron gates became a highly prestigious item and Tijou's pattern book, published in 1693, was a great influence. Whereas the Morgans of Tredegar House had turned to English smiths for their gates, families in the north-east were able to employ Welsh craftspeople. The Davies family had worked a forge at Croes Foel near the Bersham iron works since the 1670s, no doubt producing a wide range of commonplace items. The gates in the chancel at Wrexham church probably represent early work by Robert Davies, son of the founder, and it was presumably on the basis of a steadily won reputation for good craftsmanship that he and his brother John were entrusted by Sir Richard Myddelton with the much larger commission for Chirk Castle. Whether they were already aware of the work of Tijou or were introduced to it by Myddelton, the results were truly splendid and led to a series of further commissions both at Chirk and at houses all over the north-east, such as Leeswood, near Mold, and probably also in the north-west of England, notably at Eaton Hall. The Davies family were also responsible for churchyard gates at Wrexham, Ruthin and Oswestry, to which the local gentry contributed funds.[32] Such gates were particularly prone to the vicissitudes of fashion, and those at Erddig have disappeared. The Chirk gates, initially intended to be hung between stone pillars at the end of the drive, were installed under Robert Myddelton's direction before the forecourt of the castle, enclosing lead statues of Hercules and Mars made in London, which were set up in 1721.

[32] Myddelton, *Chirk Castle Accounts (Continued)*, p. 475. 22 January 1728: 'Pd Robert Davies of Groesvoel, smith, which my Master was pleased to give towards erecting Iron Gates vpon Ruthin Churchyard; Mr Watt. Williams and other subscribers money was pd ye sd smith 20li in pte for the said Gates, ye same day 5-5-0.' The work of the Davies family, together with the technical and artistic background, is dealt with in detail by Ifor Edwards, *The Davies Brothers Gatesmiths: 18th Century Wrought Ironwork in Wales* (Cardiff, 1977).

93. Robert and John Davies, *Gates at Leeswood*, Mold, c.1726, Wrought iron

Robert Myddelton's adornment of the exterior of the castle with sculpture on Classical themes was echoed by an increasing interest in the purchase of framed pictures (as distinct from integrated decorative schemes) for the interior. In this, he and his successor, John Myddelton, who was a particularly active patron, were characteristic of the wealthy people of the period. The late seventeenth and early eighteenth centuries witnessed a revolution in the patronage and practice of painting in Britain as a whole, the results of which are clearly discernible in the nature of gentry collections in houses all over Wales. The idea that a painting had an inherent value beyond its value as a representation of an ancestor or a religious theme finally took hold many years after it had come to dominate continental taste and practice. The attraction of continental fashions was attested by the dominant position of immigrant painters working in London until well into the first half of the eighteenth century. However, the full expression of continental taste was arrested by a number of factors, not least of which was the statutory prohibition on the importation of works of art. Even for those highly placed at court or with influential friends, such as Richard Clough, it had proved extremely difficult to circumvent customs officers, and for lesser mortals and potential dealers it was impossible. The prohibition was formally lifted in 1695, although it had been ineffective by that time for about a decade, and the results were spectacular.[33] The desire to buy pictures of a much wider range than before, including landscape, still life, historical and mythological subjects, as well as religious pictures and portraits, increased with great rapidity, as did the number of dealers within the flourishing market. Inventories of property in houses throughout Wales in the second half of the seventeenth century noted pictures as a part of the general goods and chattels of the deceased. For instance, the inventory taken in 1650 of the goods of Edward Carne of Ewenni, a grandson of Sir John Morgan of Tredegar House, noted twelve pictures in his dining room and fifteen in the gallery, as well as a number of tapestry hangings.[34] Unfortunately such lists are generally of limited use because of the reluctance of compilers to name the subjects of pictures, although we may be sure that portraits were in the majority. However, the case of Thomas Walker, owner of Newton, near Brecon, demonstrated the change in the nature of patronage at the end of the century in the most dramatic fashion. Although Newton was not a particularly large house, a detailed inventory taken after his death in 1707 revealed that Thomas Walker owned more than a hundred and fifty pictures.[35] More significant than their number alone, however, was the range of the collection, for although it included portraits both of the family and of the high and mighty, it was dominated by subject pictures, still lifes and animal pictures, mostly originating in the Low Countries.

Walker began collecting as the importation laws ceased to be enforced in the mid-1680s, making use of one Mr Doyley at Gray's Inn in London. The variety of the pictures available by then is evident from an invoice sent by Doyley in October 1689:

[33] Iain Pears, *The Discovery of Painting: The Growth of Interest in the Arts in England 1680–1768* (New Haven, 1988), pp. 52–3.

[34] J. P. Turbervill, *Ewenny Priory: Monastery and Fortress* (London, 1901), pp. 93–101.

[35] NLW, Penpont Supplementary Papers, 1582–4. The inventory was taken in 1722, but it is most unlikely that significant additions to the collection had been made following Walker's death fifteen years earlier. Another early collection of pictures (c. 1700) which extended beyond portraiture was at Nanteos, Cards. The works were brought from Cologne to Wales by Cornelius Le Brun when he married Ann Jones, heiress to the estate.

[36] Ibid., 1575.

[37] Ibid., 1589.

[38] Only daughter of Sir Thomas Myddelton, 2nd Bart., who subsequently married Joseph Addison, the English essayist.

[39] Myddelton, *Chirk Castle Accounts (Continued)*, p. 464.

	£	s	d
Ann of Bullen	03	00	00
Three Dutch men with a Base Viole	01	18	00
A fruite peece	01	04	00
A History out of Ovid of Satona & her two children (Appollo and Diana) trying to drink water & being hinderd by two Clowns [who] turned them into ffroggs	01	00	00
A Goa Havon with building	01	18	00
A Landskip with Lambs in it	01	00	00
a parrott with ... grapes	00	00	00
this I gott into the bargain			
	10	00	00

They have all of them gold fframes.[36]

Walker's appetite was unusually voracious but nonetheless indicative of the dramatic upturn both in the desire to buy pictures for their own sake and the availability of the raw material. Although the basic market for new pictures remained in portraiture, even within that genre a change of attitudes towards the meaning of art works began to manifest itself. James Still, summoned to assess Walker's pictures in 1724, remarked that 'Portraits are chiefly useful to the person of whose ancestors they are representative',[37] but works attributed to Holbein, Van Dyck, Lely and Kneller were clearly considered to have artistic qualities which set them above the rest, and they were among the most highly valued items in the inventory. Two years later, in a letter to Charlotte Myddelton, Countess of Warwick,[38] Robert Myddelton demonstrated his appreciation not only of a portrait she had given him as a likeness but also its merits as a work of art and her good taste in commissioning the unidentified painter:

the Painter is a great Master & treads on the heels of Van Dyke, exactly drawn, very like you both in its beauty and gracefullness, verily so Genteel that the person it represents can only exceed it in the sense that the Romanists say they Image worship (who would have the world believe that it only brings to their memory the absent saint), I shall always worship yours.[39]

For Myddelton, Van Dyck was still the benchmark, eighty-five years after his death, and continental painters continued to set the London taste. Peter Lely, born in Westphalia and no doubt driven out partly by the chaos of the Thirty Years War, had the misfortune to arrive in England in 1643 at the start of another conflict, but proved himself a survivor and dominated Restoration painting until his death in 1680. His studio produced prodigious numbers of formulaic portraits and copies which dominated the market. Lely was succeeded as the most prestigious court painter by another German, Godfrey Kneller, until 1723,

94. William Henry Toms after Thomas Badeslade, *The North East Prospect of Chirk Castle*, detail of gates and statues of Hercules and Mars, c.1735, Engraving, 602 × 815

95. *Inventory of paintings at Newton House*, Breconshire, 1707, Pen and ink, detail

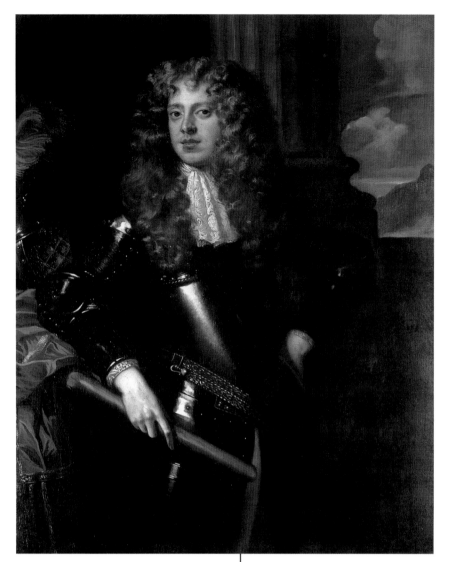

96. Peter Lely,
Sir Thomas Myddelton, First Baronet,
c.1660–3, Oil, 1257 × 1022

97. Peter Tillemans,
Mary Liddell, Mrs John Myddelton,
c.1724, Oil, 1244 × 1009

[40] The history of the Welsh gentry in the period was characterized by the failure of the male line in an unusually high number of families. Welsh heiresses married into English families and, as a consequence, many ancient Welsh houses became home to collections of English family portraits. Such mixtures remained characteristic of collections in many Welsh houses until the great dispersal which occurred in the mid-twentieth century. See John Steegman, *A Survey of Portraits in Welsh Houses* (2 vols., Cardiff, 1957, 1962).

[41] NLW MS 6383D, f. 169, 4 November 1720.

with the Swede, Michael Dahl, close behind. The bulk of Welsh gentry portraits in the period, even if not the work of these studios, reflected the trends they established.[40] The more illustrious who sat for the most fashionable painters no doubt usually did so in London. Sir Thomas Myddelton, the first baronet, sat in Lely's studio, for instance, shortly after the Restoration. Somewhat less well-established painters travelled to Wales to work. The Myddeltons of Chirk again provide a case in point, since in 1720 the castle accountant recorded the visit of the Antwerp painter Peter Tillemans, who was paid for 'Canvace bought by him and Coulors 2:3:6, for pencills and brushes 7d., for Coach Hire and expenses on the Roade down into ye Countrey 3:10:0.'[41] Tillemans' commissions were substantial, and were probably not all carried out on this visit. He painted at least two portraits, *Anne Reade, Mrs Robert Myddelton*, and *Mary Liddell, Mrs John Myddelton*, who has a sprig of orange blossom, symbolic of marriage, in her hand. However, Tillemans also painted landscapes and a subject picture, *The Battle of Belgrade*, which signified the widening of taste in the period.[42]

99. Anon.,
James Stedman of Strata Florida,
*c.*1720–30, Oil,
609 × 736

98. John Lewis,
Bridget Vaughan, Madam Bevan,
1744–5, Oil, 1245 × 990

In south Wales the pattern was similar. In 1744–5 John Lewis painted a notable series of portraits of members of the Vaughan family of Golden Grove and Derwydd in Carmarthenshire. The grand but fanciful backgrounds to his portraits reveal Lewis's penchant for theatre, for which he is known to have painted scenery. Among his six paintings, that of Madam Bridget Bevan is of particular historical significance since the sitter was patroness of Griffith Jones of Llanddowror, who developed the circulating school system to provide a basic education for the poor. After Jones's death in 1761 Madam Bevan carried on this remarkable social enterprise, linking the sitters for portraits in the grand houses to a common people all but invisible in the Welsh art imagery of the period.[43] Such a substantial commission, and work done by Lewis in other houses in the area, suggest that the painter may have had Welsh family connections, though he also worked in London and, between 1750 and 1757, in Ireland. Written evidence for the patronage of Welsh-born or Welsh-based painters in the period is scarce, but visual evidence in surviving gentry collections, especially those of the less prominent families, suggests a pattern

[42] Presumably this picture was bought from the stock of works held by the painter in his London workshop, rather than done as a commission. The portraits are discussed in detail in Alistair Laing, 'Changelings at Chirk Castle', *Country Life*, 8 June 1989, 272–5. Laing suggests that a portrait probably representing *Mary Myddelton and her infant son Richard* is also by Tillemans.

[43] For the portraits, see the catalogue to Sotheby's sale of the contents of Derwydd Mansion, 15 September 1998, pp. 28–32.

102. Robert White,
Sir John Vaughan of Trawsgoed,
*c.*1677, Pencil, 136 × 91

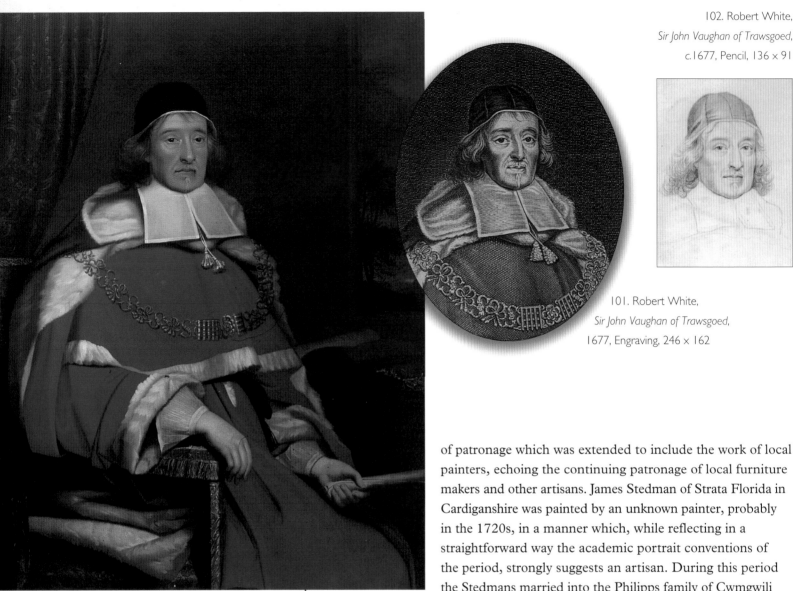

101. Robert White,
Sir John Vaughan of Trawsgoed,
1677, Engraving, 246 × 162

100. Anon.,
Sir John Vaughan of Trawsgoed,
*c.*1668, Oil, 1270 × 1016

opposite:
103. Anon.,
Sir Charles Kemeys of Cefnmabli and
Sir William Morgan of Machen and
*Tredegar House, c.*1710–15,
Oil, 2030 × 1680

44 NLW, Courts of Great Sessions, Wales, 4,
735/4. On 20 March 1734 a Carmarthen jury
included Tindale and identified him as a limner.
I am grateful to Dafydd Lloyd Hughes for this
reference. A second portrait of an unidentified
member of the Stedman or Philipps families,
clearly by the same hand, also survives.

of patronage which was extended to include the work of local
painters, echoing the continuing patronage of local furniture
makers and other artisans. James Stedman of Strata Florida in
Cardiganshire was painted by an unknown painter, probably
in the 1720s, in a manner which, while reflecting in a
straightforward way the academic portrait conventions of
the period, strongly suggests an artisan. During this period
the Stedmans married into the Philipps family of Cwmgwili
near Carmarthen, and the presence of one John Tindale,
described as a 'Limner', at Carmarthen in 1734, if not directly related to this
portrait, confirms that it was possible to obtain a painter locally in this period.[44]

During the Restoration period several talented Welshmen rose to positions
of eminence at Westminster and portraits survive, for instance, of Sir Leoline
Jenkins, Secretary of State (1680–4), Sir John Trevor of Bryncunallt, Speaker
and Master of the Rolls under James II, and the infamous Judge George Jeffreys,
Lord Chancellor. Among the gifted lawyers and politicians who became the
subject of engravings based on painted portraits was Sir John Vaughan of
Trawsgoed. His engraved portrait also provides some insight into the working
methods of the period since a drawing also survives. At the Restoration Vaughan
was an intimate of Charles I's Chancellor, the Earl of Clarendon, but in 1667 he
was prominent among those who promoted his impeachment. The following year
he was knighted and appointed Chief Justice of the Court of Common Pleas. He

prospered mightily and associated with the leading intellectuals of the age. As a judge, he handed down a number of significant verdicts, and it was for a posthumous collection of these that his portrait was splendidly engraved by Robert White in 1677. It appears that White's drawing of Vaughan was done from the full-length portrait of the sitter in his official robes, in preparation for the engraving.[45]

Private iconographies in the form of painted portraits did, on occasion, extend beyond the house of the sitter as a result of the practice of sending copy portraits to relatives and friends, and also in the form of group portraits which linked families. One of the most attractive examples of this genre links the Monmouthshire families of Kemeys of Cefnmabli and Morgan of Machen and Tredegar House. *Sir Charles Kemeys and Sir William Morgan* was painted about 1710–15 by an unknown artist who set them in woodland with a view to a distant landscape. A servant attends, discreetly, in the middle distance, holding a horse.[46] Such tokens of friendship and alliance between families remained fashionable. In about 1742–5 John Wooton was commissioned to paint Sir Watkin Williams Wynn of Wynnstay and the Duke of Beaufort in sporting mode, inspecting a horse called Legacy. Each sitter owned a version of the portrait.

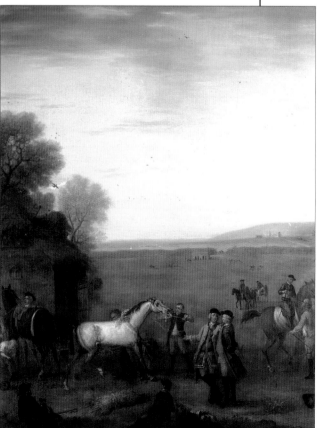

106. John Wooton,
*Sir Watkin Williams Wynn
of Wynnstay and the Duke of Beaufort,*
c.1742–5, Oil, 2360 × 1930

above:

108. Anon.,

The Submission, 1741,

Engraving, 257 × 158

above left:

107. Anon.,

A Welch K-t Roasted and Baisted,

1745, Engraving, 176 × 304

S ir Watkin Williams Wynn, third baronet of Wynnstay, acquired by far
the greatest iconography, public and private, of any Welsh person of the
eighteenth century.[47] He did so not only because he was immensely wealthy, but
also because of his political activities. As Watkin Williams, he accumulated land
through his first marriage in 1715 to Ann Vaughan, daughter and heiress of
Edward Vaughan of Llwydiarth and Llangedwyn, and, finding himself by this
good fortune one of the richest men in Wales, he added Wynn to his name and
embarked on an ambitious programme of development and patronage. He began
at Llangedwyn, where he created formal gardens, celebrated in the earliest portrait
to survive, probably painted in the mid-1720s. The iconography of the second
portrait was also celebratory. In 1729 he successfully brought an anti-corruption
bill before Parliament, and Michael Dahl's picture, showing him holding a copy of
the document, was presumably painted shortly after it became law. Half a dozen
smaller variants of this image were commissioned for friends and associates, and
it was engraved by George Vertue, though not until 1742. This late resuscitation
of Dahl's picture may have been due to a second celebrated event in Sir Watkin's
political career. The previous year he had been ousted from his Denbighshire
parliamentary seat by the rival Myddelton family of Chirk, whose county
supremacy had been threatened by the sudden rise of Wynnstay. However,
the Myddeltons had stooped to foul play to achieve their ends and Sir Watkin
was reinstated, an episode which attracted the attention of the London makers
of popular prints. In *The Submission*, Sir Watkin receives the not entirely contrite
apologies of the Bishop of St Asaph, who had injudiciously supported the
Myddeltons in their conspiracy.

Sir Watkin featured in a number of London popular prints of the period, though
not always in an advantageous light. Following the publication of a pamphlet
denouncing the Tory squire in 1745, John Myddelton and another old enemy,

[45] For Robert White, 'the leading exponent of
his day' of portrait engraving in line, see Edward
Croft-Murray and Paul Hulton, *Catalogue of British
Drawings* (London, 1960), p. 539. White is most
unlikely to have been responsible for the painted
portrait. His engraving was published in *The Reports
and Arguments of that Learned Judge Sir John
Vaughan* (London, 1677).

[46] The portrait presents some difficulties since the
age difference of twelve years between the two
sitters is not immediately apparent. The style of
the picture is reminiscent of Knyff's *Arthur, 3rd
Viscount Erwin*, for which see *The Burlington
Magazine*, XCVI, November 1954, 337–8.

[47] I am indebted to Miles Wynn Cato for the
details of the Wynn portraits given here. My
text is based on his research. In his unpublished
iconography of Sir Watkin, Cato also lists a
miniature portrait by C. F. Zincke, and a
proliferation of portraits of other members
of the family, many of which certainly resulted
directly from Sir Watkin's patronage.

110. *Sea Serjeants' drinking goblets,* 1750, 162h.

111. Thomas Hudson, *Sir Watkin Williams Wynn, 3rd Bart., c.*1740, Oil, 1270 × 1010

109. Robert Taylor, *John Williams of Congarfer,* 1747, Oil, 609 × 736

[48] For details of this and other popular prints of Sir Watkin, see Lord, *Words with Pictures,* pp. 54–5.

[49] It may be significant that the painter, Thomas Hudson, was also commissioned to paint a group portrait, *Ben's Club of Aldermen,* depicting Sir Watkin's main Jacobite agents in London. Sir Watkin's second wife, Frances Shakerley, mother of his heir, was an ardent Jacobite.

[50] Letter from Donald Cameron to Prince Charles Stuart, quoted in James Browne, *A History of the Highlands, and of the Highland Clans; with an extensive selection from the hitherto inedited Stuart Papers* (4 vols., Edinburgh, 1852–3), III, p. 491. For a discussion of the political significance of the portraits, see Stephanie Jones, 'Jacobite Imagery in Wales: Evidence of Political Activity?', *The Historian,* 57 (Spring, 1998), 32–5. Only the portrait of Gwynne was engraved. A line engraving by Benoist of Sir John Philipps, another member of the Society, does not indicate his Jacobite sympathies.

Sir George Wynne of Leeswood, were depicted gleefully roasting Sir Watkin on a spit before a great fire.[48] By this time Sir Watkin had sat for a second large oil portrait, painted by Allan Ramsay, and the first of two portraits by Thomas Hudson, the leading English portrait painter of the day. Hudson's portrait, perhaps painted in 1740 when Sir Watkin inherited Wynnstay, became the most widely distributed and recognized image of the man. The picture was the source of an engraving by John Faber and a number of studio copies, the significance of which may be indicated by their presence in the houses of Jacobite sympathizers. Sir Watkin was President of the Cycle of the White Rose, a clandestine Jacobite society, so called because their meetings, at which they drank the health of the Stuart Pretender to the throne, circulated round the houses of the members. The Cycle was believed to be implicated in the risings of 1715 and 1745, though few of its members had much appetite for military involvement, and to a considerable degree it was a social club. Copies of the Hudson portrait may well have signified allegiance to Sir Watkin and to the cause.[49] The ascription of such political significance to a group of portraits is enhanced by the existence of a parallel group from south-west Wales, whose Jacobite context is quite explicitly stated in its iconography. The Dolphin emblem of the Jacobite Society of Sea Serjeants appears on various items, such as the drinking goblets used to toast the health of the Pretender, and on the badges worn by the sitters for this remarkable series. Twenty-eight portraits of members, one of their chaplain and one of the painter of the series, Robert Taylor, were painted in 1747 and hung together at Taliaris, Carmarthenshire, home of Richard Gwynne, President of the Society. The date of the portraits and an associated mezzotint engraving suggests strongly that the Society was more than a drinking club for Tory squires, since it was in 1747 that plans were made for Charles Stuart once again to sail for Scotland, supported by an invasion of Wales by three or four thousand French troops.[50]

112. John Michael Rysbrack,
Memorial to Sir Watkin Williams Wynn, 3rd Bart.,
Church of St Mary, Ruabon, 1751–4, Marble

113. John Michael Rysbrack,
*Memorial to Sir Watkin Williams
Wynn, 3rd Bart.,* Church of
St Mary, Ruabon, c.1751,
Pen, ink and wash, 349 × 266

Sir Watkin came to an untimely end in 1749, killed in a fall from
his horse, but the grand scale of the patronage he had initiated was
continued by the commission of his tomb in Ruabon church. It is a
magnificent tomb, with a reclining effigy, carved by John Michael
Rysbrack, born in Antwerp but then at the height of his career in
London. At the same time, and perhaps indicative of the rivalry
between the Wynns and the various branches of the Myddelton
family, Mary Myddelton was memorialized in Wrexham church by
one of Rysbrack's greatest rivals, Louis François Roubiliac, regarded
by many as the greatest sculptor working in London in the period.
Roubiliac's memorial was an extraordinarily dynamic conception.
The great conventional pyramid of mortality, exemplified in Rysbrack's
memorial to Sir Watkin, crashes down behind a rejuvenated Mary
Myddelton, who rises from the black tomb accompanied by a
vigorously sprouting plant.

114. Louis François Roubiliac,
Memorial to Mary Myddelton,
Church of St Giles, Wrexham,
1751–2, Marble

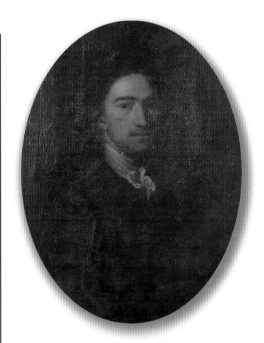

The new enthusiasm for buying pictures in the early eighteenth century, coupled with the dominance of continental practitioners, stimulated fundamental changes in practice among painters in London which had particular implications for Wales. Among the most important was the final demise of the generalist painter at the top end of the market. Not only did painting practice fragment into exclusive specialisms but a clear distinction of status was made between art painters and artisans. The demise of generalists such as Thomas Ffrancis of Montgomery was accelerated by the end of the fashion for the Baroque schemes of decoration involving the integration of the different skills of a number of individuals – carpenters, carvers, painters – of similar status. The painters of the portable framed pictures of people, subjects and landscapes which replaced such schemes assumed a high status, while wall, sign and coach painting became the province of a distinct lower order of artisans.[51] Changes affecting the nature of art training in particular also had consequences in Wales which persisted until the second half of the nineteenth century. As we shall see, on the one hand artisan painting evolved into a very particular and unusual role, while on the other the first of a long list of individuals intent on making their careers as artists set out for London to acquire training in the studios of the masters, and before long in art schools and academies.

Despite the diversification of taste at the top of the market in the early eighteenth century, it is indicative of the continued dominance of the portrait in Welsh patronage that the first three painters from Wales of whose training we have some knowledge aspired to portraiture as a career. They came from very different parts of the country. John Dyer, who went to London in 1720, was from Carmarthenshire; Edward Owen, who began his apprenticeship five years later, was from Anglesey; and Richard Wilson took the long road to London from Penegoes, near Machynlleth, in 1729. However, Dyer and Owen shared a similar background among the minor gentry, and Wilson, although he was the son of a country parson, was well connected on his mother's side to the gentry of the north-east. This gentry background was clearly important in enabling the aspirants to pay for their training, but more fundamentally in the formulation of their aspiration to paint portraits in the first place. Wilson, in particular, seems to have had an excellent Classical education and was a sophisticated individual by the time he arrived in London, and his behaviour there reflected the recent elevation of his chosen profession from its artisan roots. Good family connections also provided a potential starting point for subsequent patronage.

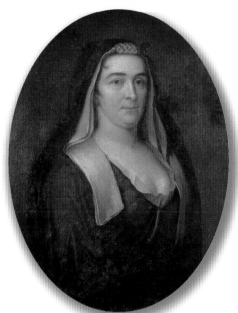

[51] However, the field of scenery painting for the theatre remained a prestigious adjunct of picture painting in the second half of the eighteenth century. Pears, *The Discovery of Painting,* pp. 113–19.

117. Richard Wilson,
The Princes George and Edward Augustus,
Sons of Frederick, Prince of Wales, with
their Tutor, Dr. Francis Ayscough,
c.1748–9, Oil, 635 × 765

Of these three, John Dyer had by far the most illustrious teacher, namely the English painter Jonathan Richardson, and his life among the up and coming avant-garde in the fashionable coffee houses of London, as well as his early departure for Italy to continue his training, reflected his master's status. Richardson was among the leaders of a movement among English artists

to overcome the domination of the art world by practitioners born on the Continent. His patriotism reflected the early stirrings of a national movement in art expressed more conspicuously in the construction of empire. The year before Dyer joined him in 1720, Richardson had published his influential *An Essay on the Whole Art of Criticism as it relates to Painting*. Richard Wilson, financed by Sir George Wynne of Leeswood, went to a little-known portraitist called Thomas Wright, and Edward Owen to the more prestigious Thomas Gibson, though he soon developed an admiration for his master's competitor, Richardson, which caused some embarrassment. As Owen observed in a letter written in 1729: 'Whilst I continue with my Mastor I know he would take it ill if I were to coppy any Paintors works but his own.'[52] Copying was an essential part of the training of the period.

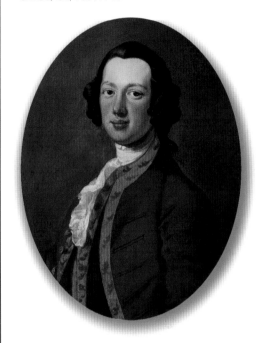

118. Richard Wilson,
Captain Walter Griffith of Bron-gain,
c.1750, Oil, 760 × 740

The letters of Edward Owen of Penrhos give an unusually personal insight into the world of an apprentice painter in this period. Although he was able to speak Welsh, he had been sent to school in England and consequently wrote in English. He determined on painting as a career while he was at school and, as his brother remarked, 'As his inclinations lead that way, so it is best to let him follow it, & no doubt but with Gods Grace he may make a Competant Honest lively Hood. No time ought to be lost in placing him out ...'[53] The network of family and friends which extended to London was employed to find him a master and to settle him down with Gibson early in 1726, where he continued his studies in geometry and arithmetic and took up French as well as drawing. He reported that it was necessary to dress well, confirming other contemporary sources which suggest the gentrification of the profession in the period. This caused the family much expense, as did the materials for his studies:

> I find my business vastly expensive to what I thought it would be when I was first bound, theres not a week passes but it costs me above eighteen pence only in pens pencils chalks blew brown & white paper, besides what it costs me in things to coppy after as drawings prints & plaister figures. My master tells me it will yearly cost me 10 pound in my business, as it is not meerly coppying makes a painter but seeing and buying great masters performances, and minding where in one excell'd, where in another. Tho' master is the best Drawer in England, as allow'd by every one, yet he lays out above 40 or 50 pound a year in drawings.[54]

Owen's apprenticeship was so plagued by financial difficulties and the sickness of his master that by 1729 he was seeking to buy a place as a gentleman usher at court. He painted members of his family and friends and in 1732, on his return home, a self-portrait. His career, which may well have already run its course, was

[52] NLW, Penrhos Papers 1025, dated 6 February 1729.

[53] Ibid., 991, dated 31 March 1725.

[54] Ibid., 997, dated 17 March 1726.

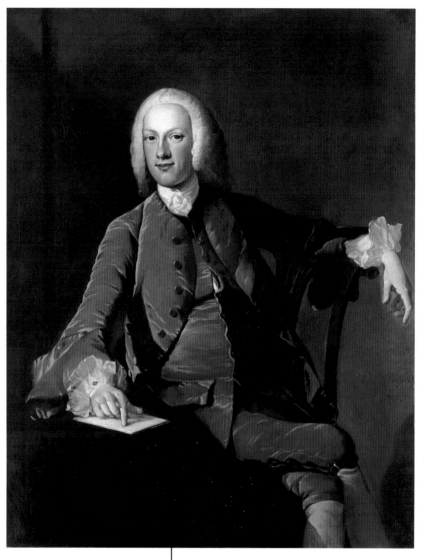

119. Richard Wilson,
Edward Lloyd of Pengwern,
1750, Oil, 1270 × 1016

[55] The present whereabouts of only one of Owen's portraits, that of his mother, is known. The self-portrait was seen by Isaac Williams in 1926, although he seems to have dated Owen's death incorrectly as 1748. Edward Owen died of 'a kind of galloping consumption ... My brother and self will lose a sincere good friend in him. You may remember that I was with you when at London at his lodgings at the King and Pearl, in Tavistock Street. He was then a limner, and a second brother'. Ibid., letter dated 17 March 1740.

[56] Myddelton, *Chirk Castle Accounts (Continued)*, p. 501. The connection with the Chirk family continued, since in 1742 John Myddelton noted in his diary that 'Mr Wilson a painter in Covent garden has a picture of mine in his custody'.

cut short by his death in 1740.[55] Similarly, John Dyer did not make his way professionally as a portrait painter, but a self-portrait survives among a few other examples representing members of his family. Richard Wilson was more financially fortunate than Owen and, initially, more single-minded than Dyer. He was able to survive the difficult transition from apprentice to portrait painter and by the 1740s he was in receipt of substantial patronage from the Lyttleton family which took him briefly to the fringes of the court, where he painted the group portrait *The Princes George and Edward Augustus, Sons of Frederick, Prince of Wales, with their Tutor, Dr. Francis Ayscough*. Many of his early patrons, however, were the Welsh gentry, such as Richard Owen of Ynysymaengwyn, whom he painted in about 1748. His portraits of younger individuals had a freshness and a relaxed quality which made them quite distinctive. Among the best were Captain Walter Griffith of Bron-gain, a young man who would gain a considerable reputation as a soldier in the American War of Independence, and Edward Lloyd of Pengwern, seated at a table with his finger pointing to a detail in a letter, the significance of which is long forgotten.

Among Wilson's earliest and wealthiest patrons were the Myddeltons at Chirk Castle. In 1738 he had been commissioned to draw a portrait of John Myddelton, for which he was paid £6 16s. 6d.[56] While at the castle, Wilson no doubt took the opportunity to study not only the other portraits hanging there but also the landscapes which were becoming increasingly prominent in such collections and to which he would shortly turn his attention, with consequences of fundamental importance for the development of Welsh art culture.

chapter

three

A SENSE

OF PLACE

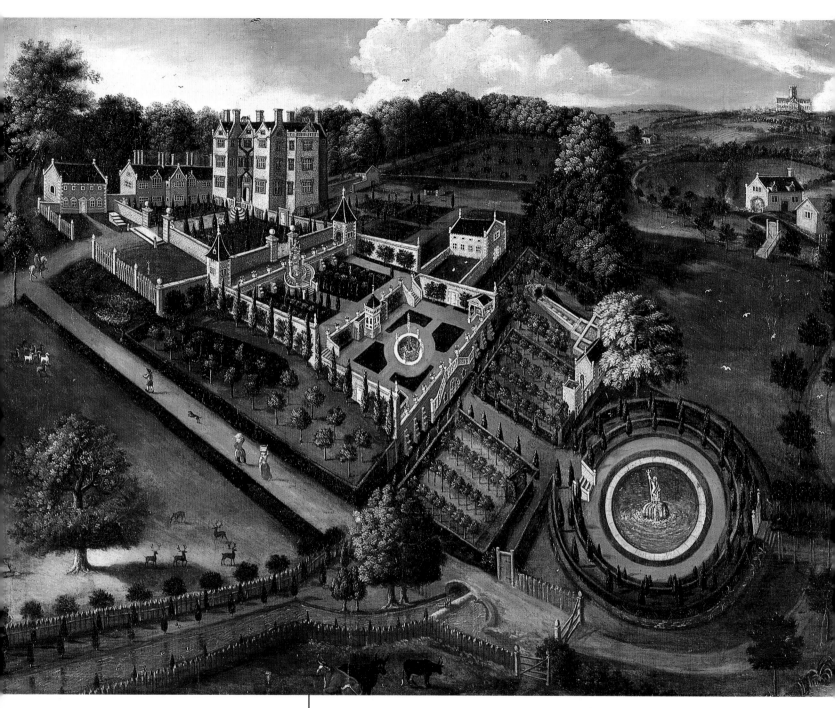

120. Anon.,
Llannerch, Denbighshire,
c.1662, Oil, 1142 × 1517

The most significant of the commissions given in 1672 by Sir Thomas
Myddelton to the artisan Thomas Ffrancis was to paint three landscapes to
set above the new fireplaces at Chirk Castle. On the Continent, a long established
tradition of landscape painting flourished, but landscapes were a new kind of
picture in Welsh, as in English art, at this time. The only earlier Welsh landscapes
were to be glimpsed in the backgrounds of portraits which broke with the prevailing
heraldic tradition of the early seventeenth century, such as that of Edward Morgan
of Llantarnam. In such cases the landscape replaced the family coat of arms, but

the intention was probably much the same – to identify the sitter and to celebrate the continuity of the family. After the Restoration identification by place became the most important element in the new genre of landscape painting. Although the idea that a landscape could be beautiful was not a novel one, the idea of purchasing a picture of a rural scene simply for itself, rather than for its particular associations, had not yet taken root. Welsh landscapes between 1660 and the end of the century almost invariably depicted the countryside as the surrounding environment of a house (often principally the estate of the patron) or occasionally another building or a town associated with him or her in some way. The landscape painting was a statement of the patron's identity, rather than an emotional response to nature.

The sudden arrival of the fashion for such depictions at the Restoration can be attributed to a combination of psychological and practical factors. Psychologically, the need to reaffirm long-standing relationships after the disturbance of the preceding two decades was clearly met by the depiction of the permanence of place. At least three groups of pictures, those of Newton in Carmarthenshire, and Troy House and Tredegar House in Monmouthshire, were associated with Restoration rebuildings. At a practical level, increasing interest in continental fashions and the renewed availability especially of Dutch painters both stimulated demand. In the half century after the Restoration an interesting difference of concept informed two distinct schools of landscape. The first to manifest itself was a conceptual tradition, the precedents for which were to be found ultimately in map-making, but which were probably mediated through continental engravings of great houses and their formal gardens depicted at an oblique angle as if from the air. Although collections of such prints would be published depicting English subjects in the early eighteenth century, and Welsh subjects from the 1730s, the first manifestation of this approach in Britain was in painting.[1] The earliest surviving bird's-eye-view paintings are two closely similar prospects of Llannerch in Denbighshire, one of which carries the date 1662.[2] The circumstances of the patron, Mutton Davies, exemplified the combination of internationalism and a sense of the indigenous tradition which characterized some of the leading Welsh intellectuals of earlier times. Mutton Davies was the son of Robert Davies of Gwysaney, who had commissioned family portraits from Thomas Leigh, and the father of another Robert Davies who developed the important collection of Welsh manuscripts which still bear the name of the family home. After the civil wars, Mutton Davies had been dispatched on the Grand Tour, and although his precise movements are unknown he certainly visited France and Italy. It was probably there that he acquired his taste for the kind of statuary and features which enlivened the garden at Llannerch, such as a sundial which spouted water in the visitor's face as it was approached.[3]

The two Llannerch paintings, celebrating the taste and affluence of Mutton Davies, were reflected in a contemporary *cywydd gofyn* written by a little-known poet called Foulk Wynn. The poem was written in a tradition of praise extending back many centuries but which, by the Restoration period, was in decline. The

[1] A manuscript of *c*.1600 in the collection of the Marquess of Salisbury has a view of Conwy Castle and town in an oblique projection, but is best considered as a late manifestation of the medieval tradition of illumination. The earliest English engraved bird's-eye view was Hollar's *Windsor Castle*, which was followed in the early eighteenth century by a number of collections, notably in *Britannia Illustrata* (1708). The work of the Dutch painter Leonard Knyff, engraved by Jan Kip, was published in Robert Atkyns, *The Ancient and Present State of Gloucestershire* in 1712.

[2] Unless the inscribed date is a mistaken later addition, the painting almost certainly represented the garden of the house as planned. Mutton Davies, who commissioned the garden, returned to Wales in 1658 but was promptly imprisoned in Chester as a Royalist. He was, therefore, unlikely to have commenced work before 1660 and yet the gardens were shown in a mature and finished condition only two years later. The Llannerch picture, which is now at the Yale Center for British Art, is about three-quarters the size of the picture which remains in a private collection in Wales. The pictures are substantially similar but differ in the details of figures and animals.

[3] The sundial carried a motto which made clear that it was intended as an encouragement to humility in the unfortunate victim: 'Alas! my friend, time soon will overtake you; / And if you do not cry, by G-d I'll make you.' Philip Yorke, *The Royal Tribes of Wales* (Wrexham, 1799), p. 98.

121. Hendrik Danckerts,
A Panorama of Monmouth
with Troy House, c.1672,
Oil, 1981 × 1320

[4] NLW MS 263B, a book of poems by Foulk Wynn of Nantglyn, c.1684, p. 10: 'i'r Cathedral, daw'r gŵr tal iach / 'n buraidd, doed dippin boreuach / Gŵr tyner a llawer lle, / ai blesser yw ei blasseu: / yn fwyna dŷn, o fewn ei dai / ei ddyfais ef fydd ddifai: / Gwych y trosglwyddodd y gŵr / iw erddi ffrydiau o oerddwfr: / da ei glod eiff i rodio, / i ardd fawr a urddodd fo: / ei lawr o gwmpas ei lys / ai gastiau ydynt gostus ...' (to the Cathedral, the tall healthy man comes / undefiled, may he come a little earlier / A gentle man owning several places, / and his pleasure, his palaces; / the most courteous of men, within his houses / his design is faultless: / The man brilliantly transferred / to his garden fountains of cold water. / great is the praise of he who walks / in the large garden which he has adorned: / his ground around his court / and his tricks are expensive).

[5] Blanche inherited the estates through her father, Judge William Morgan of Y Dderw, Llys-wen. Similar identification of a spouse by landscape iconography is to be seen on a portrait of Roach Vaughan of Tretower in Breconshire, who married into the Harley family of Herefordshire. A prominent escarpment just to the north of Tretower is clearly identifiable in the background of the picture.

rise of the visual image as a medium of praise and the simultaneous decline of the poem during the seventeenth century echoed the social evolution of many, though not all, gentry families, who were gradually losing touch with indigenous customs and learning, especially as transmitted through the Welsh language. The poet told his audience of the patron's travels to Rome (and apparently also to India) and of his return to Wales to create a paradise reflecting these experiences at home. As in the picture, the gardens were described (including the water-tricks) and, in a particularly striking parallel between the visual and the literary, attention was also drawn to Mutton Davies's association with St Asaph Cathedral.[4] The painter's composition had placed St Asaph so conspicuously on the horizon that the intention was clearly more than simply to indicate a local feature and create a visual counterbalance to the house.

The bird's-eye-view picture enabled the painter to celebrate the contemporary world of the patron with a realism which extended to the smallest details of the life of the common people and animals outside the gates. Clearly, the painter of the Llannerch views was closely familiar with that world and displayed a love of the narratives of everyday life which were presented in tiny vignettes. In a field a group of sheep start in alarm at a yapping dog in the lane leading to the house. Tiny rabbits, mallards and swans are painted in characteristic attitudes, and two women walk up the lane with baskets on their heads. The painter of the Llannerch pictures is unknown, but it is reasonable to suppose that they were the work of a locally-based artisan, such as Thomas Ffrancis.

Unfortunately, Ffrancis's landscapes have not survived and so it is impossible to determine whether they were done in the bird's-eye-view manner or reflected the very different conventions of some contemporary Dutch painters, at least one of whom came to Wales in the seventeenth century. Their different approach was exemplified by the depiction of Troy House in Monmouthshire painted by Hendrik Danckerts in about 1672. The patron was Henry Somerset, third Marquess of Worcester, and it is worthy of note, given the choice of painter, that he had spent some years in exile at the end of the civil wars in the Low Countries, and also in France. The old house at Troy, owned by Somerset, was shortly to be

122. Hendrik Danckerts,
Caerphilly Castle, c. 1670–80,
Pen, ink and wash, 249 × 422

demolished to provide a new Welsh residence for the family in preference
to Raglan, which had been ruined following its unsuccessful defence by his
grandfather during the civil wars. It was probably the planned rebuilding which
gave rise to the commission. Danckerts chose a high vantage point for his view
of Troy, but a naturally occurring one, or at least one which was made to appear
natural by the inclusion of rising ground at the bottom of the picture, to which
particular attention was drawn by the inclusion of a figure group. Like the overall
concept of the picture, such details were also strikingly different from those in the
Llannerch pictures. The Troy house figures depict Arcadian ideals, rather than
the common people at their everyday work. Danckerts' lady was painted in a
state of Classical *déshabillé*, the meaning of which has been lost in the meantime.
The mountainous background of the picture was a remarkable exaggeration of
the topography beyond the town of Monmouth, and was apparently designed to
enhance further the other-worldly effect of the Arcadian figures.

A group of landscapes at Tredegar House, probably commissioned at about the
same time as the Troy House picture, closely reflected both Danckerts' approach
and his figurative detail. As we have seen, Dutch taste had a strong influence on
the patron, William Morgan. Like the lost landscapes at Chirk, the Tredegar House
pictures were built into an overall decorative scheme in the Gilt Room. One of
them had a woman reclining in a closely similar state of undress to the Troy
House view. It is possible that the Tredegar House pictures may be associated with
Danckerts since the painter's visit to Troy was not an isolated incursion into Wales.
He certainly ventured as far west as Caerphilly, where he made three drawings of
the ruined castle. Like these drawings, the Tredegar House pictures were unusual
for their date in that they did not depict the house itself, and, indeed, the Classical
figure groups seem to be admiring the distant views which are clearly identifiable
as the Brecon Beacons. Blanche Morgan, wife of William Morgan of Tredegar
House, was heiress to estates in Breconshire.[5]

123. Anon.,
Landscape in the Gilt Room at
Tredegar House, c. 1688, Oil, 1600 × 520

124. Anon.,
The Church of St Andrew, Presteigne,
c.1680, Oil, 965 × 1219

125. Thomas Dineley,
The Church of St Andrew,
Presteigne, 1684,
Pen and ink,
255 × 185

126. Thomas Smith,
Troy House, Monmouthshire,
Oil, c.1680–90, 610 × 711

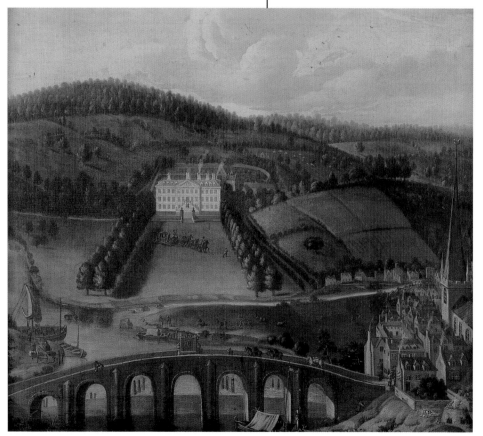

The intense involvement of Henry Somerset, third Marquess of Worcester, with political life, which extended back to the first civil war, continued at the Restoration with more positive consequences. In 1682 he was elevated to the title of Duke of Beaufort by Charles II, and two years later he undertook a vice-regal tour of Wales in his role as Lord President of the Council of Wales. Among his attendants was Thomas Dineley, who made a detailed record, both written and visual, of his master's progress around the great estates of the country. Dineley's pictures now provide an invaluable record of buildings subsequently demolished or greatly altered, although they are not to be relied upon in matters of detail. Many of their inaccuracies probably arose from his method of taking notes at the scene which were later worked up into the final drawing. His approach was generally consistent with that of the contemporary bird's-eye-view painters, and

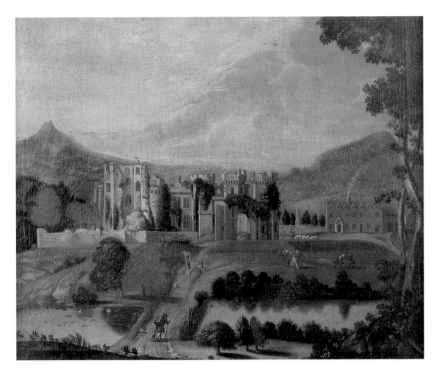

128. Detail of
Thomas Smith,
Raglan Castle

127. Thomas Smith,
Raglan Castle, 1680–90,
Oil, 610 x 736

129. Thomas Smith,
Chepstow, 1680–90
Oil, 610 x 711

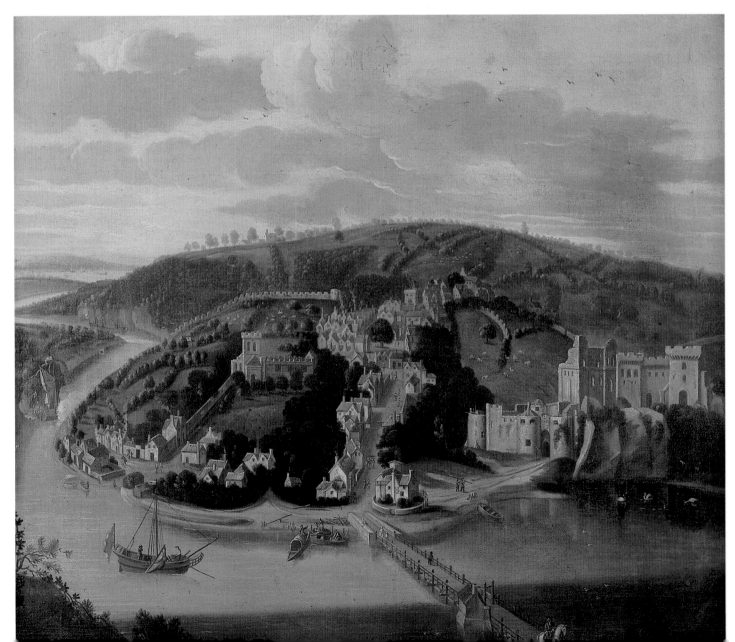

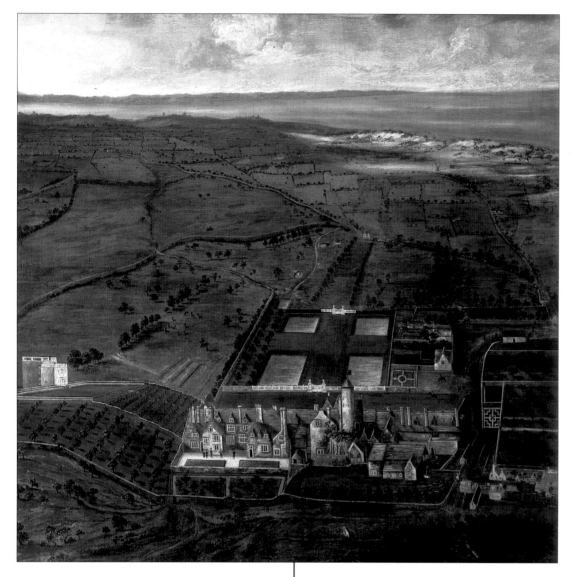

130. Anon.,

Margam House from the north,

*c.*1695, Oil, 1460 × 1450

he was, no doubt, familiar with examples of that genre. He often placed subjects, such as Powis Castle, grandly in their landscape setting, and was equally fond of human detail. Among the smaller buildings noted by Dineley was Presteigne church, where he saw 'the ruines of good painted Glass', no doubt a casualty of the civil wars. His drawing of the church is particularly interesting since it was exactly contemporary with a most unusual painting of the same subject. Given the extreme rarity of images of individual buildings in this period, the appearance of two in the same year suggests more than coincidence, and Dineley himself, or more likely his master, may have had some part in the commission to the unknown painter. At about the time of his grand progress, the Duke of Beaufort seems to have been seized with a particular enthusiasm for views. He commissioned the painter Thomas Smith to produce four pictures of his Welsh estates – two of the town of Chepstow, one of the ruined Raglan Castle, and one of the new Troy House, which he had built since his commission to Danckerts. A comparison of the two Troy House pictures demonstrates clearly the different conventions at work in contemporary painting, both in terms of the viewpoint chosen to depict a scene and more dramatically in attitudes to the depiction of everyday life. Perhaps surprisingly, considering the Dutch taste for realism, it was the indigenous paintings which demonstrated a fascination with the commonplace, whereas Danckerts' work had escaped into vague Classical allusion. All of Smith's pictures, like the work of the Llannerch master, presented the peasantry with the same literal eye as the lord. A pedlar with his pack approaches Raglan, while Beaufort's carriage and six horses turns, with difficulty, on the grassed area in front of Troy House. Both the Chepstow and the Troy pictures recorded details of town life, such as a limekiln burning above the quay and painted chequers – presumably an inn sign – on the wall of the last house before Monmouth bridge.

[6] Dineley, *The Account of the Official Progress of His Grace Henry the First Duke of Beaufort through Wales*, p. 313. Among the Dutch pictures may have been the portrait of Edward Mansel by Simon Du Bois, dated 1682. Mansel's wife, Martha, was also painted by Du Bois, but Steegman gives the picture as dated 1686.

[7] NLW, Penrice and Margam Papers, 2208, inventory of the library made in 1747. The library also contained illustrated books such as an edition of *Aesop's Fables*, 'with fine cuts', published in London in 1665 by Stoop and Barlow. Clearly, since the inventory was made many years after the time of Sir Edward Mansel, it is not possible to be certain that the books mentioned were already in the library by 1684.

131. Anon.,
Margam House from the south,
c.1695, Oil, 1120 × 1120

132.
Thomas Dineley,
Margam House,
1684, Pen and ink,
117 circum.

133. *Frontage of the Summer Banqueting House,*
Margam, c.1680, later rebuilt as the Temple of
the Four Seasons. Statues, 19th century

Among the houses visited by the Duke on his progress was Margam, which
Dineley drew from the south, imagining the view over the top of the gatehouse.
At the eastern edge he included Sir Edward Mansel's summer banqueting house,
a separate building 'built after ye Italian where regular simetrie Excellent sculpture
delicate graving & an infinity of good Dutch and other paintings make a lustre
not to be imagined'.[6] Sir Edward also owned an impressive library which included
books about Classical and Renaissance art and architecture published in Paris.[7]
Whether or not he was encouraged by the Duke's enthusiasm for bird's-eye
views, Sir Edward subsequently commissioned two pictures of his own estate.
The northern prospect was limited by the hills and valleys of Glamorgan, but
the southerly prospect extended over the Bristol Channel to Somerset. One of
a group of well-painted figures in the courtyard may represent Sir Edward.[8]

Further west, in Carmarthenshire, Beaufort visited Dinefwr Castle. Had he called at
Edward Rice's new seat of Newton, close by, he might have seen a remarkable set
of four bird's-eye views, probably painted about fifteen years earlier.[9] Edward Rice,
who was almost certainly the figure striding confidently towards the unknown
painter in the view depicting the front elevation of the new house, was a modernizer.
He was the first of his family to Anglicize his name, and his house represented the
cumulative efforts of his ancestors for over a century to recover the position they
had lost under Henry VIII. Those ancestors had been praised in a large body of
poems in the Welsh language which came to an end in the time of Edward's father.
Like Mutton Davies at Llannerch, the son's chosen medium of celebration was

[8] Mainly on the grounds of the tenuous
connection between Sir Edward Mansel and the
Duke of Beaufort, John Harris, in *The Artist and
the Country House: A History of Country House and
Garden View Painting in Britain 1540–1870*
(London, 1979), p. 127, attributed the Margam
landscapes to the Duke's painter Thomas Smith.
The pictures, almost certainly, post-date the
Duke's visit, since there is planting before the
summer banqueting house, not recorded by
Dineley. Moreover, stylistic differences make
an attribution to Smith unlikely. The pictures are
discussed in Patricia Moore and Donald Moore,
'Two topographical paintings of the Old House at
Margam, Glamorgan', *Arch. Camb.*, CXXIII (1974),
155–69. Subsequent to the writing of this article,
the pictures were cleaned, revealing that the
southern prospect had been overpainted to
accommodate an extension of the tree-lined ride
towards the sea. This alteration was made not
long after the initial painting of the pictures, since
they were soon relegated to the attic, probably
being considered old-fashioned.

[9] Dineley did not report a visit to the new house,
but since it was immediately adjacent to the
castle, this is not unlikely. The party's base in
Carmarthenshire was Golden Grove.

134. Anon.,
*Newton House, Dinefwr
from the north*, c.1670,
Oil, 838 × 1219

135. Anon.,
Newton House, Dinefwr from the east,
c.1670, Oil, 838 × 1498

[10] Despite the sombre tone of the pictures and
their essentially serious meaning, they are not
without humour. In one of the views, two young
women walking below the castle seem to be in
some difficulty as a result of the unwanted
attentions of an escaped calf. See Peter Lord,
'Tir y Cymry – Golau Newydd ar Hen Ddelwedd',
Taliesin, 89 (Spring, 1995), 54–75.

the picture, though there is no way of knowing by
what example he had been inspired, especially since
the works seem to be particularly early. Neither is
there evidence of connoisseurial interests which
might have led him to continental prints. Edward
Rice's painter was almost certainly local, and judging
by the style, which was dissimilar to all other works
of the period, he was probably working to a verbal
description of what was required, presumably given
by the patron. However, these pictures stand out by
virtue of more than their distinctive style. Two of the
views represented not the house but the old castle of Dinefwr, and a third showed
the castle amidst ancient trees, brooding down over sparse lines of new planting
and the freshly-painted stucco of the house.[10] The fact that a modernizer such
as Edward Rice should have bothered to celebrate the ancient site of the castle
indicates that the building was profoundly significant, a perception borne out by
the fact that Dineley also chose to draw a view of it, from almost exactly the same
point as that chosen by Edward Rice's painter.

During his visit Dineley had clearly been made aware of the layered meaning of the
site. The poets who had celebrated Edward Rice's family had done so above all
because the family was descended from Lord Rhys, the military leader who had
re-established Welsh power in south Wales in the second half of the twelfth century:

Tall Cai of the South like your lively and old grandfather,
 The oldest of the Britons;
Strongest his word, who multiplies the two sides,
Strong leader of the warriors of Urien's host.[11]

The consummation of the family recovery marked by Edward Rice's new house
was clearly an elegant echo of the achievement of his direct ancestor Lord Rhys,
but there can be little doubt that the old castle held a significance which extended
beyond the family. The memory of Lord Rhys had been perpetuated by the bards
in national terms which called up the myth of an Ancient Britain in which the
islands had been united by a single culture and language. In this context Dinefwr
was doubly significant since it was widely believed to have been the site of the
prophecies of Merlin, the most important of which was that the British people,
defeated by the Saxon invaders, would one day regain their homeland and rule
over it. That the accession to the English throne of the
Welsh house of Tudor represented the fulfilment of that
prophecy was an accepted convention among the Welsh
gentry, who profited much from the status it afforded, as
we have seen, at the Tudor court. It was Spenser's *Faerie
Queene* (1590), dedicated to Queen Elizabeth, which
provided the most potent redaction of the myth. During
the seventeenth century this Welsh conceit was increasingly
derided by the English in popular prints, plays and ballads,
but the gentry clearly continued to believe it afforded them
credibility at the heart of English affairs. When Charles I
visited Henry Somerset at Raglan in the early stages of the
civil wars, 'Some of the chief rooms were richly hung with
cloth of Arras, full of lively figures and ancient British
stories'.[12] There can be little doubt that Edward Rice's
paintings of Dinefwr carried the same meaning and
represented the local, family and national layers of self-
esteem which sustained his enterprise – the three layers
identified in the ancient Welsh law as the responsibility
of the aristocrat and expressed in the word *perchentyaeth*.

No landscapes in the bird's-eye-view convention seem
to have been painted after 1700. It may be significant
that the larger of the two views of Chepstow painted by
Thomas Smith for the Duke of Beaufort in about 1690
already suggested a coming together of conventions.
Although it was broadly similar to the other, Thomas
Smith gave the impression of having abandoned the
conceptual approach by including rising ground at the
bottom of the scene, where he set himself, with a friend,
in the process of taking the view.

[11] 'Cai Hir Ddeheudir mal dy hoyw daid –
hen, /Hynaf o'r Brytaniaid; / Cryfa' air, ddybla'r
ddwyblaid, / Cadarn blaen coed Urien blaid',
Huw Llŷn, quoted in E. R. Ll. Davies, 'Noddwyr y
Beirdd yn Sir Gaerfyrddin' (unpublished University
of Wales MA thesis, 1977), p. 149.

[12] Phillips, *Memoirs of the Civil War*, II, p. 27.
These tapestries with their national imagery were
presumably destroyed by the Parliamentarian
forces, if they were not among the pictures sent
to Troy House for safekeeping. See above, p. 55.
For attitudes in English popular art towards
Welsh pretensions, see Lord, *Words with
Pictures*, pp. 33–51.

136. Anon.,
Dinefwr Castle from the north,
c.1670, Oil, 838 × 1219

137. Anon., *Dinefwr Castle from the south-west*,
c.1670, Oil, 838 × 1219

138. John Wooton,
View with Stag Hunt, c.1715,
Oil, 1003 × 1244

139. Peter Tillemans,
North Prospect of Chirk Castle,
1720, Oil, 882 × 1327

[13] Wooton also worked for the Duke of Beaufort at Badminton. The Chirk picture may have been commissioned by Richard Myddelton, who died in 1716, rather than by Robert. Hunting pictures were beginning their rise to the great popularity they achieved among gentry patrons in the late eighteenth and nineteenth centuries. The Plymouth family collection at St Fagans Castle contains an early and naively painted hunt.

After the Duke of Beaufort, the most notable patron to show a sustained and early interest in landscape was Robert Myddelton. At some point prior to 1719, when the Davies brothers' screen and gates were set in place before the Chirk Castle forecourt, the English artist John Wooton painted a view with a stag hunt in progress in the foreground.[13] During his visit in 1720, Peter Tillemans not only painted portraits but also two views of the castle and a *Landscape with Llangollen and the River Dee*. For his north prospect of the castle, which included the Davieses' gates but not the statues of Mars and Hercules, Tillemans stood exactly where Wooton had worked before him. However, either the landscape had undergone substantial developments in the intervening few years or Tillemans supplied fanciful additions in the form of a pool and trees placed strategically to mask unsightly structural accretions to the medieval castle. He produced an ideal *pastorale* much like Danckerts' *Troy House* painted half a century earlier, in contrast to the down-to-earth activity of Wooton's hunt.

Shortly after Tillemans' visit, Chirk Castle was the subject of two engravings in which the bird's-eye view made its last and rather anachronistic appearance in Welsh visual culture. The views were the work of William Henry Toms, following drawings made by Thomas Badeslade, an English artist who specialized in country house subjects. The two engravings of Chirk Castle, one of which was dated 1735, preceded by five years the views

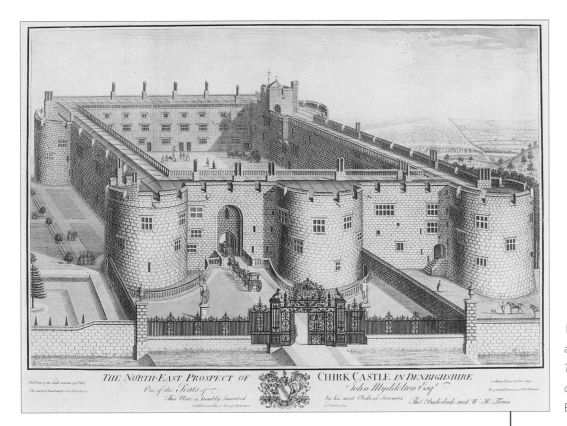

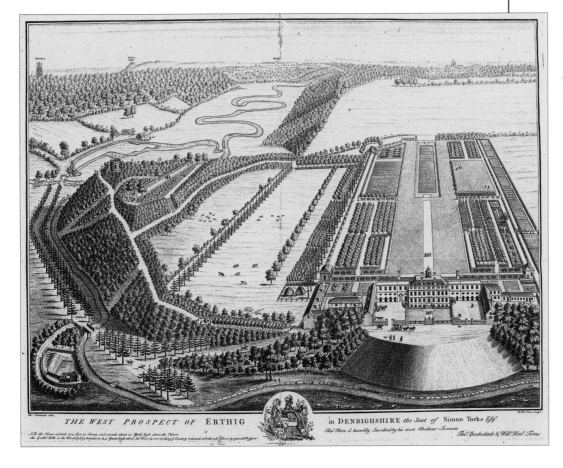

140. William Henry Toms
after Thomas Badeslade,
*The North East Prospect
of Chirk Castle*, 1735,
Engraving, 602 × 815

141. William Henry Toms
after Thomas Badeslade,
The West Prospect of Erthig,
c.1740, Engraving,
400 × 550

142. Samuel and Nathaniel Buck,
The South East View of Carmarthen,
1748, Engraving, 315 × 820

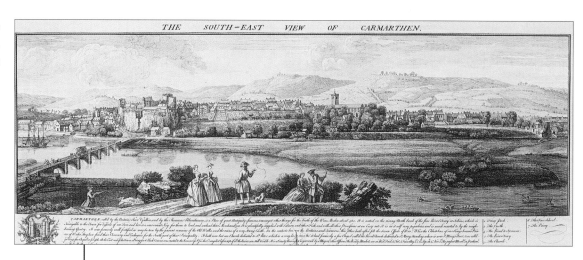

142. Samuel and Nathaniel Buck,
The South East View of Carmarthen,
1748, Engraving, 315 × 820

[14] The Erddig engraving is undated but was made to the same format as the Hawarden picture of 1740. Curiously, the plates were retained at Chirk, suggesting the unusual possibility that the engravings, as well as the drawings, were done on site. However, it must be more likely that Robert Myddelton retrieved them from the engraver's workshop in London. Myddelton seems to have known Toms, since the castle accountant recorded his purchase from the engraver of 'portraits of Painters & Artists' in 1739 for 15s. Myddelton, *Chirk Castle Accounts (Continued)*, p. 502.

[15] The engravings may have been based on drawings made on the earlier tours, and do not necessarily indicate a second visit to Wales.

[16] There are several references to painters and engravers of the name of J. or John Lewis in the period 1736 to c.1775. Whether or not the landscape engraver is to be identified with John Lewis, painter of the Derwydd portraits, above, p. 67, is unclear. The 1736 engravings have been dated by a reference to them in Bangor, Henblas A MS 11, quoted by B. Dew Roberts (ed.), *Mr. Bulkeley and the Pirate: A Welsh Diarist of the Eighteenth Century* (London, 1936), p. 92. Lewis was paid 1½ guineas by his subscribers in advance for their prints. I am grateful to David Sturdy for this reference. Sturdy is of the opinion that Lewis is more likely to have been a gentleman amateur than a professional artisan. In addition to those mentioned in text, his subjects included Denbigh, Bangor, St Asaph, Ruthin and Harlech.

by the same artists of nearby Hawarden and Erddig.[14] All the engravings contained vignettes of everyday life like those which characterized the Llannerch landscapes painted over seventy years earlier. They must have seemed very old-fashioned by this time since engravings of country seats made by Samuel and Nathaniel Buck had set a quite different stylistic trend when they began to appear in the early 1730s. The Buck brothers toured throughout Wales and England in the summer months, making drawings and collecting subscriptions, mainly from the owners of the buildings they depicted, and in the winter producing copper engravings. Architectural features were faithfully transferred from drawings to engravings, but movable details, such as people and boats, were often redrawn or added for effect. The brothers published views of Monmouthshire seats in 1732, grouped with views in Gloucestershire and Wiltshire. Between 1740 and 1742 they published three sets of exclusively Welsh views, taken in both the north and south of the country, and in 1748 townscapes of Cardiff, Swansea, Carmarthen and Wrexham.[15] In these panoramas, the difference in approach from that of Badeslade and the earlier bird's-eye-view painters was emphasized by the addition of foreground figures of well-heeled gentlemen and ladies at leisure, drawn by J. B. C. Chatelain and H. F. B. Gravelot with considerably more sophistication than the Bucks had achieved in their earlier series.

The Bucks' example was quickly followed by other engravers, notably one J. Lewis. Nothing is known of Lewis's personal life, other than that in 1736 he was based in Shrewsbury, but his name and his series of twelve engravings 'of the most Beautiful Prospects in North Wales' suggest that he had Welsh connections. The fact that the Bucks did not repeat his subjects in their 1748 series may indicate their awareness of his work. Lewis's panoramic views of towns, villages and castles were more open than those of his famous contemporaries, and he succeeded in attracting the patronage of Sir Watkin Williams Wynn of Wynnstay, William Myddelton, MP for Denbigh, and Robert Davies of Llannerch.[16]

143. Samuel and Nathaniel Buck,
The South East View of Laugharne Castle,
c.1740, Engraving, 195 × 340

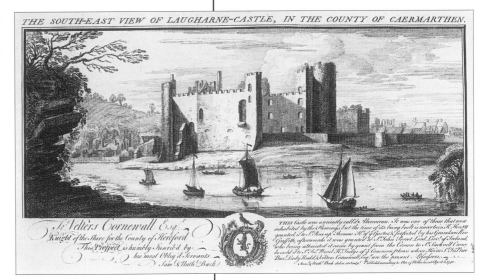

THE SOUTH-EAST VIEW OF LAUGHARNE-CASTLE, IN THE COUNTY OF CAERMARTHEN.

The engravings by the Bucks and by Lewis were characteristic of that documentary spirit which complemented the modernism of the Restoration period and which resulted not only in visual images but also in literary descriptions such as Daniel Defoe's *A Tour thro' the Whole Island of Great Britain*, published in 1725. However, they also demonstrated that the antiquarian interests of the Tudor and Stuart gentry and intellectuals, expressed in the fascination with heraldry and the courtly life of the medieval period, were evolving into something more complex. This evolving perception of the past was expressed in the engravings of the first half of the eighteenth century in two ways. Firstly, the Bucks' series depicted not only thriving towns and the homes of the gentry but also many ruined abbeys and castles. Although writing in retrospect and at a time when the fashion for such antiquities had swept all before it, there is no reason to doubt that the emotions described by the Bucks in their introduction to the 1774 edition of their collected works were not truly felt as they sat before their subjects forty years earlier:

144. Samuel and Nathaniel Buck,
Laugharne Castle, c.1740,
Ink and wash, 150 × 355

> Upon the whole, there is something in ancient Ruins that fills the mind with contemplative melancholy; for, while they convince us of the truth of that important expression, 'All Flesh is Grass, and the Glory thereof as the Flower of the Grass', they point out to us a striking proof of the vanity of those who think their works will last for ever.[17]

[17] Samuel and Nathaniel Buck, *Buck's Antiquities* (London, 1774), p. viii.

145. Francis Place,
The West side of
Flint Castle, 1699,
Watercolour,
93 × 173

146. J. Lewis,
View of Dyserth, c.1736,
Engraving, 391 × 786

This melancholy was, perhaps, an inevitable reaction to the assertive modernism of the Restoration period, and it made its appearance well before the end of the seventeenth century. As we have seen, Danckerts had drawn Caerphilly Castle in the 1670s, and not long afterwards, in 1678, an English antiquarian and amateur artist, Francis Place, toured south Wales. Place returned to visit the north of the country in 1699, drawing Flint Castle, among other subjects, but his work was not engraved and it can have had little contemporary influence. The importance of the Buck engravings lay in their extensive dissemination of images which enabled patrons to indulge in fashionable melancholy, without having to visit ruins in distant parts.

The second aspect of evolving attitudes to the past, perceptible even in the generally urbane work of the Buck brothers, concerned the landscape settings of the ruins they engraved, which were sometimes extensively depicted, even at the expense of a closer viewpoint which might have revealed architectural detail more clearly. This developing interest in the landscape itself was manifested in the work of J. Lewis. In his view of Diserth the castle was a very distant object and the scattered buildings of the foreground were subsumed by the extensive rural scene. The artist drew himself in a foreground vignette, in the company of friends, admiring the grand prospect. Furthermore, in Lewis's engraving *Pistill Rhaiadr*, not only human habitation but also the agricultural landscape were abandoned altogether in favour of a depiction of the natural world in its primitive state. Such ancient landscapes, unaffected by humanizing influence, had for long been regarded as barbarous and disagreeable by those who determined artistic taste. Demonstrating that opinions were beginning to change as early as 1709, the Earl of Shaftesbury remarked:

> I shall no longer resist the Passion growing in me for Things of a *natural* kind; where neither *Art*, nor the *Conceit* or *Caprice* of Man has spoil'd their *genuine Order*, by breaking in upon that *primitive State*. Even the rude Rocks, the mossy *Caverns*, the irregular unwrought Grotto's and broken Falls of Waters, with all the horrid Graces of the *Wilderness* itself, as representing NATURE more, will be the more engaging, and appear with a Magnificence beyond the formal Mockery of Princely Gardens.[18]

The Earl of Shaftesbury was at the forefront of avant-garde thinking and the planned garden and rational landscape, so well used by the Llannerch master to suggest security and order after the chaos of the civil wars, was not, as yet, *passé*.

[18] Anthony Ashley Cooper, 3rd Earl of Shaftesbury, 'The Moralists, a Philosophical Rhapsody' in idem, *Characteristicks of Men, Manners, Opinions, Times* (3 vols., 5th ed., London, 1732), II, pp. 393–4, quoted in John Dixon Hunt and Peter Willis (eds.), *The Genius of the Place: The English Landscape Garden 1620–1820* (London, 1975), p. 124.

[19] Daniel Defoe, *A Tour thro' the Whole Island of Great Britain* (London, 1725), p. 81.

[20] Donald F. Bond (ed.), *The Spectator* (5 vols., Oxford, 1965), III, letters 411–21, esp. no. 414, which is also quoted in Hunt and Willis (eds.), *The Genius of the Place*, pp. 141–3.

[21] A. C. Fraser (ed.), *The Works of George Berkeley, D.D.* (4 vols., Oxford, 1871), I, p. 302.

[22] Malcolm Andrews, *The Search for the Picturesque* (Aldershot, 1989), p. 45.

147. J. Lewis,
*Pistill Rhaiadr, c.*1736,
Etching, 618 × 307

PISTILL RHAIADR a surprizing Cataract in Denbighshire, the Parish wherein it takes its Name from the Cascade. Rhaiadr signifying a Spout in the British. To the Hon.ble W.m W.ms WYNN., Esq.r

The fall is 72 Yards from the Mountain whence it comes to the lower Foot, about ye middle is a large Bason thro which ye Water has made in may ysself an Arch which Country People pass over, this Plate is Humbly Dedicated by J. Lewis.

It would take many years for the Earl's different perception of natural order, a reaction against the man-centred and controlled world of the Classical Renaissance, to become dominant. His ideas contrasted strikingly with those expressed by his contemporary, Daniel Defoe, when travelling in Wales. Defoe used the same vocabulary of horror, but his evaluation of the emotions it induced was profoundly different. The Black Mountain was:

> all a Ridge of horrid Rocks and Precipices between, over which, if we had not had trusty Guides, we should never have found our Way; and indeed, we began to repent our Curiosity, as not having met with any thing worth the trouble; and a Country looking so full of horror, that we thought to have given over the Enterprise, and have left *Wales* out of our Circuit: But after a Day and a Night conversing thus with Rocks and Mountains, our Guide brought us down into a most agreeable *Vale*, opening to the *South*, and a pleasant River running through it, call'd the Taaffe.[19]

Nevertheless, an underlying change of perception was under way. In 1712 Joseph Addison had talked of it in terms of 'The Pleasures of the Imagination'[20] and a year later, more famously, Bishop George Berkeley described the sensation induced by the experience of the barbaric landscape as 'pleasing horror'.[21] These perceptions would ultimately be formulated into a coherent aesthetic theory by Edmund Burke in his *Philosophical Enquiry into the Origin of Our Ideas of the Sublime and Beautiful*, published in 1757.

As Malcolm Andrews has pointed out in his analysis of the origins of the Picturesque movement, '"Agreeable horror" and "pleasing melancholy" are nourished by images of decay, by monstrous, broken and irregular forms, in both natural scenery and the works of man.'[22] The ruin of Dolwyddelan Castle, drawn by the Bucks in 1742, was therefore an exact emotional complement to the primitive landscape surrounding it. Wales offered more abundantly than England both antiquities to induce melancholy and

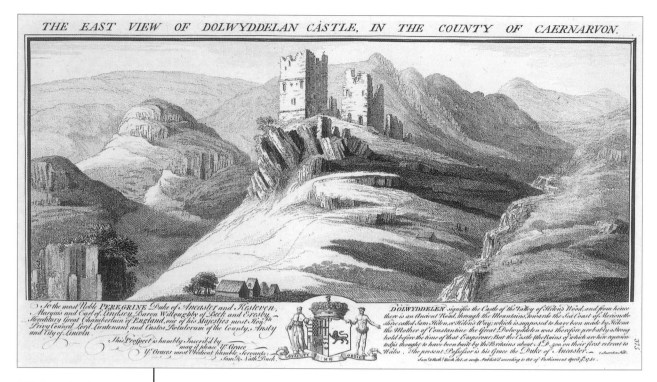

THE EAST VIEW OF DOLWYDDELAN CASTLE, IN THE COUNTY OF CAERNARVON.

148. Samuel and
Nathaniel Buck,
*The East View of
Dolwyddelan Castle*,
1742, Engraving,
193 × 375

unsullied nature to inspire awe, the two closely associated emotions which arose in response to a sense of the weakness of man and the power of God. This was an extension of taste, and the pastorale did not become unfashionable. Indeed, the dialogue between proponents of the calm rural landscape, ordered by man, and those who delighted in the primitive power of raw nature, the handiwork of God, would be a persistent theme in aesthetics.

Wales became famous as a stage on which this dialogue was enacted, a performance complicated by the peculiar entanglement, dating from the Tudor period, of English and Welsh history. In the second half of the eighteenth century, the consequence was an unprecedented interest among English intellectuals in Wales, a trend which has been better documented than any other art historical phenomenon related to the country. This is the so-called 'Discovery of Wales', an expression which identifies itself as being of English origin. Welsh intellectuals did not need to discover their own land since they were already fully aware of its significance as their national home. However, the ancient image of themselves, to which they clung with remarkable tenacity, as heirs to a united Britain with its centre in London, encouraged them to feed with enthusiasm the new interest in Wales manifested by their neighbours. Indeed, many of them lived or spent their time in London, and so they observed their homeland from an outsider's viewpoint, though always underpinned by an insider's emotions and deeper cultural understandings. Their perceptions expanded to include the idea of their land as being also a landscape, but the underlying concepts of the Welsh remained distinct from those of their English contemporaries.

chapter

four

ANCIENT

BRITAIN

149. John Dyer,
Caerfilly Castle, 1733,
Pen, ink and wash,
263 × 466

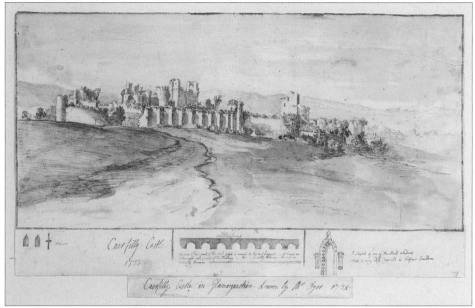

150. John Dyer,
Landscape, possibly the
Vale of Neath, c.1724, Oil, 740 × 615

[1] William Wordsworth, 'To the Poet, John Dyer' in idem, *Poems, Volume I*, ed. John O. Hayden (Harmondsworth, 1977), p. 736. Some passages from Dyer's notebooks have been preserved in J. P. Hylton Dyer Longstaffe, 'John Dyer as a Painter', *Montgomeryshire Collections*, XI (1878), 396–402.

Although he did so primarily through his poetry, the painter John Dyer exercised considerable influence on the changing perception of landscape in Britain in the first half of the eighteenth century. His most famous work, 'Grongar Hill', described the area in which he had spent his childhood in Carmarthenshire. The language was designed to stimulate Addison's 'pleasures of the imagination' – the emotions aroused by the contemplation of historical sites – but also the appreciation of the forms, colours and organization of the landscape itself, as if it were a picture. Furthermore, Dyer's work helped to establish the link between the Welsh landscape in particular and the new aesthetic. In 1724 and 1725 he was in Italy, where he rewrote 'Grongar Hill' in the form in which it was published in 1726, but it seems likely that he had travelled widely in Wales before his Grand Tour. He certainly did so soon afterwards. The loss of his notebooks at some time in the middle of the nineteenth century has left a large gap in our knowledge of the early evolution of the new aesthetic in Wales and a failure fully to acknowledge Dyer's contribution. Wordsworth remarked of him:

> Though hasty Fame hath many a chaplet culled
> For worthless brows, while in the pensive shade
> Of cold neglect she leaves thy head ungraced …[1]

It appears that only one Welsh landscape drawing and two oil-painted landscapes have survived. One of these probably depicts the Vale of Neath, an area which would be much visited later in the century by travellers in search of picturesque landscapes, though Dyer's visit there may have been associated with a journey to view the gardens created by Humphrey Mackworth at the Gnoll near Neath.

151. John Dyer,
*Sarcophagus, Italy, c.*1724–5,
Pen and ink, 205 × 260

151. John Dyer,
*Sarcophagus, Italy, c.*1724–5,
Pen and ink, 205 × 260

It is possible that the other surviving picture, a more Italianate composition, reflects that particular site in its inclusion of a Classical pavilion, since Mackworth's garden is believed to have included such features by this time.[2] Surviving extracts from Dyer's lost notebooks recorded visits to sites spread over a wide area of Wales, including a 'cascade a little above New Radnor', Chirk Castle, Trevernon 'by the sea side', Pembroke Castle and Devil's Bridge. In 1728 he had 'a surprising escape on horseback, on a very narrow wooden bridge in North Wales, about fifty feet above rocks and a great torrent of water, which frightened the horse, who could not turn for the narrowness of the bridge, and entangled his feet in the side rails'.[3]

These were pioneering journeys made for the purpose of writing about and drawing the landscape of his own country. Since they were as yet unpublished, it seems unlikely that Dyer was familiar with Place's accounts of earlier visits. In Rome, his Romantic sense of the beauty of decay was also developed well before it became commonplace among intellectuals in the second half of the eighteenth century:

> There is a certain charm that follows the sweep of time, and I cannot help
> thinking the triumphal arches more beautiful now than ever they were. There
> is a certain greenness, with many other colours, and a certain disjointedness
> and moulder among the stones, something so pleasing in their weeds and tufts
> of myrtle, and something in the altogether so greatly wild, that, mingling with
> art, and blotting out the traces of disagreeable squares and angles, adds certain
> beauties that could not be before imagined, which is the cause of surprise that
> no modern building can give.[4]

[2] For Mackworth, see Lord, *The Visual Culture of Wales: Industrial Society*, p. 52.

[3] Quoted in Longstaffe, 'John Dyer as a Painter', 401. Thomas Lloyd has suggested that Trevernon may be Briton Ferry, the location of Vernon House, which was subsequently demolished.

[4] Ibid., 397–8.

152. A.M, *The Chief Druid*,
from Henry Rowlands,
Mona Antiqua Restaurata,
1723, Engraving,
192 × 150

153. Anon.,
Frontispiece to John Dyer,
The Ruins of Rome, 1740,
Engraving, 65 × 145

Dyer's training with Jonathan Richardson had placed him among the avant-garde in London, where he frequented Serle's coffee shop in Carey Street, a favourite haunt of young poets and painters such as Thomas Hudson. There he could sense the English mood and comprehend it in Welsh terms. That mood was one of assertiveness, in which artists reflected the growing political and economic power of England. Richardson established one of the first academies in the country as a part of his wider endeavour to demonstrate that English painters could compete with those from continental Europe.[5] Undoubtedly, the most significant aspect of English national assertiveness for Wales was the renewed vigour of the concept of a united Britain, following the union with Scotland in 1707. The prestige of the Tudor dynasty as the agent for the re-establishment of the imagined union of Ancient Britain had by now acquired the gloss of 'the good old days', and Spenser's *Faerie Queene* remained among the most popular of texts. The sense of English hegemony inside a united Britain was strongly reinforced by the contributions of Welsh and Scottish intellectuals making their way in London. In the literary world, Dyer's 'Grongar Hill' was superseded as the most influential poem of the new aesthetic of nature by the Scot James Thomson's *The Seasons*, completed in 1730. Its political sub-text of a united Britain was apparent even when Thomson described lambs playing on a hillside:

> They start away, and sweep the massy Mound
> That runs around the Hill; the Rampart once
> Of iron War, in ancient barbarous Times,
> When disunited BRITAIN ever bled,
> Lost in eternal Broil; ere yet she grew
> To this deep-laid indissoluble State,
> Where *Wealth* and *Commerce* lift the golden Head;
> And, o'er our Labours, *Liberty* and *Law*,
> Impartial, watch, the Wonder of a World![6]

[5] Despite the advancement of England in other fields, changing the visual arts remained a difficult task.

[6] James Thomson, 'Spring' in idem, *The Seasons*, ed. James Sambrook (Oxford, 1981), 'Spring', p. 42, lines 840–8.

Thomson was not entirely subsumed by the mood of the period; he retained sufficient distance from emerging English nationalism to remark of a section of 'Summer' from *The Seasons* that the British sentiments expressed there 'may perhaps contribute to make my poem popular. The English people are not a little vain of themselves and their country'.[7]

In 1723, the year before Dyer left for Italy, Henry Rowlands published an account of the antiquities and history of Anglesey, *Mona Antiqua Restaurata*, which asserted the centrality of his island in the druidical tradition of Ancient Britain. The book was notable for its inclusion of an engraving of a druid, and since it was widely read by the intellectual community it stimulated further the interest of the English in Wales.[8] Whether or not Dyer had read the book before he left for Rome in the following year, he was certainly inspired there to imagine parallels between ancient Classical civilization and Ancient Britain. In his poem 'The Ruins of Rome' he insinuated the idea of Wales as an indigenous substitute for Rome, both providing historical legitimacy for the imperial ambitions of the English and affirming the quality of their contemporary culture. Surveying pines growing among the ruins of the baths of Caracalla, Dyer imagined 'Britannia's oaks / On Merlin's mount, or Snowden's rugged sides'. 'Merlin's mount' was a reference to Dinefwr, emphasizing the continuing importance of Spenser as a source.[9]

Since 'The Ruins of Rome' was not published until 1740, it was James Thomson's British sub-texts which set the tone, not only through specific references but also in a more subtle way through his topographical reunification of the island as a single landscape. This perception would be of immense importance in the succeeding two hundred and fifty years, and – notwithstanding the role of poetry – landscape painting was its main vehicle of transmission. For the English observer, the very structure of the land of Britain operated as a historical and a political metaphor, echoing the rules of the well-constructed painting. The orderly and peaceful foreground of rural England was set against the mountain background of Wales, with its associations of ancient druidical history and human transience in the form of standing stones and ruined medieval castles. When Thomson described Worcestershire he did not do so from within that county, and certainly not from Wales, but rather from the seat of Anglocentric perceptions in the south-east, looking:

> To Where the broken Landskip, by Degrees,
> Ascending, roughens into rigid Hills;
> O'er which the *Cambrian* Mountains, like far Clouds
> That skirt the blue Horizon, dusky, rise.[10]

[7] Letter to David Mallet, published in *Miscellanies of the Philobiblion Society*, IV (1857–8), 20.

[8] Henry Rowlands, *Mona Antiqua Restaurata* (Dublin, 1723), p. 65. The drawing was signed 'A.M', probably either Andrew Miller or A. Malone, whose source was the engraving published in Aylett Sammes, *Britannia Antiqua Illustrata* (London, 1676). For the origins of the image, see Peter Lord, *Gwenllian: Essays on Visual Culture* (Llandysul, 1994), pp. 106–7.

[9] John Dyer, 'The Ruins of Rome' in idem, *Poems* (London, 1761), p. 34. Dyer was deeply familiar with the mythology of his own country. For instance, he referred to Macsen Wledig: 'Nor yet the car of that fam'd British chief, / Which seven brave years beneath the doubtless wing / Of vict'ry, dreadful roll'd its griding wheels / Over the bloody war', ibid., p. 41. Dyer copied passages from Spenser in his notebooks, and his use of eccentric vocabulary, such as the word 'griding', also originates in the same source. Milton – Dyer's other favoured source – also used this unusual word. Dyer sought to link more nearly contemporary Welsh figures with illustrious forebears. He elevated Inigo Jones, generally accepted in the period as being of Welsh blood, to the company of the great Renaissance masters: 'here, curious architect, / If thou assay'st, ambitious, to surpass / Palladius, Angelus, or British Jones', ibid., p. 28. Dyer was not the first to commit his feelings about Welsh landscape to paper from exile in Italy. In the sixteenth century Gruffydd Robert had imagined himself in his Arcadian homeland, sitting 'by running waters in a dingle of young sap laden trees ...' For sixteenth- and early seventeenth-century Welsh perceptions of landscape in the English language, see W. J. Hughes, *Wales and the Welsh in English Literature from Shakespeare to Scott* (Wrexham, 1924).

[10] Thomson, *The Seasons*, p. 47, lines 959–62. Later poets, such as William Sotheby, described this wall sheltering the garden of England even more fully, with the point of their descriptive compass set firmly in London: 'What lovelier views than Albion's scenes display, / ... Whether he gaze from Snowdon's summit hoar, / Or scale the rugged heights of bold Lodore, / ... Or hermit visions feed on Lomond's lake.' William Sotheby, *A Poetical Epistle to Sir George Beaumont, Bart., on the Encouragement of the British School of Painting* (London, 1801), p. 15.

11 Giraldus Cambrensis, *The Journey through Wales and The Description of Wales*, translated by Lewis Thorpe (Harmondsworth, 1978), p. 194.

Early Welsh perceptions of the landscape had been profoundly different, since they had been centred in Wales and therefore looked in the other direction. As a result, mountains had a quite different meaning. In the eleventh century Ieuan ap Sulien described the land of Ceredig from the inside, noting that 'a lofty mountain rises at the source of the sun', while in the late twelfth century Gerald of Wales recorded the insider's perception of the mountains of Snowdonia, viewed from Anglesey, which 'seem to rear their lofty summits right up to the clouds'[11] and which afforded both pasture for the herds and protection from England – a remote and different place. Like Thomson, Dyer must surely have been aware of the Anglocentric nature of the emerging perception of the Welsh landscape but, swimming with the tide of English assertiveness, he contented himself with infiltrating Welsh material into his poetry, especially in the context of Ancient Britain.

154. John Boydell, *The North-east View of Wrexham Church in the County of Denbigh*, 1748, Engraving, 395 × 520

The publication of Dyer's 'The Ruins of Rome' came at the beginning of a decade in which the availability and range of art images in printed form – including images of Wales – began to expand, thereby reinforcing the perceptions of the poets. Among the most influential agents of this expansion was John Boydell, who was born in Shropshire in 1719 but who moved with his family to Hawarden in 1731. Boydell began to copy book illustrations as a child and an anecdote, current in his lifetime, linked his subsequent career as a publisher of engravings in particular to Badeslade's image of Hawarden Castle:

Soon after it was published and came down into the Country it was seen by Boydel, then a poor and ignorant lad in the obscure village of Hawarden; and this being an object familiar to him from his earliest days, had such an effect on him, that he could not rest till he had walked up to London, and bound himself apprentice to the Engraver of the Print (Toms) whom He looked upon as the greatest Man in the World.[12]

[12] Recorded in an eighteenth-century hand on the back of a copy of the Toms engraving of Hawarden Castle in a private collection. The story is denied in Boydell's entry in *DNB* but is confirmed by Shearer West in *The Dictionary of Art* (34 vols., London, 1996), IV, p. 607. See also S. Bruntjen, *John Boydell 1719–1804: A Study of Art Patronage and Publishing in Georgian London* (New York, 1985).

Rhaidder Fawr, A great Cataract, three Miles from Penmaen Mawr.

155. John Boydell, *Rhaidder Fawr, A Great Cataract three miles from Penmaen-mawr,* 1750, Engraving, 315 × 468

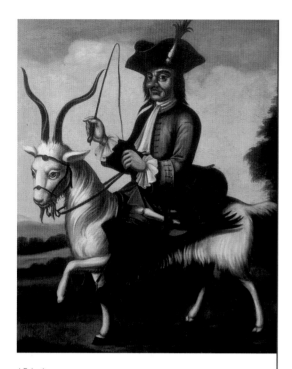

156. Anon.,
Poor Taff, c.1770,
Oil, 762 × 635

In 1746 Boydell established himself independently, initially engraving his own works but soon turning to publish the work of more sophisticated engravers. There were many Welsh subjects among his early publications, notably Wrexham church in 1748, followed in 1749 and 1750 by views of other parts of Denbighshire, Flintshire and Caernarfonshire. These repeated the canon of architectural subjects portrayed earlier by the Bucks, but they also included several works illustrating wonders of the natural world, such as the dramatic *Rhaidder Fawr*, *Caunant Mawr*, and a *View of Snowden*, which signified the evolution of taste towards pure landscape. These prints were significantly cheaper than the productions of his predecessors and pioneered the extension of the market for such images into the professional and mercantile classes. Nevertheless, it should be noted that in the truly popular London prints of the period the old stereotype of the Welsh nation, embodied in the poverty-stricken *Poor Taff*, riding to London through a barren wilderness on the back of a goat, retained its popularity, and was copied in painted form on several occasions.[13] The emerging image interested those with a taste for new fashions, but it did not supersede the old. The ability of the English mind simultaneously to treat Welsh landscape with great seriousness and Welsh people with contempt would prove a persistent characteristic.[14]

It was also in the 1740s that Richard Wilson, while continuing to depend on his moderately successful practice as a portrait painter in Covent Garden, began to paint landscapes. His pictures were closer in spirit to the later products of the Bucks than to the cheaper prints of Boydell, especially in their foreground images of the well-to-do at leisure. Indeed, Gravelot, one of the artists who provided such images for the adornment of the Bucks' topography, was a leading teacher at St Martin's Lane Academy, which was frequented by Wilson. As we have seen, Wilson's London practice was supplemented by Welsh patronage which from time to time brought him back to his own country. In 1738, for instance, he drew the portrait of John Myddelton at Chirk, and there is every reason to suppose that while in attendance at the castle he inspected Tillemans' Welsh landscapes. He may well have been beginning to consider the potential of Wales as a focus for his own work by this time. Among the earliest of Wilson's landscapes is a view of Caernarvon Castle, probably painted in 1744 or 1745, in which he revealed the extent to which his ideas were in tune with those of the avant-garde.[15] Boydell's *A North West View of Caernarvon Castle*, published in 1749, revealed the building in pristine condition, surrounded by the mercantile activity of the port. But Wilson presented the same castle as a broken ruin, admired by the artist and a gentleman in a foreground vignette no doubt both for the pictorial and moral implications of its decay. Their viewpoint obscured the busy town, making the castle appear as if floating on the edge of a lagoon in a rural arcadia.

[13] The finest printed examples of the image, *Shon-ap-Morgan, Shentleman of Wales*, and *Unnafred Shones, Wife to Shon-ap-Morgan*, were published c.1747 by William Dicey. See Lord, *Words with Pictures*, pp. 47–9. A number of seventeenth-century painted versions are known, including one whose provenance is linked to the London Cymmrodorion and their Welsh school.

[14] Boydell included many of these engravings in *A Collection of One Hundred and Two Views, etc., in England and Wales* (London, 1755).

[15] The *Extensive Landscape with Lake and Cottages*, painted at about the same time, also seems likely to represent a Welsh subject.

157. Richard Wilson,
Caernarvon Castle,
1744–5, Oil,
800 × 1118

158. John Boydell,
*A North West View of
Caernarvon Castle*, 1749,
Engraving, 280 × 440

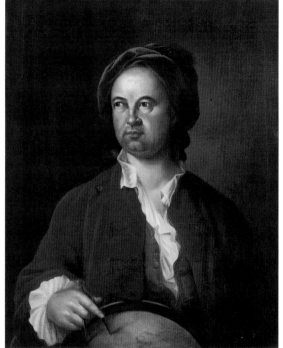

above:

159. Anton Raphael Mengs,
Richard Wilson, 1752–6,
Oil, 850 × 749

right:

160. Anon.,
Lewis Morris, c. 1740–50,
Oil, 981 × 825

[16] Vaughan was known to Lewis Morris as early as 1738. His post was distinct from that of President, which was filled by Richard Morris. To some extent the Cymmrodorion inherited the work of the Honourable and Loyal Society of Antient Britons, founded in 1715, although the older society continued to function, at least in name. Both societies had charitable as well as intellectual and social aims, the most notable expression of which was the 'Welch School', founded in 1718. For the societies, see R. T. Jenkins and Helen M. Ramage, *A History of the Honourable Society of Cymmrodorion and of the Gwyneddigion and Cymreigyddion Societies (1751–1951)* (London, 1951).

Richard Wilson went to Italy in 1750, where he abandoned portraiture in favour of landscape, drawing from nature and painting limpid Italian scenes in the studio. When he returned, in 1756 or 1757 (the year of the death of John Dyer), he took up Welsh imagery from the point at which he had left it with *Caernarvon Castle*. Indeed, he repeated the subject on several occasions. However, by this time Welsh intellectual life had entered a significant new stage. In 1751 the Cymmrodorion Society had been established in London with the intention of providing a focus for those with literary and antiquarian interests in their native country. The Society was the creation of the Morris brothers of Anglesey, and in particular Lewis Morris, who provided the concept, and his younger brother Richard, who lived in London and took the practical steps. The foundation of the Society reflected the interest in Welsh antiquities, language and literature of a widening circle of intellectuals. Furthermore, the confidence of this Welsh circle was enhanced by the willingness of English intellectuals to make the link between the contemporary land and people of Wales, and Ancient Britain. The word 'Cymmrodorion' was a composite, devised by Lewis Morris, meaning 'original inhabitants'. The society included not only the literati but also landowners, patrons and prominent political figures, most of whom were dormant members but who counted among their number a few individuals of energy and vision, such as William Vaughan of Corsygedol. Vaughan, who was a Welsh speaker and a poet in his own right, became the first 'Chief President' of the Society.[16] Lewis Morris conceived of the Cymmrodorion as a Welsh equivalent of the Royal Society, led by the great minds of the time, debating learned papers and publishing important texts, both ancient and contemporary. However, many Welsh people of the mercantile class, few of whom had intellectual pretensions, became members

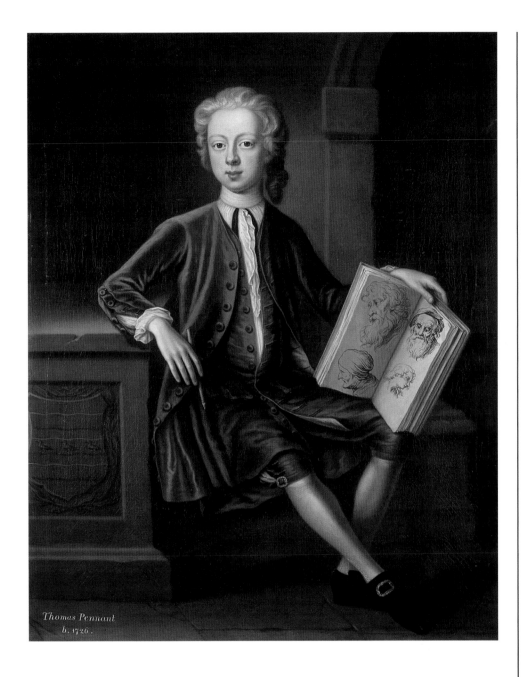

162. Thomas Pennant,
A Mountain Pass,
probably in Switzerland,
c.1750, Ink and wash,
174 × 124

161. Probably Joseph Highmore,
Thomas Pennant, c.1740,
Oil, 1260 × 1000

and it was as a social club that the Cymmrodorion functioned with most vigour. In terms of the development of Welsh life by publications or direct acts of patronage it achieved very little, though it did provide a point of contact between Welsh intellectuals in London and 'corresponding members' in Wales and other parts of England such as Thomas Pennant and Evan Evans (Ieuan Fardd). This network was of great importance both internally and in developing links with leading English thinkers and poets. In visual culture the Society attempted little and the voluminous letters of the Morris brothers are remarkable for the paucity of their references to artists. Nevertheless, several members and officials proved, as individuals, important patrons of the visual arts. The only project tenuously associated with the Society which provided significant patronage in that field was the publication of the first part of Thomas Pennant's *British Zoology* in 1766.

163. Richard Wilson,
Pembroke Town and Castle,
c.1765–6, Oil, 1027 × 1282

below: 164. Peter Mazell
after George Edwards, *The Ptarmigan* from
Thomas Pennant's *British Zoology*, 1766,
Engraving and watercolour, 320 × 320

bottom: 165. Peter Mazell after Peter Paillou,
*The Goldfish, the Chaffinch, the Brambling, the
Siskin and the Linnet*, from Thomas Pennant's
British Zoology, 1766, Engraving
and watercolour, 450 × 350

Thomas Pennant, squire of Downing in Flintshire, was born in 1726. He claimed that his interests in the natural world and in its visual representation had been stimulated at the age of twelve by the loan of a book from John Salusbury of Bachegraig. That early awakening was celebrated in the portrait taken of him as a child, probably by Joseph Highmore, in which he is depicted holding a substantial volume of drawings. Pennant travelled widely in Britain from his early twenties and in 1755 began a friendship with the great Swedish botanist Linnaeus. Ten years later he visited the Continent, where he met Voltaire, among other distinguished intellectuals. This association, together with his extensive correspondence with English intellectuals such as Horace Walpole and Gilbert White, provides an example of the high status of some members of the Cymmrodorion Society. Pennant was certainly the most visually orientated of them all, occasionally recording his observations by his own drawings, but generally preferring to employ artists as visual amanuenses. Thus the splendid engravings by Peter Mazell which illustrated the *British Zoology* were drawn for Pennant mainly by Peter Paillou, 'an excellent artist, but too fond of giving gaudy colours to his subjects',[17] though he also commissioned some more obscure Welsh painters, including one Watkin Williams from Tegeingl, known to William Morris as 'a painter by trade ... employed by Mr. Pennant now for a long time past and to come to draw prospects, virtu, etc., for him (and me too now and then)'.[18] The *British Zoology* was a remarkable example of art patronage, but it must be said that its appearance under the imprint of the Cymmrodorion was largely a matter of convenience, since the project, both intellectually and financially, was Pennant's own.[19]

166. Richard Wilson,
Kilgaran Castle, c.1765–6,
Oil, 504 × 737

[17] Thomas Pennant, *The Literary Life of the late Thomas Pennant* (London, 1793), p. 3.

[18] John H. Davies (ed.), *The Letters of Lewis, Richard, William and John Morris of Anglesey (Morrisiaid Môn) 1728–1765* (2 vols., Aberystwyth, 1907–9), II, p. 94. In 1758 William Morris refers to a number of drawings of antiquities, including the effigy of Pabo and Maen Chwyfan, made by Williams. Among the few other painters mentioned in the correspondence of the brothers was one Bowen, described by Lewis in 1761 as 'downright antiquity mad'. Ibid., II, p. 332. Pennant also employed George Edwards (1694–1773), author of *History of Birds* (1743–64) and other volumes of natural history. Edwards was an Englishman of Welsh descent.

[19] Richard Morris owed him £63 at his death, which Pennant 'forgave to his widow', according to the *Catalogue of my Works* (Darlington, 1786), no pagination. When the volumes were reprinted in octavo in 1768, Pennant gave the £100 paid to him by the publisher to the Welsh school.

[20] The pictures were in the family collection in 1800. See David H. Solkin, *Richard Wilson* (London, 1982), p. 139.

That Richard Wilson did not join the Cymmrodorion on his return from Italy is surprising, given the admiration he shared with the Morris brothers for the Classical tradition. It would be reasonable to suppose that he was invited, given his rising status in the London art world and the substantial patronage afforded him by William Vaughan, the President, to whom he was distantly related. Vaughan seems to have bought *Snowdon from Llyn Nantlle*, *Pembroke Castle* and *Kilgaran Castle*, all painted in the mid-1760s.[20] These Welsh works followed the establishment of Wilson's reputation by the phenomenal success of *The Destruction of the Children of Niobe*, exhibited at the first annual exhibition of the Society of Artists in London. The picture was perceived as challenging the notion that native painters could not equal the works of the continental masters of the Grand Manner, among whom Claude was regarded as the greatest, although Wilson's style suggests that he may have had a particularly high regard for Gaspard Dughet. Wilson's picture was an intellectual *tour de force* of complex references which appealed to an intellectual élite, but it is clear from the large sales of the engraving by William Woollett, commissioned by Boydell, that interest was not confined to the *cognoscenti*. Boydell was believed to have made a profit of some £2,000 from it – a sum far exceeding that made on any other work by a British painter. Six of the substantial group of Welsh

167. William Woollett
after Richard Wilson,
The Destruction of the Children of Niobe,
1761, Engraving, 435 × 580

168. Richard Wilson,
Llyn Peris and Dolbadarn Castle,
1762–4, Oil, 960 × 1310

169. Richard Wilson,
*The Lake of Nemi or Speculum Dianae with
Dolbadarn Castle*, c.1764–5, Oil, 2292 × 1834

pictures which Wilson painted in the years following *The Destruction of the
Children of Niobe* – the three bought by Vaughan and *The Great Bridge over the
Taaffe*, *Caernarvon Castle* and *Cader Idris, Llyn-y-Cau* – had also been issued as
engravings by 1768, though whether or not Boydell was involved is unclear since
his imprint appears only on the set issued in 1775.[21]

This group of Welsh pictures painted in the early 1760s by Wilson both reflected
the level of interest in the country among leaders of taste and gave considerable
impetus to its development, since the painter's reputation was, by this time,
second to none in the field. He took both apprentices and students, among
whom was Thomas Jones, second son of the squire of Pencerrig near Builth
Wells, who joined Wilson in 1763 at the age of twenty, and who later described
his teacher's circumstances:

Wilson being an unmarried man, kept no house – but had commodious Appartments in the Piazza Covent Garden, which consisted of a *Study*, or painting room for himself – A large Exhibition or Show-room, a Study for his Pupils, Bed Chamber, Garrets &c – The two Apprentices ... not having advanced any Premium, were expected to make up that deficiency by their assistance in dead Colouring and forwarding the Pictures, in proportion to their Abilities ... As to the Other two Pupils, there being no claim on their time, They were left to their own Discretion – It would have been better indeed, if there had been more Restraint upon us all, too much of the time that ought to have been dedicated to Study, being squandered away in idle Mirth and frolick – and when Our Master surprised us at our gambols, he only shook his head and, in his dry laconick manner, said 'Gentlemen – this is not the way to rival Claude'.[22]

First-hand reports of this kind about Wilson's circumstances and attitudes are surprisingly rare, considering his prominence in the London art world. The even greater dearth of manuscripts in his own hand makes the interpretation of his complex images difficult. Very few business letters survive and no attempt by Wilson to express his philosophical standpoint is known. Information about his private life is largely anecdotal, and few written sources convey much about his attitude to Wales. Thomas Wright reported that 'Wilson appears to have been partial to his native country, and is known to have declared that, in his opinion, the scenery of Wales afforded every requisite for a landscape painter, whether in the sublime, or in the pastoral representations of nature'.[23] Although Wilson painted many English views, it seems reasonable to suppose that patriotic sentiment was a significant motivating factor in his use of Welsh subject matter to address both Welsh and English patrons. In his celebrated analysis of the work of Wilson, David H. Solkin remarked that he 'would like to do away immediately with the idea that he painted Welsh views simply out of loyalty to the country of his birth',[24] but to suggest that national pride was not central to his motivation is to presume that Wilson stood apart from the mood which characterized almost all of his contemporaries in Welsh intellectual life. Solkin himself recalled that Lewis Morris, 'by drawing attention to Welsh history, and to the quality of Welsh literature ... hoped "to restore to Wales a portion of its ancient prestige amongst the people of Britain"'.[25] Solkin also speculated that Wilson's Welsh works of the 1760s were the result of a renewal of his acquaintance with George Lyttelton, his most important patron prior to his sojourn in Italy. In 1755, while Wilson was away, Lyttelton made the first of a number of tours in Wales, the description of which seems to have been circulated in manuscript form among the literati and to have exerted a considerable influence on the fashionable status of the country even before their first publication in 1774.[26] If Wilson did resume his acquaintance with his former patron, then Lyttelton's enthusiasm might have encouraged him.

[21] Solkin, *Richard Wilson*, p. 229, speculates that Wilson initially commissioned the set himself and subsequently sold the plates to Boydell, who reissued them. *The Great Bridge over the Taaffe* is illustrated in Lord, *The Visual Culture of Wales: Industrial Society*, p. 41.

[22] 'Memoirs of Thomas Jones Penkerrig Radnorshire 1803' in *The Thirty-Second Volume of the Walpole Society 1946–1948* (London, 1951), pp. 9–10. One of the two pupils was Joseph Farington.

[23] Thomas Wright, *Some Account of the Life of Richard Wilson* (London, 1824), p. 14.

[24] Solkin, *Richard Wilson*, p. 86.

[25] Ibid.

[26] In the *Annual Register*, XVII (1774), pp. 160–4. The full text was published in George Lyttelton, *The Works of George, Lord Lyttelton* (London, 1774).

170. Richard Wilson,
Cader Idris, Llyn-y-cau,
c.1765–6, Oil,
511 x 730

On the other hand, given that Wilson's early Welsh landscapes, painted in the 1740s when the two men were certainly in contact, pre-dated Lyttelton's first tour, it is more plausible to suggest that the influence was exerted in the opposite direction. In the absence of documentation, such questions cannot be conclusively answered, but on some philosophical matters the evidence offered by the pictures themselves is compelling. The use of images of Wales to construct an ancient history for England to parallel that of imperial Rome, first noted in the poetry of John Dyer, is quite clear in Wilson's pictures. Sometime between 1762 and 1764 Wilson painted *Llyn Peris and Dolbadarn Castle* in which he reorganized the geography of the site in order to present an ideal of tranquil harmony between man and nature. That Wilson intended his audience to make the connection between Wales and antiquity is clear not simply from the formal similarity of such pictures to the works of the continental masters of the Grand Manner, but also from his use, probably shortly after completing *Llyn Peris and Dolbadarn Castle*, of an identical view in which the Welsh peasants shown fishing contentedly in the foreground of the earlier picture were transformed into Diana and Callisto before Lake Nemi.[27] The picture was one of a series painted for an English gentleman, Henry Blundell of Ince Hall in Lancashire, though this patronage may ultimately have been Welsh in inspiration since Blundell was married to Elizabeth Mostyn. Sir Roger Mostyn, the fifth Baronet, became a patron of Wilson at about the same time, buying the *Summer Evening (Caernarvon Castle)* and *Cader Idris, Llyn-y-cau*. Although Sir Roger had not joined the Cymmrodorion Society, he was associated with the governing of the Welsh school in London, and was certainly counted among the literati. His sister married Thomas Pennant.

[27] Appropriately, the subject was from Ovid, *Metamorphoses*, II, lines 401–530.

The mood of these pictures, reverting to the presentation of the Arcadian Wales of *Caernarvon Castle* painted before Wilson's visit to Italy, appears quite different from the turbulence of the *Niobe*. The latter work seems closer to the spirit of the visual interpretations of Thomas Gray's poem, 'The Last Bard', which, since its publication in 1757, had both intensified the interest of intellectuals in Wales and modified their perceptions of the country.[28] Gray's poem crystallized several philosophical and political concepts into an icon which exerted a profound influence on the culture of both Wales and England into the twentieth century. As we have seen, the basic visual form of the druid, soon to be subsumed in the bard, had already been formulated by the time Henry Rowlands wrote *Mona Antiqua Restaurata*. Its national significance for the Welsh intellectual, as a symbol of the ancient poetic tradition, was well enough established for the Cymmrodorion to choose it to adorn the banner of the new society in 1751, opposite Saint David, a symbol of that other pillar of Welsh self-identity, the Celtic-Christian church. The genesis of Gray's poem illustrates the role of members of the Society in disseminating information about Ancient Britain in a period when English national sentiment had need of it. It seems that Evan Evans was the medium for the transmission of Sir John Wynn's *History of the Gwydir Family* in manuscript to the English historian Thomas Carte, who took from it the myth that, following his defeat of Llywelyn ap Gruffudd, Edward I had ordered the massacre of all the Welsh bards in order to curtail the oral transmission of the history of the nation. It was in Carte's *History of England* that Gray first read of this alleged act of genocide. Having begun work on the subject in 1755, the poet laid it aside until he was inspired to complete it on hearing John Parry, the blind harpist of Wynnstay, play at Cambridge. Following publication of the poem, Gray pursued his research into Welsh poetic tradition by studying the manuscript of Evan Evans's *Some Specimens of the Poetry of the Antient Welsh Bards*, which was eventually published in 1764.

In 1760, three years after the appearance of 'The Last Bard', the English painter Paul Sandby exhibited a picture based on the poem at the Society of Artists, and it may well be that he was motivated by a desire not only to compete technically with Wilson's *Niobe* but also to present a subject of similar character in a British context, thereby appealing directly to the current national mood in England. Sandby's picture is lost but it clearly made a strong impact on those who saw it. William Mason wrote that 'Sandby has made such a picture! such a bard! such a headlong flood! such a Snowdon! such giant oaks! such desert caves! If it is not the best picture that has been painted this century ...'[29] Sandby's picture represented an alleged event that was part of medieval Welsh history rather than of Ancient Britain, but its meaning linked it both to notions of that more distant world and to the spirit of his own times. The Last Bard had chosen to commit suicide by throwing himself over a precipice and into the river Conwy rather than submit to Edward I, who was cast in the role of a continental tyrant. This expression of defiance called to the eighteenth-century mind the resistance of the Britons to the Roman invaders. Its contemporary significance related both to the perception of Protestant England standing against a Catholic-dominated continent

171. *Banner of the Cymmrodorion Society*, 1751, medium and size uncertain

[28] Sir George Beaumont, who knew Wilson, was of the opinion that he could have interpreted Gray's poem to good effect. He made his point, along with an oblique comment on the failure of Wilson's career, in a contrast of mood with Gainsborough: 'Both were poets; and to me "The Bard" of Gray, and his "Elegy in a Country Churchyard" are so descriptive of their different lines, that I should certainly have commissioned Wilson to paint a subject from the first, and Gainsborough one from the second; and if I am correct in this opinion, the superior popularity of Gainsborough cannot surprise us; since for one person capable of relishing the sublime, there are thousands who admire the rural and the beautiful.' Quoted in W. G. Constable, *Richard Wilson* (London, 1953), p. 122.

[29] E. W. Harcourt (ed.), *Harcourt Papers* (14 vols., Oxford, 1880–1905), III, p. 15.

172. Richard Wilson,
*Solitude, c.*1762,
Oil, 1003 × 1251

of Europe, and to more abstract notions of liberty. The Ancient Briton's love of liberty was believed to be an inherent characteristic of his race and condition, in harmony with the untrammelled forces of nature. The barren mountains of Wales, so disagreeable to the early eighteenth-century traveller, became the concomitant of this love and inspired a new generation of English radicals.

The American art historian, James Thomas Flexner, noted of the Virgilian mode of landscape painting, so brilliantly expressed by Wilson in the 1760s, that 'The aesthetic was, if not aristocratic in the old sense, anti-democratic. Its distrust of emotion was in essence a belief that man's natural instincts were evil and, indeed, dangerous unless controlled by "decorum"'.[30] Wilson's success in presenting Wales in this way seems paradoxical, therefore, in the context of the contemporary popularity of 'The Last Bard' of Gray and Sandby. It has been argued by Solkin that the rapid fall from favour of Wilson in the 1770s suggests that his conception was outmoded even as it was expressed and that he was sustained only by a fragile base of patronage among a group of patricians whose attitudes were about to pass into obscurity. Yet in his picture *Solitude*, painted around 1762, Wilson, too, made use of bardic imagery, and it is perhaps significant that Woollett's engraving of the work, published by Boydell, was second only to the *Niobe* in popularity.[31] It was not published until 1778, when it was inscribed with lines from Thomson's 'Summer', describing a grove in Anglesey where 'all is listening gloom around':

THESE are the Haunts of Meditation, These The Scenes
Where antient Bards th'inspiring Breath,
Extatic, felt; and, from this World retir'd ...

More closely related to the genesis of the painting may have been Henry
Rowlands's description of the island, surely well known to the painter:

In a word, whether a Country by Nature remov'd from the Noise and Tumults
of the World, equally free from the Annoyances of Heat and Cold, furnish'd
with all Necessaries of Life; full of delicious Groves, pleasant Shades, bubling
Springs: Their Woods resounding with Nature's Musick; curiously cut into
various Forms, into Theatres and Temples: Here running out into pleasant
Walks, and there extended in shady Vista's and Apartments: And above all,
walking and meditating *here* a Company of divinely Inspir'd Souls, abounding
with instructive Documents of Virtue, and profound Discoveries of Nature.
I say, whether a Country thus advantaged and qualify'd, being represented to
the Genius of a studious Greek or Phœnician, would not with him compleat
the Idea of a wish'd *Elyzium*.[32]

In presenting Rowlands's Welsh Elysium, Wilson certainly harked back to a
philosophical standpoint in which the Bard represented contemplative virtues,
and which was overtaken by images of Gray's more emotional conception. This
evolution was plainly signalled in the work of Wilson's own pupil, Thomas Jones,
who in 1774 painted the picture which (in the absence of Sandby's work) has
become the definitive interpretation of the subject. In retrospect, it seems
uncharacteristic of the younger painter's work, but Jones himself
regarded it as 'one of the best I ever painted'.[33] It is unlikely that
Jones had yet visited Snowdonia, although he had ventured from
London to inspect Stonehenge, which was regarded as a druidical
monument and which in his picture was transposed to the mountains
of Gwynedd. By this time, the association of the Welsh mountains
with Liberty was firmly established, and the importance of the
image to the patriotic pride of Welsh intellectuals is clear. In 1771
the satirist Evan Lloyd, who was among Jones's acquaintances in
London, wrote to the leading English radical, John Wilkes, from
his home which looked out onto the Berwyn mountains:

If Milton was right when he called Liberty a mountain nymph,
I am now writing to you from her residence; and the peaks of
our Welch Alps heighten the idea, by wearing the clouds of
Heaven like a cap of liberty.[34]

[30] James Thomas Flexner, *History of American Painting* (3 vols., New York, 1970), III, p. 11.

[31] The picture was probably that exhibited at the Society of Artists in 1762 under the title *Landskip with Hermits*.

[32] Rowlands, *Mona Antiqua Restaurata*, p. 73.

[33] 'Memoirs of Thomas Jones', p. 33. Jones continued: 'This Picture was engraved by Smith, in Mezzotinto – but the Plate being very soon bought up by that great Leviathan, Mr Alderman Boydel, was never that I heard of, published – Another Instance of my illfortune with respect to Engravers.' The comment illustrates both the importance of the engraving in the development of a painter's career and also the kind of practice which enabled Boydell to secure his domination of the market.

[34] *The European Magazine and London Review: Containing the Literature, History, Politics, Arts, Manners and Amusements of the Age*, 18 (1790), 168.

173. Thomas Jones,
The Bard, 1774, Oil,
1156 × 1676

174. Richard Wilson,
Castell Dinas Brân from Llangollen
and the River Dee, c.1770,
Oil sketch, 660 × 855

[35] Wynn's picture is probably that now held
at the Yale Center for British Art, New Haven,
U.S.A. For the pictures and Wynn's Grand Tour,
see Richard Dorment, *British Painting in the*
Philadelphia Museum of Art, from the Seventeenth
through the Nineteenth Century (Philadelphia,
1986). Among Wynn's other Italian acquisitions
was his wife, purchased from her father (the
former gaoler of Faenza) for about £4,000. Maria
Stella Chiappini was fifteen when she became
Lady Newborough, and she later described her
first meeting with him, when he was fifty: 'At the
sight of him I gave a wild cry, and, falling at his
knees, with sobs implored him … to think of my
youth … He did nothing but laugh at my pitiful
simplicity.' For her relationship with the odious
Wynn, see Maria Stella Wynn, *The Memoirs of*
Maria Stella (Lady Newborough) by Herself, trans.
M. Harriet Capes (London, 1914), pp. 60–97.

Nevertheless, to suggest that a Classical perception had simply been overtaken by a Romantic one would be to oversimplify the intellectual cross-currents of the time. In the art of a culture, Classical style often overlies and disguises an essentially Romantic idea. In the same year as Lloyd's letter, Wilson himself succeeded in combining the decorum of the 'Virgilian mode' with the use of a mountainous Welsh landscape patriotically to express the link between Wales and Liberty. His *Castell Dinas Brân from Llangollen*, like its companion picture, *View near Wynnstay*, was painted for Sir Watkin Williams Wynn, probably to mark his coming of age in 1770. Twenty-one years after the death of his father, he finally inherited the immense wealth of the family, along with its Tory and patrician traditions. However, the young baronet was also fashion-conscious and was much more interested in pictures and music than in the hunting which had led to his father's premature demise. In London society he mixed with artists and actors, among them Reynolds and Garrick, and acquainted himself with Classical antiquity, enjoying a Grand Tour in 1768–9. Following a well-established convention, he had the fashionable Pompeo Batoni record his visit in a group portrait with his friends Edward Hamilton and Thomas Apperley. Some eight years earlier, his fellow countryman, Thomas Wynn of Glynllifon and his neighbour John Mytton of Halston, near Oswestry, had, with two friends, commissioned Nathaniel Dance-Holland to paint a similar conversation piece. The group was imposingly set in front of the Colosseum, with Wynn inspecting an engraving of the temple of Jupiter, held by his friend. It is possible that Sir Watkin Williams Wynn had seen at least one of the versions of the picture made for each of the four sitters.[35] In his own picture, the Classical references included an allegorical sculpture of Painting, a copy of a Raphael fresco (which he seems to have made himself), and an open volume of Dante. He also favoured Batoni with a commission to paint *Bacchus and Ariadne*. These were the first Italian examples of his patronage of the visual arts and crafts, which he exercised on a scale unprecedented in Wales except by his neighbours, the Myddeltons. Occasionally Sir Watkin's contemporaries among the Welsh gentry commissioned pictures from the élite of European painters working in London. Henry Knight of Tythegston was magnificently painted with his children by Johann Zoffany in 1770, but such inspired commissions were sporadic compared with the sustained patronage at Wynnstay. Shortly before

175. Johann Zoffany,
Henry Knight of
Tythegston, with his
three children, Henry,
Robert and Ethelreda,
c.1770, Oil,
2405 × 1490

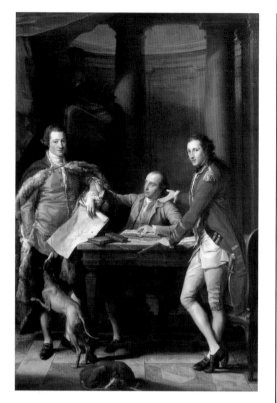

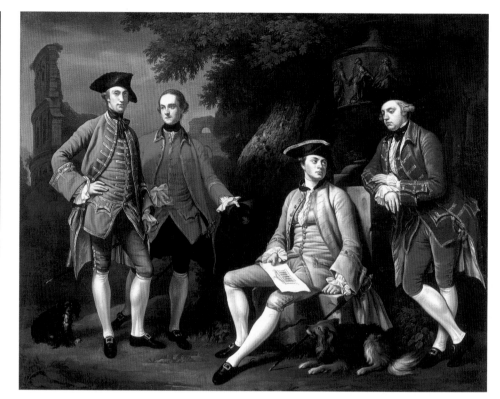

above: 176. Pompeo Batoni,
Sir Watkin Williams Wynn,
4th Bart., Thomas Apperley and
Captain Edward Hamilton,
1768–72, Oil, 2890 × 1960

above right: 177.
Nathaniel Dance-Holland,
James Grant of Grant, John Mytton,
the Hon. Thomas Robinson and
Thomas Wynn, 1760, Oil,
981 × 1239

opposite: 179.
Anton Raphael Mengs,
Perseus and Andromache,
1774–7, Oil, 2270 × 1535

178. Joshua Reynolds,
Charlotte Grenville, Lady Williams
Wynn, with her three children,
c.1780, Oil, 1594 × 2157

leaving for Rome, Sir Watkin Williams Wynn had begun to sit for Reynolds for a double portrait with his mother, a picture later echoed in a portrait with his wife by the same painter. In Rome, Raphael Mengs was favoured (through an agent) with a large commission to paint *Perseus and Andromache*, a picture for which Sir Watkin paid but never saw since the ship carrying it home was captured by a French privateer.[36] His agent may have been James Byres, who assiduously cultivated the young baronet and succeeded not only in persuading him to part with over £1,000 for works of art – a prodigious sum in the period – but also extracted a commission to design a new house at Wynnstay. The enormous project never materialized but the drawings were made and remain among the most complete and splendid sets of architectural designs of the period. Sir Watkin's architectural aspirations were transferred to the building of a new London house in St James's Square, designed by Robert Adam in 1772.[37] In 1773, shortly before its completion, Sir Watkin paid £650 for Poussin's *Landscape with a Snake* to adorn its walls – an unprecedented price for an old master painting.

Sir Watkin Williams Wynn's purchases on the Grand Tour and his patronage of Reynolds and Adam were entirely characteristic of the English gentry of the period. However, another side of his character, which differentiated him from these contemporaries, was manifested in his support of Welsh artists and promotion of Welsh subject matter. Sir Watkin had purchased at least five pictures by Wilson by 1770, and his subsequent acquisition of the portrait of Wilson painted by Mengs in Rome in 1752 suggests a relationship of deeper significance than that, for instance, with the English Reynolds.[38] The nature of the greatest of his commissions to Wilson, for *View near Wynnstay* and *Castell Dinas Brân from Llangollen*, tends to confirm the national aspect of this and other acts of patronage by Sir Watkin.

[36] The picture is now in the Hermitage in St Petersburg. See Brinsley Ford, 'Sir Watkin Williams Wynn. A Welsh Maecenas', *Apollo*, 99 (June, 1974), 435–9.

[37] Building work began on site in 1771, but Adam may not have been involved initially. His name does not appear in surviving documentation until April 1772. See [John Olley], *20 St James's Square* (London, 1991).

[38] Sir Watkin, along with many others, also owned a portrait of Reynolds, but his ownership of a portrait of Wilson was unique.

180. J. Bowles, *View of St James's Square, London*, c.1752, Engraving and watercolour, 266 × 400

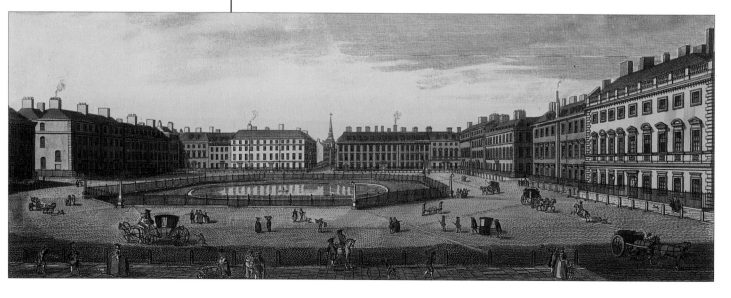

181. James Byres,
*Design for a new
Wynnstay, No. 34.
Ceiling for the Library*,
1770, Pen, ink and
watercolour, 590 × 920

182. James Byres,
*Design for a new Wynnstay,
No. 25. Section of the Chapel*, 1770,
Pen, ink and watercolour, 590 × 925, detail

The Wynns did not own Castell Dinas Brân – indeed, the site was the property of Wynn's political rivals, the Myddeltons, and therefore its choice as a central motif for Wilson's massive pictures cannot have been motivated by pride of possession or family lineage.[39] Furthermore, Wilson chose as his viewpoint for the Llangollen picture a place close to that from which Tillemans had drawn and painted his view for the Myddeltons, and which, as we have noted, Wilson could have inspected when he worked at Chirk Castle. Sir Watkin Williams Wynn may also have been familiar with Tillemans' landscape, and the prospect of outdoing his rivals with an avant-garde version of the same subject done by a great native painter might have been in the back of his mind. No concrete evidence exists for such a speculation, but the iconography of Wilson's picture clearly suggests that Sir Watkin had commissioned a work of national sentiment. It was shown at the Royal Academy in the same year as Benjamin West's *The Death of Wolfe*, with which the American painter caused a sensation by meeting the need of the English public for a dramatic expression of what Flexner described as that 'most modern of virtues, patriotism'.[40] The parallel patriotic iconography of Sir Watkin and Wilson was more complex and allusive than that of the American painter since they took landscape as their form, but even if by implication rather than by explicit narrative (since there were no human actors placed on the landscape stage) *Castell Dinas Brân from Llangollen* was clearly a Welsh national subject with contemporary political implications. By forming a break in the clouds Wilson created a perfectly circular halo of light around the summit of Dinas Brân in order to draw the eye to the place and the mind to the idea that it was a kind of Welsh Mount Olympus, home of the native gods. Even to those among the intellectual community who did not speak Welsh, the association of the hill with Celtic deities was by this time familiar, since Evan Evans had published at least one reference to it as 'the spacious palace of Brân'.[41] Furthermore, the ruins of the castle built by Gruffudd ap Madog on top of the hill were associated with the wars of Llywelyn ap Gruffudd against Edward I and hence with the idea of the Welsh love of Liberty.[42] The idea was presented in a different way from the contemporary iconography of 'The Last Bard', just as in terms of modern politics Sir Watkin's understanding of Liberty was considerably different from that of the radicals. Nevertheless, at a deeper level the particularly Welsh gloss on the term united Sir Watkin even with the likes of Evan Lloyd. That Wales represented a kind of pre-history of England was by 1770 a widespread if vague and retrospectively acquired perception among the English. The Welsh, on the other hand, had for two hundred and fifty years clearly perceived the evolving British state as the product of an ancient and preordained process begun and carried through by themselves. Sir Watkin Williams Wynn, Richard Wilson, Evan Evans, Evan Lloyd, the Morris brothers and many of their contemporaries among the avant-garde identified closely with that triumphal historical continuity. Rather than at Wynnstay, Sir Watkin probably hung his huge pictures at his new house in London, where his Welshness was displayed for the benefit of the visiting gentry and intellectuals throughout Europe. As if to confirm his patriotic inclinations, in 1771, the year in which Wilson completed the pictures, Sir Watkin began his patronage of Evan Evans, perhaps the most important medium for the transmission

[39] Contrary to the assertion in Solkin, *Richard Wilson*, p. 237, and therefore undermining a central plank of his argument that the pictures were primarily an expression of the pride of possession.

[40] Flexner, *History of American Painting*, II, p. 34.

[41] Evan Evans, *Some Specimens of the Poetry of the Antient Welsh Bards* (London, 1764), p. 15.

[42] D. J. Cathcart King, 'Two Castles in Northern Powys: Dinas Brân and Caergwrle', *Arch. Camb.*, CXXIII (1974), 113–39, suggests that Castell Dinas Brân was built c.1270 by Madog ap Gruffudd, but J. Beverley Smith, *Llywelyn ap Gruffudd: Prince of Wales* (Cardiff, 1998), p. 308, n. 122, believes the evidence strongly favours an earlier date and Gruffudd ap Madog as the builder. The Powys family turned traitor to Llywelyn and the castle was probably demolished by a garrison holding it for Llywelyn on the approach of the English under the Earl of Lincoln, ibid., p. 300. Notwithstanding the complex history of the castle, Wilson's patriotic message is clear. The stronghold of the turncoat family stands in ruins.

[43] D. Silvan Evans (ed.), *Gwaith y Parchedig Evan Evans (Ieuan Brydydd Hir)* (Caernarfon, 1876), pp. 135–6. Evans provided perhaps the classic example of the accepted reading of Welsh history in the British context in the period, bringing his violent anti-English sentiments to a conclusion with the lines: 'The day of liberty, by heaven design'd, / At last arose – benevolent and kind – / The Tudor race, from ancient heroes sprung ... / The English galling yoke they took away, / And govern'd Britons with the mildest sway.' In his introduction, Evans attacked both Lyttelton and Joseph Cradock's recently published *Letters from Snowdon* (London, 1770), for their historical and contemporary misrepresentations of Wales. He described Cradock as a 'despicable scribbler'.

below right:

184. Peter Tillemans,

The Vale of Llangollen,

1720, Watercolour,

292 × 578

right:

183. Richard Wilson,

Castell Dinas Brân from Llangollen,

c.1770, Pencil and chalk,

194 × 549

of Welsh-language culture and national sentiment to the English-speaking world. His poem 'The Love of Our Country', published in the following year, was dedicated to his new patron:

> Nor did this genius shine in Greece alone,
> In other nations equally it shone,
> Witness the Bards that grac'd the Celtic clime,
> Whose images were bold and thoughts sublime ...
>
> Old Llywarch and Aneurin still proclaim,
> How Britons fought for glory and for fame;
> Whole troops of Saxons in the field they mow'd,
> And stain'd their lances red with hostile blood ...[43]

Although Wilson was almost certainly unaware of the fact, the iconography of *Castell Dinas Brân from Llangollen* provided striking evidence of the continuity of this particularly Welsh perception. The unknown painter of one of Edward Rice's Dinefwr Castle landscapes had earlier implied in just the same way both the mythological and historical national associations of his subject. In the two pictures, separated by nearly a century in which English perceptions of Wales had undergone profound change, even the rivers circling Dinefwr and Dinas Brân, the two bridges, and the towns of Llandeilo and Llangollen, were disposed in a strikingly similar way.

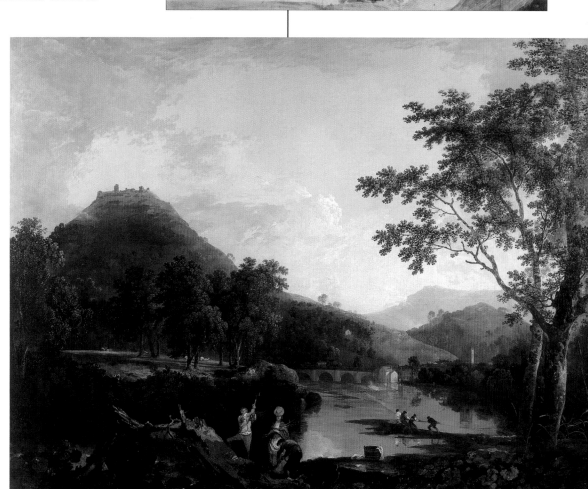

185. Richard Wilson,

Castell Dinas Brân from Llangollen,

1770–1, Oil, 1804 × 2447

left: 186. Edward Edwards, *William Parry*,
1804, Engraving, 163 × 125

right: 187. Giuseppe Marchi after J. Berridge,
*Evan Lloyd, c.*1772, Mezzotint, 500 × 353

Further evidence for the belief that patriotism was an important motive for Wynn's patronage of Wilson is provided by his contemporary support of William Parry.[44] Although he was probably not born in Wales, Parry was the son of John Parry, the harpist who had inspired Gray to complete 'The Last Bard'. Parry's initial training in London was with William Shipley, from whom he moved in 1766, under Sir Watkin's patronage, to the studio of Sir Joshua Reynolds and, three years later, to the Royal Academy Schools. Wilson's pupil, Thomas Jones, had also trained initially with Shipley and it may have been there that he made the acquaintance of Parry. Certainly, by 1769, they were well known to each other, and Jones's memoir for 7 July of that year gives a vivid impression of the interaction of young Welsh artists and intellectuals in London:

> On the 16th Evan Lloyd the Poet, Charles Hemmings an old fellow collegian, Parry, late a pupil of Reynolds, and my self hired a Coach for the day, dined at the *Toy* at Hampton, and after dinner Lloyd introduced us to Mr Garrick at his elegant Villa there, who very politely shewed the house, attended us round the walks and Shrubberies, and as a particular Compliment, conducted us to his Study, a detached Building in the Garden, which being, as he told us, dedicated to Retirement, had only one Chair in it – A bottle of Wine was ordered, and standing round his writing desk, The glass was circulated and enlivened with the flippant Conversation of these two Wits, untill a Coach driving up, announced My Lord Somebody – upon which we took our leave, and returning to the Toy to take the other Bottle – concluded the Evening together at the Crown and Anchor tavern in the Strand.[45]

188. Johann Joseph Zoffany,
*David Garrick and his wife by his
temple to Shakespeare, Hampton,*
*c.*1762, Oil, 1022 × 1346

A fortnight later, Jones noted that he had accompanied Lloyd and Joseph Farington, his former colleague in Wilson's studio, on a journey to Wales. William Parry was already there, and had spent a considerable amount of time over the previous three years staying at various gentry houses where he seems to have been treated as a social equal, a privilege no doubt accorded as a result of his Wynnstay connection. He caused much amusement at Rug, for instance, by attending a ball dressed as a Spaniard. In 1768 he toured Merioneth houses in the company of William Williams of Peniarth Uchaf, earning a reputation as a competent young painter. Elizabeth Baker, writing to Hugh Vaughan of Hengwrt, described the particularly enthusiastic reception given to a portrait of her correspondent taken in this period:

[44] The support of the Wynn family for William Wynne Ryland is also pertinent. Ryland was the son of the Welsh-born engraver and copperplate printer Edward Ryland, who worked in the Old Bailey. William Wynne Ryland was born in London in 1732, and after his apprenticeship with Ravenet he was helped by Sir Watkin Williams Wynn, 3rd Bart., who was his godfather, to visit France and Italy. Ryland's subsequent career as an engraver and publisher was highly successful. He introduced stipple engraving to England and was celebrated in particular for his work after Angelica Kauffman. However, his career ended in tragedy when he over-reached himself financially. He defrauded the East India Company and was hanged in 1783. See *The Authentic Memoirs of William Wynne Ryland* (London, 1784).

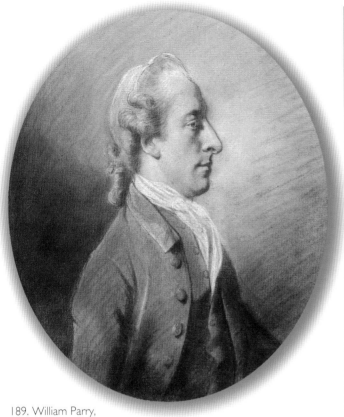

189. William Parry,
John Pugh Pryse, Gogerddan, 1770,
Monochrome chalk drawing, 330 × 273

190. William Parry,
*Various sitters, c.*1770,
Coloured chalk

'tis a strong likeness but far from a flattering one – is not Parry the artist? I was
much pleased with a circumstance, a woman whose name I know not asked to
see it, when she entered the room clapt her hands in a transport crying Oh! Da!
Da! *Mister Vaughan* and kept curtsying and at the same time crying as long as
she stayed – an instance of reverence to your person as well as a compliment
to the painter.[46]

Parry's tour of 1768 with William Williams also included an Englishman,
one J. Jackson, and it appears that its primary purpose was to prepare a text
and drawings for publication. Jackson's text, echoing the form of Lyttelton's
Letters, remained in manuscript and Parry's drawings have disappeared entirely.
Nevertheless, the intention to publish an illustrated tour at this date is remarkable
and testifies to the participation of many gentry families in the growing
intellectual fashion for Welsh landscape.[47]

The height of Parry's activity in Wales as a portraitist came in 1770. He was
employed at Wynnstay to carry out a variety of commissions, including painting
scenery for theatrical performances, but his most notable achievement was a group
of at least fourteen chalk portraits, mostly of members of the Jacobite Cycle of the
White Rose of which Sir Watkin Williams Wynn, following in his father's footsteps,

[45] 'Memoirs of Thomas Jones', p. 21.

[46] NLW, Peniarth MS 416D, part II, letter dated
9 February 1780. I am indebted to Miles Wynn
Cato for this and other material quoted
in the text relating to William Parry.

[47] Extracts from Jackson's letters were published in
the *Journal of the Merioneth Historical and Record
Society*, III, part IV (1960), 360–73, and ibid., IV,
part II (1962), 146–59.

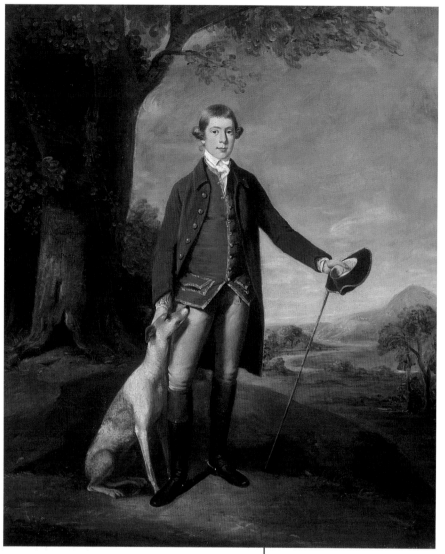

191. William Parry,
Watkin E. Wynne,
1770, Oil, 760 × 636

was the leading figure. The Cycle met in that year at one of Owen Wynne's houses (Llwyn in Denbighshire or Pengwern in Merioneth) and it seems likely that eight coloured drawings of members in uniform and six monochrome portraits were taken at the gathering. Owen Wynne himself featured twice in the coloured set and once in the monochromes, along with his three younger children. His eldest son, Watkin E. Wynne, was painted in oils by Parry in the same year. Among the other sitters for the monochrome drawings were Robert Howel Vaughan of Nannau and John Pugh Pryse of Gogerddan. This last portrait emphasizes the close-knit nature of the small circle of gentry patrons, intellectuals and artists in which Parry moved both in Wales and in London, and which was so characteristic of the period. Pryse was a close friend of Evan Lloyd and as MP for Cardiganshire attracted the attention of the caricaturists. In 1772 Mat Darnley satirized him as *The Merionethshire Macaroni*, grotesquely resplendent with leek, staff and an excessively long pigtail.

The Cycle portraits were probably the last of the 'official' Welsh Jacobite commissions, although a number of other portraits done by Parry in this period suggest that individuals linked socially by the Jacobite society provided the core of his patronage. The Vaughans of Nannau and the Pulestons of Emral and Pickhill commissioned him to paint family portraits. However, ultimately this patronage stemmed from his relationship with Sir Watkin Williams Wynn, who, in the autumn of 1770, paid for Parry to work in Italy, where he stayed until 1775. He was paid a retainer and agreed to paint two copies and two originals a year for his patron. The most celebrated of these productions was a copy of Raphael's *Transfiguration*, for which Sir Watkin paid him the large sum of 400 guineas.[48]

On his return, he was again in receipt of Welsh patronage, both in London and in Wales. In 1778 he painted portraits of Thomas Lewis and Richard Jones for the Welsh school, of which they were governors, and yet another portrait of Owen Wynne of Llwyn seems likely to date from this year. It was probably also in this period that Parry completed a picture of his father for Sir Watkin. This intense

[48] The arrangement, along with the pictures received by Sir Watkin Williams Wynn, are recorded in Denbighshire Record Office, DD/Wy/7943. Parry's retainer was £60 in his first year, £70 in the second, £80 in the third and fourth years, and £100 in 1775.

[49] Parry's portrait of his father hung at Wynnstay and Parry painted a second version which remained in his family until it was purchased by NMW with the double portrait. Later portraits by Parry of his father were exhibited at the Royal Academy as *Portrait of Mr Parry (who is blind) playing at draughts with portraits of two other gentlemen* (1778) and *The Late Mr Parry* (1787). Parry's attempt to build a career in London met with only limited success. He returned to Rome where he was more successful, but died during a visit to Wales in 1791.

[50] 'Memoirs of Thomas Jones', p. 15.

192. Mat Darley,
The Merionethshire Macaroni,
1772, Engraving and
watercolour,
180 × 124

portrait of the famous harpist became
celebrated and consequently was often
attributed to Reynolds. Its Romantic
quality related it closely to the evolving
genre of bardic pictures stimulated by
Gray's poem. Parry painted a number of
portraits of his father, including a double
portrait in which the artist himself stood, examining a music manuscript.
Parry is easily recognizable by comparison with the engraving dated 1804
in which he is identified as the sitter, but whose source is unknown.[49]

William Parry's exploitation of Welsh patronage at this time was not unique, and
it is probably no coincidence that it was another member of the London network
of which he was a part, along with Thomas Jones and Evan Lloyd, who made
a contemporary attempt to establish a portrait painting practice in Swansea.
Giuseppe Marchi had left Rome for London with Reynolds in 1752 and
thereafter became acquainted with Jones, who described him in 1768 as
'my old friend'.[50] In that year Marchi painted family portraits at Pencerrig,

193. William Parry,
Thomas Lewis, 1778,
Oil, 1219 × 914

right: 194. William Parry,
*John Parry, Harpist to Sir Watkin
Williams Wynn*, c.1760–80,
Oil, 848 × 739

far right: 195. William Parry,
*John Parry with his son,
William Parry*, c.1760–80,
Oil, 870 × 712

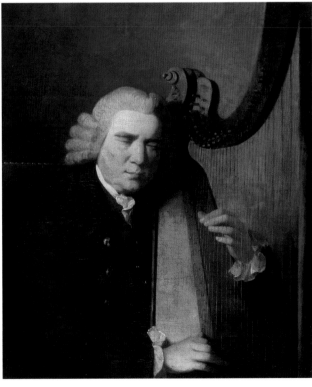

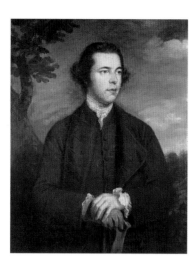

196. Giuseppe Marchi,
Thomas Jones of Pencerrig,
1768, Oil, 920 × 720

[51] Joseph Farington, *Memoirs of Sir Joshua Reynolds* (London, 1819), p. 32.

[52] For images of the early development of Swansea, see Lord, *The Visual Culture of Wales: Industrial Society*, Chapter 1. Significantly, the first purely architectural practice in Wales was established by William Jernegan in Swansea at the same time.

although he may still have been working as an assistant to Reynolds. Marchi also engraved portraits, including that of Evan Lloyd, after Berridge. Farington later recalled that it was in about 1770 that Marchi started to practise on his own account, 'but being induced by some friendly offers of employment in South Wales, he shortly left the metropolis, and resided in or near Swansea in Glamorganshire. His encouragement in this place failing after remaining several years, it became necessary for him to remove'.[51] Although it is not known how long Marchi persisted in Swansea, his venture there was the earliest recorded attempt by an academically-trained painter to establish a practice in a Welsh town. His choice of Swansea was sensible since the town was beginning to flourish both as a summer resort and an industrial centre.[52] William Parry's contemporary activity in Denbighshire is better documented by surviving pictures, but it is clear that he worked in the established way by exploiting the gentry network, moving from house to house to carry out commissions. Marchi's practice was a new departure, though a premature one. It would be fifty years before Swansea could provide sufficient patronage to engage a resident portrait painter on a permanent basis.

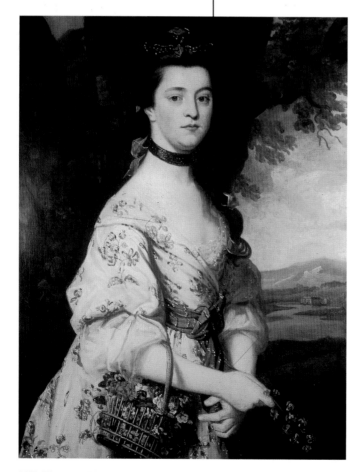

197. Giuseppe Marchi,
Sarah Humphreys, 1768, Oil, 900 × 690

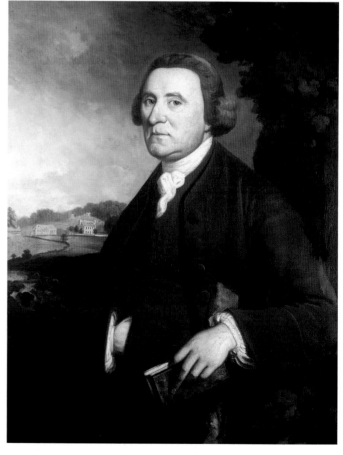

198. Giuseppe Marchi,
Thomas Jones Senior, 1768, Oil, 900 × 698

c h a p t e r

f i v e

THE IDEA OF

LANDSCAPE

199. William Parry,
Paul Sandby sketching,
1776, Pencil, 291 × 240

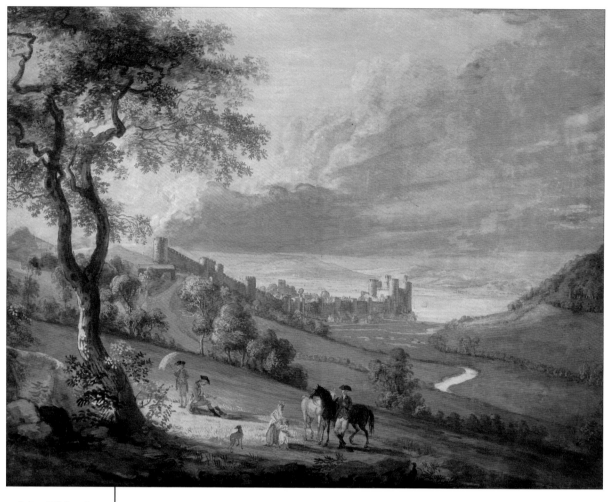

200. Paul Sandby,
Conway Castle, c.1776,
Watercolour and gouache,
424 × 535

[1] NLW, Wynnstay MSS, Group II, Box 115, bundle 21. For a summary of the Wynnstay manuscripts relating to Sandby, see Peter Hughes, 'Paul Sandby and Sir Watkin Williams-Wynn', *The Burlington Magazine*, CXIV (1972), 459–66. On the basis of a signed drawing of *Llanberis Lake and Dolbadarn Castle*, dated 1764, Hughes argued that Sandby's 1770 visit to Wales was not his first. However, it seems likely that the drawing was based on an engraving, rather than taken on the spot.

[2] Among the gentlemen in attendance was Thomas Apperley, one of Sir Watkin's companions in Rome, portrayed by Batoni.

[3] NLW, Department of Printed Books, XCT 399 P93 (4to), 'Curious letters, from Mrs Presland, nearly all of them dated at Peniarth, about the year 1771', a typewritten transcript, no date, no pagination. The letters, addressed to Mrs Presland's sister, may date from the late 1760s and cannot have been written after 1771, which is the most likely date. Elizabeth Presland was married to Thomas Presland of Walford Hall, Shropshire. She was by no means to be counted among the literati, though she clearly kept abreast of fashion and had read Lyttelton's account of his journey in Wales. As we have seen, William Parry also stayed at Peniarth, and this suggests that the house was a focus for those with advanced taste in the period.

Among William Parry's London acquaintances with an interest in Wales was the English landscape painter Paul Sandby, whom he once drew sketching, shaded from the sun by a servant's parasol. In 1770 Sandby was brought to Wynnstay by Sir Watkin Williams Wynn to contribute to the intense artistic activity which already involved Parry and Wilson. Sandby gave drawing lessons to his patron for which he was paid 5s. each and additionally compensated at the rate of 2 guineas a day for 'loss of time [in Wales]'.[1] He also painted masks, presumably for performances in the Wynnstay theatre. Sandby and Sir Watkin clearly got on well and the following August the painter returned to Wales to undertake a fortnight's tour with his patron. Attended by an entourage of three gentlemen, nine servants and fifteen horses, and with their belongings packed in a large cart, they lumbered into Snowdonia via Llangollen, Bala and Dolgellau, turning north through Aberglaslyn to Caernarfon. They made excursions to Llanberis and Beaumaris before returning along the north coast.[2] This journey, with its visits to waterfalls and ascents of mountains, has often been described as the first tour in Wales undertaken for the appreciation of landscape. As has been shown, this it certainly was not. Indeed, a group of letters written in the same year by Elizabeth Presland, who was staying at Peniarth in Merioneth, make it clear

201. Probably Henrietta
Elizabeth Williams Wynn,
The Williams Wynns of Wynnstay,
going to the waterfalls,
1805, Pen and ink,
311 × 203

202. J. Green after John Evans,
Pistyll Rhaiadr, 1794, Engraving,
495 × 347

203. H. Bunbury and I. Evans,
Admission Tickets to Sir Watkin
Williams Wynn's Theatre
at Wynnstay, c.1786,
Engraving, 81 × 117

that by this time the appreciation of
romantic scenery was commonplace
among the Welsh gentry and their
English cousins. From the front
window at Peniarth, Presland noted
that 'you see one very high rock, and
the highest Mountain in North Wales
cald Cadridrous, which Nombers go
to see, but when they get to the top
are quite lost in clouds, except it be by
chance, and then from it the view is said
to be wonderfull beyond discription'.[3]
Among the excursions she made was one
to Pistyll Rhaeadr, and her description
of it represents the experiences of many
others of her class who followed her on
tour in Wales in the last quarter of the
eighteenth century:

204. Paul Sandby,
Manerbawr Castle, from
XII Views in South Wales,
1775, Aquatint, 238 × 314

The next day we set out to see the finnest fall of water my eyes ever beheld, it is Cald pistleridge (or something like it but cant pronounce it properly) on the rode we see variety of Beautyfull views, and at last came in face of the Rock, which is prodigous high, and seemingly the hend of the world, down the middle of it falls the Caskade, Broad and beautyfull, it drops in to a large bason about half way down through which the water has worked a large hole in to another, some yards below, out of which it hemtys it self in to the Brooke, and I am told is in frosty weather the finnest sight you can conceive, just under it is a long room, where by dinner time met at least twenty Gentlemen, Ladys, and servants, who brought out all sorts of provisions, which was set on a Long table, with here, and there a knife, not forgeting som few Trenchers, off which we eat with as much pleasure as if China itself, we had many Different kinds of liquour, our punch Bowl a large pail, which the Ladys took a taste of; they servants rather to much, after dinner, our Desert was Welch songs, and drole storrys, by this time we was in spirits to assend the Rock, from the front of which, we looked between Rocks and Mountains down a sweet Vally, at the hend of which appeard Shropshire in great Beauty, behind us Denbyshire Hills, and a charming Country.[4]

205. Paul Sandby,
*Llangollin in the County
of Denbigh,* from
XII Views in North Wales,
1776, Aquatint,
238 × 314

It is not clear whether, when Sir Watkin Williams Wynn and Paul Sandby set out, their journey was intended to be more than a personal indulgence of such fashionable behaviour, and it was the publication, five years later in 1776, of engravings based on the tour under the title *XII Views in North Wales* which gave it a special place in the development of Wales as a destination for artists. Together with the volume illustrating a second tour which Sandby had made in the south, published a year

earlier, the views focused the attention of artists on Wales. The impact of the two collections was the result not so much of the views portrayed, many of which were already familiar from the work of earlier engravers, but of the aquatint technique of which Sandby was one of the pioneers. Aquatint offered the artist the ability to break out from the pedantic constraints of the line engraving and to show the effects of nature in a more fluid way which approximated closely to the wash drawing and to the aspirations of romantically-minded artists. In views such as *Llangollin in the County of Denbigh*, Sandby took full advantage of the technique by showing the rays of the sun striking down through the clouds after rain. Such effects had not been seen before in printed form.

Sandby's journey in south Wales, although published in the year before the north Wales volume, had been undertaken in 1773 in the company of Joseph Banks, the botanist.[5] Banks had returned three years earlier from the celebrated circumnavigation of the globe with Captain Cook on the *Endeavour*, and the close association of Welsh intellectuals and artists with him demonstrates once more the high profile and prestige which Wales enjoyed in England in this period. William Parry was commissioned to paint Banks in the company of his colleague Dr Solander and Omai, a native chief taken to England in 1774 following a second expedition to the South Seas. The precise origins of the artist's relationship with the botanist are unknown, although the picture was owned by Sir Robert Williams Vaughan of Nannau and may well have been commissioned by him. The Welsh connections of Joseph Banks were extensive as a result of the marriage of his uncle Robert to Bridget Williams, the heiress of Edwinsford in Carmarthenshire. Banks, 'determin'd to visit the land of Cymri before any foreign soil', had spent three months in Wales at his uncle's invitation in 1767. Among the excursions he made on that occasion was to Downing, home of Thomas Pennant, with whom he shared the wide range of interests of the dilettante of the period, but especially with engraved illustrations.[6] The second volume of the *British Zoology* was published in the year of Banks's visit, and Pennant's achievement was recognized by his election as Fellow of the Royal Society.

206. William Parry,
Sir Joseph Banks introducing
Omai to his secretary and librarian
Dr Daniel Solander, the Swedish
botanist, c.1776, Oil,
1525 × 1525

[4] Ibid.

[5] A second visit with Sandby followed in 1775.

[6] H. P. Carter, *Sir Joseph Banks, 1743–1820* (London, 1988), p. 47. The two men first met in London in March 1766, an event described in Pennant's *Literary Life* (London, 1793), p. 9.

207. Moses Griffith,
Self-portrait as a Young Man,
c.1770, Watercolour,
133 × 113

208. *Advertisement*
for Moses Griffith, painter
to Thomas Pennant,
1784, 192 × 121

MOSES GRIFFITH,

PAINTER to THOMAS PENNANT, Efq;

BY PERMISSION FROM HIS MASTER,

Takes the Liberty of offering his Services to the
Public, at his leifure Hours,

AT THE FOLLOWING RATES.

A Landfcape or Ruin, from Fifteen £. s. d.
to Twenty Inches in Length — 1 11 6
From Ten to Fifteen Inches 1 1 —
From Eight to Ten Inches — 10 6
For the Margin of a Book, from Four
to Five Inches — — — 6 -
A Head, within a Margin, Five Inches by
Four — — — — 10 6
A plain Coat of Arms — — — 1 3
Or with Quarters and Creft — — — 1 6

Witnefs, in Whiteford Parifh, Flintfhire,
December 18, 1784.

In 1769 Thomas Pennant took into his employment the most prolific of his many visual amanuenses, an event which he recalled in a celebrated passage in his autobiographical *Literary Life*:

> In the spring of this year I acquired that treasure, *Moses Griffith*, born *April* 6th, 1749, at *Trygain-house*, in the parish of *Bryn Groer*, in *Llein*, in *Caernarvonshire*, descended from very poor parents, and without any other instruction than that of reading and writing. He early took to the use of his pencil, and, during his long service with me, has distinguished himself as a good and faithful servant, and able artist; he can engrave, and he is tolerably skilled in music. He accompanied me in all my journies, except that of the present year. The public may thank him for numberless scenes and antiquities, which would otherwise have remained probably for ever concealed.[7]

Pennant continued to commission works from a wide variety of artists and engravers, many of whom, such as Sandby and Mazell, were distinguished in their fields. However, Pennant's attitude to Griffith was far more paternalistic than that which he maintained with other artists. Indeed, until 1781 Griffith was a member of the household at Downing and at his master's beck and call. Even after he began to work on his own account, he felt obliged to state in his advertisements that he did so only when not working for Pennant.[8] Griffith's initial tour with Pennant occurred in 1769, the first year of his employment, when they went to Scotland, an exploration which was completed in 1772 with a tour to the Hebrides. The resulting publication, *A Tour in Scotland and Voyage to the Hebrides* (1774), was mainly illustrated by Griffith. By this time Pennant and Griffith were making periodic expeditions within north Wales for the purposes of a similar volume which appeared in 1778 as *A Tour in Wales*, to which was added *A Journey to Snowdon* in 1781. Through these publications and his work for others – most notably Pennant's friend Francis Grose, who included views by him in his *Antiquities of England and Wales* – Griffith's engraved work became known to the reading public.[9] Furthermore, as a result of his master's enthusiasm for his work, Griffith's original watercolours also became widely disseminated, though they were not exhibited in his lifetime. Pennant remarked that he 'never should deny copies of them to any gentleman who would make a dignified use of them',[10] and, indeed, drawings were often loaned or copied especially for his extensive

[7] Pennant, *Literary Life*, p. 10. The author made inexplicable factual mistakes in this passage. Griffith was born on 25 March 1747 at Trygam in the parish of Bryncroes. Pennant did not explain how Griffith came to his attention in the first place. Perhaps an early propensity for drawing led to his being recommended to his master.

[8] NLW MS 5500C, item 14, 13 July 1781: 'Moses is now on the point of becoming [a] ... housekeeper & to work on his own account unless when employed by me.' Pennant continued to act as an agent for him among his extensive circle of acquaintances, as well as employing him directly, but it is clear that Griffith was financially dependent on his artwork from this time and was not paid a retainer by his former master.

[9] Francis Grose (1731–91) was an antiquarian and a draughtsman, known both as a topographer and a caricaturist. He interpreted satirical ideas for Pennant. See Lord, *Words with Pictures*, pp. 76, 163. He began to publish his *Antiquities of England and Wales* in parts in 1773, bringing it to a conclusion in 1787.

[10] Pennant, *Literary Life*, p. 25.

209. Moses Griffith,
Pages from an extra-illustrated copy
of Thomas Pennant, *A Tour in Wales*,
c.1778, Watercolour, 290 × 445

circle of correspondents. Griffith's greatest achievements were copies of *A Tour in Wales* printed on large paper so that they could be illustrated with original paintings at the head and foot of the pages and in the margins. Only twelve copies were printed, Sir Watkin Williams Wynn being among the recipients, along with Anthony Storer, Sir William Burrell and Richard Bull.[11] Pennant's correspondence with Bull throws considerable light on the dissemination of Griffith's works and on the employment of other copyists. In May 1780 he wrote to Bull:

> I would most cheerfully permit Moses to copy for you; but I give you my word his time is so fully taken up that he has not a moment's leisure. But if you wish for any particular things out of my book I believe there is a neighbours young man one Ingleby who would copy them reasonably.[12]

This appears to have been the first of many occasions on which Pennant employed John Ingleby, a local man, born at Halkin in 1749. He made drawings at 5*d*. each in Bull's copy which was nearing completion by August, when Pennant wrote again:

[11] Storer's copy went, with the rest of his library, to Eton College. A note in that copy, dated 1792, recorded that 'The twelve copies were distributed as follows: 2 Mr Pennant retained one of which was destroyed / 1 Mr Storer / 2 Mr Chiswell — one of which was destroyed / 1 Sir Wm Burrell / 1 Mr Bull / 1 Sir Watkin Williams Wynn / 1 Lady Lloyd / 3 Robson the bookseller had, but what became of them is uncertain.' Chiswell had ten copies of *A Journey to Snowdon* printed on large paper which went to Pennant, Storer, Burrell, Sir Watkin and Bull, with Chiswell retaining the other five. Two copies survive in the National Library of Wales, both from Downing. It had been Pennant's intention to 'dispose' of the original five-volume set in favour of the second set of three volumes only, but, clearly, he retained both. See letter to Bull, NLW MS 5500C, item 43, 25 July 1784. University of Wales, Bangor, holds one copy, but that taken by Sir Watkin was probably burnt in the Wynnstay fire of 1858, and the others are untraced.

[12] NLW MS 5500C, item 6.

210. John Ingleby,
View from the Eccleston Hill of Chester,
*c.*1795, Watercolour, 143 × 192

212. John Evans,
The North East View of Whitington Castle,
*c.*1778, Watercolour, 134 × 179

213. Robert Baugh after John Evans,
Valle Crucis Abbey, from *A Map of the Six Counties*
of North Wales, 1795, Engraving, 520 × 598

[13] Ibid., item 8. Ingleby also made original drawings and engraved for Pennant, including, on one occasion, after a drawing by John Evans, 'View & Plan of Tre'r Caeri', Thomas Pennant, *A Tour in Wales* (2 vols., London, 1784), II, p. 215. For other examples of his original works, see Lord, *The Visual Culture of Wales: Industrial Society,* pp. 37, 39. Ingleby died on 26 August 1808 and was buried at Halkin. Why Pennant's original intention also to print *A Journey to Snowdon* on large paper appears to have been carried out by Chiswell, rather than by the proprietor, is unclear.

[14] For a discussion of the work of Moses Griffith, see Donald Moore, *Moses Griffith* (Cardiff, 1979).

[15] Pennant, *A Tour in Wales,* II, p. 98.

If no public calamity happens I hope to put my second and last part of the Welsh tour in the press in October. A copy on large paper will beg your acceptance ... and Ingleby if you desire shall instantly copy all the marginal additions Moses puts on my copy.[13]

During the following six years Moses Griffith himself worked for Bull on subsequent volumes of *A Tour in Wales,* at the same time as he illuminated Pennant's own copies. The miniature-sized marginalia included heraldry, portraiture, topography, and natural history, and there were occasional full-page inserts, such as a view of Caernarfon Castle to which his limpid style was well suited.[14] Pennant's own extra-illustrated copies of *A Tour in Wales* were further supplemented by engravings and

original works by other artists, collected by the author. The most notable of these was the watercolour *The West Side of Flint Castle* made by Francis Place on his tour of 1699, an item the significance of which in the history of tours by artists in Wales would not have been lost on Pennant. He demonstrated his awareness of the Welsh work of earlier artists in his account of the ascent of Cadair Idris:

> On the other side, at a nearer distance, I saw *Craig Cay*, a great rock, with a lake beneath, lodged in a deep hollow ... This is so excellently expressed by the admirable pencil of my kinsman, Mr. *Wilson*, that I shall not attempt the description.[15]

Pennant's confidence that he could take for granted the familiarity of Wilson's view, borne out by many similar references in later published and manuscript tours, underlines the importance of the painter's work in creating the fashion for Wales.[16] It is surprising that no Wilson drawing survives among those collected by Pennant to annotate his large-paper editions of the *Tour*. However, his interest in indigenous talent, well-attested by his commissions to Griffith and Ingleby, is confirmed by a watercolour of *The North East View of Whitington Castle*, signed by John Evans of Llanymynech. The drawing has the appearance of a preparatory work for a print and, indeed, Evans was in touch with Pennant in 1777 over an unidentified scheme involving engraving. In 1794 a fine print of *Pistyll Rhaiadr* was published, based on a drawing by Evans in which a party of visiting connoisseurs are aided in their appreciation of the scene by a primitive Ancient Briton. The following year *A Map of the Six Counties of North Wales*, engraved by Robert Baugh of Llandysilio, included a view of Valle Crucis.[17]

When Joseph Banks visited Wales in 1767, the edition of William Camden's *Britannia*, published in 1695, had been his guide. From the late 1770s, however, Pennant's *A Tour in Wales* rapidly established itself as the new standard text for visitors to the north – a position it held, endorsed by the likes of Dr Johnson, for many decades.[18] Its generally objective approach did not endear it to the more romantically-inclined, among whom was an unidentified female traveller who confided to her diary in 1795:

> this whole Countery is so wild & romantic in most respects, that even Mr Pennant (a very litteral & cold author) who gives as it were an inventory of every thing he sees finds it impossible when he travils where *we have done*, to avoid taking a Poetical as well as an Historical View of the morals and manners of the old Britains.[19]

[16] Wilson's pictures are cited in several published eighteenth-century tours, for instance in Arthur Aikin, *Journal of a Tour through North Wales and a Part of Shropshire; with observations in minerology, and other branches of Natural History* (London, 1797), and also in manuscripts. John Skinner, who toured in 1800, remarked while ascending Cadair Idris that 'Mr Wilson, the English Claude, has conferred celebrity on this spot by his pencil'. Cardiff Central Library MS 1.503.

[17] Pennant kept a copy of Evans's proposal for the publication of the map, pasted into his extra-illustrated tour, which suggests that he may have been involved. However, it was dedicated to Sir Watkin Williams Wynn (son of Wilson's patron), and the *Pistyll Rhaiadr* jointly to the Earl of Powis and Robert Myddelton. A smaller version of the map included a view of Harlech Castle. The unidentified earlier project was mentioned in a letter from Evans to Pennant, 7 May 1777 (NLW MS 15421C, f. 62). Edward Pugh, who used Evans's map on his travels early in the nineteenth century, met 'the ingenious Mr Baugh' at Cann Office, Llangadfan; Edward Pugh, *Cambria Depicta* (London, 1816), p. 250.

[18] Johnson toured north Wales in 1774. His experiences are recorded both in Johnson's *A Diary of a Journey into North Wales in the year 1774* and in *Journal of a Tour in Wales with Dr Johnson* by his Welsh-born companion, Hester Piozzi (formerly Mrs Thrale), both of which are published in *Dr Johnson and Mrs Thrale's Tour in North Wales 1774*, with an introduction and notes by Adrian Bristow (Wrexham, 1995). Johnson was interested in the fate of the Welsh language. At Gwaenynog he noted: 'After dinner the talk was of preserving the Welsh language. I offered them a scheme. Poor Evan Evans [Ieuan Fardd] was mentioned as incorrigibly addicted to strong drink ... Middleton is the only man who in Wales has talked to me of literature. I wish he were truly zealous. I recommended the republication of David ap Rhees's Welsh Grammer,' *Dr Johnson and Mrs Thrale's Tour in North Wales*, p. 42. Piozzi was of a more romantic turn of mind: 'This morning we set out for the Lake of Llynberris at the foot of Snowdon; Mrs. Wynn accompanied us and provided a horse for me ... It is the wildest, stoniest, rockiest road I ever yet went, and in fifteen miles' riding we came to a cottage by the side of the lake, where we found a Harper, and Mrs. Wynn sang Welch songs to his accompaniment', ibid., p. 117.

[19] BL Add. MS 37926, f. 143, quoted by Malcolm Andrews, *The Search for the Picturesque* (Aldershot, 1989), p. 113.

MODERN TOILET.

CAMBER's LETTER TO JOHN BULL.

214. After Thomas Pennant,
*Modern Toilet, Camber's Letter to
John Bull*, 1781, Mezzotint, 300 × 203

215. Thomas Gainsborough,
Thomas Pennant, c.1770–80
Oil, 950 × 740

216. Moses Griffith,
Bachwen, c.1778,
Watercolour, 74 × 134

As a Welshman himself, personally familiar with so many of his compatriots, high and low, Pennant did not fantasize about them as Ancient Britons. Only once did Moses Griffith hesitantly refer to the druidical idea in his illustrations for the *Tours in Wales*. Although interested in customs and costume, Pennant was always a realist, and in his love of science and his enthusiasm for economic development he was a modernist. His views were conservative but he made use of that most modern medium, the popular print, to publicize them. He employed visual amanuenses to work up his ideas attacking practices as various as the new fashion among women for cross-dressing and abuses within the Established Church.[20] Nevertheless, it cannot be said that the man who unforgettably described Caernarfon Castle as 'the most magnificent badge of our subjection' was devoid of historical imagination.[21]

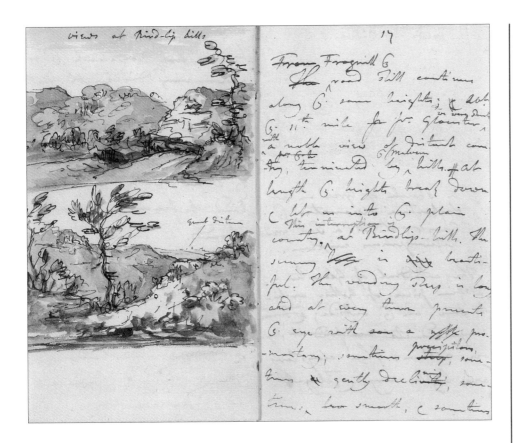

218. William Gilpin,
River Wye, 1770–82, Watercolour,
227 × 132

above left:

217. William Gilpin,
Views at Bird-Lip Hills, pages from
The Wye Tour sketchbook, 1770,
Pen, ink and wash, 197 × 245

Along with the excitement generated by Sandby's avant-garde aquatints and with Pennant's *Tours in Wales* as a guide, the Revd William Gilpin's *Observations on the River Wye* provided the theoretical component of a powerful triumvirate of stimuli to connoisseurial tourism in Wales. Gilpin was by no means the first to take a boat down the Wye from Ross to Chepstow for the purpose of appreciating the views. John Egerton, rector of Ross, had accompanied his friends on river excursions in his pleasure boat in mid-century, and the area was probably the first to witness the development of commercial tourism.[22] Among Gilpin's distinguished precursors was Thomas Gray, who noted in 1770 that 'I descended in a boat for near 40 miles from Ross to Chepstow: its banks are a succession of nameless wonders'.[23] Gilpin's observations were not published until 1783 but, like the paintings of Moses Griffith, his manuscripts circulated widely among a network of cognoscenti during the 1770s, partly as a result of Gray's appreciative reading of them in 1771. Gilpin's introduction to his work expressed with characteristic precision the extra dimension which his observations added to the tourism of the period:

We travel for various purposes; to explore the culture of soils; to view the curiosities of art; to survey the beauties of nature; to search for her productions; and to learn the manners of men; their different polities, and modes of life.

[20] Pennant's prints are discussed and illustrated in detail in Lord, *Words with Pictures*, pp. 74–82.

[21] Pennant, *A Tour in Wales*, II, p. 223. For Pennant's interest in economic development and its visual manifestation, see Lord, *The Visual Culture of Wales: Industrial Society*, pp. 36–9.

[22] Andrews, *The Search for the Picturesque*, gives a good summary of the history of the Wye valley tour, pp. 84–107.

[23] P. Toynbee and L. Whibley (eds.), *Correspondence of Thomas Gray* (3 vols., Oxford, 1935), III, p. 1142, letter to Wharton, 24 August 1770. Gray noted Tintern, New Weir and, in particular, Morris's gardens at Piercefield as familiar sights. The gardens were published in the same year in Thomas Whateley, *Observations on Modern Gardening* (Dublin, 1770).

The following little work proposes a new object of pursuit; that of not barely examining the face of a country; but of examining it by the rules of picturesque beauty: that of not merely describing; but of adapting the description of natural scenery to the principles of artificial landscape; and of opening the sources of those pleasures, which are derived from the comparison.[24]

Gilpin proposed a definition of beauty in a landscape involving the juxtaposition of formal elements, and he encouraged tourists to indulge in an intellectual pastime of searching out those natural views which most nearly approached the ideal and to analyse their qualities and deficiencies. Unlikely as it might seem, this essentially sterile game, the rules for which were described in language as dry as dust, became highly fashionable in England. It led to the arrival of substantial numbers of enthusiasts, clutching the holy writ, from over the border. Some, it is true, though following the trend, paused to question the wisdom of their guide. Hannah More expressed her misgivings with delightful sarcasm in a letter to Horace Walpole, written in 1789:

> sailing down the beautiful river Wye, looking at abbeys and castles, with Mr Gilpin in my hand to teach me to criticize, and talk of foregrounds, and distances, and perspectives, and prominences, with all the cant of connoisseurship, and then to *subdue* my imagination, which had been not a little disordered with this enchanting scenery.[25]

Applying his method to the Tywi valley, Gilpin incidentally disclosed the importance of John Dyer as a precursor. His criticism of Dyer was extensive and of particular interest since he knew the poet also as a painter:

> This is the scene, which Dyer celebrated, in his poem of *Grongar Hill*. Dyer was bred a painter; and had here a picturesque subject: but he does not give us so fine a landscape, as might have been expected. We have no where a complete, formed distance; though it is the great idea suggested by such a vale as this: no where any touches of that beautiful obscurity, which melts a variety of objects into one rich whole. Here and there, we have a few *accidental* strokes, which belong to distance; though seldom masterly; I call them *accidental*; because they are not employed in producing a landscape; nor do they in fact unite in any such idea; but are rather introductory to some moral sentiment; which, however good in itself, is here forced, and mistimed.[26]

In perhaps the most celebrated passage of *Observations on the River Wye*, Gilpin proposed that the ruins of Tintern Abbey 'hurt the eye with their regularity; and disgust it by the vulgarity of their shape. A mallet judiciously used (but who durst use it?) might be of service in fracturing some of them'.[27] As we have seen, Dyer's similar observation made in Rome nearly half a century earlier, when he felt that nature, by 'blotting out the traces of disagreeable squares and angles, adds certain

[24] William Gilpin, *Observations on the River Wye* (London, 1782), pp. 1–2. Despite the publication date, the book did not appear until 1783. The text was illustrated, after Gilpin's original drawings, by the author's nephew, William Sawrey Gilpin.

[25] W. S. Lewis (ed.), *Horace Walpole's Correspondence* (43 vols., Oxford, 1961), vol. 31, p. 320.

[26] Gilpin, *Observations on the River Wye*, pp. 59–60.

[27] Ibid., p. 33.

[28] In his remarks on Robert Wynne's memorial to Henry Wynn at Ruabon, Pennant sarcastically remarked of the main figure: 'His attitude is that of a fanatical preacher.' Pennant, *A Tour in Wales*, I, p. 302.

beauties that could not be before imagined' to the buildings, had a strong moral undertone which was brought to its ultimate refinement by Wilson. To Gilpin's amoral eye, such undertones were an obstruction laid in the true path of artist and connoisseur. Under his influence, English ladies and gentlemen, some of whom recorded for themselves with pen and pencil, and others who were spoken for by artist-guides who led them like the ciceroni of Rome, constructed a huge and detailed record of the natural and architectural beauties of Cambria. Their thoughts of the people, however, were expressed largely in terms of decorative elements in the construction of the picturesque scene, or as primitive tokens of Ancient Britain, generally in the form of blind harpists. That the common people they so remotely observed were, at that moment, undergoing a dramatic process of regeneration either passed them by entirely or ran counter to the way in which they wished to picture them.

Nonconformity, and especially Methodism (which developed within the Established Church to which most of them subscribed), was distasteful to them and drew their scorn – although a sense of alarm in the observations of those who chose to address the matter suggests that some of them sensed the democratizing implications of such schisms. It is not surprising that the leaders of Welsh society and intellectual life were the most exercised by the new enthusiasts. The first Sir Watkin Williams Wynn became infamous for his persecution of early Methodists, and among the next generation Evan Lloyd and his friends attacked the movement with vicious satire. Although mystified by the irrationality and immoderation of Methodism, Pennant was objective enough to observe that the shortcomings of the Established Church which he supported were largely to blame.[28] However, in their images and descriptions, most English tourists chose to ignore what they believed (and no doubt hoped) to be an aberration. The almost total absence of a visual record of eighteenth-century Nonconformity, in a period when its heartlands were scrutinized in closer detail than any other place in Europe, is remarkable.

220. George Delamotte,
Mr Howells, Methodist Preacher, Swansea,
1810, Watercolour, page size 287 × 234

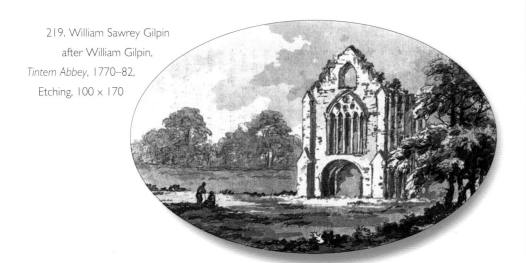

219. William Sawrey Gilpin
after William Gilpin,
Tintern Abbey, 1770–82,
Etching, 100 × 170

221. Attributed to Sir William Beechey,
John Boydell, 1801, Oil,
521 × 419

29 NLW MS 5500C, item 59. Pennant
overestimated his age by some two years.

30 For Smith, see Basil S. Long, 'John (Warwick)
Smith', *Walker's Quarterly Magazine*, no. 4 (1927).

31 'Memoirs of Thomas Jones', p. 68. Jones was
more impressed by the pomp than by the picture,
the principal merit of which was 'its laborious
high-Finishing – The result of Germanic flegmatic
Industry', a comment which should be understood
in the context of Jones's high regard for his master,
Richard Wilson, who was famous for his lack of
high finish. Ibid., p. 69.

32 Greville was the brother of Smith's patron,
Lord Warwick.

33 For Ibbetson's career, see Rotha Mary Clay,
Julius Caesar Ibbetson, 1759–1817 (London, 1948).

34 Wyndham, *A Gentleman's Tour through
Monmouthshire and Wales*, p. 161.

Those of cool and cerebral inclination followed Gilpin to the picturesque scene, while the more romantic temperaments went in search of Ancient Britain and the delicious terror of the still fashionable Burkean sublime. Most took a more vacillating line, inclining to the picturesque or the sublime as their moods changed, led by the particular landscape through which they travelled and by the state of the weather. Their enthusiasms were fuelled by an unprecedented flood of landscape engravings, published singly, in collections and as illustrations to guides and tours. By this time John Boydell had grown rich and powerful in the trade, becoming an Alderman of the City of London in 1782. Five years later Pennant reported a visit made by the publisher to Downing, which illustrated both his status and the common perception of him in Wales as a Welshman:

> The great Alderman Boydel (a countryman of mine) called here last week and passed some hours with me. He is going to publish a set of Welsh views, houses etc., ... among others my house with as much of its environs as he can take in. Is it not happy that at the age of seventy! or more he can have the spirit to attempt great affairs.[29]

Among the most enthusiastic English travellers in Wales was the painter John Smith, who was called 'Warwick' Smith after the patron who had borne the costs of the five years he spent in Italy.[30] He visited Wales at least thirteen times between 1784 and 1806, and we may speculate that his enthusiasm owed something to his friendship with Thomas Jones, Pencerrig, which was established in Rome and which continued in Naples, where they shared lodgings. Characteristic of many passages in Jones's memoirs was that dated 2 February 1778, when the two men viewed Sir Watkin Williams Wynn's ill-fated painting by Mengs:

> Went with *Smith* the Landscape Painter & *Hardwick* to see a Picture of *Perseus & Andromache* which the Caval're Mengs had just finished for Sr Watkin William Wynne & which was now exhibiting to the Public at his Palace near St Peter's – This Picture made a Stir in Rome in proportion to the Celebrity of the Painter – & the Exhibition was conducted with the utmost Pomp.[31]

In 1792 Smith acted as cicerone in Wales for Robert Fulke Greville[32] and the painter Julius Caesar Ibbetson. Their tour was unusually thorough and epitomizes many others taken by fashion-conscious artists and connoisseurs in the *fin de siècle* period. They travelled in a phaeton, a fast and light carriage, indicative both of improvements to roads in the twenty years since Sir Watkin Williams Wynn's tour, and of Greville's sense of style, for which he was renowned. Nevertheless, in Welsh matters Smith was the leader, and as an artist he was much admired by Ibbetson, who was ten years his junior.[33] The party entered Wales through Llangollen and proceeded north-west to Conwy, where they experienced delights which came to be regarded as characteristic of the tour. Nearly twenty years after Henry Penruddocke Wyndham, who travelled with his artist Samuel Hieronymous

Grimm, had heard the blind harpist John Smith play all night,[34] the performance was repeated for Greville, 'Warwick' Smith and Ibbetson. They would certainly have read Wyndham's account and Ibbetson painted watercolours of the scene. With the landscape reworked by Smith and etched by Rowlandson, one of these views achieved particular celebrity as the frontispiece to Edward Jones's *The Bardic Museum* of 1802. Jones was harpist to the Prince of Wales, subsequently King George IV, and consequently became known as 'Bardd y Brenin' (The King's Bard). His history of traditional Welsh music, which included examples, did much to persuade the touring public that, when serenaded by what became a proliferation of blind harpists, they were hearing the music of the Ancient Britons. A typical manifestation was witnessed at Llangollen by a tourist from London:

222. Julius Caesar Ibbetson,
Colonel Greville at Briton Ferry,
1792, Watercolour,
177 × 222

223. Thomas Rowlandson
after Julius Caesar Ibbetson
and John Warwick Smith,
Frontispiece to *The Bardic Museum
of Primitive Literature,* 1802, Etching
and watercolour, 223 × 185

224. Julius Caesar Ibbetson,
Penillion Singing near Conwy,
c.1792–3, Watercolour,
215 × 292

225. Julius Caesar Ibbetson,
The Flash of Lightning,
1798, Oil, 673 × 928

Breakfast was announced by the Harper of the Inn commencing his
Performance. His name is Edward Jones, first Cousin to the Prince of Wales's
Harper, an excellent performer and good musician, although Blind and by Trade
a Shoe-Maker; he is besides an ingenious mechanic; the custom is for visitors
to contribute upon quitting the Inn Money as a Reward for his Labour.[35]

In his introduction to *The Bardic Museum*, the other Edward Jones acknowledged
'the Hon. Colonel Greville, a gentleman remarkable for his elegant taste in native
picturesque scenery and costume, for the loan of his rural drawing, taken after
nature, from a group of Welsh Peasants, singing in alternate theme around the
Harp, with a distant view of Snowdon and Dôlbadarn Castle, in Caernarvonshire'.[36]
Ibbetson's watercolour, *Penillion Singing near Conwy*, was characteristic of his
attitude towards the recording of everyday life as he witnessed it on this tour.
No doubt he found the scene picturesque, and he had no scruples about its
transposition by Smith to the environs of Dolbadarn, for the sake of effect. His

[35] 'Percy Bull, son of John Bull', 'Tours through
Wales and Ireland', 1819, p. 18, Yale Center for
British Art (no index number). The following
evening, the specimen of Ancient British music
offered by Jones was 'The Roast Beef of Old
England'.

[36] Edward Jones, *The Bardic Museum*
(London, 1802), p. xvi.

226. Julius Caesar Ibbetson,
Conway Castle, Moonlight at the Ferry,
1794, Oil, 343 × 451

own oil painting, *Conway Castle, Moonlight at the Ferry*, also based on drawings taken at Conwy, encapsulated the sense of romantic escape from the urban English world which artists could still experience in Wales in 1792. Later, passing over the mountain between Aberglaslyn and Tan-y-bwlch, both Ibbetson and Smith were moved to paint watercolours of a thunderstorm during which the horses drawing Greville's phaeton panicked. The potential of this subject for a finished work in the sublime manner was realized by Ibbetson in the picture known as *The Flash of Lightning*. However, Ibbetson did not seek to transform the blind harpist John Smith into the archetypal Bard, and his portrayals of the common people often had about them a ring of truth which stemmed from a keen interest in the realities of folk life. His work denoted the beginnings of a reaction against the amorality of Gilpin's aesthetics, which would result in a fashion for depictions of the common people in the early nineteenth century. In a set of nine watercolours of such subjects exhibited at the Royal Academy in 1796, Ibbetson represented people at work from the Llŷn Peninsula to Swansea Bay.[37]

[37] Nor did his record exclude the emerging extraction industries of Wales, from the copper mines of Parys Mountain to an iron furnace at Cyfarthfa and a coal staithe at Landore. See Lord, *The Visual Culture of Wales: Industrial Society*, Chapter 1.

227. Francis Engleheart after Anon.,
Thomas Johnes, c.1810,
Engraving, 228 × 178

Among the drawings in Ibbetson's set of nine was one of women washing sheep taken at Hafod, the estate of Thomas Johnes near Aberystwyth. Greville and Johnes were old friends although this was Ibbetson's first visit to Hafod which, for this group as for many others, before and after, represented a high point in their exploration of ideas about landscape. On inheriting his dilapidated estate in 1780 Johnes travelled from his parents' house in Herefordshire to the Ystwyth valley, where he seems to have had something of a visionary experience. He began to expend huge sums of money in the construction of a new house, in creating walks, gardens and views, and in improving the farms in an attempt to create Arcadia on the principles of picturesque landscape. Johnes was predisposed to the vision which inspired him on first seeing Hafod by both his education and his family connections. Although born and brought up at Croft Castle, he was entirely of Welsh descent. At the University of Edinburgh he was able to mix with an exceptional generation of Scottish intellectuals, and subsequently made a Grand Tour with one of them, Robert Liston, who would distinguish himself among the leading diplomats of the period and became a lifelong friend. Among his English connections, Johnes was cousin to Richard Payne Knight, whose pioneering Gothic-style house of Downton he visited regularly. Knight and his neighbour, Uvedale Price, were to become the leading exponents of the Picturesque Movement. Hafod became a kind of workshop for their ideas, and the network of individuals who worked and visited there was of central importance in the evolution of the movement, which affected not only painting but also garden design and architecture.

In 1794 Richard Payne Knight dedicated his poem 'The Landscape' to Uvedale Price, who, in the same year, published his *Essay on the Picturesque*. Together, these works extended Gilpin's concepts beyond the critical observation of nature and its correction in painting. Price sought to differentiate more clearly the picturesque experience from that of the beautiful and the sublime, and gave expression to a wider shift in taste, already discernible in Ibbetson's interest in folk life. Price changed the man-made focus of the Picturesque away from the Classical or even the Gothic ruin towards the humbler dwellings of the common country people. What they, from their privileged position, liked to imagine was the untutored 'natural' irregularity of the dilapidated cottage animated a landscape in which variety of form, texture and colour became the ideal. With the assistance of Thomas Johnes, by 1788 Price had acquired the lease of a piece of land on the seafront at Aberystwyth, below the castle ruins, with the intention of building a villa. In 1790 he made the acquaintance of John Nash, a young architect working in Carmarthen, and the result was a commission which not only helped to change the course of Nash's career but also fed the developing theories expressed with

such influence in Price's *Essay on the Picturesque.* The brief for Castle House was described by Price in a letter to the painter and connoisseur George Beaumont, later to become another influential devotee of Welsh scenery:

I must have not only some of the *windows* but some of the *rooms* turned to particular points, and that he must arrange it in his best manner; I explained to him the reasons why I [*must have it*] built ... so close to the rock, shewed him the effect of the broken foreground and its varied line, and how by that means the foreground was connected with the rocks in the second ground; all of which would be lost by placing the house further back.[38]

Nash's response to the brief was to design three octagonal towers on a triangular ground plan, providing rooms which faced the desired prospects of the sea, the castle and the mountains. Clearly excited by the potential of the new aesthetic, in his next project he departed even further from the Classical tradition to which he had hitherto confined himself. He created The Cottage at Newcastle Emlyn in the Gothic style, with each façade different from the other, 'suggesting a place of antient rusticity appropriate for retirement', from which the client, Mrs Brigstocke, could contemplate the ruined castle across the river.[39] Whilst engaged on this project, Nash received a commission from Thomas Johnes to build at Hafod.

Johnes had commissioned his new house from Thomas Baldwin of Bath in 1786. After two years of acquaintance, in 1793 Nash was invited to make important additions which radically altered the character of Baldwin's building. The greatest of Johnes' many passions as a collector was for books and manuscripts, among which his early Welsh and French material was perhaps the most important.[40] Nash was commissioned to design a library to do justice to these treasures,

228. Edward H. Martineau, *The Castle House, Aberystwyth, Additions and alterations no. 2,* 1858, Pen, ink and wash, 538 × 745 (building designed by John Nash, 1792)

[38] Pierpont Morgan Library, Coleorton Papers, MA 1581 (Price) 16, quoted in Richard Suggett, *John Nash: Architect in Wales* (Aberystwyth, 1995), p. 67. As Suggett points out, 'This was of course the language of painting – in other words, of the picturesque.'

[39] Ibid., pp. 73–6.

[40] Johnes made his Welsh manuscripts available to scholars, including Iolo Morganwg, just as the old gentry of Merioneth had opened their doors to antiquarians in the seventeenth and early eighteenth centuries. His French material, notably the medieval romances of Froissart, were made available through his own translations, eventually published by the private press he established in 1802.

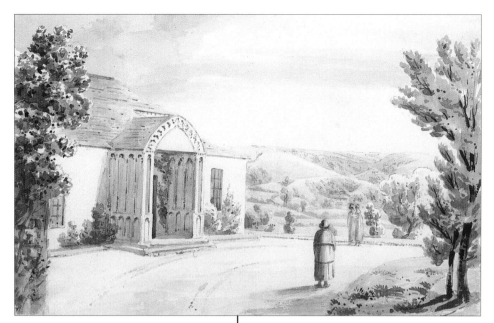

229. Peter Richard Hoare,
The Cottage, Newcastle Emlyn,
with Mrs Brigstocke and daughters,
c.1800, Pen and ink, 254 × 165
(building designed by John Nash, 1792)

230. Anon.,
The Octagonal Library at Hafod,
1809, Engraving, 119 × 92
(library designed by John Nash, 1793)

[41] Elis Jenkins, 'Rheola', *Neath Antiquarian Society Transactions* (1978), 61–8. Thomas Hornor's watercolour of Rheola is illustrated in Lord, *The Visual Culture of Wales: Industrial Society*, p. 71.

[42] Bradford City Art Gallery, Danby Papers, 4 September 1803.

[43] Stothard to his wife, quoted in Elisabeth Inglis-Jones, *Peacocks in Paradise* (new ed., Llandysul, 1990), pp. 218–19. Inglis-Jones's famous, if romanticized, account of Hafod, is supplemented by R. J. Moore-Colyer (ed.), *A Land of Pure Delight: Selections from the Letters of Thomas Johnes of Hafod, Cardiganshire (1748–1816)* (Llandysul, 1992).

together with a long conservatory and new offices. The octagonal library, crowned by a cupola which rose high above the existing roof, along with the other additions, broke the symmetry of Baldwin's design in accordance with picturesque principles.

Having established a reputation at Hafod, most of Nash's subsequent large-scale building was done outside Wales. His designs for alterations and a series of picturesque lodges and other outbuildings for Nanteos, not far from Hafod, were never built, but his picturesque ideas were given expression between 1814 and 1818 in his reconstruction of Rheola, in Glamorgan, for his cousin John Edwards. His commission included the caveat, characteristic of advanced taste, that he 'preserve its cottage-like appearance'.[41] Nash succeeded in disguising what was, in fact, a substantial country house as a rustic retreat appropriate for a nouveau-riche client of radical political persuasions, who wished to present an image of himself in architecture which clearly set him apart from the surrounding conservative gentry.

Hafod was built with old money, although the supply was often inadequate to meet the demands placed upon it by Thomas Johnes. He commissioned pictures and sculpture on a lavish scale, beginning with a family group by George Romney, work on which had been curtailed by the death of his first wife. His second wife, his cousin Jane Johnes of Dolaucothi, was inserted in her place in the guise of a fashionably picturesque gypsy. When their daughter, Mariamne, was eighteen,

Ibbetson was invited to return to Hafod (ten years after his visit with Smith and Greville) as a drawing teacher. In a letter he remarked: 'The most advantageous offer I ever had made in my life I refus'd last April, from Mr Johnes, Hafod, Cardiganshire, to live a year at His house and Teach His only Daughter.'[42] His loss was the gain of Thomas Stothard, one of the most distinguished painters and illustrators of the period, who was soon appointed. Stothard's relationship with the family lasted for several years and resulted in him painting grisaille panels in the octagon library to illustrate the romances of Monstrelet, held in manuscript by his patron, as well as family portraits and the delightful *Fête Champêtre at Hafod*, which summed up the idyllic life to which Johnes aspired, but which his prodigious energy and ambition seldom allowed him to enjoy. Stothard wrote to his wife of life at Hafod:

> You have not an idea how my time is filled up ... I have no exercise but what the pencil affords me, and sometimes running from one part of the house to the other. Sometimes I get an hour out of doors to get a little air. The small room I paint in affords me none; filled, as it is, with eight canvases, with my colours, oils and turpentines, etc.[43]

Among the most distinguished products of Johnes' patronage of contemporary artists were sculptures made by Thomas Banks. He often came to Hafod from London, producing busts of Jane and Mariamne as well as decorative work, including the library fireplace with heads of Socrates, Plato, Alcibiades and Sappho. His most notable achievement was *Thetis dipping the infant Achilles into*

231. Mariamne Johnes
after George Romney,
*The Johnes Family at Hafod
and friends*, c.1800,
Watercolour,
150 × 235

233. Thomas Banks,
Thetis dipping the infant Achilles into the Styx,
1790, Marble

the Styx. Banks took as his models Jane and Mariamne Johnes, and the work was highly praised when exhibited at the Royal Academy in 1789. The *Morning Post* noted:

> Banks advances very forward in his beautiful sculpture. The Thetis, we understand, is intended as a likeness of Mrs. Johnes, the Lady of the Member for Radnorshire. What degree of similitude there is we know not, but if the artist has not flattered, she is highly beautiful and elegant.[44]

The marble block on which Banks worked had originally been intended for a monumental sculpture of Achilles to be set on the Cardiganshire coast, an abortive project characteristic of the scale on which Johnes' imagination worked.

232. Thomas Stothard,
Fête Champêtre at Hafod,
c.1803, Oil, 457 x 266

234. Thomas Jones,
Images from the Hafod sketchbook,
1786, Pencil, 186 × 145

The precise order in which recommendations were made and relationships established among the complex network of Welsh and English patrons and artists in the second half of the eighteenth century is sometimes difficult to determine. Johnes had first met Banks in Rome, where the sculptor later came to know Thomas Jones of Pencerrig. In June 1778 Jones sat for a bust by Banks. Whether as a result of the sculptor's recommendation or as the continuation of an earlier acquaintance, Thomas Jones was visiting Hafod by 1786.[45] In that year he filled a sketchbook with drawings of the estate, Devil's Bridge and Cwm Rheidol, and also exhibited an oil painting of a waterfall in the grounds at the Royal Academy.[46] In 1803 a visitor to the house noted: 'Over the doors of [the winter dining room] are four coloured drawings of scenes within the precincts of Havod, by Jones.'[47] The friendship between Johnes of Hafod and Jones of Pencerrig is of particular interest in the context of the development of the aesthetics of landscape since, during the second half of the twentieth century, the painter became the focus of critical acclaim. It was not so in his own lifetime, when – much to his chagrin – he cut a very minor figure with critics taken up with the Picturesque. In 1787 William Gilpin was visited by Johnes, who showed him 'a large port-folio, full of paintings (on paper) of a variety of views around his house. They were done by [Thomas] Jones, a pupil of Wilson. On the whole, they were not amiss, considering he is one of your *religious copyists*. But tho I could have criticized the paintings, I very much admired the views; which were both great & beautiful; & as far as I could judge from pictures, well managed.'[48] Gilpin's complaint about Jones was that he depicted nature as he found it, rather than attempting to improve it according to the rules of the Picturesque. His pictures were acceptable only because he faithfully reproduced the scenery which Johnes had already improved along recommended lines.

When Thomas Jones first went to Wilson's studio in 1763 he had regarded his master's pictures as 'coarse unfinished Sketches'.[49] His opinion changed rapidly and, notwithstanding his excursion in 1774 into the historical sublime with *The Last Bard*, he painted mainly Classical landscapes and subject pictures before his departure for Italy. Early during his stay there he had the uncanny experience of seeing the land not through his own eyes, but through his master's:

> It appeared Magick Land – In fact I had copied so many Studies of that great Man, & my Old Master, Richard Wilson, which he had made here as in Other parts of Italy, that I insensibly became familiarized with Italian Scenes, and enamoured of Italian forms, and, I suppose, *injoyed pleasures unfelt by my Companions.*[50]

[44] *Morning Post*, 28 August 1789, quoted in Inglis-Jones, *Peacocks in Paradise*, p. 99.

[45] The suggestion that the two men knew each other at an earlier date derives from the presence of the name 'Thomas Johnes Esq. Croft Castle' among the subscribers to Thomas Jones's *Six Views in South Wales, Drawn After Nature*, published c.1775–6. However, this may have been Johnes' father, and in any case does not necessarily imply that the two were acquainted personally.

[46] *Waterfall in the Garden of Thomas Jones Esq. at Havod*. A second scene at Hafod was exhibited by Jones in 1788.

[47] B. H. Malkin, *The Scenery, Antiquities, and Biography, of South Wales* (London, 1804), p. 357.

[48] Carl Paul Barbier, *William Gilpin: His Drawings, Teaching, and Theory of the Picturesque* (Oxford, 1963), p. 72, Gilpin to William Mason, April 1787.

[49] 'Memoirs of Thomas Jones', p. 9.

[50] Ibid., p. 55. Jones later made money by marketing fake Wilsons: 'I must own too, that I was guilty of a few *innocent* Impostures – by making Imitations of my old Master, Wilson and Zuccharelli – which passed among Our Connoisseurs at some of the public Sales for Originals – but this trade of Imposition was not suffered to last long, from the Jealousy of certain persons, whose province I had, by these Means infringed upon.' Ibid., p. 141. Jones's suggestion that there was something of an industry in copying Wilsons is borne out by the large number of pictures still doubtfully attributed to him in both public and private collections.

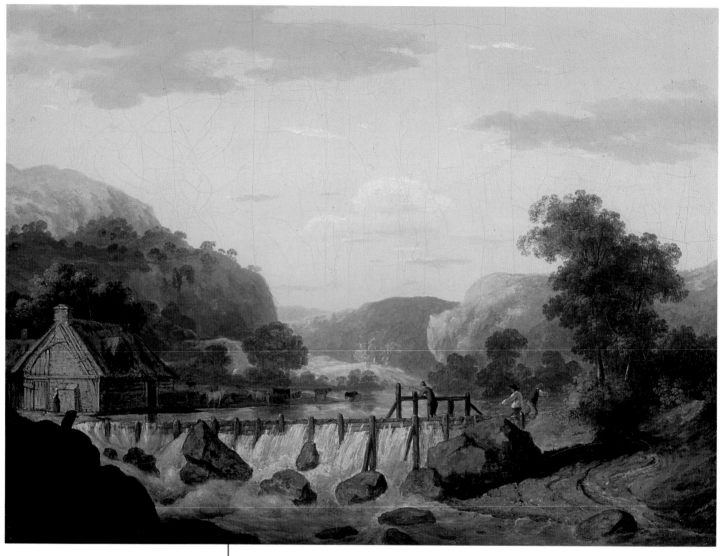

235. Thomas Jones,
Welsh River Landscape,
1775, Oil, 430 × 590

236. Thomas Jones,
Buildings in Naples,
1782, Oil, 140 × 216

[51] Lawrence Gowing, *The Originality of Thomas Jones* (London, 1985), p. 12.

[52] Francis W. Hawcroft, *Travels in Italy* (Manchester, 1988), p. 89.

[53] 'Memoirs of Thomas Jones', p. 141.

Nevertheless, another and perhaps deeper aspect of Jones's temperament had begun to emerge before his stay in Italy. As early as 1772 oil sketches which he made in Wales demonstrated an inclination to respond in an unsophisticated way to landscapes, without seeking to impose Classical, sublime or picturesque principles on what he saw. In a study published in 1985 which opened the way for a reassessment of Jones's work, Lawrence Gowing described this directness of approach as 'a glimpse of the future':

> It looks like the kind of painting that only came to be recognized as a picture a hundred years later. What belongs to the future is not only the colour and light, not only the painter's confidence in an empirical method, not even the freedom of touch but most of all the unity, the sense of visual experience as constituting a whole, almost a separable object.[51]

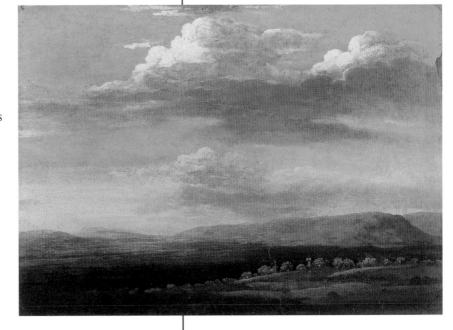

237. Thomas Jones,
A View in Radnorshire, c.1776,
Oil, 228 × 321

It was precisely this empirical method and acceptance of what was presented to his eye as sufficient in itself for a picture that Gilpin sensed and distrusted in Jones's work of the 1780s. This opinion was probably shared by most of his contemporaries, though apparently not by Thomas Johnes. Despite his initial confusion and a steady stream of conventionally Classical prospects painted in Italy, the originality of Thomas Jones had emerged in a series of townscapes painted in Naples which were described two hundred years later as 'some of the most beautiful and original works inspired by the 18th century Grand Tour'.[52] They had gone largely unnoticed by his contemporaries, and by the time of Jones's visit to Hafod in 1785 the painter himself believed his professional career had ended. In 1798 he remarked that 'whatever I have done in the walk of Art since, has been for my own Amusement'.[53] Perhaps liberated by this state of mind, the paintings of his later years, many of them done around his estate in Radnorshire, manifested the naturalism to which his instincts had led him, years before it became the fashion.

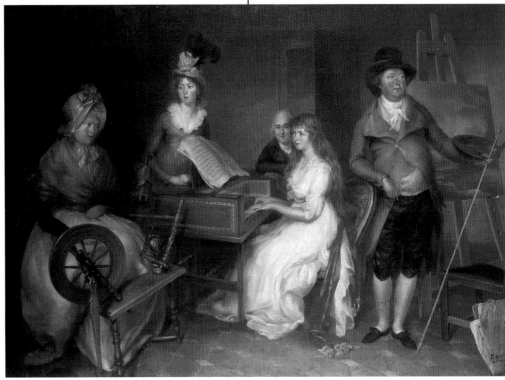

238. Francesco Renaldi,
Thomas Jones and his family,
1797, Oil, 749 × 1016

The arcane debate about what did and did not constitute beauty in a landscape preoccupied the art intelligentsia against a background of violent revolution and war. Hafod rapidly became the great exemplar of the Picturesque, immortalized in publications such as George Cumberland's *An Attempt to Describe Hafod* in 1796 and James Edward Smith's *A Tour of Hafod*, a collection of fifteen large aquatints after John Warwick Smith's watercolours, published in 1810. Yet Hafod did not please all those who saw it. During a tour of the land of his ancestors in 1805, Hugh William Williams, a painter of Welsh parentage who had been brought up in Scotland, offended the proprietor of Hafod with his indifferent response:

239. J. C. Stadler
after John Warwick Smith,
Cavern Cascade from James
Edward Smith, *A Tour of
Hafod*, c.1810, Engraving,
400 × 560

240. Hugh William
Williams, *Caerphilly Castle*,
c.1805, Watercolour,
497 × 883

I asked him to dinner twice when he called & when I met him in the walks. His ideas of Landscape & mine are somewhat different, for he complained of *too much* wood in Glamorganshire!! I saw only two slight Scetches [*sic*], of the Devil's Bridge & part of Chepstow Castle, & to judge from them I do not think he will make a great figure.

⁵⁴ National Library of Scotland, Liston MS 5609, f. 82, Johnes to Robert Liston, 17 July 1805, quoted in Moore-Colyer (ed.), *A Land of Pure Delight*, p. 197. Williams had been recommended by Mrs Liston: 'Mrs Liston's painter, Williams, has been here, but I find she never saw him. If she had, I do not think she would have given him so strong a letter of recommendation.' Johnes' meaning in his reference to a 'maiden view' was that it had not been drawn before. This was a common expression among artists and connoisseurs in the period, for whom the discovery of such a thing on their travels in Wales was an important – and increasingly unusual – achievement.

My chain bridge is up, and more than answers my expectations. It suits the place admirably, which is lower down than where I at first intended it, and the effect is delightful. I wanted Mr Williams to draw it, for it was a maiden view, but he preferred another spot, that could not include it, but which admitted some *naked* hills.⁵⁴

Johnes' estimation of Williams was incorrect, for he went on to make a considerable reputation for himself as 'Grecian' Williams, but the difference of opinion was characteristic of the aesthetic arguments of the period.

241. J. M. W. Turner,
Interior of Tintern Abbey, Monmouthshire,
1794, Pencil and watercolour,
321 × 251

If Thomas Jones's influence on landscape art in his own lifetime was minimal, that of another visitor to Hafod in the period was little short of revolutionary. When J. M. W. Turner visited Wales for the first time in 1792 he was seventeen years old and unknown. Assisted by the critical interpretation of John Ruskin, however, he rose to a status in English art approached by no other painter. Turner's five tours in Wales, all undertaken before the turn of the century, laid the foundations of his art, but demonstrated clearly the stylistic influences of established painters on the young man. On his first visit, Turner had embarked on the conventional Wye tour, making drawings at sites such as Tintern which, over the following three years, he worked up into watercolours for exhibition at the Royal Academy. Turner deviated inland to Abergavenny and Llanthony Abbey, before taking a more unusual route by rejoining the Wye and following it to its source on Pumlumon and beyond, at least as far as Devil's Bridge. It seems most unlikely that he did not visit Hafod, then at the height of its energy, though the watercolour of the house which provides the strongest evidence for such a visit differs in significant respects from the drawing made by John Warwick Smith. It may represent the house as it would have been had Nash's plans been pursued beyond the rear elevations.

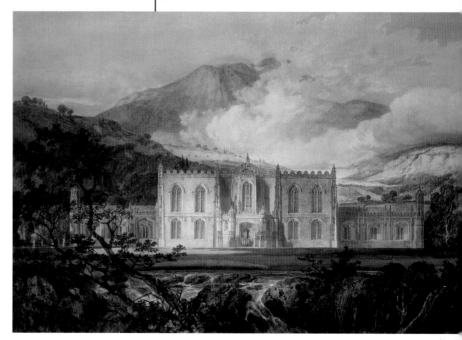

242. J. M. W. Turner,
Hafod, c.1799, Watercolour,
610 × 915

155

243. Probably William
Weston Young,
The Last Bard, Cambrian
pottery mug, c.1805, 155h.

244. John Downman,
The Bard, c.1800,
Chalk and stump on paper,
365 × 204

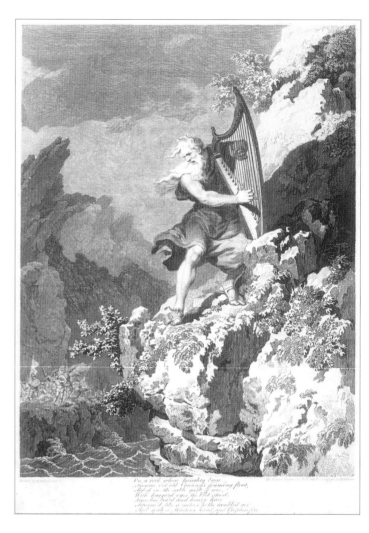

above right:

245. Hall and Middiman
after Philippe de Loutherbourg,
The Last Bard, frontispiece to Edward
Jones, *The Musical and Poetical
Relicks of the Welsh Bards*, 1784,
Engraving, 310 × 228

The results of Turner's exploration of the Wye, like the paintings done on a brief visit to Denbighshire and Flintshire two years later, suggested the influence of Philippe de Loutherbourg, a painter born in Alsace but who was at the height of a very successful career in London. In 1784, like Paul Sandby and Thomas Jones before him, de Loutherbourg had produced a version of *The Last Bard* prior to visiting the site of the supposed genocide. De Loutherbourg's picture was of particular significance in the genre because it was reproduced as the frontispiece to Edward Jones's *The Musical and Poetical Relicks of the Welsh Bards*. Jones's work, the precursor of *The Bardic Museum* illustrated by Ibbetson's image of the harpist John Smith, reached a wide audience and further stimulated the contemporary interest in Wales as a kind of living archaeology of Ancient Britain. De Loutherbourg's picture was certainly the inspiration for a new rash of bardic images, culminating, as far as English painters were concerned, in the exhibition of John Martin's high-romantic work at the Royal Academy in 1817. Among the Welsh contributions to the genre were John Downman's drawing of about 1800, which was clearly intended as the basis for a painting, and the humbler renditions painted on ceramic at the

246. Philippe de Loutherbourg,
View of Snowdon from Llan Berris Lake,
with the Castle of Dol Badon, 1786,
Oil, 499 × 1480

Cambrian Potteries in Swansea.[55] The Bard theme would, in due course,
touch Turner, but at the time of his first Welsh tours his interest seems to have
been in de Loutherbourg's landscape style rather than in his subject pictures.
De Loutherbourg had visited Wales in 1786, resulting in both the publication
of prints in his collection *Romantic and Picturesque Scenery in England and Wales*[56]
and in the exhibition of magnificent atmospheric images of mountain scenery and
turbulent seascapes whose style Turner closely imitated in his Welsh drawings.

In 1795 Turner made a comprehensive tour of Glamorgan and Pembrokeshire,
the material from which he reworked in his London studio for more than a decade.
However, his most comprehensive tour of Wales began in the summer of 1798,
extending from St Donat's in the south to Beaumaris in the north. The works he
produced showed unmistakable signs of the influence of Wilson. Indeed, Turner
visited Wilson's birthplace at Penegoes on his way north. The restrained intensity
of his sketches of Cilgerran Castle and his studio oil painting *Harlech Castle from
Tygwyn Ferry, Summer's evening twilight*, exhibited at the Royal Academy in 1799,

[55] The Downman drawing is squared up in
preparation for transfer to canvas. John Downman
was born in Denbighshire in 1750 and trained at
the Royal Academy schools in 1769. He worked
mainly as a portrait painter, although he exhibited
subject pictures at the Royal Academy, of which
he became an associate member in 1795. Although
he drew and painted some Welsh sitters, and was
a contemporary of Parry and Jones, he seems to
have had little contact with them and worked for
most of his life in England. In his later years he
moved to Chester and finally to Wrexham, where
he died in 1824. Some of the Cambrian Pottery
images were based on the painting by S. Shelley,
published as an engraving in 1786, rather than
on de Loutherbourg's work.

[56] Philippe de Loutherbourg, *Romantic and
Picturesque Scenery in England and Wales* (London,
1805). The text is in English and French.

247. J. M. W. Turner,
*Harlech Castle from Tygwyn
Ferry, Summer's evening twilight,*
1799, Oil, 870 × 1194

seems uncharacteristic of the exuberant romantic he was soon to become, much to the disgust of Ibbetson, who clearly had Turner in mind when he remarked of the works of his old friend John Warwick Smith that they 'will always retain their value, when the dashing doubtful style has long been exploded, in which everything appears like a confused *dream* of nature'.[57]

Turner's final journey, in 1799, took him to Snowdonia and around what was rapidly becoming the standard circular tour of the north. Aided by new roads from Shrewsbury through Betws-y-coed and Capel Curig, the tour included the Conwy valley and such nearby sights as Dolwyddelan Castle. Turner's exploration of mountain scenery in this final Welsh season was notable for its development into historical subject matter inspired by such sites. It is clear from a series of drawings, culminating in the very large watercolour, *Scene in the Welsh Mountains with an army on the march*, that Turner intended to exhibit a Last Bard picture. In the

[57] Julius Caesar Ibbetson, *An Accidence, or Gamut, of Painting in Oil and Water Colours, etc.* (London, 1828), p. 21.

158

248. J. M. W. Turner,
Scene in the Welsh Mountains with an army on the march, 1799–1800,
Oil, 686 × 1000

event, he did not complete the work and his interest in Welsh historical subject matter was expressed publicly in the *Dolbadern Castle, North Wales*, exhibited at the Royal Academy in 1800.[58] Turner appended some lines of poetry to the picture, probably written by himself, which summed up its Romantic mode and epitomized the Welsh experience of so many of his English contemporaries:

> How awful is the silence of the waste,
> Where nature lifts her mountains to the sky,
> Majestic solitude, behold the tower
> Where hopeless OWEN, long imprison'd, pin'd,
> And wrung his hands for liberty in vain.

The subject, visible in the foreground of the painting, was the casting into prison at Dolbadarn of Owain Goch by his brother Llywelyn ap Gruffudd in 1255.

[58] Presented as Turner's diploma piece to the Royal Academy in 1802.

249. J. M. W. Turner,
Sketch for *Dolbadern Castle, North Wales,*
*c.*1799, Oil, 355 × 335

By the turn of the century the flights of fancy indulged by Turner and other Romantics were beginning to supplant the more cerebral entertainments of the seekers after the Picturesque. The theories of Gilpin and Price and the addiction to Welsh tourism which they induced were attracting cynical comment among the English. The humourless Gilpin was a particularly tempting target; he was satirized by William Combe and Thomas Rowlandson in the character of Dr Syntax, the obsessive picturesque traveller.[59] Rowlandson, who was in a position to speak with authority, having accompanied Henry Wigstead on tour in 1797, expressed his misgivings most famously in the aquatint entitled *An Artist Travelling in Wales.* The painter, heavily encumbered with the paraphernalia of the tour and drenched to the skin, was observed with some bewilderment by a family of locals. The reactions of more elevated Welsh observers of the phenomenon, which Sir Watkin Williams Wynn, Thomas Pennant, Thomas Johnes and others had done so much to stimulate, were, as ever, ambiguous. The feeling that any kind of recognition by the English was better than life in the vacuum which had preceded it was matched by signs of increasing irritation at the perception of Wales as an aesthetic object, and at what many regarded as misinformed comment on both its history and the current condition of its people. The first stirrings of

250. M. Williams,
*A Perspective View of
Newton in Carmarthenshire*,
1773, Engraving, 98 × 169

Wales as a nation with opinions about itself in the contemporary world began to be heard. The earliest attempt at producing a Welsh periodical in English which might provide a forum, like *The Gentleman's Magazine*, for the discussion of the arts and sciences appeared in 1773. *The Cambrian Magazine* promised that 'no expence of Copper-Plates will be spared towards illustrating this Work',[60] and views of Newton and of Golden Grove in Carmarthenshire by Matthew Williams, a land surveyor by profession, were published.[61] However, the venture was short-lived and not until the publication of *The Cambrian Register* in 1796 did any further imagery or comment representing a Welsh point of view appear in periodical form. The frontispiece to the magazine, *BRITANNIA directing the attention of HISTORY to the distant view, emblematical of WALES*, was a revealing manifestation of the state of mind of the older Welsh intellectual of the period. The commissioned artist, Richard Corbould, was English, though he clearly had an interest in Welsh imagery since in the same year as his frontispiece he also engraved an image of the Last Bard for an edition of Gray's poems.[62] His presentation of Wales as a distant view precisely echoed Thomson's Anglocentric perception in *The Seasons* sixty-six years earlier; nor had the chosen emblems changed significantly in the meantime: 'The ruined castle and bardic circle, in the back ground enveloped in clouds, allude to ancient times; and the intermediate space represents the present state of the country', that is, Anglican and peaceful, indicated by a church and a ploughman. For the

[59] William Combe and Thomas Rowlandson, *The Tour of Doctor Syntax in search of the Picturesque, Consolation and a Wife* (3 vols., London, 1823).

[60] *The Cambrian Magazine*, I (1773), p. vii.

[61] For Williams, see *DWB* and Paul Joyner, *Artists in Wales c.1740–c.1851* (Aberystwyth, 1997), p. 131.

[62] *The Cambrian Register for the year 1795* carried the imprint 1796, as did Bromley's engraving after Corbould. It was dedicated to Robert Fulk [*sic*] Greville. Corbould exhibited an oil painting of the Last Bard at the Royal Academy in 1807.

251. Thomas Rowlandson,
An Artist Travelling in Wales,
1799, Aquatint,
310 × 380

253. Edward Pugh,
Frontispiece to *Cambria Depicta*,
1816, Aquatint, 249 × 170

BRITANNIA *directing the attention of* HISTORY *to the distant view, emblematical of* WALES. *The ruined castle and bardic circle, in the back ground enveloped in clouds, allude to ancient times; and the intermediate space represents the present state of the country.*

252. Bromley after Richard Corbould,
BRITANNIA *directing the attention of* HISTORY
to the distant view, emblematical of WALES,
1796, Engraving with watercolour,
136 × 90

likes of the ageing Thomas Pennant at Downing and Thomas Johnes at Hafod, as much as for their English associates, these emblems had a particular resonance in a country increasingly disturbed, as they saw it, by Methodist enthusiasm and radical sentiment, while a revolution against the old order of which they were part was under way in France. Nevertheless, the second volume of *The Cambrian Register* included a lengthy satirical attack, entitled 'Cursory Remarks on Welsh Tours or Travels', which voiced the irritation of patriotic Welsh intellectuals at the misrepresentation of their nation by the English:

> I fear that, in most of those who have honoured Wales with a visit, will be found a lamentable deficiency. Whether it be from the want of knowledge of the language, or from too transient an acquaintance with the inhabitants, it is remarkable, that, among all the tours into this country, which have met the public eye, (Mr. Pennant's only excepted ...) we have nothing like a resemblance of the men and manners of Wales.[63]

With a sideswipe at 'Wenglish' – 'swearing–G–t splutter hur nails (a Welsh oath manufactured in England)' – the anonymous critic, calling himself 'Cymro', turned to the description of a recently published tour:

> Through South Wales this writer darts with the rapidity of lightning. A compliment, indeed, (envolant) is paid to its beauties; but its description, if such it may be called, is comprised in the table of contents. 'Beautiful landscapes for the pencil and the pen.' 'Abergavenny' – 'Brecknock' – 'Carmarthen' – 'Sea-pieces' – 'Rock-work' – 'New and old Passage' ... Now, from this prospectus, the reader might be lead to expect to hear something about these places:– Not a word. Even their names are never introduced or mentioned through the whole chapter. As to the remaining towns in South Wales, we must rest satisfied with being told, that they are sweet places. Then, hark for Machynlleth ... in North Wales! By all the Jack o'lanthorns – if he takes such rapid strides, there is no following this fellow! The man in the seven league boots was a snail to him.[64]

[63] Cymro, 'Cursory Remarks on Welsh Tours or Travels', *The Cambrian Register for the year 1796* (1799), 422. 'Cymro' has not been identified, but was clearly a Welsh speaker from south Wales, and probably resident in the country.

[64] Ibid., 424–5.

255. Robert Havell after Edward Pugh, *Shâne Bwt*, from *Cambria Depicta*, 1816, Aquatint, 127 × 102

above centre:

254. T. Cartwright after Edward Pugh, *A Visit to Cader Idris*, from *Cambria Depicta*, 1816, Aquatint, 103 × 137

That 'Cymro' echoed a general feeling of dissatisfaction with published Welsh tours is borne out by a conversation which occurred around 1800 between the artist Edward Pugh and John Boydell. Pugh was primarily a miniature painter who was patronized by several well-known Welsh sitters, but he also contributed topographical and architectural illustrations to London publications, including Henry Wigstead's *Remarks on a Tour to North and South Wales* (1799).[65] The conversation resulted in ten years' labour on the text and drawings for Pugh's *Cambria Depicta*:

> A few years before the demise of that venerable patron of the arts, ALDERMAN BOYDELL, chance gave me the opportunity of an hour's conversation with him, at the Shakespeare Gallery. To that conversation the following work owes its origin. Mr. Boydell lamented that the landscape painters, whom he had employed in Wales, confined the efforts of their pencils to the neighbourhood of Snowdon: thus multiplying copies upon copies of the same sketches ... This practice they defended on the ground of the difficulty in which a stranger, unacquainted with the language or the country, involved himself, the moment that he quitted the high roads, and plunged into the intricacies of the mountains. To obviate this inconvenience, Mr. Boydell suggested the expediency of publishing a small volume of direction by a native, whose local knowledge should qualify him for the task.[66]

Accompanied by a 'very pretty little dog', Pugh travelled on foot, with 'a light knapsack on my back, containing only what was barely necessary, an umbrella in my right hand, and under my left arm a small portfolio suspended to my right shoulder by a broad piece of tape'.[67] He set himself the task of giving an insider's view and, indeed, provided all the necessary information to lead artists and

[65] Edward Pugh (1763–1813) was probably born in Ruthin. Among the most notable volumes to which he contributed illustrations was *Modern London*, 1805. Although Pugh is named among the illustrators of Wigstead's text, his signature does not appear on any of the engravings. Among Pugh's more curious commissions was one from Richard Llwyd, Bard of Snowdon, who in London in 1800 happened upon 'a living likeness' of his deceased mother. Pugh painted her in miniature and subsequently the poet had Mrs Cobbold of Ipswich paint a half length from it. Llwyd wrote a poem to her in thanks, though it does not rank among his finest effusions: 'O Cobbold! while the greatful glow is mine, / A parent's smile celestial shall be thine!' The poem was published in *The Cambro Briton and General Celtic Repository*, II (1821), 329.

[66] Pugh, *Cambria Depicta*, Preface. Boydell died in 1804, giving the approximate date of 1800 for the conversation with Pugh. The artist did not begin work until the year of Boydell's death (although he made use of some earlier drawings), and did not live to see his book published. He died in 1813, shortly after the completion of the text, which was published by Evan Williams in 1816.

[67] Ibid., pp. 10, 17. In his 'Cursory Remarks on Welsh Tours or Travels', p. 451, 'Cymro' had castigated a reverend English gentleman for travelling on foot, finding it 'impossible to avoid saying two or three words upon this silly and ridiculous whim of converting pleasure into toil'.

connoisseurs to the best prospects in north Wales. However, his account – by far the most entertaining of any in the period – was also notable for a distinct change of tone. Thomas Pennant had been an insider, but Pugh's voice was touched by a democratic spirit, quite different from that of the squire of Downing. He regaled his readers with interesting incidents, gossip, and his own idiosyncratic opinions, especially on matters of aesthetics. Pugh was clearly inclined to the Picturesque, commenting favourably on the variety of architectural forms to be observed in the main street of Bala, for instance, in unlikely contrast to the 'great formality' of 'the modern method of building in London', exemplified by Portland Place and Cavendish Square. This was an implicit criticism of the chameleon John Nash, who was at that time setting a Classical trend in metropolitan architecture.[68] Contrarily, Pugh was an advocate of Wilson, referring to him as 'a brilliant of the first water',[69] and – like Pennant and Thomas Jones – he confirmed that Wilson's images had imprinted themselves indelibly on the mind's eye of the period. At Cadair Idris, for instance, Pugh 'stood upon the spot where … Mr Wilson must have sat, to sketch for that fine picture of his, a subject which he afterwards published'.[70]

As a patriot, Pugh was occasionally moved to righteous indignation at the misrepresentation of Welsh people:

I have but too often seen it observed by tourists, that the Welsh are an 'unpolished and ignorant people'; if at all ignorant, it must be ignorance of those fashionable dissipations, the never-failing promoters of diseases, incident only to the *great* and fashionably *wise*, who take so much pains to secure them; so far as the Welsh are ignorant of such *finished*, such *elegant* refinement of manners, may they ever remain so![71]

Nevertheless, his patriotic feelings involved him less often in vacuous praise of the virtues of his people than in pointing out their need for improvement. Although not consistently radical, he was concerned about the condition of the Welsh people, and to that extent his voice was a new one in the field of visual culture. His self-confessed limitations as a draughtsman may have resulted in conventional illustrations, but the text of *Cambria Depicta* represented a profound change of view which would rapidly overtake Welsh intellectual life. Despite his interest in such matters as the precise location of the suicide of Gray's 'Last Bard',[72] Pugh signalled that the Welsh were no longer simply Ancient Britons but also a people who might be expected to sustain a modern culture.

[68] Pugh, *Cambria Depicta*, pp. 278–9. The new buildings in London, according to Pugh, were 'ever offensive to the eye'. Among a number of Nash's projects setting the architectural tone in London was Regent Street. His fondness for stucco was mocked in *The Quarterly Review*, XXXIV, June and September 1826, 193: 'Augustus at Rome was for building renown'd / For of marble he left what of brick he had found. / But is not our Nash, too, a very great master; / He finds us all brick and he leaves us all plaster.'

[69] Pugh, *Cambria Depicta*, p. 345.

[70] Ibid., p. 204.

[71] Ibid., p. 53.

[72] For Pugh's fascination with this subject and his opinion of de Loutherbourg's image, see ibid., p. 416.

256. Francis Chantrey,
Thomas Johnes, c.1819,
Plaster, 720h.

257. Francis Chantrey,
Memorial to Mariamne Johnes,
Hafod Church, Cwmystwyth,
c.1811

In 1807, as Pugh travelled through the north, a disastrous fire at Hafod burnt many of Thomas Johnes' books and art works. Although Johnes rebuilt the house with the aid of Baldwin (though not of Nash), and bought new libraries, painting and sculpture, the enterprise was ill-fated. In 1811 the death of Mariamne occasioned a great valedictory commission to Francis Chantrey for a memorial to his daughter, which was installed in the church he had built on the estate. Johnes struggled on until 1815, when he left Hafod to live in Devon, where he died the following year. His departure symbolized the end of the era in which the old gentry and those who clustered around them could claim the intellectual leadership of the nation, just as *Cambria Depicta* indicated the beginning of the new age. The likes of Johnes gave way to a new class, rising from below. Despite their varying political standpoints, the connoisseurs and aesthetes of the second half of the eighteenth century – Sir Watkin Williams Wynn, Thomas Pennant, Evan Lloyd, Thomas Johnes and others – had been united in their hostility to the powerful religious movement among the common people and the middle classes which would redefine Welshness in the nineteenth century. All of them were appalled by 'the extravagant ravings of methodism'.[73]

In the summer of 1820 the painter Hugh Hughes arrived at Devil's Bridge to draw the view for his book of wood engravings, *The Beauties of Cambria*. Hafod was a thing of the past, and apart from an oblique reference to the excessive planting of trees in the area, Hughes paid it no attention.[74] His project was in the tradition of the Bucks, Boydell and Sandby, and he was well aware of the vocabulary of landscape aesthetics, as demonstrated in his description of his own locality of the Conwy valley, where 'the sun shining nearly horizontal between still heavy clouds upon the hills & fields recently washed with heavy rain, and the stillness [and] crystaline brightness of the gliding stream made the meanest objects appear magnificent, and the magnificent inexpressably grand and awful'.[75] However, such language was a veneer, laid over a perception of the world with its origins in a different set of circumstances from those which had conditioned the products of Dyer, Wilson, Parry and Thomas Jones. Hughes had been born into a poor Welsh-speaking family, had largely educated himself and had learnt wood engraving in a craft workshop. Moreover, he was a Methodist of strong convictions. Following his visit to Devil's Bridge, he set off in the direction of Aberystwyth only to become hopelessly lost.

[73] Cymro, 'Cursory Remarks on Welsh Tours or Travels', 431.

[74] Hugh Hughes, *The Beauties of Cambria* (London, 1823), 'Devil's Bridge': 'The exquisite natural beauty of the surrounding scenery is also, in a great measure, destroyed by the thickness, and the uniformity of the trees that have been planted here in all directions, it would almost seem, for that purpose.'

[75] NLW, Cwrt Mawr MS 130A, The Diary of Hugh Hughes, 5 July 1819.

[76] Ibid., 4 September 1820.

258. Hugh Hughes, Handbill advertising *The Beauties of Cambria*, with wood engraving of Caernarfon Castle, 1818, 231 × 192

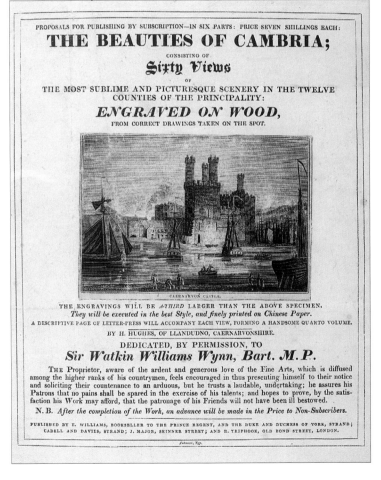

165

259. Hugh Hughes,
Brynllys Castle, from *The Beauties of Cambria*,
Wood engraving, 1822, 84 × 125

His feelings, recorded in his diary but not published in *The Beauties of Cambria*, owed much less to Gilpin than to the Methodist hymn writer William Williams, Pantycelyn, in their appreciation of his circumstances as an allegory of the human condition – a 'Benighted bewildered traveller!'[76] lost in the wild landscape of life but hoping to find both human and eternal habitation:

> A pilgrim in a wasted land
> Roaming here and there,
> And half expecting every hour
> My father's house at hand.[77]

Hughes had received no academic training as an artist. Nevertheless, since 1812 he had worked not only as an engraver but also as an itinerant portrait painter, and had depended largely on people of his own class and of similar religious persuasions for patronage. Both as patrons and as makers, that class would dominate the imaging of the nation until the second half of the nineteenth century.

260. Hugh Hughes,
Falls of Helygog, from *The Beauties of Cambria*,
Wood engraving, 1821, 84 × 125

[77] 'Pererin wyf mewn anial dir /Yn crwydro yma a thraw, / Ac yn rhyw ddisgwyl bob yr awr / Fod tŷ fy nhad gerllaw.'

chapter

six

THE ARTISAN

AND THE

MIDDLE CLASS

261. Randle Holme III,
The Limner, from *The
Academy of Armory*, 1688,
Woodcut, 31 × 24

By the early eighteenth century a gradual change in the status of certain kinds of painting had largely removed portraiture from the hands of the general artisan. Gentry patrons came to recognize the portrait as an art object of intrinsic value rather than simply a record of lineage, even if most of them could scarcely be termed art lovers. As well as an expression of self-esteem, the portrait commission became a display of wealth and of the increasingly important idea of good taste among the peer group. The rise in the status of the painting was matched by that of the painter, and the craft branched into a series of specialisms with their own hierarchy – history painting, portraiture, landscape and so on – each involving specialist training. In the absence of a centre of training and patronage within Wales, comparable to that of the Scots at Edinburgh, where the Academy of St Luke was established in 1729, the patronage of the Welsh gentry was dominated by London taste throughout the eighteenth and nineteenth centuries. The descendants of those who patronized Reynolds in the mid-eighteenth century might patronize Herkomer in the late nineteenth, and the less well-placed sought out the second-ranked painters who reflected the trends set by these giants of the metropolitan art world.[1] The sense of national or parochial identity of which Wilson was able to take advantage both as a portrait and as a landscape painter in the eighteenth century was periodically reflected in nineteenth- and early twentieth-century patronage when a Welsh painter such as Penry Williams or Augustus John rose to high status, but it cannot be said that it was a dominant or even widespread tendency among the gentry.[2]

Nevertheless, the rise in the status of the art painter did not bring to an end the tradition of the artisan in Wales. Elements within the broad range of commissions given to Thomas Ffrancis at Chirk Castle in the 1670s, for instance, persisted – subject to the vicissitudes of taste – well into the nineteenth century. It seems likely that the painting of wainscot at Chirk Castle involved only simple colour washing of the sort that gave rise to the description of many rooms in inventories of the period as 'the red room', or 'the blue room'. Yet Ffrancis would certainly have been able to carry out more complicated decorative schemes such as that at Tudor Street in Abergavenny, and although the advent of hand-painted and then printed wallpaper reduced the number of such schemes in the eighteenth and nineteenth centuries, artisan-painted wall decorations periodically returned to fashion. In the early nineteenth century Edward Pugh noted with distaste a trend, filtering down from high fashion, which he regarded as being particularly prevalent in the Welshpool area:

[1] Frederick Vaughan Campbell of Golden Grove, for instance, whose ancestors had patronized Reynolds, Lawrence and Beechey, commissioned Herkomer in 1886.

[2] For example, the Guest family patronized Penry Williams, for which see Lord, *The Visual Culture of Wales: Industrial Society*, pp. 60–2, 74, and in the 1930s the Davies sisters patronized Augustus John.

Before I quit this neighbourhood, I shall take the opportunity of noticing how general it is, to paint the walls of the rooms of public-houses in size, with decorations of festoons, and in pannels ornamented with various devices, strongly mimicking the present mode, so prevalent among the fashionable world; than which nothing can more display a want of taste.[3]

In developing his point, Pugh incidentally made quite clear the firm distinction that now existed between the artisan and the art painter, and that the relationship between them was hierarchical:

Is it not to be lamented, that preference should be given to the performances of those who follow the meanest, and lowest parts of the arts (it is a question, indeed, whether they belong to them at all), and which are often executed by sign-painters, when the highest and most noble branches of painting are neglected, and suffered to decay?[4]

The patronage of artisans by the Myddelton family in the seventeenth century extended well outside the private apartments of the castle and into commissions with a public aspect. Indeed, the new inn sign painted by Thomas Ffrancis for the Bull in Denbigh shows that their patronage penetrated to the heart of urban community life. The Bull was owned by the Myddelton family and the commission was echoed nearly thirty years later, in September 1700, when Shadracke Pride was paid £2 9s 6d 'for painteing & making a new white Lyon (the ould one beinge broke) at the white lion in Ruthin'.[5] The wording of the account suggests that the lion may have been carved in wood rather than painted on board, and a few examples of carved and lettered signs are recorded, notably Y Tŷ Gwyrdd, set up in 1719 at Llanfihangel Llantarnam in Monmouthshire, which promised:

Good Beer
 And Cider for you
Come in
 To sample them.[6]

The sculptor depicted a variety of drinking vessels, including a glass or goblet, a tankard and a horn, set above this encouraging text. Thomas Ffrancis's sign at the Bull apparently lasted for nearly fifty years, but was finally repainted or replaced in 1721.[7] Since they were exposed to the weather, surviving eighteenth-century

262. Anon.,
Y Tŷ Gwyrdd, Llantarnam,
Monmouthshire, 1719, Stone

[3] Pugh, *Cambria Depicta*, p. 247.

[4] Ibid.

[5] Myddelton, *Chirk Castle Accounts (Continued)*, p. 316. In 1696 Pride had painted sundials in the grounds and the churchwardens' accounts at Ruthin record a payment made to him in 1692 for mending two Books of Common Prayer.

[6] Translated from the Welsh original: 'Cwrw da / A Seidir i chwi / Dewch y mewn / Chwi gewch y brofi.'

[7] The new sign was painted by John Maurice.

263. D. J. Williams,
*The Four Alls, c.*1850,
Oil, 1193 x 787

264. John Thomas,
The Goat Inn, Bala,
c.1860–70

signs are very rare, but nineteenth-century examples, such as *The Four Alls*, painted by D. J. Williams at Porthaethwy, emphasize the continuity of artisan work through two centuries, although by this time it seems unlikely that the local gentry would have been the patrons. Photographs taken in the 1860s by John Thomas demonstrate that even in the poorest villages of rural Wales painters were available to produce signboards.[8] The impact of sign paintings on the common people, not exposed to framed academic paintings on the walls of their houses, can be gauged from the experience of the young John Gibson in Conwy at the end of the eighteenth century. The great sculptor acknowledged their role in his visual awakening:

When about seven years old I began to admire the signs painted over ale-houses, and used constantly to gaze up at them with great admiration.[9]

Continuity in the tradition of artisan painting in public places was also maintained into the nineteenth century in churches. In 1679 Thomas Ffrancis was paid £5 by the Myddeltons 'for writeinge the Ten comaundments to be sett vp in Chirke Church',[10] and in theory such work became widespread since church law required that scriptural inscriptions be set up 'at the charge of the parish upon the east end of every church … and chapel, where the people may best see and read the same'.[11] However, the law was only sporadically obeyed, and even where new inscriptions and paintings were carried out in the seventeenth and eighteenth centuries subsequent generations of churchwardens might not have been assiduous in ensuring their upkeep. The archdeacon's visitation report for Penllyn and Edeyrnion in 1729 was critical of the efforts of many parishes like Llangywer, where 'The plaistering of the whole church is dirty and foul, and within the chancel the King's Arms, the Creed, the Lord's Prayer and other useful, chosen sentences are almost quite defac'd.'[12] Few churches survive with more than fragments of paintings and texts made by eighteenth-century artisans, but Cil-y-cwm in Carmarthenshire is remarkable not only for the extent of the work, which includes a Royal Arms, a Creed, a Decalogue and two other scriptural quotations, but also because the work is dated and the artist identified with some certainty. The paintings were carried out in 1724 (though some may have been reworkings of older designs) and the artist was probably John Arthur, who also worked as a monumental mason, reflecting the need for such a craftsman to be a generalist in a rural area.

Some artisans worked directly on plaster, while others worked on board, as at Llanerfyl, where a remarkable series of religious subjects were painted on three panels in 1727. The panels were originally part of the gallery front and the subjects, which included Moses, the Baptism of Christ, a Madonna and Child and the Crucifixion, were most unusual in Wales in the period. Although figurative imagery crept back into church decoration after the Restoration, acceptable subject matter – such as Moses and Aaron accompanying the Ten Commandments – was very limited. The imagery at Llanerfyl stood outside this conventional canon. It is reasonable to suppose that the unidentified painter relied on engravings after Renaissance paintings, published in illustrated bibles, as a source, but the circumstances of the commission are unknown. Documentation of such commissions, public or private, is generally very scarce, though something is known of that given in about 1746 by Simon Yorke of Erddig for the Ten Commandments and the Creed for Berse Drelincourt Chapel near Wrexham. The Berse Drelincourt paintings were done on canvas and were unusually

265. Anon.,
Biblical Subject Paintings,
Church of St Erfyl,
Llanerfyl, 1727, Oil

[8] Contrary to the report of Revd H. Longueville Jones in his evidence to the Committee of Council on Education for 1854–5, which suggested otherwise. For a discussion of this evidence see Peter Lord, 'Mr Richard's Pictures: Published for the Encouragement of Native Talent', *Planet*, 126 (December 1997/January 1998), 66–74.

[9] Thomas Matthews, *The Biography of John Gibson, RA Sculptor, Rome* (London, 1911), p. 3.

[10] Myddelton, *Chirk Castle Accounts (Continued)*, p. 134.

[11] Canon 82.

[12] NLW SA/RD/21, quoted in G. M. Griffiths, 'A Report of the Deanery of Penllyn and Edeimion By the Reverend John Wynne 1730', *The Merioneth Miscellany*, series 1, no. 3 (1955), p. 20.

266. Anon.,
The Creed, Berse
Drelincourt Chapel,
1746, Oil,
1120 × 890

267. Thomas Jones,
The Lord's Prayer and
the Ten Commandments,
Church of St Melangell,
Pennant Melangell,
1791, Paint on plaster

sophisticated. The Commandments were accompanied by images of Moses and Aaron, and the Creed was encircled by an image of Britannia clothed in the whole armour of God and the works of mercy.[13] Nearly fifty years later, in 1791, Thomas Jones was paid £3 for a painting at Pennant Melangell of *The Lord's Prayer and the Ten Commandments*, flanked by two figures (though not, apparently, Moses and Aaron, since one of them is winged). In this case the work was painted directly on the wall. Some other surviving examples can also be identified as the work of named artisans, as at Llansilin, where the vestry book recorded a payment of £3 3s 0d to one Mr Griffiths for a Lord's Prayer in 1813.[14] Llansilin also provides a particularly fine example of the painting of charity boards, a further type of public commission carried out by artisans and usually found in churches. The Llansilin board, dated 1740, is framed in an architectural setting of fluted columns, and the names of those who left monies to the poor of the parish are flanked and surmounted by angels, painted in subdued greys and browns.[15]

[13] The Berse Drelincourt Chapel was constructed as part of a charity school for girls. In addition to the conventional texts and imagery, a 'Large Picture of Our Saviour Discovering Himself to the Disciples in Breaking of Bread was given by the Rev. Mr. Henry Lewis Young of Ireland'. See A. N. Palmer, *History of the Thirteen Country Townships of the Old Parish of Wrexham* (Wrexham, 1903), p. 96. The *Ten Commandments* was destroyed by a fire in the chapel. There is a further example of the Moses and Aaron iconography at Cil-y-cwm, Carmarthenshire.

[14] Griffiths may possibly have been the stonemason Richard Griffiths of Oswestry.

[15] At the church of St Teilo in Tre-lech, Carmarthenshire, a most unusual nineteenth-century example of a charity board depicts the interior of a charity schoolroom. It was painted by Job Brigstocke.

The Royal Arms which adorn many churches could provide
an occasion for the public display of a painter's abilities on
a large scale.[16] For obvious reasons, surviving Royal Arms
predating the civil wars are uncommon,[17] but numerous
examples from the Restoration period and from the early
eighteenth century remain. These include some signed by
an artisan, as at Colfa in Powys, where the name of Jeremiah
Cartwright appears with the date 1733. At least two generations
of Cartwrights, Jeremiah and William, worked in the area as
both painters and monumental masons. Similarly, the personal
hatchments of prominent local families set up in churches in
the tradition of the herald painters of the sixteenth and early
seventeenth centuries could also be elaborate affairs, and
some groups represent a continuity of tradition into the
nineteenth century.

268. Jeremiah Cartwright,
The Royal Arms, Church of St David,
Colfa, Powys, 1733, Oil,
2032 × 2159

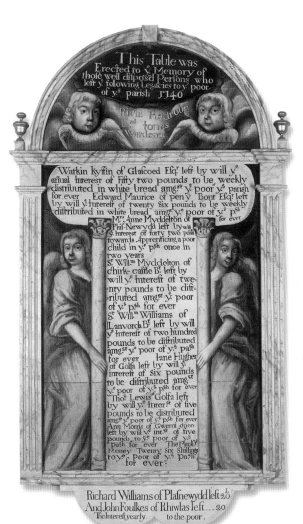

269. Anon.,
Charity Board, Church
of St Silin, Llansilin,
1740, Oil

[16] Occasionally the Royal Arms were carved
or moulded in plaster. A particularly impressive
example in plaster survives at Llansilin from the
time of Queen Anne (1702–14).

[17] An example survives at Llantwit Major.

18 The whereabouts of the picture are unknown. It was published by W. M. Myddelton, *Pedigree of the family of Myddelton of Gwaynynog, Garthgynan and Llansannan* (Horncastle, 1910), p. 24.

19 The Myddelton poem preserved on the painting is not entirely legible but begins 'Yfwn Gwrw yn Gaerog / Mewn llawen fodd galluog / ... MILTWN [i.e., Myddelton] ...' (Let us drink beer staunchly / In a happy and able manner / ... MILTON [i.e. Myddelton]). Robert Myddelton of Gwaenynog was a supporter of the Welsh language, see above, Chapter 5, note 18. The Wynn *englyn* is more complete: 'Fel yr Haul araul iw Oror, cadam / I cododd ein Blaenor; / Trwsiwn WYNN, WYNN yw'n Try[sor] / Fu fawr fawl o for i for!' (As the bright sun to its border, strongly / Did our leader rise; / Let us enrobe WYNN, WYNN is our Treasure / Who was great his praise from sea to sea!)

20 The Wynn picture is also of great interest because it is painted over a picture of an urn with a ribbon, which is almost certainly a rare survivor of the temporary funerary art commissioned so often by the Myddeltons in the seventeenth and early eighteenth centuries. The second picture was revealed by X-ray photography.

That some artisan painters of the early eighteenth century, working in rural areas or in small towns, were capable of painting portraits is clear from the evidence of their efforts in other genres. In 1785 an unknown artisan painted a group portrait of seven male servants at Gwaenynog celebrating the coming of age of Richard Myddelton of Chirk Castle.[18] Four of the portraits were painted in full profile and there are two inscriptions – conventions long abandoned by academic portrait painters but familiar to painters of inn signs and church texts. The first inscription appeared as a painting within a painting, pinned to the wall behind the revellers, and took the form of verses above an image of the castle. The second was an otherwise unrecorded poem in praise of the family, which was inscribed in identical style to a celebratory *englyn* on another painting, recording the coming of age of Robert William Wynn of Melai, Maenan and Garthewin, dated 1787.[19] Melai and Garthewin stand close to Gwaenynog and it seems certain that the same painter was responsible for both pictures. The Wynn painting, however, has no portraits, but combines heraldry, an angel and trumpet (typical of church painting in the period), and a symbolic sunrise over a landscape, all familiar elements in the artisan painter's repertoire. Whether the two pictures represent the sole survivors of a widespread tradition of commissioning artisans to paint coming of age pictures, comparable to the poetic celebration of such events, is unclear, as is their precise place in the associated customs. In the case of Robert William Wynn, it is reasonable to speculate that the picture may have been exhibited in public at a celebratory ball or some such event.[20] The painting of servant portraits, however, certainly became a genre in the eighteenth century and was usually practised by artisans. The earliest Welsh example, known as *The Gamekeeper at Edwinsford*, is in fact one of several versions of a work by the Danish painter Bernhardt Keil, presumably copied from an engraving. The architecture of the grand house in the background has been adapted, but the features of the sitter remain close to those of the original.[21] Nevertheless, the Edwinsford keeper seems to have been a remarkable individual since he was also celebrated in a lead statue, presumably commissioned by Sir Nicholas Williams.

The servant portrait genre, of which the Edwinsford picture is a very early example, was represented at Chirk Castle by a more typically artisan product which may, indeed, represent the work of the Gwaenynog painter. The humorous depiction of a member of the household straining to ring the castle bell suggests strongly that it was the work of an individual of similar status. The servant genre reached its impressive high point not far from Chirk Castle, at Erddig, near Wrexham.

271. Anon.,
Ringing the Castle Bell,
c.1785, Oil,
558 × 469

272. Anon.,
The Coming of Age of
Robert William Wynn
of Melai, Maenan
and Garthewin,
Denbighshire, 1787,
Oil, 635 × 584

273. Anon.,
Servants at Gwaenynog
celebrating the Coming of Age
of Richard Myddelton of Chirk
Castle, 1785, medium and
size uncertain

opposite: 270. Anon. after Bernhardt Keil,
The Gamekeeper at Edwinsford, 1725,
Oil on canvas, 1250 × 1000

A portrait of a coach-boy was painted for John Mellor in the early eighteenth century,[22] to which Philip Yorke I, a later owner of the estate, added celebratory verses in English in the 1790s. This addition was to make the picture consistent with a series of portraits of servants and tradespeople which he himself had commissioned. In 1793 Yorke noted in his diary a payment of four guineas to John Walters of Denbigh for painting portraits which can be identified as those of Jane Ebrell, described as a 'spider brusher' and William Williams, a blacksmith. Jack Henshaw, a gamekeeper, Jack Nicholas, a porter, and Edward Prince, a carpenter, had been painted in 1791 and 1792, and in 1796 the series was completed by a portrait of Tom Jones, a butcher and publican in Wrexham. The style of the pictures and the absence of any other portrait commissions attributable to him strongly suggest that Walters was an artisan in general practice. The pictures vary considerably in iconography. The two earliest echo the conventional portrait of the gentleman with his house in the distance, and may possibly be deliberate pastiches, directed by Philip Yorke, whose sense of

[21] A closely similar copy, originally in Berkshire, is illustrated in Sotheby's sale catalogue, *Important British Paintings,* 24 November 1999, p. 106.

[22] Assuming it was painted from life and not in retrospect. The picture was sufficiently celebrated to encourage the painting of at least one full-size copy.

274. John Walters,
William Williams, Blacksmith,
1793, Oil on canvas,
1115 × 930

opposite:

275. John Walters,
Thomas Jones, Butcher and Publican,
1796, Oil on canvas,
1095 × 1090

humour is evident from the verses he appended to the whole series. The portraits of Jane Ebrell, William Williams and Edward Prince depicted the sitters less formally, at their homes and places of work, and seem much more likely to represent the painter's own sense of design. The narrative of the texts is strongly taken up in the imagery of the Williams portrait, since he is shown simultaneously outside his smithy and, in the background, participating in a fist fight, a sport for which he was renowned. This narrative approach is most clearly evident in the last picture in the series. The scene is identified as Wrexham by the famous Yale Tower of the town church, which is brought into the picture by the expedient of slicing the side of an intervening building in half. Tom Jones is portrayed in front of his shop and inn, the Royal Oak, which displays a sign of the kind that Walters himself had probably painted many times.

276. Anon.,
Memorial to
Jeffrey Johnes,
Taylor of Brecon,
Cathedral Church
of St John the
Evangelist, Brecon,
1618, Stone,
800 × 330

277. Anon.,
Gravestone of
Alice Evans
of Llangattock,
Church of
St Cadoc,
Llangattock Vibon
Avel, 1706, Stone,
1100 × 480

[23] The makers have not been identified, perhaps because their workshop was located outside the centre of the town. The wider practice of the workshop is suggested by a contemporary fireplace at Newton, Breconshire, inscribed in the same letter style.

[24] See A. O. Chater, 'Early Cardiganshire Gravestones', *Arch. Camb.*, CXXV (1976), 140–61; ibid., CXXVI (1977), 116–38.

The emergence of named artisans such as Walters, who sometimes signed their pictures, and the painting of portraits of people below the gentry in the social order, was echoed in the work of stonemasons from the late seventeenth century. The marking of graves by inscribed and sometimes decorated slabs and then headstones gradually spread down through the merchant to the artisan classes and the common people, and within general trends apparent throughout the country, such as the winged head, symbolic of an angel, distinct stylistic characteristics became apparent in particular localities. A remarkably large and idiosyncratic group of memorials centred on Brecon Cathedral but which extended into surrounding parishes represents a transitional phase between the medieval sepulchral slab and the modern gravestone. They were of unified style, despite extending in date from the end of the sixteenth to the early eighteenth century, which suggests that a single workshop maintained a practice through at least four generations.[23] The image of a floriated cross on a stepped base was derived from medieval prototypes, but was overwritten by bold genealogical inscriptions cut in the manner of wood-carved inscriptions of the late sixteenth century, such as those of the north Wales carpenter. The arms of gentry families were replaced on a number of slabs by the guild insignia of the merchant or artisan. By the beginning of the eighteenth century their letter style was very old-fashioned and the group ended abruptly, to be replaced by upright gravestones and memorials with Roman or italic lettering, and styles reflecting the influence of printed books, which were also widely used for painted inscriptions.

Many of the examples which seem most attractive to the modern eye were naive in design and eclectic in their use of letter forms and symbols. The remarkable gravestone at Llangattock in Monmouthshire to Alice Evans, who died in 1706, combined the standard eighteenth-century symbolism of the winged angel with interlace patterns close to those cut on high crosses in the Celtic-Christian period. By the end of the eighteenth century the marking of the graves of the common people was widespread and detailed local study even in the poorest areas of Wales reveals substantial groups of works made by individual carvers. In Cardiganshire six distinct groups have been recognized down to about 1820, from which time local idiosyncrasies declined rapidly.[24] Perhaps the most notable of the regional styles, both for its evolution over two centuries in the hands of one workshop and for its early emergence, was that of the Brute family, centred at Llanbedr Ystrad Yw, near Crickhowell.[25] No signed work by John Brute, the earliest recorded mason in the family, born in 1665, has been identified, but his descendants, Thomas, Aaron and John, carried the practice into the early nineteenth century. Their work was characterized by linear, floral designs and idiosyncratic interpretations of conventional angels and winged heads. Changes in high art fashions were occasionally reflected in the appearance of classical motifs, an early example being Thomas Brute's memorial to his infant son, cut in 1724, but generally their work retained its distinct family characteristics. The memorials of Brute were usually made of local sandstone but many of those set up inside churches were given a ground coat of black, perhaps in imitation of marble or slate, before

278. Aaron Brute,
Memorial to Nicolas Vaughan, Church of St Teilo,
Llantilio Pertholey, 1784, Stone, 965 × 660, detail

being highly coloured and gilded. In some areas masons applied colour to stones
set up outside the churches as well as to interior wall memorials, giving well-kept
churchyards a much more colourful appearance in the eighteenth century than they
possess today. However, this practice was not universal. At the beginning of the
nineteenth century it was reported that in Glamorgan headstones were limewashed,
the work being done three times a year, at Easter, Whitsun, and Christmas.[26]

By the end of the eighteenth century the widespread marking of graves
indicated a substantial increase in the number of people who could afford to
raise themselves above the utter anonymity of their ancestors, even if only at death.
Among them a middle class of professional people, such as lawyers, ministers
and shopkeepers, and in the coastal towns people involved in shipping, acquired
disposable incomes and aspirations to aspects of civilized life previously enjoyed
only by the gentry. Advances in the creative crafts reflected this extension of
patronage both by their diversity and in the levels of skill and awareness of
metropolitan fashion which they displayed. In Carmarthen, for instance, by the
early nineteenth century Daniel Mainwaring was making high-quality funeral
monuments of marble and the ornamental plasterer Stephen Poletti could provide
the finishing touches to a new town house designed by an architect, rather than
the local builder.[27] Inside such new houses, as an alternative to traditional oak
furniture, David Morley supplied items made in mahogany in the latest taste.
Morley's cabinets were probably stocked with fine books printed by John Ross.
For the walls of such new houses in towns like Carmarthen, Swansea or Caernarfon,
portraits could be commissioned either from resident generalist artisans or from
itinerant portrait specialists coming into Wales from outside. They were a motley
crew, and some of them made claims to academic training, but certain common
features of their practice between the late eighteenth century and the 1840s are
apparent. They were particularly active in the coastal towns of the south and west,
which suggests that they travelled from one to the other by sea,[28] and they offered
one or more of three portrait services – the silhouette, the miniature and, to a
lesser extent, the oil portrait. Most seem to have left their products unsigned and

279. Thomas Brute,
Memorial to Ann, the wife of Mr William Griffiths,
Church of St Ishow, Patrisio, Breconshire,
*c.*1804, Stone, 1397 × 813

[25] The rich tradition of memorial carving in
south-east Wales, particularly of wall-mounted
tablets, is described in Bob Silvester and Liz
Pitman, 'Eighteenth-century Stonemasons in the
Black Mountains', *Church Archaeology*, 2 (March,
1998), 29–34. I am grateful to Liz Pitman for
making available to me her detailed research on
the Brute family. Pitman has shown that the family
did not use slate for their memorials, as frequently
reported in earlier studies.

[26] F. Burgess, 'Painted Tombs – Some
Historical Precedents', *Commemorative Art*,
XXXIII (July, 1966), 241.

[27] For Daniel Mainwaring (1776–1839), see
Thomas Lloyd, 'Sculpture in Carmarthenshire: A
Survey of Church Monuments', *The Carmarthenshire
Antiquary*, XXV (1989), 35–60.

[28] This choice was also sometimes made by their
middle-class customers. In 1834 Sarah Hughes
took a steamer from Carmarthen to Aberystwyth
to visit her sister Eliza Davies, in preference to
travelling by road. NLW MS 10548B, 1 August
1834. Unfortunately, 'She took a violent cold in
coming up which confined her to bed.'

280. Isaac Thomas,

Handbill advertising the painter Thomas Wright, c.1815–16, Letterpress, 170 × 105

281. Anon., *Edward Landeg of Swansea*, c.1770, Cut paper silhouette and watercolour, 125 × 125

the best evidence for the activity of named individuals is often the handbills they printed to announce their presence in a town or the advertisements they placed in local newspapers. Swansea was certainly the principal source of patronage because of its combination of industrial wealth and summer trade based on its reputation for sea bathing.[29]

Swansea was the first port of call on a route which might also include Carmarthen, Haverfordwest, Cardigan and Aberystwyth. In August 1815 an advertisement placed in the *Carmarthen Journal* announced the presence of the miniaturist Thomas Wright in Tenby. He also visited Haverfordwest and seems, perhaps unusually, to have spent the winter in the area because in February 1816 he announced his presence in Carmarthen. He painted miniatures 'on Ivory, for Rings, Brooches, Lockets, etc. from Three Guineas to Twenty; – on Card, One Guinea and upwards'.[30] Three years later, one G. Romney, advertising himself as 'from London', offered miniatures on ivory at the considerably cheaper rate of one guinea and also portraits in crayons at two guineas and 'shade profiles', by which he meant silhouettes, at two shillings.[31] Both artists noted that payment was due only if the sitter was satisfied with the likeness.

Several painters found the west Wales circuit sufficiently lucrative to warrant a return visit. A Mr Brooke, advertising himself as 'a student at the Royal Academy under Mr. Fuzele', worked in Carmarthen and Aberystwyth in 1826 and Swansea the following year. If not before, he certainly returned to Swansea in 1841 and to Carmarthen in 1846, moving north to Cardigan where he had handbills printed.[32] He established himself on the premises of W. A. Davies, a watchmaker, a characteristic pairing with a fellow craftsman whose clientele would have been a likely source of patronage. Davies would doubtless have profited from providing settings for miniatures in the form of frames, brooches, lockets and the like. Families might acquire considerable collections of miniatures and silhouettes representing successive generations, and in many homes it was the practice to hang them in groups around the hearth. The collection of the Landeg family of Swansea, for instance, began with a fine coloured profile of the 1770s, and was added to at regular intervals with miniatures and silhouettes into the 1840s. Most were probably carried out locally, but one pair of portraits was done at Bath, where the affluent might spend a season commemorated by a commission to one of the many artists who assembled there.[33]

[29] Between 1750 and 1850 the number of artists and art teachers visiting Swansea outnumbered by a factor of more than three its nearest rival, Caernarfon. Paul Joyner, 'A Place for a Poussin' (unpublished University of Cambridge PhD thesis, 1989).

[30] *Carmarthen Journal*, 25 August, 27 October 1815, 23 February, 1 March 1816.

[31] Ibid., 26 March, 16 April 1819.

[32] The handbills were printed by Isaac Thomas, for whom see below, pp. 222–3.

[33] The Landeg collection survives complete at the Museum of Welsh Life, St Fagans. The Bath miniatures of Mr and Mrs John Landeg were by Hamlet.

[34] Silhouettes might also be painted on paper or card, or painted on glass.

[35] Eliza Jones (fl. 1807–52) is reputed to have been Welsh, but nothing is known of her family background and she worked in London. She exhibited at the Royal Academy, The British Institution and the Water-colour Society. She was a close friend of William Owen Pughe, who commissioned her and seems also to have taken lessons from her.

282. The Hubard Gallery,
Anne Temple and
Robert Griffith Temple
of Glansevern, Powys, 1835,
Cut paper silhouettes,
380 × 280

far right:
283. Isaac Thomas,
Handbill advertising the Hubard Gallery,
1848, Letterpress, 220 × 140

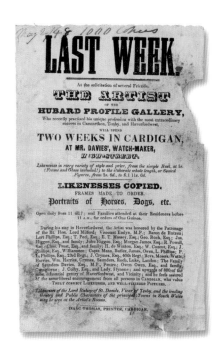

By mid-century the cutting of paper silhouettes, in particular, was a well-organized business.[34] William Hubard, who established his business in England and subsequently expanded into the United States, was dispatching artists under his name to work the west Wales circuit by 1834. On a tour in the area in 1848, an unnamed Hubard artist worked on the premises of Davies the jeweller, like Mr Brooke, the painter. Self-taught local practitioners may also have established themselves, but the names of only two Welsh-born miniaturists of the period who worked in Wales are recorded.[35] Although most of his career before the turn of the century was spent in London, it is possible that Edward Pugh occasionally worked in Wales, and he may later have helped to sustain himself on his explorations while writing *Cambria Depicta* by taking portraits.[36] Thomas George, a native of Fishguard, certainly worked in Wales, though his practice seems to have been confined to the south-west. George was born in about 1790, the son of James George, a watch and clock maker, but nothing is known of his training. His earliest recorded works were portraits of the Leach family of Milford Haven, done in 1819, and in 1824 he signed another miniature giving his address as Haverfordwest. However, by 1826 he had moved to London, where he mixed in Welsh circles and came to know William Owen Pughe and the painter and engraver Hugh Hughes.

[36] Few of the sitters for Pugh's exhibited portraits between 1793 and 1821 were named. John Roberts, c.1795, was noted as 'of London', Silhouettes and Miniatures Sale, Sotheby, 20 July 1981, lot 181, and a commission given by William Owen Pughe, c.1802, was to be done at Pughe's home in Pentonville, NLW, MS 13224B, item 203. However, Pugh also painted the mother of Richard Llwyd, 'Bard of Snowdon', and, although the poet recovered the portrait in London, this commission seems most likely to have been done at the family home in Beaumaris. See above, Chapter 5, note 65. It is unclear where his most celebrated portrait, *Mr Edwards the bard, commonly called the Welsh Shakespeare,* 1799, was carried out. The original miniature of Twm o'r Nant is lost, but it achieved lasting celebrity in the form of an engraving, see below, p. 203.

left: 284.
Thomas George,
Self-portrait, c.1840,
Watercolour, 210 × 165

centre: 285.
Thomas George, *Gertrude Leach,*
c.1819, Pencil, 102 × 105

right: 286. Thomas George,
Lady with a Purple Shawl,
1835, Watercolour, 180 × 152

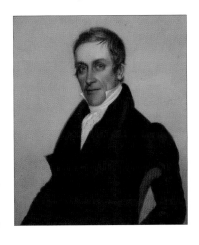
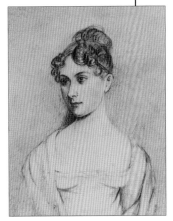
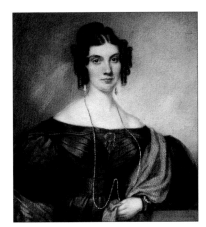

288. Hugh Hughes,
Laura Hughes,
aged 9, 1813,
Oil, 257 × 200

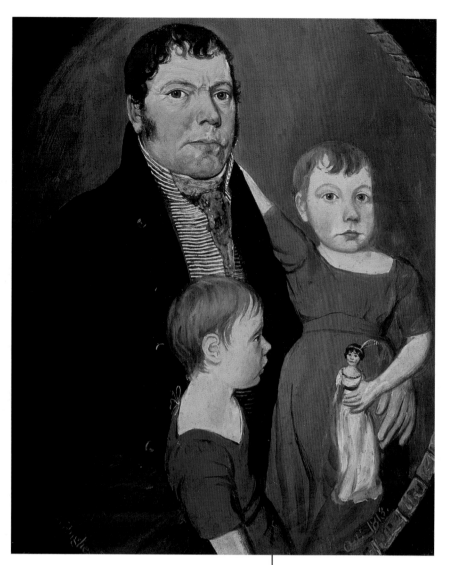

287. Hugh Hughes,
The Family of Huw Griffith,
Bodwrda, 1813, Oil,
460 × 305

The long portrait-painting career of Hugh Hughes had begun in Wales in 1812. Initially, it foreshadowed in the north the peripatetic pattern of English painters working in the south and west. Ten years earlier, when he was twelve, Hughes's family had left Llandudno for Liverpool, and so it was from England that he entered Wales on tour in 1812, 1813 and 1814. He probably came during the summer months only and may well have walked from place to place, carrying his painting equipment on his back to Bala, Caernarfon and the Llŷn Peninsula. Nevertheless, Hughes was not an outsider since he both spoke Welsh and had maintained in Liverpool, particularly through the new Calvinistic Methodist church of which he was a zealous member, an extensive network of friendships in north Wales. It was this network, as well as family connections in the Conwy valley and Llŷn, which provided a base for his patronage. He painted miniatures, but the most informative products of the period so far as artisan practice was concerned were a group of small oil portraits painted mainly in Pwllheli, a sufficient number of which survive, some of them signed and dated, to establish a sequence.[37] The most characteristic of artisan practice, both in

[37] The earliest portraits of the series are those of Robert Griffith, a lawyer in Pwllheli, and his son Humphrey, painted in 1812. Hughes painted Robert Griffith for a second time the following year.

289. Hugh Hughes,
The Family of John Evans of Carmarthen at Breakfast, c.1823, Oil, 710 × 1070

terms of patronage and style, were portraits of the three children of William Hughes, a shopkeeper with interests in ship insurance, painted in 1813. Hughes chose to portray the children in full profile, a convention he repeated in his finest portrait of the period, *The Family of Huw Griffith, Bodwrda*, painted in the same year. Griffith was a tenant farmer on the Nanhoron estate, and the portrait was probably painted at his home near Aberdaron or perhaps at a *sasiwn* in Bala since the sitter, like the painter, was a prominent Calvinistic Methodist.

The Griffith family group and the individual portraits of John, Robert and Laura Hughes, represent archetypal artisan practice, both in their middle-class patronage and in the visual conventions adopted by their non-academic painter.[38] Their use of profile, as in the Gwaenynog servant group painted nearly thirty years earlier, and their unsophisticated approach to lighting, background and to the tokenistic objects held in the sitters' hands, recall the practice of the sixteenth century. Indeed, these artisan conventions were lineally descended from the decorative insular style of that period. In the United States seventeenth-

[38] The pictures were painted on tinplate, rather than on canvas, an unusual though not unique choice of ground, which also differed from conventional academic practice. Hughes's life and work is described in detail in Peter Lord, *Hugh Hughes, Arlunydd Gwlad, 1790–1863* (Llandysul, 1995).

and eighteenth-century paintings of this sort, sometimes described as neo-medievalist to distinguish them from the continental realism of Van Dyck, Lely and their followers, took root and became a model into the early nineteenth century in the work of artisan painters such as Ralph Earl.[39] Similarly, in Wales the taste of the gentry for the flat, decorative style of masterpieces such as *Sir Thomas Mansel of Margam and his wife Jane* persisted well into the seventeenth century, and was carried forward into the eighteenth and nineteenth centuries by artisans in their sign and heraldic paintings, and then back into portraiture as the new demand arose. Both practice and painting style in Wales were remarkably similar to that in the north-east of the United States, where painters were often peripatetic and dependent on middle-class patronage.

[39] Samuel M. Green 'The English Origins of Seventeenth-century Painting in New England', in Ian M. G. Quimby (ed.), *American Painting to 1776: A Reappraisal* (Virginia, 1971), pp. 15–62.

Hughes's finest portraits and those in which his conventions came closest to those of north American practice were made in the early 1820s. The seven works identified include two magnificent portrait groups.[40] Although it is not signed, *The Family of John Evans of Carmarthen at Breakfast* forms the basis for attributions in the period since it is known for certain to be his work, and was probably painted in 1823, when his relationship with John Evans was at its closest.[41] Evans was the archetypal new patron, a successful printer and publisher whose Nonconformist beliefs were as important a formative influence on his social attitudes as they were on his inner life. Having advanced economically and educationally through his own endeavour, he believed that the acquisition of knowledge was central to the improvement of society. Furthermore, like Hughes, he associated these advances not only

with Nonconformity but in particular with its Welsh forms and with the Welsh language. Hughes portrayed Evans opening the morning post while his eldest son read the *Carmarthen Journal*, which the family owned and published. Yet Hughes chose to make Mrs Evans, rather than her husband or son, the focus of the sober family group by placing her precisely at the centre of the scene. Hughes did this with symbolic intent, since he held strong views on the centrality of the mother in Nonconformist life. With Protestant objectivity, he carefully delineated Mrs Evans's harelip and placed a daughter who suffered from curvature of the spine in profile. These things Hughes regarded as the gifts of God and, in stark contrast to the flattery and deceit of fashionable academic portraiture, he presented them in a forthright manner to the world.

At about the same time as the Carmarthen picture, Hughes painted an even more formal group, although nothing is known of the circumstances of the commission or of the sitters. The composition of *A Gentleman's Society Meeting* suggests a distant Renaissance model such as the Leonardo *Last Supper*, perhaps transmitted by engravings published in illustrated bibles. In the United States the artisan Edward Hicks based his celebrated paintings of *The Peaceable Kingdom* on engravings of this kind. On the wall behind the sitters in Hughes's picture hang three landscapes of the type that he himself would paint in increasing numbers in later years.[42]

290. Hugh Hughes,
A Gentleman's Society Meeting,
c.1823, Oil, 800 × 1450

[40] The other pictures are portraits of Mr and Mrs Lawford of the Mumbles, a self-portrait, dated 1821, and portraits of Hannah White, c.1822–3 and David Morley, 1824, both of Carmarthen.

[41] The significance of the picture and its provenance are discussed by Peter Lord in 'The Family of John Evans at Breakfast – The Concept of Quality in Painting', *Planet*, 114 (1995–6), 62–71. The picture is closely paralleled by such distinguished American works as *The Moore Family*, painted in 1835 by Erastus Salisbury Field. The Lawford portraits are attributed to Hughes on stylistic grounds and on the basis of the painter's visit to the area in 1821.

[42] The identity of the sitters is unknown and they may be members of a hunt. However, this seems unlikely given the total absence of gentry patronage to Hughes before 1826. The provenance of the picture suggests that it was painted in the Mold area.

291. William Roos,
John Williams, 'Yr Hen Syr',
1827, Oil, 750 × 580

The pattern set by Hugh Hughes was repeated, a generation later, by the early practice of William Roos, who was born in Anglesey in 1808. Roos was educated at the navigation school of William Francis in Amlwch but since it is most unlikely that he received instruction in painting there the level of competence demonstrated in his portrait *John Williams, 'Yr Hen Syr'* (The Old Sir), made when he was nineteen, was remarkable. Williams, the headmaster of Ystradmeurig Grammar School, had died in 1818, and so Roos developed his picture from an engraving of an earlier portrait by an English painter. The circumstances of the commission are unknown, but Roos transformed the academic image into a characteristically bold and forthright artisan painting. Few of his early works have survived, but at least until 1835, when he painted the Baptist minister Christmas Evans, his work retained the unsophisticated virtues of the non-academic painter. Between them, Roos and Hughes dominated peripatetic artisan practice in Wales, and over two hundred of their pictures have been documented. Many other artisans who worked within the same network of patronage and visual conventions are known only from their advertisements or from a few isolated works. In the north-east, for instance, in 1846 one William Jones painted a fine portrait of Owen Lloyd of Bachymbyd Fawr near Ruthin. The sitter, aged about fourteen, was the son of a prosperous tenant farmer of similar status to Huw Griffith of Bodwrda, who had

292. William Jones,
Owen Lloyd of Bachymbyd Fawr,
1846, Oil, 950 × 730

293. Anon.,
*Captain John Evans,
Aberaeron*, c.1840,
Oil, 762 × 635

294. Anon., *Margaret Rowlands, Holyhead, her daughter Ann and her son Robert Hugh*, c.1845, Oil, 840 × 676

295. Anon., *Hugh Rowlands, Holyhead and his son Owen*, c.1845, Oil, 840 × 676

296. Anon., *Edith Eleanor, Aberystwyth*, c.1881, Oil, 380 × 540

297. Anon., *Figurehead for an unknown vessel*, Aberystwyth, c.1838, Painted wood carving, 2000h.

298. John Cambrian Rowland,
James Beynon Lloyd-Philipps
of Pentyparc, 1840,
Oil, 368 × 254

299. John Cambrian Rowland,
Woman with a shawl, c.1850,
Oil, 711 × 558

300. John Roberts,
Robert Owen, the Shoemaker,
c.1840, Oil, 656 × 530

[43] The pictures are also similar in size. The 1841 census revealed a coach painter resident in Holyhead called William Hopson, who might have been responsible for the Rowlands portraits. William Jones has not been traced.

[44] This is in contrast to the situation in the United States where the recovery of such works, which are now highly valued, began earlier than in Wales. See Peter Lord, *The Aesthetics of Relevance* (Llandysul, 1992), pp. 43–5.

sat for Hugh Hughes over thirty years earlier. The pictures share the timeless, static quality so often seen in the best artisan work. Owen Lloyd holds an apple in the delicate manner of the ladies of sixteenth-century portraiture. In the north-west, the portraits of Hugh Rowlands of Holyhead and Margaret Rowlands with their children were taken at about the same date as the Lloyd portrait and bear a striking resemblance to it.[43] Whether or not they were the work of the same painter – an otherwise unidentified peripatetic artisan – may never be established, since so many pictures of this kind have been destroyed for lack of appreciation of their qualities.[44] Expansion of the shipping industry provided new patronage for artisans along the Welsh coast both to paint portraits and the ships themselves – pictures which were commissioned by their captains or owners. At Aberystwyth the tradition persisted late into the nineteenth century, with a portrait of the *Edith Eleanor*, the last vessel built in the port, in 1881. The unknown artisan may well have painted, and perhaps also carved, the figureheads fitted to ships in the port. Down the coast at Aberaeron, Captain John Evans of Milford House was painted in mid-century by another unknown artisan, standing at a table covered with a brilliant blue cloth, and presenting his bible as a token of his moral rectitude.

The best-attested artisan known to have painted both ships and portraits was John Roberts, who was born in the parish of Aber-erch in Llŷn in 1810. According to John Jones (Myrddin Fardd), when Roberts was a child 'a travelling painter happened to come past the cottage and discovered John busily working at his painting ... he promised to take him as an apprentice – and John started

immediately on the work of being one of these birds of passage, and before long he excelled over his master'.[45] Establishing himself in independent practice in his own area, Roberts became a generalist artisan, painting portraits such as *Robert Owen, the Shoemaker*, as well as inn signs, inscriptions and religious pictures. He worked both at the parish church of Llanystumdwy and the nearby chapel of Rhos-lan, where the scheme included a picture of a ship. Pictures of boats sailing from Pwllheli and Porthmadog brought John Roberts particular celebrity in the area and probably provided him with a substantial part of his income.

In Cardiganshire at about the same time, the career of John Cambrian Rowland was developing. Like John Roberts, Rowland was born in a small rural community, but took advantage of the patronage of the nearby coastal town, in this case Aberystwyth, where he was established by 1841. It is unlikely that Rowland had more than a craft training and his practice seems to have been peripatetic since portraits from Carmarthenshire, Pembrokeshire and Radnorshire survive. However, unlike John Roberts, he was able to attract some patronage from the minor gentry. As early as 1840 he was working for the Lloyd-Philipps family of Pentyparc. His small full-length portrait of James Beynon Lloyd-Philipps against a background scene of soldiers outside a barracks (presumably they were the Cardiganshire militia), though straightforward in execution, suggested an aspiration to more academic conventions which would later be fulfilled.

The infiltration of academic conventions into artisan portrait practice was generally more common in Wales than in the United States since examples of such works were to be seen all around in gentry houses and, relatively speaking, London was not far away.[46] The painting business of the Jones family in Beaumaris clearly demonstrates the phenomenon. Hugh Jones was a generalist artisan painter in Holywell who, by 1795, had moved his business to Beaumaris, where it flourished to the extent of receiving the patronage of the Paget and the Bulkeley families.[47] No doubt acquiring both the aspiration to become an art painter and the means to fulfil it from contact with such families, Hugh Jones's eldest son, William, attended the Royal Academy Schools in 1808. William became a Wesleyan Methodist minister as well as a painter and was sent by his church to the Chester circuit in 1816, where he practised both professions. He

301. William Jones,
Thomas Rogers, Carpenter,
1830, Oil, 1115 × 938

[45] Myrddin Fardd, 'John Roberts, Llanystumdwy', *Cymru*, VIII (1895), 63, translated from the Welsh. Unfortunately, Myrddin Fardd did not name John Roberts's master. The area was much frequented by Hugh Hughes, but the period in which the incident presumably occurred, c.1825, coincided with the concentration of that painter's activity in Carmarthen and London.

[46] Hugh Hughes's portrait of Robert Griffith of Pwllheli, done in 1813, suggests strongly that the sitter requested the painter to create an image of himself in the manner of the high-quality academic portraits which he may well have seen at Nanhoron, since he worked for the family. John Opie, for instance, had recently worked at the house.

[47] In January 1798 two bills of £30 were settled by Plas Newydd and in 1797 and 1799 payments were made for painting and gilding a cupola at Baron Hill. I am grateful to E. M. Hughes-Jones for making his research on the Jones family of painters available to me.

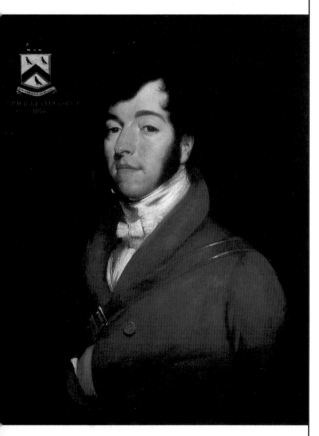

302. Hugh Jones,
Thomas Peers Williams, Comptroller
of the Anglesey Hunt, c.1830,
Oil, 616 × 602

303. James Flewitt Mullock,
The Children of William Evans
of 'The Fields', Newport, c.1855,
Oil, 510 × 610

[48] The attribution of these pictures to William
Jones, which could not have been made on the
basis of style, depends on the obituary notice of
Thomas Rogers from a Wrexham newspaper,
quoted in 'A Mystery Solved', *The National Trust*
Wales Newsletter, Spring 1996, no pagination.

[49] Anglesey Record Office, MD/I/1.

did not lose contact with Wales, however, and in 1830 he was commissioned
to extend John Walters's series of Erddig portraits by painting *Thomas Pritchard,*
Gardener, Edward Barnes, Woodman and *Thomas Rogers, Carpenter*. Jones clearly
attempted to paint to what he probably considered his predecessor's standard,
since the portraits were very sketchily done.[48] However, as a result of William
Jones's removal to Chester, his younger brother Hugh inherited the family practice
in Beaumaris on the death of his father in 1827. There is no evidence that Hugh
Jones received training outside Wales and it was probably his elder brother who
taught him the academic conventions and techniques which are so apparent in
his own portraits, undertaken side by side with the general run of craft painting
which sustained the family business. By far the most substantial commission
gained by Hugh Jones was to paint a series of portraits of the Comptrollers of
the Anglesey Hunt. It was given in 1830 'for the encouragement of native Talent',[49]
and mainly involved copying the faces of deceased gentlemen from loaned
portraits and dressing them in the uniform of the hunt. In 1835 this practice
gave rise to the unusual circumstance of Hugh Jones copying his elder brother's
portrait of John Bodychan Sparrow, done in about 1820. The commission also
required Hugh Jones to paint original portraits of new Comptrollers and the
work continued until 1839, resulting in at least twenty pictures.

below:

305. William Watkeys,
Self-portrait, c.1830, Oil,
386 × 308

below:

306. William Watkeys,
Unknown man of Swansea, c.1830,
Pencil, 251 × 197

304. William Watkeys,
George Martin Lloyd of Bronwydd,
1837, Oil on canvas,
368 × 298

By raising the standard of living in the small towns of the north and west, agricultural improvements and a general increase in trade enabled the artisan portrait painter to flourish on a peripatetic basis. In the industrializing south, economic progress on a far more dramatic scale allowed some artisans and painters with a limited academic training to sustain a portrait practice within an individual town. Sixty years after Giuseppe Marchi's short-lived attempt to develop a practice, Swansea had expanded sufficiently to enable William Watkeys to establish himself as a long-term resident. Watkeys was probably born in Stroud in 1800 and attended the Royal Academy Schools in 1821. He came to Swansea in 1829 where his cousin, David Watkeys, kept the Wheatsheaf Inn,[50] and he first advertised as a portrait painter in the town in 1831. Watkeys' portraits fall into two groups. Firstly, there are those few signed by himself and others closely related to them by their style, which is clearly academic but with certain idiosyncrasies, notably a tendency to give his sitters very small hands. The second group carry a stencilled attribution to Watkeys on the back of the canvas and include some pictures of very inferior quality, strongly suggesting that he employed another painter to work for his less discriminating or wealthy clients.[51] However, most of his sitters were well-to-do Swansea citizens[52] and Watkeys also benefited from a certain amount of gentry patronage. He painted George Martin Lloyd and James John Lloyd of Bronwydd

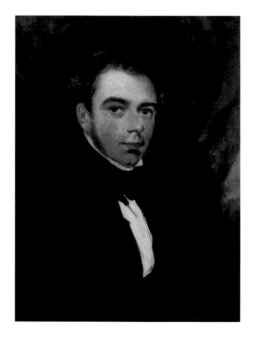

[50] The source of this information was John Deffett Francis, the Swansea painter. Joyner, *Artists in Wales*, p. 125, claims he was born in Swansea. Watkeys worked in Swansea until at least 1850 and died in 1873.

[51] For instance, the portrait of John Thomas of Pengwern, 1833, illustrated in Joyner, *Artists in Wales*, p. 125.

[52] His sitters included Dr Hewson, vicar of Swansea, Mrs Hewson, and the Baptist minister Dr David Rhys Stephen, whose portrait was engraved. Not all were quite as respectable as these pillars of society, however, for Watkeys' most celebrated portrait was of the novelist Julia Ann Hatton, sister of the actress Sarah Siddons. Known as 'Ann of Swansea', she had acquired a somewhat scandalous reputation.

307. James Flewitt Mullock,
Sir Charles Morgan at the Castleton
Ploughing Match, 1845,
Oil, 635 × 760

308. James Flewitt Mullock,
Shorthorn Cow,
*c.*1840–50, Oil,
535 × 660

opposite:
309. James Chapman,
William Williams, 'Wil Penmorfa',
1826, Oil, 1380 × 990

[53] Only the portrait of George Martin Lloyd is
signed and dated. The existence of these portraits
do not imply that Watkeys' practice was
peripatetic, for the family had strong Swansea
connections through the boys' mother.

[54] Mullock's career and its social context is
described in detail in John Wilson, *Art and Society*
in Newport: James Flewitt Mullock and the Victorian
Achievement (Newport, 1993).

in 1837.[53] Similarly, in Newport, James Flewitt Mullock, a native of the town, benefited from mixed patronage, especially in the early part of his career in the 1840s and 1850s. He painted *The Children of William Evans of 'The Fields', Newport*, a local entrepreneur, in about 1855, and *The Lloyd Family*, proprietors of the King's Head hotel. The Lloyd family had extensive contacts with the gentry as hosts of the dinner and prize-giving at Sir Charles Morgan's annual cattle show. Mullock exploited his circle of landowners, their agents and substantial tenant farmers to the full, producing the finest group of animal paintings in nineteenth-century Wales. Sir Charles Morgan of Tredegar House was a notable agricultural improver and his show was an event of considerable importance in Glamorgan and Monmouthshire. Mullock's opportunity to paint Sir Charles came at the Castleton ploughing match in 1845. Nothing is known of any formal training that he may have received, but portraits such as the *Shorthorn Cow* display considerable facility, especially in their characterization.[54] From time to time, the painter was able to extend his range to include sporting pictures for the hunting and racing community.

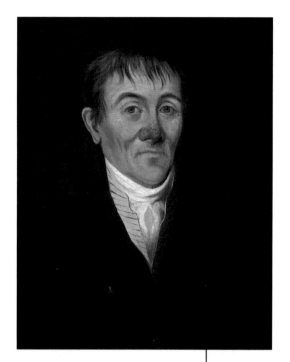

310. W. J. Chapman,
George White, Butler at Nanteos,
1836, Oil, 457 × 362

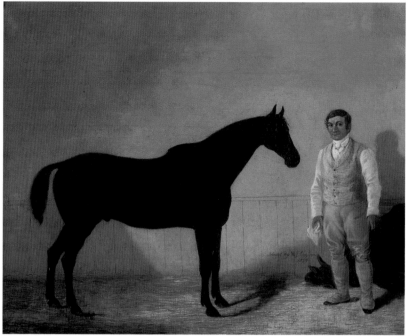

311. W. J. Chapman,
Bumble, the Carriage Horse, with Thomas the Coachman,
1859, Oil on canvas, 610 × 495

opposite: 312. Anon.,
*Lady Pryse in a carriage drawn by Merlin
and Vulpecide, with the dogs Topsy and
Blackberry, and Dick the coachman,*
1863, Oil, 540 × 790

[55] The picture and the portraits of industrial
workers painted by Chapman in the same area
are discussed in Lord, *The Visual Culture of Wales:
Industrial Society,* pp. 63–9, and in idem, *The
Francis Crawshay Worker Portraits / Portreadau
Gweithwyr Francis Crawshay* (Aberystwyth, 1996).

[56] The unusual extent of his Welsh practice
suggests that Chapman may have been Welsh.
Nevertheless, his English works, such as *Uncle John
Crundle, a Sportsman with Game Dogs and Game*
(Dreweatt Neate, Newbury, sale 23 October
1991) and *A Family before a Country House*
(Bonhams, sale September 1993), suggest a
similar pattern of patronage to that from which
he benefited in Wales. James Loder of Bath
developed a similar peripatetic practice in south
Wales, painting horses in the 1840s and 1850s.
Chapman exhibited at the British Institution
between 1854 and 1866.

[57] James Chapman had published an engraving of
Swansea in 1825, for which see Joyner, *Artists in
Wales,* p. 15.

The taste for sporting pictures had expanded sufficiently by the early nineteenth century to sustain a growing band of peripatetic painters with varying degrees of academic training. The best attested among them in Wales was W. J. Chapman, though nothing is known of his personal life. His earliest recorded work was *The Cyfarthfa Hunt*, painted in the booming town of Merthyr Tydfil in 1830, although the industrial patronage associated with this splendid picture made it a special case.[55] Chapman found his main source of patronage among the gentry in south and west Wales over a period of nearly thirty years, which suggests an especially close relationship with the country, although he also worked in England.[56] He may have been related to the James Chapman who worked in Wales in 1825 and 1826, and who produced a fine picture in the servant-portrait genre of *William Williams, 'Wil Penmorfa'*, the blind harpist of Tre-gib.[57] It set William Williams not in the Carmarthenshire countryside around Tre-gib but against the mountains of his native Snowdonia and, presumably, the cottage in which he was born, in the narrative manner of John Walters. There is no further record of activity by James Chapman, but W. J. Chapman was soon employed not far from Tre-gib by the Lloyd-Philipps family of Pentyparc and their relatives to paint a series of portraits between 1835 and 1840. Sometime after 1840 he made *A Prospect of Aberglasni*, by which time he had also ventured as far north as Aberystwyth to paint *George White, Butler at Nanteos*, celebrated locally for the redness of his nose, which was meticulously depicted by the artist.[58] In 1859 Chapman advertised his presence in Carmarthen in the local newspaper and was commissioned at Cwmgwili to paint three pictures of horses owned by Grismond Philipps. The importance of

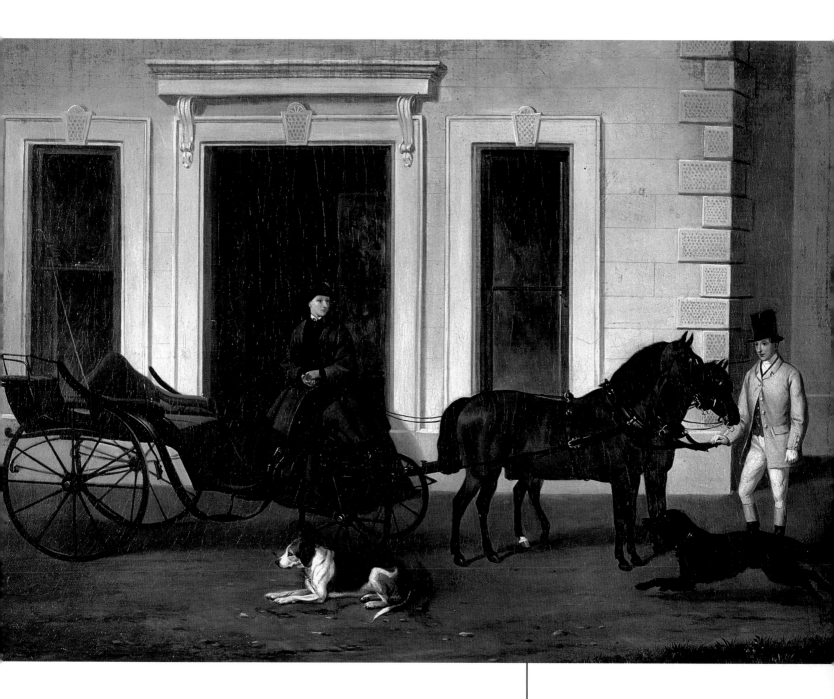

such commissions to gentlemen of sporting tastes is indicated by the detailed inscriptions written on the back of the canvases by Philipps, who affectionately listed the achievements of his hunter Isaac, who 'won a match agst. A. S. Davies Grey Horse. For £20 a side. Owners up. Two miles ... I shall never have such a Horse again.' Chapman had also to paint *Bumble, the Carriage Horse, with Thomas the Coachman,* another minor genre beloved of the gentry of the period and often entrusted to peripatetic painters. It was particularly well represented at Gogerddan, near Aberystwyth, where an unknown artist painted *Lady Pryse in a carriage drawn by Merlin and Vulpecide, with the dogs Topsy and Blackberry, and Dick the coachman.*

[58] The identification of the sitter as George White of Nanteos is based on the celebrity of his nose, recorded in *The Welsh Gazette*, 2 February 1905. While in London, this prominent feature attracted a challenge from a drinking companion: "'I'll give you a gallon of ale, if you will answer in rhyme a rhyming question." "Try him 'etto'," (meaning "try me again"), exclaimed the old toper. "Well," said the challenger – "you mortal man that lives by bread, What makes your nose to look so red?" "Try him 'etto'," again chuckled the rhyming butler and immediately replied:– "Nanteos ale both strong and stale / Keep my nose from looking pale"'!

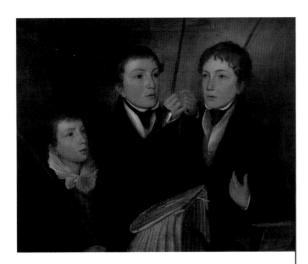

313. Hugh Hughes,
The Sons of Pryse Pryse of Gogerddan,
1826, Oil, 622 × 627

314. Hugh Hughes,
The Llanidloes Pig Fair,
c.1847, Oil, 420 × 515

Although the gentry provided an unusually high proportion of Chapman's patronage, in 1859, the year of his visit to Cwmgwili, he was also in Swansea painting portraits of the Congregational minister Thomas Thomas and Mrs Thomas, a more characteristic middle-class source of artisan patronage in Wales.[59] Hugh Hughes was almost entirely dependent on this source for the whole of his career and only for a brief period did he receive gentry patronage. In 1826 he was commissioned by Pryse Pryse of Gogerddan to paint three pictures which denoted not only a temporary change of patronage but also a change in style. What may be termed Hughes's unselfconscious artisan manner, so magnificently represented in 1823 by *The Family of John Evans of Carmarthen at Breakfast*, was replaced by an attempt to imitate academic conventions with which he was never comfortable. When painting individual portraits such as that of Pryse Pryse of Gogerddan, Hughes was able to cope adequately, but his new patron's request to paint *The Gogerddan Hunt* on a large scale revealed that, in the absence of academic training, he was unable to make a satisfactory transition. His third Gogerddan picture, *The Sons of Pryse Pryse of Gogerddan*, found Hughes on familiar ground and as a result he produced a fine study with strong echoes of his early artisan style, a pattern which would persist in his portraits of children late into his career.

By 1834 Hughes had taken up residence in Caernarfon, which became a centre of artisan practice. William Roos had arrived in the town by that year and in 1838 Hugh Jones of Beaumaris rented a portrait studio in Segontium Terrace. A generalist artisan, William Griffith, was also at work between 1835 and 1850, and is known to have painted portraits, though none of his works has been identified.[60] This extraordinary concentration of painters could not be sustained by the patronage available in the town alone, and Hughes not only continued to travel long distances from his home to find work but also painted landscapes. In 1836 he attempted to supplement his income by charging visitors to enter his home in Church Street to view a series of vast panoramas:

> Diaromic Exhibition; consisting of the following views, each Picture containing from 200 to 300 feet of canvas, and painted on the spot; the first is the SUMMIT OF SNOWDON, Comprehending The whole range of sea and land, from the middle of Cardigan Bay to Carnarvon Bar. ABERYSTWYTH, From the Castle Hill, with portions of the old Ruin; the Castle House; the Bay, with the Vale of Clwyd steamer, landing her passengers; the Bar of Aberdovey; the Towyn Point; with Snowdon in the extreme distance.[61]

316. Hugh Hughes,
John Davies,
Fronheulog, 1841,
Oil, 1136 × 908

Exhibitions of panoramas of this kind were unusual in Wales, only one earlier example being recorded, and Hughes's work was probably of the kind exhibited on rollers to reveal the view piece by piece. His work was doubly noteworthy for having been painted on the spot, though whether this excursion into *plein air* painting on a vast scale was due to a very early awareness of an imminent fashion among landscape painters or to his undoubted originality of mind is unclear. In any case, his first venture to the top of Snowdon for this purpose was unsuccessful. According to William Morgan Williams (Ap Caledfryn), 'H.H.'s ideas were sometimes very broad especially when he attempted a panoramic landscape from the top of Snowdon unfortunately his tent and paraphernalias were blown to pieces and he had to abandon all'.[62] Nevertheless, landscapes painted mainly for tourists were an increasingly important source of income to Hughes in the 1840s and 1850s. They were exhibited in a tent beside which he worked in summer. His diverse output also included figure compositions such as *The Llanidloes Pig Fair*, echoing the scenes of everyday life painted by visiting academic painters in Wales in the period, especially in the developing artists' colony at Betws-y-coed. Although Hughes visited Betws-y-coed regularly, it is significant that he seems to have had no professional contact whatsoever with these English painters. Middle-class portrait patronage among Welsh people continued at the heart of his practice and was often related to his deep involvement with religious affairs. Among his most accomplished portraits in an academic manner were those of Jennett Davies and John Davies, Fronheulog, both prominent and influential Methodists, painted in 1841.

above left:

315. Hugh Hughes,
Jennett Davies, Fronheulog,
1841, Oil, 1136 × 908

[59] The commission is recorded in *Yr Annibynwr*, III, no. 29 (1859), 114. The portraits have not been traced. Chapman was paid £34, considerably in excess of the fees charged by Hugh Hughes and William Roos in mid-century.

[60] Griffith appears in trade directories at Castle Ditch and subsequently at Pool Street, where he was recorded in the 1851 census. He was then thirty-nine and two carvers and gilders were staying with him. Several portraits in private collections in the area, clearly not the work of Hughes, Roos nor Jones, may well be attributable to Griffith, but are unsigned.

[61] *Carnarvon and Denbigh Herald*, 2 July 1836. There were eventually four views on display, 'occupying 1200 feet of canvass', *Y Papyr Newydd Cymraeg*, 22 September 1836. Admission was one shilling with a reduction for children and servants.

[62] NLW MS 6358B, unpaginated. The only earlier exhibition of a panorama reported in Wales was at Cardigan in 1835. See Lord, *Hugh Hughes, Arlunydd Gwlad*, pp. 221–2.

317. William Roos,
John Cox, Printer, of Aberystwyth
1845, Oil on canvas,
650 × 490

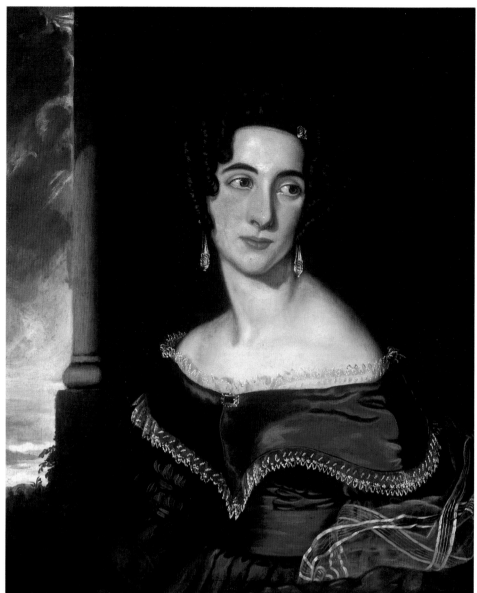

318. William Roos,
The Woman in a Blue Dress,
1838, Oil, 762 × 635

[63] NLW, Cwrt Mawr MS 74C, f. 58, dated
27 December 1836, translated from the Welsh.

[64] *The Welshman*, 9 July 1875. Roos's evidence
is unclear on the matter of the identity of his
teacher. He mentions an untraced painter called
Ben Caunt, but there is some circumstantial
evidence that his teacher may have been William
Beechy. This is discussed in Peter Lord, *Arlunwyr
Gwlad/Artisan Painters* (Aberystwyth, 1993), p. 29.

Like that of Hugh Hughes, the work of William Roos underwent a distinct change of conventions early in his career. In a letter written in 1836 to his friend David Owen, the poet Dewi Wyn, Roos noted that he had 'wandered hundreds of miles' and had recently spent three months painting among the Welsh community in London:

> I fulfilled my desire to see one of the main Cities of the World, the next in my sights is Rome, Paradise of the arts, which I hope I will be able to see before the end of a year and a half.[63]

Until his death Roos retained the simplicity of character displayed in his unfulfilled romantic aspiration to visit Rome. However, while in London he had some lessons from an artist he described as 'the best portrait painter in England',[64]

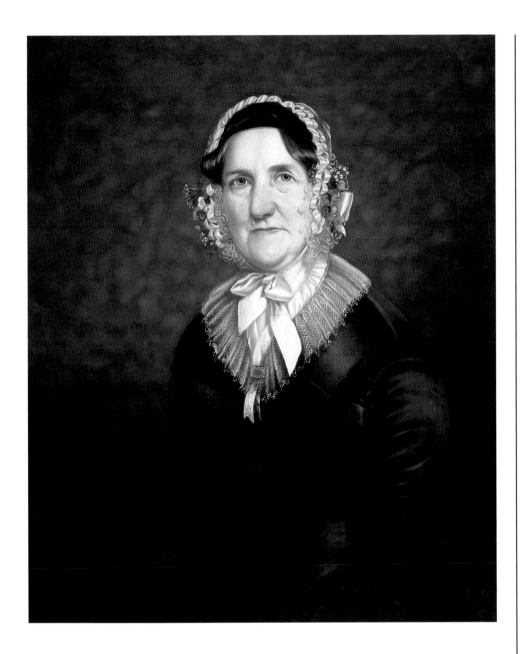

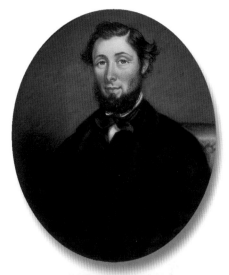

and subsequently both the conventions of his work and his subject matter changed. His new portraits, such as *John Cox, Printer, of Aberystwyth*, painted in 1845, were built up in glazes, fully modelled and with an enamel-like brightness, which, in association with a certain set of the head that Roos gave most of his sitters, made his work distinctive. Unlike Hughes, Roos was clearly at ease working within these more academic conventions, though he never entirely lost the interest of the older tradition in decorative detail and the surface quality of silks and satins. Furthermore, his patronage, wandering lifestyle and the pitifully small sums of a few guineas he was paid for his work, kept him firmly within the artisan class.[65]

Roos was at the peak of his powers in the 1840s. A set of individual portraits of the Anglesey farmer Hugh Thomas of Llangaffo, his wife Margaret and their two sons, painted in 1847, are among the finest. He sometimes worked in pastel,

[65] For instance, Roos offered a portrait of Joseph Jones of Amlwch for sale at 2½ guineas in about 1840. He produced copy portraits of his own work and that of other painters which were often of very inferior quality.

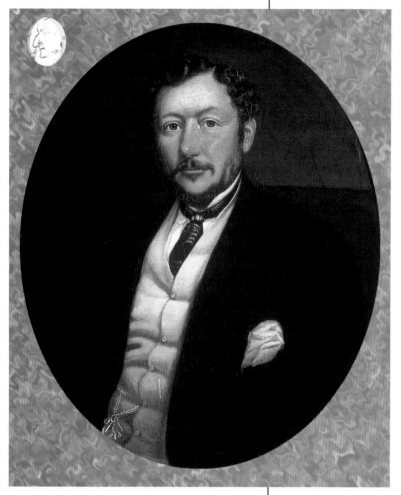

322. William Roos,
*Colonel Thomas Rowland
Powell of Nanteos,*
1862, Oil, 410 × 340
(caricature self-portrait
of the artist revealed
beneath spandrel)

though the only surviving examples, a group of three portraits of members of the Bryan family of Denbighshire done in 1862, suggest that this may have been a late development.

Roos took some advantage of the market for sporting pictures of various kinds from at least as early as 1841 when he painted *Still Life of Partridges* and inscribed it with the information that the birds were 'killed by H. Webster, Esq.'. This picture, done on panel, was a remarkable achievement for a largely self-taught painter and was clearly indebted to Dutch still-life models. Roos was very conscious of his Dutch ancestry, which he acknowledged both in his letters and in the clear realism of his portrait style. By 1849 he was painting hunters for the gentry, and his work in this genre seems to represent his only substantial English patronage.[66] Only once is he known to have painted a portrait for a gentry patron, *Colonel Thomas Rowland Powell of Nanteos*, near Aberystwyth, in 1862. Individual portraits of middle-class doctors, ministers, printers, solicitors and the like remained his forte into the 1860s but, despite the high quality of his work, Roos's talent was never rewarded financially. In 1873 he wrote to Nicholas Bennett of Trefeglwys:

If you want a boy to look after the Sheep & Cattle, weed the fields & garden, do some light work on your Farm in return for his Board & Lodgings and, he would expect a little pocket money now & then, please to let me know. I have an overgrown boy, in London, who wants pure air, and plenty of milk diet, to strengthen him he is 15 yrs old & 5ft 7½ in in height, a nice amiable Boy. every one, who see his countenance like him, – very obedient, his only weakness is his pride ... I lost my eldest son 12 months ago. he died at Pennal within 8 miles of the place where he was born ... I fear my second & third son is going the same way, if they stop long in London, the Smoke and Gasses destroy them fast ...[67]

Nicholas Bennett was a musician, remembered for his collection of folk songs, *Alawon fy Ngwlad*, published in 1896. He was well-known among the intellectuals of his time, and his contact with William Roos signifies a distinguishing characteristic of Welsh artisan painting. Whereas in many other countries portraiture among the intellectual community was the preserve of an equivalent élite of academically-trained artists, in Wales artisan painters largely met their needs.

[66] For instance, he worked for Robert Lowther of Acton, Shropshire.

[67] NLW MS 584B, item 194, dated 16 May 1873.

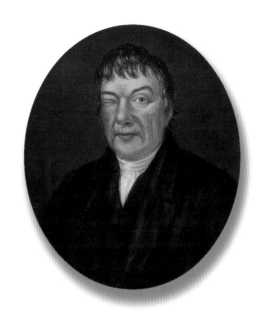

chapter
seven

THE ARTISAN

AND THE

INTELLECTUAL

323. Anon.,
Welch Chapel Jewin Street,
*c.*1825, Wood engraving,
size uncertain

From the second half of the eighteenth century onwards Welsh intellectual
life, which focused mainly on religion and the arts, moved increasingly from
dependence on gentry patronage and leadership into the hands of the middle
class. This class largely emerged from among the indigenous common people
and, even if many of them preferred to use English in their everyday lives as a
symbol of their social progress, their access to the Welsh language kept them
close to their roots. The literature of the period was predominantly Welsh, and
many of the new intelligentsia – though by no means all – were Nonconformists.
There was no single geographical centre for this renaissance, and activity was
spread over most of the country. Metropolitan Wales continued to exist mainly as
one of the sub-cultures of London, though with important communities also in
Liverpool, Manchester and Chester. In these centres, as in Wales itself, intellectual
activity was decreasingly located within the gentry circles which had initially
patronized the Cymmrodorion and increasingly found in newer groupings such
as the Cymreigyddion societies, with their origins in the democratic radicalism of
John Jones (Jac Glan-y-gors) and Thomas Roberts, Llwyn'rhudol, members of
the original London Cymreigyddion. The membership of these groups was small
but their influence was considerable. Welsh chapels, such as Jewin Crescent in
London, also formed centres not only of religious observance but of social and
intellectual interaction whose influence extended back into Wales.

The new intellectual leadership was therefore to be found among the same
people who formed the patronage base for artisan painters. For all the similarities
of its peripatetic painters and their visual conventions, in this respect Welsh artisan
practice evolved differently from the distinguished tradition of the United States.
In the urban centres of New York and Boston, as in the capital cities of the large
European nations, academically-trained portrait painters served the needs of the
intellectual and political leadership. In Wales, where there was no indigenous
politics and no academy of painting, artisan painters fulfilled their needs. The
success of Hugh Hughes, and later William Roos, in exploiting middle-class
patronage led them naturally into the new intellectual circles, and through
them into contact also with the older tradition of Anglican antiquarians. Several
members of the new intelligentsia of writers, musicians, scientists and ministers
would acquire a substantial iconography derived mainly from artisan images.
Through the medium of engravings, that iconography became public and of more
than documentary or aesthetic importance. The capacity of Welsh publishers to
commission and print engraved portraits increased in symbiotic relationship with
the demand for them among a wide public, whose sense of Welshness was expanding
beyond that of local and denominational identification to the national level.

324. J. Chapman
after Edward Pugh,
Thomas Edwards,
'Twm o'r Nant',
The Cambrian Shakespeare,
1800, Engraving,
368 × 315

325. Anon.,
Thomas Edwards, 'Twm o'r Nant',
c.1800–10, Oil, 450 × 350

The first of the new literati to acquire an extensive iconography was the poet
and playwright Thomas Edwards (Twm o'r Nant). He was first painted in the
year of his marriage, 1763, by an unknown artisan, and his second documented
portrait was also of a celebratory nature, associated with the reviving Eisteddfod
tradition, which would stimulate a number of important portrait commissions
over the following hundred years. At the Bala Eisteddfod of 1789 Thomas
Jones, an exciseman, of Corwen, 'produced and hung in the assembly room
an emblematical painting representing on one side the Muse in tears, the
other depicting "The sense and thoughts of Jonathan Hughes", "The Muse
and flowing vein of Thomas Edwards", and "The rules and purity of language
of Walter Davies"'.[1] This picture was a humorous reference to events earlier in
the year at the Corwen Eisteddfod during which Twm o'r Nant's entry had been
adjudged second to that of Walter Davies (Gwallter Mechain), resulting in a public
dispute and the award to Twm of a silver pencil, plainly to be seen in Edward Pugh's
miniature painted sometime before the end of the century. It was this image, with
its visual cue to the hagiography of Twm o'r Nant, which first presented his face
to the public in an engraving by J. Chapman in 1800.[2] It remained in currency
among the common people well into the second half of the nineteenth century. In
1854, for instance, when George Borrow went in search of the grave of Iolo Goch
at Valle Crucis, the 'old dame' who occupied the former monastery 'said she had
never heard of him, but that she could show me the portrait of a great poet'. She
went away and 'presently returned with a print in a frame':

[1] Gwilym Hughes, 'Old Eisteddfod Medals',
Young Wales, V (1899), 91.

[2] An engraving after the same original by Stoddart
is undated. William Owen Pughe painted a
miniature of Twm o'r Nant in 1809.

'There', said she, 'is the portrait of Twm o'r Nant, generally called the Welsh Shakespear.'

I looked at it. The Welsh Shakespear was represented sitting at a table with a pen in his hand; a cottage-latticed window was behind him, on his left hand; a shelf with plates and trenchers behind him, on his right. His features were rude, but full of wild, strange expression.[3]

No Welsh person since the first Sir Watkin Williams Wynn acquired such a substantial iconography as Twm o'r Nant, and the social gulf between the two, and the homeliness of the imagery of 'a great poet', which clearly impressed Borrow, was indicative of a profound change in Welsh life. In the nineteenth century no gentleman, landowner or even industrialist would approach the extensive iconographies of literary figures and of ministers of religion. Two further portraits of Twm were painted in his old age, one of which was never reproduced, but the other, commissioned by William Madocks on the occasion of the playwright's last appearance in public at the opening of Peniel Chapel at Tremadog in 1810, gave rise to a bewildering array of copies and engravings.[4]

[3] George Borrow, *Wild Wales*, with an introduction by William Condry (Llandysul, 1995), p. 60.

[4] It is not clear which (if either) of the portraits held in the National Library and the National Museum was commissioned by Madocks. The National Museum version carries the inscription 'Lewis Hughes, Painter', an otherwise unrecorded artisan. However, a small watercolour, also at the National Museum and clearly derived from the same obscure original, is inscribed 'From a painting by Newberry'.

326. Hugh Hughes,
Mrs Mary Jones, Denbigh,
c.1812, Watercolour,
82 × 69

327. Hugh Hughes,
Thomas Jones, Denbigh,
c.1812, Watercolour,
82 × 69

328. A. R. Burt after Hugh Hughes,
Revd. Thomas Jones, Denbigh,
1820, Engraving, 97 × 78

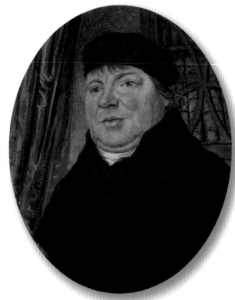

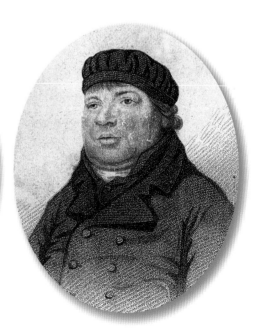

329. Robert Bowyer,
Daniel Rowland, c.1775–90,
Watercolour, 85 × 67

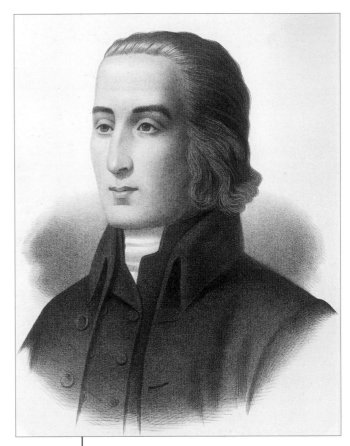

330. Anon. after John Williams,
William Williams, Pantycelyn, 1867,
Engraving, 624 × 425

Within a year or two of the last portrait of Twm o'r Nant, the career of Hugh Hughes had turned to the depiction of public figures. Hughes was keenly aware of the potential effect of such portraits on national consciousness if they could be disseminated among the common people in the form of printed images. He was present at the fateful *sasiwn* (the association of the Calvinistic Methodist denomination) at Bala in 1811 at which Welsh Calvinistic Methodism broke away from the Church of England by ordaining its first group of ministers. This was the culmination of the progress of the so-called 'Great Revival' of the mid-eighteenth century, a movement of fundamental importance in the evolution of modern Wales but which gave rise to very little contemporary visual imagery. Of the leaders of the movement, only Daniel Rowland was the subject of a formal portrait, a miniature by Robert Bowyer.[5] The familiar engraving of the most celebrated poet of the movement, *William Williams, Pantycelyn,* was a nineteenth-century product, based on a tiny cameo drawn from memory. However, Hugh Hughes ensured that the new generation of leaders who transformed Methodism into a separate Welsh denomination were not so poorly served. By 1812 he had set about painting the portraits, mainly in miniature, of all the leading figures in the movement in the north, including the earliest known pictures of the women involved, such as Mary Lloyd, who was married to Thomas Jones of Denbigh, the most forceful advocate of separation. Jones was one of at least four of the Methodist Fathers whose portraits were reproduced as engravings. Most notable among them was the portrait of John Evans of Bala, an image of remarkable presence, engraved by Hughes himself

[5] The Revd Howel Davies (c.1716–70), a prominent early Calvinistic Methodist in Pembrokeshire, was painted by an unknown artist (Tabernacl chapel, Haverfordwest). Three years after his death, the London publisher of popular prints, Carington Bowles, issued an engraving. However, the case of Davies is exceptional since he married a wealthy heiress and received gentry patronage. His painted portrait and engraved image reflect this aspect of his life as much as his celebrity as a Methodist.

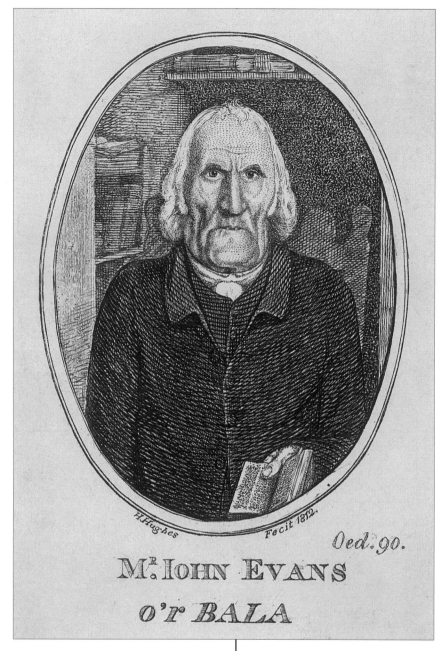

and widely distributed with the denominational magazine, *Y Drysorfa*, in 1819. Hughes's artisan background enabled him to transcend the conventions of the engraved minister portrait, so numbingly perpetuated in the formulaic images published in every issue of *The Evangelical Magazine*. Nevertheless, it was primarily in the hands of other and more conventional engravers that his earliest and most primitive portrait, that of the figurehead of the new church, Thomas Charles of Bala, became his most pervasive and influential image. Despite the existence of more sophisticated portraits, Hughes's picture was the source of the public image of Thomas Charles which was periodically reconstructed throughout the nineteenth century.[6] It reached its apotheosis with the statue by William Davies (Mynorydd) in Bala, begun in 1872, by which time the mythology of Methodism had become closely entwined with that of the nation itself. The personality cults of the preachers, which dominated the mythology, were constructed in a deliberate and purposeful manner. For example, in 1838 Robert Saunderson, a printer in Bala, instructed the engraver, Bailey, through an employee of the publisher Edward Parry in Chester, to adapt Hughes's portrait for a new print:

331. Hugh Hughes,
Mr John Evans o'r Bala, 1819,
Engraving, after his original
painting of 1812, 176 × 125

[6] Lord, *Gwenllian: Essays on Visual Culture*, pp. 43–72. Most of the engravers worked outside Wales, though some developed a considerable Welsh *œuvre*. Richard Woodman of London, for instance, worked on originals by Hugh Hughes from 1827, and also engraved for William Watkeys. Among Woodman's portrait engravings for Hughes were *W. J. Rees, Casgob* (1827) and *John Evans, Llwynffortun* (1841).

[7] NLW MS 9031E, f. 88.

I have ... directed him to place a Pen in the hand, as if in the act of writing a Letter – it has since occurred to me, that as Mr. C. is to appear in his Black Gown, it will be better to alter that part of the Portrait, and instead of a pen, he had better appear in the act of preaching – and to have the Bible before him, and a Reading Glass in his right hand ... You will also please to tell him to put as much benevolence as he can in Mr. Charles's countenance – for he certainly had a most benign smile when animated by his subject.[7]

Most of Hughes's series of the Methodist fathers had been completed by 1814, when he moved to London. However, he returned regularly to Wales and in 1816 engraved the *sasiwn* at Bala, adding an image of the common people of the movement to those of the leaders. Two years later he was again in Wales to

332. Hugh Hughes,
Thomas Charles, Y Bala,
c.1812, Watercolour,
110 × 110

333. Bailey after Hugh Hughes,
Parch. Thomas Charles, c.1838,
Engraving, 236 × 150

begin work on the landscape wood engravings of *The Beauties of Cambria*, but the process of creating and marketing this work brought him into contact with a circle of individuals extending well beyond his church. In 1820 he attended an eisteddfod, apparently for the first time, held at Wrexham. This was the second in a series of regional meetings organized by a group of Anglican clergymen with antiquarian interests, under the leadership of John Jenkins (Ifor Ceri).[8] Their first meeting, held the previous year at Carmarthen, had been a turning point in the evolution of the eisteddfod since Iolo Morganwg had attached his Gorsedd of the Bards and its attendant ceremonial to the proceedings. This series of eisteddfodau proved to be a great melting pot, attracting antiquarians of Iolo's generation, such as William Owen Pughe, the gentry, Anglican clergymen, and young Nonconformist intellectuals such as Hughes and the poet William Williams (Caledfryn), who also attended the meeting at Wrexham. They were of critical importance in fusing the old guard and the new, and in laying the foundations of the movement which would provide the most important institutional framework for Welsh art well into the second half of the nineteenth century. At Wrexham, where the *Beauties of Cambria* was publicly noticed by Sir Watkin Williams Wynn, Hughes met Ifor Ceri and his associate Walter Davies, widely regarded as the leading poet and critic of the day. Hughes's contact with these individuals meant that his name spread widely for the first time outside the Methodist movement. In 1823 Peter Bailey Williams, vicar of Llanrug, wrote to Richard Jones (Gwyndaf Eryri), winner of the chair at the Caernarfon Eisteddfod of 1821:

[8] John Jenkins, who kept open house for poets, artists and intellectuals, was known as Ifor Ceri (Ifor of Ceri) in reference to Ifor Hael (Ifor the Generous), a princeling of early medieval Wales celebrated for his hospitality.

334. Hugh Hughes,
The Sasiwn at Bala, 1816,
Engraving, 102 × 168

335. William Jones,
Richard Llwyd, 'Bard of Snowdon',
c.1810–20, Oil, 763 × 641

336. William Jones,
David Thomas, 'Dafydd Ddu Eryri',
1821, Oil, 740 × 620

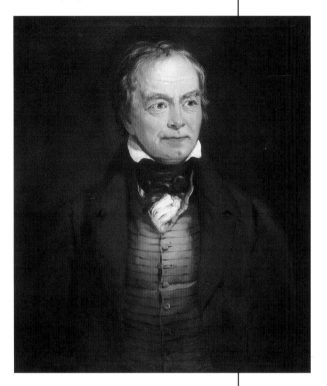

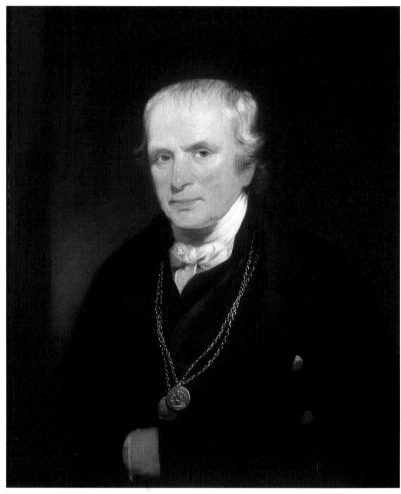

9 John Jones (Myrddin Fardd), *'Adgof Uwch Anghof': Llythyrau Lluaws o Brif Enwogion Cymru* (Pen y Groes, 1883), p. 180, translated from the Welsh.

10 The commission was given by one of his earliest sitters, John Williams of Treffos.

11 Among Jones's sitters at Chester was the minister John Parry, a portrait of whom was engraved for Edward Parry. The original portrait is lost, a circumstance for which the meanness of the Methodists of Chester at the beginning of the twentieth century may be responsible. R. Morgan reported in 1904: 'The Methodists of Chester are not worthy of the name while they continue deaf to the need for a memorial of their greatest benefactor. It is said that they refused to buy an oil painting of him, done by William Jones (the limner), which was originally bought for fifty pounds, and which was offered to the Methodist authorities in Chester for the small sum of five pounds', *Cymru*, XXVII (1904), 191, translated from the Welsh. William Jones painted original and copy portraits for the Grosvenor family, and one other Chester patron, John Lloyd of the Mount, is known from an engraving published by Parry in 1841. Jones also continued to work for the gentry of north Wales. Notable among his sitters was E. M. Lloyd Mostyn, who was also painted by Hugh Hughes. The portraits are illustrated and discussed in Lord, *Hugh Hughes, Arlunydd Gwlad*, p. 229.

My income is but small: the Llanberis tythe is only fifty pounds, and less than that in some years; and I cannot do much – but there is something I want to do, that is to support, to the best of my ability, every young man, in every craft and office, who is likely to do honour to his country. I do not judge that there is a lack of genius and talent among the Welsh, more than among the English, but that it wants education and instruction. Men who bring credit to their country (in my opinion) are Mr Wm. Jones, the Painter from Beaumaris; and Mr Hugh Hughes, from near Conwy, the fine Engraver and Painter; and others like them.[9]

William Jones had come into contact with the new Eisteddfod movement at its Caernarfon meeting, where he was commissioned to paint the poet David Thomas (Dafydd Ddu Eryri), a prominent figure in the proceedings. Thomas

337. Hugh Hughes,
John Jenkins, 'Ifor Ceri', 1825–6,
Oil, 552 × 419

338. Hugh Hughes,
Elizabeth Jenkins, 'Eos y Bele',
1825–6, Oil, 533 × 419

339. Unknown architect,
The Moat, Ceri,
Montgomeryshire, 1810

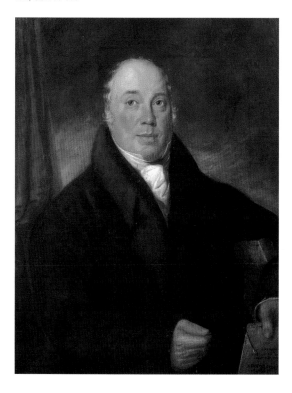

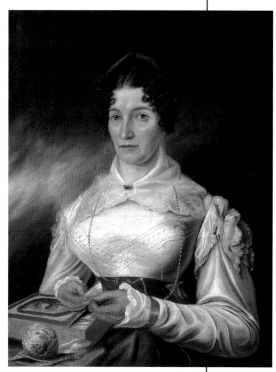

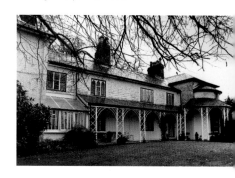

¹² This change has already been
noted in connection with the few
gentry portraits painted by Hughes
at this time and, indeed, the source
of these commissions was Gwallter
Mechain. See above p. 196.

¹³ The series is unusually well documented in
Hughes's letters to Ifor Ceri and correspondence
between members of the Anglican circle. Lord,
Hugh Hughes, Arlunydd Gwlad, pp. 130–44.
Hughes's portrait of Beynon, painted for the
Cymreigyddion, must have been a splendid
affair, since the artist was paid 25 guineas, a
fee far higher than he was accustomed to
receive. It was described in *The Carmarthen
Journal,* 10 December 1824.

wore his eisteddfod medals, which thereafter became a convention adopted for
official bardic portraits.¹⁰ At his home in Chester, Jones moved in a circle of
'exiled' Welsh intellectuals which centred on the publisher Edward Parry and
which included the poet Richard Llwyd, Bard of Snowdon, who also sat for
him.¹¹ The patronage stimulated by this increase in literary activity associated
with the new eisteddfodau had extended to Hugh Hughes by 1824, when he was
commissioned to produce an official portrait of Thomas Beynon, a member of
the Ceri circle. This commission no doubt involved his friend John Evans, the
Carmarthen publisher, since it was given by the Cymreigyddion Society of the
town, of which he was a leading member. *Thomas Beynon as President of the
Carmarthen Cymreigyddion* is lost, but soon afterwards a series of portraits of
the Ceri circle was commissioned. The portrait of Gwallter Mechain followed
the bardic iconography established by William Jones and, as a whole, the series
marked a departure from Hughes's early style to the imitation of an academic
manner. It was probably the painter's contact with the improving sophisticates
of the Ceri circle which lay behind this unfortunate change.¹² After completion
in 1826, the pictures, clearly conceived as a national series in celebration of the
achievements of the 'Hen Bersoniaid Llengar' (the Old Literary Parsons), as they
became known, were hung in the beautiful and avant-garde Gothic-style house,
the Moat, where Ifor Ceri lived with his wife Elizabeth Jenkins, the first woman
to be made a member of the Gorsedd of the Bards.¹³

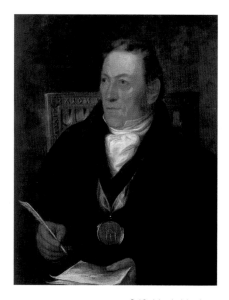

340. Hugh Hughes,
Walter Davies, 'Gwallter Mechain',
1825–6, Oil, 540 × 425

14 The dispute is described in detail in Lord, *Hugh Hughes, Arlunydd Gwlad*, pp. 145–72.

15 On its first appearance the engraving was accompanied by a written explanation, leaving the meaning of the image in no doubt. For this and Hughes's contribution to the Cymreigyddion Society, see Lord, *Hugh Hughes, Arlunydd Gwlad*, pp. 173–201.

16 An expanded translation of Peter Roberts's *Cambrian Popular Antiquities* with wood engravings by Hughes.

17 Evans also published *Brut y Cymry*, an attempt to produce an illustrated historical gazetteer of Wales both written and illustrated by Hughes, which failed after its first issue in 1824.

Hugh Hughes's flirtation with these establishment Anglicans was brief. It was cut short by the notoriety he acquired as a result of his support for Catholic emancipation in 1828 and the indecorous tone of a consequent dispute with the leader of the Welsh Methodists, John Elias, which set him outside polite society. Hughes was excommunicated from the church by Elias and in retaliation he published a series of letters and a pamphlet in which he described the minister as 'the Pope in Anglesey'.[14] Hughes had painted and engraved Elias in 1812, but his uncompromising image, like that of John Evans of Bala, was redolent of the folk origins of the movement in the mid-eighteenth century and had not become popular at the increasingly bourgeois centre of Methodism. Hughes's sense of the meaning of the movement remained firmly tied to its democratic roots and was opposed to the growing cult of the ministry, to which – with considerable irony – many of his other images contributed. He moved towards what seemed to his contemporaries to be an extreme radical position of opposition to the ministry *per se*. For him, this was simply a reaffirmation of the principles of the early Methodists and, indeed, of the early Christian church, in which, so he believed, the relationship of an individual to God was not mediated through a priesthood.

Between 1828 and 1832 Hughes developed his radical religious, political and social agenda through his association with the London Cymreigyddion Society, whose members produced the magazine *Y Cymro*, for which Hughes designed and engraved a frontispiece which attempted to define a new nation, based on the progress of the common people through education. Hughes's image quoted Corbould's image of 1796, which had been intended to sum up the eighteenth-century vision of antiquarians and aesthetes, *Britannia directing the attention of History to the distant view, emblematical of Wales*. To the standing stones, Edwardian castle and ploughman of the earlier engraving, Hughes added a steamship, scientific instruments and a factory, despite his own distaste for industrial Wales. Replacing the allegorical figure of History was the new Welshman, who wrote not only of the past but also of a future for the nation based on rational enquiry.[15] The content of the magazine closely reflected this principle, including, for instance, the earliest substantial writings in Welsh on statistics and science, for which Hughes engraved illustrations.

341. Hugh Hughes,
Cyfarwyddyd i Ffurfio y genau, i Seinio y Saith Sillafau, from Owen Williams,
Egwyddorion Canu, 1818, Wood engraving, 103 × 193

342. Hugh Hughes,
Y Parchg John Elias o Fon,
1812, Engraving, 91 × 70

343. Hugh Hughes,
Frontispiece for *Y Cymro*, 1830,
Wood engraving, 212 × 126

The frontispiece which Hugh Hughes had engraved
for *Y Cymro* of 1830 was the summation of his use of the
wood engraving as a means of enlightening the common
people on matters of religion, Welsh history and general
knowledge. His religious opinions had informed not only
his social and political thinking but also his art for ten years
before his radicalization as a result of the dispute over Catholic
emancipation. In 1818 he had illustrated a musical primer,
Egwyddorion Canu by John Ellis, with a series of delightful
engravings, and three years later he engraved covers for
translations of popular moralizing English texts for children published
by Robert Saunderson in Bala. In 1823 he worked with John Evans of
Carmarthen to produce the first original children's material in the Welsh
language, illustrated with pictures. The monthly *Yr Addysgydd* became the
model for several denominational magazines for the Sunday schools which
would flourish in the following decade. Other projects relating to Welsh
antiquities undertaken with Evans, notably *Yr Hynafion Cymreig*,[16] reflected
Hughes's sense of nationhood. These attempts to introduce monoglot Welsh
speakers to material which had previously been available only to English speakers
underline the rapidly broadening agenda of Nonconformist intellectuals in the
1820s. Individuals like John Evans had acquired the self-confidence to pursue
literary and antiquarian interests pioneered in Cymmrodorion circles in the
eighteenth century through the new societies based in Wales itself.[17]

344. Hugh Hughes,
Nos Ynyd, from Anon.,
Yr Hynafion Cymreig, 1823,
Wood engraving, 60 × 100

345. Hugh Hughes,
Jonah, Illustration in *Yr Addysgydd*,
edition by David Charles and Hugh
Hughes, 1823, Wood engraving,
37 × 51

[18] There is some doubt regarding when the commission was undertaken. The minute books of the society note that Owain Myfyr was approached to sit for John Vaughan in 1802, but whether or not he agreed is unclear, since he was again approached in 1813. He died the following year and the portrait was recorded as hanging in the society's rooms by 1820. The original, along with the portraits of James Davies, Robert Hughes and Dafydd Samwell, is lost. Of the several portraits of Twm o'r Nant which survive, one may be that donated to the society and which was hanging in its rooms by 1820.

[19] *The Cambrian Quarterly Magazine*, II (1830), 112.

Hughes's radical use of imagery for national awareness again found expression in portraiture in 1830. In the cosmopolitan atmosphere of London, the painter conceived the idea of a portrait gallery to celebrate the contribution of Welsh people of all persuasions to national life. Developing the practice of the Cymmrodorion, who, as we have seen, had commissioned William Parry to paint portraits in the 1770s, the Gwyneddigion Society had commissioned at least five portraits of prominent Welsh people, including one of the founders of the society, Owen Jones (Owain Myfyr), painted by another of its members, John Vaughan.[18] It seems likely that William Owen Pughe played a prominent role in the commissioning of some of these pictures. Pughe had an apparently insatiable appetite for portraits, not least of himself; he commissioned Eliza Jones in 1824, Thomas George in 1826 and 1832, and George's friend Hugh Hughes in 1826, 1827 and 1831. Hughes also persuaded his own chosen society, the Cymreigyddion, to commission at least two portraits, the more notable of which was of Thomas Roberts, Llwyn'rhudol, the only founder member still active at that time. His proposal to establish a 'Cambro-British Picture Gallery' in London, which was announced in *The Cambrian Quarterly Magazine* in 1830, therefore came as the natural outcome of a long process:

It has long been regretted that Welshmen of eminence often sink into the grave without any memorial remaining, to inform strangers and posterity of the form of their features: and any steps likely to remedy this defect, as far as circumstances will allow, will be valued by all who are interested in the affairs

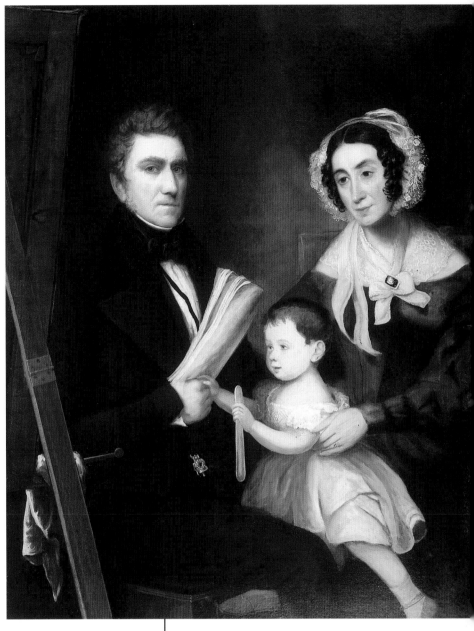

of Wales. A committee of gentlemen attached to the Royal Cambrian Institution will undertake the management of the plan, and fix upon the individuals whose portraits shall be deemed of sufficient public interest to occupy a place in the gallery. Excellent likenesses of several literary men connected with Wales have already been painted, by the individual with whom the suggestion originated. The gentleman alluded to is Mr. H. Hughes, artist, of Greek Street, Soho, a native of Wales, who has, with a liberality which does him honour, proposed to paint, in his best style, the portraits of persons introduced to his notice by the committee.[19]

William Owen Pughe saw a number of portraits in Hughes's studio in 1831, but nothing more was heard of the project. Almost all the pictures owned by the societies have disappeared, and only two portraits painted by Hughes in London in this period are known to have survived, one of which is his ambitious *Self-portrait with Sarah Hughes and Sarah Phillips Hughes*, which was perhaps intended for the National Gallery.

above:
347. Hugh Hughes,
Self-portrait with Sarah Hughes and Sarah Phillips Hughes,
c.1830, Oil, 1250 × 1010

above left:
346. Hugh Hughes,
Lord Holland and Lord John Russell, c.1828–31, Mezzotint,
457 × 305

348. Richard Woodman after
Thomas George, *William Owen Pughe*,
1832, Lithograph, 190 × 140

213

349. William Roos,
Dewi Wyn o Eifion, c.1836,
Oil, 760 × 640

20 'I was three months painting in London, also in Woolwich and Dulwich, Greenwich in which place I stayed a week to paint J. W. Thomas Arfon or the "Cymro Cadarn", that famous Welshman who is at present Astronomer to the King in the Royal Observatory. His picture has been hung in the meeting room of the Cymreigyddion in London. I also painted Gwrgant, that is Wm. Jones Esq., and many others', NLW, Cwrt Mawr MS 74C, f. 58, translated from the Welsh.

21 *Y Tyddynnwr*, 1, 4 (May, 1923), 310, translated from the Welsh. The close relationship which existed between artisan painters and poets such as Hugh Derfel, and the many social and professional similarities between them, has given rise to the Welsh term 'Arlunwyr Gwlad' to describe the painters, corresponding with the long-established 'Beirdd Gwlad' for the poets. The term was coined by Delyth Prys.

As Hugh Hughes's radical activity reached its peak in the early 1830s, the career of William Roos was beginning to develop. In many ways he was the antithesis to Hughes – although far more gifted technically, he was essentially a simple man and certainly not an intellectual. Nevertheless, his client base also drew him into contact with the new intelligentsia. For instance, when he ventured to London for the first time in 1836, among those he was commissioned to paint was John William Thomas (Arfonwyson), a distinguished mathematician working at the Royal Observatory in Greenwich and a prominent member of the Cymreigyddion Society. The son of a Caernarfonshire labourer, Arfonwyson had risen to prominence by his own efforts, and might be considered a classic example of the new middle-class intellectual. The portrait is known only from a letter, dated 27 December 1836, written by Roos to his friend Dewi Wyn o Eifion, who was himself a figure of note and by the 1830s reckoned to be among the leading poets of his generation.[20] Similarly, Roos knew Hugh Derfel Hughes, a young poet whose most famous work, 'Y Cyfamod Disigl' (The Steadfast Covenant), made a deep impression on him. Hugh Derfel had met Roos at Christmas, 1844, on his return from a tour to south Wales where he had sold his book of poems, *Blodeu'r Gân*. The painter was also on tour, taking portraits, and Hugh Derfel described him as:

> a man of average height, rather fat and fleshy. His round, smooth face is shaven and ruddy with a peaceful and contented expression. His walk is laborious and slow and his general manner low and humble. His pictures are fine and deserving of praise. Coming from a family of most humble circumstance, Roos worked his way up through many disadvantages to the aforementioned skilfulness.[21]

The many examples of acquaintances made between artisan painters and poets such as Hugh Derfel – the *bardd gwlad* – emphasize the similar social standing and craft traditions of the two groups. John Roberts, for instance, knew and painted Robert Williams (Robert ap Gwilym Ddu), and may have also been responsible for a particularly fine lost portrait of the poet.

Roos both contributed new images which became the basis for popular iconographies and benefited from those already established. The familiarity of images such as that of Thomas Charles created a small market among the better-off for copies of oil paintings, which sometimes purported to be originals. In the mid-1830s William Roos based an oil portrait of Charles closely on the 1812 engraving by Collyer, but placed spectacles in the rather unnatural empty hand added by the engraver, in a similar way to that adopted in the engraving

350. John Roberts,
Robert Williams, 'Robert ap Gwilym Ddu',
c.1840, Oil, 704 × 560

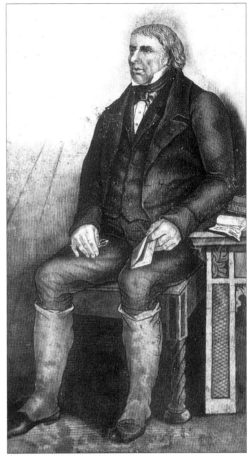

351. Anon., *Robert Williams,*
'Robert ap Gwilym Ddu', c.1835,
medium and size uncertain

commissioned by Saunderson. In the case of several copy portraits of the Baptist minister Christmas Evans, the source was his own work. Roos's original had been painted as a speculative venture when the two were neighbours in Caernarfon in 1835, and proved highly successful in a mezzotint which he engraved himself. Clearly conscious of the competition from a portrait by Hugh Hughes,[22] Roos remarked, when trying to sell one of his copies, that 'it is considered the most correct of any taken of him'.[23] On the back of one of these, Roos wrote the words 'To Christmas Evans. The most ideal preacher Wales ever produced. Robert Hall called him a world of ideals.' Such evidence of the high status of the sitter is reinforced by the transference of the image to other forms. In a fine naive copy of the engraving, an unknown painter ignored the classical column which Roos had added to dignify the sitter, creating instead a brightly coloured frame around the portrait. The painting was made on a small panel into which was screwed a brass ring in order to hang it on a wall. Both in its form and function this reconstructed image echoed the icons of the eastern Orthodox churches. For those able to afford to buy their Nonconformist icons ready-made, one of the ceramics factories of Staffordshire in England manufactured an earthenware figurine, clearly based on the Roos print. The product was intended exclusively for the Welsh market since the subject of the statuette was unknown to the general public in England, as were other subjects, including John Bryan and John Elias, presumably made at the same factory. The source for the Elias statuette was a portrait painted in 1838 by Hugh Jones of Beaumaris. By this time Elias, leader of the Calvinistic

[22] Hughes's portrait was commissioned by Daniel Jones, Liverpool, and Caledfryn, and was reproduced in mezzotint by the artist as a frontispiece to the memoir of Christmas Evans published in 1839. The original portrait was destroyed during the Second World War in London, but a copy by Ap Caledfryn survives. The commission is described in detail in Lord, *Hugh Hughes, Arlunydd Gwlad,* pp. 231–3.

[23] NLW MS 7165D, f. 288, letter to William Roberts (Nefydd), 1870: 'you must recollect Christmas at the said time – circumstances cause me to offer this Portrait for sale, should yourself, or any of your acquaintances want a correct as well [as] a good painting, of the great man, of ideas, and Eloquence, they can buy it for £2.0.0. It is half life size, the face is 5 inches long.' By this time Roos was living in poverty. At least three versions of Roos's portrait of Christmas Evans survive, in NMW, NLW and a private collection.

352. William Roos,
Christmas Evans, c.1835, Oil,
394 × 332

353. William Roos,
Revd. Christmas Evans, c.1835,
Mezzotint, 235 × 180

354. Anon. after William Roos,
Christmas Evans, date uncertain,
Oil, 220 × 180

Methodists, was at the height of his fame. The engraved version of Jones's portrait, published by Edward Parry in Chester, was available in forms to suit a variety of pockets, including first proofs signed by the sitter at 7s 6d. Their popularity was soon confirmed by the emergence of both a cheap engraved copy and of copy paintings by Roos. The portrait by Hugh Jones also became the basis for kitsch items such as silk scarves produced in the second half of the nineteenth century.

355. Hugh Jones,
John Elias, 1838, Oil,
760 × 635

356. After Hugh Jones,
John Elias, c.1860,
Silk, 830 × 850

357. After William Roos,
Christmas Evans, Staffordshire
pottery figure, *c.*1840, 365h.

Popular portrait iconographies occasionally extended beyond the staple diet of ministers and poets. For instance, the Liverpool banker William Roscoe (patron of John Gibson) interested himself in the eccentric wandering linguist Richard Robert Jones (Dic Aberdaron). In 1822 Roscoe published a study of Dic Aberdaron which contained both psychological insights remarkable for the period and a romantic engraving which gave a distinctly misleading impression of the handsome but ragged linguist.[24] There seems little doubt that it was Roscoe's study and its engraved portrait which encouraged A. R. Burt of Chester to produce a rival and more credible image the following year, intended for a very different market. Burt's engraving sold at 1*s* plain and 1*s* 6*d* coloured and with it *Richard Robert Jones, the wonderful Linguist* truly entered popular consciousness.[25] This was followed in 1837 by an image of Dic adorned with his French horn and travelling library, which formed the basis of numerous variants, especially after his death in 1843, and the publication of a popular memoir by Hugh Humphreys of Caernarfon. Humphreys reported that 'several of our most important artists have taken Richard's portrait; but probably the last to be painted was by Mr. Richard Williams, Llan St. Sior – he took two pictures of him in August last – one was put up for a raffle in the Bee Hotel in Abergele shortly before his death, and came into the possession of Lady Gardner, Kinmel Park'.[26] In fact, the painter of the portrait at Kinmel was William Roos and it ranks among his finest productions.[27]

In 1850 a large copy of the portrait was hung at the Rhuddlan Eisteddfod, among whose promoters was the architect and poet John Jones (Talhaiarn), one of the rising stars of the London-Welsh intelligentsia. At that time he was working as an assistant to Sir Joseph Paxton on the construction of the Crystal Palace. Talhaiarn designed the eisteddfod pavilion and may well have conceived the idea of the copy portraits which, along with painted arms and mottoes, adorned the walls.[28] Probably in celebration of his own role in the proceedings, Talhaiarn himself was painted in the year of the eisteddfod by Roos. This was not only one of the finest portraits of the nineteenth century but also an unusually complex artisan product. On the back of the canvas Roos inscribed the words 'The Bard in Meditation', which, along with

[24] Dic was known among English ladies of Roscoe's acquaintance as 'the learned pig', because of his distaste for washing. A later wood engraving cast him, with an equal degree of fancy, in the classical mode. For this print and the iconography of Dic Aberdaron in the wider context of the popular print, see Lord, *Words with Pictures*, pp. 113–15.

[25] A. R. Burt carried out a number of Welsh subjects in similar style, including John Evans, a Welsh miner celebrated for being trapped underground for twelve days in a pit near Wrexham, for which see Lord, *The Visual Culture of Wales: Industrial Society*, p. 141.

[26] H. Humphreys, *Hanes Bywyd Dic Aberdaron* (Caernarfon, 1844), p. 39, translated from the Welsh. Richard Williams is untraced, but he was among the mourners at the funeral of Dic Aberdaron. Other contemporary images of Dic included a portrait bust in the Liverpool Mechanics' Institute, now lost. This may be one of the two busts noted in Humphreys' memoir. Among the most notable artists to record Dic Aberdaron was John Orlando Parry, who made a drawing at the Beaumaris Eisteddfod of 1832, for which see Lord, *Words with Pictures*, p. 115. Dic was also the subject of numerous portraits made after his death, including two fine naive stone carvings, based on engravings, for which see Lord, *Gwenllian: Essays on Visual Culture*, p. 85 and colour section, no pagination.

[27] Roos painted at least two other portraits of Dic Aberdaron.

[28] Other copy portraits included Roos's own *Dewi Wyn o Eifion*, William Jones's *David Thomas, 'Dafydd Ddu Eryri'*, and the portrait *Thomas Edwards, 'Twm o'r Nant'* commissioned by William Madocks. The portraits were not signed, which suggests that they were not painted by Roos himself. The series seems to be the work of two different hands. One of the painters may have been Thomas Jones (Taliesin o Eifion), an artisan painter by trade but also a poet who moved in eisteddfod circles in the north east.

358. A. R. Burt,
Richard Robert Jones,
the wonderful Linguist,
1823, Etching and
watercolour, 275 × 200

359. William Roos,
Richard Jones of Aberdaron, the celebrated
*linguist, c.*1838, Oil, 736 × 609

[29] Roos's romantic image of 1850 stood in dramatic contrast to the image of bourgeois respectability which he produced of the same sitter the following year. An earlier portrait of Talhaiarn by Roos, dated 1839, is lost. W. Wilson Roberts, 'Talhaearn', *Cymru*, XXXI (1906), 250.

[30] Following the 25 guineas which Hughes received for *Thomas Beynon as President of the Carmarthen Cymreigyddion* in 1824, his prices declined. In 1845 he charged £5 each for large portraits of Ellen Lloyd and Ann Williams of Llannor, which were among the best of his later career. In 1870 William Roos offered one of his portraits of Christmas Evans for sale at £2, and five years later he attempted to establish a portrait club in Carmarthen in which members were to be charged £3 18s, probably a reduction from a standard fee of 4 guineas.

[31] Ellis Owen, *Cell Meudwy sef Gweithiau a Bywgraphiad Ellis Owen, FSA Cefn-y-meusydd* (Tremadog, 1877), p. 48. Ellis Owen also wrote a poem in celebration of the work of the painter Ellis Owen Ellis, ibid., p. 52.

the imagery of loose clothing, wind-ruffled hair and beard, was clearly a reference to the eighteenth-century tradition of bardic pictures made by academic painters. Although it was not widely distributed, Roos might have seen Thomas Jones's painting *The Last Bard* in engraved form, and Philippe de Loutherbourg's version was extremely well known.[29]

The eisteddfod copy portraits demonstrate that, by mid-century, artisan portrait imagery was perceived as part of a national heritage. Roos's *Talhaiarn, The Bard in Meditation* suggests that the painters, for all their humble origins and the pitiful remuneration they received, were conscious of their role in creating a national mythology.[30] Roos and other painters were occasionally celebrated by the poets whom they counted as friends. In 1850 Ellis Owen, Cefnymeysydd, wrote – in English, in imitation of the *englyn* form – a rather bizarre epitaph for Roos, who was still in the prime of life:

360. William Clements,
Richard Robert Jones, Engraving
printed on silk, *c.*1843 after the
original of 1837, 225 × 140

361. William Roos,
Talhaiarn, The Bard in Meditation,
1850, Oil, 635 × 530

He painted life so well that Death
Envied his art; – withdrew his breath:
Although with mortals here he lies,
His Fame both Time and Death defies.[31]

Ellis Owen was one of a small number of sitters among the literati who were
painted both by Roos and Hugh Hughes. Despite drawing for over forty years
on the same small pool of potential patrons, no written reference survives to
link the two men, but they must surely have met on many occasions. The absence
of evidence is probably attributable to the gulf between them in terms of both
personality and intellect. Roos recorded the faces of the élite with great panache,
but he was never a power among them. Hughes, on the other hand, both as a
thinker and as an artist, was a figure of influence in their midst.

ADDA ac EFA
Yn Ngardd Eden.

YR HWSMON DIOG AR CRISTION DIOFAL.

Cenir ar "God save the King." yr hen ffordd.

YN EDEN, fan odiaeth, y bu-fy nhrestadaeth
 A Nhad yno 'n benaeth yn byw ;
Fe'i troed i boenydio yn ddimerth oddiyno,
 Am iddo fo ddigio'r gwir Dduw ;
A finau ddanfonen i drin y ddaearen,
 Ar gwr yr Iorddonen, oer ddwr,
Gan beri i mi 'n buredd lafurio 'n ddioferedd,
 'Rol colli'r wlad sanctaidd yn siwr :
Cael tir mewn lle ffrwythlon, fel hen fynydd *Sion*,
 Ynghanol glyn tirion glân tëg,
Yn dyddyn dedwyddol,—gallaswn fyw'n llesol,
 Yu *Hwsmon* da freiniol di ffêg.

Yn lle cloddio ac arloesi, mi ynddygais i ddiogi ;
 O b'le daw fyth dd'ioni o'r fath ddyn ?
Heb unwaith ofalu, am droi na braenaru,
 Na gwneuthur ar lyfnu fawr lûn ;
Hau mewn tir tenau, anialwch a chreigiau,
 A gwaeth, mi wn droeau, mewn drain ;
Yr adar a'i bwytty, y gwres sy'n ei grasu,
 A thyfu wna i fynu'n o fain :
Yn lle gwenith i eginio, yr ysgall afrosgo
 A welir yn cuddio pob cefn,
O eisiau i mi arloesi y drain a'r mieri,
 Drwy ddiogi daw drysni di drefn.

isiau bod ffosydd, drwy ganol y gweunydd,
 ae nolydd yn gorsydd i gyd ;
th a ddisgwylia, o achos fy 'sg'leusdra,
 d *Gaua'* tyn laddfa tan lid :

Dylaswn ystyrio yn forau i lafurio,
 Cyn i'r *Haf* basio'n rhy bell,
Mi â'n gwrwm di gariad, mewn ffair ac mewn
 Na b'sai fy nillad i'u well : (marcanad
Daw angen, tlodi, fel ceisbwl i'm cospi,
 Am i mi droi i ddiogi drwy ddydd.
Cewch weled yn sydyn, mai niwedd fydd newyn,
 Nes dirwyn fy nghloryn ynghudd.

Fel hyn wrth naturiaeth, mae dyn mewn cyff'lyb-
 I'r *Hwsmon* di dorraeth ar dir ; [iaeth,
Yn llwyr anystyriol, o'i enaid anfarwol,
 Mewn cyfiwr anianol yn wir ;
Pan ga'dd ei fedyddio, adduned oedd yno,
 Am iddo filwrio'n ei le,
Un aelod ysprydol, o'r Eglwys Grist'nogol,
 Ymrwymo'n ufuddol wnae 'fe ;
'Fe addawodd ymwrthod, â satan a phechod,
 A bod yn dra pharod drwy ffydd,
I ymladd yn wrol, dan faner Duw nefol,
 Rhyfeddol mor foesol a fydd.

Pan elo'r gwr tyner, mewn oedran ac amser,
 'Fe gymmer fwyn bleser mewn blâs ;
Gân redeg yn ebrwydd, i ganlyn ynfydrwydd,
 Heb ynddo fawr arwydd o ras :
Distyru cynghorion, iaith rywiog athrawon,
 Gan ddilyn ynfydion y fall ;
Fel 'nifail gwar galed, heb synwyr i synied,
 I ystyried na gweled y gwall :

Halogi'n resynol, y *Sabbath* sancteiddiol,
 Trwy'ffol anfucheddol ddewr chwant,
Ac enwi drwy 'sgafnder, Dduw nefol yn ofer,
 Sydd'arfer gwan bleser gan blant.

Bydd ynddo 'fe hefyd arferion dychrynllyd,
 Aflendid ac erlid y gwir ;
Mae chwant yn cynnyddu, i'w galon heb gelu,
 Fel chwyn a fo'n tyfu mewn tir ;
Pan elo fe'n daclus, oer oglyd i'r eglwys,
 I wrando gwir dawnus gair Duw,
Er clywed a'i glustiau, na ddieng yn nydd angau,
 Ni bydd ar ei fronnau fawr friw :
Pob cynghor a glywo, mae'n gollwng yn ango',
 Wneiff dim a ddarlleno ddim lles,
Fel hâd a fo'n syrthio, ar graig lle mae'n gwywo,
 Nes iddo lwyr grino mewn gwres.

Edrychwn yn mhellach, ei fuchedd afiachach,
 Ni a'i gwelwn yn arwach yn wir ;
Ei Dduw ydyw Mammon,--mae'n ofni'n ei galon,
 Na cheiff ef mor digon o dir ;
Rhyw chwantau cybyddlyd, a gofal a gyfyd,
 Pan glywo 'fe agoryd y gair,
Gan edrych o'i ddeutu, myfyrio am y foru,
 Pa fodd i fwyn ffynu mewn ffair ;
Os hittia iddo feddwl, rhaid gadael i cwbl,
 Ni phery ei fyr drwbl fawr dro,
Er clywed a'i glustiau, na ddieng yn nydd angau,
 Cynnyddu yu ei feiau mae 'fo.

Edrychwn drachefen, ei drafael a'i drefen,
 Ni a'i gwelwn a'i gefen yn gam ;
Ei gorph yn fethedig, mewn henaint crynedig,
 A'i enaid mewn peryg ;—mi wn pa'm,
Ei bleser a'i hoffder fydd sôn am ei gryfder,
 Fel byddai 'fe'n amser ei nwy',
Gan osod ei hyder, mewn hunan gyfiawnder,
 Heb feddwl am fatter sydd fwy,
Hyfrydwch ei galon, fydd 'mofyn rhyw n'wyddion
 Yn hen ddyn lled wirion llwyd wedd,
Ac angau dychrynllyd, yn barod bob munyd,
 I'w symud o'r bywyd i'r bedd.

Mae'n oleu i ni weled, os darfu i ni 'styried,
 Fel yr ydym ddieithriaid i Dduw ;
Mae dyn pechadurus, o'i enaid anian truenus,
 A chyflwr enbydus yn byw ;
Mae calon lygredig, dyn annychweledig,
 Fel tir heb ei aredig erioed,
Neu bren wedi ei blanu, heb ffrwyth arno'n tyfu
 Pwy fedr fyth garu'r fath goed ?
Gadewch i ni 'mdrechu, cyn henaint gan hyny,
 A pheidio rhyfygu'n rhy fawr,
Nid oes yn y beddrod, ddim gwaith na myfyrdod,--
 Dyled bod yn barod bob awr.

 JOHN THOMAS.

JOHN JONES, ARGRAFFYDD, LLANRWST.

The impact of Hugh Hughes on the development of the printed image was particularly important. In the eighteenth century some books and ballads had been illustrated with wood blocks bought in from England and occasionally with what appear to be locally-cut pictures, but the main suppliers of illustrated material in the Welsh language had been presses in the border towns, notably Shrewsbury and Chester. Hughes had done much to transform that situation and, although by 1834, when he moved to Caernarfon, he no longer practised as an engraver, his early influence on the publisher John Jones of Trefriw manifested itself in the production of printed visual images on a large scale. Jones represented the third generation of printers at Trefriw, but by including engraved illustrations in his output he was breaking new ground since his forebears, like printers elsewhere in Wales, had shown only limited interest in pictures. He began printing engravings for Hughes in the early 1820s, and in one of his own publications, a reprint of Theophilus Evans's classic of early Welsh history, *Drych y Prif Oesoedd*, he included Hughes's engraving of *Brad y Cyllill Hirion* (The Treachery of the Long Knives). The press moved from Trefriw to Llanrwst in 1825 and began to use a wide variety of blocks acquired from various sources, augmented by new work carried out primarily in Caernarfon by James Cope. Nothing is known of Cope's background other than that he was born in Caernarfonshire in 1805 or 1806. More than thirty of his woodcuts survive, nearly all of which were printed by John Jones, probably between the early 1830s and 1842.[32] A large proportion of them were on religious subjects, printed with more or less appropriate songs in ballad sheet form, and were probably distributed mainly at fairs and markets by ballad singers. The Welsh images formed part of a tradition of cheap woodcut imagery from all over Europe; it was brought to Wales via the popular press in London which had been recently

opposite:

362. James Cope,
Adda ac Efa, Woodcut,
1832–42, 420 × 330

[32] Twelve prints were signed by Cope and a further twenty are attributed to him on stylistic grounds. See Lord, *Words with Pictures*, pp. 93–104. Most unusually, several blocks made by Cope and two which are the work of Hugh Hughes survive at the Museum of Welsh Life. The press on which they were printed, made by John Jones himself, is at the Science Museum, London. For Jones, see Gerald Morgan, *Y Dyn a Wnaeth Argraff: Bywyd a Gwaith yr Argraffydd Hynod, John Jones, Llanrwst* (Llanrwst, 1982).

363. Hugh Hughes,
Brad y Cyllill Hirion, 1822,
Wood engraving, 80 × 132

364. Unknown photographer,
John Jones of Trefriw, c.1860–5

221

365. James Cope,
Golwg ar y Groes,
c.1832–4, Woodcut,
242 × 365

366. James Cope,
Gwahoddiad i Adferiad
Gwylmabsant Bangor, 1841,
Woodcut, 427 × 257

[33] It is probably significant, given the coincidence of Hugh Hughes's arrival in Caernarfon and the contemporary development of James Cope's cuts, that Hughes had worked as an engraver in London from 1814 in close proximity to the centre of print publishing at Seven Dials, and he may well have been employed there by Catnach.

[34] John Harvey, *The Art of Piety: The Visual Culture of Welsh Nonconformity* (Cardiff, 1995), pp. 46–53.

reinvigorated by the publishers John Pitts and James Catnach.[33] James Cope's boldest compositions illustrated Old Testament subjects such as the splendid *Adda ac Efa* (Adam and Eve), built up from six separate blocks. More surprisingly, Cope also cut New Testament subjects, notably *Golwg ar y Groes* (A View of the Cross), which survives only as a fragment. The press of Isaac Thomas in Cardigan also produced scriptural subjects on a large scale. Although the image of a pious Nonconformist Welsh folk, who had rejected religious pictures as idolatrous,

was assiduously cultivated by nineteenth-century religious writers, it is not borne out by the substantial evidence provided by the woodcut prints and by the fascination with engraved portraits of preachers.[34] Indeed, the printer Isaac Thomas was a leading figure in the Baptist community in Cardigan.

The presses of John Jones and Isaac Thomas continued to dominate the production of popular printed pictures in the second half of the nineteenth century. The unknown engraver who cut blocks for Thomas was considerably more naive than James Cope. He depended on developing images from London originals and, on at least one occasion, the work of his northern counterpart.[35] Nevertheless, the transformation of these models under the Cardigan engraver's hand was so considerable that they may justly be considered originals in themselves. Only on one occasion do surviving prints suggest a completely new design. *Lazarus y Cardottyn* (Lazarus the Beggarman) is a moralizing biblical story retold by Dafydd William and illustrated in modern dress. The obese and ill-fated gentleman, who is the villain of the piece, emerges from his respectable new villa and passes by Lazarus without giving alms. Isaac Thomas's style of assembling these pictures and texts was more bombastic than that of John Jones and was characterized by heavy borders and corner blocks. The Cardigan printer produced more English and bilingual texts than Jones, and was also more inclined to produce ballads describing murders and scandals than his northern counterpart. Providing a wide range of funereal images, both men met the large and characteristic demand of the times for dismal reflections on the insubstantial nature of human existence.

Isaac Thomas published few works of social or political comment,[36] but James Cope cut a number of fine blocks on contemporary issues. This reflected the more intense intellectual atmosphere of Caernarfon, where, following his co-operation with Caledfryn on the periodical *Y Seren Ogleddol*, Hugh Hughes established the

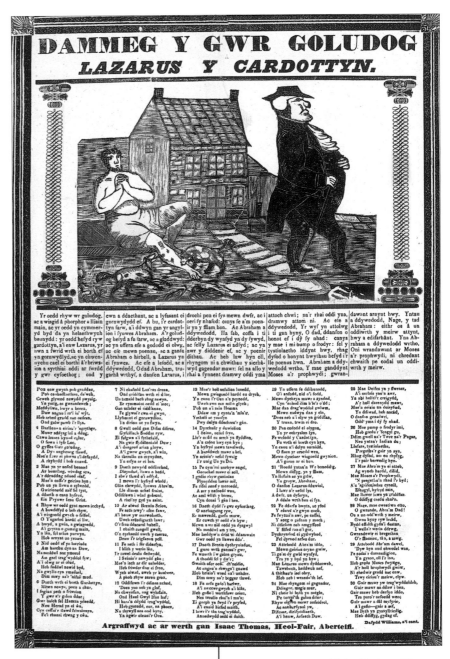

367. Anon., published by Isaac Thomas,
Lazarus y Cardottyn, c.1835–53,
Woodcut and watercolour, 484 × 350

[35] The *Adda ac Efa*. A substantial collection of material relating to Isaac Thomas is held at NLW, Department of Pictures and Maps, The Cardigan Printer's File. It includes the London and Llanrwst prints from which the Cardigan engraver developed his cuts.

[36] A ballad by Levi Gibbon on the subject of the Rebecca Riots is the only surviving illustrated print on a political subject. However, the blocks were taken from stock rather than cut specially. For this and other representations of the Rebecca Riots, see Lord, *Words with Pictures*, pp. 137–41.

opposite:

368. James Cope,
Y Tories yn cael eu Cymeryd
Adref at eu Teulu, c.1834–6,
Woodcut, 400 × 315

369. James Cope,
Can Newydd am Leshad Dirwest,
1836–7, Woodcut, 338 × 225

first weekly newspaper in the Welsh
language in 1836. The *Papyr Newydd*
Cymraeg, edited and printed by Hughes,
continued the radical tradition of *Y Cymro*
by addressing both British and Welsh
issues. It did not include woodcuts, but
James Cope's contemporary anti-Tory
broadsides derived from the same radical
tradition. Of more particularly Welsh
interest was the broadside published
in 1842 by L. E. Jones, with a woodcut
by Cope, attacking the Bishop of Bangor
for his promotion of games and sports
in celebration of the baptism of Arthur,
Duke of Connaught. Such use by
Nonconformist intellectuals of satire to
attack the alleged licentiousness of the
Church establishment truly represented
the Welsh world stood upon its head. In
the eighteenth century it had been the
Methodists who were satirized for their
Puritanism by libertarian intellectuals
such as Evan Lloyd.[37] Nevertheless, the new Nonconformist intellectuals were
not always of one mind, and differences of opinion among them on moral issues
were sometimes expressed in visual satires. The debate between supporters of
total abstinence from alcohol and those who favoured moderation, for instance,
became important in the mid-1830s. Hugh Hughes was a believer in moderation,
and he printed a controversial pamphlet on the subject written by Caledfryn. If
James Cope's images, published with ballads by Owen Griffith (Ywain Meirion)
and William Edwards, truly reflected his beliefs (and not simply the exploitation
of a market), then he was a teetotaller.

[37] An English-language satirical monthly, *Figaro*
in Wales, was published in Bangor in 1835. The
paper soon found itself in court, successfully sued
for libel, and L. E. Jones of Caernarfon (the printer
of the attack on the Bishop of Bangor) was also
fined £100 merely for selling it. See Lord, *Words*
with Pictures, ibid., pp. 128–9. The attribution of
the attack on the Bishop of Bangor to James
Cope is made on the grounds of style. Neither
the artist nor the author of the highly libellous
verses appended to it identified themselves.

370. M. Jenkins after Moses Harris,
The Steward, 1787, Engraving and
watercolour, 337 × 263

371. L. Barree,
*Conversation between the Bridewell and
Town Hall, Swansea (set to music)*, 1828,
Watercolour, pen and ink, 365 × 263

Regrettably, apart from the work of James Cope, social and political comment was expressed only to a very limited extent in Welsh visual imagery in what constituted one of the most turbulent periods in the history of the nation. Political prints were largely an urban, if not a metropolitan phenomenon throughout Europe, and only in Swansea, for a time the largest town in Wales, did politics manifest itself in the visual image. The Swansea prints, important as they are, were concerned with local matters. Events of wider import, such as the disturbances in Merthyr in 1816 and 1831, and the Chartist rising of 1839 at Newport, produced only a meagre crop of pictures. Such limited framework as did exist in Caernarfon and Cardigan for initiating and publishing cheap prints on a large scale was far removed, both geographically and intellectually, from the industrial centres of these protests. Hugh Hughes and most other Nonconformist intellectuals were committed to democratization, but were opposed to violence and certainly to insurrection. They believed it necessary to raise the people to a level of awareness of political issues and to equip them with the means to engage in rational debate, in the power of which they had absolute faith. It was fundamental to their belief system that God had given men and women the power of reason to raise them above animals and therefore that violent protest was not only irrational but also irreligious. Furthermore, as the geographical range of activity of Hughes and Roos as portrait painters makes clear, many also felt generally alienated from industrial Wales, whose people they perceived to be the antithesis of the enlightened rural folk and who were increasingly mythologized as the bedrock of the Welsh nation. In 1848, reflecting on the Rebecca Riots and the Chartist Rising at Newport, Hughes aligned himself with those who believed:

> Both originated with, and were conducted by men, not of the unenfranchised, and *unanglified* Welsh, but chiefly by Englishmen. The working classes of Wales were not the parties principally aggrieved by the *turnpike* impositions; and as to Chartism, the Welsh, unacquainted with the English language, had known nothing of its principles, but had lived entirely beyond the pale of its influence. Dissenters in particular, of every grade, were not only uncontaminated with English infidelity and insubordination, but they were the chief impediments in the way of the success of both the riotous movements alluded to.[38]

Hughes's condemnation of these events was published as part of the most important patriotic defence of Wales made through the medium of images in the first half of the nineteenth century. *Pictures for the Million of Wales* was a series of cartoons with bilingual texts directed against the reports of the commissioners sent by the government from London to investigate the condition of education in Wales and published in 1847. They were perceived to have condemned the Welsh nation not only educationally but also morally. It may seem ironic that Hugh Hughes's condemnation of the Rebecca Riots and the Chartist Rising was made in his patriotic defence of the nation against the commissioners' Blue Books, as they came to be known, given the modern mythologizing of the disturbances as a central part of a radical Welsh heritage, but Hughes was perfectly consistent in his attitudes. His belief as a Nonconformist in reasoned argument supported by piety, values which he believed the Welsh nation above all others had taken to heart, was threatened equally by riotous behaviour and the arrogance of the English government.

Hughes's lithographs against the Blue Books were published by *The Principality* newspaper in Cardiff, probably while it was briefly under the editorship of Evan Jones (Ieuan Gwynedd). Although in some ways they reflected the eighteenth-century tradition of English political satires, they were a modern and sophisticated response, and became well known among the intellectual community. R. J. Derfel's play of 1854, whose title gave to the Welsh language one of its most potent and resonant expressions, *Brad y Llyfrau Gleision* (the Treachery of the Blue Books), followed the cartoons closely in both plan and iconography. However, it may be that the cartoons did not reach a wide audience. Nothing is known of how they were distributed and their approach was quite different from that of the truly popular wood engraved ballads or broadsides, which were still being produced in large quantities in Llanrwst and Cardigan.[39] It was not until January 1858 that this popular tradition developed a sustained social and political critique in the form of *Y Punch Cymraeg*, published monthly at 1*d*. The magazine was initially produced in Holyhead by Lewis Jones and Evan Jones, though the idea probably originated with Richard Evans, known as 'Twrch', who was responsible for much of the written material and also for designing (though probably not drawing) some of the cartoons. From March 1858 the visual content of the magazine was dominated by the woodcuts of Ellis Owen Ellis.

[38] Hugh Hughes, text to 'Dame Venedotia Sousing the Spies', *Pictures for the Million of Wales* (Cardiff, 1848). The visual representation of protest in industrial Wales is discussed in Lord, *The Visual Culture of Wales: Industrial Society*, pp. 137–9.

[39] No works by James Cope made after 1842 have been identified. Nothing is known of his subsequent history. However, his blocks were re-used for many years by the press in Llanrwst.

372. Hugh Hughes, *Gathercoal, Scuttleworth's Final Charge to the Spies*, no. 2 from the series *Pictures for the Million of Wales*, c.1848, Lithographs, 190 × 165

373. Ellis Owen Ellis,
Ellis, Bryn Coch (self-portrait
of the artist), 1860,
Woodcut, 160 × 112

Ellis Owen Ellis was born in Aber-erch, Caernarfonshire, in 1813 and may have spent some time in London in the mid-1830s. However, Liverpool seems more likely to have been the metropolitan focus of his professional life. He was certainly there in September 1855, engaged in the ancient artisan tradition of 'preparing Illustrations and Armorial Flags and Figures for the Liverpool Corporation, who are making great preparations to welcome the visit of His Royal Highness the Duke of Cambridge to the town of Liverpool on the 9th and 10th of October'.[40] The few painted portraits by Ellis which survive, such as that of Morris Hughes of Llanrwst, suggest that he was self-taught. Only one, *Y Bardd yn ei Wely* (The Poet in his Bed) – a portrait of the poet John Thomas (Siôn Wyn o Eifion) – was engraved, though it became well known as the frontispiece to a collection of the poet's works, among which was a celebration of Ellis:

> A limner, accomplished,
> Refined, his work revered.
> No idol from Ellis' hand
> No better from an artist, grand.
> To praise, what poet would shirk,
> In fair words his fine work?[41]

[40] NLW MS 1804E, Vol. II, f. 259, letter from Ellis Owen Ellis to Miss Davies, Penmaen Dovey, Machynlleth.

374. Ellis Owen Ellis,
*Morris Hughes of Llanrwst, c.*1840–50,
Watercolour, 145 × 117

375. Ellis Owen Ellis,
Y Bardd yn ei Wely, 1861,
Lithograph, 78 × 144

376. Ellis Owen Ellis, *The Funeral of Richard Jones at St Asaph,* from *The Illustrated Life of Richard Robert Jones of Aberdaron,* 1844, Pencil, 289 × 460

Ellis's home was reported to be 'the rendezvous of many prominent Welshmen of those days, including Ceiriog, Llyfrbryf, Idris Fychan and Robin Ddu',[42] many of whom featured in his historical group portrait of the greatest figures of Welsh literature, *Oriel y Beirdd.* The picture was intended only as the basis for an engraving to be published by subscription, but it was exhibited at the London Eisteddfod of 1855. Faces were copied from earlier portraits wherever possible, such as Hugh Hughes's picture of Gwallter Mechain, which Ellis borrowed from the poet's daughter. Despite the failure to publish *Oriel y Beirdd* in engraved form, it became celebrated as a result of the alleged bias it showed in the choice of northern poets to represent the contemporary scene; indignant letters from southerners appeared in the press.[43]

Early in his career, woodcuts by Ellis Owen Ellis were published by John Jones to illustrate scandals and he also produced a set of blocks for Jones's pamphlet *Hanes Turpin Leidr* (The Story of Dick Turpin). He clearly harboured unfulfilled ambitions for more substantial publications of this kind on Welsh subjects. Drawings survive for *The Illustrated Life of Richard Robert Jones of Aberdaron* and for the bawdy but moralizing tale of *Betti o Lansanffraid,* written by Jac Glan-y-gors. However, it was with *Y Punch Cymraeg* and in the last few years of his life that Ellis made his most lasting contribution to the visual culture. Whenever it detected hypocrisy and double standards, *Y Punch Cymraeg* had no hesitation in attacking individuals. One Evan Evans, for instance, much lauded in the respectable press for his financial support of the Wesleyan Methodists' new schools in Bangor, was

[41] John Thomas, *Gwaith Barddonol Sion Wyn o Eifion yng Nghyd a Chofiant o Fywyd yr Awdwr* (Tremadog, 1861), p. 141, translated from the Welsh ('Lluniedydd dillyn ydyw, / Carwn ei waith, cywrain yw. / Gan Ellis ni gawn eilun, / O un llaw ni chawn well llun. / Pwy fydd hwyr i arwyrain, / Ei luniau gwych ar lèn gain?'). Ellis's naive style does not suggest that he had received any academic training, but Blackwell reported that through the influence of Robert Vaughan of Nannau he was introduced to the painter Martin Archer Shee, and that 'he was for some time at the Government School of Design', NLW MS 9256A, f. 297.

[42] 'Maldwyn', in an unidentified newspaper cutting, c.1925, in the Samuel Maurice Jones scrapbook, NLW. Morris Hughes of Llanrwst, who sat for Ellis, was the grandfather of the painter Samuel Maurice Jones.

[43] See Peter Lord, *Y Chwaer-Dduwies: Celf, Crefft a'r Eisteddfod* (Llandysul, 1992), p. 26.

377. Ellis Owen Ellis, *Oriel y Beirdd,* c.1855, medium and size uncertain, Coloured reconstruction

known locally to be somewhat less public-spirited than he had been portrayed, and, furthermore, a person of doubtful sobriety. Ellis portrayed him as an obese drunkard, assiduously licked and greased by the Wesleyans under the leadership of the Revd William Davies, alias Mr Cocklebeau (since he was minister at Beaumaris). The use of sarcasm in the attack on the minister was particularly abrasive:

378. Ellis Owen Ellis,

Te Parti Capel y Botel, from *Y Punch Cymraeg*,

1859, Woodcut, 140 × 95

Oh how I shake in my boots as I mention the man who addressed us next! Oh fellow citizens! Doff your caps – bow politely, and grovel in the dust before him, because his name it is wonderful – *The Right Reverend Mr Cocklebeau!* – the man for whom the creation shook, the waves of the deep roared – the stars were darkened, the heavens sent forth lightning, and the heights of the heavens their thunder.[44]

The magazine was particularly well-informed on scandals in north-west Wales and in Liverpool, where, for instance, Calvinistic Methodists were attacked for hypocrisy because of their organization of a lottery to pay debts incurred by the building of Garston Chapel. For good measure, this deviation from Nonconformist opposition to gambling was blamed on the penchant of the bourgeois leaders of the Garston congregation for imitating all things English. With its increasing aspiration to set the moral tone of the nation, the Calvinistic Methodist establishment was particularly vulnerable to Mr Punch's dislike of humbug.

Notwithstanding its northern bias in local scandals, individuals of national repute and issues of general concern were also closely scrutinized in the magazine. Prominent members of the literati were favourite targets, notably Talhaiarn, against whom *Y Punch Cymraeg* had a particular

YR ARDDANGOSFA FARDDONOL.

379. Ellis Owen Ellis,

Ab Ithel, from *Y Punch Cymraeg*,

1859, Woodcut, 150 × 255

380. Ellis Owen Ellis,
Cyflawniad y Proffwydoliaethau,
from *Y Punch Cymraeg*, 1858,
Woodcut, 210 × 275

animus because of his Tory views and heavy drinking. Individuals with
exaggerated bardic pretensions were also sitting targets. In one of his most
sophisticated lampoons, Ellis attacked John Williams (Ab Ithel), the leading light
at the Llangollen Eisteddfod of 1858, an event at which druidical fantasies soared
to unusual heights and where, at the same time, suspicions about the propriety of
the adjudications were voiced. Ab Ithel was portrayed as a bird of indeterminate
species, incubating a 'mundane egg' allegedly discovered four hundred years earlier
at a druidic site at Llandaff and displayed at the Eisteddfod hanging from the
Archdruid's neck. Assorted Celtic deities of evil aspect were seen to hatch under
Ab Ithel's feathers. Richard Williams Morgan (Môr Meirion), another Celticist
satirized in 1858, had earlier been the hero of one of Ellis's finest cartoons, in
celebration of his pamphlet against the appointment of English bishops to Welsh
sees, an important bone of contention in the radical Nonconformist agenda of
the period. Môr Meirion, whip and leek in his hands, drove three of the bishops
on the skeletal horse of death into the jaws of a fiery dragon.

Y Punch Cymraeg was indicative of increasing self-confidence among Welsh
intellectuals who succeeded those who had been so deeply affected by the Blue
Books. The new confidence enabled the magazine to attack not only English
attitudes but also the cultural and religious élites of Wales itself. The cartoons
of Ellis Owen Ellis during the first three years of the magazine's existence mark
a belated but vigorous flowering of visual satire. However, Ellis died in 1861 and
no one would take his place until new techniques of reproducing drawings enabled
the daily newspapers to enter the field of visual comment on current affairs.

[44] Anon., 'Te Parti Capel y Botel', *Y Punch Cymraeg*,
2 April 1859, 6, translated from the Welsh.

381. Anon.,

H. J. Hughes's Victoria Portrait Gallery,

Caernarfon, c.1870, Engraving, 105 × 63

[45] Iwan Meical Jones, 'Datgelu'r Cymry: Portreadau Ffotograffig yn Oes Fictoria' in Geraint H. Jenkins (ed.), *Cof Cenedl XIV: Ysgrifau ar Hanes Cymru* (Llandysul, 1999), pp. 133–62.

382. *Advertisement for the photographer Richard Saxby, from The Cambrian, 1849*

383. Anon., *Huw Griffith of Bodwrda and his family,*
1848, Modern photographic print after lost original,
probably a Daguerreotype

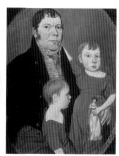

384. Hugh Hughes,
*The Family of Huw Griffith
of Bodwrda*, 1813, Oil,
460 × 305

The death of Ellis Owen Ellis also marked the beginning of the end of the broader artisan tradition to which he was closely related. Hugh Hughes died in obscurity in 1863 and the career of William Roos was in serious decline as a result of a combination of educational and technical developments in visual culture. In the 1860s the middle class who had sustained the portrait painting careers of Hughes and Roos largely transferred their patronage to High Street photographic studios, which had sprung up in nearly every town in Wales.[45] The photograph represented progress in an age wedded to that concept. It carried the prestige of an evolving new technology and met quickly, cheaply and with scientific precision the central requirement of the artisan-painted portrait, which was to provide a straightforward likeness of the sitter. In the 1840s portrait photographs, taken with the process developed by Louis Daguerre in France, were not cheap. Every image was unique

and, since they were taken on glass plates, they were fragile. Consequently, they primarily affected the market for miniature paintings, and indeed, many miniature painters turned to photography or to tinting the new daguerreotypes which were, of course, monochrome. Until well into the 1850s some painters and photographers believed that the two forms would be complementary:

Some people imagine that the Artist and the Photographer must be natural enemies, seeing how closely Photography trenches upon the province of the former; but, to a great extent this is a mistaken notion, – they may, and ought to work together very amicably combining for mutual benefit. When the photographer has succeeded in obtaining a good likeness, it passes into the artist's hands, who, with skill and *colour*, gives to it a life-like and natural appearance ... By the judicious management of them [watercolours], photographs can be made to assume the appearance of highly finished miniatures, possessing all their softness and brilliancy.[46]

The first portrait photographs in Wales were probably taken within three years of the publication of Daguerre's process. In May 1842 *The Cambrian* carried an advertisement inserted by a certain Mr Langlois seeking subscribers at a guinea each prior to establishing a photographic studio in Swansea. By September Langlois was at work in the Royal Institution of South Wales.[47] This location suggests that the group of pioneering photographers which included John Dillwyn Llewelyn and Richard Calvert Jones, who lived in the area, may also have been connected with the scheme.[48] By 1849 travelling photographers were at work, mimicking the practice of the artisan painters. Richard Saxby advertised in Swansea and Carmarthen, where he had allegedly taken five hundred portraits on a previous visit by what he described as the Heliotype process.[49] Photographers were also penetrating rural areas by this time. In Llŷn, Huw Griffith, whom Hugh Hughes had painted as a young father in 1813, sat for an unknown photographer with his grown-up children in 1848. Governed by long exposure times and by the conventions of the painted portrait, Griffith's son struck an identical profile pose to that which one of his children had taken up for Hughes thirty-five years earlier. Cheaper processes, such as the Ambrotype, further popularized photography. In the early 1850s Edward and Elizabeth Jones and their daughter Margaret braved an open-air sitting, apparently in winter, to be recorded by the new process, probably in Welshpool. By the end of the decade permanent photographic studios had been established in nearly all such towns and the age of mass photography had begun. The peripatetic Richard Saxby, for instance, had come to rest by 1858 in a studio in Church Street, Tredegar. The crucial development had been the arrival of negative-positive processes, beginning with the wet collodion in 1851, which enabled the customer to order as many paper prints as required from a single negative.

385. Anon.,
Edward and Elizabeth Jones and
*their daughter Margaret, c.*1850–5,
Ambrotype, 67 × 50

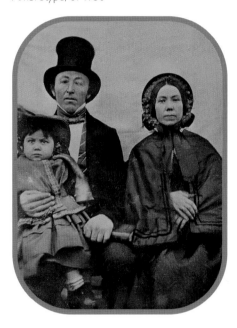

[46] A. N. Rintoul, *A Guide to Painting Photographic Portraits* (London, 1856), pp. 11–12.

[47] *The Cambrian*, 7 May 1842, 3 September 1842. A third notice, 1 October 1842, reported that the 'Patent Photographic Establishment' was to close for the winter. Advertisements duly appeared for the establishment in the summer of 1843. Joyner, *Artists in Wales*, pp. 70–1, suggests that Langlois was the Camille Langlois who exhibited at the RA, 1835–47.

[48] See Lord, *The Visual Culture of Wales: Industrial Society*, pp. 86–8.

[49] The exact nature of this process is unknown. Saxby may have invented the word for himself simply as a generic term for a photograph. However, it may have been a process for producing silhouette images. The earliest photographs taken by Niepce, c.1827, were described as 'heliographs'.

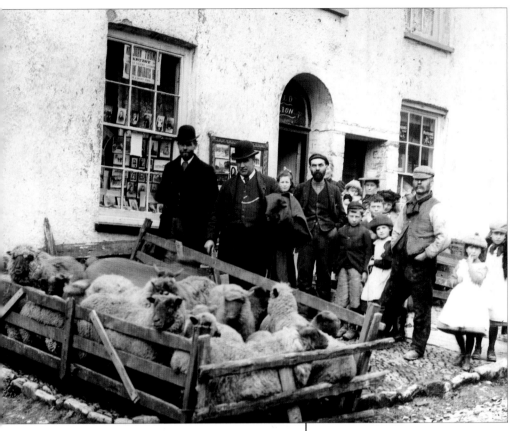

386. John Thomas,
Advertisement for the Cambrian Gallery and a
selection of John Thomas's portraits in Narberth,
Pembrokeshire, 1860–70

The carte-de-visite – a portrait photograph on a card measuring 4 x 2½ inches, the back of which carried the studio name and was often an art work in itself – became the fashion. They were collected in albums which might include not only family portraits but also prominent public figures of the day, like an eighteenth-century country house in miniature, with its mixture of family and royal copy portraits adorning the walls. The magazine *Good Words* reported on the phenomenon in 1869:

> Now that every bookseller's window is converted into a portrait gallery, and the public demands some knowledge of the *personnel*, as well as of the deeds and speeches of men of eminence and notoriety, the carte de visite has become such a great institution that it is worthy of some special notice. These handy little records of old familiar faces stand in the same relation to the grand portraits that grace the National Gallery and the drawing-room that small change does to gold or paper money. They are the democracy of portraiture.[50]

The production on a large scale of cartes-de-visite of the great and the good became an important business throughout Europe. Welsh photographers soon learnt to take advantage of the market for pictures of poets, musicians and preachers which had been pioneered by artisan painters and engravings after their works. In about 1860 William Griffith (Tydain) established a studio in London and took advantage of the patronage of the many individuals, prominent in the arts, who lived there to build up his own National Gallery.

In 1863 John Thomas acquired his first camera in Liverpool.[51] Having migrated from Cardiganshire in the 1850s, Thomas first found work in the city selling a series of photographic portraits called 'Great Personalities of the World'. He was mocked by some of his customers since the only Welsh sitters were the Bishop of St Asaph and Sir Watkin Williams Wynn. He thus decided to address the situation in a positive manner: 'I took the hint', he said, 'and considered whether it would be possible to include Wales as a part of the world. And I felt the blood of Glyn Dwr and Llywelyn rising in me since I was jealous for my country and my nation at that time when its tide was only just on the turn.' By 1867 he had established

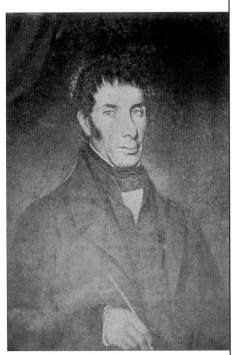

387. Hugh Hughes,
John Elias, lost portrait
photographed by John Thomas,
c.1870

his own business, recording not only the middle classes of Liverpool but also the famous men and women of the day. He travelled throughout rural Wales, setting up his studio in villages to take portraits and to market *cartes* of the famous for *6d* each or *5s* a dozen. He extended his range by photographing painted portraits of national leaders of the past, many of them the work of artisans, whom he did not acknowledge. Indeed, several early portraits by Hugh Hughes, including that of John Elias, are known only from the photographs taken of them by John Thomas for his catalogue. Eventually his Cambrian Gallery included 450 portraits, all but thirty-four of which were of ministers, preachers or priests. In addition to individual portraits, Thomas and other photographers created composite portrait groups which achieved great popularity at the height of the cult of the preacher, either as photographs or transformed into engravings. In 1877, for instance, E. Vandermees of Aberystwyth produced a composite of no fewer than 288 portraits of Methodist ministers and secured testimonials from prominent individuals such as Thomas Charles Edwards, first principal of the University College of Wales, Aberystwyth, to encourage sales. Edwards considered the group 'in every respect excellent'.[52]

The collections of cartes-de-visite made in the 1860s offer a valuable insight into the psyche of many middle-class people of the period. Among Tydain's first sitters was Talhaiarn, whose album of *cartes* survives. It opens with the Royal Family, proceeds through great English political and literary figures, and comes finally to the Welsh intellectual community, many of whom were known personally to him, including John Thomas (Pencerdd Gwalia) and Edith Wynne (Eos Cymru) from the world of music, the sculptor William Davies (Mynorydd), and poets such as John Ceiriog Hughes. Since Talhaiarn was an Anglican Tory, the Nonconformist ministers who dominated other collections gained admittance to his National Gallery only if, like Caledfryn, they were also literary figures, but the expression of Welsh national pride as a sub-division of the British establishment, expressed in the arrangement of his album, was typical of the period.

388. J. H. Lynch, 'Cenhadon Hedd', Trefnyddion Calfinaidd, 1861, Lithograph, 675 × 465

[50] *Good Words*, 1 March 1869, 57.

[51] Hillary Woollen and Alistair Crawford, *John Thomas, 1838–1905, Photographer* (Llandysul, 1977).

[52] Advertisement for Vandermees' '288 Portraits of Calvinistic Methodist Ministers', *Yr Arweinydd*, III, 28 (1878).

389. Unknown photographer,
John Jones, 'Talhaiam', Daguerreotype,
c.1850–5, 60 × 40

[53] NLW MS 584B, item 195. Roos was writing from Cardigan, the 'country' to which he referred.

[54] The diary of Clarence Whaite, private archive. Whaite used photographic reference material throughout his long career as a landscape painter. See Peter Lord, *Clarence Whaite and the Welsh Art World: The Betws-y-coed Artists' Colony 1844–1914* (Aberystwyth, 1998).

[55] Alternatively, it may indicate that Roos did not normally sign his landscapes because he considered them to be of lower status than his portraits.

[56] The account of the proceedings was published in *The Welshman*, 9 July 1875. Roos was renowned as a caricaturist, and acquired the bardic name 'Hogarth o Walia'. No caricatures have been identified except the self-portraits to be seen, with his signature, on the back of a number of his canvases.

[57] Ibid. Roos lost the case and another arising from a dispute about a portrait club which he had attempted to establish in the town in order to drum up business. An allowance was made on the price of a portrait if the client paid by instalments prior to the completion of the work.

Talhaiarn figured among the earliest Welsh celebrities to be photographed by the daguerreotype process, shortly after he sat for William Roos in 1850 and 1851. The writing was on the wall for the artisan painter, and the effect of photography on the career of Roos, in particular, was devastating. In 1873, in a previously mentioned letter to Nicholas Bennett of Trefeglwys, Roos wrote:

> I have taken to Animal & Landscape painting for the last few years, this is the only thing in art Photography cant do – I have painted a few Hunters & hounds for the sporting Gentry of this Country, and have given great satisfaction.
>
> If you happen to know of some Prize Cattle, or Hunters, the owners wanting to ... have the portraits ... you can safely recommend me to paint them.[53]

Roos was incorrect in his assessment of the potential of photography as a landscape art. As early as 1852 the young landscape painter Clarence Whaite had met a Mr Field at work with his Talbotype apparatus in Betws-y-coed. In contrast to Roos, Whaite was enthusiastic about the potential interaction between photography and landscape painting. He noted in his diary that Field had 'a few pictures with him which are really wonderful and their usefulness to the Artist, I think, we cannot question'.[54] In contrast to its effect on portrait painting, landscape photography probably increased the demand for landscape paintings, at least at the bottom of the market. As we have seen, Hugh Hughes was able to diversify into the production of tourist pictures of which many survive, but few landscapes by Roos have, as yet, been identified, which suggests that his attempts met with little success.[55]

Roos's attempts to adapt to the new circumstances by diversification were supplemented by tinting photographs. Unfortunately, his efforts ended in a court case which illustrates not only the relationship between photographers and painters in the period, but also the innocent and gullible personality of the painter. The dispute concerned a full-length portrait of Alderman Thomas of Carmarthen, painted by Roos over a photograph taken by Henry Howell. Both painter and photographer claimed that the portrait had been produced at the instigation of the other to publicize their respective skills. However, Howell declined to pay Roos the £4 he asked for his work, whereupon the painter sent him a final demand with 'a very good pencil sketch of Plaintiff's head surmounted by an ass'.[56] Roos sued Howell, who stated in court that the portrait was 'a photograph painted over and not an oil painting':

390. William Roos,
Hereford Ox, 1844, Oil,
910 × 710

391. William Roos,
*Self-portrait and letter to Nicholas
Bennett of Trefeglwys*, 1873,
Ink, 225 × 160

I had a small photograph of Mr. Thomas in my studio, and plaintiff suggested
that it would make a nice portrait if enlarged and coloured; and I had it enlarged
for him on the understanding that he was to paint it for a guinea. He brought
it back before it was finished and said he thought the price that had been agreed
upon was too little for the amount of work. I said I did not wish to be hard with
him, and that I would pay him something more, but I little thought I should
be charged four times the amount ... I have never had a photograph painted
before, but I can get them done for that price by sending them away.[57]

392. Joseph Josiah Dodd,
Castle Square, Caernarfon, detail showing Hugh Humphreys'
Fine Art Gallery, *c*.1860, Lithograph, 282 × 512

393. Hugh Humphreys,
John Roberts, 'Ieuan Gwyllt',
c.1877

394. Evan Williams,
John Roberts, 'Ieuan Gwyllt',
1878, Oil, 880 × 680

395. Evan Williams,
Ebenezer Thomas, 'Eben Fardd',
1851, Oil, 1240 × 990

Among William Roos's sitters in an earlier and happier period was the wife of Hugh Humphreys, the Caernarfon printer, publisher and bookseller.[58] Humphreys was among several tradesmen in the printing business who diversified through the production and sale of portrait engravings into photography. By 1877 his Fine Art Gallery on Castle Square included a photographic studio. Humphreys also employed at least one painter in the production of oil paintings based on photographs and engravings. As an additional spur to business, Humphreys helpfully pointed out in his publicity material that the use of photographs enabled portraits of deceased individuals to be produced. Perhaps the most important example of this morbid genre was a portrait of the musician John Roberts (Ieuan Gwyllt), who died in 1877. The presence in Caernarfon of the National Eisteddfod in that year may have been the occasion for the commission, which was carried out by Evan Williams.[59] The same painter had earlier been responsible for an original portrait of the prominent Calvinistic Methodist minister John Jones, Tal-y-sarn, which was subsequently engraved and of which several oil copies, perhaps the products of Humphreys' Fine Art Gallery, are known. Like his sitter, Evan Williams, who was born in Cardiganshire in 1816, was a Calvinistic Methodist minister, as well as a painter. He worked as a young man in London but was established in Caernarfon by 1848, where he painted Ebenezer Thomas (Eben Fardd) shortly afterwards. The commission was paid for by public subscription and was presented to the poet at the Madog Eisteddfod of 1851.[60] Official portraits of this kind, connected with eisteddfodau, the Nonconformist seminaries or individual chapels, provided one of the few continuing sources of portrait patronage for artisans following the advent of cheap photography. The last recorded portrait commission given in 1854 to Hugh Hughes was of this type. Hughes was in Liverpool at the time and the commission to paint the Congregational minister, David Williams, Troedrhiwdalar, was observed by the Revd John Thomas:

[58] Roos's portrait seems to have been commissioned to match an earlier one of Humphreys himself, the style of which suggests that it might have been the work of Hugh Jones.

[59] Humphreys may have been involved in the commission process. He is known to have employed Leon Turgeny [Tusgera?] Kieweci [Kiewicz?], a painter born in Poland c.1828. Among his copy portraits was one of Lewis Morris, probably based on an engraving rather than the original portrait. See Helen Ramage, 'Wynebau Lewis Morris', *Y Casglwr*, 10 (1980), 8. A portrait of the Baptist minister David Hughes also survives in a private collection.

[60] Dyfed Evans, 'Darlun neu ddau heb ddod i'r fei', *Y Casglwr*, 21 (1983), 3.

396. Hugh Hughes,
David Williams, Troedrhiwdalar,
1854, Oil, 900 × 700

He was something of a hit and miss artist, as they say. He was always an excellent colourist, and nothing but the best craftsmanship came from his hand, and often the sitter would seem alive on the canvas. But at other times it was as if he had not seen the object of his paintings at all. He made many attempts to get a satisfactory position, and I was many times surprised at the patience of the old artist. He was noted for his ability to take pains. Mr Williams's misfortune was to assume too intense and melancholy an expression while holding the same pose at length, and I saw him many times as if he were undergoing agonies and tortures; Mr Hughes had no humour by which he might prevent him becoming excessively so.[61]

Hugh Hughes's only pupil, William Morgan Williams (Ap Caledfryn), son of his friend Caledfryn, would later paint many such official portraits for the Congregationalists, including figures of national repute such as the brothers John and Samuel Roberts.[62] Hughes had given Ap Caledfryn his first lessons in drawing in the mid-1830s in Caernarfon. Many years later, he wrote the last eyewitness account of Hughes at work, on a visit to the same town for the National Eisteddfod of 1862. At the age of seventy-two, Hughes was still painting, though, significantly, his subjects were landscapes:

I called and asked him did he recognise my features, he simply turned off to his picture (then painting the Menai Bridge, 20 x14 or so) and said 'Should I be expected to know you?' to which I replied he had painted my portrait at Carnarvon when I was a boy of 6 or 7 but that my hair was then almost

[61] *Y Tyst a'r Dydd*, 18 December 1874, 2–3, translated from the Welsh.

[62] Ap Caledfryn also painted a lost portrait of Richard Evans, Twrch, founder of *Y Punch Cymraeg*, shortly after the establishment of the magazine. See NLW MS 12029C, ff. 157–8.

397. William Morgan Williams (Ap Caledfryn),
Samuel Roberts, Llanbrynmair, c.1870–80,
Oil, 740 × 620

398. Unknown photographer,
William Morgan Williams,
'Ap Caledfryn', c.1865

golden. He sharply turned round and said 'its black enough now'. I gave him another hint and asked did he remember Twthill, Rock Cottage he at once dropped his brush and stood erect and shook me most heartily by the hand and asked 'and are you William, son of the great Caledfryn?'[63]

Hughes died the following year, and the career of William Roos, his core market seriously depleted by photography, was also in decline. Despite his exceptional technical ability as a portrait painter, he was last reported in Oswestry attempting to sell photographs of the church which he had tinted, 'which enhanced their sale value to the amount of a few shillings'.[64] When he died in poverty in 1878 the age of the peripatetic artisan painter came to an end. The photographer John Thomas reflected the old practice for another twenty years as he toured rural Wales, setting up his portrait studio in shops and rented rooms, but the immediacy and cheapness of the photograph as a medium began to create a new documentary language. Although Thomas's studio portraits of ministers and poets were little different in their conventions from the portraits painted by Roos, in other works, such as *The Cerrigydrudion Alms House*, previously unseen faces were recorded with a minimum of artistic contrivance.

The remnants of demand from middle-class patrons for painted portraits were met in a few centres where businesses combining painting and photography struggled on. At Swansea, Henry Alfred Chapman painted portraits and subject pictures, but it was as a photographer that he was best known. His father, an Englishman, had established the business which came to dominate photography in the town

[63] NLW MS 6358B, unpaginated.

[64] *Bye-gones* (1880–1), 17.

399. John Thomas,
The Cerrigydrudion Alms House,
Denbighshire, c.1865

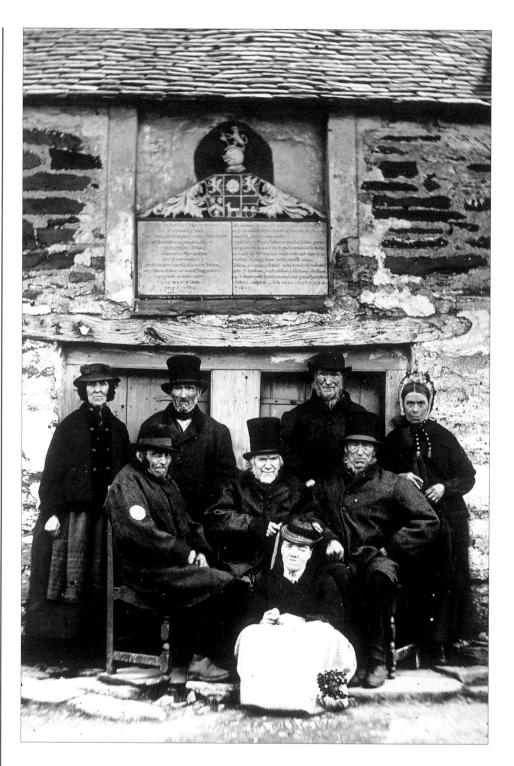

400. Henry Alfred Chapman,
John Deffett Francis, Pastel
and chalk, c.1880–90

65 H. A. Chapman died in 1915, leaving the business in the hands of his two sons and two daughters. One of them, Sam Chapman, was a pioneer of press photography, making the first zinc plate for newspaper reproduction in Wales. His sister Daisy was also a photographer and is believed to have been the first woman to take aerial photographs. Photographs by the Chapman family are reproduced in Lord, *The Visual Culture of Wales: Industrial Society*, pp. 175, 183.

for three generations.[65] At Aberystwyth, Alfred Worthington established himself in about 1870 both as a portrait painter and photographer, but it was primarily as a marine painter that he flourished until his death in 1927. At Llanidloes Hugh Jerman painted some portraits, including the notable *Glanyrafon Hunt* group in 1885. The most successful attempt to combine the two media was made by the Harris family in Merthyr, who flourished during the last three decades of the nineteenth century. Nevertheless, George Frederick Harris supplemented his

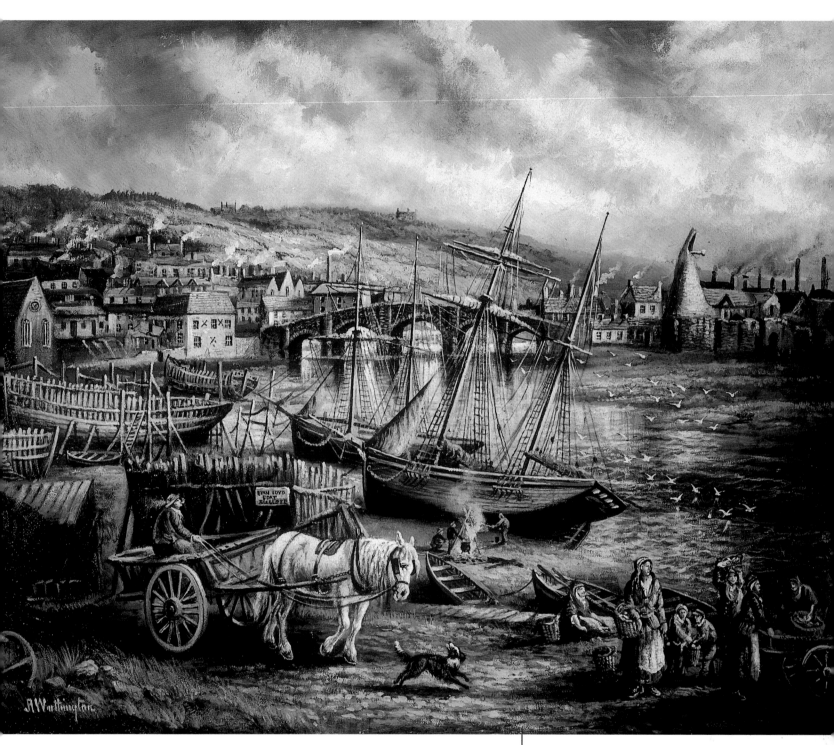

401. Alfred Worthington,
Aberystwyth Harbour, c.1880,
Oil, 1000 × 1300

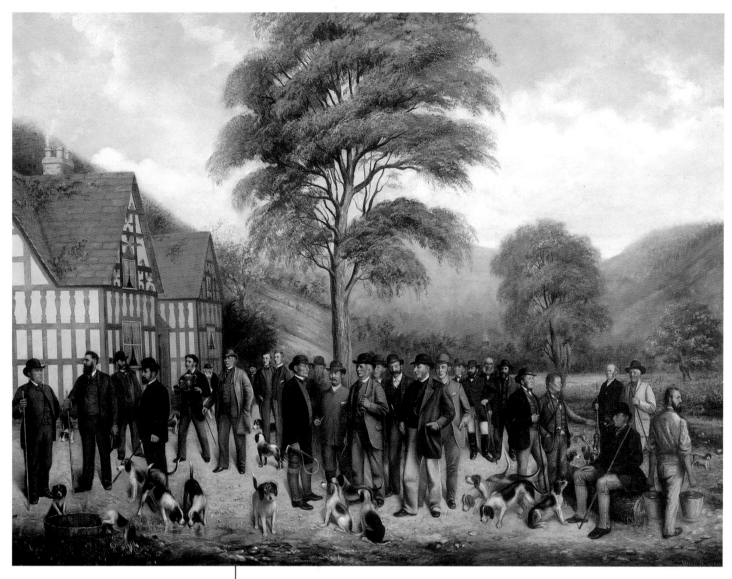

402. Hugh Jerman,
The Glanyrafon Hunt, 1885,
Oil, 914 × 1219

403. Unknown photographer,
Hugh Jerman, c.1865

[66] The Harris family are discussed in ibid., pp. 113–14. In some centres professional painters found niche markets. For instance, since 1828, when James Harris arrived from Exeter, a distinguished tradition of marine painting had flourished in Swansea. Harris worked in oil and to high standards, but in the convention of academic painters rather than the simple style of the true artisan. He was succeeded by his son, James Harris Junior, who worked mainly in watercolour. The tradition of maritime painting in Swansea is described in detail in Roderick Howell, *Under Sail: Swansea Cutters, Tallships and Seascapes, 1830–1880* (Swansea, 1987). James Harris, *View of the Hafod Copper Works*, is reproduced in Lord, *The Visual Culture of Wales: Industrial Society*, p. 85.

portrait practice with landscapes and subject pictures, and eventually became secretary of the South Wales Art Society, one of the institutions which indicated the emergence of a new kind of Welsh art world in the late nineteenth century not based on artisan practice.[66] The world had changed beyond recognition from that of a hundred years earlier when the artisan portrait painter emerged to create, for a short while, an indigenous mainstream in Welsh painting.

chapter
eight

DEFINING

WELSHNESS

404. Mary Parry, *Wales*, Sampler,
1804, 270 × 220

405. P. Stamp,
An Emblem of Wales,
1799, Mezzotint, 305 × 241

[1] J. Clarke, 'Art in Wales', *Young Wales*, I
(1895), 205.

[2] Owain Myfyr once more became the object
of the Society's memorializing campaign when,
following a proposal from Richard Llwyd in
Chester, William Owen Pughe conceived a
commemorative structure on a mountain above
Cerrigydrudion, 'Gwyddfa Myfyr', based on the
form of tumuli. Gwyddfa Myfyr was never built.
A drawing of the proposed structure by John
Orlando Parry was kept in the minutes of the
Gwyneddigion Society, BL Add MS 9850, f. 296.

[3] William Owen Pughe, *The Heroic Elegies and
Other Pieces of Llywarç Hen* (London, 1792).
Pughe's personal copy with illustrations is
accessioned W.S. 1792 at NLW.

For the large European states, the nineteenth century was a period of empire building in the Americas, Africa and the Orient. At the same time, small European nations who had been subsumed in the old pluralistic empires and many ethnic or linguistic groups, fragmented among city states and small principalities, were driven forward by the same mood of assertiveness and aspired to statehood. As a necessary stage in their progress, their writers, musicians and artists set about defining their identities both by memorializing mythology and history, and by creating images which, according to contemporary perceptions of ethnicity, expressed the cultural characteristics of the people. The visual expression of group identities was not a new phenomenon, of course, and we have already observed that in Wales, as in other small nations, patriotic symbols and images were produced in the seventeenth and eighteenth centuries. In the early nineteenth century new items, such as the three feathers of the Prince of Wales, joined the national repertoire. The feathers were popularized in printed form and the evidence of a sampler made by Mary Parry in 1804 demonstrates that the emblem soon penetrated deeply into the public consciousness. However, by the

end of the nineteenth century the possession not simply of national symbols but of a national art, music and literature, expressing its mythology, history and psyche, came to be perceived as essential for peoples aspiring to statehood. In 1895 a Welsh critic expressed the prevalent belief when he declared: 'History furnishes no example of a nation great in commerce or renowned for its intellectual progress, and possessing no well-developed national art.'[1] Furthermore, such an art was required to speak with a single voice since it was precisely between, on the one hand, the pluralism of the old European empires and, on the other, the fragmentation of the city states and principalities that the new unitary path of the nation state led. In this respect, Wales was held back by the traditional reluctance of its intellectuals to resolve the ambiguity of their self-image both as Welsh and as British. Nevertheless, the new nationalism which affected the whole of Europe from the Slavic nations of the east to Greece in the south and Finland in the north also shaped Wales in the long nineteenth century which ended in 1914 with the outbreak of the Great War.

In Wales a crucial element which divided patriotic attitudes to art in the eighteenth century from those in the nineteenth was the emergence of a sense that painting and sculpture could express not only an ancient history but also a contemporary attitude to life which continued to evolve in a distinct way. Whereas Richard Wilson and the antiquarians had looked exclusively backwards in time for their Arcadia, the Nonconformist intellectuals of the nineteenth century looked forward to its construction. A modern nation would produce both identifying imagery and institutions by which national improvement in the appreciation and practice of art might be secured. Throughout the century great strides forward would be made on both fronts, although imagery remained stubbornly historicist, except when it celebrated the great and the good of the new religious order. Nineteenth-century intellectuals failed to recognize the potential of the extraordinary phenomenon of industrial Wales as a marker of a distinct contemporary identity, despite the fact that the economic gains it brought had made their renaissance possible.

406. William Owen Pughe, *Llywarç Hen*, 1792, Watercolour, 130 × 105

The circle of William Owen Pughe among the London-Welsh societies showed early signs of the emergence of a nineteenth-century national consciousness in their celebration of distinguished modern figures in portraiture. The Gwyneddigion Society commissioned Gauci to engrave the portrait it owned of Owain Myfyr (and subsequently also that of Twm o'r Nant) in order to disseminate the images of these intellectual and artistic leaders among a wider public. The society also commissioned a carved memorial to Twm o'r Nant and another to Goronwy Owen, the latter being a substantial affair in Anglesey marble set up in Bangor Cathedral.[2] Pughe was an artist *manqué*, who took drawing lessons from Eliza Jones and exercised his limited talents in miniatures and historical subjects. He illustrated a copy of his own edition of *The Heroic Elegies … of Llywarç Hen* with a frontispiece depicting the mythical bard in the act of creation, and many pictures of the Gorsedd ceremonies invented by his colleague Iolo Morganwg.[3]

407. Samuel Mitan,
The Bard, frontispiece to
W. Bingley, *Sixty of the Most
Admired Welsh Airs*, 1803,
Engraving, 320 × 240

408. Abraham Raimbach,
Hu Gadarn, Engraving,
1801, 91 × 96

above right:
409. Turnbull
after an unknown artist,
*King Cadwalader Residing at an
Eisteddfod*, frontispiece to John Parry,
A Selection of Welsh Melodies, 1821,
Engraving, 295 × 205

The first enactment of the ceremonies on Primrose Hill in London took place in the year of publication of the book. Pughe also arranged for one of Iolo's wilder flights of fancy, Hu Gadarn, supposedly the founder of the nation, to be visualized. He persuaded Owain Myfyr to pay for Abraham Raimbach to portray him 'jumping out of his coracle with a plough in one hand and a club in the other', as Jac Glan-y-gors somewhat cynically described him.[4] Raimbach's image was first published in 1801 and was still regarded as credible by Pughe in 1822 when he commissioned a wood engraving to accompany his lengthy poem about the newly-revealed hero. Pughe would have been familiar with the painting of *Caractacus before Claudius* in the rooms of the Caradogion Society, and there may have been other historical or mythological pictures in the possession of the other societies.[5] For all their naivety, so characteristic of the man, Pughe's activities revealed his awareness of the need to popularize myths in the national cause.

Several printed images relating to the growing interest in national music emanated from the same circle in London. They were led, as we have seen, by illustrations for Edward Jones's *The Musical and Poetical Relicks of the Welsh Bards*, published in 1784, and to the second volume of his trilogy, *The Bardic Museum*, in 1802. The following year the Revd William Bingley's *Sixty of the Most Admired Welsh Airs* was

above:

410. Probably William Jones,

The Last Bard, 1819,

Oil, 750 × 610

top right:

411. Anon., *John Parry*,

'*Bardd Alaw*', c.1820,

Oil, 330 × 290

[4] The poet Dafydd Ddu Eryri was no less cynical about Iolo's newly revealed myth, asking with mock outrage: 'Does the picture of Hu Gadam accord with the rules of natural taste and good judgement? Was it a little coracle or a brewer's vat that brought Hu from the land of summer to the Island of Britain?' Raimbach's image was used on medals awarded by the society from 1800. The first recipient was Gwallter Mechain. In 1803 Sharon Turner wrote to the society to express his thanks for one of them: 'Nothing could give me more pleasure than your very elegant medal. The conception of the subject, the selection of Hy Gadam as the hero, his coracle and plough – his attitude and the rising sun are extremely appropriate and as happily invented as they are tastefully executed.' BL Add MS 9848, 3 November 1803. The engraving seems to have been first published as a frontispiece to *Cyhoeddiadau Cymdeithas y Gwyneddigion, yn Llundain, am y flwyddyn 1800* (London, 1801). Raimbach was an English engraver of Swiss descent, later noted for his engravings after David Wilkie. In 1820 Pughe was responsible for a commission given to John Flaxman by the Cymmrodorion for a medal.

[5] *Caractacus before Claudius* is recorded in Jenkins and Ramage, *A History of the Honourable Society of Cymmrodorion*, p. 128. Caractacus was a favourite subject of English artists and writers in the eighteenth and nineteenth centuries, and was rivalled only by Boadicea, and – perhaps for that reason – was less favoured by Welsh artists.

[6] In the background of the images published in both *The Bardic Museum* and *Welsh Airs* was Dolbadam Castle, for the iconization of which see Paul Joyner (ed.), *Dolbadam: Studies on a Theme* (Aberystwyth, 1990).

[7] For Evan Williams, see Lord, *Hugh Hughes, Arlunydd Gwlad*, p. 47. Williams was also the publisher of Edward Pugh's *Cambria Depicta*.

[8] Parry, who was very much the successor to Edward Jones as the leading figure in Welsh music, was an intimate of Pughe. No artist is acknowledged on the engraving, but the concept may have been that of Pughe, following the manner of Henry Corbould, whose father, Richard, had designed the frontispiece for the *Cambrian Register* of 1796. Henry Corbould was much interested in Ancient Britain subjects and his title-page for the 1812 edition of Hume's *History of England* offers a close precedent for illustration to Parry's *A Selection of Welsh Melodies*. For thirty years he was employed to draw the antiquities at the British Museum. William Owen Pughe was a well-known reader there and it is likely that he had made the acquaintance of Corbould.

accompanied by a fine engraving of a bard in a Snowdonian landscape.[6] The book carried the imprint of Evan Williams, the cornerstone of Welsh publishing in London in the period. Williams published several of the works of Pughe,[7] whose influence may well be detected in the most original of all these engravings on the theme of national music, *King Cadwalader Residing at an Eisteddfod*, published in 1821 as the frontispiece to John Parry's *A Selection of Welsh Melodies*.[8] Meanwhile, the Last Bard retained his currency among Welsh painters: William Jones exhibited a fine head-and-shoulders version at the Royal Academy in 1819.

412. Anon.,
Maria Jane Williams,
*Aberpergwm, c.*1822–5,
Oil, 2387 × 1447

William Owen Pughe's penchant for commissioning portraits of himself by Welsh painters led him around 1802 to Edward Pugh, who had recently begun work on his *Cambria Depicta*. This volume contains some of the earliest references to the need for Welsh institutions in the visual arts, another clear indication of the emergence of a new kind of progressive national consciousness. Pugh believed that good collections of paintings were rare in Welsh gentry houses:

> Indeed, a general apathy and want of taste for the arts, and I may add for the sciences, are too observable among my wealthy countrymen; which may account why so few natives excel in them. Talents, in a latent state, may exist among them; but while they are left to encounter all the discouragement of neglect, and no fostering hand appear to cherish and hold forth the means of pursuing the bent of genius, they are left like
> 'Many a flower, born to blush unseen,
> And waste its sweetness in the desert air.'
> The superfluous wealth of the country is fully competent to form and sustain a national work, or some institution that might be the means of thus cherishing the buds of native genius, and of giving energy to more matured talents, which may sometimes be found even among the wilds of Penmachno and the vales of Nantglyn.[9]

Again using the term 'national institution', Pugh cited Scotland as the example for Wales to follow, clearly suggesting the need for an Academy to teach and exhibit work.[10] These calls for national improvement from a new and democratic voice would be echoed many times throughout the nineteenth century, primarily on the Eisteddfod stage, which became the main focus both for the production of national imagery and for debate about institutional development.

In 1826 Augusta Hall (who became Lady Llanover in 1859) attended the regional eisteddfod at Brecon, along with surviving luminaries of the previous age, including William Owen Pughe and Ifor Ceri. At the age of twenty-four she was inspired by the patriotic spirit of Thomas Price, whose bardic name, Carnhuanawc, expressed his passion for the culture and language of Brittany. Carnhuanawc was vicar of Llanfihangel Cwm-du and lived at Crickhowell, not many miles from her own estates. He was already well known as an antiquary and was also interested in visual culture, being a competent draughtsman.[11] In 1833 both were involved in establishing a Cymreigyddion Society at Abergavenny. Four years later Lady Llanover's new house, Llanover Hall, was completed and soon became the centre for a circle of patriotic intellectuals and artists which lasted

413. Charles Augustus Mornewicke, *Augusta Hall, Lady Llanover*, 1862, Oil, 813 × 495

[9] Pugh, *Cambria Depicta*, p. 75. Pugh had assisted the painter William Jones when he was studying in London in 1808. For an analysis of attitudes to the development of native talent, see Lord, *The Aesthetics of Relevance*.

[10] Pugh, *Cambria Depicta*, pp. 76–7.

[11] Some of his drawings were published in Theophilus Jones, *A History of the County of Brecknock* (2 vols., Brecknock, 1805–9), although most of the illustrations were the work of Richard Colt Hoare. Edward Pugh was responsible for the illustration on the title-page.

415. Anon., *Interior of the Cymreigyddion Hall, Abergavenny*, 1845, Wood engraving from *The Illustrated London News*, 180 × 240

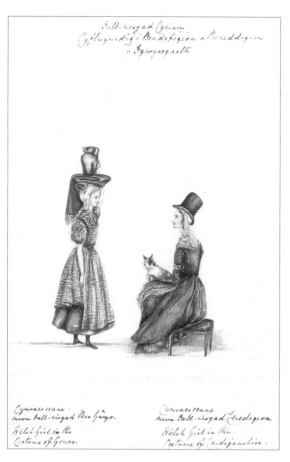

414. Augusta Hall, Lady Llanover, *Welsh Girls in the costumes of Gower and Cardiganshire*, c.1830, Watercolour, 255 × 165

right:

416. Unknown photographer, *Women in National Costume*, c.1902, 140 × 190

well into the second half of the nineteenth century. The circle included other patriotic gentry families such as the Williams family of Aberpergwm, where Maria Jane Williams, a notable collector of folk songs, was celebrated in one of the finest romantic portraits of national sentiment painted in the period.[12] There were also individuals from outside Wales, among whom was a little-known English artist, Charles Augustus Mornewicke, who painted a number of sitters, including Lady Llanover herself, and Carnhuanawc.[13] In 1838 the Cymreigyddion held its first triennial *cylchwyl* or eisteddfod, which included prizes not only for literary and musical achievement but also for weaving and the manufacture of items of clothing such as gloves and hats. This recognition of the importance of traditional crafts reflected the views that Lady Llanover had made public in her prize-winning essay submitted to the Cardiff Royal Eisteddfod of 1834, entitled 'The Advantages resulting from the Preservation of the Welsh Language and National Costumes of Wales'. These costumes, made from the heavy woollen fabrics still worn in many areas, had been described and drawn by Lady Llanover, and classified county by county. The classification spoke more of the preoccupation of a scientific and technological age with tidy organization than of the costumes themselves, which were based on a selective interpretation by Lady Llanover of remnants of what were, in fact, peasant costumes common to large areas of Europe in medieval times. Nevertheless, as Ffransis Payne has pointed out, 'it can fairly be said that it was she who turned farm servants' working clothes into a conscious,

[12] Maria Jane Williams was an early patron of Penry Williams, for whom see Lord, *The Visual Culture of Wales: Industrial Society*, p. 60.

[13] How Augusta Hall came upon Mornewicke, a little-known painter based in the east of England, is unknown. Among his other sitters in the Llanover circle was the Revd John Evans, whose portrait is now in NMW.

[14] F. G. Payne, *Welsh Peasant Costume* (Cardiff, 1964), p. 9. Carnhuanawc's familiarity with Breton costume may well have influenced Lady Llanover in her attempts to 'preserve' Welsh national costume.

[15] Contrary to the impression given in a passage from the essay frequently quoted in abbreviated form by writers on the national costume, Lady Llanover did not promote the costume on the grounds of evoking the interest of visiting artists. Her argument was based on concern for the economic and moral well-being of the common people: 'We have *not* enlarged upon the loss Artists would experience by the destruction of the costumes of Wales, or on their value to the traveller, after the Picturesque, or on their forming one of the most characteristic and *ornamental* features of the principality. We feel that our arguments for their support are better founded on the firm basis of health and industry, which are the first steps to happiness and prosperity, and the best preventatives of poverty and immorality.' Gwenynen Gwent, *The Prize Essay on the Advantages Resulting from the Preservation of the Welsh Language and National Costumes of Wales* (London, 1836), pp. 12–13.

[16] Since Rowland's first child was born in Chester in 1855, he may have resided there briefly, although the event may, of course, have occurred on a working trip to the town.

[17] For postcard stereotypes of Welshness, see E. G. Millward, *Cymry'r Cardiau Post* (Llandysul, 1996).

or rather self-conscious, national costume'.[14] By wearing the dress at eisteddfodau and other ceremonial occasions, Lady Llanover gave the costume the authority of sanction by an upper-class élite. Painters, notable among whom was John Cambrian Rowland, met an increasing demand for what rapidly became the primary icon of Welshness.[15] In a sketchbook of 1849–50 Rowland drew scenes of peasant costume and of everyday life which, initially through the publisher Edward Parry of Chester, he converted into engravings.[16] They sold well, and subjects such as *The Welsh Wedding* were reproduced not only as engravings but on kitsch ceramics manufactured as far away as Scotland. Rowland moved to Caernarfon in the 1850s and transposed some of his costume drawings, done in Cardiganshire, into a Snowdonian landscape, in order to appeal to tourists. Photographers were also quick to meet the increasing demand, generally with studio compositions, although some documentary images were marketed. The trade reached its peak in the early twentieth century with the advent of the postcard.[17] An unassertive, female image of Wales overtook the heroic Bard of the eighteenth century and became an unquestioned part of national identity for insider and outsider alike, thereby reflecting the assimilation of Wales as a picturesque facet of Britishness.

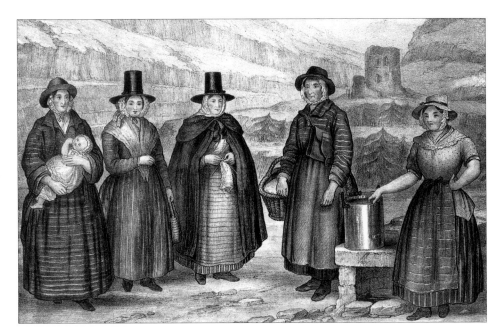

417. John Cambrian Rowland,
Welsh Peasantry Drawn from Living Characters in 1850,
c.1850–60, Lithograph, 240 × 375

418. Anon. after John Cambrian Rowland,
Staffordshire pottery plate, c.1855–60, 200d.;
Lockart and Arthur (Glasgow), *Pottery jug*,
1855–64, 100h.

At the 1845 Eisteddfod, held in a specially-constructed new hall in Abergavenny, academic art joined the national crafts and costume in a place of honour on the stage. Its arrival was celebrated by Carnhuanawc and was reported in *The Illustrated London News*:

> But Ladies and Gentlemen, as well as publishing books,[18] we patronise the loom of the weaver, and endeavour to cultivate the taste for music; and in addition to this, we now have evidence before us that the fire of patriotism has even awakened the chisel of the sculptor. He has dared to gaze at the visions of glory which oppressed the aching sight of many an ardent Welshman; and has called even the great Taliesin from his grave (tremendous cheering) – and seems, moreover, to have breathed a soul to animate his noble form. I shall not trouble you, Ladies and Gentlemen, with any further observations. I merely wish to remind you how much we are indebted to the gentleman who has brought that rich specimen of sculpture to which I have been alluding 150 miles in order to place it among our decorations today. (Loud cheers).[19]

The encouragement of visual art for its own sake had at last become an objective of the Eisteddfod rather than simply a means for its celebration, as was the case in Hugh Hughes's portraits of Ifor Ceri and his colleagues. The sculptor to whom Carnhuanawc referred in his oration was William Lorando Jones, the eldest of three brothers who had trained as monumental masons in Merthyr. William Lorando, who held strong Unitarian views not likely to endear him to the Anglican establishment, went to London in the late 1830s and earned a living as an artisan carver on various public buildings.[20] In his spare time he developed his own ideas and first exhibited a Welsh subject, *Caswallon*, at the Royal Academy in 1843. His plaster of *Taliesin Penbeirdd* had also been exhibited at the Academy before it was transported to the Abergavenny Eisteddfod.[21]

An enthusiastic critic, writing in *The Illustrated London News*, optimistically remarked that 'We shall see it in marble', a prediction which, like many others of a similar nature in the mid-nineteenth century, did not come to pass. No doubt stimulated by the example of the Westminster Hall exhibition of 1844, in which sculpture designed for the new Houses of Parliament in London had been displayed, the Eisteddfod had recognized the importance of national art. However, Wales possessed no building of national status and very few local public buildings or monuments of sufficient distinction to warrant sculpture. Only the Carmarthen memorial to General Sir Thomas Picton, who had been killed at Waterloo, had resulted in a major commission, given through

419. William Lorando Jones, *Taliesin Penbeirdd*, 1845, Wood engraving from *The Illustrated London News*, 130 × 70

[18] The Society had just published a transcription of *Llyfr Llandav*.

[19] *The Illustrated London News*, 25 October 1845, 265.

[20] William Lorando Jones was joined in London by his brother Watkin D. Jones. His Unitarianism caused him great difficulties later in his career. In 1855 or 1856 he emigrated to Australia, where, in 1871, at a public meeting in Parramatta Park, Sydney, he publicly denied that Jesus Christ was the son of God and that the Bible was the Word of God. He was prosecuted for blasphemy and sentenced to two years' imprisonment. The case became a *cause célèbre*, with Jones known as the New South Welsh martyr, and the sentence was commuted by the Governor. Two years later he published *The Origin of Theology or the Worshipping of the Sun* (Sydney, 1873), but as a consequence of these activities he found it impossible to gain public commissions. His wife wrote of him as follows: 'The New South Welsh martyr has to roam far from his dear family and home: / From day to day and week to week, a living for them joyfully does seek. / Photography and dissolving views, are his daily occupation; / He lectures on astronomy and the wonders of creation.' *The Stockwhip*, 13 March 1875, 50.

[21] A second national subject, *The Infant Taliesin*, depicting the finding of Taliesin in a coracle on the river Conwy, was exhibited by Jones at the Royal Academy in 1852.

[22] Nash was working with Baily at the same time on the Marble Arch in London. Unfortunately, the workmanship and the quality of the materials used at Carmarthen were of a much lower standard and the monument was demolished. Fragments of this remarkable piece survive in Carmarthen Museum.

[23] John Howells, 'Reminiscences of Merthyr Tydvil', *The Red Dragon*, II (1882), 342–3.

[24] John Evan showed a plaster of *The Second Lord Londonderry*, which was later carved in marble and placed in Westminster Abbey. William Meredyth exhibited *Prince Harry*, of which no version survives.

[25] Soon afterwards a competition to design a cartoon on the subject of *Brân Fendigaid* (the Blessed) *introducing Christianity into Britain* was added. Given the absence of any building which might offer the opportunity to carry out such a project, it is perhaps not surprising that no entries were submitted in the painting competition.

[26] Cast in 1856, though at the expense of whom is unclear. Two copies were made.

the memorial's designer, John Nash, to the English sculptor Edward Baily.[22]
In a memoir of William Lorando Jones, John Howells could 'well remember the
gleeful and enthusiastic manner of William, in describing a statuary group which
he intended to make, but which, alas! never took any outward form. It was to be
from Welsh history, and would represent a lady handing a bouquet of
poisonous flowers to some famous Welsh Prince who had deceived
her'. As Howells rightly observed of the brothers, 'Theirs were cases
in which a liberal patron would have been of paramount value ...', but
no such private patron, nor public body, was forthcoming.[23]

Nevertheless, the Abergavenny Cymreigyddion, excited by the
potential of William Lorando Jones's work and also, no doubt, by the
success of the brothers John Evan and William Meredyth Thomas of
Brecon, both of whom had shown works at the Westminster Hall
exhibition,[24] proceeded to organize their own sculpture competition.[25]
The works were to be completed by the following eisteddfod in 1848.
The competition resulted in the production of the most notable
example of national academic art in the first half of the nineteenth
century, and one of the few to survive in the form of a bronze.[26]
Whether the competition was entirely fair must be in some doubt
since the Thomas brothers were members of the Llanover Hall circle
and Lady Llanover's husband, Benjamin Hall, along with William
Williams of Aberpergwm, another aficionado, were the adjudicators.
The closeness of the conception to ideas expressed by Lady Llanover
in her Cardiff Royal Eisteddfod essay of 1834 supports the traditional
view that she was consulted over the design.

421. John Williams after John Nash,
Memorial to General Sir Thomas Picton,
1860, Lithograph, 435 × 270
(Memorial designed by John Nash, 1824–7)

420. Edward Hodges Baily, *Bas relief carving*
from the *Memorial to General Sir Thomas
Picton*, 1827, Portland stone, 1560 × 5140

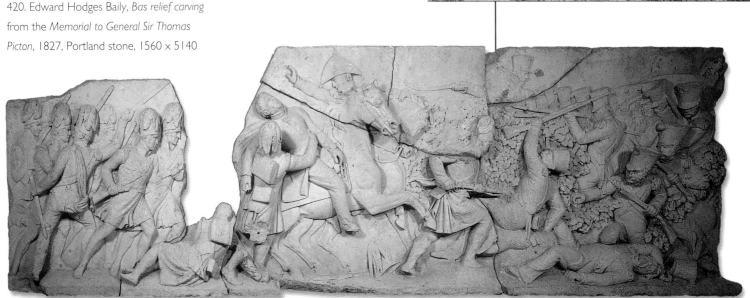

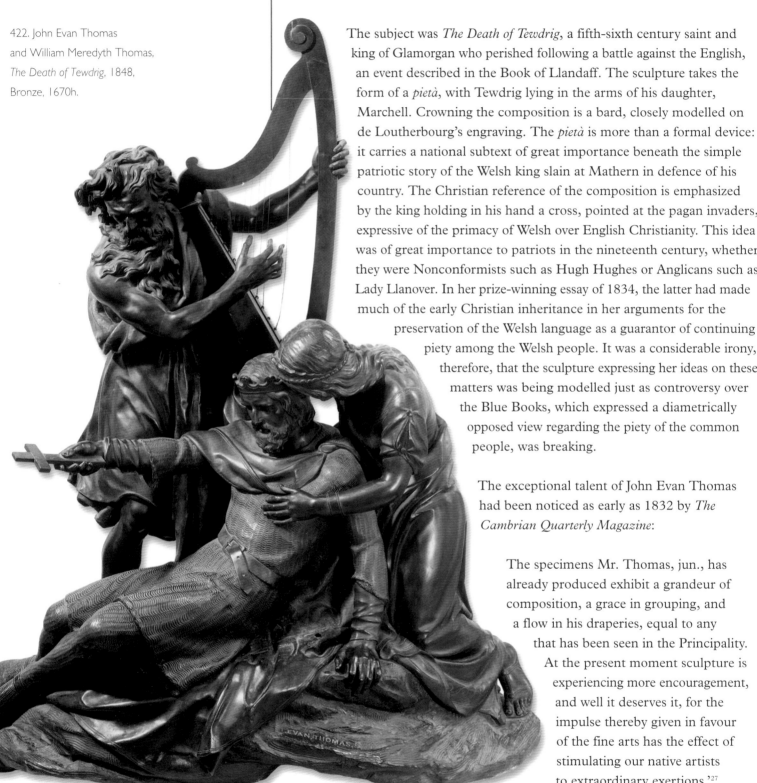

422. John Evan Thomas
and William Meredyth Thomas,
The Death of Tewdrig, 1848,
Bronze, 1670h.

The subject was *The Death of Tewdrig*, a fifth-sixth century saint and king of Glamorgan who perished following a battle against the English, an event described in the Book of Llandaff. The sculpture takes the form of a *pietà*, with Tewdrig lying in the arms of his daughter, Marchell. Crowning the composition is a bard, closely modelled on de Loutherbourg's engraving. The *pietà* is more than a formal device: it carries a national subtext of great importance beneath the simple patriotic story of the Welsh king slain at Mathern in defence of his country. The Christian reference of the composition is emphasized by the king holding in his hand a cross, pointed at the pagan invaders, expressive of the primacy of Welsh over English Christianity. This idea was of great importance to patriots in the nineteenth century, whether they were Nonconformists such as Hugh Hughes or Anglicans such as Lady Llanover. In her prize-winning essay of 1834, the latter had made much of the early Christian inheritance in her arguments for the preservation of the Welsh language as a guarantor of continuing piety among the Welsh people. It was a considerable irony, therefore, that the sculpture expressing her ideas on these matters was being modelled just as controversy over the Blue Books, which expressed a diametrically opposed view regarding the piety of the common people, was breaking.

The exceptional talent of John Evan Thomas had been noticed as early as 1832 by *The Cambrian Quarterly Magazine*:

The specimens Mr. Thomas, jun., has already produced exhibit a grandeur of composition, a grace in grouping, and a flow in his draperies, equal to any that has been seen in the Principality. At the present moment sculpture is experiencing more encouragement, and well it deserves it, for the impulse thereby given in favour of the fine arts has the effect of stimulating our native artists to extraordinary exertions.'[27]

423. William Meredyth Thomas,
Thomas Price, 'Carnhuanawc',
c.1848, Plaster

The early optimism of this unknown critic regarding the career of Thomas would be fully borne out by his subsequent career. He had trained under Francis Chantrey in London and was early rewarded with Welsh gentry and industrial patronage. He made a statue of the Duke of Wellington for Joseph Bailey of Glanusk in 1840, and subsequently produced statues and memorials of members of the Morgan family of Tredegar House,[28] the Vivians of Swansea and the Clives of Powis Castle, among others. The year of his success at the Abergavenny Eisteddfod was particularly rewarding since he also made statues for the House of Lords. Shortly afterwards, he became one of the original guarantors of the Great Exhibition of 1851, where he showed his *Second Marquess of Bute* before its removal to Cardiff.[29] His successful career was dominated by such monumental portrait commissions and it was his younger brother who demonstrated much the greater interest in national subject matter of a historical kind. Regrettably, owing to the absence of appropriate institutions able to invest in preserving William Meredyth Thomas's plaster originals in bronze or marble, such subjects as *Sabrina Rising from the Severn, The Welsh Harper,* and *The Lament of Llewellyn over his Dog Gelert,* have not survived. *The Death of Tewdrig* provides a measure of the loss, since it is known that, although it carries the signature of his elder brother, the piece was modelled by William Meredyth Thomas.

The 1848 Abergavenny Eisteddfod was the last to be addressed by Carnhuanawc, who died a few weeks later. His final oration was witnessed by the Thomas brothers, as a result of which William Meredyth produced one of the finest portrait busts of the period. The circumstances were described by his elder brother in terms characteristic of the patriotic sentiment of the Llanover circle:

> In 1848, I attended the Abergavenny Eisteddfod, in company with my brother, and there met Carnhuanawc, who appeared much altered from illness. We were much struck with the poetic cast of his countenance as we sat listening to his eloquent address. The poetic fervour, the vivacity of his manner, and the brightness of his eye – 'In a fine frenzy rolling', and glistening with flashes of true genius, made a lasting impression upon our minds. There he stood on that platform for the last time, the object of admiration and the theme of applause … My brother treasured up that noble countenance in his memory; and on our return to London, he employed his best efforts to embody those thoughts in sculpture; the result was the bust you saw at the Eisteddfod … I trust that some day he will be rewarded by his countrymen, who may be patriotic enough to hand down to future generations the immortal Carnhuanawc in marble.[30]

[27] *The Cambrian Quarterly Magazine,* V (1832), 147–8.

[28] Thomas's statue of Lord Tredegar is reproduced in Lord, *The Visual Culture of Wales: Industrial Society,* p. 99.

[29] Illustrated in ibid., p. 97. His most remarkable imposition on the Welsh landscape was, however, the monumental statue of *Prince Albert* – 'Albert the Good', as he is described on the plinth, which towers above the town of Tenby.

[30] Thomas Price, *The Literary Remains of the Rev. Thomas Price, Carnhuanawc* (2 vols., Llandovery, 1854–5), II, pp. 391–2. According to the catalogue of the art and craft exhibition of the 1867 National Eisteddfod at Carmarthen, a marble copy was made. However, only the plaster has come to light.

424. Bernard Samuel Marks,
Joseph Edwards, c.1870,
Oil, 613 x 510

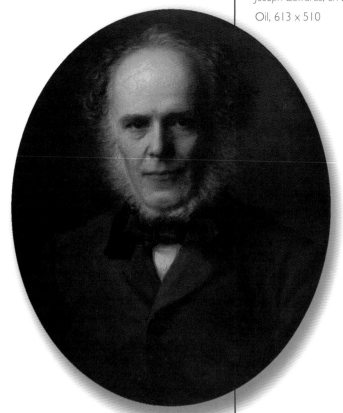

425. Joseph Severn,
John Gibson, 1828, Pen and ink,
100 x 147

This romantic national image, casting the vicar of Llanfihangel Cwm-du as a latter-day Taliesin, clad in a robe of homespun cloth, stands very close in conception to William Roos's portrait, *Talhaiarn, The Bard in Meditation*, painted two years later and probably in connection with that poet's role in the great Eisteddfod held at Rhuddlan. Talhaiarn was also prominent among the initiators of the next important milestone in the development of visual culture in the Eisteddfod movement, namely the Royal London Eisteddfod of 1855, held at St Martin's Hall. The connection with Abergavenny remained strong since the President was Sir Benjamin Hall, who was appointed that very month Commissioner of Works at the new Houses of Parliament, where his name was immortalized in that of the clock tower – 'Big Ben'. For the first time a living Welsh artist was granted a one-person exhibition by his compatriots, and, albeit in London, a central place on the national stage. The leading role in the visual arts was granted on this occasion not to John Evan Thomas but to the Merthyr sculptor, Joseph Edwards. Nevertheless, the two leading figures in the establishment Welsh art world were linked in the following critical comment, redolent of the growing aspiration of patriotic progressives to elevate the common people of Wales to a status which would reflect well on the nation so recently defamed in the Blue Books:

This sculptor [Edwards], with the well known Mr. Evan Thomas, is a specimen of a self-educated Welsh artisan, who has ascended from the carpenter's bench to the chisel, and to the brush and pallet of the artist.[31]

Observations such as these dominated the discussion of the visual arts in Wales in the mid-nineteenth century. They marked a division of patriotic sentiment into two main streams. On the one hand, the need to create explicitly national imagery continued to be expressed, but – especially in the immediate aftermath of the Blue Books – it became subordinate to the broader question of national progress in the arts. The improvement of the taste of the common people would be achieved through education in the principles of academic art and primarily measured by producing artists who achieved high status in England. The success of John Gibson, widely acknowledged by the English (whose queen had commissioned him to carve her portrait), made him the role model to whom many Welsh intellectuals pointed.[32] He seemed the very archetype of the improved common man. He was born in 1790 of poor parents at Gyffin, near Conwy, and received his early training in Liverpool from where he went to Rome in 1817, without ever having worked in a London studio. Gibson sometimes described himself as a Welshman and sometimes as an Englishman, but in truth he belonged fully to neither country, though both were equally keen to claim him since he came to be widely regarded in Britain as the greatest sculptor in the world. Ultimately he was attached only to the long line of émigré artists who settled in Rome and identified themselves with the Classical tradition. His sense of personal identity was based on the romantic idea of the artist, whose concerns he placed above those of everyday life. His pupil, the American sculptor Hariet Hosmer, memorably said of him that he was 'a god in his studio, but God help him when he is out of it'.[33]

Only a single drawing of a bard, executed when he was very young, indicates any artistic interest on Gibson's part in Welsh cultural traditions. Nevertheless, in 1844, during his first visit to London for twenty-seven years, he troubled to call on his young compatriot, Joseph Edwards, who recorded the great event in his diary:

October 8th; had the unexpected pleasure of seeing Mr. Gibson the sculptor, and my talented townsman Penry Williams the painter, – both living at Rome. Took luncheon with them and Mrs. Huskisson at her house in Carlton Gardens. It was most gratifying to me, as I had never seen Mr. Gibson before. It was a strange coincidence that both these gentlemen should have called at my studio and left their cards on the very day that I visited Durham Cathedral ... and was looking at a statue by Gibson there. Their condescension in calling at my humble place inspired me with an earnest desire and a strong determination to strive and be worthy of the honour thus conferred upon me.[34]

426. John Gibson,
The Bard, c.1810,
Watercolour, 127 × 143

31 *Camarvon and Denbigh Herald*, 28 July 1855. The father of John Evan Thomas was a monumental mason in Brecon. The rising social status of his son reached a peak in 1868 when he became high sheriff of Breconshire.

32 The idiosyncratic Hugh Hughes was born only a few miles away from Gibson in the same year of 1790, and he was also educated in Liverpool. As we have seen, Hughes devoted his life to the development of the indigenous culture, but cut no figure in England and died, as a result, in complete obscurity.

33 Lady Eastlake (ed.), *The Life of John Gibson* (London, 1870), p. 231. For Gibson's sense of national identity, see Lord, 'John Gibson and Hugh Hughes – British Attitudes and Welsh Art' in idem, *Gwenllian: Essays on Visual Culture*, pp. 18–19.

34 Quoted in William Davies, 'Joseph Edwards, Sculptor', *Wales*, II (1895), 278. The visit was probably suggested by Gibson's close friend, Penry Williams, since he, like Edwards, was a native of Merthyr. Edwards was in Durham to set up his memorial, *The Last Dream*, a sculpture which exercised a strong influence on William Davies who had seen it in progress in London the previous year: 'It was a revelation to me at the time, – the deep impression it made then has never been obliterated.' Ibid., 277.

427. John Gibson,
The Tinted Venus, c.1851–6,
Polychromed marble, 1750h.

Joseph Edwards had gone to London in 1835, and two years later, on the recommendation of Francis Chantrey, he entered the Royal Academy Schools. He was much more influenced by the example of Gibson than John Evan Thomas, and came to be regarded by many as the primary example of continuing Welsh progress in the arts, in the image of the great sculptor. However, Edwards's early attempts to attract commissions from Welsh patrons met with only limited success. By 1841 he was known to Lady Llanover and he wrote optimistically to Taliesin ab Iolo in Merthyr that 'it is probable that her Ladyship may be induced to sit for me for her bust, or prevail on Sir Benjm to sit for his', but neither agreed to do so.[35] He appears to have been much taken advantage of by English sculptors for whom he worked, notably Matthew Noble, and Edwards wrote a long list of works attributed to the Englishman which he himself had both designed and modelled. From a Welsh point of view, the most notable of these was the statue of the Marquess of Anglesey, completed in 1861, which crowns the top of the column at Plas Newydd, built in 1810. The only large-scale public work conventionally attributed to him in Wales is *Religion* in the graveyard at Cefncoedycymer, near Merthyr. Like Gibson, Edwards lived much of his life in a dream of art and philosophy which did not equip him well for the cut-throat London art world in which he had to make his way. His beliefs were expressed in a series of exquisite bas reliefs on esoteric themes. Unlike Gibson, however, the mysticism of Joseph Edwards developed a strong Welsh aspect:

> he began to conceive the idea that Wales was to be the home of that transcendentalism which had possessed his soul, and which, he fondly believed, was destined to mould and transform the religion and philosophy of the world. The Welsh race had been entrusted with the secret of poesy, and the order of bards, if once infused with the spirit of modern thought, would become the agent of a higher and more spiritual civilization, which would supersede the superstitions of the churches, and emancipate the human mind from every law, except that of the good and beautiful.[36]

Here we find echoes both of Gibson's single-minded pursuit of the beautiful through art and the Unitarianism of William Lorando Jones, who seems to have worked for a time in Edwards's studio. In 1843 Joseph Edwards was joined in London by another sculptor from Merthyr, William Davies, and subsequently

428. Joseph Edwards (but attributed to
Matthew Noble), *The First Marquess of Anglesey*,
1861, Bronze

429. Joseph Edwards,
Religion, Marble,
1872

35 NLW MS 21272E, f. 161, Joseph Edwards to
Taliesin ab Iolo, 24 May 1841. Joseph Edwards's
papers, including his diary, with extensive lists of
sitters, are at University of Wales, Bangor, MSS
6095–6134.

36 *Wales*, III (1896), 25–6.

430. Unknown photographer,
Joseph Edwards in his studio,
*c.*1870

by his brother, David. The Davies brothers, both of whom were active as musicians as well as sculptors, became pillars of a new grouping of London-Welsh artists and intellectuals who aspired to lead a renaissance in Welsh life. They were much influenced in a negative sense by the trauma of the Blue Books and in a positive way by developments within the English world of which they were so much a part. Among the most distinguished of the circle was the harpist John Thomas, the latest in a line of musicians after Edward Jones (Bardd y Brenin) and John Parry (Bardd Alaw) who combined success in the English establishment with a close identification with Welsh national music. Thomas, later known as Pencerdd Gwalia, was the exact contemporary of William Davies, who studied in the

432. Joseph Edwards, *Drawing for sculpture,*
*c.*1850–60, Pencil, 322 × 262

431. Joseph Edwards,
Hope, 1848–54, Plaster after
Memorial to William Hawkins
of Alresford Hall, Colchester,
680 × 355

studio of William Behnes, while the harpist attended the Royal College of Music. Thomas's career eventually led him back to the College as a teacher and to an appointment as harpist to Queen Victoria, while the sculptor progressed to be a regular exhibitor at the Royal Academy. From their elevated positions in London, both men addressed themselves actively to national development in Wales in association with the leading figure in the group, Hugh Owen, the educationist.[37] Owen's status in the Welsh establishment by mid-century was so high that Joseph Edwards was believed by William Davies to have 'formed a personal attachment which verged on the superstitious' to him.[38]

[37] Hugh Owen went to London in the 1820s, where he joined the Cymreigyddion Society, though not until after the departure of Hugh Hughes. He later graduated to the Cymmrodorion. His work in Welsh education began in 1843 and culminated in the central role he played in the establishment of the University College of Wales, Aberystwyth.

[38] *Wales*, III (1896), 25.

433. William Griffith (Tydain),
William Davies, 'Mynorydd',
c.1864

434. William Griffith (Tydain),
John Thomas, 'Pencerdd Gwalia',
1864

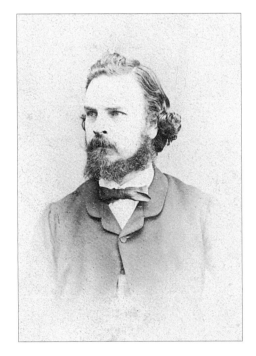

In the field of visual culture the national aspirations of the group were strongly influenced by developments in England, where they lived. The most notable of these was the Great Exhibition of 1851, an exhibition which had important consequences for education. In 1853, through the new Department of Science and Art, the government encouraged the expansion of a system of art education which already provided a central metropolitan school in London and several regional schools in England, as well as schools in Scotland and Ireland. Wales had no school, but the *Report of the Committee of Council on Education* provided

[39] *Minutes of the Committee of Council on Education, 1853–4* (London, 1854), p. 996. The 1852–3 *Minutes* defined the basis of the revamped system, pp. 29-54. The system was to be developed by local school boards but the government offered practical and financial assistance in the provision of materials, including prints and casts for study. The first School of Design was established in London in 1837, and successive Acts of Parliament in 1845, 1850 and 1854 expanded the legislative framework for provision. Because of the location of the Department of Science and Art, the schools were often referred to as South Kensington schools, giving rise to confusion in the minds of some commentators about where painters such as Ellis Owen Ellis were trained.

[40] Ibid., 1852–3, p. 31.

[41] Whether this transformation was the result of his own study or of belated formal teaching is unclear. The sketchbook of 1849–50 showed early signs of formal study in ideas for Shakespearian subjects and academic studies of heads and nudes.

[42] *Minutes of the Committee of Council on Education*, 1854–5, p. 591. I am grateful to my colleague Dr Marion Löffler for this reference.

[43] Lady Charlotte Guest organized an excursion for employees at the Dowlais works; see Lord, *The Visual Culture of Wales: Industrial Society*, p. 116.

[44] William Roos was adjudged second to Jones in the competition. All the pictures have disappeared and the written reports do not agree on whether Roos submitted one or two paintings. However, it seems clear that the picture adjudged second was on the subject of 'The Parting of Owen Glyndŵr and Sir Lawrence Berkerolles'. W. E. Jones is discussed in Lord, *The Visual Culture of Wales: Industrial Society*, pp. 112–13.

[45] Evan Williams, 'Y Gelfyddyd o Arlunio', *Y Traethodydd* (1848), 423–4, translated from the Welsh.

for further expansion and for the regulation of standards in the schools, and under this stimulus the school board in Caernarfon proposed the establishment of 'An industrial school for girls, and drawing classes for the boys'.[39] Swansea adopted a similar policy in the same year. The schools were simple affairs, consisting of no more than 'a suitable room'[40] and at least twenty scholars. John Cambrian Rowland became headmaster of the Caernarfon school, and his self-portrait of about 1870 shows a complete transformation from the manner of the peripatetic artisan of thirty years earlier.[41] Despite the development of these schools, the government inspector, the Revd H. Longueville Jones, remained pessimistic in his prognosis for art education and was frustrated in an initiative which he undertook to make special provision in Wales for exposing children to examples of high art:

> A late circular from the Committee of Council on Education led to the supposition that it was considered desirable to promote the formation of Drawing Classes and Schools of Art in Wales. But it was not sufficiently taken into account that, from the historical, geographical, and religious peculiarities of the inhabitants of the Principality, the spirit of art was dormant in the most favourable localities, and could hardly be expected to exist throughout the greatest portion of the district. It was especially necessary to sow some portion of seed, however small, over a broader rather than a narrower space, if any practical result, within the future experience of men now living, were to be looked for. It has been therefore a subject of deep regret to myself, that the simple and cheap experiment of distributing gratuitously a few good engravings, or other objects of art, among the schools of Wales ... was immediately declined ... I feel perfectly convinced that the efforts, whether of the friends of art in Wales, '... rari, nantes in gurgite vasto', or of myself as Inspector, to promote the objects of the circular in question, are almost hopeless ... I have no hope of a feeling for art being generated in Wales, without a generous and widely conceived application of public funds for that special purpose.[42]

Longueville Jones started from the premise that academic art alone was of importance. Indeed, he specifically singled out the products of artisan painters, popular printmakers and craftspeople for criticism, remarking that they 'will never send pupils to the classes at Marlborough House', the location of the Metropolitan School of Design. Apart from the few museums accessible to the public in Wales, such as the Royal Institution of South Wales at Swansea and the Powisland Museum at Welshpool, opportunities to see academic art were very limited. The middle classes and a fortunate few among the common people, for whom group excursions were organized, had travelled to London to the Great Exhibition,[43] and in 1857 the vast Art Treasures Exhibition at Manchester offered an opportunity closer at hand for those living in the north. But in Wales itself, following the last Abergavenny festival of 1854, only the occasional Eisteddfod presented a few pictures or

sculptures to the public. The most notable effort occurred at Llangollen in 1858, an event satirized, as we have seen, for its Celticist excesses by Ellis Owen Ellis in *Y Punch Cymraeg*. Nevertheless, the painting competition resulted in one notable piece of national art, *The Last Bard*, painted by William Edward Jones.[44]

The paucity of exhibitions was matched by the absence of discussion of academic art in the Welsh periodical press and little discussion of art matters relating to Wales in the English press. In 1829 *The Cambrian Quarterly Magazine* had ventured tentatively into the field with a criticism of Welsh subjects at the exhibition of the Society of Painters in Water Colours and the Royal Academy. Two years later it presented a biography of Richard Wilson and reviews of the latest engravings, but these were sporadic efforts. In Welsh, in direct response to the Blue Books, the painter Evan Williams pioneered writing about art in an article, published in *Y Traethodydd* in 1848, entitled 'Y Gelfyddyd o Arlunio' (The Art of Painting). Recalling that he had read little or nothing about painting written in the Welsh language, he introduced his largely philosophical observations as follows:

436. Anon. after William Edward Jones,
The Last Bard, 1858, Wood engraving from
The Illustrated London News, 196 × 137

above left:
435. John Cambrian Rowland,
Self-portrait, c.1870,
Oil, 762 × 635

> If better late than never, let us now commence with some simple lessons in those arts that are not yet familiar to the Welshman in his own language. And there is no doubt but that if we proceed with this, as in other things, we shall soon be on level ground with any other nation in these branches of useful knowledge. These days, as we know, there are some who seek to defame our character as a nation, and accuse us of being far behind other nations in every sense; but we know that this is a great untruth, and that we are, fortunately, much above our neighbours in religion and morals, if not in general knowledge.[45]

Over the following twenty years, Williams contributed a series of substantial and important writings on visual art to the same periodical, including a review of the 1857 Art Treasures Exhibition at Manchester. Williams felt constrained by what he regarded as a lack of technical vocabulary in Welsh, but he nonetheless succeeded in giving a lively description of the general scene and an opinionated description of the exhibits.

437. Unknown photographer,
John Gibson with his patrons
Mr and Mrs Preston at
the London Exhibition of 1862;
Pavilion with sculpture by Gibson,
including *The Tinted Venus*,
designed by Owen Jones

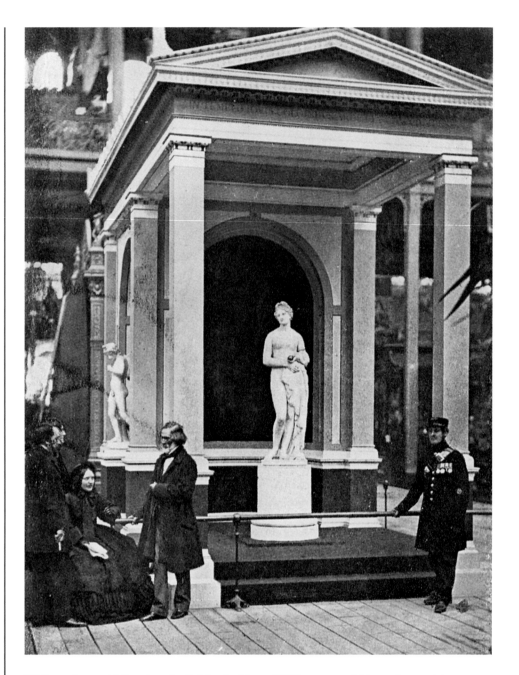

438. William Davies,
The Bard, c.1862,
Plaster, size unknown

[46] For the evolution of the Social Science Section, see Hywel Teifi Edwards, *Gŵyl Gwalia: Yr Eisteddfod Genedlaethol yn Oes Aur Victoria 1858–1868* (Llandysul, 1980), pp. 53–112.

[47] Mynorydd made both busts and medallions, copies of which he offered for sale to defray the cost of building chapels. For an extensive list of the sitters, see *Y Drysorfa*, 28 (1858), 211–12.

Like other middle-class individuals, Evan Williams would have been able to travel easily by train to the Manchester exhibition, but for the mass of the population such an excursion remained impossible. Recognizing the need to bring exhibitions of art and manufactures, along with discussion of the sciences, and economic and social issues, within their reach, the group of intellectuals around Hugh Owen decided to make use of the only available institution in Wales, the Eisteddfod. In 1862 they embarked on a revisionist programme entitled 'The Social Science Section'.[46] In the arts, the most influential figures in the new movement were William Davies (Mynorydd) and John Thomas (Pencerdd Gwalia). At the time of the Caernarfon Eisteddfod of 1862 Mynorydd was working on a bust of the harpist, the latest in a long line of images of prominent Welsh people, mostly connected with the religious life of the nation.[47] Both men

were entering the most successful period in their careers – Pencerdd Gwalia was becoming a celebrity for his concerts of national music, and Mynorydd was honoured shortly before the Eisteddfod (like Joseph Edwards before him) by a visit to his studio by John Gibson. The great sculptor came 'principally to inspect his large ideal bust of a bard, which had been prominently exhibited at the grand concert of Welsh National Music held at St James's Hall and the Crystal Palace, where it was much admired'.[48]

At the launch of the Social Science Section at Caernarfon, Mynorydd exhibited 'six graceful statuary models'[49] in the Eisteddfod pavilion, a development celebrated in a speech by the Methodist minister and writer, Thomas Jones (Glan Alun). The mantle of John Gibson had clearly passed from Joseph Edwards to Mynorydd:

> I also rejoice to see these beautiful busts, showing another very desirable new feature in our Eisteddfod. We have now a sculptor who stands very nearly at the head of his profession in the person Mr. Gibson (cheers), and we have another upon this platform who is following quickly in his steps, our friend Mr. Davies (Mynorydd), (cheers). Those nations which in ancient times attained to the highest refinement of civilisation had left their countries chequered with the monuments of their taste. We must confess that Wales is very deficient in any beautiful relics of that kind. I am very glad to see a move in that direction. A symmetrical building, a beautiful monument or painting, arrests the attention of the passer by; awakes within him a perception of the beautiful, and thus elevates and refines his mind irrespective of his will, and without any effort of his own. Other nations might also in such works see and enjoy our productions.[50]

By stages the Social Science Section expanded to include other aspects of the visual arts. An architecture competition to design a public building was held at Caernarfon. The following year, at Swansea, the sculpture of Mynorydd was seen again but this time in the company of a collection of paintings by Ap Caledfryn, for which he was awarded a medal. At Llandudno in 1864 photography appeared, once more as a result of the influence of the London circle, for it was the work of Tydain which attracted the attention of the critics:

439. Anon.,
The Pavilion of the National Eisteddfod at Caernarfon, 1862,
Wood engraving from
The Illustrated London News,
235 × 340

[48] *Carnarvon and Denbigh Herald*, 23 August 1862. The pavilion in which Gibson's work was displayed in 1862 was designed by Owen Jones, son of Owain Myfyr, patron of William Owen Pughe and Iolo Morganwg. Like Gibson, Jones was involved in a controversy, which preoccupied the art world of the period, concerning the colouring of sculpture. For Owen Jones, see below, p. 319.

[49] Ibid., 30 August 1862.

[50] Ibid.

441. William Griffith (Tydain),
Portraits of Welsh celebrities.
Sarah Edith Wynne, 'Eos Cymru',
John Jones, 'Talhaiarn', and
Henry Brinley Richards,
cartes-de-visite, c.1860–5

440. William Griffith (Tydain),
Self-portrait, c.1860

51 Ibid., 27 August 1864.

52 *The National Eisteddfod, For the Year 1865,*
Aberystwyth (Aberystwyth, 1865), pp. 6–7.

53 *Carnarvon and Denbigh Herald,* 23 September
1865.

54 William Jones, painter of *David Thomas, 'Dafydd*
Ddu Eryri', which had established the pattern for
bardic portraits in 1821, also showed his work.
He was by this time seventy-five, and he showed
again at the National Eisteddfod in Chester the
following year. Ap Caledfryn remembered him
there: 'I met Jones of Chester in 1866 at the
Eisteddfod exhibition when I took the first prize
and silver medal. There were 17 competitors
and amongst them this old gent – quite the old
fashioned gentleman dressed in good black cloth,
his hair was as white as snow.' NLW MS 6358B,
unpaginated.

Tydain's collection of Welsh celebrities was, as might naturally be expected at such a national gathering as the present, a great attraction ... and we should be glad to hear that the Council of the Eisteddfod had taken steps to secure a copy of each, a collection which might be increased from year to year, and thus give to the Principality the nucleus of a national portrait gallery.[51]

No action was taken, but that the suggestion was made at all is a clear indication of the increasing aspiration to create art institutions embodying the notion of modern nationhood.

A major step forward was taken at Aberystwyth in 1865 with the first 'Exhibition of the Art, Industry, and Products of Wales', held in association with the Eisteddfod but in two separate buildings. The organizers made their aspirations clear to the public:

When it is considered that the Eisteddfod is, and has been for many centuries, the only NATIONAL RECREATION in which the people take an interest and a part, it is not too much to aver that the essentially instructive character of this ancient Institution is thus preserved and fostered in a direction wholly in keeping with the spirit of the times, and may be highly conducive to the Institution and to the CIVILIZATION AND THE HAPPINESS OF THE PEOPLE.[52]

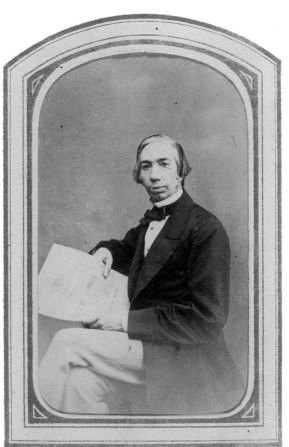

Fifty-two exhibitors showed examples of raw materials such as lead and gold ore, manufactures, including textiles and enamelled slate ware, some antiquities, painting and sculpture. Although on a tiny scale, the exhibition followed that of the great exhibitions pioneered in London in 1851, and crowds flocked to see the work, which was much lauded in the newspapers. The decorated enamelled slate ware, a speciality of the Aberystwyth and Corris areas, was particularly admired by the critic of the *Carnarvon and Denbigh Herald*, who was moved to remark that '"Life is short, art is long"... and the beautiful will at all times appeal with effect to the refined mind; even the general public appreciated these works of native art by crowding around the several stands on which they were displayed.'[53] In this, and several subsequent exhibitions, the working classes, while encouraged to attend, were kept apart from their betters who could afford a higher entrance fee charged at certain times.

The plaudits for fine art exhibits at Aberystwyth went mainly to Ap Caledfryn and to the portrait painter Thomas Brigstocke, who presented another example of a Welsh artist who could be shown to have ascended, if not from rags to riches, then certainly from a tradesman's background to a successful practice based on gentry patronage.[54] His father, David Brigstocke, had a painting and decorating business in Carmarthen which flourished

442. Anon., *Enamelled slate urn*, c.1865, 270 × 330

443. Thomas Brigstocke,
General Sir William Nott,
*c.*1845, Oil, 2500 × 1600

[55] Brigstocke reported 'Gibson's genuine sincerity and simplicity of manners, which won for him the esteem of all who knew him. His strong Welsh accent was much more marked than that of Penry Williams, so much so that in Rome (the late) E. M. Ward, RA, used sometimes to try and imitate Gibson's pronunciation, much to the amusement of his audience'. Letter quoted in T. H. Thomas, 'Life and Work of Thomas Brigstocke', *Carmarthen Journal*, 8 June 1888. Brigstocke painted a portrait of Ward, who was a leading member of the expatriate circle of artists in Rome. The continental sojourn of Thomas Brigstocke ended tragically with the death of his wife and child in Paris on his way home to Wales.

[56] Brigstocke is rumoured to have had an affair with Maria Conway Griffiths, later Lady Reade, whom he first painted at the age of seventeen. The commission to paint General Sir William Nott (1782–1845) was a highly prestigious one at the time. Nott was famous for his victory at Chuznee in 1842 during the Afghan war.

[57] As in the case of Mynorydd, music as well as art bound Brigstocke to the London-Welsh intelligentsia. In 1873 Brigstocke's play, *Eustace de St Pierre*, with his own incidental music, was performed by Edith Wynne (Eos Cymru) and John Thomas (Pencerdd Gwalia). Brigstocke lived the latter part of his life with Pencerdd Gwalia and another painter with Welsh connections, W. Cave Thomas, at Cavendish Square.

[58] *The National Eisteddfod*, 1865, p. 7.

sufficiently for him to pay for his son to be trained in the London studio of Henry Sass and the Royal Academy Schools in 1825–6. In 1833 he left London for the Continent, carrying in his pocket an introduction to John Gibson and Penry Williams in Rome, of which he took full advantage.[55] He did not return to Wales until 1841, whereupon portrait commissions began to flow, led by that of General

444. Thomas Brigstocke,
Emma Mary Carpenter,
*Mrs Tregarn Griffith, c.*1850,
Oil, 740 × 620

Sir William Nott, who, like the
painter, was a native of Carmarthen.
Brigstocke's practice flourished in
London, where he was a member of the
circle of Mynorydd and Pencerdd Gwalia.
Much of his patronage emanated from the
gentry families of Carmarthenshire and, with
the exception of the Griffiths family of Carreg-lwyd
in Anglesey, few patrons from other parts of Wales came
forward.[56] In 1847 Brigstocke was commissioned to visit Egypt
to paint the ruler of that country, Mohammed Ali. This proved to be
his most celebrated work and an engraving of it was among his exhibits at
Aberystwyth. Brigstocke painted some subject pictures, but is not known to
have attempted any with national connotations. It was his success as a society
portrait painter and as a painter of animals, acknowledged by regular exhibition
at the Royal Academy, which appealed to the London progressives of the new
National Eisteddfod as an example to the nation.[57] Their outlook was summed
up by Chancellor Williams, a central figure in the organization of the Eisteddfod
at Aberystwyth, in the classic statement of mid-nineteenth-century progressive
aspirations and methods in the visual arts:

> Wales has contributed works of Art, such as those of Wilson and Gibson,
> that may well be held up to stimulate the artistic talent that may yet lie dormant
> in our secluded vallies [*sic*], and to correct the taste of our aspirants; and it is
> hoped that those who possess these gems of art, will kindly send them for such
> a noble purpose. Other works of native Artists that have engaged the admiration
> of thousands in the Exhibition of the Royal Academy, have already been
> promised to give effect to this our first attempt.[58]

445. Thomas Brigstocke,
*Self-portrait, c.*1830–5,
Oil, 730 × 620

446. Lafayette,
William Cornwallis West,
c.1908

The project to introduce the Welsh public to paintings of the Royal
Academy type, such as those by Brigstocke, was taken up again by the
National Eisteddfod at Carmarthen in 1867. An attempt to construct a special
art gallery was thwarted by structural failings, but for the first time a collection
was imported under the loan scheme operated by the South Kensington Museum,
which attracted considerable critical attention. Furthermore, professional help
was available locally since an art school had by this time been established in the
town, and the Principal, F. F. Hosford, was prominent among the Eisteddfod

447. Unknown photographer,
Interior of Ruthin Castle, c.1880

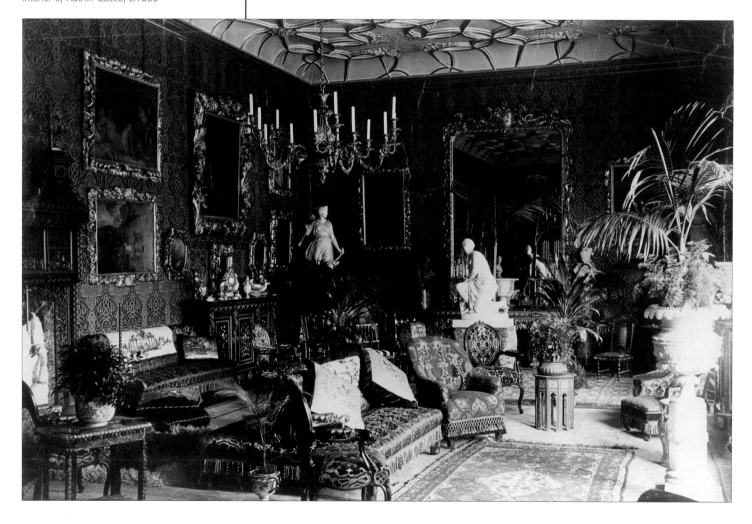

organizers. However, it was in the following year at Ruthin that the first loan exhibition of fine art on a scale comparable with exhibitions in other countries was mounted in Wales. The initiative was undertaken in parallel with the Eisteddfod by William Cornwallis West of Ruthin Castle, who was both a connoisseur and an amateur artist. Largely at his own expense, Cornwallis West assembled over a thousand exhibits in the Assembly Rooms of the new Town Hall in Ruthin. Works were borrowed from Welsh gentry collections such as that of Sir Watkin Williams Wynn, who showed his three famous family Reynolds. Many such pictures from private collections were seen by the general public for the first time, notably the early Goodman family portraits.[59] Connoisseur collections, such as that of W. Chaffers, the 'principal superintendent' of the exhibition,[60] contributed in particular to the 'Ornamental Art' section, mainly in the form of ceramics and bronzes. Cornwallis West was sufficiently well-connected to be able to persuade living artists, notably Leighton and Watts, to show major works from their studios. The Science and Art Department at South Kensington contributed a substantial mixed exhibit.

Although the opening was a glittering social occasion,[61] the underlying motivation of Cornwallis West was not to promote art among fashionable society. Cornwallis West believed that art could have a civilizing influence on a common people whom he sought to elevate, for patriotic reasons, from their alleged state of ignorance. The *Carnarvon and Denbigh Herald*, well-supplied, one suspects, with press releases from Ruthin Castle, strongly promoted this aspect of the exhibition:

> It is well known – all history tells us, how great has been the beneficent effect of pictures and works of art upon the population of a country. Their contemplation elevates the taste, they refine the mind, and lead the human soul to all that is pure, great, and good. We trust, therefore, that the people of Wales, the intelligent and ingenious artisans, the large portion of the population employed as colliers, miners, and slate quarrymen, in this the sister and neighbouring counties of North Wales, will be enabled to visit this exhibition before it closes. We hope it will not be necessary to complain of a neglect of duty of employers of labour to send men to this exhibition ... We would also suppose that it would be well worthy of the attention of the clergy and school managers. They must have many youths of good abilities, and to whose conceptions a view of the great works of which we are writing would be an invaluable impulse.[62]

[59] Since it describes collections which have since been broken up, and several pictures subsequently lost, the catalogue to the exhibition is an important document. Among the lost pictures, perhaps the most notable was *Prince Arthur and Catherine of Aragon*, owned by W. F. Wolley. The picture carried the following inscription: 'This picture came from Gwaenynog, near Denbigh, the seat of John Myddelton, Esq., and had never been out of Wales, from the time of the Prince's death at Ludlow until 1788, when it was given by Col. J. Myddelton to Horace Walpole.'

[60] *Carnarvon and Denbigh Herald*, 8 August 1868.

[61] Lord, *The Visual Culture of Wales: Industrial Society*, p. 115.

[62] *Carnarvon and Denbigh Herald*, 8 August 1868. Cornwallis West practised in his private life what he preached in public. William Roberts, a porter at Ruthin Castle, became highly skilled in the production of inlaid depictions of country seats and churches, several of which, presumably by means of the marketing expertise of his employer, found their way into collections such as that of Chirk Castle.

273

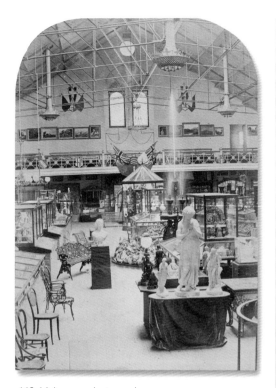

448. Unknown photographer,
The Fine Art and Industrial
Exhibition, Cardiff, 1870

449. John Evan Thomas,
Science Unveiling Ignorance,
*c.*1851, Painted plaster

[63] *The Fine Art and Industrial Exhibition, Official*
Catalogue (Cardiff, 1870), p. 13.

[64] 'I wish I could have suggested that out of an
overflowing balance the nucleus of a permanent
institution could have been formed … It has been
fated otherwise.' The speech of Cornwallis West
at the closing ceremony of the exhibition, quoted
in *Bye-Gones*, November 1876, 163.

[65] A speech by Cornwallis West at the opening of
the Wrexham Art Treasures Exhibition, *Carnarvon*
and Denbigh Herald, 23 August 1876.

The new National Eisteddfod movement failed after Ruthin in 1868, and
although an art exhibition inspired by the example set by Cornwallis West
was mounted at Bangor in 1869, it was on a much reduced scale. The initiative
passed, for the time being, to the industrial south of the country, where, at
Cardiff in 1870, a Fine Art and Industrial Exhibition was organized. In its equal
emphasis on fine art and industrial design, it represented the fulfilment of the
aspirations of the organizers of the 1865 Eisteddfod Exhibition at Aberystwyth.
Among the most prominent exhibits was John Evan Thomas's relief carving of
Science Unveiling Ignorance, of which a critic noted that it was 'in some sense an
allegorical representation of what the Exhibition is designed to effect for
benighted minds in the Principality'.[63]

Nevertheless, there was also a strong sense of celebration of the economic
achievements of Cardiff and the industrial south in particular, rather than of the
whole of Wales. The failure of the only national institution, the Eisteddfod, to

450. Anon.,

The Opening of the Wrexham

Art Treasures Exhibition, 1876,

Wood engraving from

The Illustrated London News,

165 × 220

fulfil its responsibilities in the field after 1868 continued to disappoint patriotic intellectuals. In 1876 Cornwallis West made a second attempt to show the way, in parallel with the Eisteddfod at Wrexham. His loan exhibition of fine art, ornamental art and industrial products was on an even larger scale than that held at Cardiff, and the grand conception included the construction of a special building, appropriately located on Hope Street. The main gallery alone was 147 feet long, and the roof was supported by sixteen columns, which were pale blue below and maroon above, with floral capitals. It cost the promoters £3,000 and was, in effect, the first National Gallery of Wales. Indeed, Cornwallis West hoped that it would evolve into just such a permanent institution.[64] Unfortunately, the exhibition proved to be a financial disaster as well as a critical triumph.

As at Ruthin, the underlying philosophy was a belief in the power of art to elevate and civilize the common people of Wales:

> I believe that an immense deal of humanising good can be done to every
> single man in Wales if he can only find time to visit the exhibition to see the
> wonderful produce of industry and mental power which is to be seen there.[65]

451. *Medal of the Wrexham*

Art Treasures Exhibition, 1876,

Bronze, 48d.

At the closing ceremony, chastened by the failure of the exhibition to draw the expected crowds, Cornwallis West was more guarded as to its long-term value:

> Whether it will lead to any definite and permanent result in the mind of any single individual who visited it, who can say? Let us hope it will. Let us hope that this practical attempt to interest the people in art may have more results than lecturing them seems to have. We have addresses and Social Science congresses; but preaching high art is no good. What we want is that the people of this country should, as the people of other countries, have an opportunity of seeing the beautiful in form, and colour, and design. Such an exhibition as this is a practical attempt to do so.[66]

452. William Edward Jones,
Hywel Dda codifying the Welsh Law,
1876, Oil, 1200 × 920

[66] *Bye-Gones*, November 1876, 163. The attendance at the exhibition over a period of four months was 76,901.

453. David Davies,

Elaine, 1864, Plaster,

size unknown

Although the question of producing new national imagery was overshadowed by the educational programmes of the radicals of the 1860s and 1870s, it never entirely disappeared from the agenda. At many of the national Eisteddfodau, prizes were offered for painting or sculpture on national subjects, the competitions running in parallel with the loan exhibitions. However, of all the competitive works made in the period, only one has come to light – *Hywel Dda codifying the Welsh Law* – painted by W. E. Jones. The picture was submitted in the Welsh History category at Wrexham in 1876 and failed to secure the prize, though it was described as 'an exceedingly well painted portrait in oil, the expression of the features being remarkably natural and life like'.[67] No sculpture at all from the period survives, although *Elaine* by David Davies, on a theme from Tennyson's *Idylls of the King*, modelled in 1864, is recorded in a photograph and may well have been seen at one of the Eisteddfod exhibitions of the period.[68] The low survival rate may be attributable in part to the fact that some pictures were the work of amateurs and, in the opinion of contemporary critics, were of a low standard. Nevertheless, whatever its conceptual limitations, the technical quality of W. E. Jones's *Hywel Dda* is not in doubt and it is unlikely to have been unique in this respect, given the proven abilities of William Jones of Chester, William Roos and Ap Caledfryn, all of whom competed in the 1860s and 1870s. The dearth of surviving material is more likely to be attributable to the lack of institutions capable of providing appropriate homes for such works.

The situation regarding patronage for sculpture in public places was equally depressing. The appeal by John Francis (Mesuronydd) from the platform at the Eisteddfod in Denbigh in 1860 was reported in the *Carnarvon and Denbigh Herald*:

> It was an evidence of decay when nations or peoples forget the great men whom God had risen up to be their protectors and deliverers, and it was the best possible proof of the strength and vitality of a people when it could be seen that they revered, and honoured the memory of their noble dead (applause). Numbers of such monuments recently had been seen by him in France and Belgium – many of them often repeated – to those who had brought honour and

[67] Unidentified press cutting, NLW XAS (36) 1876. *The Death of Llywelyn*, the winning picture at Wrexham, was by an untraced woman artist, identified only as Mrs Richard Williams.

[68] The identification of such works is complicated by the use of pen-names by the competing artists.

454. William Davies (Mynorydd),
Thomas Charles of Bala, 1872,
Marble

[69] *Carnarvon and Denbigh Herald*, 11 August 1860.

[70] 'During 1878 I had been steadily modelling my historical figure of Llewelyn … This work was undertaken with a view to introducing it to the Principality of Wales, feeling I was laying down the foundation of a work which would eventually stir up the Loyal people of North and South Wales to action toward a permanent Royal Memorial.' NLW MS 21233C, f. 15. The sculpture was exhibited at Liverpool that year and sent to the Cardiff Fine Art and Industrial Exhibition three years later, where it was not shown and was irreparably damaged. For the campaigns to build a memorial to Llywelyn ap Gruffudd, see Hywel Teifi Edwards, 'Coffáu Llywelyn' in idem, *Codi'r Hen Wlad yn ei Hôl* (Llandysul, 1989), pp. 187–237.

fame to their country. How were we on this point? We ought to have monuments to Caractacus, to Boadicea, to Arthur, to Cadwalladr, to Llewelyn (cheers), and to Owen Glyndwr (loud applause), as well as to other worthies; Lewis Morris, Goronwy Owen, Charles of Bala, Twm o'r Nant, and many more than he could think to enumerate (loud applause).[69]

A memorial to Llywelyn ap Gruffudd was the most frequently proposed plan, but it was also the most contentious, given the complex attitudes to Welsh and British nationality in the period. In his address at Denbigh, Mesuronydd went on to remark that the erection of memorials would excite an 'elevated national feeling' so that 'the old British element obtain a due expansion and relative weight in that united people which all the races of the British Isles are gradually becoming'. Following a visit to Abaty Cwm-hir in 1865, the sculptor Edward Griffith began to ponder a work but it was not until 1878 that it was exhibited, and he received no patronage to translate the plaster into marble or bronze.[70] Only Griffith's small polychrome of Llewelyn, sited in Conwy, and his memorial to Daniel Rowland at Llangeitho testify to his patriotic aspirations for art. Although the proposal to commission a memorial to Daniel Rowland was initiated in 1864, it was not unveiled until 1883. The only public sculpture project of a national character to be conceived and brought to a successful conclusion by the radicals of the 1860s was that of Thomas Charles of Bala, carved by Mynorydd and unveiled outside the chapel of the great leader of the Calvinistic Methodists in 1872. It was left to a subsequent generation to fulfil the aspirations of Mesuronydd and his mid-century contemporaries, and, fittingly, the dominant presence of Hugh Owen was among the first to be memorialized.

455. Edward Griffith,
Llywelyn ap Gruffudd,
late 19th century, Painted stone

chapter nine

BUILDING

AN ART WORLD

456. Thomas Hearne,
*Sir George Beaumont and Joseph
Farington Sketching a Waterfall,*
*c.*1777, Watercolour,
410 × 285

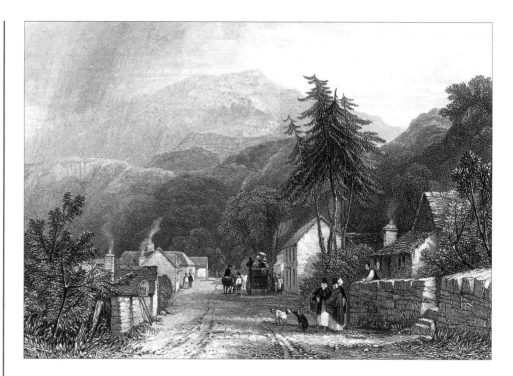

457. Unknown photographer,
*David Cox, c.*1855

Among the places visited by most artists and aesthetes on tour in Wales from the days of Sir Watkin Williams Wynn and Thomas Pennant in the 1770s were the valleys of the river Conwy and of the Lledr and the Llugwy which join it at Betws-y-coed. In 1799, the year of Turner's final tour in Wales, the painter and connoisseur Sir George Beaumont took Benarth, a house near Conwy, for the season. He returned regularly until 1806, sometimes with his old friend Joseph Farington who had studied with Thomas Jones in Richard Wilson's studio forty years earlier. Benarth became something of a base camp for expeditions into Snowdonia made by a new generation of visiting painters, including Girtin and Cotman.[1] Many of these young English watercolourists came together in 1804 to exhibit in London as the Society of Painters in Water Colours, and the scenery of the area became even more widely known than before.[2] Likewise, the Welsh painters and writers of the period sang the praises of the Conwy valley. Edward Pugh visited it on several occasions while researching *Cambria Depicta*, and a view of *The Miners' Bridge*, just west of Betws-y-coed, was among the first exhibited by Hugh Hughes in London at the Royal Society of British Artists in 1827.[3] For Hughes, of course, the Conwy valley was home territory. It was not merely a picturesque site for landscape but also the location of the press of John Jones at Trefriw, which was rapidly expanding its production of printed images.

In 1836 Thomas Roscoe, son of William Roscoe, patron of John Gibson, published the first edition of his guide, *Wanderings and Excursions in North Wales*. It was illustrated by several prominent English painters, including Thomas Creswick, but most notably by David Cox. Although Cox had worked in Wales since 1805, his exhibited works suggest that it was at this time and perhaps as a result of the commission to illustrate Roscoe's book that a particular fascination for the area

opposite:

458. William Radclyffe after Thomas Creswick,

Betws-y-coed, from Thomas Roscoe,

Wanderings and Excursions in North Wales,

1836, Engraving, 95 × 142

around Betws-y-coed began to develop. The implications for Welsh visual
art would be considerable. At first, developments at Betws-y-coed proceeded
in isolation from the attempts made by the Eisteddfod movement to develop the
taste for and practice of art in Wales. However, from the late 1860s these parallel
movements merged into a single stream of national development in visual art. The
new landscape painting lay at the heart both of Welsh historicism and the
expression of Nonconformist beliefs through visual art.

The affection of both David Cox and Thomas Roscoe for Betws-y-coed intensified
after their initial contact with the area. In the second edition of *Wanderings and
Excursions in North Wales,* published in 1844, what had been a complimentary
paragraph about the village in the first edition became a eulogistic chapter.
In the same year Cox stayed at Betws-y-coed for an extended period over the
summer, a practice which he maintained in most years until 1856. He gathered
around him at the tiny Royal Oak Inn friends and acolytes such as William Hall,
later to be his biographer. Their pictures and writings created a reputation for
the village which turned it into the first artists' colony in Britain, a Mecca for
professional and amateur painters, and subsequently for vast numbers of tourists.
When Cox first stayed at the village it was largely unspoiled, even though Telford's
post road, completed with the opening of
the uncompromisingly modernist Waterloo
Bridge in 1816, had made it easily accessible
from England: 'it could boast of only one
small shop – a mere cottage, with a little
window, in which a few useful articles were
exposed for sale ... Much Welsh, and a little
English was spoken.'[4] However, Hall later
remembered that as early as 1846, 'During
the sketching season, Bettws, as it became

[1] Sightings of artists in the area, not all of whom
were well behaved, became increasingly common.
In 1819 'Richard Bull' noted: 'On the Road
towards the Falls we passed a Pedestrian, dressed
in a Straw Hat of large Dimensions, Blue Great
Coat, White Waistcoat, dark blue Cravat, light
Trowsers, and thick Shoes with a Knapsack on
his back and a Staff in his hand, on his way to
the Falls; he was within half a mile of the first,
and being about to take a wrong Road, a Person,
whose cottage he had just passed, civilly directed
him, and was desired by this Oxonian (for so he
turned out to be) "to mind his own Business".'
For the development of the Conwy valley and
Betws-y-coed as centres for artists, see Lord,
Clarence Whaite and the Welsh Art World.

[2] At the first exhibition of the Society of Painters
in Water Colours there were fifty-two views of
Wales compared with ten of Scotland, nineteen
of Yorkshire and only a single view of the Lake
District. The fact that the great majority of the
Welsh views were of Snowdonia reflected the
importance of the area in the development of
English watercolour painting in the period.

[3] This seems to be the earliest exhibited view of
the bridge which later became a tourist icon. The
picture is lost. At the time of the exhibition Hughes
was engraving for one of the most famous English
watercolourists of the period, John Glover. He
was Treasurer of the RSBA and may well have
encouraged Hughes to exhibit.

[4] William Hall, *A Biography of David Cox* (London,
1881), p. 91.

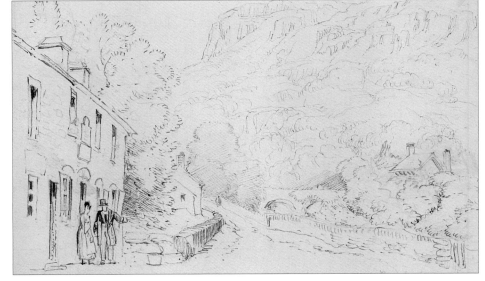

459. David Cox,

The Royal Oak Inn, c.1850,

Pencil, 168 × 271

[5] Ibid., p. 85.

[6] N. Neal Solly, *Memoir of the Life of David Cox* (London, 1873), p. 172.

[7] NLW DV17. Wightwick (1802–72) was born near Mold, educated in England and articled to a London architect. He subsequently developed his own practice in Plymouth before retiring to Clifton, where he died.

better known, was often filled to overflowing with amateurs and artists. Their white tents and umbrellas, to be seen in whichever direction the eye turned, suggested to the visitor the encampment of an invading army.'[5]

For all his love of remote mountain scenery, Cox was also a sociable man, who enjoyed his developing role as a father figure and teacher to a younger generation of painters. His circle, centred on the Royal Oak, was described by the painter George Popkin:

> In the evening he sat on the sofa in the parlour of the Royal Oak inn, which in those days was an artist's club *pur et simple*. Here he took his cigar (he smoked no pipe) and his pint of ale, with one or two cronies by his side, willing to listen and willing to teach. There was no racket, no shouting, no fastness or slang; it was an intelligent, rational, pleasant evening's amusement, and I have heard French, German, Hungarian, English, and Welsh flowing on like a polyglot stream at the same time in that same dingy parlour.[6]

Popkin was one of several painters who had taken up residence at Betws-y-coed all the year round shortly before Cox's first extended stay in 1844. He was a gentleman painter (of Welsh descent) with the means to build a substantial house to the east of the village in a style whose steep-pitched roof and deep

460. David Cox,

Capel Curig, Caernarvonshire,

c.1845, Watercolour,

318 × 527

eaves helped to set an 'alpine' pattern for the area. His fellow resident, Richard
Bond, lived in a more traditional residence, drawn and described in glowing
terms by the architect George Wightwick:

> 'Love in a cottage' is a proverbial sentiment; and I trust it is here a practical fact.
> Here lives the … 'Landscape Painter', with the finest woman I ever saw in Wales
> for a wife, and three children, 'beautiful exceedingly'. The lady brought me out
> a chair, wheron to sit and take these views. The gentleman fed me with oat-
> meal cakes, rendered delectable by butter, and facilitated by Whiskey. The
> Lady is of the blood of Glendower,
> 'serene, imperial'. The gentleman
> is an Englishman, blessed in his wife
> at all events; though I opine, rather
> content with his fate, than favoured
> by Fortune, in respect of what *should*
> be the monied estimate of his skill
> and feeling as an artist.[7]

461. George Wightwick,
View of an Artist's House
(Wern Fawr, Betws-y-coed),
1856, Pen and wash, 110 × 170

Bond lived at Wern Fawr for the rest of his
life, earning a modest living as a painter, but
the most artistically distinguished of the
early residents was William Evans, born in
Bristol of Welsh parentage. Evans visited
Wales in 1842 with another Bristol painter,
William Müller, and settled soon after at
Ty'n-y-cae, a rat-infested hovel between
Bond's house and the Fairy Glen, one of
the sites which appealed most to painters.
His life in this damp, unsanitary and
'Cyclopean' cottage accelerated the
tuberculosis which killed him in 1858,
but it also resulted in some of the most
lyrical watercolours of the period. Of all
the early residents of Betws-y-coed, his
talent was the most widely appreciated.
He was 'felicitous in grappling with the
true characteristics of the torrents that
stir the gloom of these dreary regions',
and also in his portrayal of the life of
the common people:

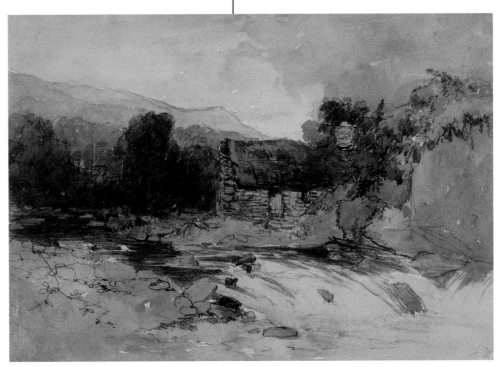

462. William Evans,
*Cottage near Betws-y-coed, c.*1844,
Watercolour, 177 × 254

464. Joshua Cristall,
Young Woman Drawing Water,
1842, Watercolour,
511 × 340

Nothing can be imagined much finer than his occasional treatment of the cottage scenery of the same district; and not limited to the exteriors, but frequently furnished by the views of their interiors, which rival, in force, colour, and light and shade, some of the finest works by the great Dutch masters.[8]

The attraction of the Betws-y-coed area to Roscoe, Cox and the early resident painters was the result of a combination of factors. It offered a wide variety of scenery, from uplands with extensive views of Snowdon and Moel Siabod to deeply-cut river valleys and waterfalls. The purported site of the massacre of the bards by Edward I and the possible birthplace of Llywelyn ap Iorwerth at Dolwyddelan added mythological and historical associations. Furthermore, the local people provided particularly good subject matter for Cox and his contemporaries. By the 1830s the attitude of painters to the Welsh people had evolved significantly from that of the late eighteenth-century visitors, who had often projected onto them an image of pagan primitivism, which complemented their search for the sublime in the landscape. Against a background of great social unrest, reassuring images of loyal and pious peasants, such as those which had made George Moreland famous, now sold best on the English art market. Such subjects with a Welsh or Irish context held the additional attraction of 'national character' for an audience increasingly interested in the idea of ethnicity, as Lady Llanover's national costume and Carnhuanawc's interest in Breton culture demonstrated inside Wales. Portrayals of the Welsh folk helped to sustain the careers of several regular visitors to Betws-y-coed, such as Alfred D. Fripp and Frank Topham, who sometimes travelled on to Ireland through the port of Holyhead to paint similar subject matter. Portraits of Welsh peasants, especially of attractive young women, peppered the exhibitions of the period.

[8] Anon., 'Mr. William Evans', *The Art Journal*, 11 (1859), 136.

465. David Cox,
The Welsh Funeral, 1848,
Oil, 464 × 711

However, the depth of David Cox's sympathy with the common people was
unusual. Cox was a provincial rather than a metropolitan Englishman, from a
middle-class tradesman's background and unpretentious by nature. Furthermore,
he was a devout Nonconformist. His perception was of a folk closely in touch with
nature in which he saw the beauty of an ordered and harmonious creation, not a
chaotic and alien one. He believed that the piety of the people, whether they were
Anglicans or Nonconformists, was related to that harmony, and the affinity he
felt with them was expressed both in his unassuming attitudes to the individuals
with whom he dealt. In 1848 he painted the first version of *The Welsh Funeral*,
a picture which epitomized the pietistic aspect of his vision and which achieved
great celebrity after its reproduction in engraved form in 1862. That a picture
which did so much to spread a positive perception of the common people of
Wales among the English was painted at a time when the Blue Books had
presented a quite contrary image is a remarkable paradox.

466. Henry Clarence Whaite,
Rain, Tyddyn Cynal, 1872,
Watercolour, 182 × 269

467. Unknown photographer,
Henry Clarence Whaite, 1863

468. Henry Clarence Whaite,
Hauling Driftwood, 1853, Oil, size unknown

Among the many young English painters drawn to Betws-y-coed by the presence of Cox and his circle was Henry Clarence Whaite, the son of the owner of a successful banner-painting and picture-framing business in Manchester. Whaite probably came to Wales for the first time in 1849, and returned two years later, when he noted in his diary that there were ten artists, including Cox, at work in Betws-y-coed. In 1852 he recorded his excitement at being, once again, in the Welsh mountain landscape: 'How its grandeur overpowers me', he confided to his diary, 'if I could paint the extent of my feelings.' Shortly afterwards he met Cox, who called to see his drawings, 'and expressed his delight'.[9] In the light of subsequent events this meeting assumes great symbolic importance. Of the hundreds of painters who had visited Wales to paint mountain scenery during the previous century, few had taken up permanent residence,[10] but Clarence Whaite – though he did not know it in 1852 – had come to stay. He would become the leading figure among a generation of immigrant painters whose presence would have far-reaching implications for Welsh visual culture. The meeting of Cox and Whaite was symbolic of a seminal change.

469. Henry Clarence Whaite,
Pages from a sketchbook, 1870,
Watercolour and pencil,
84 × 127

Whaite would travel to work in England, Scotland and
Italy, but it was Wales that held him. In the 1850s he
began to produce small and vibrant watercolour drawings
recording the mood of the upland landscape as the weather
and the seasons evolved. His fluid technique gave these
studies an appearance of generality which is misleading.
They were, in fact, specific records of particular moments
in the continually changing natural world. Similarly, he
recorded in an increasingly characteristic notational style
the collective activities of the rural communities – fairs
and markets, harvests, sheep shearing, gathering shellfish –
since they, too, followed the seasonal pattern. Most of these
drawings were done for their own sake, but some directly
informed large-scale exhibition paintings such as *Hauling
Driftwood*, painted in 1853. These were exhibited regularly
at the Royal Academy in London where, in 1859, Whaite
was noticed by the greatest art critic of the period, John
Ruskin. Writing of *The Barley Harvest*, Ruskin said:

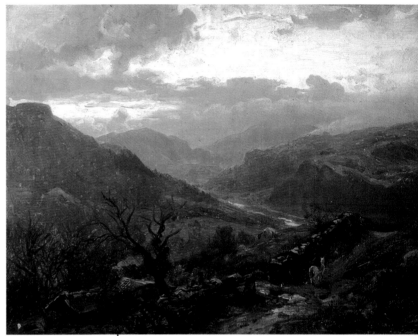

470. Hans Fredrik Gude,
Highland in Wales, 1862–4,
Oil, 335 × 460

> Very exquisite in nearly every respect; perhaps, take it all in all, the most
> covetable bit of landscape of this year, and showing good promise, it seems to me,
> if the painter does not overwork himself needlessly. The execution of the whole
> by minute and similar touches is a mistake ... Nothing finished can be done
> without labour; but a picture can hardly be more injured than by the quantity
> of labour in it which is lost. Uncontributive toil is one of the forms of ruin.[11]

Ruskin's comments on Whaite's technique reflected an important debate in
English critical circles about whether nature should be represented with minute
attention to detail and high finish, even in large canvases, or by broader statements
of mood. The Pre-Raphaelites championed faithfulness to nature in every detail
and Whaite was broadly in accord with their attitude. In 1860 he became a member
of the Hogarth Club, which had been founded two years earlier by Dante Gabriel
Rossetti, Ford Madox Brown and William Morris. G. F. Watts, to whom Whaite
probably felt closest, joined soon afterwards. David Cox, who, especially in his
later years, had favoured a broader approach, died in 1859, and notwithstanding
the warnings issued by Ruskin against excessive attention to detail, the new attitude
to landscape came to dominate the London and regional English exhibitions.

Almost all of the new generation of landscape painters came to Betws-y-coed to
work in the open air; they came not only from England but also from the Continent.
In 1862 the Norwegian painter Hans Fredrik Gude came to stay for two years 'with
his wife and their five beautiful Norse children'. At Betws-y-coed he was able to
work out of doors all year round and develop his ideas on fidelity to nature.[12]
Among the many English landscape painters of Gude's generation, the most
closely identified with Betws-y-coed was Benjamin Williams Leader, who had

[9] The diary of Clarence Whaite, private archive.
The information that Whaite had visited Wales
in 1849, two years earlier than the date suggested
in Lord, *Clarence Whaite and the Welsh Art World*,
p. 12, is given in the *North Wales Weekly News*,
7 and 14 June 1912.

[10] Cox had attempted to buy a property in the
Conwy valley in 1845 but the plan failed. See Lord,
Clarence Whaite and the Welsh Art World, p. 47.

[11] John Ruskin, 'Academy Notes, 1859', *The Works
of John Ruskin*, ed. by E. T. Cook and Alexander
Wedderburn (39 vols., London, 1903–12), XIV,
pp. 229–30.

[12] Henry Holiday, *Reminiscences of My Life*
(London, 1914), p. 87. Gude was excluded by
the Royal Academy and moved to Karlsruhe as
Professor of Landscape Painting. He gained a
reputation as the most distinguished Norwegian
painter of his time.

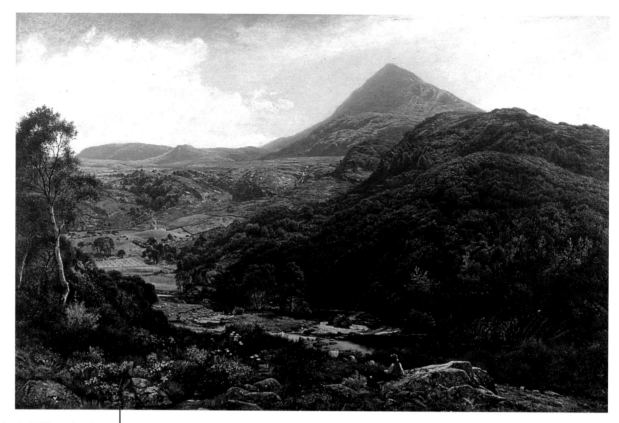

471. Benjamin Williams Leader,
*A Quiet Valley amongst the Welsh
Hills*, 1860, Oil, 710 × 1085

13 NLW, Whaite archive, letter to G. H. Walker,
23 March 1894.

14 Ruth Wood, *Benjamin Williams Leader RA
1831–1923: His Life and Paintings* (Suffolk, 1998),
p. 37. The island in the river Llugwy is common
to both pictures, but Whaite looked in a more
westerly direction, ignoring the massive form of
Moel Siabod, which formed the centre of
Leader's composition.

15 *A Leaf from the Book of Nature* was painted
c.1860, probably in the same area as *The Rainbow*
and Leader's *A Quiet Valley amongst the Welsh Hills*.

been born Benjamin Williams and was of Welsh descent. He stayed at the
Royal Oak for the first time in 1859. Like Gude and Whaite, he worked in the
open air and at Betws-y-coed he found the elements of the minute and luminous
style which would eventually elevate him to high status in the Victorian art world.
A Quiet Valley amongst the Welsh Hills, exhibited in 1860, was painted from the old,
abandoned road from Betws-y-coed to Capel Curig, a favourite location for painters.
Whaite, who had been painting in that vicinity for some time, began an even more
determined bid for fidelity to nature during the same year by having a temporary
studio erected above the old road, but a little nearer Betws-y-coed. *The Rainbow*,
a huge canvas, took two seasons to complete, during the second of which Whaite
noted in his diary that he 'remained all winter there to set the detail for the spring
foliage'.[13] Among the visitors to his mountain studio was Leader, who noted in
his own diary for 1865 – in the same spirit of truth to nature – his frustration at
not being able to 'paint the elm trees from Nature' for his *Autumn's Last Gleam*
because of severe weather.[14] Nevertheless, Whaite was far more radical than Leader
in his methods. He had read M. E. Chevreul's *The Laws of Contrast of Colour:
And Their Application to the Arts*, published in English in 1860, a book which
was to have a considerable impact on French painting. Its influence on Whaite's
method of building up his overall effects from tiny fragments of pure colour,
foreshadowing the work of Seurat, is clear.

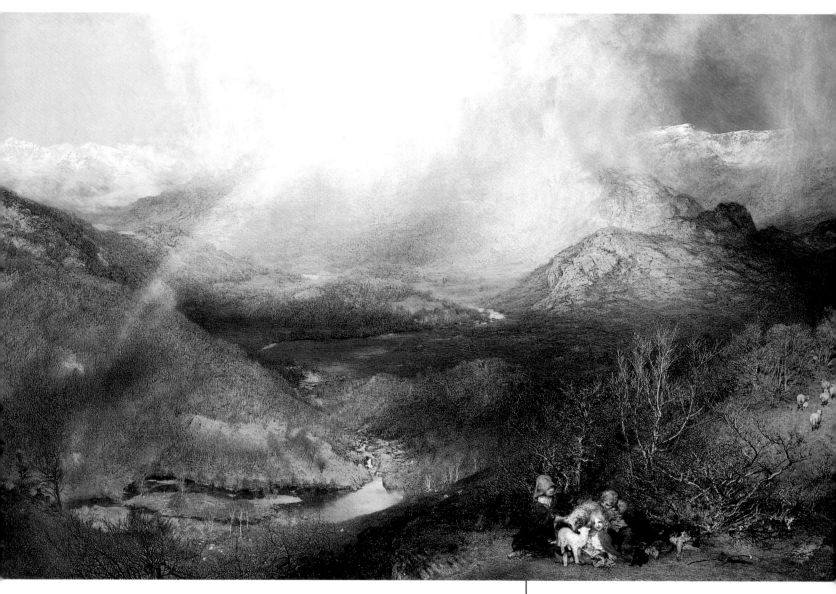

472. Henry Clarence Whaite,
The Rainbow, 1862, Oil,
1394 x 2146

Whaite's passion for the faithful recording of the details of the
natural world, and of the human activities which harmonized with
it, was closely related to his Protestantism. The title of a lost work,
A Leaf from the Book of Nature, gives a clue to his attitude.[15] This
was not topographical painting nor painting according to Picturesque
theory, and it was even further from being an expression of the angst
of the sublime. The lesson to be read in the *Book of Nature* was that
which Cox had taught about the deep rationality and order of God's
creation. The contemplation of nature, from the grandeur of its huge
scale to the precision of its smallest detail, brought the observer
close to God. To depart from nature, or fail to observe it with
sufficient intensity, was, therefore, unethical. In *The Rainbow*
Whaite introduced into the meticulously-recorded landscape
two additional elements – the rainbow itself, based on detailed

473.
Henry Clarence
Whaite, *The Rainbow*,
detail, 1862, Oil

289

474. Benjamin Williams Leader,
A Welsh Churchyard, 1863,
Oil, 815 x 1475

[16] The development of *The Penitent's Vision* is complex. In his diary Whaite suggests that 'the old ballads' provided the original theme, but having laid the painting aside for some years he reworked it on a theme from *The Pilgrim's Progress*. The subsequent history of the painting was equally complex. It was rejected by the Royal Academy in 1865, and was cut into four smaller pictures. The larger two, renamed *The Awakening of Christian* and *The Shepherd's Dream* (into which the figure of a shepherd was introduced) were accepted by the Academy and shown in 1884.

[17] *Manchester Examiner and Times*, 3 April 1865.

[18] J. Dafforne, 'British Artists: Their Style and Character with Engraved Illustrations. No. XCVII, Benjamin Williams Leader', *The Art Journal*, 33 (1871), 46. Creswick's *The Church at Bettws y Coed* depicts the new church constructed to meet the needs of English visitors.

[19] The mythology which developed around the picture held that the figure of the old man was a self-portrait of the artist. Cox's *The Welsh Funeral* achieved iconic status for a time, but was ultimately supplanted by Curnow Vosper's *Salem*, in which related themes were exploited.

[20] *The Courier*, 1 April 1865.

observations recorded in small drawings, and the group of children with their mother and a lamb. These were perfectly plausible in a naturalistic sense and so did not depart from truth, though their allegorical overtones clearly took them beyond simple observation. Unlike Leader, Whaite was inclined to point up the moral content of landscape. At about the same time as he conceived *The Rainbow*, he began developing an idea for another work, *The Penitent's Vision*, in which he carried the allegorical elements a stage further into overt Christian mysticism.[16] The painting combined truth to observed nature with an overlaid visualization of the mystical experience of the Christian penitent. This extension of moral content displeased some critics, who regarded it as being 'in somewhat questionable taste', since 'Now-a-days, most people prefer landscape pure and simple'.[17]

Nevertheless, Christian sentiment was a central theme of much Welsh art work in this period. Following the reproduction of Cox's *The Welsh Funeral* as an engraving, a genre of Welsh funereal scenes emerged. Thomas Creswick's *The Church at Bettws y Coed*, like Cox's image, became widely distributed following its reproduction in *The Art Journal* for 1870 as an engraving. Contributions from a younger generation of painters began with Leader's *A Welsh Churchyard*, exhibited in 1863, in which 'almost black yew-trees stand ... "like mourners watching over the tombs"'.[18] This picture was immediately stamped with establishment approval when it was purchased by W. E. Gladstone, the Chancellor of the Exchequer. Clarence Whaite, never among the greatest aficionados of the village of Betws-y-coed, sought his subjects elsewhere, beginning in 1865 with large and small versions of *God's Acre*. The central figures seen emerging from Llanrhychwyn churchyard are an old woman supported by a young girl, set against the ancient yew trees and stone walls of the building – a common allegory of individual transience. The picture was close in conception to Cox's *The Welsh Funeral*, which contrasted the ancient yews of the churchyard with the death of a young woman whose funeral cortège was followed by an old man.[19] *To the Cold Earth*, also painted by Whaite in 1865, set Cox's idea in a mountain landscape, and its title, once out of the artist's hands, soon became the ubiquitous 'Welsh Funeral', underlining the strength of the public perception of the association between piety and Welshness in the Victorian era:

> The subject is a Welsh funeral. The grim messenger knocks at the cottage of the lithe and hardy Cambrian mountaineer, as surely though less frequently perhaps, as at the cellar of the pale denizens of the courts and alleys of crowded cities. When a funeral occurs among these primitive people the scattered villagers for miles around assemble to pay their last token of respect to the departed. Mr. Whaite has depicted the funeral procession passing over the windings of the snow-clad mountains to the village churchyard. The idea is exceedingly poetical and is well worked out, the mist and snow of the mountain tops being well executed.[20]

475.
Henry Clarence Whaite,
God's Acre (small version),
1865, Oil, 197 × 324

476. Henry Clarence Whaite,
To the Cold Earth, 1865,
Oil, 463 × 832

477.
Henry Clarence Whaite,
The Penitent's Vision,
1865, Oil, 1000 × 1470

478. Unknown photographer,
Evan Williams, c.1875

Whaite may have reacted with some ambivalence to such an extreme outsider perception of his picture, since by this time he had spent much of the previous fifteen years in close touch with Welsh people. Nevertheless, the extent to which that contact included Welsh artists and intellectuals is unclear. There seems to have been little interaction between the Betws-y-coed painters and the London-based Welsh intelligentsia in their attempt to create an art world through the medium of the Eisteddfod movement. The only Welsh painter known to have had contact with the Betws-y-coed circle was the young Ap Caledfryn, who had seen Cox at work in the early 1850s and who subsequently trained in the village under Richard Bond. However, in 1867 Evan Williams published his essay 'Natur a Chelfyddyd' (Nature and Art), which included an intriguing reference to spending time with 'one of the most talented English painters (as a landscapist) in the Welsh mountains, where he has stayed every summer for years'.[21] Regrettably, Williams did not name the painter, but the arguments he made in his essay were in general accord with the views of Clarence Whaite. Williams believed that the main function of the fine arts was 'the rational pleasure they give to the mind, and their influence to elevate it and instruct it through the truths and beauties of nature'.[22] The artist was to be the leader 'of all who wished to be introduced into the presence of nature in all her forms and glorious effects, which were undoubtedly intended to add to the pleasures of life, and to elevate the mind to its Creator'.[23]

Nevertheless, Williams made a distinction, sometimes difficult to grasp in terms of its practical implications, between the requirement to record nature faithfully and slavish copying, on the grounds that copying denied the poetic spirit of the true art work. The effects of nature – those combinations of light and atmosphere which gave rise in the observer to human sentiments – were as important as correctness in the rendering of forms and structures. The generation of sentiment through landscape was of crucial importance to Williams since he believed that it related in a particular way to Wales. The view that a poetic spirit was a definitive characteristic of the Welsh people, manifested in the literary tradition and with its mysterious source in the relationship between race and homeland, became commonplace by the end of the century:

> This quick sensibility accounts for the susceptibility of the Celtic temperament to its natural environment. The scenery of our land has played a large share in our sympathetic development as a race … But we love to do our thinking by means of concrete symbols rather than in abstractions and cannot go far without the aid of illustrations. Thus we love Nature rather than pictures; and so we have few great artists, and those we have are mainly landscape artists.[24]

[21] Evan Williams, 'Natur a Chelfyddyd', *Y Traethodydd*, XXII (1867), 37, translated from the Welsh.

[22] Idem, 'Sefyllfa Celfyddyd yn Mhrydain', *Y Traethodydd*, XX (1865), 426, translated from the Welsh.

[23] Idem, 'Natur a Chelfyddyd', 39, translated from the Welsh.

[24] E. Griffith Jones, 'The Celtic Genius', *The Welsh Review*, I (1906), 30.

479. Anon.,
The Gallery of Modern Painters.
Art Treasures Exhibition, Manchester,
1857, Wood engraving from
The Illustrated London News,
210 × 340

Evan Williams and later critics sought to link the special relationship of national character and the new landscape aesthetics with the other definitive characteristic of nineteenth-century Welshness, Nonconformity. Establishing this link was not difficult since the requirement to be both poetic and rational echoed precisely the definitive characteristics of his religious beliefs. Williams's brand of Methodism preached rationality despite the fact that at its heart lay an inner revelation of God which transcended the mind. It was possible to argue, therefore, that landscape art – whenever it manifested this combination of the rational and the poetic – was essentially Welsh. The work of Richard Wilson could be interpreted, with fortuitous patriotic overtones, as giving credence to Williams's aesthetics. The true poetic spirit was not to be identified with the unbridled Romanticism of the English Turner, who, in Williams's opinion, was irrational and self-centred, rather than rational and therefore God-centred. Wilson, on the other hand, exemplified rational expression informed by deeply-felt spiritual content. In his review of the 1857 Art Treasures Exhibition in Manchester, Williams remarked of the landscape painters that Wilson was 'without doubt the best of them of every age and through all parts of the world'.[25] The patriotic significance of this remark must be judged in the contemporary context of the elevation by many English critics of the recently-deceased Turner to almost mythic status as the world's greatest painter.

Superficially, at least, Williams was at variance with Whaite in one respect. The Pre-Raphaelites, admired by Whaite, were condemned by the Welsh critic, but more for their love of the middle ages than for their mechanistic reproduction of the details of the natural world. Williams believed that their medievalism linked them to pre-Reformation Christianity and to its modern revival in the form of the Anglo-Catholic movement. He regarded 'the style of Mr Hunt and his friend Mr Maddox Brown as completely and fundamentally astray, as well as all those who follow them', and he associated them with 'the Puseyite tendency in religion in England'.[26] This argument, too, had strong patriotic overtones since the anti-Roman animus so deeply embedded in most Welsh Nonconformists was closely identified by them with the essence of the nation. With his Protestant aesthetic of ordered spirituality, focused on God's handiwork in nature, Evan Williams was moving towards a philosophy of art with a distinctive Welsh quality, based on parallels at several levels with Nonconformist theology, which would lay the foundations for the nationalist critique of the early twentieth century.

[25] Evan Williams, 'Arddangosiad Trysorau Celfyddyd', *Y Traethodydd*, XIII (1857), 336, translated from the Welsh.

[26] Idem, 'Sefyllfa Celfyddyd yn Mhrydain', 429–30. Williams had similarly hinted at his anti-Catholic animus in his comments on the Manchester Art Treasures Exhibition. He took exception to anything with Catholic overtones and waxed lyrical about those works which struck him as politically correct for the Welsh visitor: 'There is the Elector of Saxony, Luther and the reformers, by Lucas Cranach, a picture of great interest, to us at any rate.' Williams, 'Arddangosiad Trysorau Celfyddyd', 334, translated from the Welsh.

During the 1860s the fame of Betws-y-coed spread far and wide, and as a result both the physical appearance of the place and the nature of the artists' colony changed dramatically. Older aficionados, who remembered it in the days of David Cox, were appalled by the spate of building, which included houses, hotels, a new church for English tourists and a large and prominent chapel for the increased local population. In 1861 the Royal Oak was rebuilt for the first time, and in 1868 the railway arrived:

> at the back of the old church, near the side of the 'sweet-flowing' river Conway, the visitor may behold in all its ugliness an unsightly gasometer, placed there for the very desirable purpose of lighting 'dear old Bettws' with gas! The railway station with its shrieking engines and multitudinous noises, almost abuts upon the wall of the old churchyard ... and a wide thoroughfare now conducts the traveller to the railway platform, near the very spot, and almost over the very ground, where of old might have been seen, on a Sabbath morning, groups of pious villagers wending their way, in twos and threes, to that sacred fabric where for generations their forefathers had assembled to offer up their prayers.[27]

The vigorous (and at times boisterous) social life which now flourished throughout the year brought greater numbers of artists to the Royal Oak, most of whom 'were not attractive specimens', in the opinion of the rather prim Pre-Raphaelite, Henry Holiday.[28] The scene centred on young resident painters such as James Whittaker, whose success enabled him to rebuild the cottage Castell Pwt as 'Ffridd Castle', with an ostentatious tower topped by a steeple. Whittaker, a Manchester-born painter, had been encouraged by Frank Topham and he became an Associate of the Society of Painters in Water Colours in 1862. He was well-known to Clarence Whaite, who disclosed in his letters that by the early 1860s Whittaker already had the serious alcohol problem which would eventually kill him.[29] Whittaker was a central figure in the social life of the rebuilt Royal Oak, where a drinking club of residents known as the Loyal Incorporation of Artists met regularly and enrolled visitors, including such notables as Benjamin Williams Leader and John Syer. They inscribed anti-tourist doggerel in the pages of the visitors' book:

480. *Ffridd Castle, Betws-y-coed, home of James Whittaker*

481. James Whittaker,
Mountain Stream, North Wales,
1873, Watercolour, 355 × 650

God save thee British tourist
From Leader, Talfourd, Leche
Should you again to Bettws come
Within their vengeful reach.

British tourists were disparagingly referred to by the painter Thomas Collier as 'BTs'. The artists had become the victims of their own success in publicizing Betws-y-coed and some of the older devotees, including Collier (who had been among Cox's circle), ceased to come. Among the residents, Richard Bond stayed on at Wern Fawr, and George Harrison, who had arrived as a young romantic from Kent and married the blacksmith's daughter, lived at Tŷ Gwyn by Waterloo Bridge. A group of painters, including Edwin Alfred Pettit, occupied a row of houses to the east of the river, overlooking the village and the Llugwy valley. However, a general drift north moved the centre of the colony to Trefriw, which stood on the west side of the river, unafflicted by the railway, and which could be approached by road or by paddle steamer from the quay in Conwy. Like Harrison, Clarence Whaite married a local woman, and in about 1870 set up home at Tyddyn Cynal, between Trefriw and Conwy.

[27] Hall, *A Biography of David Cox*, p. 92. Hall's 'dear old Bettws' is a quote from Cox, and the reference to the church is, of course, intended to bring to mind *The Welsh Funeral*. While Hall's despair at the new building in Betws-y-coed is understandable, historical perspective reveals that the English church, designed to reflect the mountain scenery, was among the best buildings of its type in Wales. Like many other Anglican churches built in Wales in the period (mainly in an attempt to stem the tide of Nonconformity), its fittings were also of high quality. At Betws-y-coed the glass was designed by Edward Coley Burne-Jones (1833–98), who was considered by many patriots in the period to be a Welsh artist. Burne-Jones was born in Birmingham, the son of a carver and gilder of Welsh descent.

[28] Holiday, *Reminiscences of My Life*, p. 79. Holiday here refers to his experience at the Royal Oak in 1861.

[29] Whittaker was found dead in the river Llugwy in 1876, having fallen in while apparently under the influence of drink.

482. George Harrison,
Fisherman at Betws-y-coed, 1869,
Watercolour, 240 × 332

483. Unknown photographer,
*George and Catrin Harrison in
the studio at Tŷ Gwyn, c.1865*

484. Edwin Alfred Pettit,
Llyn Idwal, North Wales,
1876, Oil, 762 × 1016

Members of this regrouped colony began to make contact with Welsh intellectuals and artists. At the 1869 Bangor art exhibition, the last manifestation of the efforts of the Eisteddfod reformers of the 1860s, works by English-born painters such as George Wells and Joseph Charles Reed were shown alongside the works of William Roos, John Cambrian Rowland and Evan Williams. Two years later, the painter Charles Mansel Lewis of Stradey Castle, Llanelli, recorded in his diary that he had spent a day sketching with Wells and inspecting Whittaker's pictures. In 1872 the newspaper publicity for the local Nant Conwy Eisteddfod noted that Betws-y-coed was 'the Artist's home and the paradise of Wales', and the adjudication of the painting competition was carried out by Randal Leche, the leading light of the Loyal Incorporation of Artists. The winning picture was painted by William Dean Barker, a Trefriw-based painter, who, as a result of his success, was initiated into the Gorsedd under the name Arlunydd Glan Conwy. Although the art competitions

in the National Eisteddfod during the 1870s were often pitiful affairs, the
same kind of interactions became apparent. The painter William Laurence
Banks won a prize at Bangor in 1874, and by 1877 was himself an adjudicator
at Caernarfon. He awarded the watercolour prize to Samuel Maurice Jones, the
first fruit of the state art education system in Wales. Jones had begun his training
under John Cambrian Rowland at the Caernarfon school.[30] At Conwy National
Eisteddfod in 1879 Clarence Whaite was the adjudicator, the first of many such
occasions. Three years later, at Denbigh, the entries were adjudicated by a rising
star of the English art world, the German-born painter Hubert Herkomer.
Cornwallis West, still struggling to improve standards, was probably the

486. Unknown photographer,
William Dean Barker, c.1880

485. William Dean Barker,
A Lake in North Wales, 1875,
Watercolour, 134 x 219

immediate cause of Herkomer's visit to Denbigh, although the fact that
Herkomer's second and third wives were both from Ruthin may have played
a part in his acceptance of the invitation. Charles Mansel Lewis had forged the
initial link between Herkomer and Wales since the Llanelli painter was his first
British patron, and the two had become close friends. They embarked on painting
expeditions together, including several trips to Betws-y-coed.

Adjudicating with Herkomer at Denbigh in 1882 was a resident English painter,
Edwin Arthur Norbury. A few months prior to the Eisteddfod, on 12 November
1881, Norbury had convened a meeting of artists at the Llandudno Junction Hotel,
with the intention of establishing an Academy. This step, more than any other,
signified the identification of the immigrant artists not only with one another, but
also with Wales. None of the group of seven who assembled in 1881 had been born
in Wales, though W. L. Banks considered himself Welsh. Three of the others were

[30] Banks (1822–93) was born at Kington, on the
English side of the border. At the Caernarfon
Eisteddfod 'he regretted that a greater number
of pictures had not been sent in for competition,
and greater merit shown than had been. The best
was by Mr Samuel M. Jones, son of the Rev. John
Jones, Rhosllanerchrugog, late of Carnarvon'.
Carnarvon and Denbigh Herald, 25 August 1877.

487. A. Ford Smith,
Royal Cambrian Academicians, c.1882
(Clarence Whaite is the third from
the left in the middle row.)

488. Francis Frith,
Mostyn Street, Llandudno,
c.1870

[31] The seven were Norbury, Banks, John Johnson
of Trefriw, Charles Potter of Tal-y-bont, and
William Meredith, Joshua Anderson Hague
and George Hayes of Manchester.

[32] NLW, Royal Cambrian Academy Art Records,
Minute Books (Book 1), 26 November 1881, p. 3.

[33] Ibid., p. 5.

permanent residents and the remaining three were regular visitors from
Manchester.[31] Of these, George Hayes was a founder member of the Manchester
Academy (along with Clarence Whaite) and so brought with him the experience
of nurturing such an institution. Nevertheless, this was not intended to be a
provincial group. Their prospectus for a Cambrian Academy made it clear
that they had a national perspective:

> The Royal Academy and other institutions of a similar character have
> long been established in England, the Royal Hibernian Academy in Ireland,
> the Scottish Academy in Scotland, but Wales has hitherto felt the want of
> a kindred society of its own.
>
> It has therefore been resolved to establish 'The Cambrian Academy of Art' in
> the hope that such an Institution will give an impetus to the further development
> of Art in connection with the Principality.[32]

No difficulty was experienced in attracting members 'confined to artists resident
in or who have studied in Wales'.[33] The founders included most of the notable
figures in the Conwy valley, such as Arlunydd Glan Conwy and George Harrison,
followed in February 1882 by Clarence Whaite. Samuel Maurice Jones was granted
associate status and so became the first Welsh-born academician. Women, however,

were excluded, despite the presence of several professional women artists in the Conwy valley. Probably as a result of the influence of Prime Minister Gladstone, Queen Victoria granted permission for the appellation Royal to be added to the title of the new institution. In June 1882 the first annual exhibition was opened, showing works by thirty-five artists. Llandudno was chosen as the location since its commercial galleries had for some years provided the centre for art sales in north Wales. The exhibition was mocked by some critics in the Liverpool and Manchester papers, primarily because of the poor accommodation afforded by the gallery of the photographer J. M. Young. These English cities had, of course, purpose-built civic galleries by this time. Ensuing recriminations had the effect of sharpening the focus on the purpose of the Academy, and drew those with large and patriotic aspirations to the fore. In July 1882 Arlunydd Glan Conwy called for unity in the national interest:

> if the members of the Royal Cambrian Academy of Art will work honourably, consistently, and energetically, not selfishly, but with unity and for each other's good and for the welfare of Wales, a grand and noble institution will be eventually formed for the development of art in the Principality.[34]

A week later the first comment on the Academy in the Welsh-language press appeared, revealing that some indigenous artists and critics were determined to make the most of the belated establishment by a group of Englishmen of an institution which they had been airily discussing for over half a century. O. E. Hughes (Crafnant), a neighbour of Arlunydd Glan Conwy in Trefriw, reviewed the present situation in a historical context. He was well informed and had visited Cornwallis West's Art Treasures Exhibition at Wrexham in 1876, at which a great deal of art from Welsh collections had been on public display for the first time. Like Evan Williams, Crafnant saw the progression from Wilson to Cox, and suggested the idea of a developing indigenous tradition by extending that process to Clarence Whaite and Joseph Knight, one of the few later arrivals in the artists' colony to settle in Betws-y-coed rather than at Trefriw. Crafnant noted that these two, strategically located at the top and bottom of the Conwy valley, were 'considered in the first class of artists in this age'.[35] His views were supported by Samuel Maurice Jones, who made it clear for the first time in public that it was not only the intention of the new Academy to establish schools, but to do so in south Wales. By early 1883, reinforced by the presence of Clarence Whaite, the Council of the Academy had initiated contacts with the mayors of Cardiff and Swansea. The minutes of the meeting held on 21 April noted that:

[34] *Carnarvon and Denbigh Herald*, 1 July 1882.

[35] Crafnant's analysis was published in two parts in *Y Genedl Gymreig*, 5 and 12 July 1882.

489. Joseph Knight,
Conwy, 1883, Watercolour,
532 x 450

The Council of the R.C.A. agrees to Cardiff becoming the head quarters of the Academy and that the permanent gallery and schools be established and the annual exhibition held there.[36]

Academies are essentially metropolitan institutions, born out of a concentration of artists and patrons in one place. The peculiarity of Wales, where the only such concentration of artists was to be found in a rural area, had not prevented the founders from recognizing this truth.

[36] NLW, Royal Cambrian Academy Art Records, Minute Books (Book 1), 21 April 1883.

During the second half of the nineteenth century Cardiff emerged as the biggest and most dynamic town in Wales, and the national aspirations of patriots from all over the country tended to focus upon it. Regrettably, the view from inside remained stubbornly parochial, and apart from small groups of intellectuals, few of its inhabitants identified with the Wales beyond the south-eastern coalfield. From about 1870 one such group, high-minded and patriotic, and with particular interests in visual culture, began to crystallize. The Fine Art and Industrial Exhibition of that year marked the first large-scale public venture into the field in Cardiff. Museum provision had been mooted in the town as early as 1858 and three years later a subscription list was formed and a museum opened in temporary rooms. Bequests followed, the most notable of which, in the visual arts, was sculpture by Milo ap Griffith made after the 1870 exhibition. Sculpture was stronger than painting among the Welsh contributions to the exhibition, and included the work of the Thomas brothers of Brecon. Ap Caledfryn showed portraits, among them that of Henry Richard.

Three years before the exhibition the Cardiff Naturalists' Society had been formed. It provided a focus for intellectual discussion in the town over a wider range of subjects than its name suggested, prominent among which were visual culture and antiquities. The society would enjoy a long and illustrious history, and the two individuals who formed the core of the artistic community of the town, namely T. H. Thomas and Edwin Seward, would both become Presidents. Thomas was born in Pontypool in 1839 and his father's comfortable circumstances as Principal of the Baptist Theological College enabled him to attend the Bristol School of Art and ultimately the Royal Academy Schools. In 1863 and 1864 Thomas travelled to Paris and Rome to study, where he met John Gibson and Penry Williams. He subsequently returned to London, which became his base for the following twenty years, during which time he developed a career primarily as an illustrator and a lecturer. However, his contacts with Wales remained very close. He was among the exhibitors at the 1870 exhibition and later in that decade he returned frequently to draw and paint. His father retired to a house in The Walk in Cardiff in 1877, which, on his death three years later, passed to the artist and became a focus of intellectual activity.[37] Edwin Seward was born in Somerset and came to Cardiff in 1870 at the age of sixteen. He studied at the School of Art before beginning a highly successful career as an architect in the office of G. E. Robinson.[38] Seward was a public-spirited man of great energy, who identified himself thoroughly with the national cause of Wales. At about the time that T. H. Thomas returned to Wales, Seward came to prominence by winning the competition to design the

below left:

490. Milo ap Griffith,

Llywelyn Fawr, c.1865,

Marble, 411 × 320

491. Unknown photographer,
T. H. Thomas, c.1890

[37] Thomas had married Ellen Sully in 1866 but she died childless. Subsequently he lived at The Walk with his cousin, Miss David, a figure often mentioned in correspondence to and from the artist, but of whom little is known. Among Thomas's exhibits at the 1870 exhibition was *Girls Leaving Work*, which may have been the picture now known as '*Sackcloth and Ashes*', *Tip Girls leaving Work, South Wales Coal District*, discussed in Lord, *The Visual Culture of Wales: Industrial Society*, pp. 119, 155, 158.

[38] In 1875 Seward entered into partnership with W. P. James and George Thomas. An obituary, giving details of some of his most important buildings, was published in the *Western Mail*, 24 June 1924. For the Cardiff School of Art, see below, note 53.

492. Edwin Seward,
Lisvane House, near Cardiff,
home of the architect, 1898

493. Unknown photographer,
Cardiff Free Library before the
opening with the sculptures
of Reading *and* Rhetoric *by*
W. W. Taylor, 1882 (Edwin Seward
is at the left of the main group.)

494. Unknown photographer,
Fine Art and Industrial Exhibition,
Cardiff, 1881

[39] The landscape painter Vicat Cole was a friend and rival of Benjamin Williams Leader.

[40] For Menelaus, see Lord, *The Visual Culture of Wales: Industrial Society,* pp. 84, 96, 117, 144.

[41] In 1886, given the opportunity by government support for projects to celebrate Queen Victoria's Jubilee the following year, Seward had proposed that Cardiff should sponsor a National Institute to house a number of organizations, including the Royal Cambrian Academy and the Cardiff Naturalists' Society. Notwithstanding the local support of Thomas, Short, and Pyke Thompson, as well as Milo ap Griffith and Charles Jones in London, the project soon fell foul of parochial attitudes in Cardiff. Charles Vachell, the most vociferous representative of a prominent local dynasty, exhibited a particularly unpleasant animus against north Wales, culminating in a public dispute with Seward, which was assiduously reported in the local press. See Lord, *Clarence Whaite and the Welsh Art World,* pp. 133–7.

[42] The first year's programme included lectures by Seward, Thomas, Marks and Charles Jones. The prime movers, Seward and Thomas, expended prodigious energy in the interests of visual culture at this time. In February 1888, for instance, with Thomas in the chair, Seward lectured to the Cardiff Artizans' Technical and Art Association on the subject of 'Art Culture amongst Local Artizans'.

much-delayed Free Library, Museum and Art Gallery, and he soon became a close friend and ally of the artist. The furnishing and decoration of the Free Library building was funded by a second Fine Art and Industrial Exhibition, the organizing committee of which was chaired by Seward himself. It opened its doors to the public in the Drill Hall in 1881. Among other members of the committee were the Cardiff painters B. S. Marks and Richard Short, as well as T. H. Thomas and Frederick Wedmore, art critic of the *London Standard*. There were further donations to the Cardiff collection, the most notable of which was reckoned to be E. J. Reed's gift of Vicat Cole's *Noon in the Surrey Hills*,[39] though its individual importance was soon overtaken by the bequest of the collection of William Menelaus, on his death in 1882.[40]

The organizing group of the art section of the 1881 exhibition were soon at work again as a result of the visit of the National Eisteddfod to Cardiff in 1883. T. H. Thomas was the inspiration behind the largest competitive exhibition of art and craft ever assembled in Wales, shown in the unlikely location of the locomotive sheds of the Taff Vale Railway. The adjudicators were Lawrence Alma-Tadema and Wedmore, and the winner, perhaps unsurprisingly, given his association with the organizer and one of the adjudicators, was Milo ap Griffith. The exhibition also marked the first public success of Edgar Thomas, a young painter who so impressed the adjudicators that the Marquess of Bute was persuaded to sponsor his further art education. He went to London to work with Alma-Tadema before going on to study in Antwerp and Paris.

The confidence of the group which had
organized the 1881 and 1883 Cardiff
exhibitions may have exercised a strong
influence in expanding the original aspiration
of the Royal Cambrian Academy for a winter
gallery in Cardiff into the establishment of
a permanent headquarters there. National
aspirations for art institutions in Cardiff
certainly dominated the thinking of Seward
and Thomas from this point onwards. Large-
scale exhibitions were organized in 1884 and
1885 in order to raise money for the new
Academy headquarters. The second exhibition
in particular, held at the University College
of South Wales, was a notable affair in which
most of the Academicians participated,
supported by contributions from distinguished
English artists led by G. F. Watts, who showed
The Daughter of Herodias. The Academy was
sufficiently confident of success to appoint
its first honorary lecturers for the new
schools, including, most notably, James Pyke
Thompson, a rich collector of pictures who
would exercise an increasingly important
influence on developments in Cardiff.

Although it proved a success with the critics,
the 1885 exhibition, like its predecessor, was
a financial failure and ended in an unpleasant
dispute with the University College. As a
result, the Academy, although it retained a theoretical aspiration to locate in
Cardiff, signalled its retirement from the fray by establishing itself at Plas Mawr
in Conwy, where it remained for over a century. Seward struggled on until 1888
with his forlorn attempts to establish a national institution in the town, but by that
time the Academy had been sidelined as the basis for such a project.[41] Perhaps as a
consequence, Seward, Thomas, Pyke Thompson, J. A. Sant, Parker Hagarty and
others came together in the same year to form the South Wales Art Society, whose
activities included an annual exhibition, a sketching club and a lecture programme.[42]
Mischief-makers periodically sought to suggest that the new group and the Academy
were rivals, but in fact there was a degree of interaction between them and little

495. George Frederick Watts,
The Daughter of Herodias,
c.1870–80, Oil, 1092 × 838

496. J. M. Staniforth after Edwin Seward,
*Membership Certificate for the South Wales
Art Society belonging to H. Clarence Whaite,*
1888, Lithograph, 247 × 167

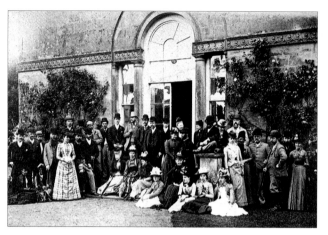

497. Unknown photographer,
The South Wales Art Society,
*c.*1890

498. Edwin Seward, *Pavilion for the Fine
Art and Industrial Exhibition, Cardiff,* 1896

animosity. Many Academicians
based in the north, including George
Harrison and Leonard Hughes, were
founder members. Clarence Whaite,
in particular, made the effort to show
regularly with the group.

Having rid itself of the unwelcome approaches of the Royal Cambrian Academy,
Cardiff turned its attention once again to the provision of a larger local art gallery
and museum, with Charles Vachell, chief castigator of the Academy project, assuming
a leading role from his position as a member of the town council. Facilitated by
an Act of Parliament in 1891, which permitted the raising of a local rate for such
a purpose, it was decided to proceed. However, Cardiff's dominant economic
position in the country meant that from the beginning it seemed obvious to many
people that the new building should become the home of a national collection.[43] A
crucial event in moving the local scheme in that direction occurred at the National
Eisteddfod at Pontypridd in 1893, where private discussions on the potential for
developing the Cardiff proposal into a National Museum found a public platform.
Under the chairmanship of Seward, a paper written by Brynmor Jones was read
to the Cymmrodorion Section by Vincent Evans, a close friend of T. H. Thomas.
The concept of a National Museum (including, at this stage, a National Library)
was promoted both in the interests of raising the horizons of the common people
and for its symbolic and spiritual role in defining the nation. Jones believed that
it was essential that the people of Wales be given equal opportunities to those
of England and Scotland:

> We should thereby advance another step in that forward movement which
> had for its objective the conversion of Wales from a mere aggregate of counties
> into a province of the British Empire, having an active and conscious national
> unity of its own.[44]

[43] In 1892 Alfred Thomas moved a National
Institutions (Wales) Bill in the House of Commons,
which was intended to take advantage of the Act
of the previous year.

[44] *Western Mail,* 1 August 1893. Among others
present at the meeting were Pencerdd Gwalia,
who formed a direct link with the Eisteddfod
campaigners of the 1860s. As far as the exhibition
of visual art was concerned, Brynmor Jones's
proposal was for a twin-track approach, presenting
both native Welsh achievements and examples of
what were considered great art from other nations.

Brynmor Jones's philosophy was in the mainstream of the nationalist thinking of the Cymru Fydd movement which was at its height at that time: it was both Anglophile in its celebration of the British Empire and patriotically Welsh in its aspiration to home rule within that framework. T. H. Thomas supported Jones's proposal, which was extensively reported in the press, and the movement was effectively launched.

In the meantime the corporation of Cardiff had acquired a site in Park Place for its own museum and commissioned a building from Seward, who was at the height of his career. In 1896 he was further involved in art developments in the town, designing the pavilion and landscaping for a third Fine Art and Industrial Exhibition, and working voluntarily as a member of the Fine Art and Antiquities committee with Thomas, Short, Parker Hagarty and J. M. Staniforth, the *Western Mail* cartoonist. They assembled a substantial collection, including many works by the recently-deceased Charles Jones, important pictures by Whaite and Leader, and also contributions from less well-known painters such as S. Curnow Vosper. Seward himself exhibited drawings for the gallery he had constructed for Pyke Thompson at Penarth in 1887.

500. Unknown photographer, *Charles Jones*, c.1880

499. Charles Jones, *Repose*, 1879, Oil, 905 x 145

[45] *Western Mail*, 20 August 1901, reprinted in John Ward, *Our Museum. What Might Be IF* – ([Cardiff], 1901), p. 29. In three articles (first published in the *Western Mail*, which campaigned strongly for Cardiff), John Ward made the philosophical and practical case for siting a national museum in the town.

[46] T. H. Thomas ('Arlunydd Penygarn'), 'A National Museum for Wales', *Young Wales*, VIII (1902), 147.

[47] NLW, Whaite Archive, Seward to Whaite, 14 January 1909. In this letter Seward also confided to Whaite that he had missed his true vocation as a painter: 'It is often a regret to me that years ago I found the pressing exigencies of bread and cheese work, – otherwise my profession, – must cut me away from my inclinations towards your profession.'

[48] As a young man Thomas Matthews (1874–1916) had travelled widely to study visual culture and literature before becoming a schoolteacher at Lewis School, Pengam. See R. W. Jones, 'Thomas Matthews', *Cymru*, LII (1917), 59–63, and Anon., 'The late T. Matthews', *The Welsh Outlook*, III (1916), 309.

[49] T. H. Thomas's particular interest in the work of Hugh Hughes may well have been stimulated by his visits to Whaite's home, Tyddyn Cynal, which stands on the west bank of the river Conwy, almost opposite the home of Hughes's family, Y Meddiant, where many of the blocks for *The Beauties of Cambria* were cut.

[50] T. Mardy Rees's source for the assertion that Watts was Welsh was the influential memoir of the artist by Julia Ady, who remarked: 'Like Sir Edward Burne-Jones, the other great imaginative artist of our day, Mr. Watts is of Welsh origins and inherits the mystic poetry of his Celtic ancestors', Julia Ady, *G. F. Watts, Royal Academician: His Life and Work* (London, 1896). Ady had been recently quoted on the subject in a widely-read Welsh source, Iona Williams, 'Welsh Art', *The Welsh Review*, I (1906), 98. T. Mardy Rees's definition of Welshness by descent was generally accepted among Welsh art intellectuals. This led ultimately to the National Museum's attempt in 1913 to present a definitive exhibition under the title 'Modern Artists of Welsh Birth or Extraction'. For critical comment, see 'Art and National Life', *The Welsh Outlook*, I (1914), 25–7, and 'Exhibition of Welsh Art', ibid, 7–8. Some English critics were more relaxed and pragmatic on the matter of nationality. In *British Water-colour Art as illustrated by drawings presented to King Edward VII by the Royal Society of Painters in Watercolours* (London, 1904), p. 190, Adam and Charles Black remarked: 'Although Mr. Hughes may claim that by birth he is the only Welshman amongst those whose biographies find a place here, I am sure that he will cede the honour of being the most thoroughly Welsh artist to Mr. Whaite.'

[51] See Lord, *Clarence Whaite and the Welsh Art World*, pp. 117–18.

With construction at Park Place yet to begin, the Corporation's plans were further complicated in 1897 when Cathays Park became available for new civic buildings, and the national aspirations of the Cardiff art intellectuals devolved onto that site. The momentum for a national museum was now irresistible, but not until 1905 would a consensus be achieved within Wales on Cardiff as the appropriate location. Various counter proposals from other parts of the country emerged and the whole issue was complicated by the question of the location of the National Library, which had been separated from Brynmor Jones's all-inclusive museum scheme. Clarence Whaite, among others, favoured two sites, one in the north and one in the south, but delays occasioned by such proposals caused much irritation to those, like T. H. Thomas, who had been campaigning for the national institution for twenty years. Writing in the *Western Mail* in 1901, Thomas remarked: 'Probably no Welshman would disagree with the statement that the present position of the question of a national museum for Wales is a disgrace to our country ... Nothing prevents Wales obtaining a national museum within a very measurable period except Wales herself.'[45] The following year Thomas restated the case in patriotic terms in the magazine *Young Wales*:

> Besides the enormous educational advantage a National Museum would afford ... we have also an opportunity which, in this direction, can never again occur, of proclaiming that the Cymry are a nation, and of building another mole to strengthen our boundary against which forever beat waves of influence, both mighty and insidious.[46]

The argument was eventually resolved in favour of Cardiff in 1905, and two years later the National Museum was granted its royal charter. Sadly, the major casualty of this tortuous progress was Edwin Seward, whose energy and vision had done much to prepare the ground. In January 1909 he wrote to Clarence Whaite:

> We have been trying to make a move at last with the National Museum. You will remember our discussing the possibility of such an institution when you paid us a visit on the R.C.A. opening their Exhibition here at the College [in 1885]. It has taken a long time to get on. Personally the whole scheme was due to my pegging away at it year in and year out – sometimes with encouragement, but more often with much disappointment. Now, however, the inevitable happens. It has been launched and is getting into the hands of a new body (the Council of the National Museum of Wales,) – a few of whom immediately want to wipe me out, and see me anywhere.[47]

Seward's plans for the building had been set aside by the new Council of the National Museum, despite the fact that they had been used in the official submission to the Treasury to secure a government grant. The architect began a campaign for financial compensation, but had lost the opportunity to crown his career by designing the first truly national building of the new Wales.

501. Unknown
photographer,
Thomas Matthews,
c.1910

502. Unknown photographer,
Mostyn Art Gallery, Llandudno,
c.1902

Frustrating as it had been in many ways, nevertheless by 1910 the interaction of the painters of the Conwy valley and the Cardiff group, supported by London-based expatriates, had at last created a professional Welsh art world. Although the Royal Cambrian Academy had been marginalized by the parochialism of some of the city fathers in Cardiff, and the National Museum was as yet little more than a name, it could be argued that nascent art institutions comparable with those of other small European nations had been formed. From within the new art world attempts were being made to create a national critique, led by the notable work of Thomas Matthews of Llandybïe which was published mainly in O. M. Edwards's magazines, *Cymru* and *Wales*. In addition to writing about contemporary art, Matthews also contributed to an emergent interest in Welsh art history by publishing a biography of John Gibson and shorter studies on a wide range of topics, notably the Llanbadarn group of Celtic-Christian manuscripts.[48] T. C. Evans (Cadrawd) and his friend T. H. Thomas had begun to collect and publish information about forgotten Welsh artists such as Hugh Hughes,[49] and in 1912 the Revd T. Mardy Rees gathered together much of this work in his volume *Welsh Painters, Engravers, Sculptors (1527–1911)*, a work flawed both by errors of fact and by the conventional philosophy of the period which defined Welsh artists by their ancestry rather than their contribution to the culture. As a result, crucial figures such as Clarence Whaite were excluded whereas G. F. Watts, because he had 'confessed that he was of Welsh extraction', was given a prodigious entry of twelve pages. Nevertheless, T. Mardy Rees's volume remained the only work in the field for nearly half a century.[50]

Commercial gallery provision was still limited, though in the north Llandudno remained a centre for art sales, where several dealers advertised their Fine Art Emporia, specializing in the work of the Betws-y-coed artists.[51] Provision for exhibitions was improved in 1902 following the opening of the Mostyn Gallery, which was established to provide opportunities for the many women artists in

503. *The Gwynedd Ladies' Art Society,*
Catalogue of the First Annual Exhibition,
1895, 138 × 108

504. *Advertisement for*
art classes in Cardiff, from
the *Catalogue of the South Wales*
Art Society Exhibition, 1906,
80 × 100

[52] Ibid., pp. 141–3. The gallery was short-lived as a venue primarily for women, and relatively little work by these artists has come to light. The best attested woman landscape painter of the period is Buddug Anwylini Pughe (1857–1939), though she does not seem to have been associated with the Gwynedd Ladies' Art Society. Pughe was born in Aberdyfi and studied in Liverpool before returning to live in her home town. She travelled widely, painting mainly in watercolour, and exhibited in Liverpool and at the Royal Academy in London.

[53] John attended the Cardiff School of Art, founded in 1865, from the age of ten. He reported: 'The school was then in limited quarters in the Old Arcade and the modelling class was held in the cellars of the old Free Library in St. Mary-street ... I was fortunate in those early days to have the late Mr. James Philpotts as my tutor for anatomy, a most interesting self-taught man, a painter in the employ of the Taff Vale Railway Company, who had acquired an intimate knowledge of the anatomy of the human figure, a very necessary foundation for artistic studies. Night after night I studied under his guidance in a small room in Hill's-terrace, on the canal bank'. *Western Mail,* 4 December 1931. Thomas John, the sculptor's father, was one of the first students at the Cardiff school in the mid-1860s.

[54] For the Swansea society, see Roy Knight, *A History of the Swansea Arts Society 1886–1986* (Swansea, 1987).

[55] Harris's stay in Cardiff was cut short by his bigamous marriage, which caused him to depart for Australia. For the Harris family business, see Lord, *The Visual Culture of Wales: Industrial Society,* pp. 113–14.

[56] *Western Mail,* 17 July 1899.

[57] Thomas Matthews, 'Oriel Cymdeithas Celf y De', *Cymru,* XLV (1913), 62.

the area. Their exclusion from membership of the Royal Cambrian Academy had brought them together in 1895, under the presidency of Lady Augusta Mostyn, as the Gwynedd Ladies' Art Society. Augusta Mostyn endowed them with one of the first art galleries in Europe dedicated to the exhibition of women's work.[52]

A system of art schools, however basic, had facilitated the emergence of several professional artists, most notably William Goscombe John.[53] There were also art societies in several towns, notably in Swansea where the first group in Wales had been formed in 1886, and provided local foci for both amateur and professional practice.[54] In the catalogue of the 1906 exhibition of the South Wales Art Society, for instance, Parker Hagarty, G. F. Harris and Edgar Thomas all advertised themselves both as painters and teachers, along with the leading supplier of specialist materials in Cardiff, Alfred Freke. The Australian-born Parker Hagarty was successful in gaining portrait commissions from many public bodies, in addition to selling his landscapes at the Art and Industrial Exhibitions, the annual exhibitions of the Society, and at the Eisteddfod when it was held in south Wales. G. F. Harris had been attracted to Cardiff from Merthyr, where his family painting and photographic business was in its second generation.[55] Edgar Thomas ploughed a more uncompromising artistic furrow on his return from training in London and Antwerp by painting mystical subject pictures and landscapes which attracted much critical interest but few sales. When *The Birth of Light* was awarded the prize at the Cardiff Eisteddfod in 1899 by Alma-Tadema and Goscombe John, the critic of the *Western Mail* complained:

> this talented artist is no prophet in his own land, so that it needs foreigners to come to Wales to tell her that she is, unknowingly, nursing a genius. For the art of Edgar Herbert Thomas is not understood in Wales, and the Paris comedy of Rodin and his bust of Balzac is being also performed in connection with Mr. Thomas's painting ... His art is for art's sake, and neither love of gain nor hope of praise will make any difference to it ... Some day it will be as great an honour to Wales as Turner is to England.[56]

505. Edgar Thomas,
The Birth of Light, 1899,
Pencil and watercolour,
622 × 471

506. Unknown photographer,
Edgar Thomas (left),
Henry Walter Shellard (centre)
and Arthur Carter, c.1905

507. Henry Walter Shellard,
Self-portrait, c.1920, Oil,
609 × 457

Thomas attracted a group of acolytes identified in 1913 by Thomas Matthews as 'the Cardiff School of Painting'.[57] H. W. Shellard and his daughter, Doris M. Shellard, were Thomas's closest followers, although Matthews also identified J. M. Staniforth with the group. Both Staniforth and Matthews promoted Edgar Thomas enthusiastically, and he was rewarded with an exhibition at the Doré

508. Edgar Thomas,
Remorse, c.1910,
Pencil, 435 × 315

509. Edgar Thomas,
Glamorgan Canal, c.1913,
Oil, 300 × 453

510. Edgar Thomas,
*Intellectual Blindness following
Old Thoughts,* c.1913,
Oil, size unknown

[58] For the artist's career until the Great War, see Thomas Matthews, *Arluniaeth Edgar H. Thomas* (Caernarfon, 1914). His most notable painting, *The Birth of Light,* is believed to have been burnt following the death of the relative to whom it had passed.

[59] 'Exhibition of Welsh Art', *The Welsh Outlook,* 1 (1914), 7. See also the fuller review under the title 'Art and National Life' in the same issue of the magazine, ibid., 25–7.

Galleries in New Bond Street in London in 1913. However, his career was a failure in terms of patronage, and few of his major works survive.[58] In the same year he was granted a place in the new National Museum's first attempt to review the condition of Welsh Art, the Exhibition of Works by Certain Modern Artists of Welsh Birth or Extraction. The critic of *The Welsh Outlook* noted that 'in an age, when we put a premium on inanity and penalise the man with a strong individuality, it is not surprising, however deplorable, that such an intensely earnest and powerful work as "Intellectual Blindness" should appear in the catalogue over the words "Lent by the Artist"'.[59] Despite its inclusion in the exhibition, the idiosyncratic nature of Thomas's work and in particular the artist's lack of interest in the patriotic subject matter which inspired his more successful contemporaries meant that it was marginalized in the new national art world.

chapter

ten

A NATIONAL

REVIVAL

511. John Linnell after G. F. Watts, *Caractacus led in Triumph through Rome*, 1847, Lithograph, 419 × 571

Against the background of an emergent art world and the general rise of the national movement in politics and the other arts, the idea of a Welsh national painting and sculpture assumed greater importance than ever before. As was the case in other small nations in the period, the question of what might constitute an art 'which in its character belongs to the Welsh people, has grown out of their story, and impresses their soul' was likely to be partially answered by the painting of historical and mythological subjects.[1] In Finland national foundation myths written down in the Kalevala began to inspire painters such as Gallen-Kallela, just as the Mabinogion and other stories would do for Welsh artists.[2] However, the question of mythological and historical imagery in Wales remained peculiarly complicated. The persistent use of Ancient Britain subjects by English artists in an attempt to create national imagery for their country left Welsh artists in an ambiguous position, though some nationalists were at last facing up to this central national problem of the previous four hundred years. In 1906 Iona Williams remarked: 'Our attitude to the idea of a national art will be largely determined by the side we take in the controversy between nationalism and Imperialism.'[3] A spate of Ancient Britain images had materialized in England in the mid-nineteenth century, the most celebrated of which was G. F. Watts's cartoon for the rebuilt Houses of Parliament, *Caractacus led in Triumph through Rome*. The high status of Watts in the second half of the century coupled with the fact that he professed himself to be of Welsh extraction did little to resolve the confusion.

Among the Welsh painters greatly enamoured of Watts was Clarence Whaite who, in 1854, exhibited *Ancient Britons surprised by Romans* at the Royal Academy. When Whaite visited Ruskin in 1865 he was advised by the great critic to choose between landscape and figure painting, and although landscape dominated his subsequent output and although he was never a prolific painter of historical or mythological subjects, Whaite's subsequent career was punctuated by occasional large-scale works on Celtic themes. Among them *The Finding of Taliesin* is significant since it was painted in 1875, five years after Whaite had taken up permanent residence in Wales and become involved in Welsh intellectual life. In contrast to the more ambiguous status of the Ancient Britain and Arthurian material of his earlier work, the subject was a particularly Welsh one, being associated with the river Conwy on the banks of which Whaite was now living. In keeping with his belief in the faithful reproduction of nature, the landscape in which the finding of Taliesin

[1] Iona Williams, 'Welsh Art', *The Welsh Review*, I (1906), 97. In this article Iona Williams asked squarely the question 'Is a national art possible?', answered it in the affirmative and, furthermore, was of the opinion that such an art was 'imperative if the national life is to attain its fulness and completeness'.

[2] Akseli Gallen-Kallela (1865–1931) studied in Helsinki and then in Paris at the Académie Julian. He became interested in using the national epic, the Kalevala, as a source whilst in Paris, and painted *Aino* in 1889. At first he attempted the Kalevala subjects in a naturalist idiom, but later turned to Symbolism for his most important works, painted in the mid-1890s.

[3] Williams, 'Welsh Art', 97.

512. Henry Clarence Whaite,
Arthur in the Gruesome Glen,
c.1908, Oil, 1060 × 1562

occurs was based on a location and a particular tree only a few hundred yards
from his house, against which the figures were set. In the 1890s Whaite again
ventured into Arthurian subject matter with *Arthur in the Gruesome Glen*, but
returned to more particularly Welsh themes with the druidical *The Archdruid:
A Throne in a Grove* in 1898. Several of Whaite's colleagues in the Conwy valley
also began to exhibit an interest in national subject matter at about this time,[4] but,
with the exception of Leonard Hughes's picture, *Myfanwy*, which was awarded
first prize by Whaite at the National Eisteddfod in Bangor in 1890, all the surviving
works of this group reveal a dominance of landscape and sentiment over narrative
detail.[5] They stand, therefore, in the tradition of Turner's *Dolbadern Castle* and
ultimately Richard Wilson's treatment of classical themes such as *The Destruction
of the Children of Niobe*, rather than in the neo-classical tradition of Jacques-Louis
David, followed in England by Lord Leighton and Alma-Tadema, Edgar Thomas's
master. Hubert Herkomer's deepening interest in Wales in the 1880s was similarly
manifested in subject paintings which were essentially landscapes of sentiment,

[4] Henry Meacham painted a picture of the
last battle of Llywelyn ap Gruffudd, probably
in 1882, and at about the same time E. A.
Norbury painted two more generally Celtic
subjects, *Caractacus Leaving Britain a Prisoner*
and *King Arthur and his Diamond Crown*.

[5] According to a contemporary newspaper report,
Hughes's picture was intended as the first in a
series of Welsh historical subjects, but no other
has been traced. *Carnarvon and Denbigh Herald*,
12 September 1890.

513.

Henry Clarence Whaite, *The Archdruid: A Throne in a Grove*, 1898, Oil, 1260 × 1000

514. Hubert Herkomer, *Hwfa Môn*, 1895, Pencil drawing, 504 × 340

[6] According to Herkomer, the Eisteddfod 'had hitherto used art merely as an appendage, as a mere necessary [*sic*], to be attended to after they were tired of hearing the same song. They must make the art section as important as they had made music, and then they would do a great work, not only for Wales, but for England as well'. *Carnarvon and Denbigh Herald*, 2 August 1895. Herkomer's comments and the reaction to them are discussed in Lord, *Y Chwaer-Dduwies*, pp. 59–62.

[7] Described by Morien as 'awful majesty', according to Hywel Teifi Edwards, *Codi'r Hen Wlad yn ei Hôl 1850–1914* (Llandysul, 1989), p. 242.

[8] NLW MS 17345C, f. 19. This was possibly the portrait presented to Baron Castletown, President of the Celtic Association at Edinburgh in 1907. See *Celtia*, VII, no. 4 (1907), 49.

invested with the merest suggestion of Ancient Britain. Only the title of his picture *The Gloom of Idwal* indicates a mythological or historical idea, although *Found* is an Ancient Britain subject picture set in Snowdonia. Both pictures were developed during Herkomer's visits to the Betws-y-coed area with Charles Mansel Lewis of Stradey Castle in the 1880s.

Herkomer had taken advantage of two Eisteddfod adjudications, in 1895 at Llanelli and the following year at Llandudno, to criticize the condition of Welsh visual culture. Coming from such an authority in England, his forthright comments caused some consternation.[6] Nevertheless, he was inspired at these meetings by the Gorsedd ceremonies, and – like many others – in particular by the powerful presence[7] of the Archdruid, Rowland Williams (Hwfa Môn). At Llanelli he drew the Archdruid and his colleagues for *The Graphic*, and was moved to redesign the great man's robes and regalia. The following year Herkomer appeared in green among the Ovates attending Hwfa Môn, who was resplendent in the new white robes, 'Breast Plate ... and Tiara with oak leaves – all (with the exception of the oak leaves) of pure solid gold'. The artist shortly afterwards painted him thus attired and posed at the mouth of a cromlech.[8] *Baner ac Amserau Cymru* reported somewhat defensively on this reassertion of early nineteenth-century romantic Celticism:

515. Hubert Herkomer,
Found, 1884, Oil,
1372 x 2305

516. Leonard Hughes,
Myfanwy, 1890, Oil,
2000 x 3000

315

[9] *Baner ac Amserau Cymru*, 8 July 1896, translated from the Welsh.

[10] Thomas went to some trouble to have the banner made in Wales, searching 'for a long time for a thoroughly good worker accustomed to the highest class of work and at last found one here in Miss Evans teacher of art needlework at the technical school'. NLW, uncatalogued Cymmrodorion material, T. H. Thomas to E. Vincent Evans, 25 November 1895. Drawings by Herkomer at the Yale Center for British Art show that the German artist also experimented with designs for Eisteddfod chairs.

[11] E. Vincent Evans, secretary of both the National Eisteddfod Association and the Honourable Society of Cymmrodorion, exercised an immense influence on Welsh affairs in the thirty years prior to the Great War.

Everyone was of the opinion that the bards were a strange sight in their robes ... though not every Englishman thought so, because Mr HERKOMER praised them, and doubtless there are many who agree with him. If they want to dress as seen above, they have the right to do so.[9]

The newspaper had its doubts, but Herkomer had indeed caught the mood of the times among many intellectuals. T. H. Thomas had been working on a similar idea for new regalia but was pipped at the post by Herkomer. However, it was Thomas who designed the new banner for the Gorsedd and who proposed extending the regalia to include a sword and a *Corn Hirlas* (Horn of Plenty), for which he produced sketches. He persuaded Lord Tredegar to sponsor both items, Herkomer designing the sword and Goscombe John the horn.[10] John later became somewhat irritated by the suggestion that he had merely followed Thomas's design.

The patronage of the Eisteddfod, particularly through the London-Welsh circle of E. Vincent Evans, drew Goscombe John increasingly into Welsh affairs.[11] He was awarded a commission to design a medal for the National Eisteddfod Association in 1896, which enabled him to combine strong reference to eighteenth-century Ancient Britain imagery with the increasingly popular Red Dragon. Goscombe John's reference to Thomas Jones and to de Loutherbourg is clear, although the Last Bard has been transformed into the first, namely Taliesin Penbeirdd, set against a cromlech and a rising sun, symbolic of the rebirth of Wales in the new age. T. H. Thomas designed the medal of the National Eisteddfod at Newport in the following year also in historicist mode, but he adopted a more pedantic and learned style for his head of King Arthur than John, who was gaining a reputation as an especially fine medallist. Indeed, John's contribution to the revival of the medal as a form in sculpture in Britain around the turn of the century was considerable. In his

517. William Goscombe John, *Merlin and Arthur*, Bronze, 1902, 577h.

518. Unknown photographer, *The First Pan-Celtic Congress, in front of Dublin Mansion*, 1901. T. H. Thomas (right), Hwfa Môn (seated third from left) and Gwyneth Vaughan (in white, centre), by William Goscombe John's *Corn Hirlas*

Medal to Llywelyn ap Gruffydd he depicted the prince on the obverse in conventional medievalist terms with a quotation from the elegy of Gruffudd ab yr Ynad Coch, but on the reverse he modelled a much more unusual and oblique reference of a nightingale in a rowan tree set against Snowdon. In 1918 John developed this image on the reverse of the medal given for merit in modelling at Cardiff School of Art. The bird was pictured in full flight over the mountain.[12] No doubt John was encouraged in his use of Celticist imagery by both his patriotism and his good business sense, but he seems to have been less inclined to make use of it than some of his contemporaries. Perhaps his most notable venture in the field was *Merlin and Arthur*, a small-scale bronze, exhibited at the Royal Academy in 1902, in which Merlin reflects the bardic figures in Wilson's *Solitude*. John was a great admirer of Wilson, and many years later, at the National Eisteddfod at Mold in 1923, he was the central figure in a ceremony to lay a wreath on the great painter's grave. In the same year as *Merlin and Arthur* was completed, the chair at the National Eisteddfod at Bangor was awarded to T. Gwynn Jones for his *awdl* 'Ymadawiad Arthur', which echoed its subject matter. Jones used Celtic mythology and ancient literary form as the basis for a new kind of poem in the Welsh language with strong contemporary relevance. Similarly, Goscombe John was a modernist and, indeed, an important contributor to the New Sculpture Movement throughout Britain, notwithstanding his use of historical and mythological themes in some of his Welsh works.[13]

top to bottom:

520.
William Goscombe John,
Medal for the National Eisteddfod Association,
Bronze, 1896, 76d.

521.
William Goscombe John,
Medal to Llywelyn ap Gruffydd, Bronze,
c.1900, 76d.

522.
T. H. Thomas,
Medal for the National Eisteddfod at Newport,
Bronze, 1897, 58d.

[12] The prize for merit in modelling was sponsored by Goscombe John himself. For other medals by the artist, see David Pickup, 'Sir William Goscombe John. "Imbued with the Artistic Spirit"', *The Medal*, 31 (1997), 68–72. Related to the medal form at which he excelled was the circular relief design for the seal of the National Museum, also carved on a large scale in stone and set into a wall in the new museum building.

[13] Goscombe John was among the sculptors encouraged by Edmund Gosse, the chief proponent of the movement in the 1890s, and he was commissioned to make a bust of the art critic to celebrate his seventieth birthday in 1919.

519. Unknown photographer, *William Goscombe John (centre, front) with Isaac Williams (left, front) and Carey Morris behind him, walking to Richard Wilson's grave*, 1923

523. J. M. Staniforth,
Poster for the *National Pageant of Wales*,
1909, Lithograph, 2020 × 3000

524. Unknown
photographer,
*Cardiff Town Librarian
as Merlin*, 1909

The renewed confidence in Celtic origins and their relevance to modern
aspirations owed much to the work of John Rhŷs, Professor of Celtic at Oxford
since the creation of that chair in 1877. Rhŷs's analysis of the early literature had
revived studies in the field from the somewhat discredited condition into which
they had fallen as a result of the fantasy and forgery of the generation of William
Owen Pughe and Iolo Morganwg. Relegated further into the background by the
trauma of the Blue Books, antiquarianism had not been highly regarded by the
cultural progressives of the 1850s and 1860s. The 1858 Eisteddfod at Llangollen,
in which the old school of Celticists under Ab Ithel held sway for the last time, had
been boycotted by Lady Llanover's circle who held a rival meeting. However, in
the 1880s it once again seemed possible to be both progressive by presenting art,
technology, science and social issues in Wales through the Eisteddfod movement

525. *Celtic Ornament*
from Owen Jones, *The Grammar*
of Ornament, 1856, 296 × 201

(and a variety of other emerging institutions) and at the same time
sustain the Celtic heritage. Rhŷs's influence was felt not only through
his publications but also as a result of his support for a small group
of students who rapidly assumed positions of power in Wales. John
Morris-Jones, Tom Ellis, O. M. Edwards and others had socialized in
Oxford within the Dafydd ap Gwilym Society, and Ellis and Edwards
in particular had been sensitized to the potential of visual art for
propagating national values as well as to the importance of literature
and political action. Both had attended Ruskin's lectures as Slade
Professor of Art and come under his influence to the extent that
Ellis was in the habit of referring to him as 'The Master'.

Nevertheless, Romantic Celticism had a tendency periodically to invade
the new 'scientific' study of the subject. Among the more remarkable
manifestations of this regressive tendency was the National Pageant
held in Cardiff in 1909. T. H. Thomas was a member of the organizing
committee, but the event was mainly directed by the adventurer and
novelist Robert Scourfield Mills (Owen Rhoscomyl).[14] One of its more
unusual aspects was the participation of the establishment as actors.
The mayor of Cardiff appeared as Hywel Dda, the town's librarian
as an apparently demented Merlin, and no less a person than Lord
Tredegar impersonated Owain Glyndŵr. Just as Ellis Owen Ellis
had mocked Ab Ithel and his associates at Llangollen in 1858, so the
most important visual satirist of the new generation, J. M. Staniforth,
produced a splendid poster suggesting that not all patriots took the
event as seriously as these individuals.

In parallel to Rhŷs's analytical study of Celtic and early Welsh literature, interest in
Celtic visual culture, and in particular in Christian Celtic manuscript illumination
and in carvings, was growing. A pioneer in the field was the architect Owen Jones,
son of Owain Myfyr, patron of Iolo Morganwg and William Owen Pughe. Jones's
highly influential masterpiece, *The Grammar of Ornament*, published in 1856,
included a section on Celtic design, setting it side by side with the arts of India
and Persia, the ancient Greeks and the Romans, thereby helping to divest the
culture of the notion that it was barbarous.[15] Interest was later stimulated by the
increasing exposure of Irish material as a result of the national revival in that country
and, in particular, by the production in facsimile of the Book of Kells. The journal
of the Cambrian Archaeological Society, *Archaeologia Cambrensis*, founded in 1846,
provided a focus for detailed discussion of Welsh material and made it available
to artists in increasing quantities in the 1880s and 1890s. In this, as in many

[14] According to Owen Rhoscomyl's niece, 'all his
life was spent as a mixture of fighting and writing'.
Quoted in Edwards, 'Pasiant Cenedlaethol
Caerdydd 1909', *Codi'r Hen Wlad yn ei Hôl*, p. 248.

[15] Owen Jones (1809–74) was born in London
but moved in Welsh circles. He published the first
systematic study of Hispano-Moresque art, and
became known to a wider public when he was put
in charge of the decoration of the Crystal Palace
at the Great Exhibition of 1851. Another notable
Welsh contributor to the study of art history was
John Griffiths (1837–1918), a native of Llanfair
Caereinion, Montgomeryshire. He became
Principal of the School of Arts, Bombay, and
published *The Paintings in the Buddhist Cave-*
temples of Ajantâ in two magnificent volumes
in 1896. He exhibited painting and sculpture at
the Royal Academy in London. For his career, see
C. H. Humphreys, 'Notes on John Griffiths, Artist',
Montgomeryshire Collections, LI (1949–50), 70–1.

16 T. H. Thomas, 'Celtic Art, with a suggestion of a scheme for the better preservation and freer study of the monuments of the Early Christian Church in Wales', *Y Cymmrodor*, XII (1897), 87–111. Thomas reported Miss Talbot's response in the *Western Mail*, 1 August 1893. Other pioneering writings by Thomas on early Welsh material include 'Inscribed Stones', *Transactions of the Cardiff Naturalists' Society*, XXV, part 1 (1892–3), 34–46, and 'Notes upon the Psalter of Ricemarch', ibid., XXXIII (1900–01), 47–52.

17 Thomas, 'Celtic Art', 110. When the new National Museum building was opened in 1927, the casts were displayed in the entrance hall, immediately making the point that the Museum dealt with the culture of a Celtic nation.

526. Unknown photographer,
*Moving the Llanbadarn High Cross
into the church*, 1916

527. Unknown photographer,
*Harry Hall working on the
Adelina Patti Casket*, 1912

528. Harry Hall,
The Lloyd George Casket,
Swansea, mixed media, c.1918

other things, the leading proponent within the art world of what he called 'the only indigenous art of Wales' was T. H. Thomas. In 1891 he addressed the Cymmrodorion Society on the need to conserve Celtic Christian monuments and two years later he was able to report that a new attitude was emerging. As an example he cited the collection of crosses brought together at Margam for safe keeping by Miss Talbot.[16] This pattern was followed in many places, and the recording of the stones photographically and in the form of casts made at Thomas's instigation for the Cardiff Museum helped to preserve and widen interest in them. Thomas's particular concern with this material, and in the transitional process by which insular Celtic art was reinvented in the Christian context, reflected the centrality of the Christian tradition to his nationalism and the concept of the Celtic saints as founding fathers. Despite his success in antiquarian circles, Thomas felt frustrated by the limited interest shown in the material by Schools of Art in Wales: 'None has examples of Celtic Art to place before its pupils. This state of things would be largely remedied could such schools as those contemplated by Prof. Hubert Herkomer be established', he remarked in a postscript to his Cymmrodorion address, published in 1897.[17] Only with the appointment of William Grant Murray as Principal of the Swansea School of Art in 1909 would new ideas in art education find dynamic expression in Wales. At about the same time the young sculptor and jeweller Harry Hall was appointed to the staff, and the teaching of Celtic design began.

T. H. Thomas's use of Celtic imagery in his own art work was limited mainly to graphics, such as his cover for the Methodist children's magazine, *Trysorfa y Plant*. He produced illuminations for a text of *The Lady of Shalott* inscribed by his close friend, Charles Conway, but his influence was mainly as a popularizer. Despite the reluctance of art schools in Wales (in contrast to Ireland) to teach the

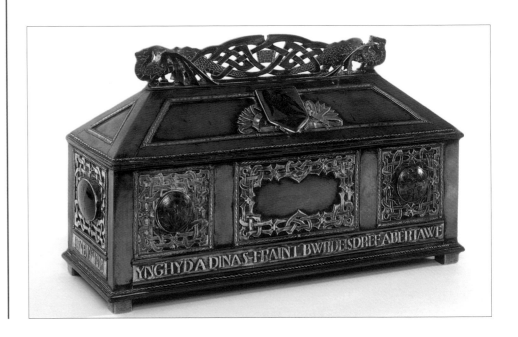

subject, by the turn of the century Celtic forms were appearing regularly in work by Welsh designers or were commissioned for Welsh patrons. At the National Eisteddfod of 1902 in Bangor, chiefly remembered for T. Gwynn Jones's *awdl* 'Ymadawiad Arthur', the winning *pryddest* by R. Silyn Roberts was also on a Celtic theme. 'Trystan ac Esyllt' was rewarded with a crown 'formed of eight panels joined together, and filled with Celtic interlaced ornament', designed by Harold Rathbone of Liverpool.[18] The National Eisteddfod would remain an important focus for the use of Celtic elements in design, a trend which reached its peak in a series of elaborately carved chairs in the years 1917, 1919 and 1920.[19] The 1917 chair, the best attested of the group, was designed by a Belgian émigré, Eugeen Vanfleteren, on the theme of 'The present day Welshmen honouring the former Celtic art'.

In south Wales, among the earliest public ventures to show the influence of the new Celtic design was a fountain commissioned for Pontypridd by Alfred Thomas, MP for East Glamorgan, in 1895. Following a competition, the commission was awarded to Charles B. Fowler, and the local press reported proudly, in the spirit of the time, that 'there is absolutely nothing English about it':

> The general outline is of early form, filled in with ancient British ornament, such as may be found at Llantwit, Margam, Llandaff and other places in Glamorganshire ... The rampant dragon immediately beneath the lamp is of bronze, so are the water-jets, which take the conventional form of leeks. The four faces of the fountain will vary in their ornament, and the basins will be lined with lead. The water will be carried off the roof by means of goats heads at each angle, and these, together with the dragon, leeks, and ancient Celtic ornament, will give the structure a purely Welsh character.[20]

[18] *North Wales Observer and Express*, 12 September 1902. Rathbone (fl.1858–1921) was the son of the influential Liverpool patron Philip Henry Rathbone. He was a painter and designer, and in 1894 founded the Della Robbia pottery in Birkenhead. He was in contact with several of the painters of the Betws-y-coed artists' colony.

[19] Among other notable ventures was the creation of a full-size copy of the Battersea Shield as a prize in 1922.

[20] *Pontypridd Chronicle*, 29 March 1895. Among Fowler's other buildings was the tower of St Catherine's Church in Cardiff. The fountain was made by Messrs Martyn of Cheltenham.

531. Charles B. Fowler, *Drinking Fountain, Pontypridd*, 1895, Stone and bronze

529. T. H. Thomas and Charles Conway, *The Lady of Shalott*, c.1874–84, Watercolour and ink, 134 × 112

530. Eugeen Vanfleteren, *The Chair for the National Eisteddfod at Birkenhead*, 1917

532. Edwin Seward,
The Celtic Corridor, Cardiff, 1905

Fowler was among Edwin Seward's rivals in architectural practice in Cardiff. Ten years after the Pontypridd commission, Seward himself ventured into Celtic themes with the construction of an arcade of shops, known as the Celtic Corridor, in Newport Road in Cardiff. The design included beaten copper panels and leaded lights based on antiquities from Ireland, Scotland and Brittany, as well as from Wales. On inviting T. H. Thomas to open the Celtic Corridor, Seward remarked that 'The launching of anything whatever, – whether abstract or realized in Wales, which touches the Celt and his contact with art, is altogether incomplete without you.'[21] The influence of Celtic design and occasionally subject matter continued to be felt, especially in the products of craftspeople, well into the 1920s. Stained glass, like the window in memory of Sir William Thomas Lewis, first Baron Merthyr of Senghennydd, at Llandaff Cathedral, was considered a particularly appropriate medium, and some committees established to erect war memorials commissioned Celtic-style crosses.[22] The Celtic cross also became popular for private memorials; both Owen Rhoscomyl and Percival Graves of Harlech, a prominent figure in the Celtic League, were memorialized in this way.[23]

533. J. Kelt Edwards,
*Eisteddfod Gadeiriol Gwŷr Ieuainc
Gwrecsam*, 1898, Woodcut,
109 × 141

Of the younger generation of Welsh painters emerging in the *fin de siècle* period, John Edwards was the most deeply involved with the new Celticism. Indeed, he adopted the name 'Kelt' (by which he became generally known), but his progress was dogged by a bourgeois family in Blaenau Ffestiniog from whom he never entirely broke free. His life was blighted by alcoholism and he spent his last years as a recluse at Ceinewydd, Maentwrog, where he died in 1934.[24] His close friend T. Gwynn Jones remembered after his death 'how confident K. would be, when we first became friends':

534. J. Kelt Edwards,
*Bookplate for the Library
of Sir John Rhŷs*, 1917,
Printed in various sizes

[21] Museum of Welsh Life, T. H. Thomas Archive, 2435/188. Two other architects of the late nineteenth and early twentieth centuries, John Coates Carter and Herbert North, also made notable use of Celtic and Welsh historical reference in their work.

[22] For examples, see Angela Gaffney, *Aftermath: Remembering the Great War in Wales* (Cardiff, 1998). However, the earliest example of a public memorial in Celtic style was the Boer War Memorial at Haverfordwest, a copy of the Celtic cross at Llandough, Glamorgan.

[23] Percival Graves was the father of the poet and novelist Robert Graves.

He knew the splendour of hope, but
The gleam faded from his eye;
Only a friend or two remember
The mastery extinguished.[25]

In the 1890s J. Kelt Edwards had begun to use Celtic and other national motifs on printed ephemera such as Eisteddfod programmes and, displaying the confidence noted by T. Gwynn Jones, had complained to O. M. Edwards of the poor design standards of his magazines. Announcing somewhat theatrically that he was 'sailing to Rome to study on Thursday', in February 1898 he asked:

> How is it that you can so highly appreciate Art (as it is very evident you do ...) and yet offer your readers the *very gems* of Welsh poetry or literature served up as it were in a bucket instead of in a decent casket as other more worthless jewels are kept?[26]

The artist offered to work for O. M. Edwards at low rates or 'for nothing at all save the satisfaction that I shall be helping Art in Wales. This in the most patriotic spirit that ever moved an artist or a poet'.[27] Many artists of J. Kelt Edwards's generation correctly perceived O. M. Edwards as a key figure in building their careers, both in terms of publicity through his magazines and in obtaining portrait and other commissions. Nevertheless, J. Kelt Edwards's criticism was unfortunate since, despite shortcomings of design, O. M. Edwards gave a much higher profile to visual culture than his rival editors.

In Italy J. Kelt Edwards was accompanied by Timothy Evans, a young painter from the Conwy valley, who also solicited the support of the editor of *Cymru*. Unlike Kelt, Evans came from a poor family and in January 1899 he sent O. M. Edwards three small pictures, playing the patriotic card in the hope of gaining a sale:

> I would be truly grateful if you could find a *customer* to buy *one* or *two of my paintings*. Will it, I wonder, be necessary for me – a *Welshman* – to give up the effort of becoming an artist from a lack of support? I believe that there are plenty of gentlemen from Wales who would help me if they could come to know me.[28]

Edwards's response was positive and he published *Unigedd* in *Cymru'r Plant* later that year.[29]

Apart from continental travels, J. Kelt Edwards worked mainly in London until 1914, but remained in close touch with Welsh affairs. He competed in eisteddfodau and carried out several commissioned portraits. His interest in Celtic design was expressed most elegantly in small items such as book plates for the libraries of E. T. John and Sir John Rhŷs. He was the designer of the second in the series of Celtic Eisteddfod chairs, presented in Corwen in 1919, which was carved by his cousin Elias Davies. His ventures into Celtic subject matter included a *Fantaisie Celtique*, drawn in Paris, and a series of small works in similar style on themes from the Mabinogion. One of these, *Rhiannon*, was among the few works reproduced in colour by O. M. Edwards, but the artist's fondness for heavy chiaroscuro, produced by working in charcoal, did not suit the reproduction techniques available to a low-priced magazine, and on the whole the results were very disappointing.

[24] According to Beriah Gwynfe Evans, Edwards adopted the name Kelt while travelling on the Continent. B. G. Evans, 'Dynion i'r Oes – XVI. Mr. J. Kelt Edwards', *Ysbryd yr Oes*, III (1906), 101–4. An oft-repeated story claims that the name was bestowed on the painter by Lady Llanover.

[25] 'Gwybu ysblander gobaith, ond pylwyd / Y pelydr o'i lygaid; / Cyfaill neu ddau sy'n cofio / Y gamp a ddiffoddwyd, gynt.' NLW, J. W. Jones Papers, 277/19.

[26] NLW, O. M. Edwards Papers, Class A, general correspondence.

[27] Ibid.

[28] Ibid., translated from the Welsh.

[29] For Edwards's support of young artists through his magazines, see Peter Lord, 'Cofeb Daniel Owen: Artistiaid a Noddwyr y Deffroad Cenedlaethol', *Barn*, 395/6 (1995–6), 36–41.

535. Unknown photographer,
J. Kelt Edwards and Elias Davies with the Chair for the National Eisteddfod at Corwen, 1919

536. John Wickens, *François Jaffrennou (Taldir)*,
Marquis de l'Estourbeillon, Madame Mosher,
Francis Even and J. Kelt Edwards at the Celtic
Congress of Caernarfon, 1904

537. J. Kelt Edwards,
'Enor d'ar re a zoug bepred
Gwiskamanchou ar Vretoned',
illustration from François Jaffrennou
(Taldir), *An Delen Dir*, 1900, 70 × 52

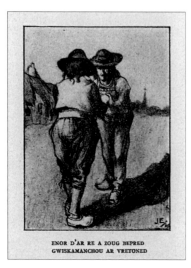

ENOR D'AR RE A ZOUG BEPRED
GWISKAMANCHOU AR VRETONED

538. John Wickens, *Théodore Botrel, Lena Botrel,*
Gwyneth Vaughan, Hwfa Môn (first four on the left), Samuel Maurice Jones
(fourth from the right, in the second row) and Christopher Williams
(extreme right) at the Celtic Congress, Caernarfon, 1904

His experience of life on the Continent made J. Kelt Edwards particularly susceptible to the international pan-Celticism of the period. While in Brittany he established a close friendship with François Jaffrennou (Taldir), a leading Breton nationalist of the period and a proponent of the Pan-Celtic movement. In Wales, the movement reached a high point at the Celtic Congress held at Caernarfon in 1904. Edwards was recorded in the company of the Bretons and representatives of the other Celtic nations, resplendent in their national costumes, in a fine series of images by the Bangor photographer John Wickens. The proceedings were enlivened by the charismatic figure of Hwfa Môn, whose masculine bardic robes were matched by the flowing attire of Gwyneth Vaughan. Self-consciously elegant in a costume supposedly derived from medieval aristocratic dress, rather than the peasant costume which had inspired Lady Llanover, Vaughan made herself prominent in Wickens's photographs, often in surprisingly close proximity to the Archdruid. This exhibition of 'mad Celts', as Wickens described them, attracted not only J. Kelt Edwards but other artists, including T. H. Thomas, Samuel Maurice Jones and the young Christopher Williams.[30]

539. William Morgan Williams (Ap Caledfryn),

The Emancipation of Woman, 'Rhydd-freiniad y Ddynes', 1898,

illustration from Beriah Gwynfe Evans, *Dafydd Dafis, sef*

Hunangofiant Ymgeisydd Seneddol, 182 × 250

540. William Morgan Williams (Ap Caledfryn),

The Dafydd Dafis Company, from left: Tudor Hughes,

Dyer Davies, T. H. Thomas, E. Tennyson Reed,

Beriah Gwynfe Evans, Ap Caledfryn, Will Morgan,

A. E. Elias, 1898, illustration from Beriah Gwynfe Evans,

Dafydd Dafis, sef Hunangofiant Ymgeisydd Seneddol

120 × 170

The sympathetic response of O. M. Edwards to the difficulties experienced by J. Kelt Edwards and Timothy Evans in earning a living extended to other young painters and illustrators. Both A. E. Elias and D. J. Davies wrote to him in similar financial straits, and Edwards did his best to assist them with commissions. However, he was able to give them opportunities to express their graphic talents in *Cymru* and *Wales* only to a limited extent since he chose to avoid party political matters in his magazines. Nevertheless, the potential of Elias and Davies, along with that of another young artist, Will Morgan, as political cartoonists was recognized by Beriah Gwynfe Evans, political journalist and secretary of Cymru Fydd, who presented them with the opportunity to illustrate his book *Dafydd Dafis* (1898), the 'autobiography of a parliamentary candidate', which took the form of a collection of satirical essays on Welsh politics in the 1890s. In his introduction, Evans was 'pleased to think that he had succeeded in showing the world that Wales could produce artistic talent of the first order, that that talent had a legitimate field in the domestic literature of the nation, and that Welsh publishers could do justice to the products of Welsh art'.[31] Evans also called on the long-established talents of T. H. Thomas and Ap Caledfryn, among whose subjects were the 'mad Celts'.

[30] For Wickens and the Congress, see Marion Löffler, '*A Book of Mad Celts': John Wickens and the Celtic Congress of Caernarfon 1904 / John Wickens a Chyngres Geltaidd Caernarfon 1904* (Llandysul, 2000).

[31] Beriah Gwynfe Evans, *Dafydd Dafis, sef Hunangofiant Ymgeisydd Seneddol* (Gwrecsam, 1898), p. vi, translated from the Welsh.

above: 542. Willy Pogany,
The Lady of the Lake, illustration from
W. Jenkyn Thomas, *The Welsh Fairy Book*,
1907, 156 × 102

top: 541. Thomas Prytherch,
Death of Llywelyn, illustration from
Owen Rhoscomyl, *Flamebearers
of Welsh History*, 1905, 38 × 102

543. Sidney Herbert Sime, *Bronwen*, cover illustration for
the score of the opera by Josef Holbrooke and T. E. Scott-Ellis
(Howard de Walden), 1922, 350 × 250

In the best tradition of Ellis Owen Ellis and *Y Punch Cymraeg*, Ap Caledfryn
undermined the noble image of Hwfa Môn in his cartoon of the undignified
scramble which resulted in the poet's elevation to the post of Archdruid in 1894.
The aristocratic posing of Hwfa Môn's acolyte, Gwyneth Vaughan, was similarly
debunked by his description of her 'brawny arms' in a cartoon on the issue of
women's suffrage. Ap Caledfryn, Will Morgan, D. J. Davies and A. E. Elias all

worked in a pictorial idiom, even
when dealing with subjects which political
cartoonists such as J. M. Staniforth, working
for daily newspapers, presented in line. Elias's
comment on the discontent which led to the
great strike at the Penrhyn slate quarries was
presented in the manner of the allegorical
academic painting.[32]

In book illustration the publishers
Hughes a'i Fab were notable for their
encouragement of indigenous talent, making
use, for instance, of the young Swansea artist
Walter W. Goddard to produce black and
white work. Opportunities for colour work
were severely limited, with the notable
exception of Owen Rhoscomyl's *Flamebearers
of Welsh History*, published in 1905, which
soon established itself among the most
influential history books of the nation,
and consequently made a reputation for its illustrator, Thomas Prytherch of
Merthyr.[33] However, many of the best illustrated texts on Welsh subjects were
produced outside the country. The American Wirt Sikes's pioneering volume
on Welsh folklore, *British Goblins*, illustrated by his friend T. H. Thomas, was
published in Boston in 1881, and *The Welsh Fairy Book*, by far the finest work
in the field, was published in 1907 by Fisher Unwin in England. The stories
were told by W. Jenkyn Thomas, but the illustrations, one in full colour and the
remainder in dramatic black and red, were designed by Willy Pogany.[34] As in the
late eighteenth century, the publication of Welsh music provided an opportunity
for graphic artists to express Welsh subject matter. The connoisseur Lord Howard
de Walden, tenant of Chirk Castle, wrote librettos for a series of three operas
based on the Mabinogion, with music by Josef Holbrooke. The published editions
of *Dylan* and *Bronwen* were provided with splendid covers by the English artist
Sidney Herbert Sime, designed with the medievalist theatricality of the Celtic
Congress or the Cardiff National Pageant, though the unidentified designer of
the cover for *Don* worked in the darker eighteenth-century tradition of Last Bard
subjects.[35] De Walden later acquired a major set of mural paintings on Mabinogion
subjects. At least eleven panels had been commissioned in about 1914 by Judge
William Evans to decorate his home at Ilmington Manor, Shipston-on-Stour.
They were painted by George Sheringham, one of the most distinguished English
muralists and decorators of the period, and de Walden seems to have acquired
them as a result of the death of the patron before their installation.[36]

544. George Sheringham,
The Quest for the Holy Grail,
c.1914, medium and size
unknown

[32] Publishing opportunities for
specialist political cartoonists
and caricaturists to develop their
skills were limited, but notable
contributions were made in the
Welsh-language press by J. R.
Hughes, working for *Papur Pawb*,
and in the English language by
'Kodak', working for the Cardiff
Figaro. In Aberystwyth H. L. Roberts,
known as Ap Rhobert, published
The Aberdons in 1910, a collection of
caricatures of university academics.
An intriguing note in the *South Wales
Daily News*, 18 May 1911, records
that '"The Cambrian" (Utica, NY)
chronicles the death of the brilliant
Welsh cartoonist, John S. Pughe,
of "Puck", New York. Mr Pughe
was a native of Dolgellan [sic],
Meirionethshire, and was only
41 years of age.'

[33] Thomas Prytherch was born
in Dowlais and began work in the
drawing office of the Dowlais Iron
Company. He came to the attention of the local
MP, W. Pritchard Morgan, who arranged for him
to train at the Slade in London. He painted
landscapes and historical subjects and illustrated
several volumes, notably the English-language
edition of Ellis Wynne's *The Visions of the Sleeping
Bard* in 1909. He died in 1926. Obituary, *Merthyr
Express*, 17 April 1926.

[34] Some Welsh material was produced with
no involvement from indigenous patrons, writers
or artists. For instance, Macmillan commissioned
Albert Herter's illustration of *Pryderi and Rhiannon*
for *Enchanted Islands of the Atlantic* in 1898.

[35] Lord Howard de Walden (T. E. Scott-Ellis,
1880–1946) was of Welsh extraction and settled
at Chirk in 1912. His romantic fascination with
history was unusually intense. In 1912 Augustus
John enjoyed deer stalking 'with bows and arrows'
in his company. He noted that 'Lord Howard goes
in for falconry also and now and then dons a suit
of steel armour'. Quoted by Michael Holroyd in
Augustus John: The New Biography (London, 1996),
p. 393.

[36] William Evans (1847–c.1916) was born in
Merthyr and pursued a distinguished legal career.
He published legal tracts and also a volume of
Welsh ballads. The panels were shown at the
National Library of Wales in the 1921 Exhibition
of Modern Paintings, and are fully described in
the catalogue, pp. 12–16.

545.
Margaret Lindsay Williams,
Lady of the Van Lake,
c.1915, illustration from
John Morris-Jones and
W. Lewis Jones (eds.),
The Land of my Fathers,
1915, 187 × 135

below: 546.
Margaret Lindsay Williams,
The City of Refuge, 1911,
Oil, 1020 × 1270

The mediocre design of Welsh periodicals, about which J. Kelt Edwards had complained, improved dramatically with the publication in 1914 of *The Welsh Outlook*, which took a serious interest in visual culture.[37] Its inclinations were modernist but a few good illustrations on mythological themes were published. Notable among them was one of Margaret Lindsay Williams's illustrations of the legend of Llyn y Fan, taken from an unusual venture sponsored by the Welsh-owned Keenora food company, based in Liverpool and Manchester. Williams's first full-colour illustration of the folk tale had been published in 1915 in *The Land of my Fathers*, a volume of extracts from Welsh literature with

548. Margaret Lindsay Williams,
Silence, c.1910, Pencil,
2100 × 1100

547. Margaret Lindsay Williams,
Portrait of a Young Woman in White,
1909, Oil, 600 × 500

pictures and photographs of sculpture
by several Welsh painters, including
J. Kelt Edwards and Goscombe John.
This ambitious patriotic project, edited
by John Morris-Jones and W. Lewis
Jones, was intended to raise money
for Welsh soldiers fighting in the
Great War.[38] Morris-Jones's translation
of the legend was reprinted as a booklet,
intended as the first in a series, and
illustrated with nine further pictures
by Margaret Lindsay Williams.[39] The
daughter of a wealthy Barry shipowner,
Williams had studied in Cardiff before
progressing to the Royal Academy. Her career had begun with some brilliance
and was followed closely in the Cardiff press which, as early as 1910, published a
photograph of a group of portraits which she had exhibited locally. The following
year she left the Academy on a high note by winning the Gold Medal for her
painting *The City of Refuge*. In one of his last essays on Welsh visual culture,
Thomas Matthews correctly noted 'the strong appeal of mysticism to Miss
Williams'.[40] He predicted for her a leading role in the decoration of the national
buildings which he optimistically foresaw in the new Wales of his imagination:
'the number will become complete when we have our own Parliament-house.
Then we should decorate it with murals. It is said that we do not possess artists
with the ability to do this. And here is one more to add to the number of Welsh
artists able to carry out this kind of painting'.[41] However, Matthews's perception
of the mystical element in the art of Margaret Lindsay Williams, reinforced by
works such as the large drawing *Silence*, was misplaced if he believed it would
lead her primarily into Welsh subject matter. *The Lady of the Van Lake* proved to
be exceptional in her career, and the subject may have attracted her because of
the centrality of a woman in the story. Many of Williams's subsequent subject
works, including *The Devil's Daughter* and *The Triumph*, large-scale allegorical
subjects which attracted considerable attention at the Royal Academy and Paris
Salon exhibitions of 1917 and 1918, were similarly concerned with women.[42]

[37] For the magazine and its contribution to the
development of visual culture, see Lord, *The Visual
Culture of Wales: Industrial Society*, pp. 173–222.

[38] John Morris-Jones and W. Lewis Jones (eds.),
The Land of my Fathers: A Welsh Gift Book
(London, 1915).

[39] John Morris-Jones clearly shared the concern
with the visual manifested by Tom Ellis and
O. M. Edwards, his student colleagues at Oxford.
His *Caniadau*, published by Fox, Jones & Co. of
Oxford in 1907, was notable for a fine illustrated
title-page in the medievalist manner.

[40] Thomas Matthews, 'Celf Miss Margaret Lindsay
Williams', *Cymru*, XLVII (1914), 217, translated
from the Welsh.

[41] Ibid.

[42] The pictures, which were last in the possession
of Urdd Gobaith Cymru, are untraced. For their
later history, see R. E. Griffith, *Urdd Gobaith Cymru,
Cyfrol 2, 1946–1960* (Aberystwyth, 1972), p. 11.
The career of Margaret Lindsay Williams is
analysed in Angela Gaffney, 'Wedded to her
Art': Margaret Lindsay Williams 1888–1960
(Aberystwyth, 1999).

Despite the interest in Welsh history, mythology and folklore which was stimulated by the general atmosphere of national revival in the *fin de siècle* period, the efforts of a substantial number of young artists who emerged at the time to image the national myth lacked coherence. Among them, only Christopher Williams seems to have had both a grand vision and the technical ability to carry it through, though he too would fail to capitalize fully on the potential created by the mood of the times.[43] Williams was born in Maesteg in 1873 and showed an early interest in art when he was taken as a schoolboy to see the pictures at Cardiff Museum. However, according to his own account, it was the sight of Lord Leighton's *Perseus and Andromeda* at the Walker Art Gallery in Liverpool in 1892 which inspired him to take up art as a career. Initially he was taught by the watercolour painter F. J. Kerr at the Neath Technical Institute, but in the following year he obtained a scholarship to the Royal College of Art. He did not turn his back on Wales, however, and by 1896 he was in contact with Clarence Whaite.[44] He subsequently studied at the Royal Academy until 1901. The influence of Leighton remained strong but it was overtaken by that of G. F. Watts, with whom Williams became acquainted shortly before his death, though he could never think of him as an old man:

> he always was to me his youthful self – Love in Love Triumphant. Even when I saw him in his bed such a short time ago I could not look upon him as an old man. His hair was white, his hands like those of Cardinal Manning, but his soul – and spirit – oh so young ... I felt at one with Watts. I felt as if I had known him all my life. I had so absorbed his work that I seem to have been part author of his ideas myself.[45]

As we have seen, the admiration of Welsh painters for Watts was partly a matter of Celticist patriotism, for the great English painter had acknowledged his own Celtic ancestry. However, to an intellectual culture permeated simultaneously by Celticism and Nonconformity, it was the perception of Watts as both a Celt and a moralist which afforded him such an elevated place in this pantheon. Christopher Williams, therefore, not only admired 'the Celtic nature' of Watts, but also believed that he was 'not an advocate of art for art's sake' since 'the highest form of art is that which portrays the deep problems and aspirations of human life and sets people thinking'.[46] This remark set the subject painting of Christopher Williams (like that of Margaret Lindsay Williams) starkly apart from the work of Augustus John, which was evolving at exactly the same time but in a radically different direction. Nevertheless, if the art of Williams seems conservative alongside that of John, it was not because the artist was escaping into the past, but because, unlike his contemporary at the Slade School of Art, he did not reject the high seriousness of his Nonconformist cultural background. Like Cox and Whaite before him, Nonconformity provided the foundation upon which his aesthetic was built. Williams was well aware of the dangers of both Nonconformist and nationalist bigotry,[47] but it was the combination of his Christian faith, patriotism and radical social views which led him, like Watts, to paint moralities. Williams's

[43] The work of Irish artists achieved a higher profile in the similar atmosphere of national revival prevailing in that country in the period. See James Christen Steward (ed.), *When Time Began to Rant and Rage: Figurative Painting from Twentieth-Century Ireland* (London, 1999).

[44] NLW, Whaite Archive. Williams wrote to Whaite regarding the confusion which might arise as a result of the adoption by the South Kensington School of the name the Royal College of Art, whose initial letters were the same as those of the Royal Cambrian Academy.

[45] Jeremiah Williams (ed.), *Christopher Williams, R.B.A. An Account of his Life and Appreciations of his Work* (Caernarfon, n.d.), pp. 46–7. Williams quotes extensively from the painter's own memoir of his life, a document which subsequently disappeared.

[46] A lost Williams memoir, quoted by A. D. Fraser Jenkins in his introduction to the catalogue, *Christopher Williams Centenary 1873–1973* (Cardiff, 1973), p. 5.

[47] See, for instance, 'The Moss Gatherer', Williams's memoir of his experience of the Nonconformist bigotry of a village community, published in Williams (ed.), *Christopher Williams*, pp. 54–7.

[48] Ibid., p. 94.

[49] The first version of the portrait, which was not commissioned, was rejected by the Royal Academy. It seems unlikely that Williams was aware of the Herkomer portrait, although the two men moved in the same artistic circles in London.

549. J. F. Lloyd,
Christopher Williams (centre)
with Mrs Emily Williams
and B. A. Lewis, c.1905

550. Christopher Williams,
Hwfa Môn, 1904, Oil,
1350 × 1080

interest in Celtic material may have
begun before 1904 but it was his
contact with the intellectual circle
of the National Eisteddfod and the
Pan-Celtic movement in that year
which activated him. His experience at
the Celtic Congress in Caernarfon and the National Eisteddfod at Rhyl inspired
him to paint the first of two versions of a portrait of Hwfa Môn.[48] The Archdruid
was arrayed in Herkomer's regalia, and Williams also followed the iconography
of Herkomer's portrait, setting the sitter in front of a cromlech.[49] The following
year, while painting a commissioned portrait of John Morris-Jones in Bangor,
Williams wrote to his wife Emily:

So here I have been with two really great men, Celts among Celts, and I have been steeped in Celtic ideals, flooded with early Welsh history and pre-Arthurian tales and mythology. The Mabinogion has been in constant use, so also has Lady Charlotte Guest's Red Book and the Black Book of Carmarthen. I have plenty of subjects for painting, three of which I shall soon tackle. It is a gold mine untouched and full of Welsh fire and imagination.[50]

Nevertheless, the translation of Williams's initial enthusiasm into paintings took several years during which the work of his contemporaries may have strengthened his resolve. In 1906 he must have seen Whaite's *The Archdruid: A Throne in a Grove* at the National Eisteddfod at Caernarfon, and in the following year he evidently read Thomas Stephens's collection of essays, *Wales: To-day and To-morrow*. In an article entitled 'Art in Wales', T. H. Thomas pointed out the visual potential of mythological material: 'Besides, there is the vast and untouched region of Cymric romance and tradition, the strange personages and actions of the earlier Mabinogion and the chivalry of the later tales.'[51]

In the same publication Augustus John was acknowledged for the first time by the Welsh establishment as a major figure by being invited to contribute his thoughts from Paris, alongside those of Thomas. John was a man in revolt against most things, among them the visual failings of his compatriots, whose 'neglected sense of beauty evaporates in fits of yawning after periodical attacks of spiritual insomnia; their architectural sense is exhausted in the effort to construct New Jerusalem; their sense of design just suffices to render intelligible to them the scheme of the universe; – while form, colour, suggest ideas entirely trivial or vaguely diabolical'.[52] Following this opening condemnation John turned to art education in Wales. With some semblance of patriotic spirit, he blamed 'English bunkum' for the failing system, though he also maintained that 'Welsh ignorance and servility'[53] were responsible for adopting it without criticism. Christopher Williams was sufficiently emboldened by John's bombastic comments to launch into a diatribe of his own on the subject in an address to the Cymmrodorion delivered at the National Eisteddfod at Llangollen in 1908. Following T. H. Thomas, who had spoken on Welsh art in the past, Williams presented a scathing attack on contemporary attitudes to art in Wales: 'There seems, somehow, to be no conception among the Welsh people of what Art really is ... Ninety-nine out of every hundred treat it with an indifference which suggests that they think it means only painting pretty pictures.'[54] Art school provision was poor and the built environment militated against an appreciation of the beautiful since the industrial valleys of the south had been desecrated by 'investors and company promoters and landlords'. However, despite his obvious indebtedness to Augustus John, he proposed a way forward based not on that painter's emerging Modernism but on the achievements of G. F. Watts, who had shown 'to what heights an artist of our race can go, if only given the needed opportunities'.[55]

[50] Quoted in Jenkins, *Christopher Williams Centenary*, p. 7. The other great man may have been Thomas Shankland, Librarian at the University College of North Wales, Bangor, with whom Williams later stayed during visits to the north.

[51] T. H. Thomas, 'Art in Wales' in T. Stephens (ed.), *Wales: To-day and To-morrow. 80 Writers. 80 Portraits* (Cardiff, 1907), pp. 356–7. Thomas continued: 'Something in this direction has been tentatively done by a few, as in Tom Prytherch's series of "Welsh Heroes", commissioned by an earnest patriot.' The series has not been traced.

[52] Augustus E. John, 'Art in Wales' in ibid., p. 349.

[53] Ibid., p. 350.

[54] Williams, *Christopher Williams*, p. 128.

[55] Ibid., p. 132.

[56] Ibid., p. 63.

551. Unknown photographer,
*Christopher Williams, standing with his
picture of the Investiture of the Prince of
Wales at Caernarfon Castle, c.1911*

Apart from the portrait of Hwfa Môn, Williams did not begin to lead by example until 1910, when *Ceridwen*, the first of his three Mabinogion pictures, was exhibited. The following year was more productive, and was also indicative of national attitudes in the period. In the summer of 1911 George V's eldest son, Edward, was invested as Prince of Wales at a ceremony in Caernarfon Castle. Although not universally welcomed, this event was regarded by most intellectuals as an affirmation, rather than as a denial, of Welsh nationality. Christopher Williams was of this persuasion and, having expressed his desire to paint the ceremony for Lord Plymouth, was granted access and, subsequently, sittings by members of the royal family. The result was a satisfactory, if rather pedestrian group, in which the painter's impressionistic enjoyment of the vivid colours of the robes in the sunlight took precedence over the gravity of setting the crown on the Prince's head, a moment greeted, as Williams himself recalled, with 'a hush and a sigh' by the loyal crowd.[56] While engaged on this officially sanctioned group portrait, Williams began to draw ideas for an allegorical picture intended to express the essence of the new Welsh age which, its supporters believed, was confirmed by the investiture. *Wales Awakening* made use of the myth that Gwenllian, daughter of Llywelyn ap Gruffudd, had been bewitched at her baptism to sleep forever.

552. Christopher Williams,
Ceridwen, 1910, Oil,
1585 × 1035

554. Christopher Williams,
Gwenllian, drawing for
Wales Awakening,
Charcoal and chalk,
c.1911, 290 × 230

opposite:
553. Christopher Williams,
Wales Awakening, 1911,
Oil, 3000 × 2000

[57] Thomas Matthews, 'Celf yng Nghymru',
Cymru, XL (1911), 19, translated from the Welsh.

[58] Ibid., 22.

[59] *Blodeuwedd* was not painted until c.1925–30,
and on a much smaller scale than the other two
pictures. It may be that Williams was inspired to
return to the national subject matter which he
had otherwise abandoned after the Great War
by the publication of the first two acts of
Saunders Lewis's *Blodeuwedd*. I am grateful
to Ceri Sherlock for this suggestion.

555. Christopher Williams,
Blodeuwedd, c.1925–30, Oil,
1105 × 510

The national spirit of Wales slept, but after seven centuries, under the influence
of the new light, which is the light of education, she awoke ... Cymru Fydd is no
longer in its infancy, but her gentle fair face and bearing are seen awakening
to the white light of dawn. She is older than England; but because she has
slept so long, she is yet young, and sees new hopes, – new and limitlessly high –
in the fields of song and art.[57]

In his detailed analysis of the picture, clearly written in consultation with the
painter, Thomas Matthews reiterated the view that much had yet to be done to
bring art forward in the culture. He saw Williams as the leader of the anticipated
revival: 'I hope that I can foresee a brilliant future for him, because his aim is not
"Art for Art's sake", but Art to elevate life.'[58]

Apart from the completion of his trilogy of Mabinogion pictures with *Branwen*
and *Blodeuwedd*, Christopher Williams did not fulfil Matthews's expectations of
him in the creation of a national art.[59] Following the Great War he pursued his
career primarily as a portrait painter, recording many important Welsh figures in
public life, such as the philosopher Sir Henry Jones. Williams painted Jones on
three occasions during his rise to the Chair of Philosophy at Glasgow University,
and seems also to have been personally close to him. They shared similar radical
Nonconformist sentiments on social issues and education, and Williams may well
have perceived in Jones a living example of the potential of a nation liberated by

556. Murray Urquhart,
Owain Glyndŵr Murals, 1912–14,
Oil, left panel (Panel 2) 2692 × 1524;
right panel (Panel 3) 2692 × 1498

education, which he had painted in allegory in *Wales Awakening*. The small number of national subjects painted by Williams might suggest uncertainty in his mind regarding the genre, but a simple absence of opportunities is more likely to have been responsible in a nation which, despite all the talk of revival, still had few major public buildings for which they might be commissioned.[60] The only large mural of this kind to be carried out before the Great War in Wales was a series of four pictures of the life of Owain Glyndŵr in Machynlleth, painted by a young Scottish artist, Murray Urquhart, in 1912 and 1914.[61]

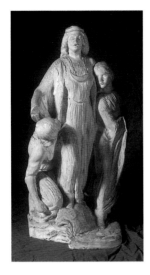

557. J. Havard Thomas,
Maquette for Buddug,
*c.*1916, Plaster, 900h.

558. Lanchester, Stuart and Rickards,
The Marble Hall, City Hall, Cardiff, 1906,
sculptures installed 1916

The importance of public buildings in providing sites for paintings and sculptures of national sentiment was made plain by the example of the one artwork which did aspire, before the Great War, to the status of a grand statement of Welsh historical identity. Of the four allegorical groups of sculpture which adorned the exterior of Cardiff City Hall, opened in 1906, only one, *Unity and Patriotism*, had a national theme. Nevertheless, although it was a local authority building, City Hall was widely perceived as having a quasi-national status (since it housed the government of by far the most important urban centre in Wales) and the *Pantheon of National Heroes* in the Marble Hall was a part of the original conception. Work on the series of sculptures which comprise the *Pantheon*, financed by the coalowner D. A. Thomas, began eight years after the completion of the building. The commissions were allocated, without competition, on the advice of J. Havard Thomas, the project consultant.[62] Thomas figured among those many artists accorded the status of Welsh by his contemporaries on the basis of his family origins, since both his parents were from west Wales. He had occasionally competed at eisteddfodau, notably in 1874 at Bangor where his relief group *Boadicea at the Head of her Army* had been awarded the prize. The same subject of Buddug became Havard Thomas's contribution to the *Pantheon*, though it was undertaken in somewhat unusual circumstances. At a late stage in the proceedings it was realized that the ten national figures selected as subjects were all men, and so Buddug was added, narrowly winning the approval of the committee over Ann Griffiths.

With the inclusion of Buddug, who represented not only women but also Ancient Britain, all the main strands of early twentieth-century national sentiment were expressed in the *Pantheon*: the early church (*Dewi Sant*), Nonconformity (*William Williams, Pantycelyn*), poetry (*Dafydd ap Gwilym*), and both Anglophile British

[60] In 1911 Thomas Matthews campaigned for Williams to be commissioned to paint a mural series on the life of John Gibson, but nothing came of the proposal. The murals were to be located at the John Gibson Memorial School at Y Gyffin, Conwy: 'A young Welsh artist, Mr. Christopher Williams, has paid special attention to mural decoration and to frescoes. He is already in the front rank as a portrait painter, and is able, I am positive, better able I would say, to draw up a scheme of mural decoration in consonance with Gibson's ideals than anyone else, for he is imbued with the same inspiration that animated Gibson.' *Western Mail*, 31 January 1911. The letter, signed 'Nationalist', is almost certainly by Thomas Matthews, who pointed out that an agreement to publish a biography of Gibson had been signed that very day, the anniversary of the great man's death. Matthews himself was the author of the biography. Christopher Williams's *Wales Awakening* remained in the artist's studio until his death, and so exercised no influence on the public for whom it was intended. A comparable Irish picture, Lady Glenavy's *Éire*, painted in 1907, became widely known. The picture was purchased by Maude Gonne and was given to St Edna's College in Dublin. One of the students later recalled how the picture had inspired him 'to die for Ireland'. Steward (ed.), *When Time Began to Rant and Rage*, p. 130.

[61] *The Westminster Gazette*, 2 February 1914, believed that 'the work is so good that, but for the tourists, it would seem almost a pity to hide it in what in these days is little more than a village', a view which irritated the editor of *The Welsh Outlook*, I (1914), 149. Urquhart was born in 1880 and had trained in Edinburgh and London and with Julian in Paris. The circumstances in which Urquhart gained the Glyndŵr commission are unknown, but the Davies sisters may have been involved. Urquhart helped hang the exhibition of their collection organized by the National Museum in 1913. O. M. Edwards also appears to have been involved. In 1912 Urquhart wrote to Edwards requesting details of the pikes used in the time of Glyndŵr and describing progress on the designs: 'I have now represented Glyndŵr leading on a crowd of his soldiers, most of them roughly dressed as peasants would be. This seems to me to suggest what you impressed upon me – that he was the leader and hero of the common people.' NLW MS 8437D, letter 40.

[62] According to the *Western Mail*, 11 March 1919, the original conception was that of Wheatley, town clerk of Cardiff, and it was he who persuaded D. A. Thomas to finance the project. The decision not to hold an open competition caused consternation among the Royal Society of Sculptors. Not surprisingly, those members of the society's Council who had been awarded commissions supported Havard Thomas. The ordinary members were outraged and the Council was forced to resign.

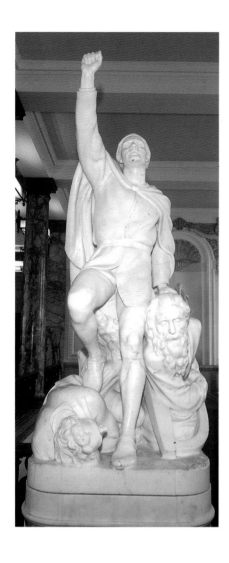

559. Harry Pegram,
Llywelyn ap Gruffudd,
c.1916, Marble

political sentiment (*Harri Tudur* and *Sir Thomas Picton*) and the independent Welsh tradition (*Hywel Dda*, *Llywelyn ap Gruffudd* and *Owain Glyndŵr*).[63] The statues were carved mostly by younger English sculptors of conservative inclinations, although two of them, T. V. Clapperton and Leonard Merrifield, had worked in the studio of Goscombe John, whose *Dewi Sant* was the centrepiece of the display. The style of the works was uniform, reflecting the process of decision-taking by committee and Havard Thomas's preference for a marble which gave soft rather than dramatic incised forms. Only Harry Pegram's *Llywelyn ap Gruffudd* made use of extant Welsh iconography in the form of the fallen bard at the Prince's feet, and, indeed, the figure of Llywelyn would have the greatest impact on public consciousness. Over fifty years after the sculpture was made, the clenched fist of the Prince entered popular iconography as a token of the defiance of young people at demonstrations by the Welsh Language Society. The *Pantheon* was opened in 1916 by David Lloyd George, an event celebrated in a massive group portrait painted by Margaret Lindsay Williams. The epigraph to *A Nation's Heroes*, a pamphlet written to explain and celebrate the works, was taken from Thomas Davis, and aptly summed up the ethos of the historicist movement in national art, which, at last, had found substantial expression:

The National mind should be filled to overflowing with native memories ... The History of a Nation is the birthright of her sons. Who strips them of that, takes that which enricheth not himself but makes them poor indeed.[64]

560. Margaret Lindsay Williams,
David Lloyd George unveiling the Pantheon of National Heroes,
1916, Oil, 1625 x 3479

561. Hugh Williams,
Y Sasiwn Gyntaf, 1912,
Lithograph, 300 × 390

At the core of Christopher Williams's picture *Wales Awakening* was the idea of education as the means to national improvement, from which both self-respect and the respect of others would flow. Those who had stood in need of improvement were the common people, identified by most patriots and nationalists as the rural and Welsh-speaking folk. By the end of the nineteenth century, many intellectuals believed that the battle had been won, and the idea of an enlightened common people – *y Werin Gymreig* – began to assume a mythic quality. Two perceptions of society, one of which originated in Wales, the other outside, came together to form this powerful myth, and both were strongly represented in the visual culture. Firstly, Nonconformist intellectuals celebrated the folk raised up from ignorance by the grace of God in the Great Revival of the mid-eighteenth century, a phenomenon perceived as particularly Welsh and therefore reinforcing the ancient indigenous notion that Wales was, in some way, a favoured land. As we have seen, Hugh Hughes propagated this notion, following the secession of the Calvinistic Methodists from the Church of England in 1811, both by celebrating the leadership of the movement in portraiture and by allegorical imagery of self-improvement, mainly in wood engravings. The celebration of the value system and leadership of Nonconformity was carried forward in the second half of the nineteenth century in popular print imagery by Ap Caledfryn and other less well-known figures, including Hugh Williams of Llanrwst, whose *Y Sasiwn Gyntaf* (The First Association) was produced for publication by Hughes a'i Fab in 1912.[65]

The extent to which the cult of the Nonconformist leader had penetrated popular consciousness is suggested by the works of the remarkable naive painter Robert Hughes of Uwchlaw'r Ffynnon in Llŷn, a minister and a poet who turned to painting at the age of about fifty. He painted friends and neighbours such as Hugh and Jane Jones celebrating their wedding anniversary in 1888 at the ages of 98 and 100 respectively, but he was best known for his long series of portraits of Nonconformist ministers.[66] Some of these images were based on photographs and engravings, but Hughes was blessed with a remarkable visual memory which enabled him to recall the features of long-departed ministers and preachers from his youth, such as *Robert Dafydd, Brynengan*, whom he painted over fifty years after his death. As a smallholder, minister and painter, Robert Hughes could truly be said to celebrate his Nonconformist rural tradition from the inside.

[63] The remaining figures were William Morgan and Gerald of Wales.

[64] Thomas Davis (1814–43), the Irish nationalist. Quoted in D. R. Jones, *A Nation's Heroes* (Cardiff, [1916]), title-page.

[65] Hugh Williams (1867–1955) made his career as a commercial artist and portrait painter in London. During the period of his early struggles he was encouraged by O. M. Edwards. For Williams, see Richard H. Lewis, 'Yr Arlunydd Cymreig a anghofiwyd', *Y Casglwr*, 46 (March, 1992), 1. Williams painted several other national subjects, including *Gwenllian* and *Owain Gwynedd*.

[66] That Robert Hughes was a celebrated figure in his own time is borne out by the visit to his studio of members of the local scientific and literary society in 1884, for which see Peter Lord, 'The Meaning of the Naive Image' in idem, *Gwenllian: Essays on Visual Culture*, p. 75. The life of Robert Hughes is recorded in Robert Hughes, *Hunan-Gofiant ynghyd â Phregethau a Barddoniaeth* (Pwllheli, 1893).

562. Robert Hughes of Uwchlaw'r Ffynnon,
Y Berl Briodas, 1888, Oil, 290 × 455

right:

563. Robert Hughes of Uwchlaw'r Ffynnon,
Robert Dafydd, Brynengan, c.1885, Oil,
315 × 250

Others celebrated it from a distance and for more complex reasons. In *Echoes from the Welsh Hills*, published in 1883, the Revd David Davies promulgated among the English the virtues of the Nonconformist rural community to which Robert Hughes belonged.[67] Simple line engravings by T. H. Thomas reinforced the archetypal images of Welsh piety presented in the text, including a funeral wending its way over the hills in a storm in the manner of Clarence Whaite. In *The Harvest Field* a chapel, a mountain landscape and the labour of the common people in the fields were brought together in the manner of William Thomas (Islwyn), one of the most celebrated poets of the period, in his poem 'Crefyddolder Cymru' (The Religiousness of Wales):

> In the principles of the precious Gospel
> How knowledgeable her people are!
> *Gospel* is almost the first word
> They are taught beneath her mountains.[68]

Such poets were among the few individuals able to challenge ministers and preachers for a place in popular iconography, usually in the form of the carte-de-visite photograph, but occasionally also in coloured prints, such as that which celebrated *Talhaiarn, Mynyddog* and *Ceiriog* in 1890.

[67] David Davies, *Echoes from the Welsh Hills: or, Reminiscences of the Preachers and People of Wales* (London, 1883).

[68] 'Yn egwyddorion yr Efengyl gu / Mor hyddysg ydynt ei thrigolion hi! / Y gair *Efengyl* yw y cyntaf bron / A ddysgir iddynt dan fynyddau hon.', William Thomas (Islwyn), *Caniadau gan Islwyn* (Gwrecsam, [1867]), p. 96.

564. Anon.,

Talhaiarn, Mynyddog and

Ceiriog, 1890, Lithograph,

510 × 395

565. T. H. Thomas,

The Harvest Field, illustration from

David Davies, *Echoes from the Welsh Hills*,

1883, 77 × 57

Like Islwyn and Ceiriog, T. H. Thomas associated the values of the people with the landscape which sustained them. By 1880 the second perception of society which fed the myth of *y Werin Gymreig* – the Arcadian image of Wales with its classical roots, reinterpreted by the Picturesque movement – had become thoroughly absorbed into the Nonconformist ethos. It was reinforced by ideas of the dignity of the labour and the craft skills of the common people with their origin in the pre-industrial world which, through the proselytizing of William Morris and the art of Burne-Jones, were also perceived as having a strong Welsh connection.[69] When Samuel Maurice Jones, the son of a Methodist minister, left John Cambrian Rowland's Art School in Caernarfon, he went to London where he frequented John Ruskin's lectures given at the National Gallery. Though propounded by one of the greatest English thinkers of the day, Ruskin's ideas had a peculiar resonance for Jones, as they would for O. M. Edwards and Tom Ellis a little later. Ruskin helped them to bind together elements of Welsh identity fragmented by the polarity between patrician and democratic views of rural society in the eighteenth century, and in the nineteenth century by contrasting images of

[69] Burne-Jones and Morris were given substantial entries in T. Mardy Rees, *Welsh Painters, Engravers, Sculptors (1527–1911)* (Carnarvon, [1912]), pp. 78–84, 107–9.

341

70 In his study of the Romantic movement in literature, *Y Nos, y Niwl, a'r Ynys: Agweddau ar y Profiad Rhamantaidd yng Nghymru, 1890–1914* (Caerdydd, 1960), Alun Llywelyn-Williams suggested that even at the high point of patriotic poetry it was possible to discern two sources, as was the case in the visual culture. He suggested that the roots of Eliseus Williams (Eifion Wyn) were to be found in the classical, patrician tradition which depicted the folk as living in a state of innocence in a Welsh Arcadia, and that Crwys and J. J. Williams were rooted in the Nonconformist idea of the reconstructed folk, raised from ignorance by the grace of God in the Great Revival. For a detailed analysis of the image of the Welsh folk, see Peter Lord, 'Yr Etifeddiaeth – Delwedd y Werin' in Ivor Davies and Ceridwen Lloyd-Morgan (eds.), *Darganfod Celf Cymru* (Caerdydd, 1999), pp. 82–109.

566. Samuel Maurice Jones,

Painting Dolwar Fechan, home of Ann Griffiths, illustration from O. M. Edwards,

Cartrefi Cymru, 1896, 50 × 63

Wales constructed from a religious standpoint by insiders and from an aesthetic standpoint by outsiders. Nonconformist religiosity and modesty were identified with the metaphorical closeness to God and purity of the mountain landscape in which they flourished.[70] In 1872 the young Samuel Maurice Jones travelled to Paris, where, sitting on the remains of the recently demolished Vendôme Column, he compared the women of Wales with the women of Paris:

> They are very fond of different colours and have a fair bit of 'paint' on their faces. I prefer the beauty of the MAID OF EITHIN FYNYDD and THE SHEPHERDESS OF SNOWDON and MEGAN'S DAUGHTER with cheeks painted by the breeze and dew of the Hills – and the scent of Heather on their clothes, and the poetic rhymes of the Land of the Golden Hills on their lips.[71]

The modesty and simplicity of such people was later celebrated by O. M. Edwards in high romantic terms and for the benefit of the Welsh people themselves, rather than for the ingratiating motives which lay behind David Davies's writings in the English language:

> In the loneliness of my meditation I rejoice to think about the Welsh folk, and I thank God for them, – for their faithfulness and honesty, for their desire to do that which is right, for their love of thought, for the correctness of their opinion, for their tenderness of feeling and the strength of their resolution.[72]

In his speeches and essays, Tom Ellis linked these abstract virtues with powerful images of landscape and homeland:

> As I traverse districts like this, I feel that every cottage built on a Welsh hillside, and every generation reared within it contain new possibilities for Wales. For from such have come the leaders of Welsh thought and movements, the makers of our nation.[73]

The quotation was copied by Samuel Maurice Jones into a notebook,[74] and it was he who, with texts by O. M. Edwards, made the idea of *Cartrefi Cymru* (the Homes of Wales) a paradigm of romantic nationalist thought at the end of the nineteenth century. Essays on the humble birthplaces of leaders of Welsh life, written by Edwards and illustrated by Jones, began to appear in the magazine *Cymru* in 1891, and were assembled in what became one of the most popular books of the period in 1896.[75] Jones's sense of the resonance of place, frequently expressed in his notebook,

567. Samuel Maurice Jones,

Birthplace of Hugh Owen, c.1890–5,

Watercolour, 310 × 493

was particularly strong: 'Does one not feel the magic and enchantment of the names TREFECA and THE OLD CHURCH AT TALGARTH. THE BIRTH PLACE OF THE NEW WALES. Where God visited in his Grace and spirit and heart.'[76] As unpretentious as the homes they represented, the illustrations of Samuel Maurice Jones peppered the pages of national publications well into the post-war period.

In literature the idea of *y Werin Gymreig* reached its apotheosis in 1911 when William Williams (Crwys) won the Crown at the National Eisteddfod in Carmarthen with his poem 'Gwerin Cymru' (The Common People of Wales). In his adjudication J. J. Williams said that 'the folk have got their poem, and we believe that they will always take pride in it', a just claim which might equally be applied in the context of visual culture to S. Curnow Vosper's painting *Salem*. The picture had been exhibited at the Royal Academy in 1908 and made available as a colour print by its owner, Lord Leverhulme. It soon superseded Cox's *The Welsh Funeral* as the visual epitome of *y Werin Gymreig* in the minds both of outsiders and the common people themselves. The reasons for its astonishing success are complex, but the recognition of the image as a token of a value system founded on the conjunction of Nonconformist piety and Wales as Arcadia was the most important.[77] In Crwys's poem more than one echo of the painting may be heard, but it is heard most clearly in those lines which refer to the tradition first celebrated in the visual culture by Hugh Hughes:

> Come closer and you will hear the sound
> Of praise rising above the neighbourhood,
> It is Pantycelyn's hymn to the Anointed One
> Being sung by the zealous great-grandsons
> Of those who sang them over a century ago
> On the green at Bala and Llangeitho Fawr.[78]

In J. Kelt Edwards's design for the frontispiece to the collected poems of Crwys, published in 1920, the painter concentrated on the idea of the folk as guardians of the cultural heritage, showing a living cottage below the ruins of a castle, clearly suggesting Harlech:

> A court and a castle it has not,
> Nor a palace or a manor now,
> But the old tongue is flourishing
> On the lips of the common people.[79]

568. J. Kelt Edwards,
Title-page of *Cerddi Crwys*
(1920), 1919, 180 × 120

569. Unknown photographer,
*Samuel Maurice Jones (second from the right)
with Crwys, crowned bard, at the National
Eisteddfod at Colwyn Bay*, 1910

[71] NLW, Samuel Maurice Jones Papers, translated from the Welsh.

[72] O. M. Edwards, *Er Mwyn Cymru* (Wrecsam, 1922), p. 65, translated from the Welsh.

[73] T. E. Ellis, 'Social Life in Rural Wales', *Speeches and Addresses by the Late Thomas E. Ellis MP* (Wrexham, 1912), p. 131.

[74] NLW, Samuel Maurice Jones Papers, notebook.

[75] O. M. Edwards, *Cartrefi Cymru* (Wrecsam, 1896).

[76] NLW, Samuel Maurice Jones Papers, notebook, translated from the Welsh.

[77] Peter Lord, 'Salem: A National Icon' in idem, *Gwenllian: Essays on Visual Culture*, pp. 37–42. The story of the picture is recounted in Tal Williams, *Salem: Y Llun a'r Llan / Painting and Chapel* (Barddas, 1991). For the picture in the context of industrial Wales, see Lord, *The Visual Culture of Wales: Industrial Society*, pp. 108–9.

[78] 'Tyred yn nes, a thi a glywi sŵn / Y moliant yn dygyfor uwch y fro, / Emyn Eneiniog Pantycelyn yw / Yn cael ei ganu gan orwyrion brwd / Y sawl a'i canent fwy na chanri'n ôl / Ar lawnt y Bala a Llangeitho Fawr'. William Crwys Williams, *Cerddi Crwys* (Llanelli, 1920), p. 20.

[79] 'Llys a chastell nid oes iddi, / Plas na maenor chwaith yn awr, / Ond mae'r heniaith yn ymloywi / Ar wefusau'r werin fawr.' Ibid., p. 17.

572. S. Curnow Vosper,
Market Day in Wales, c.1910,
Watercolour, 374 × 307

571. Unknown photographer,
*T. H. Thomas and Women from the
Aran Islands*, 1904

opposite:
573. Carey Morris,
The Welsh Weavers, c.1910,
Oil, 1422 × 1118

top: 570. Arthur Lewis, *Interior of
a house in Aberystwyth, with a print
of S. Curnow Vosper's* Salem *on the wall
(top right)*, c.1925, Photograph,
170 × 230

The expression of the idea of an enlightened folk and of a modern culture sustained by their Nonconformist values in a high art form proved to be a more elusive goal than its simple expression in printed images. The celebrity of Curnow Vosper's *Salem* was exceptional and was not repeated in his other works on similar themes painted both in Wales and in Brittany. Until his death in 1912 Clarence Whaite continued to express his love of the daily round of the common people in his notebooks, but this raw material was not developed as a central theme in his large exhibition paintings. Whaite's interest in what was becoming an international study of folk life was considerable and, like his colleague George Harrison, he collected artefacts. Harrison co-operated with T. H. Thomas in the acquisition of 'bygones', many of which he passed to the Cardiff Museum. Thomas combined his general interest in folk life with that of the Celtic peoples in particular, and he had visited the Aran Islands. However, the only Welsh painter to produce

574. Milo ap Griffith,
Hugh Owen, Bronze,
1886

575. Unknown photographer,
Milo ap Griffith (left) and his assistants in
his studio working on the 'Four Apostles'
for Bristol Cathedral, c.1875

[80] Edward Griffith reported that the commission, worth £1,000, had been awarded to him on 24 August 1886. In 1889 he visited Caernarfon and 'saw the statue of Sir Hugh Owen which I had been swindled out of. Evidently the Committee had used my model and a close copy had been made. A few of the accessories were slightly altered, but the artist Milo ap Griffith had produced a failure. Even in copying my work, he had not been successful'. Autobiographical memoir of Edward Griffith, NLW MS 21233C, f. 33.

[81] Dafydd Ifans, 'Edward Griffith a Cherflun Llangeitho', *Cylchgrawn Cymdeithas Hanes y Methodistiaid Calfinaidd*, nos. 9 and 10 (1985/86), 73.

large-scale paintings of folk life in the period was Carey Morris, who was born in Llandeilo in 1882. Having received an elementary art education at Carmarthen, he followed in Augustus John's footsteps to the Slade School in London. From there he chose to join the artists' colony at Newlyn in Cornwall, where the depiction of the common people was a central theme of the group of painters who had gathered there from the mid-1880s. By then the colony at Betws-y-coed was well past its prime and its leading painters ageing. The Cornish group represented an avant-garde which Morris was keen to join, an ambition later reinforced by his removal to a studio in Chelsea. Nevertheless, he produced several paintings of Welsh subjects after the Newlyn manner.

However, the high art apotheosis of the Welsh folk came not in Newlyn-type paintings but rather in the unexpected form of public statuary. Its particularity, therefore, is not immediately apparent, since its form was rarely different from that of public statuary throughout Britain in the period. To an audience steeped in the mythology of the Nonconformist leadership of Cymru Fydd, however, the sitters memorialized in marble and bronze conveyed a different message from the images of gentlemen, politicians and soldiers who dominated contemporary English

576. Unknown photographer,
Edward Griffith, c.1900

577. Edward Griffith,
Daniel Rowland of Llangeitho,
Marble, 1883

statuary. Wales was not without such works, as Goscombe John's splendid *Viscount Tredegar* equestrian of 1906 demonstrates, but imperialist celebrations of the military class were unusual. The first to be celebrated of the new leaders of Wales who had risen from among the common people was the educationist Hugh Owen, who had been prominent among the radical improvers of the 1860s. His statue was unveiled on the Castle Square in Caernarfon in 1886, five years after his death. The work was carried out by Milo ap Griffith, though under somewhat dubious circumstances, since it appears that Edward Griffith had originally been granted the commission.[80] Griffith, however, had already had the satisfaction of carrying out the statue of Daniel Rowland at Llangeitho, which, although strictly speaking a historical piece, was a manifestation of the same ethos. The excitement of the unveiling of the Daniel Rowland memorial in 1883 was recorded by Griffith in an autobiographical memoir:

At 10 a.m. the weather cleared up and at that hour there was a great crowd coming in from all parts, & by noon it was difficult to make a way through the crowd for Dr. Edwards to get to the Pedestal, from which he had to mount a platform slightly raised from the ground at its base. All became excited and after a speech by him Dr. Thomas followed. Then followed several others wh[ich] was again in a few brief words followed by Dr. Edwards which while he spoke gave the cords a stiff pull & away went the sheets flying in the wind among the people. A great & lusty cheer from the crowd time after time made the Hills ring out in the distance, and all was over. I was called upon to speak & though refusing, begging to be excused, I had to hold forth but I dont know how I got on, it was reported in Welsh, so I never understood what I had been gassing about, excepting that the people followed it up by cheering me when I had finished, whether they understood me I doubt very much as very little English was understood in the remote parts of Wales at that time.[81]

579. William Goscombe John,
Daniel Owen, Bronze, 1902

578. William Goscombe John,
Lewis Edwards,
Bronze, 1911

[82] NLW MS 21233C, ff. 30–1.

[83] Lewis Edwards was also celebrated in paint by Jerry Barrett, the English painter of the famous *Florence Nightingale receiving the Wounded at Scutari*. A young O. M. Edwards had fled the unctuous unveiling ceremony in 1877, reporting the words of a more dutiful friend that 'The unveiling of the Dr's picture was a scene of awful seboni [flattery]'.

[84] John Ballinger (1860–1933) was the Librarian of Cardiff Free Library and Secretary of the School of Art, which provided a travel fund, supported by the Marquess of Bute and others, for Goscombe John in 1888. The following year he travelled in Greece, Turkey, Egypt and Italy. Ballinger subsequently became the first Librarian of the National Library of Wales at Aberystwyth.

[85] NLW, O. M. Edwards Papers, bundle dated 1895.

[86] Ibid.

Edward Griffith had been commissioned in the same year to make a bust of Dr Lewis Edwards, Principal of the Theological College at Bala, who unveiled the Llangeitho statue. Griffith also made a full-length statuette of Edwards,[82] but it was Goscombe John who would be called upon in 1911 to produce a public memorial to the man who was acknowledged by all as the leader of the Calvinistic Methodists in the period and a paradigm of the improved common man.[83] Indeed, Goscombe John received the cream of public sculpture commissions in Wales between 1895 and the Great War, and his introduction to the circles that made this possible was characteristic of the influence of nationalist intellectuals in Welsh public life in the period. In 1894 O. M. Edwards published in his magazine *Wales* an illustrated article about the sculptor, written by John Ballinger, one of the group of Cardiff patrons whose support had been of crucial importance to John at the beginning of his career.[84] In the same issue of *Wales* the second part of a serialization of Daniel Owen's celebrated novel *Enoc Huws* was published in translation, and when the writer died in the following year Goscombe John wrote to O. M. Edwards confessing that although his acquaintance with the work of the novelist was slight (and probably acquired from this source) 'the news came to me as a blow, and quite as a personal loss'.[85] The sculptor made a surprising proposal:

Now nothing would give me keener pleasure than to do a memorial to our distinguished fellow countryman, for whatever sum was got together, however small this amount, counting my own remuneration as nought in this matter.[86]

Though he would prove to be an astute businessman, there is no reason to suppose that John was primarily moved to make this offer to nationalist circles beyond Cardiff by a cynical presumption that other commissions might follow. Nevertheless, this proved to be the outcome. The memorial to Daniel Owen was not unveiled until 1902,[87] by which time a second, and formally more unusual piece, had been completed. On this occasion the idea had been that of Tom Ellis, who wrote of the moment of conception in the village of Llansannan, probably in 1896:

> There you find a certain freshness and vigour of spirit and of activity and withal splendid conservatism of custom and tradition on the part of the villagers and the peasants, and I felt as I looked upon the square of the little village that it would be a real addition to that village, and something that would perhaps kindle the young mind there, if a fitting monument, say a Celtic cross ... were raised in honour of the men who have been reared in that parish.[88]

Ellis had in mind a memorial to Tudur Aled, William Salesbury, Henry Rees, William Rees (Gwilym Hiraethog) and Edward Roberts (Iorwerth Glan Aled), but Goscombe John's design proved to be, as he himself observed, 'somewhat fresh', and – under the influence of French work – avoided both the Celtic cross and the man on a pedestal:

> I felt that any *Academic* or *conventional* representations would have been out of place in an out of the world mountain village, something that would go with the surroundings & be understood by the *villagers young & old* struck me as being most fitted, so the idea I have worked on is ... a little girl, a village girl, in *modern village costume*, with *Welsh cloak* over shoulders ... You will I hope glean a notion from all this it would be an embodiment *of the present-day* thinking.[89]

580. William Goscombe John,
The Llansannan Memorial,
Bronze, 1899

[87] For reactions to the memorial, see John Owen, 'Cofgolofn Daniel Owen', *Cymru*, XXII (1902), 53–6.

[88] T. E. Ellis, 'Domestic and Decorative Art in Wales', *Transactions of the Honourable Society of Cymmrodorion* (1896–7), 31.

[89] NLW, T. E. Ellis Papers, 987.

581. Unknown photographer, *The Unveiling of the Tom Ellis Memorial at Bala by John Morley, MP*; Goscombe John is wearing a white coat, and David Lloyd George is seated on the rostrum, 1903

It is indicative of the difficulties which the creation of national sculpture involved in Wales that the Llansannan work was the first memorial in a public space to celebrate the literary figures who were supposedly held in such high regard in the culture. It was unveiled in 1899, seventy years after William Owen Pughe's grand scheme to celebrate his patron Owain Myfyr had failed.

In the year of the unveiling of the Llansannan memorial, the man who had conceived it also died. Plans were swiftly laid to fund a statue of Tom Ellis by public subscription, and Goscombe John, by now well ensconced as the nation's sculptor in the distinguished line of Gibson, Edwards, the Thomas brothers and Mynorydd, was commissioned. Assisted by John himself, the work was unveiled by John Morley MP at Bala on 7 October 1903, in the presence of Ellis's widow and son, and David Lloyd George.[90] The frontispiece of *Cymru* was devoted to a photograph of the ceremony, which was the apotheosis of *y Werin Gymreig*. Ellis had been born in Cynlas, one of those unpretentious cottages whose hearths were by now symbolic of national life. Cynlas was celebrated on the reverse of the medal

582. William Goscombe John,
Tom Ellis Medal, 1903,
Bronze, 61d.

583. Unknown photographer,
*The Father and Son of Tom Ellis
at the Memorial*, c.1903

[90] A full report of the proceedings is given in
Baner ac Amserau Cymru, 10 October 1903.

[91] NLW, Samuel Maurice Jones Papers, 'Tair Cof-
Golofn' (1920).

[92] Ibid.

struck in memory of Ellis, whose
untimely death at the age of forty
was perceived as a martyrdom in
the national cause. The sculpture
itself was deeply resonant to
patriots: 'Behold the statue of our prince', wrote Eliseus Williams (Eifion Wyn)
in a poem about the unveiling of an object which, to an outsider, might have
seemed an unremarkable memorial to a dead politician. The full extent of the
resonance of the work in the nationalist mind was revealed by Samuel Maurice
Jones in a lecture delivered at Bala on the subject of the memorial, along with those
to Thomas Charles and Lewis Edwards, also in the town. Jones described how
the Welsh people had been set on the path to their resurrection by Griffith Jones,
Llanddowror, 'the Moses of our nation ... the remarkable man who pioneered
the way for the common people to learn to read'. By establishing the theological
college or the 'school of all the saints', as Jones described it, Lewis Edwards, 'the
gentle Doctor of Bala', became the nation's John the Baptist. On the basis of these
two precursors, the symbolic progression towards Tom Ellis was clear and Jones
observed that the sculpture stood 'in the middle of the road', the resonance of his
language making it clear that he intended to insinuate an image of the road to
Calvary. In a detailed analysis of the Ellis memorial Jones drew attention to the
relief sculptures around the plinth depicting Cynlas, the university buildings at
Aberystwyth and Oxford, and the Houses of Parliament, describing them as
'the steps in his elevation'.[91]

584. William Goscombe John,
Sir John Rhŷs, 1909,
Marble, 730h.

Ultimately then, the common people of Wales were iconized neither
as pious and picturesque peasants, nor as a heroic labouring proletariat,
but as a people improved, black-coated and successful in a modern
British world. This central objective of a century of patriotic and latterly
nationalist thought, with education as its cornerstone, proselytized in the
visual culture from the humble woodcuts of Hugh Hughes to the allegorical
flamboyance of Christopher Williams's *Wales Awakening*, had never been more
clearly stated than by Goscombe John in the memorial to the poor farmer's son
Tom Ellis, 'his college gown in folds over his arm'.[92]

351

In the early years of the twentieth century Goscombe John was called upon to create busts and statues of many of the establishment leaders of the Welsh revival, including T. H. Thomas in 1902, J. Viriamu Jones, Principal of the University College of South Wales and Monmouthshire at Cardiff, in 1906, and Sir John Rhŷs. The Rhŷs portrait, exhibited at the Royal Academy in 1909, had a high romantic quality which John carried yet further in the bust of Lewis Edwards erected outside Capel Pen-llwyn, near his birthplace at Capel Bangor. Despite his unusual credentials as the Principal of a theological college, Lewis Edwards was cast by Goscombe John in the heroic mould of Rodin's *Balzac*.

In his final and most ambitious expression of the national sentiment of Cymru Fydd in sculpture, John reverted to allegory. The memorial to Evan and James James, writer and composer of the national anthem of Wales, was conceived before the Great War, but was not unveiled until 1930. The figures of Poetry and Song widened the significance of the piece beyond 'Hen Wlad Fy Nhadau' itself to a celebration of the two elements which were so widely believed to lie at the core of the national soul. However, the James Memorial was unveiled in a different world from that in which the project had begun. In the aftermath of the Great War, Welsh artists turned their back on the ambition to create major subject works of national sentiment which had characterized the early years of the twentieth century.

585. William Goscombe John, *Memorial to Evan and James James, composers of the National Anthem,* 1930, Bronze

586. William Goscombe John, *Lewis Edwards,* c.1910–25, Bronze

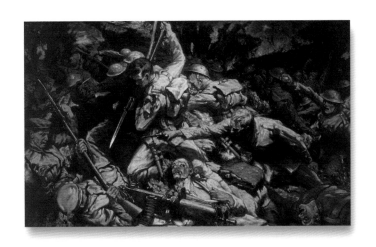

chapter
eleven

A CRISIS

OF CONFIDENCE

587. Anon., Poster for Maurice Elvey,
The Life Story of David Lloyd George, 1918

588. Frame enlargement from Maurice Elvey,
The Life Story of David Lloyd George, 1918

589. Augustus John,
David Lloyd George,
1916, Oil, 916 × 720

By bringing to the fore the ambiguities of allegiance embedded in Welsh consciousness, the Great War dealt a serious blow to romantic nationalism. The failed attempts of the movement to bring about Home Rule in the 1890s faded into a past which seemed to belong to another world. The leader of those attempts, David Lloyd George, had assumed a different persona as the man who led a united Britain through the war. At the Peace Conference in Paris in 1919 he seemed to Augustus John to 'boss the whole show', along with the American President Woodrow Wilson.[1] John had been summoned by Lloyd George to paint a grand picture of the proceedings, despite the fact that the two men did

not get on well. John had not enjoyed the experience of painting the 'hot-arse who can't sit still and be patient'[2] in 1916, before Lloyd George became Prime Minister, and it was characteristic of him that the Peace Conference picture never materialized, though the representatives of many nations sat for individual pictures.[3] It was the much more reliable Goscombe John who provided the post-war memorial to Lloyd George as a world statesman in a statue unveiled at Caernarfon in 1921.

The most remarkable memorial to Lloyd George, however, was made in film, the medium of the new century. The epic scale of Maurice Elvey's *The Life Story of David Lloyd George* sets it among the most remarkable films of its period, though its suppression, in mysterious circumstances, led to its omission from the history of the medium.[4] The first part of *The Life Story of David Lloyd George* reinforced many of the elements of the myth of *y Werin Gymreig*, which had been so central to the pre-war imaging of the nation. However, in the third part, which dealt with the war, the Welshness of Lloyd George was marginalized in the portrait of him as the heroic leader of the victorious nations.

For many intellectuals and artists, waste rather than heroism was the legacy of the war, and *dulce et decorum est, pro patria mori* became a tarnished concept. The death of the poet Ellis Humphrey Ellis (Hedd Wyn) at Pilkem Ridge in 1917 came to symbolize not only the tragedy of the war in personal terms but also its national and universal implications. His death came shortly before he was awarded the Chair at the National Eisteddfod in Birkenhead, an event which became etched on the national consciousness by the ceremony of covering the chair in a black shroud. The reaction among intellectuals and artists was complex. J. Kelt Edwards conveyed to Hedd Wyn's father, Evan Evans, his own sadness and that of all Welsh people on hearing the news, and offered to prepare a portrait for the press since 'thousands will wish to see his picture'.[5] In the event, he developed the idea in the form of an allegorical painting, *Hiraeth Cymru am Hedd Wyn*, in which a female figure, symbolic of Welsh mourning, drapes herself over a tomb on which is painted the portrait of the poet surrounded by Celtic interlace. In the background, dark trees and ruins suggest the destruction of war.[6] Some interpretations of the picture reflected the widespread redirection of pre-war Celticism into anti-German sentiment in the British cause. According to J. Dyfnallt Owen, for instance:

Before the gravestone are asphodel flowers, or 'fleur de lys': it does not matter which. These are the flowers of the Celts, the flowers which defend the countries of the muse – France and Celtia, from the destruction of the Vandal on his accursed way.[7]

The picture contributed substantially to the mythology of the death of the poet, since it was reproduced as a postcard and widely distributed. The image was soon reworked by Edwards as a drawing for the frontispiece to a collection of Hedd Wyn's poems, *Cerddi'r Bugail,* which was sold to raise money for the construction of a memorial in Trawsfynydd, the poet's home. The movement began with high

[1] Quoted in Michael Holroyd, *Augustus John: The New Biography* (London, 1996), p. 441.

[2] Ibid., p. 408.

[3] Kenneth Clarke saw a cartoon by John, forty feet in length, on the subject of *The Kensingtons at La Bassae*, in a cellar in Ottawa. It is now lost. He believed it was a 'masterpiece ... which may eventually prove to be the finest thing he ever did'. Kenneth Clarke in the introduction to Alan Ross, *Colours of War: War Art 1939–45* (London, 1983), p. 7.

[4] For the film, see David Berry and Simon Horrocks (eds.), *David Lloyd George: The Movie Mystery* (Cardiff, 1998).

[5] Letter dated 10 September 1917 from J. Kelt Edwards to Evan Evans, quoted in Alan Llwyd, *Gwae fi fy myw: Cofiant Hedd Wyn* (Cyhoeddiadau Barddas, 1991), p. 265, translated from the Welsh.

[6] Edwards's portrait of Hedd Wyn was based on a photograph. It is not clear whether the two men were acquainted. J. W. Jones, a friend of J. Kelt Edwards, reported that the model for the mourning figure was the poet's girlfriend. Jones was insistent on this point, noting that he was with the artist when the portrait was taken. See NLW PA5555, a note written on the back of a reproduction of the picture. Unfortunately, Jones did not specify which of Hedd Wyn's friends was the sitter, but photographic evidence would suggest Jini Owen.

[7] J. Dyfnallt Owen, 'Hedd Wyn', *Ceninen Gŵyl Dewi* (1918), 16, translated from the Welsh. Dyfnallt echoed the remark made by John Morris-Jones in his foreword to the Welsh edition of *The Land of my Fathers, Gwlad fy Nhadau: Rhodd Cymru i'w Byddin* (London, 1915), p. v.: 'It will undoubtedly be noted how appropriate are many of the pieces which express the patriotic tradition of the Welsh people for today's situation; the reason is that, once again, this is the old battle – between the spirit of the Celt and the spirit of the Teuton. Britain is throughout more Celtic than previously supposed, and today fights the battle of the Celt for freedom and civilization against the military arrogance and barbarity of the Teuton.' The volume includes one work by J. Kelt Edwards and it seems likely that the artist did indeed share its underlying ethos. During the Great War Edwards published two jingoistic postcards, one directed against the Germans and the other against the Turks.

591. J. Kelt Edwards,
Hiraeth Cymru am Hedd Wyn,
1917, Oil, 332 × 240

590. J. Kelt Edwards,
Frontispiece to Hedd Wyn,
Cerddi'r Bugail, 1918, 120 × 100

opposite:
594. Christopher Williams,
*The Charge of the Welsh Division
at Mametz Wood, 11 July 1916,*
1916, Oil, 1727 × 2742

ambitions at the National Eisteddfod of 1917, but the committee's proposals were eventually pared down to the commission of a bronze statue. Insufficient funds were raised to give the work to Goscombe John and John's former pupil Leonard Merrifield was commissioned in his place. The dignified and moving piece, showing the poet as a shepherd rather than as a soldier as some had wished was unveiled in 1923.[8]

Christopher Williams's reaction to the death of Hedd Wyn is unrecorded, but the painter had been deeply offended by the war from its inception. In 1916 he was given the opportunity by Lloyd George to depict the Welsh involvement in the tragic battle of the Somme. The result was

592. Unknown photographer,
*Leonard Merrifield with a maquette
for Memorial to Hedd Wyn, c.1922*

593. Leonard Merrifield,
Memorial to Hedd Wyn,
Trawsfynydd, 1923,
Bronze

The Charge of the Welsh Division at Mametz Wood, 11 July 1916, a massive canvas in which no attempt was made to romanticize the brutality of the events. Although not an official war artist like his friend, the Scottish painter Muirhead Bone, and Augustus John, Williams was given permission to visit the Western Front as a civilian and he made drawings there. His preparatory oil sketches for the subject were more modernist and dynamic in form than the official picture, a tendency which he developed shortly after the war in a study for *The Spirit of the Unknown Soldier Rising from his Grave against the Futility of War*, apparently a study for a painting, which was never realized.

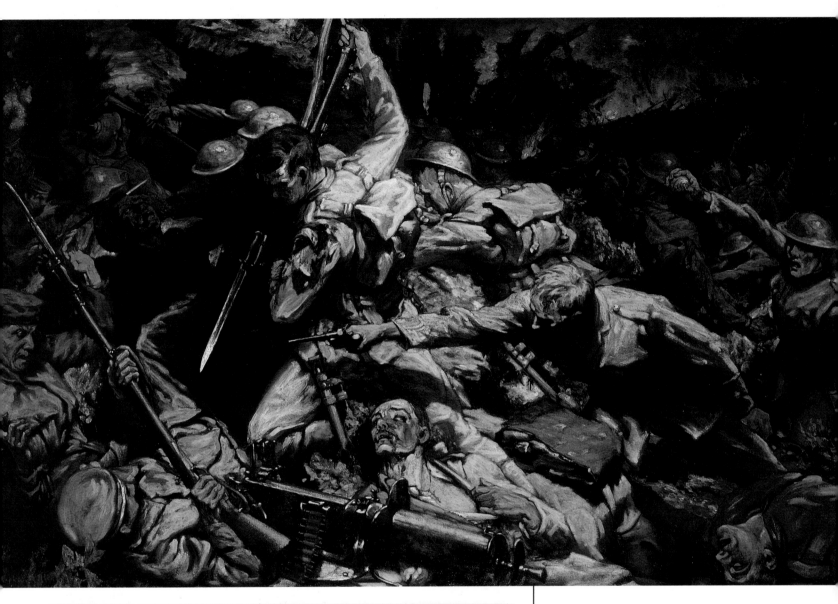

left:

595. Christopher Williams,

The Charge of the Welsh Division at Mametz Wood, 11 July 1916, 1916,

Oil sketch, 230 × 280

[8] In a letter to Silyn Roberts, quoted in Llwyd, *Gwae fi fy myw*, p. 290, T. Gwynn Jones described the proponents of the military image as 'cigyddion diawl' (devilish butchers). The memory of Hedd Wyn was famously celebrated in poetry by R. Williams Parry's *englynion* which begin with the words 'Y bardd trwm dan bridd tramor', *Yr Haf a Cherddi Eraill* (Dinbych, 1970), pp. 103–4. (For an English translation by Idris Bell, see Osborne Roberts, 'Ffarwel i'r Bardd' (Hughes a'i Fab, Caerdydd, 1954).) In 1992 the story was interpreted once more in visual terms in one of the finest Welsh-language films of the period, Paul Turner's *Hedd Wyn*.

596. Christopher Williams,
*The Spirit of the Unknown Soldier Rising
from his Grave against the Futility of War*,
c.1919, Chalk and pastel, 450 × 393

The context of national resurgence which had excited Williams before the war had disappeared, and with it his interest in large-scale national imagery. Several of the leaders of the pre-war art world did not live on into the new era, notably T. H. Thomas, Clarence Whaite and Thomas Matthews. Matthews's last book, *Perthynas y Cain a'r Ysgol* was reviewed in *The Welsh Outlook* in 1916.[9] The only complaint in an otherwise favourable review signified more than its brevity might suggest. Concerned that the list of reproductions of works by artists considered suitable for exhibition in schools did not include representations of the industrial world, the reviewer pointed out: 'The name of the great Belgian sculptor, Constantin Meunier ... whose studies of various aspects of labour ... appear so suitable for South Wales schools, might have been added.' The new periodical was a world away from O. M. Edwards's *Wales* and *Cymru* in which Matthews had published most of his criticism. *The Welsh Outlook* recognized the dominance of industrial society in Wales and proposed the work of Meunier and other Belgian realists of his period as models for Welsh artists to follow. As we have seen, Cardiff was driving institutional development in the art world by the early years of the new century. After the war, industrial south Wales also became the source of the most coherent imaging of the nation, and would remain so for the rest of the period covered by this study. From 1911 onwards the journalist and critic John Davies Williams promoted the work of Evan Walters, Vincent Evans and Archie Rhys Griffiths, painters born into the working class in the coalfield, as a national mainstream.[10]

597. Muirhead Bone,
Christopher Williams, 1916,
Pencil and charcoal, 245 × 180

[9] Anon., 'Perthynas y Cain a'r Ysgol',
The Welsh Outlook, III (1916), 134–5.

[10] The emergence of industrial Wales as a dominant force in both institutional development and imagery is discussed in detail in Lord, *The Visual Culture of Wales: Industrial Society*, chapters 4 and 5.

[11] John had interested himself in the emergence of the new generation of painters from industrial backgrounds through the Swansea School of Art. See ibid., pp. 176, 187.

Even the crowning achievements of the nationalist generation – the National Museum and the National Library – offered little in the way of national imagery. Of the groups of sculpture which encrusted the elevations of the new museum, only one was in any way national in conception. Significantly, its subject was *The Industries of Wales*. The explanation may lie in the fact that Goscombe John set the subjects for the scheme in 1913, by which time his interest in imaging the modern world had been signalled in several works, notably the memorial to *Charles Stewart Rolls*, unveiled at Monmouth in 1911.[11] The engineer and pioneer aviator was depicted in the costume in which he had flown the English Channel in the

599. William Goscombe John,
The Port Sunlight War Memorial,
1919, Bronze and stone

above left: 598.
William Goscombe John,
Charles Stewart Rolls,
Bronze,
1911

600. J. Ninian Comper,
*The Welsh National
Memorial*, 1928,
Bronze and stone

601. Mario Rutelli,
The Aberystwyth War Memorial,
1919, Bronze and stone

602. Eric Gill,
The Chirk War Memorial,
1919, Stone

[12] Among the most notable works of Mario Rutelli (b.1859) are the sculptures for the *Fountain of the Naiads* in Rome (1901–11). He also made the statue of Sir John Williams which is to be found in the reading room of the National Library of Wales and the symbolic figure of Peace at Tabernacl CM Chapel, Aberystwyth. See Brynley F. Roberts, 'Syr John a'r Eidalwr' in Tegwyn Jones and E. B. Fryde (eds.), *Ysgrifau a Cherddi cyflwynedig i Daniel Huws / Essays and Poems presented to Daniel Huws* (Aberystwyth, 1994), pp. 179–94.

previous year, holding an aeroplane of the type in which he was killed shortly afterwards. Heroic figures from Welsh myth and history were conspicuous by their absence in John's National Museum scheme, and the National Library, an impressively sited but severe piece of work designed by S. K. Greenslade in 1909, had no figurative decoration at all.

Public art in the inter-war period was almost exclusively concerned with memorializing the fallen. Goscombe John received a number of commissions, extending from Wrexham in the north-east to Llanelli in the south-west, although his masterpiece was certainly the extraordinary *Port Sunlight War Memorial*, conceived on a monumental scale in 1919. Surprisingly, the most notable memorials in Wales itself were not carried out by John. In Cardiff, the scheme initially conceived as a focus for national remembrance was designed by J. Ninian Comper, and the Aberystwyth memorial, marked by its unusual iconography and dramatic scale and siting, was made by the Italian Mario Rutelli.[12] The only truly modernist piece was the result of the private patronage of Lord Howard de Walden, who commissioned Eric Gill to produce a memorial for Chirk. Gill chose to cut his image of the watching soldier in shallow relief above an elegant inscription.

604. Unknown photographer,
*Carey Morris (centre) at the Art
and Craft Exhibition of the National
Eisteddfod at Treorci*, 1928

Among the more unusual structures in memory of the dead was the *North Wales Heroes' Memorial* at Bangor, which took the form of an arched building within which the names of the fallen were inscribed. The design was the result of an architectural competition in the National Eisteddfod,[13] which, following the successful completion of the campaign to establish the National Museum, provided the main focus for campaigning and for the expression of patriotic sentiment in the visual culture. Indeed, the 1920s proved to be a golden age in the arts and crafts for the now venerable institution. In the post-war period, as in the 1860s, patriotic sentiment was directed away from the idea of national imagery towards education. The art and craft section of the Eisteddfod was professionalized both by a concentration in most years (with the notable exception of 1926) on invited or loan exhibitions, and by the appointment of a series of exhibition organizers from within the art world. Prominent in this movement were Carey Morris and Isaac J. Williams, the first Keeper of Art at the National Museum. Their intention was to create substantial and good quality historical and contemporary exhibitions and to make them available to large audiences. The works were interpreted to the public through educational programmes. Williams regarded the Eisteddfod as a means of extending the activities of the Museum beyond its slowly rising walls in Cardiff into all parts of the country. Those figures who had already made their mark before the war, Goscombe John, Christopher Williams and Margaret Lindsay Williams, supported the reinvigorated institution by acting as adjudicators.

603. Unknown photographer, *Isaac J. Williams*, c.1925

The tone was set for the decade in 1920 at Barry, where the organizing abilities of the painter Fred Kerr, first teacher of Christopher Williams, were combined with the resources of the Museum and the collections of the Davies sisters of Llandinam. Contemporary Welsh artists, including Augustus John, found a platform in their own country, but the show was stolen by the exhibition of late nineteenth-century French works from the Davies collections. For most people this was the first occasion since the war on which it had been possible to see works by artists such as Monet and Gauguin. This prompted Hugh Blaker, the guiding hand behind the patronage of the Davies sisters, to remark that 'the display at Barry this year was one of the finest he had seen outside London in recent years'.[14] The close relationship between the Eisteddfod organizers and the Museum was underlined by the transfer of the profits from the exhibition to the new institution, thereby enabling Williams to purchase twenty-six works – a significant contribution, given that internal funds for purchases were 'ridiculously small'.[15]

[13] For the competition at Caernarfon in 1921 and the resultant building, see Lord, *Y Chwaer-Dduwies*, p. 73.

[14] *Western Mail*, 26 July 1920. Works from the collection had been shown in 1913 in the National Museum's first major venture, entitled 'Loan Exhibition of Paintings' in which Manet and Monet, but, most conspicuously, Millet had featured. The Gauguin exhibited was in fact a work by Armand Séguin. A lecture programme, including contributions from Frederick Wedmore and Patrick Geddes, had been organized to coincide with the exhibition. The only sour note at Barry was an unfortunate dispute between Fred Kerr and Margaret Lindsay Williams, which led to the exclusion of the artist from the exhibition in her home town. For the dispute, see Lord, *Y Chwaer-Dduwies*, pp. 77–8.

[15] Williams complained to his committee of 'the utter impossibility of attempting to build up a Welsh National Art Collection worthy of the name on the ridiculously small sums of money which appear to be available for this purpose'. Quoted by Mark L. Evans in *Portraits by Augustus John: Family, Friends and the Famous* (Cardiff, 1988), pp. 9–10.

opposite:

606. Evan Walters,
*Poster for the National Eisteddfod at
Swansea*, 1926, Lithograph, 1010 × 630

605. Unknown photographer,
*Clough and Amabel Williams-Ellis
at Plas Brondanw, Garreg*, 1975

16 Carey Morris, 'The Teaching of Art and
Architecture in Wales', *Transactions of the
Honourable Society of Cymmrodorion* (1923–4),
103–4.

17 Ibid., 63–70.

18 Bertram Clough Williams-Ellis (1883–1979) is
now best known as the creator of Portmeirion,
begun in 1925. His architectural practice had
commenced before the war, in which period
Llangoed Castle was his most notable building.
Among his other Welsh commissions, the design
of the Lloyd George Memorial at Llanystumdwy
is perhaps the most important.

19 The exhibition and the debate between the
modernists and the traditionalists is described
fully in Lord, *Y Chwaer-Dduwies*, pp. 84–91. The
consequent emergence of Evan Walters as the
leading Welsh painter of the day is described in
Lord, *The Visual Culture of Wales: Industrial Society*,
pp. 187–9.

Two years later, at Ammanford, Carey Morris was appointed organizer of the
exhibition, a post he also held in 1923 and 1924. With his encouragement, the
Cymmrodorion Society attempted to make the Eisteddfod a focus for discussion
of contemporary issues in art, craft and design by organizing seminars in 1923 on
the question of town and country planning. Among the participants was Patrick
Abercrombie, one of the leading radicals in a field which attracted much attention
in the aftermath of the Great War. At the National Eisteddfod at Pontypool in
1924 art education was the topic, with contributions from several important
figures, including Carey Morris, who had particularly strong feelings:

> In common with other Welsh artists, I have been reproached sometimes by
> Welsh newspapers, for lack of patriotism in that I left Wales, and went elsewhere
> for my Art training. We went elsewhere because the only Art training we could
> obtain in Wales was that given by the Board of Education, and we knew that it
> would be fatal to our artistic development. If Wales wants to keep her artists
> truly national, in the sense that they receive their training in Wales, then she
> must cut herself free from the Board of Education. After all, may I ask, what
> is there of Welsh Nationalism about the Board of Education? It is a thoroughly
> English, stereotyped institution.[16]

The contribution of the architect, Clough Williams-Ellis, with its references to
'Darkest Cambria' and the destruction of the Garden of Eden, was characteristically
bombastic.[17] Williams-Ellis was already a prominent figure, alongside Patrick Geddes
and Patrick Abercrombie, in the Town and Country Planning movement, and he
was noted for his controversial writing. His *The Pleasures of Architecture*, written
with his wife Amabel (sister of Lytton Strachey), was published in the year of the
Pontypool Eisteddfod. It was reinforced by a series of attacks on contemporary
philistinism, along with important contributions to the establishment of the
Council for the Preservation of Rural England, and, subsequently, the equivalent
Welsh body.[18] The publicity gained for visual culture in Wales by the new Eisteddfod
circle reached a peak at the National Eisteddfod held at Swansea in 1926, where
the exhibitions were designed by William Grant Murray, the Principal of the School
of Art. They occupied three buildings and were organized largely on a competitive
principle which concentrated attention on the work of contemporary artists. The
exhibition catalogue carried provocative mottoes such as 'Purchase your pictures
from living artists, the Old Masters do not require your support'. Grant Murray
orchestrated an entertaining clash between Modernism and the old school by
appointing Augustus John and George Clausen as co-adjudicators in the painting
competitions. The result was disagreement and extensive press coverage, especially
of a provocative poster designed by Evan Walters.[19] This was heady stuff, the like

EISTEDDFOD GENEDLAETHOL
FRENHINOL CYMRU.

AWST
2-7 **ABERTAWE** 1926.

Y BRODYR SEARGEANT Y FENNI.

608. Unknown photographer,
Gwendoline Griffiths with her portrait
of Mrs D. M. Clasbrooke, 1922

607. Trevor C. Jones,
Mr W. Grant Murray ARCA,
1926, medium and size uncertain

of which had not been heard since the interventions of Herkomer in the 1890s, and the momentum was sustained until the National Eisteddfod at Llanelli in 1930, where the link with Herkomer was re-established. The 1930 Eisteddfod exhibition – the biggest of the decade – was organized under the chairmanship of Charles Mansel Lewis of Stradey Castle, the painter who had introduced Herkomer to Wales. It proved to be his last contribution to the development of the Welsh art world, for he died the following year. His exhibition was also the last of its kind, since many of the professional artists who had involved themselves with the Eisteddfod subsequently withdrew their support, apparently in frustration at the failure of the institution to ensure continuity of policy. Despite the undoubted achievements of professional artists throughout the decade, dissatisfaction about poor art education, the lack of patronage and exhibition spaces was never far below the surface. The establishment of a National Museum had provided a focus for patriotic efforts before the war. Having achieved that end and finding that neither the Museum nor the Eisteddfod was a panacea, the leaders of the new generation – almost exclusively based outside Wales – once again resorted to criticizing their own country largely on the basis that it was still not like London.

With national sentiment out of fashion and a general decline in confidence resulting from the trauma of the war and the worsening economic situation, few public art commissions of note, apart from the memorializing of the dead, were given. The bulk of establishment portrait busts continued to be awarded to Goscombe John and, similarly, there was little change in the pattern of patronage for painters, with Christopher Williams (who had completed three portraits of Lloyd George by 1917) and Margaret Lindsay Williams the most favoured artists. The career of Margaret Lindsay Williams flourished, especially in fashionable society in England, where it culminated in royal commissions which were extensively reported in the Welsh press, and she also spent periods painting in the United States of America. Similarly, the portrait career of Gwendoline Griffiths, born and initially trained in Swansea, developed mainly outside Wales.[20] For those of an adventurous turn of mind, the brilliant but erratic Augustus John now provided an alternative as a portrait painter.[21] Despite being turned away from John's door at his manor house in Dorset by his suspicious lover, Dorelia McNeill, in 1912, the persistent Lord Howard de Walden invited John to stay at Chirk Castle, and so began a saga of ten years' duration which culminated in a pair of portraits, first exhibited in 1917 but subsequently reworked, though never to Lady Margherita's satisfaction. She had been appalled by the first effort, 'a horrible picture', done when she was pregnant, but 'one had to be patient in a good cause'.[22]

609. Augustus John,
Thomas Evelyn Scott-Ellis, Lord Howard de Walden,
1917 with subsequent reworking, Oil, 865 × 635

610. Augustus John,
*Margherita Scott-Ellis, Lady Howard
de Walden,* 1917 with subsequent
reworking, Oil, 1223 × 914

Her husband's portrait apparently gave him 'the severest shock he has
experienced since the War began'.[23] Nevertheless, John's relationship with
the de Waldens coincided with probably the most creative period of his life. His
visits to France and the celebrated London exhibition in 1910 of Manet and the
Post-Impressionists had brought John's awareness of modern French painting to
the fore and had resulted in a number of fine portraits, especially of his own family,
in which he made use of flattened perspective and colour. This was in marked
contrast to the Rembrandtesque chiaroscuro of earlier oils and etchings to which
he returned during the latter part of the war, when he painted his celebrated
portrait of the poet and author W. H. Davies. It was also in this period that John
became most involved with his own country, though he never associated himself
with the mainstream of Welsh life at the time. John abhorred the industrial valleys,

[20] Gwendoline (Gwenny) Griffiths (b. 1867)
subsequently studied at the Slade School in
London and at the ateliers of Julian and Colarossi
in Paris. She spent much of her life in the south of
France, only exhibiting occasionally in Wales. She
was Honorary Secretary of the Women's
International Art Society in 1906–7.

[21] Although he was twice commissioned to
paint Lloyd George, Augustus John's Welsh
patronage was found mainly among the intellectual
community. He painted portraits of the novelist
Richard Hughes and his wife Frances in 1938, as
well as pictures of Dylan Thomas. Margaret Lindsay
Williams received portrait commissions primarily
from families in south Wales, such as the Philippses
of Cwmgwili, Carmarthenshire, in 1933. Christopher
Williams died in 1934, by which time Evan Walters
was in receipt of a variety of public and private
portrait commissions.

[22] Lady Howard de Walden, *Pages from My Life*
(London, 1965), pp. 109–10.

[23] Quoted in Holroyd, *Augustus John*, p. 394.

'where colour is apparently taboo or non-existent',[24] and the gloomy constraint of his childhood in Tenby left him with an intense aversion to respectable church- or chapel-going society, which he chose to believe was characteristic of Wales as a whole. Set against these negative forces was a love of the landscape, also acquired early in life, which resulted in occasional outbursts of sentimental attachment to his native country which flared up and subsided with equal rapidity throughout his life. As we have seen, one such outburst, published in *Wales: To-day and To-morrow* in 1907, had already made its mark. John had sarcastically opened that essay by stating: 'In Wales, as I am told, lies hidden the soul of art; the body being doubtless no less reticent and inconspicuous.' With equally characteristic ambiguity, he had concluded with a patriotic appeal to 'rouse the old Mervyn from his slumbers of ages and welcome Arthur back'.[25] Three years later, Arthur did, indeed, return and Mervyn was aroused by the first of a series of vibrant landscapes which were the most influential images of the period created outside industrial Wales.

611. Augustus John,
Dorelia McNeill in the Garden at Alderney Manor,
1911, Oil, 2010 × 1016

612. Augustus John,
Self-portrait, 1905, Pen
and ink, 205 × 128

613. Augustus John,
John Sampson, c.1910–20,
Pen and ink, 180 × 115

614. Charles Slade, *'En Voyage',*
Palling, Norfolk, Augustus John (right)
with Dorelia McNeill in the doorway, 1909

Augustus John's Welsh landscapes painted between 1910 and 1914 owed much to his awareness of modern French painting and the excitement of working in the south of France in 1910. On the way to the coastal village of Martigues, he had arranged to meet Dorelia and his children at Arles, a name full of romance for a painter as the home of Van Gogh. John painted small landscapes and figure groups, mainly on panel, with flat but vibrant colour. His decision to transport this way of painting, so redolent of the heat and light of France, into Wales (rather as Wilson had imported the heat and light of Italy in the eighteenth century) had its origins in his long-standing affection for the wilder parts of his own country, and a particular combination of circumstances in 1909–10.

During the period 1901–3, when he was working in Liverpool, John had become acquainted with John Sampson, the town's librarian and the foremost English expert on Romany dialect.[26] The painter accompanied the librarian on expeditions to gypsy encampments for the purposes of study and debauchment, and he also became an expert in Romany. One of Sampson's ambitions was to record the Welsh dialect of the language and in 1909 he succeeded in locating Matthew Wood, linear descendent of the famous Abraham Wood, 'King of the Gypsies', who was living at Betws Gwerful Goch. John hastened to join Sampson there, with riotous consequences. The visit brought renewed enthusiasm for Wales, which was reinforced on his return from France the following year by the deepening of his acquaintance with J. D. Innes, a young Welsh painter who had trained, like John, at the Slade. Innes was born in Llanelli in 1887 and arrived in London from the Carmarthen School of Art in 1906. He painted mainly landscapes in watercolour and, again like John, divided the year 1910 between France and Wales, where he had found 'the lonely inn of Rhyd-y-fen', in the shadow of the Arennig.[27] He began to paint the mountain, which soon acquired for him some of the mystic quality which Mont Saint Victoire had possessed for Cézanne.

[24] NLW MS 22779E, f. 7, letter to David Bell, dated 30 July 1951.

[25] John, 'Art in Wales', p. 351. In his essay Augustus John acknowledged his 'ambiguous destiny', attributing it to his birth 'in that part of the country known as "Little England beyond Wales"'. In a later flash of patriotic enthusiasm, John briefly joined Plaid Cymru.

[26] For an analysis of the gypsy cult of the period and John's involvement, see Malcolm Easton, 'Wheels within Wheels', *Augustus John: Portraits of the Artist's Family* (Hull, 1970), pp. 43–58.

[27] Augustus John, 'J. D. Innes', *Catalogue of the Art and Craft Exhibitions* (Llanelli, 1930), p. 92, reprinted from the catalogue to the Innes exhibition at the Chenil Galleries, 1923.

615. Augustus John,
J. D. Innes, c.1912,
Gouache, 1302 × 699

The art historian A. D. Fraser Jenkins noted that Innes's return to Wales in 1910 was 'a novel idea' and that 'the Welsh mountains had not been a source of original art since the time of David Cox'.[28] Though inaccurate, these statements probably reflected the consciousness of both Innes and John. The remarkable watercolours and drawings of Clarence Whaite (which included depictions of gypsy encampments) were certainly unknown to them and, in all probability, so were the large, mystical oil landscapes. As Innes toured in north Wales, Whaite was still at work nearby, painting the vast *Snowdon* at the age of eighty-two.[29]

John's French works were shown at the Chenil Gallery in London in November 1910, followed by Innes's pictures in January 1911, and it appears that the two men recognized in each other both a personal sympathy and converging artistic paths. Innes took John to Rhyd-y-fen and by March they were established at Nant Ddu, a cottage a few miles away. The work they produced in Wales over the next three years had a radical intensity which gave them a high profile among modernists. In 1913 both John and Innes sent work to the celebrated exhibition at the Armory in New York, which introduced the American art world to Modernism. In the same year John established himself in a new cottage at Llwynythyl, above the Vale of Ffestiniog, though not with Innes, who had gone to Tenerife in search of a cure for the tuberculosis which afflicted him. He did not long survive his return to England. In the words of John: 'The last chapter is short. He was taken to Brighton. The War broke out. Innes took no interest in it, and shortly after died in Kent.'[30] He was twenty-seven.

Three years before Innes died, John had written to his patron, John Quinn: 'He is not the sort who learns anything. He will die innocent and a virgin intellectually which I think a very charming and rare thing.'[31] John continued to believe that Innes 'was an original, a "naïf"',[32] and his work, though much admired, was of limited influence. John's further assessment that 'in spite of his short life and immaturity he will belong always to the great line of British landscape painting' is therefore difficult to sustain.[33] Apart from John himself, the Australian painter Derwent Lees, rather to Innes's annoyance, seems to have been most strongly affected by the work. Some critics have suggested that his influence

616. James Dickson Innes,
Cloud over Arennig, c.1911,
Watercolour, 245 × 345

617. James Dickson Innes,
Evening: Sun setting behind Arennig Fach,
c.1910, Oil, 390 × 490

[28] A. D. Fraser Jenkins, *J. D. Innes at the National Museum of Wales* (Cardiff, 1975), p. 10.

[29] In 1907 John had stated, apropos of tradition: 'It was in truth very simple in the old days. Young artists learnt from old artists, and thus the Tradition was handed down and grew. But in Wales there is no Tradition, and no really old artists.' John, 'Art in Wales', p. 350.

[30] John, 'J. D. Innes', p. 92.

[31] Quoted in Holroyd, *Augustus John*, p. 355.

[32] Ibid.

[33] John, 'J. D. Innes', p. 92.

was felt by members of the Seven and Five Society, who included Cedric Morris, though if they did carry his vision forward they painted, like John, as *faux-naïfs*. In Wales it was John, rather than Innes, whose influence was eventually felt, though it was often his personality and reputation rather than his art which impinged on Welsh consciousness. Despite the fact that he was almost certainly aware of his

618. Augustus John,
Llyn Tryweryn, 1911,
Oil, 317 × 405

work, Thomas Matthews made no mention of John in his attempts, around 1911, to construct a Welsh tradition. They moved in different worlds. John had become friends with Picasso in 1907, four years before Matthews attempted his construction on the basis of a landscape painting which had gone through its radical phase forty years earlier. However, recent work by John was shown in the National Museum's exhibition of Welsh painting in 1913, alongside that of Benjamin Williams Leader and Christopher Williams. John's inclusion was almost certainly at the instigation of Lord Howard de Walden, the main sponsor of the exhibition, and Matthews was forced to confront the problem of placing the new artist in his construct. In his review, the critic acknowledged what he regarded as the extreme difficulty of understanding John's pictures, but he nonetheless emphasized with a positive gloss their primitivism in his attempt to interpret the work for a lay audience:

> There is nothing more difficult than understanding the work of Augustus John – but the best way to understand it is to see that he is trying to protest against the smooth and finished style of academic painting, and instead give us painting in its bare simplicity ... Simplicity is his aim, his slogan 'Let us be as children'. That is why I used the word 'primitive'. In his romantic protest he tries to paint with the simplicity of primitive art.[34]

Seeking to justify this interpretation, Matthews made use of a lengthy quotation from the Welsh-language version of John's essay of 1907, including the artist's challenging declaration 'rhaid barbareiddio Cymru!' (we must barbarize Wales!), but he was sufficiently perspicacious to add: 'and yet, it is not simple – there is more artistry hidden in the simplicity of Augustus John than is seen in many people's work'.[35] Although John was not immediately welcomed as the new voice of Welsh art, from this point onwards his work became part of the accepted canon and was reproduced in colour for the first time in John Morris-Jones and W. Lewis Jones's *The Land of my Fathers* in 1915, alongside works by Goscombe John, J. Kelt Edwards, Margaret Lindsay Williams, and – most significantly – Christopher Williams.

Although it is clear that Christopher Williams had been influenced by the rhetoric of Augustus John as early as 1908,[36] the point at which his painting began to impress the older man is difficult to determine. By 1917, however, Williams was also producing small landscapes of vibrant colour and simple

[34] Thomas Matthews, 'Celf yng Nghymru: Arddangosfa'r Amgueddfa Genedlaethol', *Cymru*, XLVI (1914), 98, translated from the Welsh.

[35] Ibid.

[36] See above, p. 332.

[37] He only exhibited one of these late landscapes, *Among the Mountains, Spain*, at the Royal Academy, in 1925. In the same year he also showed *Hero and Leander*.

619. Christopher Williams,
The Red Dress, 1917,
Oil, 300 × 387

structure. Like John and Innes, he was moved not only by an awareness
of the work of other modern painters, but also, having travelled in Spain
and Morocco in 1914, by the experience of the intense light of the south.
His Welsh landscapes formed a sub-stratum of his work, below the
portraiture and occasional subject pictures in which he harked back
to pre-war academism, albeit with an unusual and intense interest
in colour for its own sake.[37] In retrospect, however, works probably
regarded by Williams as exercises and experiments assume greater
significance, and his landscapes and figure studies begun towards the end of
the Great War, such as *The Red Dress*, are among his most attractive works.
They waver between a simple and celebratory Impressionism and a more
self-conscious simplification which reflected his awareness of Innes and John.

620. Christopher Williams,
Tyrau Mawr, c.1917, Oil,
452 × 607

However, Williams was tiring and did not pursue his interest in colour to the extent of questioning the conventional language of painting. He was suspicious of continental Modernism and observed in 1927 that 'our artists are not being influenced by the foreign schools to the extent England is, to the detriment of English art'.[38] Given the strong disinclination of much of the English art world of the period to formal innovation, this was a remarkable observation. Precisely who Williams had in mind is unclear, but Augustus John had certainly by this time

621. Unknown photographer,
Harry Hughes Williams,
c.1940

622. Harry Hughes Williams,
Yr Ogof Mill, c.1942,
Oil, 610 × 762

become detached from the avant-garde, such as it was, and other Welsh painters following more or less successful careers, notably Margaret Lindsay Williams, Timothy Evans and Carey Morris, had always had conservative inclinations.

Nor was the next generation of landscape painters interested in radical aesthetics. Harry Hughes Williams went to art school in Liverpool immediately prior to the outbreak of the Great War, but because of a childhood injury he was not called upon to enlist. Nevertheless, the war affected the course of his career since it prevented him from taking advantage of his success in winning a travelling scholarship gained during his subsequent training at the Royal College of Art. Instead of travelling on the Continent, as Timothy Evans and J. Kelt Edwards, Augustus John and J. D. Innes had done, he returned to his home in Anglesey and by the mid-1920s had found both the technique and the subject matter which sustained his art until his death in 1953. He achieved considerable mastery of an impressionist manner, which suffused his pictures of rural life in Anglesey with great luminosity. Nevertheless, he struggled to earn a living as a painter during

[38] Quoted by Jeremiah Williams, *Christopher Williams,* p. 99. The untraced speech was given in Bangor in 1927.

623. Harry Hughes Williams,
Haystack, Tŷ Mawr III, c.1929,
Oil, 254 x 330

624. William Grant Murray,
Winter Sunshine, Richmond Road,
*Swansea, c.*1930, Oil, 437 × 304

626. Unknown photographer,
Swansea artists, 1957, standing from
left, Griff Edwards, Donald Cour,
George Fairley, Bill Price, Alfred
Janes; seated, Arthur Charlton,
Kenneth Hancock, David Bell,
Will Evans, Howard Martin

the inter-war years. Although he showed his work at the Royal
Cambrian Academy and occasionally in London and Liverpool,
he won only limited patronage and was little known outside the
north-west.[39] His finest achievement was a series of pictures based
on single motifs of haystacks and windmills. The combination of
their subject matter and conservative technique gave these pictures,

625. Will Evans,
Stormy Down, 1924,
Oil, 483 × 635

[39] In 1938 Williams gained a
school-teaching position which
gave him financial security. For
the career of Harry Hughes
Williams, see Siân Rees, *Harry
Hughes Williams 1892–1953: A
Selective Retrospective / Detholiad
yn Edrych yn Ôl* (Oriel Ynys Môn,
1992) and Peter Lord, 'Harry
Hughes Williams in Context',
Planet, 98 (1993), 16–21.

627. Edward Morland Lewis,
A Welsh Landscape, c.1935–8,
Oil, 265 × 350

some of which were made in the second half of the
twentieth century, a strange sense of belonging to a
lost past, achieved without a self-conscious attempt
at nostalgia on the part of the painter.

In south Wales the landscape painting of Harry Hughes
Williams was echoed in the work of several painters of
high quality but similarly conservative aesthetics. William
Grant Murray's remarkable achievements as a teacher at
the Swansea School of Art proved to be of much greater significance than his
painting, competent and popular though it was.[40] Grant Murray and other painters
in south-west Wales were better placed to exhibit and sell pictures in their own
locality than was Harry Hughes Williams since the South Wales Art Society and
the Swansea Art Society both provided opportunities. The Glynn Vivian Gallery
was an excellent venue and was sympathetic to their efforts, for Grant Murray was
a firm believer in widening public participation in art, both in terms of amateur
practice and patronage. Among the most notable of the Swansea painters was Will
Evans, a commercial lithographer by trade, whose part-time career as a landscape
painter continued well into the second half of the century. Similarly, B. A. Lewis
played an active role in the art community of his native Carmarthenshire and in
the South Wales Art Society.[41] However, Lewis is now remembered chiefly as the
father of the painter Edward Morland Lewis, who trained initially at Carmarthen
before moving to a London school and eventually, in 1924, to the Royal Academy.
He was taught there by Walter Sickert and soon left to pursue his training directly
under this chosen master, acting also as his assistant until at least 1929. The
influence of Sickert on his pupil was manifested both in his idiosyncratic working
methods and his love of subdued tonalities, which were very different from those
of Harry Hughes Williams, despite the adherence of both to simple, open-air
subject matter, painted in the light of the far west. Morland Lewis adopted
Sickert's method of developing paintings from carefully squared up monochrome
drawings or photographs, though his interest in photography predated his London
training. The low key of Morland Lewis's paintings was echoed in the development
of his career, but (unlike Williams) he was well connected in the English art
world and able to sell his work. His early death from malaria in 1943 while on
active service in the Second World War was much lamented by his many admirers,
including the more radical Ceri Richards, who believed that 'his work would have
developed into something very special and personal'.[42]

628. Unknown photographer,
Edward Morland Lewis at Ferryside, c.1938

[40] For Grant Murray as a teacher, see Lord, *The
Visual Culture of Wales: Industrial Society*, Chapter 4.

[41] B. A. Lewis was known beyond south Wales.
He exhibited at the Royal Cambrian Academy on
several occasions, but was not granted membership
despite repeated applications, for which see NLW,
Clarence Whaite archive, letter from Lewis to
Whaite, 14 January 1908.

[42] *Western Mail*, 24 February 1962. The
relationship between Morland Lewis and
Sickert and his use of photography is discussed
by A. D. Fraser Jenkins in 'Edward Morland Lewis:
landscape and photography', *Apollo*, 99 (May,
1974), 358–61.

629. Graham Sutherland,
Entrance to a Lane, 1939,
Oil, 614 × 507

630. Graham Sutherland,
Solva Hills, Valley above Porth Glais,
1935, Pen, ink and wash, 123 × 210

[43] Graham Sutherland, 'Welsh Sketch Book', *Horizon*, V, no. 28 (1947), 234–5.

[44] Ibid., 230.

[45] Myfanwy Evans had worked in Paris in 1934 with Jean Hélion, one of the intellectual leaders of Modernism and editor of such influential publications as *Art Concret* and *Abstraction-Création*. It was he who proposed that Evans should establish a comparable English-language periodical in London.

[46] Unidentified Arts Council of Great Britain publication, 1962, quoted in Anthony West, *John Piper* (London, 1979), p. 154.

[47] Ibid., p. 128.

Morland Lewis had been a member of the London Group of artists and he subsequently taught at the Chelsea School of Art at the same time as Graham Sutherland and John Piper. They formed part of a circle of radical painters which included Ceri Richards. The two English painters both made use of the Welsh landscape at crucial periods in the development of their work, as Turner had done at the end of the eighteenth century. For Sutherland, in particular, his Welsh period, which began in 1934, was of fundamental importance both in artistic terms and in the progress of his career. He had been encouraged to see Pembrokeshire by Robert Wellington of the Zwemmer Gallery, one of the main foci of the radical London art world, and he visited the county regularly for many years. His method was to draw in the open air and to paint in the studio, so that the works he made are not so much Welsh landscapes as mystical explorations of the primitive forces which he came to perceive beneath all landscape:

> The spaces and concentrations of this clearly constructed land were stuff for storing in the mind. Their essence was intellectual and emotional, if I may say so ... I did not feel that my imagination was in conflict with the real, but that reality was a dispersed and disintegrated form of imagination ... it was in this area that I learned that landscape was not necessarily scenic, but that its parts have an individual figurative detachment.[43]

Sutherland's pictures were devoid of the human culture of the place and his few written comments about the people echoed the thoughts of English art tourists down the centuries:

Complete, too, is the life of the few inhabitants – almost biblical in its sober dignity ... The immense soft-voiced innkeeper and his wife, small as he is big, sit, when they are not working, bolt upright, on a hard bench in the cool gloom.[44]

Even in his work as a war artist in the industrial towns of Wales, which began in 1940, Sutherland was primarily concerned with questions of translating the collapsed physical structure of the world he observed into pattern and colour. His move towards abstraction took him in the opposite direction to John Piper who, by the time of his first visit to Wales in 1937, had established a reputation as an uncompromising non-figurative painter. In that year he married Myfanwy Evans, with whom he had edited the magazine *Axis*, which described itself on the cover of its first issue in 1935 as 'A Quarterly Review of Contemporary Non-Figurative Painting and Sculpture'.[45] However, Piper's first visit to Wales coincided with the beginning of his withdrawal from non-figurative art, which eventually led to his reputation among enthusiasts for his work as a quintessentially English landscape painter, firmly in the great Romantic tradition of Turner. Those of an internationalist and modernist turn of mind regarded his development as a betrayal, 'a nostalgic retreat into insular sensibilities'.[46] Whatever the value of this change, Piper's observation of the Welsh landscape certainly played an important part in its evolution, and he acquired a second home in Nant Ffrancon in 1947. His pictures of Snowdon, begun in 1944, have been described as 'unique in English painting in their presentation of the continuing storm of creation, and in the intelligence of their interpretation of the facts of geology and landscape', thus locating him close to Sutherland in his a-cultural interpretation of the country to which he often returned.[47]

632. John Piper,
In Llanberis Pass, 1943,
Watercolour, pen and chalk,
578 × 699

631. John Piper,
Llanthony Abbey, 1941,
Oil, 290 × 400

633. Unknown photographer,
Alfred Janes in his studio at College Street,
Swansea, c.1936

634. Alfred Janes,
Dylan Thomas, c.1934,
Oil, 406 × 305

Most of these landscape painters of the 1920s and 1930s knew one another, or at least were aware of one another's works. However, it cannot be said that they formed a national art world of the kind which had emerged before the Great War and which linked indigenous and visiting artists. They lacked the focus of that earlier generation with its aspiration to create national art institutions and its fascination with the idea of national aesthetics. Only in the work of painters and critics concerned with industrial imagery was there some sense of a national agenda, albeit a very different one from that proposed by Thomas Matthews before the war. Occasional references by critics and artists to the Celtic temperament, beloved of the generation of Cymru Fydd, now focused less on a particular kind of artistic sensibility than on the erratic behaviour of Augustus John and the circle of young expatriate writers and artists who joined the great man in the London art world in the mid-1930s. Dylan Thomas carried John's bohemian image forward and was surrounded by an unusually talented supporting cast which included the poet Vernon Watkins and the Swansea-trained painters Alfred Janes, Mervyn Levy and James Govier.[48] Janes – 'enthusiasm sparkling through his round specs'[49] – was at the Royal Academy and Levy at the Royal College, but they shared a flat with Thomas. They were visited there, 'ankle-deep in cigarette cartons'[50] by John Petts, a London-born artist who had recently begun a relationship with Brenda Chamberlain from Bangor, a fellow student at the Royal Academy. Morland Lewis was well known to them,[51] but Ceri Richards, despite his Swansea training, did not move in quite the same circles. He had arrived in London in 1924, eight years before Levy and Janes, and associated himself with the English avant-garde. Levy recalled: 'It was tremendous fun. The ideal Bohemian was Augustus John – he was our lode-star – we tried to live a Bohemian life, as we saw it ... There was a point at which Dylan felt that you couldn't really be an artist of any consequence and certainly not a writer, unless you had T.B.'[52] They had little feeling for Wales as a cultural entity and aspired to go to Paris but, unlike most of their predecessors, they never achieved this ambition in the difficult economic circumstances of the time.[53] When Levy left the Royal College in 1936 he earned

a living painting cinemas. Although Brenda Chamberlain and John Petts were also in straitened circumstances, they chose – against the prevailing ethos – to return to Wales, and in 1936 established themselves in a cottage at Llanllechid, near Bethesda. As a result of Petts's interest in graphics they acquired a printing press and began to make a reputation as 'The Caseg Press' among their artistic and literary contemporaries with wood engravings, some of which were published in magazines, including *The Welsh Review*.[54] Among those who noticed their work was the young poet Alun Lewis who wrote to Petts, from which contact in 1941 sprang the 'Caseg Broadsheets' series – simple collections mainly of contemporary poetry by Lewis and his friends (notably Dylan Thomas), accompanied by the wood engravings of Petts and Chamberlain.

635.
Brenda Chamberlain,
Self-portrait, 1936,
Pencil drawing,
225 × 175

below: 636.
Brenda Chamberlain
and John Petts,
Yr Heuwr, and
Cludwyr Coed, illustrations from *Caseg Broadsheet*,
1941–2, Wood engravings, 100 × 130

[48] Govier arrived from Swansea at the Royal College in 1935, three years after Levy. Although Janes attended the Royal Academy Schools, like most of his contemporaries there he found the Royal College a more convivial social centre.

[49] John Petts in Meic Stephens (ed.), *Artists in Wales 3* (Llandysul, 1977), p. 177.

[50] Ibid. The flat in which they lived was also occupied by the English painter William Scott.

[51] Dylan Thomas was best man at Morland Lewis's wedding in 1939.

[52] NLW, Welsh Visual Culture Research Project Deposit, Mervyn Levy, interview with Peter Lord, 13 September 1995.

[53] Levy observed: 'We didn't have any real feeling for Wales as a cultural thing.' Ibid. The attitudes of the older Cedric Morris to Wales in this period were different, and are discussed in detail in Lord, *The Visual Culture of Wales: Industrial Society*, pp. 203–10.

[54] The press was named in celebration both of the mountain pony which Chamberlain rode and the river Caseg nearby.

637. Augustus John,
Richard Hughes, c.1938,
Oil, 525 × 425

During the 1930s there was little opportunity for these young Welsh painters, emerging from their art education, to exhibit their work. The only progressive spirit was at work in Swansea, where Ceri Richards was given a one-person show at the Glynn Vivian Gallery by Grant Murray as early as 1930. Emphasizing the painter's close links with the London avant-garde, the exhibition was opened by Colin Anderson, Graham Sutherland's most important patron. The National Eisteddfod exhibitions were in severe decline through the 1930s, and the two national institutions with permanent galleries – the National Museum and the National Library – presented very limited and conservative programmes to the public. The 1933 exhibition of Works by Modern Welsh Artists at the National Library, for instance, showed the familiar canon of Christopher Williams, Margaret Lindsay Williams, Frank Brangwyn and Augustus John, with a younger generation represented by Evan Walters.[55] The National Museum's record was even more dismal: D. Kighley Baxandall's catalogue of the etchings of Augustus John was the only exhibition or publication about a living Welsh artist or artists generated between the great 1913 exhibition and the Second World War.[56]

Frustrated by the lack of a platform in Wales, Cedric Morris, supported by Augustus John and several affluent patricians, including Clough Williams-Ellis of Llanfrothen, Frances Byng-Stamper of Manorbier Castle, and Richard Hughes of Laugharne Castle, organized a travelling Contemporary Welsh Art Exhibition in 1935. In his introduction to the catalogue, Hughes weighed up the advantages and disadvantages of metropolitan and dispersed cultures, and concluded that although artists working in Wales might achieve a good average standard, without the competitive stimulus of a metropolis true excellence was beyond any individual. The exhibition would therefore serve as 'a metropolis that moves from place to place'.[57] However, this notable venture was limited in its scope by cronyism and a reversion to the definition of a Welsh artist as a person whose ancestry was Welsh, which resulted in the inclusion of Wyndham Lewis and Allan Gwynne Jones, who had no practical connection with Wales. The association of Augustus John with the exhibition as selector secured excellent publicity, but it also meant that his own work and that of his sister, Gwen, brother Edwin, and daughter Vivien, was greatly over-represented, a fact which Evan Walters regarded as 'most undignified'.[58] The young painters of the industrial world, Vincent Evans and Archie Rhys Griffiths, were excluded, as was Harry Hughes Williams. Timothy Evans declined to show for various reasons, but principally because he believed 'it is not for some half-English snobs like Clough Williams-Ellis and his cronies to control and chatter

[55] Most unusually, this exhibition also included an important work by Archie Rhys Griffiths, *Miners Returning from Work*, illustrated in Lord, *The Visual Culture of Wales: Industrial Society*, p. 191. Other painters shown included F. J. Kerr and Fred Richards. Sir Frank William Brangwyn (1867–1956) was born in Belgium to a Welsh mother. His career and work had little relevance to Wales, but his high status in the English art world made him attractive to those who sought to elevate the idea of Welsh art in the early twentieth century. As a result, he was frequently referred to in Wales as a Welsh artist.

[56] The Museum's Exhibition of Paintings by Contemporary British Artists, which included some Welsh work, was organized by the Contemporary Art Society for Wales in 1938.

[57] Richard Hughes, introduction to the *Catalogue of the Contemporary Welsh Art Exhibition* (Aberystwyth, 1935). The exhibition opened in Aberystwyth and travelled to Swansea and Cardiff. Its genesis is discussed in detail in Lord, *The Visual Culture of Wales: Industrial Society*, pp. 205–8.

about art in Wales. All these rubbish want is to be in the limelight and make an exhibition of themselves'.[59] Presumably Janes and Levy were considered too young, although Kenneth Hancock, yet another product of Swansea School of Art and the Royal College in London, showed one picture.[60] Critical reaction, which was enthusiastic about the work but negative about Wales, reflected the attitudes of the organizers:

> The official title of this Exhibition is 'Contemporary Welsh Art', but, although this is a convenient enough name, it is misleading, because there is, of course, no such thing as Welsh painting and sculpture today, although there is a great deal of truly important contemporary painting by Welsh artists.[61]

The most significant figure omitted from the 1935 exhibition was Ceri Richards. He may have declined to exhibit, but his association with the excluded Archie Rhys Griffiths and his own radical aesthetics are more likely to have counted against him. Richards's period of study at the Royal College of Art between 1924 and 1927 had exposed him to many continental influences, of which Matisse appears to have been the strongest, especially in his portraits. At the beginning of the 1930s he also encountered the teaching of the Bauhaus, albeit at second hand, through his friendship with Richard Llywelyn Huws. After graduating from the University of Liverpool, where he had discovered a talent for drawing and a commitment to the new nationalist party, Plaid Genedlaethol Cymru, Huws went to France and then to Vienna, where, during the period 1927–30, he studied with former Bauhaus teachers at the Kunstgewerbeschule. Leaving Vienna for London, he earned a living as a cartoonist and sculptor of very modernist aesthetic inclinations and left-wing politics. His belief that 'there is no tradition of true Art in Wales, but only the corrupt art of the European and American bourgeoisie' was widely publicized by the *Western Mail* in an attack on the National Eisteddfod art exhibition at Bangor in 1931 and, by implication, its conservative adjudicators, among whom was Margaret Lindsay Williams.[62] Between 1933 and 1935 the families of Richard Huws and Ceri Richards shared a house in London, and it was during this period that the latter's modernist aesthetics became fully formed. He began to experiment with collage and construction and to exhibit at the Zwemmer Gallery with the Objective Abstraction Group. In the exhibition catalogue the young artists shown attempted to answer some of the questions likely to be raised by a bemused public. When asked what he was seeking to express in his painting, Richards replied that he was 'trying to give a visual expression in coherent form and colour equivalent to the stimulus and reflections provoked by objects'. Somewhat less forbidding on the question of the relationship between his works and the natural world, he described a similar approach to that of Sutherland: 'I have to refer directly to nature for stimulus before I can start painting. Once I have transferred to the canvas an expression of this stimulus, the painting grows on its own as an entity.'[63]

[58] Private archive, letter from Evan Walters to Winifred Coombe Tennant, 19 August 1935: 'There are about 150 exhibits with about 120 paintings, water colours and drawings. Aug. John and his family and Cedric and his cousin (whom I had never heard of before) [Caroline Byng-Lucas] have about 70 leaving about 50 between the other 16 artists. Of these Innes who is dead and is no longer a rival has 23. Rivals have either been cut out or badly and sparsely represented. The first committee was John, Cedric and Cedric's two cousins [Byng-Lucas and Frances Byng-Stamper]. The rest of the committee is a sleeping one selected afterwards just to bluff the public. Now they want to rope you in. Aug. John himself has 31 things there, most undignified.' Apart from a few very early works, Gwen John (1876–1939) did not paint in Wales and rarely visited Wales. Following her training at the Slade School of Art in London, she went to Paris, where she remained for the rest of her life. Like John Gibson and Frank Brangwyn, her significance in Welsh visual culture is largely symbolic. Some later twentieth-century historians and critics, who followed T. Mardy Rees in his belief that ethnic origin was the appropriate factor by which to define a Welsh artist, have attempted to make use of her high international status to raise the prevalent evaluation of Welsh culture as a whole. Although Gwen John is now regarded by many connoisseurs as a more important painter than her brother Augustus, her involvement with Welsh culture was even less than his; hence the limited reference to her in this text.

[59] NLW, J. W. Jones Papers 3619, 13 September 1935, translated from the Welsh. By this time Evans was a disappointed man, and often expressed his resentment in attacks on Wales and Welsh institutions: 'I don't see many Welsh people. And this is not strange. My nation is not interested in my art nor in any other art in fact except for a little competition', ibid., 3625, 11 July 1938, translated from the Welsh. At the National Library Evans was surprised to see the work of 'crach arlunwyr Seisnig' (poor English artists) filling the gallery, ibid., 3652, c.1935.

[60] In 1936 Janes was included in the second exhibition organized by the group.

[61] D. Kighley Baxandall, 'Cyfraniad Cymru at Gelfyddyd Heddiw', *Tir Newydd*, no. 2 (1935), 3, translated from the Welsh.

[62] *Western Mail*, Eisteddfod Supplement, 1 August 1931. The controversy is discussed in Lord, *Y Chwaer-Dduwies*, pp. 97–9.

[63] Catalogue to the Objective Abstraction Group exhibition at the Zwemmer Gallery, London, 1933, quoted by J. R. Webster in *Ceri Richards* (Royal National Eisteddfod at Rhosllannerchrugog, 1961), no pagination.

638. Richard Huws,
Cartoon in *The Listener*,
1934, Mixed medium,
size uncertain

639. Ceri Richards,
Tulips, 1949, Oil, 914 × 1067

Richards broadly maintained this approach throughout his career, producing abstract images in painted and printed form which seldom abandoned figurative reference to the human body or botanical forms. He liked to work in series of images such as those based on his observation of the pearly kings and queens of east London, made in 1937 and 1938. Their occupation of an aesthetic ground outside the conventions of painting and sculpture observed by most of his Welsh contemporaries was paralleled by the even more ambiguous position of the contemporary works of his friend, Richard Huws, who in 1938 designed the huge *Mechanical Man* for the Glasgow Empire Exhibition.

640. Ceri Richards,
Costerwoman, 1939,
Oil, 760 × 630

641. Unknown photographer,
Richard Huws with the Mechanical Man,
Glasgow Empire Exhibition, 1938

642. Ceri Richards,
Cycle of Nature, 1944, Oil, 1022 × 1527

Professional contact between Ceri Richards and Wales was negligible in the period of development of his modernist aesthetics, but in 1940 he returned to become Head of Painting at the Cardiff School of Art, where he remained for four years. Richards had a deep love of poetry and music (he was a good pianist), which he had acquired from his father during his childhood, and the transfer of ideas between the visual, the musical and the poetic became central to his work. In particular, the poetry of Dylan Thomas was an important stimulus, which resulted in both graphic work and paintings on the theme of the *Cycle of Nature*, inspired by 'The force that through the green fuse drives the flower', published in 1934. After Thomas's death in 1953, Richards created a series of meditations on the poet's last major work, 'Do not go gentle into that good night', first published in 1951. Explorations by Richards of the relationship between music and painting reached their peak in a series stimulated by Debussy's 'La Cathédrale engloutie'. This piece, based on the Breton legend of the cathedral of Ys, submerged beneath the sea, clearly had resonances of

644. Ceri Richards,
Do Not Go Gentle into that Good Night,
1956, Oil, 1067 × 711

Cantre'r Gwaelod (lit. The Lowland Hundred) for the Welsh painter: 'In a succession of extraordinarily inventive and often very beautiful variations on the theme, fragments of the cathedral itself, washed by the restless movements of the sea, fill the pictures. Looking down into the greeny-blue waters one can discern rose-windows or arches filled with flowering tracery or the great round piers that seem to echo from the depths like Debussy's saturated chords.'[64]

With the benefit of hindsight it is clear that the omission of Richards from the 1935 Contemporary Welsh Art Exhibition was a major error. Within fifteen years Richards had become by far the most internationally renowned Welsh painter. More perspicacious was the inclusion of David Jones, whose voice would eventually prove to be the most influential of all, following the decline in status of the kind of abstraction presented by Richards (along with Sutherland and Piper) in the late twentieth century.[65] Having been born and raised in London, Jones's relationship with his father's land was complex, but by 1935 his meditations on the matter of Wales as a part of the idea of Britain were beginning to secure for him a place in the intellectual life of the nation. The text of his volume *In Parenthesis*, in which that relationship forms a complex sub-text to his experience of life in the trenches during

[64] Alan Bowness, quoted by Webster, ibid.

[65] The bibliography of David Jones exceeds by far that of any other Welsh artist. See Jonathan Miles and Derek Shiel, *David Jones: The Maker Unmade* (Bridgend, 1995), pp. 317–20.

[66] The book was not published until 1937. Its complexity and originality caused some confusion among the critics.

[67] From notes made in 1935 and published in *David Jones: A Memorial Exhibition* (Kettle's Yard Gallery, 1975), unpaginated.

[68] Jones had first been shown in Wales in the National Eisteddfod at Llanelli in 1930, and was also exhibited in the 1934 Eisteddfod.

645. Ceri Richards,
La Cathédrale engloutie,
c.1960, Oil

647. Unknown photographer,
David Jones and Eric Gill, c.1927

below:

648. David Jones, *An Ancient Mariner
meeteth three Gallants bidden to a
wedding feast and detaineth one*,
1928–9, Engraving, 176 × 137

646. Unknown photographer,
Ceri Richards, c.1955

the Great War, was completed two years before the exhibition in which his work was so prominently placed.[66] As a child he had been fired by the idea of his Welsh ancestry and, as a student at Camberwell School of Art, he had entertained the notion of becoming an illustrator, 'preferably from Welsh history and legend'.[67] His most important practical, rather than imaginative, experience of Wales came in the years 1924–6, when he lived with Eric Gill and his family at Capel-y-ffin, near Abergavenny, and during visits to the monastery at Caldey Island. In this rarefied atmosphere Jones learnt the engraving techniques which brought his work to public attention in illustrations to a series of publications, culminating in *The Book of Jonah* in 1926, *The Chester Play of the Deluge* in 1927, and *The Rime of the Ancient Mariner* in 1928. Jones's startlingly individual interpretations of the last two of these ancient themes were shown in the 1935 exhibition.[68] It was at Capel-y-ffin, too, that Jones developed his highly individual watercolour technique,

649. David Jones, Frontispiece for
The Rime of the Ancient Mariner, 1928–9,
Size of engraving, 44 × 76

385

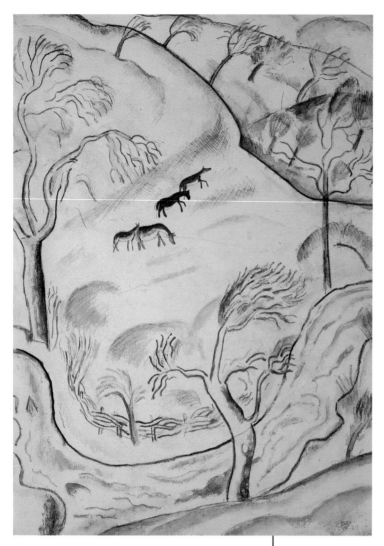

650. David Jones,
Capel-y-ffin landscape, Nant-y-bwlch (horses),
c.1924–5, Watercolour and pencil,
388 × 278

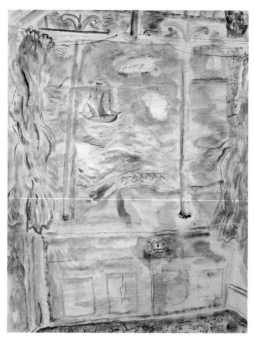

651. David Jones,
Manawydan's Glass Door,
1931, Watercolour,
620 × 480

painting landscapes in which his sensitivity to the mythic quality of place was made to shine through the objective reality. Jones's mind was of the kind which encompassed a deeper resonance in his immediate observation of a place or of animals, such as the ponies which populate many of his Capel-y-ffin landscapes. The legend that the Welsh ponies he saw in the hills were the descendants of the horses which ran free from the scene of the Battle of Camlan was a living element in his observation. Jones saw beneath the physical and temporal surface of the land, transposing myth from place to place and perceiving the after images of history. Thus, *Manawydan's Glass Door* was not a simple illustration of the famous passage about Pwyll in the first of the *Four Branches of the Mabinogi* to which the title made reference, but a meditation on its universal meaning, and it was transposed from south Wales onto a seascape in the south of England, where Jones was living in 1931.

In its withdrawal from the primacy of the objective record of the natural world and in its *faux-naïf* aesthetics, the work of David Jones was consistent with that of several of his contemporaries. However, in terms of content and purpose, he stood apart. Both in his visual imagery and in his writing he searched in Celtic mythology and the history of Ancient Britain for a key to his own divided identity. Viewed from a Welsh perspective, his interest in the 1930s in historical and mythological subject matter represented a reversion to one of the two sources of the national art of the late nineteenth century. At the same time, the other source, the myth of *y Werin Gymreig*, was revived in the work of Iorwerth C. Peate as the search for national continuity through a period of social upheaval again began to preoccupy leading Welsh intellectuals and artists.

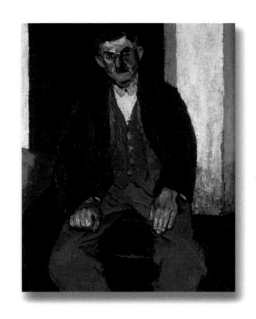

c h a p t e r

t w e l v e

POST-WAR

RENEWAL

652. Unknown photographer,
*The Welsh Kitchen in the
National Museum*, 1926

In 1934 the archaeologist Cyril Fox, Director of the National Museum of Wales, chose to address the conference of the Museums' Association in Bristol on the subject of open-air museums of folk life.[1] He remarked on the 'vision and energy of men such as the late Mr. T. H. Thomas of Cardiff', who had laid the foundation for the eventual construction of a folk museum. Thomas's collection of 'bygones' had passed from the Cardiff Museum to the National Museum and in 1926 it was incorporated into a display in a temporary gallery which included a typical Welsh kitchen and a bedroom. The wider context of Fox's remarks had been the report of a Royal Commission on National Museums and Art Galleries which had concluded in 1929 that open-air folk museums should be established for England, Northern Ireland, Scotland and Wales. The following year Fox visited Scandinavia, where he was greatly enthused by his experience of museums such as Skansen in Sweden and Lillehammer in Norway. He was particularly impressed by the Norwegian museum since it was concerned not simply with the preservation of a concluded past but with changing the future. Like his contemporaries in the Town and Country Planning movement, Clough Williams-Ellis and Patrick Abercrombie, Fox was much exercised by the desecration of natural beauty and the low standards of architecture which accompanied the suburbanization of Britain. He believed it to be 'undeniable that a more widespread understanding of native and traditional design and technique in arts and crafts, especially in that of building, would save western peoples from the worst vulgarities in construction and decoration of the present day'.[2] Institutions like Lillehammer had demonstrated to him the potential of the museum as the source for a national revival in art, craft and design:

> To them artists and craftsmen resort for ideas; and they have served to initiate and maintain in the North a renaissance of the native culture, to which is due much of the noble present-day craft work in glass, textiles and pottery, and the splendid originality of recent architecture and sculpture.[3]

Among Fox's staff at the National Museum of Wales at the time of his visit to Scandinavia was Iorwerth C. Peate, Assistant Keeper of Archaeology since 1927. By 1932 Peate had been elevated by Fox to take charge of a new sub-department of Folk Culture and Industries, from which seed it was intended the open-air

[1] Cyril Fred Fox (1882–1967) was President of the Association. He had joined the National Museum of Wales as Curator of Archaeology in 1924, under Mortimer Wheeler, whom he succeeded as Director two years later. He retained the post until 1948.

[2] Cyril Fox, 'Open-air Museums', *The Museums Journal*, 34 (1934–5), 113. Contributions by Mortimer Wheeler and Iorwerth C. Peate on the subject were published in the same volume.

[3] Ibid.

654. Geoff Charles,
*Iorwerth C. Peate and
Aneirin Talfan Davies at
the National Eisteddfod
at Rhosllannerchrugog*, 1945

653. Unknown designer,
Illustration by T. C. R. Hitchings,
cover for *Y Crefftwr yng Nghymru*,
1933, 106 × 77

museum should grow. He foresaw a time when, 'on the fair land of Glamorgan,
in close contact with the beautiful establishment in Cardiff – remaining when the
ugliness of the coal industry has disappeared – a complete picture of our national
life will be safeguarded in an Open-Air Museum, which will be a home for every
movement which aims at a renaissance of the old country'.[4] As well as securing
the heritage, the museum would, in Peate's romantic phrase, become '*teml yr
awenau byw*' (a temple of the living muse).[5]

In this essay Peate not only expressed the same ideas as Fox but did so
in strikingly similar language, though it is not clear in which direction the
mainstream of influence had run between the two.[6] It may be that Fox and
Peate had independently come to believe in the importance of the display of
folk culture since it is evident that their convergence of opinion had its origins
in profoundly different points of departure. Peate's beliefs were based on his
awareness, as a linguistic insider, of the power of the myth of *y Werin Gymreig*
as transmitted by O. M. Edwards and his contemporaries. He felt an intense
allegiance to the rural community from which he himself had sprung and which
he presented as a complete expression of that myth. He established the name of
the village of his birth, Llanbryn-mair, as a synonym for his philosophy in a series
of publications, notably *Cymru a'i Phobl* (1931), *Y Crefftwr yng Nghymru* (1933),
and *The Welsh House* (1940), which secured a place for him as a major force in
intellectual life. In his *Guide to the Collection of Welsh Bygones*, Peate presented
his romantic view of the virtues of the craft-based community, and clearly
implied that it defined Welshness:

[4] Iorwerth C. Peate, 'Diogelu ein Gwreiddiau' in
idem, *Sylfeini: Ysgrifau Beirniadol* (Wrecsam, 1938),
p. 105, translated from the Welsh.

[5] Ibid, p. 102.

[6] It should be noted that the Bygones Gallery,
with its two 'typical' Welsh rooms and exhibition
hall, preceded Peate's arrival at the National
Museum. Peate's *Guide to the Collection of Welsh
Bygones: A Descriptive Account of Old-Fashioned
Life in Wales* (Cardiff, 1929) incorporated some
material from John Ward's account of the
collection written to coincide with the exhibition
of a selection of the material at the City Hall in
Cardiff in 1913. A preface and an introduction
were written by Cyril Fox, who has been accused
of damning the work with faint praise in these
essays. See Catrin Stevens, *Iorwerth C. Peate*
(Cardiff, 1986), p. 2. This seems unjust, and the
matter is of some importance, given the almost
total identification of Peate with the collection.
Peate was part of a continuum, and although
his role in the creation of the open-air museum
was clearly central, it is nonetheless worth
remembering that Fox's term as Director of
the National Museum spanned the whole period
up to the founding of St Fagans in 1948. It might
not have been achieved without his support.

655. T. H. Thomas,
*Llywelyn Pugh addresses his friends at
the Smithy on the rise and virtues of Welsh
Nonconformity*, illustration from David
Davies, *Echoes from the Welsh Hills*,
1883, 89 × 133

one is led to believe that it is something more than an
accident of history or of local conditions that rural wisdom
should have manifested itself in the village smithy or the
carpenter's shop and at the shoemaker's bench. Anyone
who knows the real Wales well can estimate the importance
of these craftsmen in the life of their communities, and
with the decline of the demand for their services comes
the disintegration of small societies of folk which are of
real value in a civilized state.[7]

Peate's view was not substantially different from that
of David Davies and T. H. Thomas in *Echoes from the
Welsh Hills*, published in 1883, but it came disguised in
the form of the supposedly objective study of folk life. Peate
recognized his own detachment from the matrix of craft and
agriculture, carried on within a Welsh-speaking community
of Nonconformist religion and independent spirit, which he
studied. He described himself and the middle-class urbanities
around him as 'Black Coats'.[8] Nevertheless, he proposed not
only its centrality in the Welsh culture of the past but that it
should remain the source of the life of the modern nation. This
view proved influential, especially among Welsh-speaking
intellectuals already in sympathy with the myth, and it

656. Unknown photographer,
*Tom David, Cowbridge, demonstrating
thatching at the National Eisteddfod
at Mountain Ash*, 1946

impressed many more people than those with a specific interest in material culture.
Yet, as an individual, Peate was far from being a populist and the straight, though
narrow, furrow which he ploughed often isolated him from other important forces
in the culture. His philosophical position (despite occasional protestations to the
contrary) largely excluded industrial and urban Wales as an aspect of Welshness.
Even within the nationalist and Welsh-speaking community Peate was at odds with
Saunders Lewis and his followers because, in his view, they sought to attach Wales
to a continental tradition of urban high-culture. His anti-Catholic animus led him
to remark that 'Wales inherits the European tradition as a whole, and it is high
time for her to realise the arrogance of the assertion that nothing good can or
ever will come to her but from the direction of France and Italy – or, in short,
from Rome'.[9] He was equally estranged from Anglo-Welsh modernists, such as
those who associated themselves with Keidrych Rhys's magazine *Wales*, which he
attacked when it appeared in 1937. For many modernists, including the circle of
Dylan Thomas, Welsh-speaking Nonconformist Wales was a black shadow from

[7] Peate, *Guide to the Collection of Welsh Bygones*,
p. 1.

[8] Idem, *Diwylliant Gwerin Cymru* (Lerpwl, 1942),
p. 124.

[9] Idem, 'Traddodiad Ewrop', *Y Llenor*, XV, no. 1
(1936), 15, translated from the Welsh.

657. Unknown designer,
*Catalogue of the National
Eisteddfod Exhibition of Art,
Craft and Folk Life, Bridgend,*
1948, 120 × 180

which they fled to London. For Peate, that tradition retained the radical excitement of the mid-eighteenth century, when the poetry of Pantycelyn exploded 'like a hydrogen bomb on the Welsh horizon':

> Pantycelyn transformed the whole mind of the nation and its entire spiritual quality: he created the Nonconformity of the nineteenth century, and that is as much as to say that he *created* our Wales.[10]

Peate was anxious not only to preserve but to develop that Wales in a new flowering of material culture based on traditional crafts, and his crusade extended beyond the walls of the National Museum to a series of exhibitions and demonstrations in the eisteddfodau of the immediate post-war period. In 1946, while opening the Art and Craft Exhibition at the Mountain Ash National Eisteddfod (pointedly referring to it as the 'Craft and Art Exhibition') he mentioned the imminent creation of the long-awaited open-air museum, to be located at St Fagan's Castle, near Cardiff, and pointed out its implications:

> We shall preserve and develop every significant traditional craft in Wales. We shall have craftsmen's workshops where Welsh craftsmen will work and there you will see all the year round what you see at this Eisteddfod for one week ... Who can measure the influence of this revolutionary development on the whole future of Welsh craftsmanship?[11]

658. Unknown photographer,
*David Bell (left) with Myra Owen, Director
for Wales of the Arts Council of Great
Britain, and Wyn Griffith, Chairman of the
Welsh Committee of the ACGB, at the
opening of an exhibition of paintings by
Joshua Reynolds at the Glynn Vivian Art
Gallery in Swansea, c.1950*

At this point, the National Eisteddfod once more became the stage on which a debate about Welsh visual culture was conducted. Peate's high ambitions for a craft-based revival coincided with an equally forceful intervention in fine art. It was led by David Bell, Deputy Director in charge of art at the newly-created Welsh Committee of the Arts Council of Great Britain. Bell's appointment in 1946 led to an immediate increase in the number of exhibitions of contemporary art, many of them designed to begin or end their tours at the National Eisteddfod, where, as Bell pointed out, 'more people see the Arts and Crafts ... in one week than see any other exhibition in Wales in a year'.[12] Notwithstanding the populist aspect of Bell's approach, which aimed to extend both the enjoyment of looking at and of making art among the public, the philosophical starting points of the two movements were in opposition to one another. Bell argued that it was necessary to educate the Welsh public in a high art tradition to which, he believed, the culture had contributed little. He clearly perceived this to be a radical position

[10] Idem, 'Cymru a Rhamantiaeth', *Llên Cymru*, VI, no. 1 and 2 (1960), 23, translated from the Welsh.

[11] *Western Mail*, 6 August 1946.

[12] David Bell, 'Note on the Fine Art Exhibition', *Eisteddfod Genedlaethol Frenhinol Cymru. Celf a Chrefft. Caerffili, 1950* (Caerffili, 1950), p. 15. The creation of the Arts Council of Great Britain and the activities of Bell and the Welsh Committee are discussed in detail in Lord, *The Visual Culture of Wales: Industrial Society*, Chapter 5.

659. Geoff Charles,
D. J. Davies with visitors, 1951

rather than one which set him in the mainstream of the progressives of the nineteenth century. In fact, despite its conservatism, Peate's belief in regeneration from within was the more radical and visionary position. In 1950 the National Eisteddfod at Caerphilly provided both Peate, as Chair of the Art and Craft Committee, and Bell, intervening from his position on the Arts Council, a platform for the expression of their views. The catalogue contributions of both men did not seek to conceal the difference of opinion between them.[13] Through the Chair of the Exhibition Committee, James Tarr, and its secretary, Esther Grainger,[14] Bell succeeded in creating a selected, rather than a competitive exhibition, chosen by Cedric Morris, Ceri Richards and George Mayer Marton. Peate showed his irritation at the abandonment of what he (erroneously) believed to be the true Eisteddfod principle of competition by remarking that 'from time to time there has been much criticism of the Eisteddfod for holding competitions, especially among "intellectual" critics.'[15] He went on to make the case for a Welsh art created from within the craft tradition:

> we continue to depend excessively on critics and patterns of thought which are foreign to our tradition ... If the saying that 'from a body of living crafts grows a living art' is true, it is equally the case, I believe, that a completely Welsh contribution to art will come from the work of Welsh people under the criticism of people who know about Wales.[16]

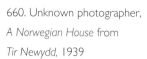

660. Unknown photographer,
A Norwegian House from
Tir Newydd, 1939

661. Unknown photographer,
*Dewi Prys Thomas at
Frank Lloyd Wright's
'Falling Water'*, 1984

The fine art exhibition at Caerphilly was far from meeting these criteria but there was no doubt in the minds of most critics that it was an outstanding success. Peate's acknowledgement of this rebuff was less than generous: 'Welsh artists should not become too complacent about the establishment of a Welsh School of Painting just because they had enjoyed a successful exhibition at Caerphilly.'[17] David Bell's programme had won the day and the following year he attempted a comprehensive statement of his position in an article published in *The Welsh Anvil / Yr Einion*, which opened with the provocative and misleading statement that 'There never has been in Wales any tradition of the fine arts'.[18] In diametrical opposition to Peate, Bell emphasized the centrality of urban life to art, pointing out that south Wales had already 'produced a number of painters of great promise'. He predicted a rosy future:

> There is in fact growing in Wales to-day a sense of community among practising painters and a consciousness among the public of the art [of painting] as a part of Welsh life ... I want to ... suggest that what we are witnessing in Wales is the first stirrings of a new and vital interest in the fine arts, which will one day grow into a tradition of painting ... the hedges are beginning to move.[19]

Peate largely retired from the fray but continued to believe as late as 1960 that there was no such thing as 'urban Wales'. However, the optimism of the pre-war period had turned to pessimism: 'As the "rural society" disappears (and disappearing it is) Wales too will disappear', he remarked.[20] This was a tacit admission that a Welsh craft revival, the encouragement of which had been a central argument, thirty years earlier, for the establishment of the Welsh Folk Museum was doomed, and with it the potential for a new Welsh art. It is certainly the case that no new school of craftspeople, painters or architects emerged to dominate the arts in Wales as a result of Peate's philosophy, or its primary expression at St Fagans. Individual craftspeople and artists, however, were impressed by Peate's ideas. The efforts of Dewi Prys Thomas, who became Principal at the Welsh School of Architecture in 1960, provide a notable example of how some elements of his philosophy were passed down to a generation of architects practising in the latter part of the twentieth century.[21] Thomas's love of the vernacular architectures of Wales, which derived from the interaction of particular patterns of life and local materials, was expressed as early as 1939 in an article in the magazine *Tir Newydd*. Like Peate, he regarded these architectures as a source, not as an end in themselves, and chose to illustrate his article with a modern Norwegian house, which he believed 'would fit perfectly in Wales'. However, Thomas's attitude was nationalist in a more mainstream political sense than that of Peate. He expressed the view that what he regarded as the second-rate and derivative nature of much of the architect-designed building of Wales was an aspect of political oppression.[22]

[13] Significantly, Peate's essay was printed in Welsh only, while that of Bell was also printed in English.

[14] For James Tarr, see Lord, *The Visual Culture of Wales: Industrial Society*, pp. 245–6, and Esther Grainger, ibid., pp. 227–47.

[15] Iorwerth C. Peate, Introduction to the catalogue *Eisteddfod Genedlaethol Frenhinol Cymru. Celf a Chrefft. Caerffili, 1950*, p. 5, translated from the Welsh. Peate's use of the word 'uchel-ael', translated here as 'intellectual', which carries distinct overtones of class snobbery, was intended to distance the fine art tradition from the craft tradition which he identified as being of the common people. Peate's attitude carried a strong echo of the animus against college-educated intellectuals often expressed by the painter Hugh Hughes. Both men were strongly wedded to the Nonconformist tradition which celebrated self-improvement.

[16] Ibid., pp. 5–6.

[17] *Western Mail*, 8 August 1950.

[18] David Bell, 'Contemporary Welsh Painting', *The Welsh Anvil / Yr Einion*, III (1951), 17. The statement was misleading because it failed to distinguish between a tradition and a body of works, leaving the impression in the minds of most people (rightly or wrongly) that what Bell meant was that there was no Welsh art. Bell's colleague at the Arts Council, Wyn Griffith, was less ambiguous on this point, remarking in 1950: 'So much for the past. No patron, no critic, therefore no painter, no sculptor, no Welsh art. It is as simple as that.' Wyn Griffith, 'The Visual Arts in Wales', *The Welsh Anvil / Yr Einion*, II (1950), 39. The belief that there had been no art in Wales is discussed in Lord, *The Aesthetics of Relevance*.

[19] Bell, 'Contemporary Welsh Painting', 17, 28.

[20] Peate, 'Cymru a Rhamantiaeth', 24, translated from the Welsh.

[21] For a discussion of the influence of Dewi Prys Thomas, see Peter Lord, 'The Genius Loci Insulted' in idem, *Gwenllian: Essays on Visual Culture*, pp. 141–8.

[22] Dewi Prys Thomas, 'Pensaernïaeth a Chymru', *Tir Newydd*, no. 15 (1939), 8–11, translated from the Welsh. Thomas (1916–85) was inspired by the American architect Frank Lloyd Wright, who acknowledged that his Welsh ancestry was of significance in the development of his career. As a practising architect, rather than as a teacher, Thomas's ideas were not given full expression until he co-operated in the design of the new headquarters for Gwynedd County Council at Caernarfon, begun in 1982.

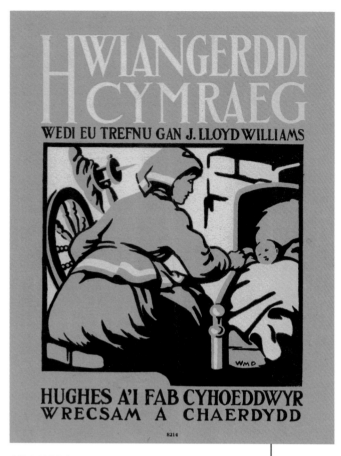

662. W. Mitford Davies,
Hwiangerddi Cymraeg, 1928,
Linocut, 220 × 155

Although national sentiment of a political kind found little expression in fine art after the Great War, visual imagery was utilized for patriotic purposes, especially in support of the Welsh language. The national sentiments of Hughes a'i Fab continued to be expressed both in the nature of their publications and in their commitment to the use of Welsh illustrators. The publication of music, in particular, provided an opportunity for graphic art as it had done regularly since the end of the eighteenth century. Among the most talented of the illustrators was W. Mitford Davies, whose covers for Hughes's various editions of children's songs were particularly attractive.[23] Mitford Davies's prodigious output was also the mainstay of the children's periodicals of the period, such as those published by Urdd Gobaith Cymru. The vision behind these publications was provided by Ifan ab Owen Edwards, whose wife, Eirys M. Edwards, was herself an able illustrator. Undoubtedly the most successful venture in children's literature produced by Hughes a'i Fab was *Llyfr Mawr y Plant*, published in 1931, from which the character Wil Cwac Cwac, drawn by Peter Fraser, became beloved among generations of children.[24]

663.
Unknown photographer,
*Lewis Valentine, Saunders Lewis
and D. J. Williams*, 1936

664. Geoff Charles,
*Carneddog and his wife Catrin
preparing to leave Y Carneddi,
their farm near Beddgelert*, 1945

[23] The archive of Hughes a'i Fab is held at NLW (Department of Manuscripts, not catalogued) and contains useful material on their relationship with illustrators such as W. Mitford Davies.

[24] Jennie Thomas and J. O. Williams, *Llyfr Mawr y Plant* (Wrecsam, 1931).

[25] In addition to his work for Welsh periodicals, including Y *Ddraig Goch*, Y *Ford Gron* and *Heddiw*, Richard Huws (1902–80) worked on English publications, including *Radio Times*. His radical social and political views were most clearly expressed in English in his work for *Everyman*.

[26] Frederic Evans was the son of T. C. Evans (Cadrawd). O. M. Edwards published several of his narrative pictures. Evans became interested in the use of film in schools in the 1930s, see NLW MS 16704E, letters 51–6.

[27] The remarkable photographic archive of Geoff Charles (b. 1909) is held at the National Library of Wales.

665. Frederic Evans,
Y Gwladgarwr dan Wawd,
1916

Explicitly political imagery emanating from a
nationalist standpoint was led by the cartoons
of Richard Huws,[25] although the most lasting
and resonant images were made in photography
and film. Some pioneering attempts to use
photography creatively for political purposes
were made in the children's magazine *Cymru'r
Plant* as early as 1916 by Frederic Evans,
whose *Y Gwladgarwr dan Wawd* showed
a patriotic child standing firm against the
mockery of his teacher and fellow pupils by
insisting on using his Welsh name rather than
an Anglicized form.[26] However, such attempts
at narrative photography made little impression
in comparison with the work of documentary
photographers who linked images to resonant

666. Peter Fraser,
Wil Cwac Cwac, frontispiece
of *Llyfr Mawr y Plant,* 1931

events in the nationalist struggle. The very artlessness of the amateur photograph
of Saunders Lewis, Lewis Valentine and D. J. Williams, taken after the burning of
the bombing school at Penyberth in Llŷn in 1936, contributed to its iconic status
within the national movement. At about the same time, the photographer Geoff
Charles began to work for the newspaper *Y Cymro*. Among the most celebrated
images created during the course of a career which lasted into the 1970s was that
of the poet Carneddog and his wife about to leave their farm near Beddgelert.
The photograph, taken in 1945, is a powerful visual expression of personal
and cultural loss of the kind against which Iorwerth Peate was simultaneously
campaigning with the written word.[27]

667. Frame enlargement from
Ifan ab Owen Edwards,
Y Chwarelwr, 1935

668. Frame enlargement from
Mark Lloyd, *Noson Lawen*, 1950

[28] D. Tecwyn Evans, 'Cadwraeth yr Iaith', *Transactions of the Honourable Society of Cymmrodorion* (1924–5, Part II), 70, translated from the Welsh. I am grateful to Dr Marion Löffler for this reference.

[29] *Y Cymro*, 13 April 1935, translated from the Welsh.

[30] 'Mr Ifan ab Owen Edwards's particular purpose may be described as making his public "Wales-conscious". The Urdd, in fact, has been quick to see the powerful propagandist uses to which documentary film making can be put. It is along these lines, I suggest, that a national art of the film in Wales should develop.' Anon., *Western Mail*, 8 February 1937.

The most notable individual works emanating from a philosophical position close to that of Peate were made in the medium of film. Nationalists who believed that the loss of the culture of Welsh-speaking rural communities would mean the end of Wales had been aware from an early date of the importance of film in the determination of their fate. In an address given to the Cymmrodorion section of the National Eisteddfod at Pwllheli in 1925, D. Tecwyn Evans maintained that 'it is not too late to prevent the death of Wales'. The first among several proposals he made to win back the 'comparatively uneducated *gwerin*' who were 'turning their backs' on the indigenous culture was to:

> Use the 'moving pictures' to this end – and make them Welsh and Welsh-speaking. For better or for worse, the moving pictures have 'come to stay' (as the English say). They are attended by hundreds every week in our small towns, and if Welsh people were to see, day and night, Welsh on the screen, that would be a great help.[28]

Evans's suggestion was not acted upon until 1935, when Ifan ab Owen Edwards made his film *Y Chwarelwr* in Blaenau Ffestiniog. The story, written by John Ellis Williams, concerned that central pillar of the myth of *y Werin Gymreig*, the aspiration to improvement by college education, so characteristically manifested in the career of Tom Ellis. Ifan ab Owen Edwards had a clear vision of the purpose of the film in his contemporary Wales:

> This effort is part of our campaign to keep it truly Welsh, in the face of extreme difficulties – to create Welsh talking-pictures, because we know for sure, without a shadow of doubt in our belief, that our responsibility as citizens of the world is to keep Wales pure in its ideals in the terrible crisis in which the world finds itself.[29]

Y Chwarelwr was widely shown in a mobile cinema which could function even in small villages without electricity, and was much appreciated by the general public. Some critics regarded its documentary background as a model for Welsh propagandist film.[30] However, apart from Edwards's other films concerning Urdd Gobaith Cymru, the Welsh-language youth movement, it proved to be an isolated experiment before the Second World War. In 1950 *Noson Lawen*, made by Mark Lloyd, enjoyed similar popularity and echoed many of the themes of its predecessor. The episodic script, celebrating family life in the context of a rural community, was linked together by the story of the successful college career of the son. The film took an optimistic view, with little suggestion of social estrangement resulting from his experience of the kind which Iorwerth Peate identified as the great paradox of educational improvement. Indeed, the film concludes with the *noson lawen* of the title, in which the honoured son is seen to participate fully. However, *Noson Lawen* had been preceded, a year earlier, by a much more remarkable, realistic and darker film, full of the foreboding of Peate's prognostications of the death of Wales. *Yr Etifeddiaeth / The Heritage*, filmed by Geoff Charles and written by the journalist

669. Frame enlargement from
Geoff Charles and John Roberts Williams's
film, *Yr Etifeddiaeth / The Heritage*, 1949

670. Frame enlargement from
Geoff Charles and John Roberts Williams's
film, *Yr Etifeddiaeth / The Heritage*, 1949

John Roberts Williams, was conceived as a protest against the building of a holiday camp near Pwllheli. The camp was perceived by the writer in both practical and symbolic terms as the advanced guard of Englishness, which threatened to destroy the indigenous culture of Llŷn. The clash of values epitomized by this intrusion into one of the heartlands of Peate's idea of Welshness was described in a series of telling images. The struggle for religious freedom and the persistence of the Nonconformist tradition were central themes, with a sequence of the public preaching of Tom Nefyn Williams providing a direct link to the eighteenth-century origins of this aspect of the culture. The poetic tradition was also strongly emphasized; the filming of the home of the poet Dewi Wyn was redolent of Samuel Morris Jones's drawings for O. M. Edwards's *Cartrefi Cymru*. The film toys with the possibility of an optimistic outcome, as a young evacuee from Liverpool learns from the poet Cybi of the Welsh heritage. Nevertheless, the most memorable sequences are unmistakably pessimistic. The young evacuee, Freddie, hands back the aged books, shown to him as symbols of the old culture, and the film concludes with a protracted, grey sunset over the sea – 'the sun of Wales setting too with people like Butlin invading us with their foreign culture'.[31] The film was Charles's first venture in a medium in which he was untrained, and it was made on a minimal budget. Despite considerable critical and popular acclaim he himself came to feel that, for the purposes of propaganda, 'amateurism wasn't good enough – we hadn't succeeded'.[32]

[31] Geoff Charles, recorded interview with Iwan Meical Jones, NLW Sound Collection, RM 115–16. The film received its most important early screening at the National Eisteddfod at Dolgellau in 1949. It then toured, providing a direct link with Ifan ab Owen Edwards's pre-war ventures, since the film was shown by the same projectionist.

[32] Ibid. Charles felt this was particularly true of the English-language version, which 'sounded corny'. The commentary in both versions, spoken by the poet Cynan, is almost continuous: 'Cynan boomed and rattled on and on … but when the visual was good enough we should have left it to speak for itself.' Charles made several other films, notably *Tir na n-Og*, about Galway, for which see David Berry, *Wales and Cinema* (Cardiff, 1994), p. 245.

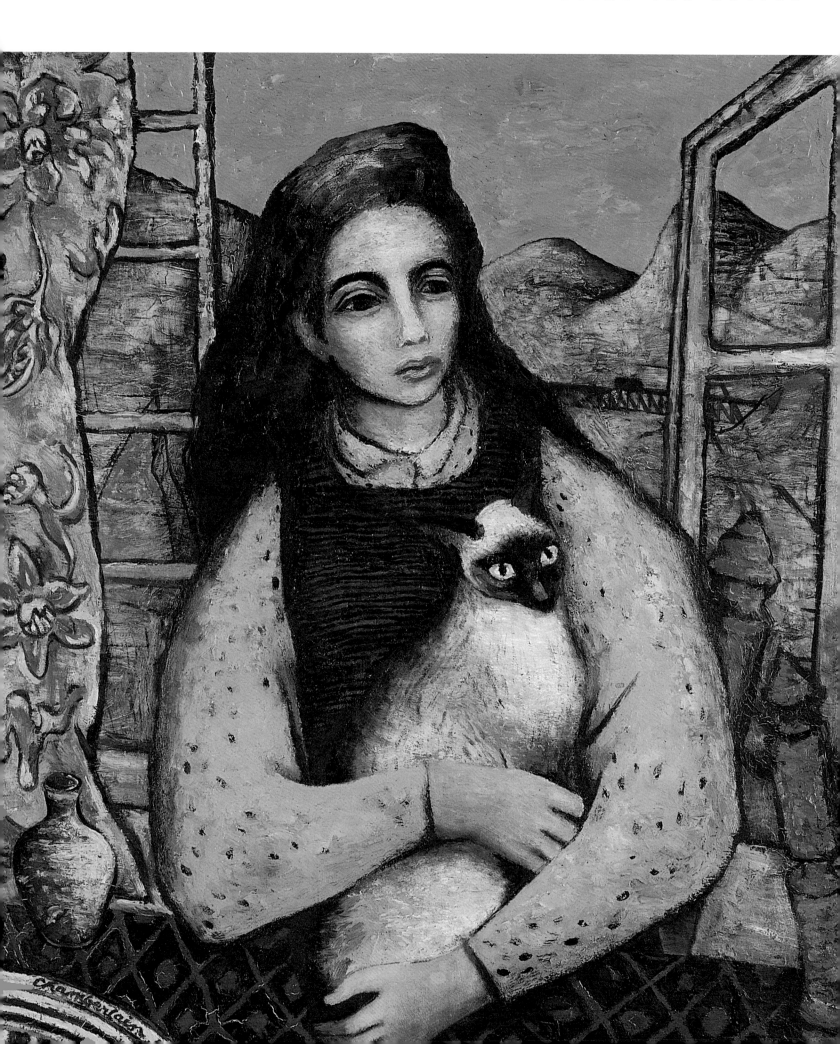

left: 672.

Unknown photographer,

Brenda Chamberlain with the

National Eisteddfod Gold Medal

for Art, with her painting 'The

Cristin Children', 1953

opposite: 671.

Brenda Chamberlain,

Girl with a Siamese Cat,

1951, Oil, 584 × 552

[33] Robert Lambert Gapper was born in 1897 in Llanaelhaearn, Caernarfonshire, and trained at the Royal College of Art from 1923 until 1927. He returned to Wales in 1928, eventually moving to Aberystwyth where he combined his career as a sculptor with teaching at the University. He carried out many public commissions, notably as a portrait sculptor. He was closely associated with the development of art and craft in the National Eisteddfod.

[34] Chamberlain's domination of Eisteddfod art exhibitions in the early 1950s led to the decision to prohibit the award of the medal to the same artist on more than two occasions. For the work of Brenda Chamberlain, though viewed primarily from the point of view of her contribution to Welsh literature, see Kate Holman, *Brenda Chamberlain* (Cardiff, 1997).

[35] For Ray Howard Jones (1905–96), see the obituary by David Stephenson and Lottie Hoare in *The Independent*, 27 June 1996.

The philosophical victory of David Bell over Iorwerth Peate, confirmed by the exhibition of Art and Craft at the National Eisteddfod at Caerphilly in 1950, set the agenda for the development of painting and sculpture in Wales in the succeeding decade. State funding by the Arts Council assumed increasing importance through its exhibition programme and the purchase of works to form a national collection of contemporary art. The status of Ceri Richards in the international art world was utilized on several occasions to give authority to the programme as a selector and adjudicator, and he also exhibited alongside a talented but disparate group of younger artists, many of whose careers had been interrupted by the Second World War. Brenda Chamberlain emerged as a leading figure, winning the new Gold Medal for Art at the National Eisteddfod at Llanrwst in 1951 with her picture *Girl with a Siamese Cat*. The medal, designed by the sculptor R. L. Gapper,[33] became the most prestigious Welsh art award, and was won for the second time by Chamberlain at Rhyl in 1953 with *The Cristin Children*, a work which reflected the persistent influence of the paintings of Gauguin which she had first seen twenty years earlier on a visit to Copenhagen. Following the breakdown of her marriage to John Petts, in 1947 Chamberlain went to live on Bardsey Island where, as well as painting, she developed the texts which eventually emerged as *Tide Race*, published in 1962 to coincide with an exhibition of her painting at the Zwemmer Gallery in London.[34] The work of another island dweller of the same generation, Ray Howard Jones, took longer to become familiar to the general public. Jones worked at the National Museum making archaeological reconstruction drawings before becoming a war artist in Cardiff and Swansea, in which capacity she also recorded the fortifications on Flat Holm and Steep Holm. In 1947 she moved to London but between 1949 and 1958 she stayed on the island of Skomer for long periods, an experience which provided the core material for her work.[35]

673. Ray Howard Jones,

Thunderstorm over Skomer, 1958,

Watercolour and gouache, 393 × 520

674. Claudia Williams,
Family on the Beach, 1957,
Oil, 775 × 102

675. Vera Bassett,
In the Gallery, c.1960, Watercolour, 570 × 395

The 1950s saw the emergence of several other talented women artists who, alongside Esther Grainger,[36] Brenda Chamberlain and Ray Howard Jones, provided a degree of gender balance in what had been, in the nineteenth and early twentieth centuries, a particularly male-dominated art world. Joan Baker was born in Cardiff, trained there, and developed her career as a painter while teaching at Cardiff College of Art. Claudia Williams first came to national attention as winner of the art prize in the young people's section of the National Eisteddfod at Caerphilly in 1950 and was a prominent exhibitor in Eisteddfod and Arts Council exhibitions throughout the decade. Vera Bassett was less widely known, although she was given a one-person exhibition at the Glynn Vivian Gallery in 1949 and her work was appreciated by critics. Mervyn Levy regarded her as 'that rarest of all the elements that go to make the complicated "world of art" – littered with its foibles, hypocrisies, and pretences – she is *the pure artist*':

> She seems to me ... to express the very essence of the Welsh flair for interpreting aesthetic matters through the crystal flame of the lyrical, poetic eye. The vision of Innes, Gwen John, and David Jones is there, but sufficiently uniquely, in her own, finely wrought line, and pure, deft washes of colour.[37]

Women featured prominently in the subject matter of both Vera Bassett and Claudia Williams. Bassett's women were sometimes portrayed with sympathetic humour, but also revealed an underlying sense of isolation and sadness, whereas Williams tended to monumentalize her subjects, often as madonna-figures in the company of children.

676. Kyffin Williams,
Llynnau Cwm Silyn, Caernarfon,
1948, Oil, 505 × 675

677. Kyffin Williams,
Dr Thomas Parry, c.1970,
Oil, 755 × 905

Two of the dominant figures in the Welsh painting of the period were domiciled outside the country which provided almost all the material for their work. Kyffin Williams, a native of Llangefni, became a teacher at Highgate in London in 1944 after training at the Slade School; John Elwyn from Newcastle Emlyn, who had trained at the Royal College, taught at Portsmouth and subsequently Winchester College of Art. Both men soon developed the distinct aesthetics which would sustain their long careers. The simple and monumental style of Kyffin Williams evolved through direct observation of the landscape of Snowdonia and of the people who lived and worked there. Unlike the generalized figures who populated the landscapes of many artists on tour in the eighteenth century, the smallholders and shepherds who featured in Williams's work were usually individuals known to the artist. He also painted them in single portraits, the quality of which created a demand for public portrait commissions, where his honest eye could lead to controversy. For instance, his penetrating portrait of Dr Thomas Parry did not coincide with the image of the famous literary scholar held in the minds of many people in the academic establishment.[38]

In contrast to the importance of direct observation in the work of Williams, many of the works of John Elwyn were landscapes of memory and of types, recalled from his childhood in Cardiganshire. In 1941 John Elwyn had begun to attend classes at Cardiff School of Art, where a degree of formal experiment reflected the teaching of Ceri Richards. The darkness of vision expressed in the work of this period has

[36] For Esther Grainger, see Lord, *The Visual Culture of Wales: Industrial Society,* pp. 227–35.

[37] Mervyn Levy, 'Vera Bassett', *Dock Leaves,* 6, no. 16 (1955), 29.

[38] Kyffin Williams describes his childhood and the early development of his career in his autobiography, *Across the Straits: An Autobiography* (London, 1973).

679. John Elwyn,
Before the Meeting, 1950,
Oil, 595 × 895

its origins in the position of the painter as a conscientious objector during the war. However, by the late 1940s the memory of the rich land of his youth had begun to give his work the vibrant colour and intimate detail for which it soon became celebrated. The fertility of his landscapes was often emphasized by symbols of maternity which expressed the closeness of the women of the rural community to the land which sustained them.

The talents of Kyffin Williams and John Elwyn were recognized by patrons such as Winifred Coombe Tennant as early as the late 1940s and Williams went on to become the most extensively collected of all Welsh painters in the twentieth century. Notwithstanding their individuality, the remarkable popularity of both artists was undoubtedly the consequence of the affirmation of the romantic myth of the landscape and *y Werin Gymreig* in their work. John Elwyn's images of chapel-goers, painted in the late 1940s and early 1950s, resonated deeply with those who, like Iorwerth Peate, sensed the imminent loss of a way of life with which they identified as characteristically Welsh.

680. Unknown photographer,
John Elwyn in his studio,
1955

opposite:
678. John Elwyn,
The Pet Cockerel, 1953,
Oil, 765 × 1275

681. Frederick Könekamp,
Jetsam on the Beach, 1959,
Oil, 1828 × 1219

A s was the case in the eighteenth and nineteenth century,
this sense of the cultural particularity of landscape was not
transmitted by all those who worked in Wales. A revival of the
fashion for Welsh landscape, stimulated by the acclaim accorded
outside the country to the work of Piper and Sutherland, attracted
distinguished English painters such as Kenneth Rowntree, whose
co-operation with Gwyn Jones, *A Prospect of Wales,* achieved
considerable success. Others came through England from further
afield, notably the German *émigrés* Fred Uhlman and Frederick
Könekamp. Although the English painter Mildred Eldridge did not
come to Wales as a part of this fashion but rather as a consequence
of her marriage to the poet R. S. Thomas, she also made extensive
use of her observation of the natural environment of various parts
of the country in her work. However, she was less concerned than
Thomas with the particular cultural associations of the landscape
and more concerned with a global view of the negative impact of
human society on the natural world. Her attitude, expressed most completely
between 1953 and 1956 in the extensive mural series commissioned to decorate
the nurses' refectory at the Robert Jones and Agnes Hunt Orthopaedic Hospital
at Gobowen near Oswestry, was unremittingly pessimistic.[39]

In the early 1950s the implicitly cultural nature of the landscapes of Kyffin
Williams and John Elwyn reflected similar values expressed in contemporary
industrial landscape. This suggested to David Bell and other critics the emergence
of a particularly Welsh painting. The case for Welsh Environmentalism[40] was
reinforced by the writing of the period, especially in the English language. It is
difficult not to associate characters such as Iago Prytherch, created in the early
poems of R. S. Thomas, with contemporary portraits by Kyffin Williams of Tom

[39] See Peter Lord, 'Parallel Lives?', *Planet,* 129
(1998), 17–26.

[40] The idea was most clearly expressed in the
introduction to the catalogue of the Welsh Arts
Council's Open Exhibition in 1953. See Lord, *The
Visual Culture of Wales: Industrial Society,* p. 262.

682. Margaret Thomas,
Kyffin Williams, 1948–50,
Oil, 900 x 500

far right:
684. Mildred Eldridge,
*Mural at the Robert Jones and
Agnes Hunt Orthopaedic Hospital
at Gobowen near Oswestry*, part
of Panel 6, 1953–6, Oil, 1600h.

right:
detail of *Panel 6*

683. Kyffin Williams, *Tom Owen*,
1951, Oil, 762 x 635

Owen and other members of the farming community. Similarly, aspects
of the work of John Elwyn were echoed in the writing of his close friend
Glyn Jones. Throughout the 1950s other painters, notably Gwilym
Pritchard, emerged to reinforce this sense of a Welsh art to which the
cultural resonance of particular landscapes gave meaning.[41] However,
the idea that this painting manifested a definitive Welshness and might
therefore be described as a national art elicited strong objections from
those who regarded such a national agenda as regressive. Brenda
Chamberlain believed that parochialism rather than the universality
which she sought would be the consequence of concentration on the
particularities of the culture. Writing about literature, but in terms
equally appropriate to visual art, she remarked in 1946:

> Until the tale is made universal, rooted maybe in locality, but
> reaching out to the full stretch of man's spirit, there will be more
> than the stalemate that has begun to show itself in Anglo-Welsh
> letters. There will be decadence and corruption where, not so
> long ago, was renaissance.[42]

The idea that universal values might be approached through the
particularities of Welsh culture was unattractive to political radicals on
the left in the aftermath of a war fought, in their view, as a consequence
of nationalism. The conservative nature of the aesthetics of the most
able Welsh painters, echoing that of Christopher Williams, Harry
Hughes Williams and Morland Lewis before the Second World War,
deepened suspicions that Welsh painting was simply inward looking
and consequently second-rate at a time when formal experiment in

what was fashionably regarded as the universal language of art was becoming highly valued. Many modernists believed that universality necessitated the denial of the particular cultural experience, and attempted to achieve their large aim either by working with the fundamental elements of visual language in a non-figurative manner or through the creation of highly personalized languages. American models in which the idea of external subject matter as central to painting were rejected in favour of the centrality of painting itself exerted a strong influence. The radical reaction against Welsh Environmentalism was manifested most obviously in the creation of an association of artists which took its name from the year of its creation, the 56 Group. Although the group had no formal aesthetic agenda, its establishment by invitation to like-minded individuals from the founders Eric Malthouse, David

[41] See Jonah Jones, 'The Art of Gwilym Pritchard and Claudia Williams', *The Anglo-Welsh Review*, 11, no. 27 ([1961]), 37–9. Arthur Pritchard, elder brother of Gwilym, also made an important contribution as a painter in this period.

[42] Quoted in Holman, *Brenda Chamberlain*, p. 89.

685. Gwilym Pritchard,
Cottages on Anglesey,
c.1950, Oil, 360 x 600

686. Robert Hunter,
Carmarthenshire
Landscape, Sunset,
1955, Oil, 787 × 546

ARTISTS HAVE A WORD FOR IT

687. Unknown photographer,
56 Group Exhibition at Tenby, 1957;
from left, the artist member George
Fairley, Philip Jones, Assistant Director
(Wales) of the Arts Council, and the
artist members Arthur Giardelli, Robert
Hunter and John Wright, in front of
Sorting Fish by Eric Malthouse

Tinker and Michael Edmonds, all of whom worked in Cardiff, gave it a broadly modernist feel. David Bell's attempt to write a Welsh history of art, *The Artist in Wales*, published the year after the formation of the group, conspicuously made no mention of them, but accorded a central place in its discussion of contemporary work to Kyffin Williams and John Elwyn. As Director of the Glynn Vivian Gallery, Bell gave the group an exhibition in Swansea, but, according to David Tinker, he 'didn't like us – in fact he had an exhibition of us down there and then bad-mouthed us'.[43] The reaction of Rollo Charles, Keeper of Art at the National Museum, was more positive and the group was shown in Cardiff in 1957. Tinker recalled that Lord Raglan, while opening an exhibition of work by the South Wales Group in an adjacent gallery, upbraided them as 'those clowns over there',[44] a hostile reaction which Tinker regarded as characteristic of Wales, whereas the group's exhibitions in England and beyond were, he believed, warmly welcomed.[45] Of the twelve original members of the group, only two, Ernest Zobole and Will Roberts, were Welsh-born, and Roberts was soon eased out.[46] It may be that a sense of outsiderness contributed to the hostility of some members, notably David Tinker, to the more culturally integrated work of the painters they depreciated. On the other hand, Robert Hunter sought to make use of the indigenous culture in a modernist idiom by creating visual equivalents for the sounds of the Welsh language to which he was exposed in Carmarthenshire. 'I do not consider my not wanting to speak Welsh as a barrier to understanding', he observed, 'I think I am in sympathy with the Welsh language; I like the sound it makes.'[47] In his non-figurative paintings he used symbols adapted from pagan and Christian-Celtic stone carving:

The Celtic crosses in the National Museum carry decorations and inscriptions which cannot be easily read but their form leaves no doubt that meaning is there. The precise meaning is obscured by time but the coherence and therefore the validity of the form remains. When a river has dried out the character of the movement of the water is recorded in the rivulets and runnels of the river bed; bird and animal tracks provide a visual record of their movements. Collectively these signs become a symbol for a happening and a feeling.[48]

688. Selwyn Jones,
Sgwrs, c.1958, Gouache,
533 x 736

The expanding art colleges provided a living for many artists like David Tinker and Robert Hunter who came to prominence as modernists in the late 1950s. Several individuals exerted their influence on a younger generation not only as painters but also as inspiring schoolteachers, notably Selwyn Jones at Caernarfon and Elis Gwyn Jones at Pwllheli.[49] By the late 1950s it can be said that a national art world of the kind which had emerged briefly in the late nineteenth century, but which had largely faded away between the two world wars, had been re-established. Like its precursor, it derived its energy from a mixture of Welsh-born artists, some based inside the country and others contributing from outside, and newcomers who chose gradually to identify themselves with Wales. However, the scale of state funding marked a crucial difference between the two periods. It manifested

689. Jonah Jones,
Y Tywysogion, Aberffraw,
Anglesey, 1969, Slate

[43] NLW, Welsh Visual Culture Research Project Deposit, David Tinker, interview with Lindsay Clements, November 1998.

[44] Ibid.

[45] Arthur Giardelli's wide range of contacts beyond Wales facilitated the group's exhibition programme. See Lord, *The Visual Culture of Wales: Industrial Society*, p. 264.

[46] 'We had problems when one person in particular – we thought the stuff was not very good – heard we were going to review the work, and he left ... We thought Will Roberts was simply imitating Jo Herman', NLW, Welsh Visual Culture Research Project Deposit, David Tinker, interview with Lindsay Clements. Brenda Chamberlain declined an invitation to join the group.

[47] 'Robert Hunter' in Meic Stephens (ed.), *Artists in Wales*, 2 (Llandysul, 1973), p. 55.

[48] Ibid.

[49] Elis Gwyn Jones taught at Pwllheli for the whole of his career. Selwyn Jones left Wales in 1960 but returned three years later to teach at Newport College of Art and subsequently at Bangor Normal College.

690. Jonah Jones,
John Cowper Powys,
1956, Bronze, 500h.

691. Geoff Charles,
Jonah Jones in his Studio at Tremadog, 1962

692. David Jones,
Trystan and Esyllt, c.1962, Pencil,
watercolour and gouache, 775 × 571

itself in art education, direct support of artists and craftspeople, and the development of the exhibition programme and infrastructure. Critical comment, led by David Bell after the war, also increased in quantity, though it remained largely in the hands of practising artists who were also able to write and present ideas on radio and latterly television. Elis Gwyn Jones contributed to the discussion of the visual arts, especially in the Welsh language, but in the absence of any periodical specializing in visual culture his observations and those of his contemporaries were published in magazines which dealt primarily with literature, notably *Dock Leaves*, edited by Raymond Garlick, which subsequently became *The Anglo-Welsh Review*. Prominent among the artist-commentators in the English language was the sculptor Jonah Jones who, in 1949, had worked in Eric Gill's workshops, where the interaction between word and image was a central concern. From there he moved to Llanystumdwy to work at the revived Caseg Press in 1951. As a letter-cutter and portrait sculptor he occupied an important place in the post-war art world.

In an autobiographical essay Jonah Jones acknowledged his indebtedness to the example of the painter and poet David Jones in resolving the crisis of identity which led to his coming to Wales:

> I read David Jones's *In Parenthesis* and was so moved, so impressed by the sheer rootedness of it that I believe it marked a turning-point in my life. Furthermore, its author looked back with pride on the Cockney-Cymro blend of his ancestry and fixed it in this time, this space. Meantime, I well remember, I once looked across the Bristol Channel from Exmoor to the Promised Land and resolved that come what may, I would somehow get to Wales and there root down. Taid John Jones had emigrated from the Caerffili area, I would return.[50]

During the 1950s David Jones explored the ambiguities of his individual identity and, through that, those questions of Welshness, Celticity and Britishness which had persistently surfaced in the work of Welsh image makers over the previous four hundred years. Gradually emerging from the smokescreen of avant-gardism, his works of the late 1950s and early 1960s, especially the inscriptions and images of mythological themes such as *Trystan and Esyllt*, reasserted the priority of content over form. To some, who considered themselves artistic and political radicals, these works seemed at best esoteric and at worst regressive. They were slow to make a direct impact upon the general public, but their influence on those among

the intellectual community for whom the issue of Welsh identity remained central cannot be doubted. In the last three decades of the twentieth century they informed the thinking of many who were (perhaps unwittingly) preparing the way for an evolution in Welsh consciousness with the potential to carry the nation beyond the division which had seemed to be the permanent inheritance of the emergence of industrial society. David Jones himself reviled industrialization, but from the perspective of the post-industrial world the intensity of his mythological imagery seems only to complement the equally intense imaging of industrial Wales which emerged after the Great War. We may see the work of David Jones in the mid-twentieth century as symbolic of several related constructs of nation which underlie much of the imagery presented in this volume. The imaging of industrial society, discussed in a separate volume in this series, now appears to be a parallel, rather than a divergent, stream. Together, it is to be hoped, the images that have emerged from these two groups of constructs will inform the representation of the Wales which evolves in the twenty-first century.

693. David Jones,
Cara Wallia Derelicta, 1959,
Watercolour on Chinese
white, 584 x 387

[50] 'Jonah Jones' in Stephens (ed.), *Artists in Wales*, 2, p. 104.

Acknowledgements

Every attempt has been made to secure the permission of copyright holders to reproduce images.

The following people and institutions have been acknowledged for the kind loan of transparencies and any copyright requirements. All churches have been acknowledged with their relevant images in the captions.

Aberdeen Art Gallery and Museum: 589 (© Courtesy of the Estate of Augustus John and the Bridgeman Art Library)
Abergavenny Museum, Monmouthshire Museums Service: 67
Art Gallery of New South Wales, Sydney: 206
Arts Council Collection, Hayward Gallery, London: 632 (© The Estate of John Piper)
Arts Council of Wales: 643 (© The Estate of Ceri Richards 2000. All rights reserved Design and Artist Copyright Society); 671 (© The Estate of Brenda Chamberlain); 673 (© The Estate of Ray Howard Jones); 681; 683 (© Kyffin Williams); 686; 688 (© The Estate of Selwyn Jones)
Austin/Desmond Fine Art Limited, London: 650 (© The Trustees of the David Jones Estate)
Birmingham Museums and Art Gallery: 457, 465
Board of Trustees of the National Museums and Galleries on Merseyside
Lady Lever Gallery: 242
Walker Art Gallery, Liverpool: 200, 427, 489
Bodleian Library, University of Oxford, MSS. Eng. Misc. e. 486/1, ff. 16v–17r: 217
Brecknock Museum, Brecon: 422
British Library: 47, 48, 72, 73
British Museum: 102, 244
CADW: Welsh Historic Monuments, Crown Copyright: 12, 34, 65, 66, 69, 70
Caernarfon Record Office, Gwynedd Archives and Museums Service: 325, 478, 569
Caernarfon Town Council: 516, 553
Cardiff Central Library: 498, 524, 532 (photos: Charles and Patricia Aithie, Ffotograff)
Cardiff City Hall: 559; 449, 558, 560 (photos: Charles and Patricia Aithie, Ffotograff)
Carmarthen County Museum: 98, 420, 443, 549; 627 (© The Estate of E. M. Lewis)
Ceredigion Museum,

Aberystwyth: 296, 297, 442
Church of St Andrew, Presteigne: 124
City of Bristol Museum and Art Gallery: 169
City and County of Swansea Glynn Vivian Art Gallery: 172; 552 (© The Estate of Christopher Williams): 640 (© The Estate of Ceri Richards 2000. All rights reserved Design and Artist Copyright Society) Swansea Museum: 305, 306, 370, 382
City of Nottingham Museums, Castle Museum and Art Gallery: 472, 473, 476
Detroit Institution of Arts: 157 (Founders Society Purchase, Robert H. Tannahill Foundation Fund, Joseph H. Parsons Fund, Ralph Harmon Booth Bequest Fund, DeRoy Testamentary Foundation Acquisition Fund, Edna Burian Skelton Fund, Mary Martin Semmes Fund, Abraham Borman Family Fund, Mr and Mrs Allan Shelden III Fund, and funds from Stanley R. and Lynn W. Day, Mr Richard A. Manoogian, Marvin and Betty Danto, Marianne Schwartz, European Paintings Council, Margaret H. Demant, Ruth F. Rattner, and other contributors)
Dove Cottage, The Wordsworth Trust: 456
Fifty-six (56) Group Archive: 687
Fitzwilliam Museum: 459
Friends of Hafod Archive: 234
Glamorgan Record Office: 497
Glantwymyn County Primary School, Powys: 678 (© The Estate of John Elwyn)
Glasgow Museums, The Burrell Collection: 9
Guildhall Art Gallery, Corporation of London / Bridgeman Art Gallery: 22, 474
Leeds Museums and Galleries, City Art Gallery / Bridgeman Art Library London: 225
Llandovery College, Llandovery: 413, 423
Lloyd George Museum, Llanystumdwy: 528
Magdalen College Library and Archives, Oxford: 166
Manchester City Art Galleries: 485
Martin Gregory Gallery, London: 462
Musée des Beaux Arts de Strasbourg: 246
Nasjonalgalleriet, Oslo: 470 (photo: J. Lathion)
National Gallery of Scotland: 240
National Gallery of Victoria, Melbourne: 168 (Felton Bequest, 1949)
National Library of Wales: 2, 6, 17, 18, 29, 30, 44, 64, 71, 74, 75, 78, 79, 88, 94, 95, 101, 107, 108, 118, 125, 132, 140, 141, 142, 143, 144, 145, 146, 147, 148, 151, 152,

153, 154, 155, 158, 161, 162, 164, 165, 167, 171, 174, 181, 182, 187, 192, 202, 203, 204, 205, 207, 208, 209, 210, 211, 212, 213, 214, 216, 219, 220, 223, 227, 228, 230, 231, 233, 239, 245, 249, 250, 251, 252, 253, 254, 255, 256, 257, 258, 259, 260, 261, 264, 273, 280, 283, 291, 294, 295, 298, 302, 312, 313, 317, 319, 320, 323, 324, 328, 329, 330, 331, 332, 333, 334, 336, 340, 341, 342, 343, 344, 345, 347, 348, 351, 353, 354, 356, 358, 360, 362, 363, 364, 365, 366, 367, 368, 369, 371, 372, 373, 374, 375, 376, 378, 379, 380, 381, 386, 387, 388, 389, 391, 392, 393, 394, 396; 397 (© University of Wales, United Theological College); 398, 399, 401, 406, 407, 408, 409, 411, 414, 415, 416, 417, 419, 421, 425, 426, 430, 433, 434, 436, 437, 439, 440, 441, 445, 446, 447, 448, 450, 453, 458, 461, 464, 479, 488, 493, 494, 496, 501, 502, 503, 504, 518, 519, 525, 527, 530, 533, 534, 536, 537, 538, 539, 540, 541, 542, 543, 544, 545, 547, 550, 551, 557, 561, 564, 565, 566, 568, 570, 576, 581, 582, 584, 590, 592, 597, 603, 604, 607, 608; 612, 613 (© Courtesy of the Estate of Augustus John and the Bridgeman Art Library); 614; 620 (© The Estate of Christopher Williams); 626, 636 (© The Estate of Brenda Chamberlain / John Petts); 631 (© The Estate of John Piper); 648, 649, 693 (© The Trustees of the David Jones Estate); 652, 654, 655, 656, 659, 660, 663, 664, 665; 677 (© Kyffin Williams); 679 (© The Estate of John Elwyn); 682, 691
National Museums and Galleries of Wales
National Museum and Gallery Cardiff: 7, 8, 23, 25, 26, 32, 36, 41, 43, 55, 61, 110, 119, 159, 160, 163, 173, 175, 176, 178, 191, 194, 195, 196, 215, 224, 236, 237, 238, 243, 284, 309, 321, 335, 349, 350, 352, 361; 400, 424, 432; 435 (© Private Collection); 490, 499, 505, 509, 510, 514, 517, 529, 567, 572, 575, 583; 594, 595, 596, 619 (© The Estate of Christopher Williams); 609, 610, 611, 615 (© Courtesy of the Estate of Augustus John and the Bridgeman Art Library); 630 (© The Estate of Graham Sutherland); 634 (© The Estate of Alfred Janes); 642, 645 (© The Estate of Ceri Richards 2000. All rights reserved Design and Artist Copyright Society); 692 (© The Trustees of the David Jones Estate)
Museum of Welsh Life: 270, 281, 282, 288, 300, 357, 404, 491, 522, 523, 571

National Portrait Gallery, London: 24, 186, 221
National Trust Photographic Library: *Chastleton House* – 149 (photo: Charles and Patricia Aithie, Ffotograff); *Chirk Castle* – 76 (By kind permission of the Guildhall Art Gallery, Corporation of London), 84, 85, 92, 96, 97, 138, 139, 271; *Cotehele House* – 10; *Dinefwr Park* – 134, 135, 136, 137; *Erddig* – 274, 275 (photo: John Hammond), 301; *Powis Castle Estate Trustees* – 5, 37, 38 (photo: Andreas Von Einsiedel), 35 (photo: John Hammond)
Nelson Museum and Local History Centre, Monmouth: 121
Newport Museum and Art Gallery: 307, 308 (© Private collection); 463, 555
Private Collections: 31; 33 (Property of Edward Harley Esq.); 39, 40, 45, 46, 54, 58, 59, 99, 100, 104, 105, 106, 109, 111, 115, 116, 126, 127, 128, 129, 130, 131, 150, 156, 189, 190, 197, 198, 201, 229, 232; 235 (Transparency kindly lent by Sotheby's); 272, 285, 286, 287, 289, 290, 292, 293, 299, 303, 304, 310, 311, 314, 318, 322, 337, 338, 346, 359, 377, 383, 384, 385, 390, 402, 403, 405, 410, 412; 418 (© Michael and Ann Gibbs Collection); 438, 444, 451, 466, 467, 468, 469, 475, 477, 481, 482, 483, 484, 487, 492, 495, 506, 507, 508; 512 (Transparency kindly lent by Sotheby's); 513, 520, 521, 526, 535, 546, 554, 562, 563, 573, 591; 605 (© Robin Llywelyn); 606 (© The Estate of Evan Walters); 616; 621, 622, 623 (© The Estate of Harry Hughes Williams); 624 (© The Estate of William Grant Murray); 625 (© The Estate of Will Evans); 628 (© The Estate of E. M. Lewis); 633 (© The Estate of Alfred Janes); 635 (© The Estate of Brenda Chamberlain); 638, 641 (© The Estate of Richard Huws); 646 (© The Estate of Ceri Richards); 647, 651 (© The Trustees of the David Jones Estate); 653, 657, 658, 661, 662, 666, 672; 674 (© Claudia Williams); 675 (© The Estate of Vera Bassett); 676; 680 (© The Estate of John Elwyn); 685 (© Gwilym Pritchard); 689, 690 (© Jonah Jones)
Robert Jones and Agnes Hunt Orthopaedic and District Hospital NHS Trust: 684 (© Mark Fiennes)
Royal Cambrian Academy, Conwy: 486, 500
Royal Collection © 2000, Her Majesty Queen Elizabeth II: 199
Royal Commission on the Ancient and Historical Monuments of Wales, Crown

Copyright: 3, 14, 15, 16, 21, 277
St David's School, Ashford, Middlesex: 193
St John's College, Cambridge: 42
State Hermitage Museum, St Petersburg, Russia: 179
Tabernacle, Machynlleth, Museum of Modern Art: 617
Tate Gallery Picture Library: 170, 248; 618 (© Courtesy of the Estate of Augustus John and the Bridgeman Art Library): 515; 629 (© The Estate of Graham Sutherland); 644 (© The Estate of Ceri Richards 2000. All rights reserved Design and Artist Copyright Society)
Tenby Museum and Art Gallery: 637 (© Courtesy of the Estate of Augustus John and the Bridgeman Art Library)
Tredegar House: 81 (© Rex Moreton): 82, 83, 103, 123
United Theological College, Aberystwyth: 315, 316, 355
University of Wales Centre for Advanced Welsh and Celtic Studies: 1, 4; 11 (photo: Charles and Patricia Aithie, Ffotograff); 13; 19 (© Gellilyfdy Farm, Strutt and Parker); 20, 80, 93, 133, 262, 339, 428, 429, 454, 455, 480, 531, 556, 574, 577, 578, 579, 580, 585, 586, 593, 598, 599, 600, 601; 602 (© The Estate of Eric Gill)
University of Wales, Aberystwyth: 431, 452; 639 (© The Estate of Ceri Richards 2000. All rights reserved Design and Artist Copyright Society)
University of Wales, Bangor, Bangor Collection, Bangor Museum: 263, 326, 327, 395
University of Wales, Cardiff, Welsh School of Architecture: 548
V&A Picture Library: 113, 222, 226, 241, 511
Welsh Film and Television Archive, Aberystwyth: 667, 669, 670 (© National Library of Wales); 668 (© National Savings, London); 587, 588 (© Welsh Film and Television Archive)
Westminster City Archives: 180
Worcester City Art Gallery: 471
Yale Center for British Art, Paul Mellon Collection: 117, 120, 122, 177, 183, 184, 185, 188, 247, 460

Picture captions
Extant works:
Sizes are given in millimetres, height before width.
Main media only are given.
Photographic prints from negative/positive processes are not sized.

Destroyed or unlocated works:
Size and medium are not given unless known for certain.

Index